D0216228

THE ATHENIAN ACROPOLIS

The Athenian Acropolis: History, Mythology, and Archaeology from the Neolithic Era to the Present is a comprehensive study of the art, archaeology, myths, cults, and function of one of the most illustrious sites in the West. Providing an extensive treatment of the significance of the site during the "Golden Age" of classical Greece, Jeffrey Hurwit discusses the development of the Acropolis throughout its long history, up to and including the recent discoveries of the Acropolis restoration project, which have prompted important reevaluations of the site and its major buildings. Throughout, the author describes the role of the Acropolis in everyday life, always placing it within the context of Athenian cultural and intellectual history. Accompanied by 10 color plates, 172 halftones, and 70 line drawings, *The Athenian Acropolis* is the most thorough book on the Acropolis to be published in English in nearly a century.

Jeffrey M. Hurwit is Professor of Art History and Classics at the University of Oregon.

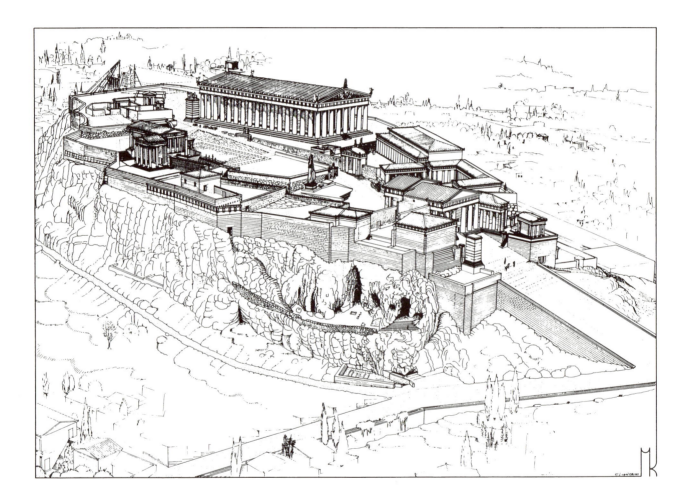

THE ATHENIAN ACROPOLIS

HISTORY, MYTHOLOGY, AND ARCHAEOLOGY

FROM THE NEOLITHIC ERA TO THE PRESENT

JEFFREY M. HURWIT

CAMBRIDGE
UNIVERSITY PRESS

PUBLISHED BY THE PRESS SYNDICATE OF THE UNIVERSITY OF CAMBRIDGE
The Pitt Building, Trumpington Street, Cambridge CB2 1RP, United Kingdom

CAMBRIDGE UNIVERSITY PRESS
The Edinburgh Building, Cambridge CB2 2RU, UK http://www.cup.cam.ac.uk
40 West 20th Street, New York, NY 10011-4211, USA http://www.cup.org
10 Stamford Road, Oakleigh, Melbourne 3166, Australia

First published 1999

Printed in the United States of America

Typeset in Palatino and Avant Garde in QuarkXPress [BA]

*A catalog record for this book is available
from the British Library*

Library of Congress Cataloging-in-Publication Data
Hurwit, Jeffrey M., 1949–
The Athenian Acropolis : history, mythology, and
archaeology from the Neolithic era to the present / Jeffrey M. Hurwit.
p. cm.
Includes bibliographical references and index.
ISBN 0-521-41786-4 (hb)
1. Acropolis (Athens, Greece) – Influence. 2. Athens (Greece) – Civilization.
3. Historic monuments – Greece – Athens – Conservation and restoration.
4. Excavations (Archaeology) – Greece – Athens.
I. Title
DF287.A2H87 1998 98-3713
938'.5 – dc21 CIP

ISBN 0-521-41786-4 (hardback)

For Joshua, Sarah, and Daniel

CONTENTS

CONTENTS

LIST OF ILLUSTRATIONS

List of Plates

ACKNOWLEDGMENTS

The first Greek phrase I remember ever learning was *mega biblion, mega kakon* – "a big book [is] a big evil." The lesson obviously did not sink in then, and all I can do now is hope that there are exceptions to the ancient rule.

I have many people and institutions to thank for many things. For first igniting my interest in the Acropolis so many years ago, there is J. J. Pollitt. For generously supplying photographs or facilitating their acquisition, there are: John Boardman (Oxford), N. Catsimpoolas (Boston), Stephano De Caro (Museo Archeologico, Naples), K. Demakopoulou (National Museum, Athens), the Deutsches Archäologisches Institut (Rome), Ev. Giannoussaki (TAP, Athens), H. Getter and I. Bialas (Staatliche Museen, Berlin), W. Geominy (Antikensammlung der Universität, Bonn), Hans. R. Goette (Deutsches Archäologisches Institut, Athens), Hirmer Verlag (Munich), I. D. Jenkins (British Museum), Gerhard Jöhrens (Deutsches Archäologisches Instituts-Zentrale, Berlin), Jan Jordan (Agora Excavations, American School of Classical Studies, Athens), Ch. Kritzas (Epigraphical Museum, Athens), Alain Pasquier (Musée du Louvre), Wesley Paine (Nashville), Maria Pilali (American School of Classical Studies, Athens), Steven Shankman and Holly Campbell (University of Oregon Humanities Center), Staatliche Antikensammlungen und Glyptothek (Munich), Ismene Triandi (Acropolis), Natalia Vogeikoff (American School of Classical Studies, Athens), E. Wasmuth Verlag (Tübingen), and E. Zervoudakes (National Museum, Athens).

For permission to reproduce their own excellent drawings and plans I am heavily indebted to Ernst Berger, Tessa Dinsmoor (for the work of W. B. Dinsmoor, Jr.), Evelyn Harrison, Ira Mark, Mary B. Moore, Candace Smith, and especially Tasos Tanoulas and Manolis Korres, whose brilliant studies of the Propylaia and Parthenon have so changed and deepened our understanding of those monuments and their history. The book would be much the poorer without their exquisite work.

For simply being willing to talk or write to me about various aspects of the Acropolis, both major and minor, in Athens and elsewhere, or for reading earlier drafts of parts of the book, I thank Judith Binder, Jeffrey Burden, Michael Hoff, Manolis Korres, Kenneth Lapatin, Carol Lawton, Alexander Mantis, Margaret Miles, Olga Palagia, Gregory Retallack, Jeremy Rutter, Geoffrey Schmalz, Andrew Stewart, Anne Stewart, Ronald Stroud, and W. Gregory Thalmann. These generous friends and scholars have offered welcome advice, encouragement, and constructive criticism and have saved me from many errors. They should not be blamed for those that remain.

My travel and research has received generous support (financial and technical) from a number of sources, above all the American School of Classical Studies in Athens, a Faculty Research Award from the University of Oregon, the Oregon Humanities Center (University of Oregon), where as a fellow I wrote several chapters and which supplied funds subventing the cost of the color plates, and Robert Melnick, Dean of the School of Architecture and Allied Arts, University of Oregon. I warmly thank all those concerned for their assistance. Then, too, none of this would have happened without the support and tolerance of my wife, Martha Ravits.

Finally, I wish to acknowledge the editorial labors of Jo Ellen Ackerman and Robin Ray, and most of all the guidance and saintly patience of Beatrice Rehl. This book has been a long time in the making, and I thank her for being willing to wait.

A few random notes. Translations are my own unless otherwise stated. My transliteration of ancient Greek is admittedly inconsistent (using "c" in "Acropolis" but "k" in "Perikles," for instance): I have my reasons, but they do not matter much. Finally, all dates (even little ones like "27" or "2") are "BC" unless otherwise stated, and they are often expressed in slashed terms such as "566/5" because the Athenian calender year began in the summer of one of our years and ended in the summer of the next.

August, 1997

ABBREVIATIONS

AA *Archäologischer Anzeiger*
AD *Arkhaiologikon Deltion*
AE *Arkhaiologike Ephemeris*
AJA *American Journal of Archaeology*
AJP *American Journal of Philology*
AM *Mitteilungen des Deutschen Archäologischen Instituts, Athenische Abteilung*
ANRW *Aufstieg und Niedergang der römischen Welt*
AntK *Antike Kunst*
AR *Archaeological Reports*
ARV² J. D. Beazley, *Attic Red-Figure Vase-Painters*, 2nd. ed. Oxford, 1963.
ASAtene *Annuario della Scuola archeologica di Atene e delle Missioni italiane in Oriente*
BABesch *Bulletin antieke beschaving*
BCH *Bulletin de correspondance hellénique*
BICS *Bulletin of the Institute of Classical Studies of the University of London*
BM British Museum
BSA *British School at Athens, Annual*
ClAnt *Classical Antiquity*
CJ *Classical Journal*
CP *Classical Philology*
CRAI *Comptes rendus des séances de l'Academie des inscriptiones et belles-lettres*

DAI Deutsches Archäologisches Institut
EM Epigraphical Museum, Athens
FGrHist F. Jacoby, *Die Fragmente der griechischen Historiker*, I–II (Berlin 1923–26), III (Leiden 1940–58)
GRBS *Greek, Roman, and Byzantine Studies*
IG *Inscriptiones Graecae*
JdI *Jahrbuch des Deutschen Archäologischen Instituts*
JHS *Journal of Hellenic Studies*
JMA *Journal of Mediterranean Archaeology*
JRA *Journal of Roman Archaeology*
JRS *Journal of Roman Studies*
LIMC *Lexicon Iconographicum Mythologiae Classicae*
NM National Archaeological Museum, Athens
OJA *Oxford Journal of Archaeology*
OpAth *Opuscula Atheniensia*
Pliny, NH Pliny the Elder, *Natural History*
RA *Revue archéologique*
REA *Revue des études anciennes*
SEG *Supplementum Epigraphicum Graecum*
ZPE *Zeitschrift für Papyrologie und Epigraphik*

COLOR PLATES

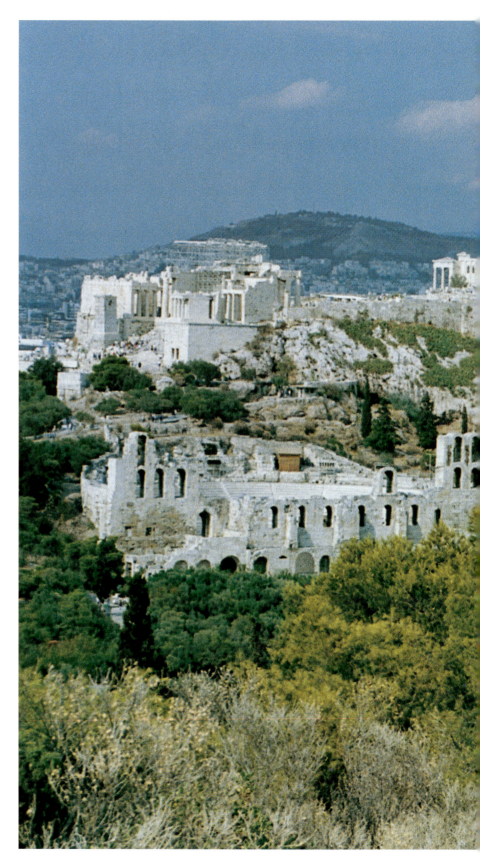

Plate I. The Acropolis from the southwest.
Photo: author.

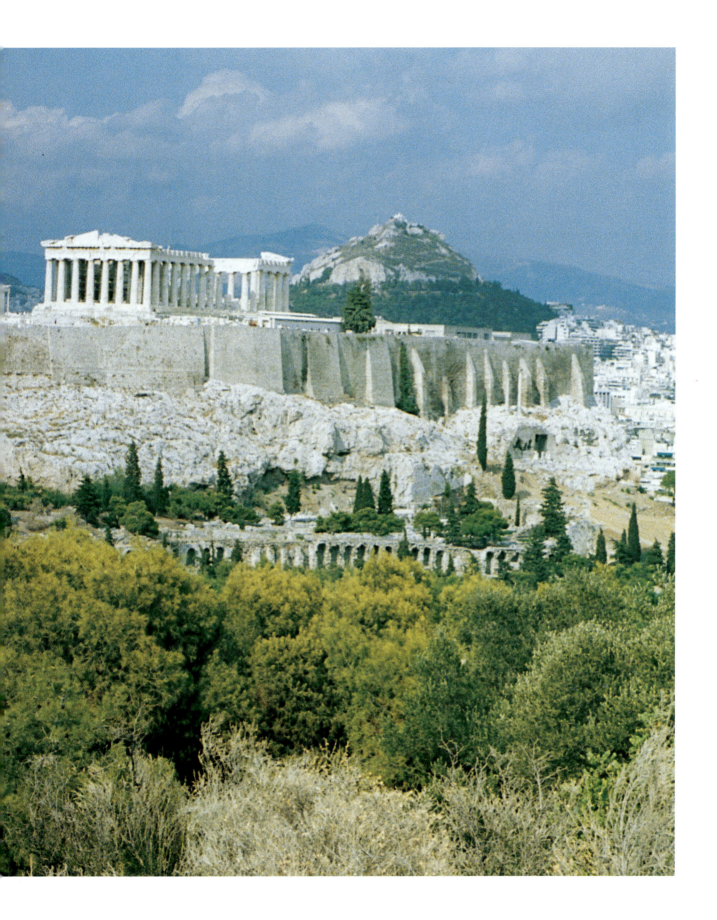

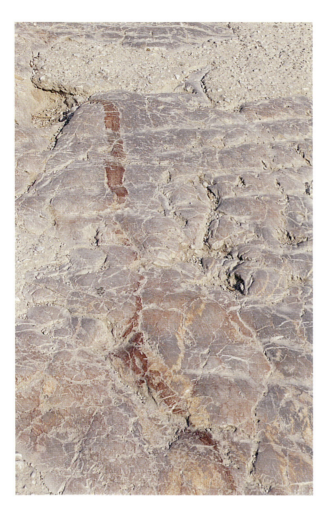

Plate II. Detail of Acropolis limestone. Photo: author.

Plate III. "Bluebeard" from a pediment of an early 6th-century temple, c. 560. Photo: author.

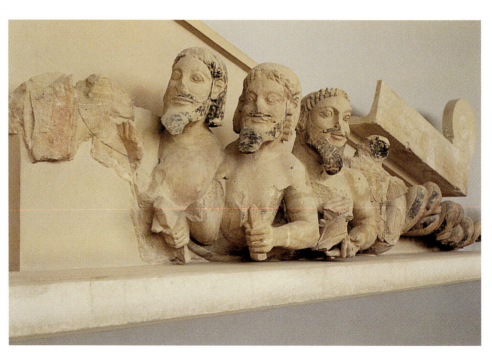

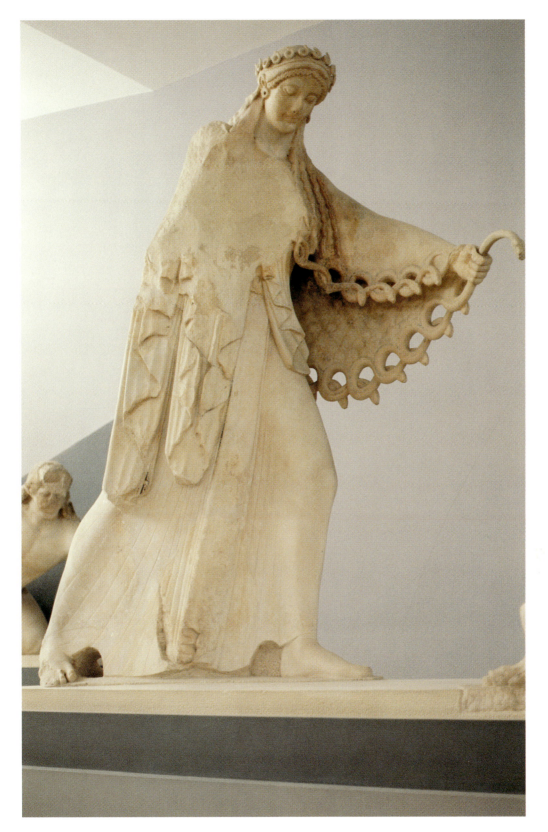

Plate IV. Athena from the Gigantomachy pediment of the
Archaios Neos, c. 500. Photo: author.

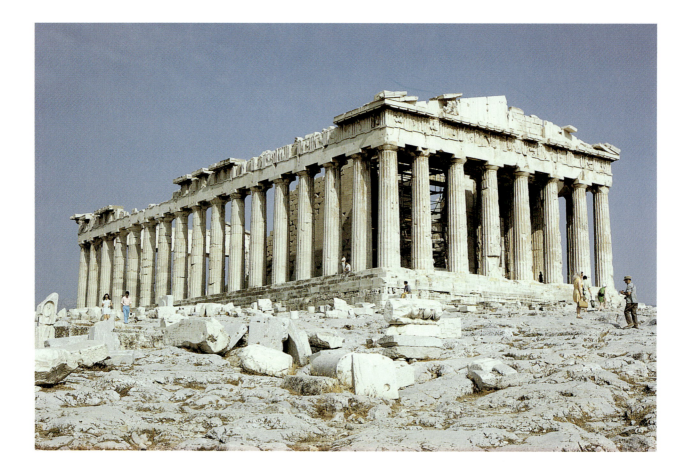

Plate VI. The west frieze of the Parthenon, detail.
Photo: author.

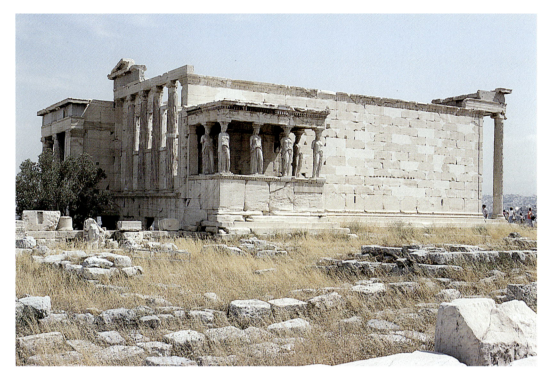

Plate VII. The Erechtheion (last Temple of Athena Polias) from
the southwest (430s?–406). Photo: author.

Plate VIII. The Propylaia (437–432) from the east.
Photo: author.

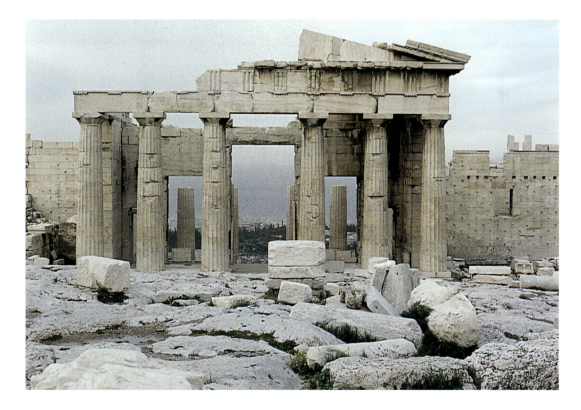

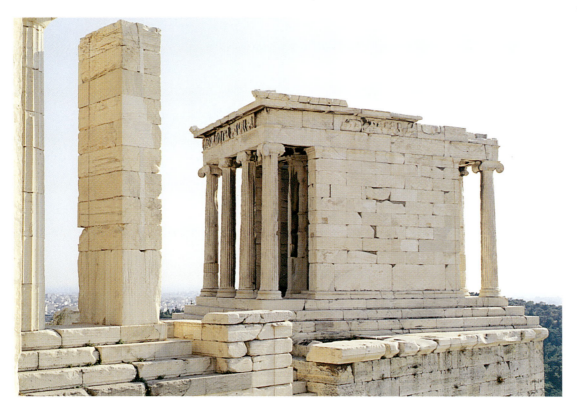

Plate IX. The Temple of Athena Nike (420s) from the north.
Photo: author.

Plate X. The Temple of Roma and Augustus (20/19).
Photo: author.

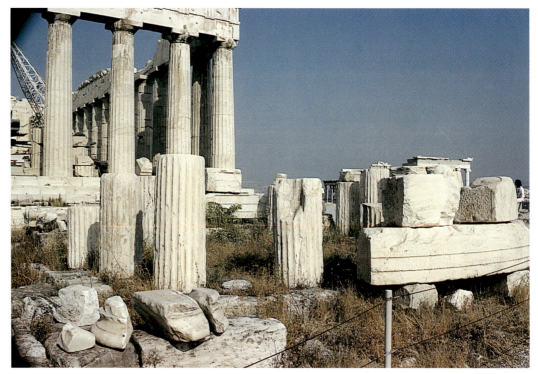

PROLOGUE

CHAPTER ONE

THE ROCK

First of all, the Acropolis was not then what it is today. For a single night of tremendous rainfall washed away the soil and left it bare, and at the same time there were earthquakes and a flood, the third before the destruction of Deukalion. But in earlier times the extent of the Acropolis reached to the Eridanos and Ilissos streams, and it included the Pnyx on one side and Mount Lykabettos directly opposite on the other, and the whole thing was covered with deep soil and, except for a few spots, was level on top.

<div align="right">Plato, Kritias, 111e–112a</div>

About 300 million years ago (at the end of the Paleozoic era), the forces of erosion, the course of rivers, and the natural death of marine creatures began to deposit enormously thick layers of sediment on the floor of Tethys, the great primal sea that once separated the mobile tectonic plates and land masses of Africa and Eurasia. During the last phase of the succeeding Mesozoic era (the Cretaceous period, lasting roughly from 145 to 65 million years ago), the African plate, drifting inexorably northward, struck the Eurasian, and in geological terms it struck hard. Among other things, the collision partly sealed off the western Tethys (the shrunken remnant is what we call the Mediterranean Sea), crumpled the accumulated ocean sediments (by now mainly limestones and sandstones), lifted part of the Eurasian plate, and eventually (in the Miocene epoch, about 20 million years ago) drove up the jagged Alps.

The Alps, however, are only the most conspicuous elements of a vast complex of mountain ranges extending from Gilbraltar to the Middle East. This so-called Alpine system comprises several smaller tectonic plates whose

jostlings have in turn created a large number of smaller mountain or "fold" belts. Among them are the mountain ranges of Greece, which stretch generally from the northwest to the southeast and extend into the Aegean Sea, where the tops of mountains appear as the islands of the Cycladic archipelago. Greece, then, is a by-product of the same titanic forces that threw up the Alps: it belongs to the Alpine range and (as earthquakes large and small continue to demonstrate) it remains tectonically very active.

At the south end of one of the dozen or so geotectonic zones that make up Greece lies Attica and the triangular Athenian basin [Fig. 1], with its "basement" of schist, its lowlands of marl, sediments, and alluvium, and its three great mountains: Parnes (1413m high) on the north, Pentelikon (1106m) on the east, and Hymettos (1037m) on the southeast. Parnes is basically limestone. Hymettos is mostly grey and white marble. And though there is grey marble on Pentelikon, too, it was the source for the fine white marble used to build the principal monuments of Classical Athens. At all events, these mountains, together with the less impressive limestone

<div align="center">3</div>

Mt. Aigaleos on the west, ring the Attic plain and as Greek plains go this one, about 22 kilometers long and 12 kilometers wide, is fairly large. Rising above the central plain are the sandstone and limestone hills of Athens itself, and at their center is the freestanding rock known as the Acropolis [Plate I, Fig. 4].[1]

The creation of the Acropolis – that is, the formation of its limestone in the late Cretaceous period (not long, relatively speaking, before the dinosaurs died off) and its eventual separation from the rest of the Athenian landscape – was considerably more complicated than Plato imagined in his *Kritias*, and far older, too (Plato believed it occurred just over 9,000 years before his own day). But compared to the collision of continents and the lifting of the Alps, of course, it was still a minor geological event. Rising 156.63 meters (about 514 ft) above sea level at its highest point, the Acropolis is not even the tallest hill in Athens: that distinction goes to Mt. Lykabettos, not quite two kilometers to the northeast, which is nearly twice as high (277m, or about 909 ft, above sea level) [Figs. 4, 5a]. But the Acropolis had just the right combination of accessibility (it rises only about 70m, or 230 ft, above its surroundings), usable summit (roughly 30,000 sq m, or over 7 acres), natural defenses, and water to make it the obvious choice for Athens's "high city" or "city on the hill" (for that is what *akropolis* means). Most every Greek city-state (or *polis*) had one, but no other acropolis was as successful as the Athenian: a massive urban focus that was always within view and that at various times throughout its virtually uninterrupted 6,000-year-long cultural history served as dwelling place, fortress, sanctuary, and symbol – often all at once.

The Acropolis is about 270 meters (885 ft) long at its longest and about 156 meters (512 ft) wide at its widest, but it is rugged and irregularly shaped, and the builders of its later, facetted walls merely regularized its essentially polygonal form [Figs. 3, 4]. They also created its flat-topped appearance: the rock actually slopes markedly from a ridge at its center down to the south [Fig. 5b], and only a long and complex series of retaining walls and artificial terraces on that side, together with a huge stone platform originally built to support a Parthenon planned decades before Perikles's great building [Fig. 106], extended the natural summit in that direction. Originally, then, the Acropolis was most sheer on the north and the east, and these sides especially are marked by virtually perpendicular cliffs about 30 meters (100 ft) high: the fortification walls built by men almost seem to emerge from them, as if the natural form had

somehow transformed itself into architecture [cf. Figs. 8, 35]. But even the south side of the rock is marked by great rocky bulges and escarpments [Fig. 4], and the only easy ascent was (and is) on the west side, where the Acropolis is joined by saddles to lower, smaller nearby hills (above all the Areopagos and the Pnyx, Fig. 2) that would themselves play significant roles in the political history and civic life of Athens.

The Acropolis itself is a complex, soft mass of schist, sandstone, marl, and conglomerate capped by a thick layer of hard, highly fractured limestone [Figs. 5b, 6]. The stone is fundamentally bluish to light gray in color but it is also frequently tinged pink, and irregular streaks of almost blood-red marl or calcite course through it [Plate II]: the brecciated, veined character of the stone is especially clear in those exposed portions of the rock that over the centuries have been heavily polished by feet. In places the stone is nearly crystalline and its character thus approaches that of marble (since marble is simply limestone that has undergone a lot of high pressure and heated metamorphosis, the line between them is sometimes hard to draw). At all events, this same "Acropolis limestone" caps the other outcrops and hills of Athens [Fig. 5a] and this, together with his keen observation of the environmental degradation of the Classical landscape, must have led to Plato's bold speculation that the separate hills of Athens were once covered by deep soil to form a single great plateau extending all the way from the Pnyx to the Acropolis to Lykabettos. In fact, eons ago the hills of Athens (before they *were* distinct hills) probably did belong to the same continuous physical feature, but it was not an earth-filled terrace, as Plato imagined. It was a long mountain ridge – the Acropolis and the other hills were originally knolls or bumps on its surface – that was eventually broken down by tectonic lifts, folds, thrusts, and intense erosion in the Miocene epoch. In more recent geologic times the gaps or valleys between the resultant hills were filled in by alluvial and coastal deposits (at one point the sea seems to have virtually lapped the slopes of the Acropolis itself). In other words, the Acropolis is basically an ancient mountaintop, a remnant of a once much greater limestone formation that, like the other hills of Athens, came to be partly buried by the levelling sediments that created the Athenian plain.[2]

The Acropolis is characterized on all sides by hollows and projections, by deep folds and fissures, and by caves large and small. A series of caves (once sacred to Pan, Zeus, and Apollo) marks the northwest shoulder of

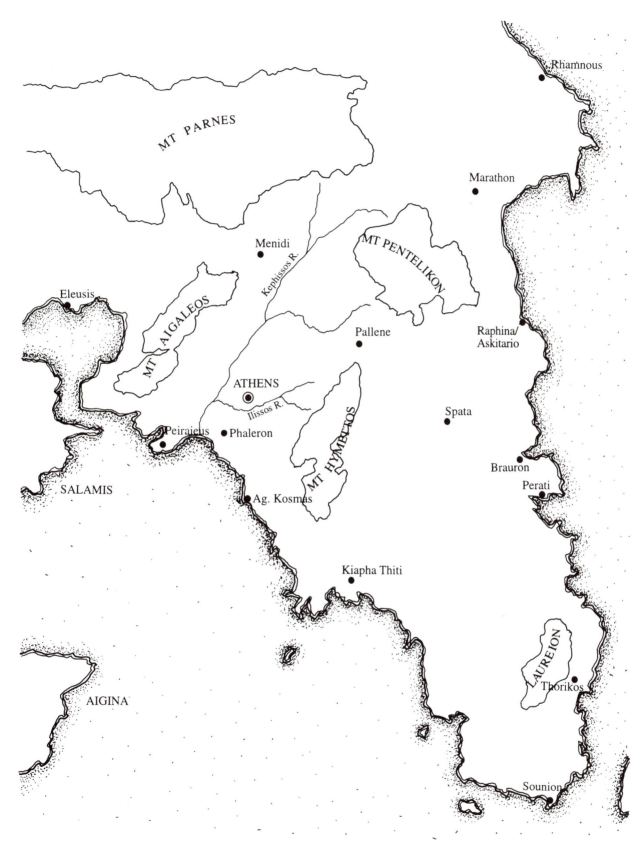

Fig. 1. Map of Attica, by I. Gelbrich.

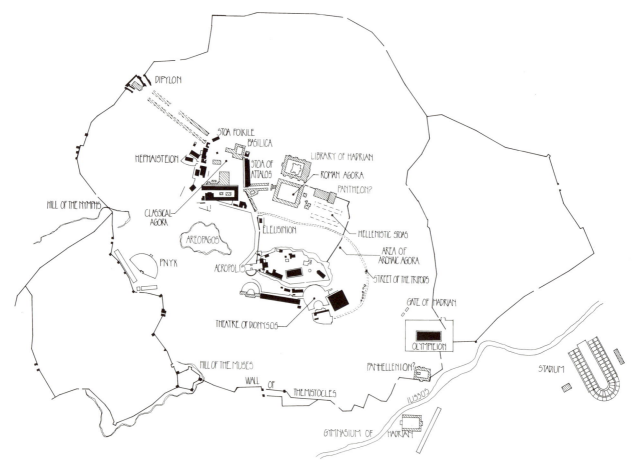

Fig. 2. Map of Athens, by I. Gelbrich.

the rock [Figs. 7 and 124]. A high, deep cave gouges the middle of the north side [cf. Fig. 57]. A huge, rounded grotto is the principal feature of the east [Fig. 8].[3] And on the south ancient architects, having shaved smooth the bulging face of the limestone, collaborated with the caves nature provided to create such structures as the Monument of Thrasyllos [Fig. 9]. The effects of natural erosion are everywhere palpable, and the action of earthquakes, taken together with the seepage of water channeled through widening fractures in the limestone – in places the Acropolis has split or has been in danger of splitting apart – have at various times sent great pieces of the rock to the ground below (an inscription marking the extent of the *peripatos*, the roadway that encircles the Acropolis, is carved on such a fallen boulder, for example [Fig. 208], and in the first century AD another large chunk smashed into the center of the paved court of one of Classical Athens's most splendid fountainhouses, the Klepsydra, on the northwest slope). The interior mass of the Acropolis now appears to be

stable, and the citadel seems in no danger of splitting deep at its core.[4]

The limestone that caps the Acropolis, though hard, is porous and water-soluble. The schist-sandstone foundation of the rock, though soft, is neither. Thus, water percolates down through the limestone only to be stopped by the impermeable layer below. It collects atop the seam, and as a result, it could be tapped at relatively shallow depths on the periphery of the Acropolis, where the limestone meets the schist-sandstone layer, where the forces of erosion have hollowed out caves or rock-shelters, and where the water naturally emerges again in springs.[5] In essence, then, the lower slopes of the Acropolis were full of natural reservoirs, and it was this ready supply of water that early on made it an attractive site for human occupation. At the northwest corner of

Opposite: Fig. 3. Plan of the Acropolis by I. Gelbrich (after Travlos 1971, fig. 91, and Korres 1994b, 43).

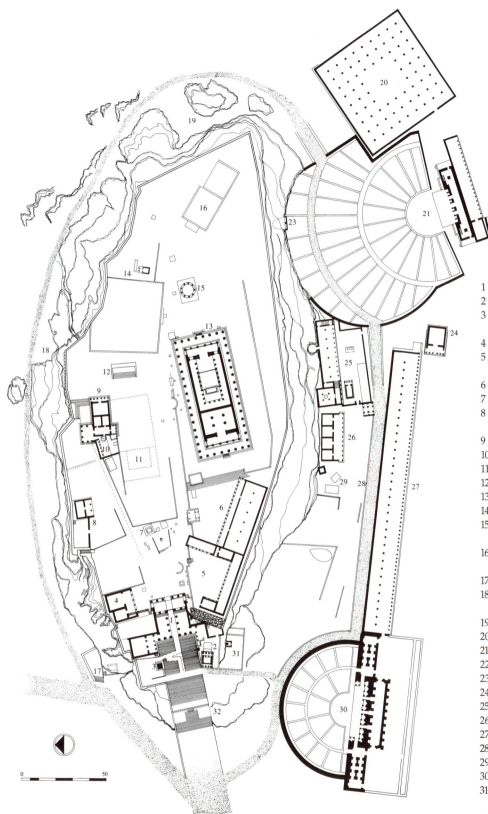

1 Propylaia
2 Sanctuary of Athena Nike
3 Monument of Eumenes II
 (later, Agrippa)
4 Northwest Building
5 Sanctuary of Artemis
 Brauronia
6 Chalkotheke
7 Bronze Athena
8 Building III (House of the
 Arrhephoroi)
9 Erechtheion
10 Pandroseion
11 Opisthodomos?
12 Altar of Athena
13 Parthenon
14 Sanctuary of Zeus Polieus
15 Temple of Roma and
 Augustus
16 Building IV (Heroon of
 Pandion?)
17 Klepsydra Fountain
18 Shrine of Aphrodite and
 Eros
19 Cave of Aglauros?
20 Odeion of Perikles
21 Theater of Dionysos
22 Temple of Dionysos
23 Monument of Thrasyllos
24 Monument of Nikias
25 Asklepieion
26 Ionic Stoa
27 Stoa of Eumenes II
28 Boundary of the Spring
29 Temples of Isis and Themis
30 Odeion of Herodes Atticus
31 Sanctuary of Aphrodite
 Pandemos
32 Beulé Gate

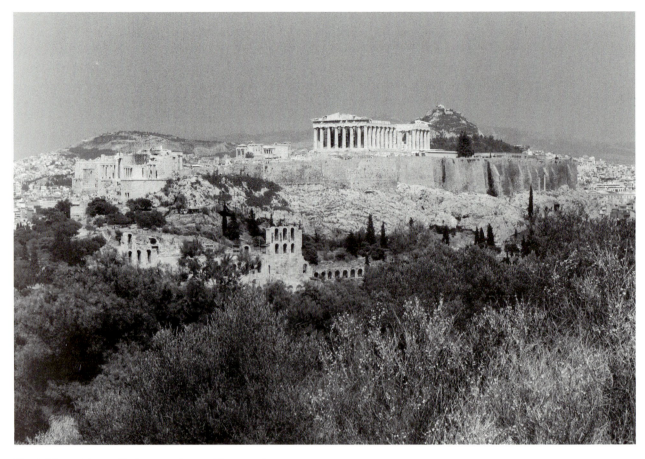

Fig. 4. View of Acropolis from southwest. Photo: author.

the rock shallow artesian wells tapped the supply virtually as early as habitation can be documented at Athens, in the Neolithic period, and this is the area that became the location of the Klepsydra. Midway along the north side of the rock, Late Bronze Age Athenians dug a well at the bottom of a deep, hidden fissure, and built a remarkable stairway of wood and stone to reach it [Fig. 57]. On the south side, natural springs were thought sacred and played important roles in Classical cult (for example, in the sanctuary of Asklepios, Figs. 192, 193).[6]

This, then, was the easily defensible, relatively water-rich rock that would dominate the political, military, religious, and cultural history of Athens – the hub of what the oracle of Delphi knew as "the wheel-shaped city."[7] Historical Athenians called it the "Acropolis" or even just "polis."[8] What the prehistoric inhabitants of Athens called it (and what divinities they first worshipped upon it), we do not know. There was a Classical memory of a distant time when the Athenians themselves were known as the Kekropidai or Kranaoi,

after their prehistoric kings Kekrops and Kranaos, though there is no memory of what they called the Acropolis.[9] But it is entirely plausible that they called it (and the small clusters of houses they eventually planted atop it and its slopes) *Athene* or, in the plural, *Athenai*, words that seem, etymologically, pre-Greek. If that is so, the rock lent its name to the patron deity who would be so particularly and strongly associated with it, the city goddess who was, in effect, imminent in the rock and whose three principal sacred emblems or symbols – the owl, the snake, and the olive tree – dwelled or grew upon it. Some small trace of that primeval identity may, in fact, be preserved in the seventh book of Homer's *Odyssey* when *Athene* (an epic form of Athena) is said to travel to *Athene* (the city, in the singular): the words are the same and so, linguistically, the goddess visits herself.[10] In short, it seems that Athena was in the beginning named after the rock. No matter what later myths, mythographers, and tragedians suggest, the city was not named after her.[11]

8

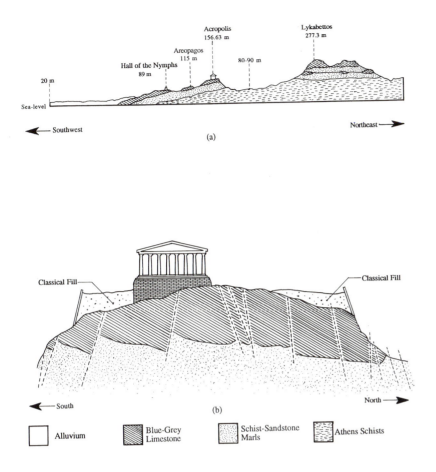

Acropolis
156.63 m

Lykabettos
277.3 m

Areopagos
115 m

Hall of the Nymphs
89 m

80-90 m

20 m

Sea-level

← Southwest

Northeast →

(a)

Classical Fill

Classical Fill

← South

North →

(b)

Alluvium

Blue-Grey
Limestone

Schist-Sandstone
Marls

Athens Schists

Fig. 5. a. Section through the hills of Athens (after Judeich 1931, fig. 7) b. Section through Acropolis (after Higgins and Higgins 1996, fig. 3.4). Drawings by I. Gelbrich.

Fig. 6. View of Acropolis limestone, south slope. Photo: author.

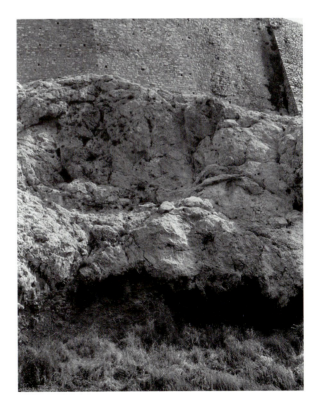

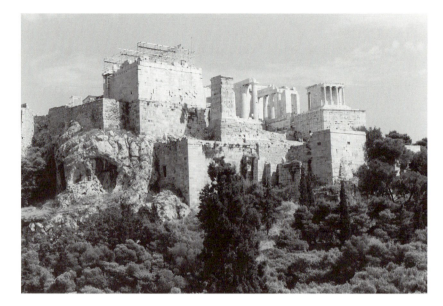

Fig. 7. Northwest slope of Acropolis. The caves marking the slope were sacred to Apollo Pythios/Hypoakraios (Under the Long Rocks), Zeus Olympios, and Pan. Photo: author.

Fig. 8. Grotto on east slope (Cave of Aglauros?). Photo: author.

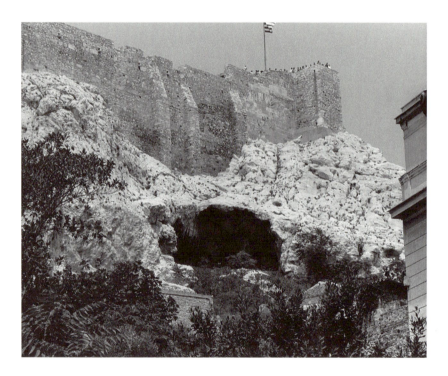

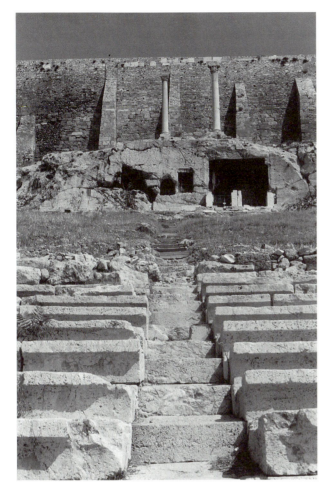

Fig. 9. Monument of Thrasyllos (320/19), above Theater of Dionysos. Photo: author.

And yet, in the end, who was named for what did not matter much. What mattered was the special relationship the city forged with the goddess and how completely Athena came to be regarded as Athens itself. The Athenians virtually spoke her name (*Athena* or *Athenaia*) every time they named their city (*Athenai*) and themselves (*Athenaioi*).[12] And although Athena was, of course, a goddess for all Greeks, the Athenians claimed her as their own, identifying themselves with her, and claimed for themselves many of the very qualities Athena herself embodied: military valor, boldness, love of the beautiful, love of reason and moderation, and knowledge.[13] Athena was their guide and their security.[14] She was the Athenian ideal and in the Athenian mind, where religious belief and secular patriotism dwelled so easily, so inextricably, together, the goddess and the city were one.[15]

THE GODDESS

Of Pallas Athena, glorious goddess, I start to sing,
goddess of the flashing eyes, resourceful, implacable of heart,
modest virgin, guardian of cities, warlike,
Tritogeneia, whom Zeus himself, all-wise, bore
from his august head, with warlike armor,
golden and flashing bright, and awe held all the gods
as they watched. And she swiftly rushed before Zeus
who holds the aigis, leaping from his immortal head,
shaking her sharp spear. Great Olympos quaked
fearfully under the might of the flashing-eyed one, and the
earth shrieked terribly all around, and the sea was moved,
confounded with purple waves. But the sea suddenly
calmed, when the shining son of Hyperion
stayed his swift-footed horses so long until the maiden,
Pallas Athena, took her godlike armor from her immortal
shoulders. And Zeus, all-wise, rejoiced.
And so hail to you, child of Zeus who holds the aigis!
I shall remember you and another song, too.

Homeric Hymn XXVIII: To Athena

The Origins of Athena

We do not know where the Greek gods came from, but the conventional view is that most of them came from somewhere else. It is widely believed, for example, that when the Indo-European people who would in time become "the Greeks" arrived on the mainland early in the Bronze Age, they superimposed their own system of "sky-gods" (mostly male) upon a stratum of chthonic, or earthly, powers (mostly female) worshipped by the peoples they found in place – above all, fertility and earth-mother goddesses (such as Gaia, or Earth, herself) of Neolithic and even Palaeolithic origin, the very embodiments of fecundity [cf. Fig. 47].[1] Now, it was indeed typical of most ancient peoples to respect and absorb, or else co-opt, the gods of others rather than reject them (why take chances, and why fight holy wars?). And so the Greek pantheon has often been considered the result of a Bronze Age mixture of more or

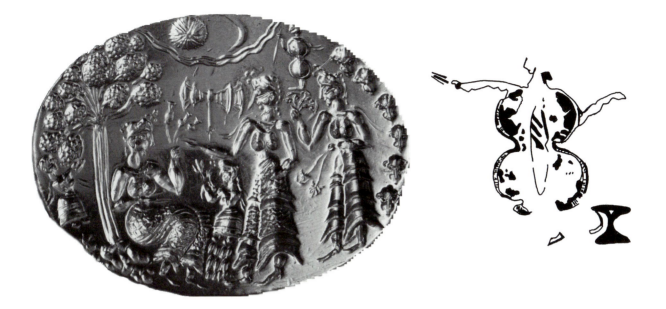

Fig. 10. Gold Ring from Mycenae,
c. 1500. Courtesy Hirmer Verlag München.

Fig. 11. "Shield Goddess" on painted tablet from Cult Center,
Mycenae (NM 2666). Late 13th century. Drawing after Rehak
1984, 537.

less indigenous nature divinities, broadly responsible for the welfare and fertility of human beings, plants, and animals, and newly arrived Olympians, with their own more specific functions and limited spheres of action – "special department gods," as they have been called.[2]

Things are not likely to have been that simple. Although the distinction between "earth gods" and "sky gods" was taken for granted even in antiquity,[3] the notion that one set of divinities (the chthonic ones) was "native" and the other (the Olympians) consisted of "Indo-European invaders" is hard to prove. It is remarkable, for example, that only one of the canonical twelve Olympian gods can confidently be said to have an impeccable Indo-European pedigree, and that is Zeus, god of the shining sky and thunderbolt. Yet some gods outside the canon (the sun-god Helios, for example) are almost certainly Indo-European, too. On the other hand, Demeter, the principal goddess of the cultivated earth, is also an Olympian, while the canonical Aphrodite is probably a post-Bronze Age eastern immigrant to Olympus from Cyprus (she is not nicknamed "the Cyprian" for nothing). As for Athena, who is firmly entrenched as one of the Olympian twelve, her name at least probably predates the arrival of the people who would worship her.

The formation of Greek religion was clearly a long and complex process, and the origins of some divinities cannot be precisely identified. In fact, Greek religion had already undergone many centuries of combination, assimilation, and transformation by the time Athena (or her prototype) first enters the archaeological record. Interestingly, she first appears not in Athens or on its Acropolis,[4] but on the acropolis of Mycenae, the heavily fortified citadel that was the leading cultural and political center of Late Bronze Age Greece. And she appears in a cluster of images that present her very much as later Greeks knew her: as an armed, warrior-goddess.

On a gold ring that may date as early as 1500 [Fig. 10], two bare-bodiced, flounced-skirted women present lilies and poppies to another woman seated on rocks beneath a lush tree, while two small girls raise their arms in adoration; it is a good guess that the seated woman is a goddess or priestess. In the center of the field there is a double-axe, a symbol of ritual; six disembodied lion heads form a row along the edge of the bezel; and above the two standing women hovers a small figure with a head, two arms, a spear in her right hand, and a body covered by (or possibly in the form of) a figure-eight shield (a common Bronze Age sort). No one pays this curious interloper any attention: it is as if it has floated in from another scene. Over two centuries later, however, on a small painted stucco tablet from the area of Mycenae's Cult Center, this shield-figure (now with a sword in its right hand) has moved from the margins to the center: there is an altar beside her, and two symmetrical women, arms outstretched, pay homage on either side [Fig. 11]. The paint has largely flaked off, but enough

remains to show that the flesh of the limbs that emerge from the figure-eight shield was painted white, and that is enough, given the conventions of Late Bronze Age art, to show that the divinity was female.[5] From the same shrine (and of the same thirteenth-century date) there is now a miniature fresco of a female figure (the flesh is white) wearing a boar's tusk helmet and carrying in her arms a small griffin [Fig. 12].[6] There is no proof that this is the same divinity as the shield-goddess, but that is more likely (and more economical) than assuming the Mycenaeans had *two* such warrior-goddesses in their pantheon. It is, at any rate, no surprise to find that the Mycenaeans – best known for their fortified citadels, weapons, and armor – worshipped a female deity charged (apparently) with the defense of the citadel and royal house. Warrior-goddesses were commonplace in the eastern Mediterranean and Near East – the Mesopotamians had Ishtar or Astarte, the Canaanites had Anat, and the Egyptians had Neith – and there is no reason why such a goddess should not have figured in the pantheon of Bronze Age Greece.[7]

Whether Mycenaean Greeks actually called their warrior-goddess "Athena," we do not know. She *may* be mentioned – once – in the Bronze Age linguistic record, but the record is controversial, and it comes from neither Mycenae nor Athens but from Knossos on Crete. On a narrow clay tablet baked hard in the fire that destroyed the Palace of Minos, two inscribed lines of Linear B (a syllabic script that is the earliest known form of written Greek) seem to record gifts issued to four deities.[8] The top line reads *a-ta-na-po-ti-ni-ja*, and that, as soon as the text was deciphered, rang a loud bell: the almost identical phrases *potnia Athenaia* and *potni' Athana* (both meaning "Lady Athena") are found many centuries later in Homer and, later still, on inscriptions from the Acropolis.[9] The trouble is that the title *potnia* ("lady" or "mistress" in the sense of "she who masters") is apparently applied to more than one deity in Linear B (including one goddess who seems a *Potnia* par excellence),[10] and that when names are linked to it they are normally toponymns – place names. So *a-ta-na-po-ti-ni-ja* means not "Lady Atana" (that is, Athena), but "Lady *of* Atana," and we have no idea whether the Atana referred to is "our" Athens, or another one, a town on Crete,[11] or whether the lady of the place is Athena herself or some other goddess closely associated with it.

All in all, though, it is inconceivable that the Greeks of the Mycenaean Age did not worship a goddess like Athena – a goddess of cities or citadels, at the very least – and it is a very good bet that Athena is what they

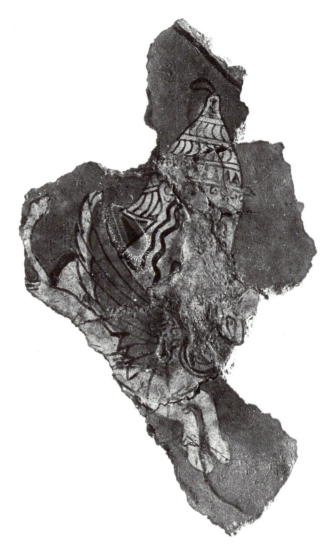

Fig. 12. Helmetted Goddess holding griffin. Fresco from Cult Center, Mycenae (NM 11652). Late 13th century. Courtesy National Archaeological Museum, Athens.

called her after all. Although the goddess will not appear in the archaeological record again for some 500 years, that record was still Greek, and some degree of religious and linguistic continuity across the centuries is assured. It certainly seems more than coincidence that when an Archaic temple was built directly atop the ruins of the Bronze Age palace of Mycenae in the seventh century, it was dedicated to Athena (or to her together with Hera). And even the little creature that the warrior-goddess from Mycenae's cult center carries in her arms [Fig. 12] may provide another fragile link between the Bronze Age deity and her great Archaic and Classical descendant: for when in the fifth century Phei-

dias made the great gold-and-ivory statue of Athena for the Parthenon [cf. Fig. 132], he set reclining griffins on either side of her helmet.[12]

The Nature of Athena

In a sense, the Greeks did not worship one Athena; they worshipped many. Like any Greek god or goddess, Athena was a force of multiple powers, with many roles and manifestations, with the capacity to intervene in human life in a variety of ways. And the wide range of her associations with special spheres of human activity is reflected in the dozens of epithets or titles by which Athena was known. Athena loomed large in the lives of Greeks other than the Athenians, of course. At Sparta, for example, she was worshipped as *Chalkioikos*, Athena of the Bronze House, and she is the second most popular Olympian on the vases of Corinth.[13] But it is in Athens that her cultic persona was most developed. There she was Athena Polias (originally, perhaps, "she who dwells on the [acro]*polis*," later "[guardian] of the city") or, as variants, Athena Polioukhos ("protector of the city") or Athena Arkhegetis ("Founder" or "Leader").[14] Athena was called "Polias" in cities other than Athens, but Athena Polias was, along with Zeus Polieus, Athens's principal civic deity. She was also Athena Parthenos and Pallas Athena (or sometimes just Pallas): Parthenos means "maid" or "virgin" but we do not know what Pallas means (and it is not certain that the Greeks did, either).[15] At all events, Athena's virginity – so crucial to her mythology and Athenian ideology, as we shall see – was inviolable and pugnacious, and so it was a symbol for and guarantor of the impregnability of her citadel: to breach the walls of the Acropolis [Fig. 4] would be to violate Athena herself. She was Athena Promakhos ("fighter in the forefront," "champion"), a goddess who delights in battle. And she got results, for she was also Athena Nike, goddess of victory [cf. Fig. 182].[16] Still, though a warrior goddess, she is for the most part the goddess of tactics, not the goddess of the wild chaos and rage of war (that domain is proper to Ares, the brutish and bloodthirsty god she despises in Homer).[17] On the other hand, in a more peaceful vein, she is Athena Ergane, the Work-Woman,[18] and Athena Hippia, goddess of the horse, and Athena Hygeia, goddess of health. Most of these and the other epithets by which she was known on the Acropolis and in Athens designated her as an object of cult, as the focus of particular patterns of worship and ritual: Athena Hygieia, for example, had her own little shrine abutting the southernmost column on the eastern facade of the Propylaia [Fig. 172]. And it is clear that she acted by means of many interventions. Still, many of her roles in Greek life are subsumed under her overarching functions as goddess of *tekhne* (skill or craft) and *metis* (intelligence, ingenuity, or craftiness), and in Greek art and legend she functions above all as the active patron of heroes.

"I am famed among all the gods for my *metis* and tricks," Athena tells her protegé Odysseus, who is no slouch in the *metis* and tricks department himself.[19] And it is by her *metis* that we principally know her. The word denotes "intelligence" both cunning and practical: it is the quality that guarantees success in many different fields of action (for example, in the *agon* or athletic competition).[20] And Metis, personified, is in some accounts Athena's mother (though of a special sort, as we shall see). Athena is, at all events, not only the goddess of wiles and artifice but also the goddess of invention and technology, and so she can intervene in a variety of domains or divine departments that are not strictly her own. She is sometimes associated with agriculture, for example, but she is no fertility or grain goddess like Demeter: she is the inventor of the plow, the instrument by which the soil is exploited for the benefit of mortals.[21] The earth is Demeter's natural province, but it is Athena's technology that tills it. Similarly, the sea in all of its power and unpredictability is Poseidon's, but Athena is, according to various myths, the designer of the first ship, the goddess of shipwrights,[22] and the guide of seagoers like Odysseus' son Telemachos and pilots like the Argonaut Tiphys. She is not a sea goddess: she is the goddess whose craft and *metis* makes the sea navigable. She is, again, called Hippia (Of the Horse), but she is not so much goddess of the beast itself (the animal in all of its wild, fiery passion is properly Poseidon's, and he was called Hippios) as she is the inventor of the bridle and bit that bring the beast under control and the chariot and wagon that allow men to harness its power.[23] Athena Hippia means, we might say, "Athena, tamer of the horse," while Poseidon Hippios is the god of the animal untamed, its wild spirit. It cannot be accidental, then, that statues of horsemen were common dedications on the Acropolis [cf. Figs. 90, 103], or that on the west pediment of the Parthenon, where Athena (goddess of the *agon*) and Poseidon competed for rights to Athens, rearing horses were so prominent [Figs. 140, 143], or that on the Parthenon's west and south metopes

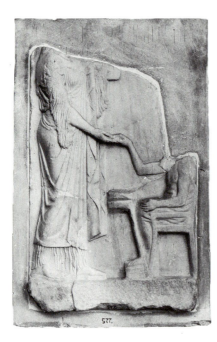

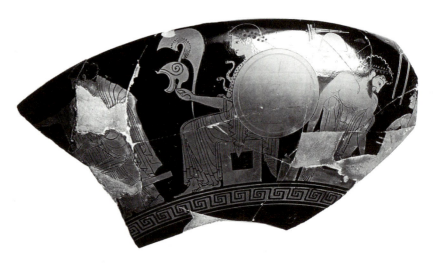

Fig. 13. Relief, Athena receives offering from craftsman. Acropolis 577, c. 480–470. Courtesy Acropolis Museum.

Fig. 14. Red-figure cup by Euergides Painter (Acropolis 166), c. 515–500. Courtesy DAI-Athens (Neg. Nr. Akr. V 805)

the violence of wild horses is associated with Amazons [Fig. 126] and embodied in centaurs [Fig. 138], while on about half of the Parthenon frieze horses of nearly demonic force are mounted and ridden around the building by youths who seem to control them as much with the power of their intellects as with reins [Figs. 152, 153].[24] The horse, then, is itself a major theme of the Parthenon sculptural program. Through it the power of Athena Hippia (and, perhaps, her superiority to Poseidon Hippios) is made visible.

When in the *Odyssey* Athena boasts of the fame of her *metis*, it is in the shape of a "tall, beautiful woman, skilled in splendid handiworks" – in other words, it is as Athena Ergane – that she speaks.[25] Athena's "cunning intelligence" extends to the practical, mundane realms of domestic craft and commercial industry, and she (along with Hephaistos, with whom she is closely associated in art, myth, and cult, Fig. 30) is patron of both professional artisans and women who work at home. Athena Ergane is the goddess of those who work "on the anvil with heavy hammer," as Sophocles said.[26] An old potter's song begins with a prayer to Athena to come

and hold her hand over the kiln for protection.[27] When a metalsmith works gold and silver, Homer says, it is with the skill (*tekhne*) taught him by Athena and Hephaistos.[28] The Rhodians, Pindar says, excel all others in art because of Athena's gift.[29] It is Athena Ergane who, on a relief from the Acropolis [Fig. 13], receives an offering of some kind from an artisan seated behind his workbench, and it is she who sits amid potters, sculptors, and metalworkers on a fragmentary cup from the Acropolis [Fig. 14]. And whether it is a metalsmith's or a potter's studio that is shown on a famous vase in Milan, the goddess arrives with a band of Nikai (Victories) to crown the artisans, winners of some competition or other.[30] In myth Athena helps Epeios create the Trojan Horse – the wooden stratagem that epitomizes both her practical skill and her cunning, her *metis* and her trickiness (the results were to be seen on the north metopes of the Parthenon, Fig. 134). And there are even portraits of the goddess as a young artist. On a vase in Berlin, for example, Athena is shown in a workshop (tools hang behind her) modeling a horse [Fig. 15]: here she is both Athena Ergane *because* she makes and Athena Hippia because of *what* she makes.

Still, the craft with which she is most intimately associated is weaving. This is, after all, a goddess who makes her own clothes (as well as garments for other goddesses).[31] Penelope knows beautiful crafts and the famous trick of her loom (the symbol of her own formidable *metis*) because of the knowledge Athena bestows upon her, and the women of Phaiakia have received the

16

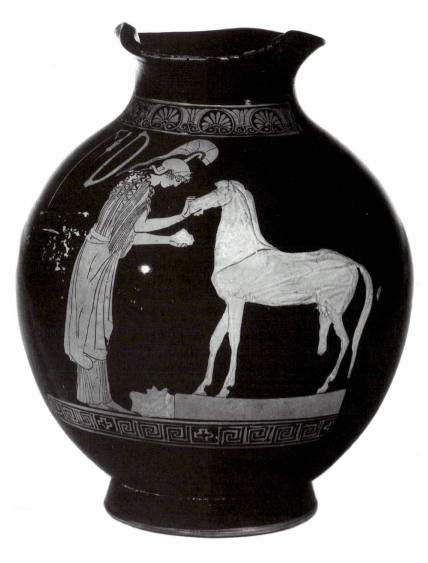

Fig. 15. Athena fashioning horse. Berlin F 2415, c. 470. Courtesy Antikensammlung, Staatliche Museen zu Berlin, Preussischer Kulturbesitz.

same benefits.[32] The art of weaving, a silvery dress, and an intricate veil are Athena's gifts to Pandora, the first woman, at her creation [cf. Figs. 132, 200, 201].[33] A fine woven, human-scaled robe or *peplos* (an object that becomes nearly an attribute of Athena) was offered to the goddess annually at the Athenian civic festival known as the Panathenaia; a far grander tapestry (also known as a *peplos* but as large as a ship's sail) was presented to her every four years at the Greater Panathenaia.[34] And Athena herself presents a robe to her favorite, Herakles, upon his retirement from labor and struggle.[35] She is, in short, the goddess who provides

human beings with the technological power to control their environment and the skill to manufacture both images, utensils, and necessities.

We can tell a lot about a goddess by the company she keeps, and if in life Athena was friend to artisans, in myth and art she is, above all, friend to heroes. In art even more than in literature she enjoys a particularly close relationship with Herakles, which is a mild surprise, since his mighty and unsubtle heroism largely consists of superhuman strength and endurance rather than the sort of mental agility we might expect from a

protegé of Athena. Herakles relies on his biceps, not his *metis*. But it is *metis* that Athena regularly supplies him (in the *Iliad* she even complains that Zeus sent her down to help the hero every time his labors proved too much and he cried out to heaven),[36] and it is Athena who is his constant ally in battle against assorted villains and monsters and who eventually leads him to godhead upon Mt. Olympos [cf. Fig. 85].

Athena frequently keeps the company of other heroes who, like her, have tricks up their sleeves, or who accomplish their tasks through the good counsel, artifice, or tools she provides. At the very beginning of Greek literature, for example, in the first book of the *Iliad*, an enraged Achilles prepares to draw his sword to slay Agamemnon when Athena suddenly appears (to Achilles alone), grabs him by the hair, looks at him with flashing eyes, and talks him out of it: here, she is Intelligence Personified, and the little conversation goddess and hero have (a dialogue no one else can hear) is a representation of the victory of reason over wrath.[37] She is almost an actor in the play of his mind, his superego. But the time for fighting and vengeance will come, and when it does Athena covers Achilles with her shield-like *aigis*,[38] causes fire to blaze from his head, and adds her terrible war-cry to his own. Goddess and hero nearly fuse: it is almost a case of possession. [39]

The roster of Athena's heroes includes Perseus, whose hand she guides when he severs the Gorgon Medousa's head (he, in turn, awards it to her and she places it either in the middle of her shield or upon her *aigis*) [cf. Fig. 25];[40] Bellerophon, who captures the winged horse Pegasos (Medousa's offspring) with a golden bridle Athena provides and who appropriately builds an altar to Athena Hippia in thanks;[41] Jason, whose marvellous ship, the Argo, was built to Athena's specifications;[42] Theseus, the quintessential Athenian hero, who, though he is rarely linked to Athena in extant literature, is nonetheless seen with her from time to time in art; and, above all, Odysseus, her closest mortal counterpart, a hero who lives by his wits and deviousness, whose special affinity with Athena is a major theme of the *Odyssey* and whom she could never abandon because, she says, he is a smooth-talker, shrewd, and always keeps his head – a man after her own heart.[43] In short, virtually wherever there is a hero in Greek legend or art, Athena, the special patron of heroes, cannot be far away. It was this relationship that Peisistratos may have exploited around 557/6 when he drove through the city in a chariot beside a *faux* Athena

to confirm his second tyranny – a new hero for Athens.[44] And it must have been Athena's flair for action and her inventiveness that appealed most to the Athenians themselves. Their natural affinity with this innovative and manipulative goddess was close and apt. If we can trust the words Thucydides puts in the mouths of Corinthian ambassadors to the Spartans, it was sensed even by Athens' foes: the Athenians, the Corinthians say, are "innovative and quick both to plan and to execute in deed what they plan."[45] She was their intellectual and spiritual "mother" and they – adventurous, daring, and restless – were, in effect, chips off the old block.

The Images of Athena

Just before Athena reveals her devotion to him, resourceful Odysseus tells her how difficult it is even for a man of understanding to recognize her, since she can assume any shape.[46] In fact, the iconography of Athena – that is, her portraiture in Greek art – is rich and complex.[47] The earliest post-Mycenaean images of the goddess may simply have been minimally carved wooden pillars or slabs (so-called *xoana*, "scraped things"). And even after the early seventh century (when the first certain images of the goddess appear on vases), she is not always the heavily armed Valkyrie we have come to expect. She often goes without any armament (or any other attribute) at all. In what may be her debut in Attic art, on a huge mid-seventh-century amphora from Eleusis [Fig. 16], the goddess, dressed in an ornate gown and standing stiff as a post (or, perhaps, a *xoanon*), blocks the Gorgons pursuing Perseus: her only attribute here is a spear (or is it a staff?). Even in the early sixth century Athena is sometimes identified by context or written labels rather than by her special equipment,[48] and much later still it is not always clear when we are seeing the goddess herself or a mortal. At least some of the many elegantly dressed marble *korai* from the Archaic Acropolis, who are usually thought to represent no one in particular but just generic "beautiful maidens," probably represent Athena [Fig. 101], and on a series of terracotta votive plaques from the Acropolis a seated woman, wearing a long thin dress, her hair in a kerchief or snood, spinning wool, might be either Athena Ergane or one of her devotees [Fig. 17].[49]

But, of course, Athena is primarily a goddess in warrior's clothing. In a sense, her very attire – armor worn over a dress – blurs boundaries of gender. But her military garb is what catches the eye and so signals her

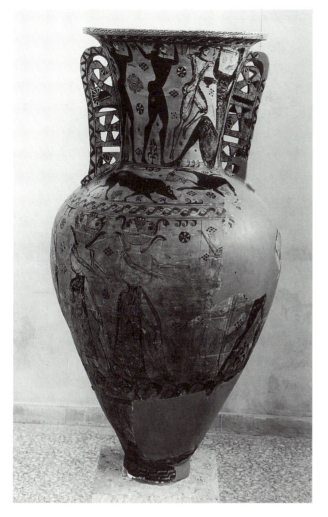

Fig. 16. a. Eleusis Amphora by Polyphemos Painter, 675–650.
Photo courtesy DAI-Athens (Neg. Eleusis 544) b. Drawing of
Athena on Eleusis amphora

preference for the male in nearly every cultural domain.
By far the greater number of representations of her
(including some as early as the seventh century) show
her wearing her helmet and *aigis* or holding a spear and
shield, or some combination of them. After all, all
Greeks knew that she was born fully armed from the
head of Zeus, shaking her sharp spear, and most would
think of her as the powerful martial goddess Homer
describes in the *Iliad* (5.733–47), dropping her womanly
robe in favor of a masculine tunic, then arming herself
and mounting her war chariot (as she frequently does on
Athenian vases and terracotta votive plaques):

But Athena, daughter of Zeus the *aigis*-bearer,
at her father's doorstep let fall her rich embroi-
 dered *peplos*,
which she made with her own hands.
Putting on the *khiton* of Zeus Gatherer of Clouds
she armed herself for mournful war.
She put over her shoulders the terrible, tasselled
aigis, ringed all round with Fear,
and Strife is upon it, and Might, and chilling
 Battle Din,
and the head of the monstrous Gorgon,
terrible, a thing of dread, portent of *aigis*-bearing
 Zeus.
On her head she put the double-crested, four-
 folded helm
of gold, wrought with the soldiers of a hundred cities.
She placed her feet in a chariot ablaze, took up
 her great spear,
heavy and strong: she uses it to subdue the ranks
 of heroes
when, daughter of a mighty father, she is angered
 against them.

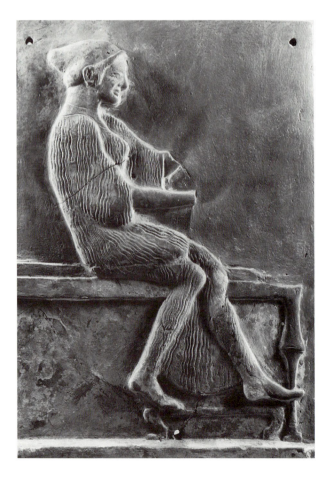

Fig. 17. Terracotta plaque (Athena Ergane?), Acropolis 13055, c. 500. Courtesy Acropolis Museum.

If the goddess is most often clear from her armor and weapons, it is still not easy to categorize the abundant images of her in Greek art. Many "portraits" of Athena do not fit neatly into any broad type, and the types themselves are, for the most part, modern rather than ancient conventions, their boundaries often blurry. Nonetheless, certain kinds of Athenas would have clearly stood out on the Acropolis, and it will be useful here to survey briefly the major images and types the ancient visitor would have seen and known.

The Athena Polias

The most sacred image on the Acropolis – the statue of Athena Polias, Guardian of the City – was an olivewood idol so ancient that the Athenians themselves were not sure where it had come from, and so simple that one later Christian author (a hostile witness, to be sure, writing when the statue had probably deteriorated) called it "a rough stake and a shapeless piece of wood."[50] According to one tradition, it had miraculously fallen down from heaven. According to others, either Kekrops or Erichthonios had it made when he was king of the city. However it got there, it was surely among the oldest cult-statues to be seen anywhere in Greece.[51] While there is, indeed, the possibility that the statue was a Bronze Age or Mycenaean relic – a prehistoric fetish – and while we can be confident that throughout its long history it always inhabited a series of temples built on the north side of the Acropolis (culminating in the late-fifth-century building we call the Erechtheion but whose official title was "the temple on the Acropolis in which the ancient image is") [Fig. 3, no. 9, and Fig. 173],[52] we know, strangely, very little about it. We think it was life-size or probably less, since we can infer from a variety of evidence that it was removed from the Acropolis in 480 when the Persians came and that women could dress it, undress it, and possibly even carry it around like a mannequin. Several fourth-century inscriptions inventory an impressive array of ornaments somehow attached to the statue – "a diadem (or crown) which the goddess wears, the earrings which

the goddess wears, a band which the goddess wears on her neck, five necklaces, a gold owl, a gold *aigis*, a gold gorgoneion, and a gold *phiale* (a shallow libation bowl) which she holds in her hand"[53] – but we are not sure when or over how long a period she acquired the items, and she may also have worn a bronze helmet that (because of its relatively poorer material) did not make it into the inventories. One ancient source claims that Endoios, a celebrated sculptor who can be dated on other grounds to the second half of the sixth century [cf. Fig. 99], "made" the statue of Athena Polias. This cannot be right as it stands, but it could mean he was responsible for her rich outfit, for transforming the venerable image from an almost featureless wooden chunk into a glistening composition in gold.[54] Still, it is by no means certain that such a grand makeover ever took place (the ornaments could have been acquired gradually over many years) and the ancient source attributing the Athena to Endoios is in other respects highly unreliable. We do not even know for sure whether the statue was seated or standing. There are a number of small painted terracotta seated goddesses from the Acropolis that might crudely imitate the Athena Polias [Fig. 18], but there are standing terracottas that might imitate her, too, and it is likely that the ancient statue stood post-like, rigidly upright, with a gold *phiale* in one hand and an owl in the other.[55] Indeed, it is just possible that it – or something like it – was represented in south metope 21 of the Parthenon [Fig. 139].[56]

One thing is sure: the olivewood Athena Polias wore cloth as well as gold. Every year the statue was dressed in a new saffron-colored *peplos* (measuring perhaps 5 feet by 6) woven by select Athenian girls and women and principally decorated (in contrasting purple) with inwoven scenes from the battle between the gods and giants, the savage sons of Earth (Gaia) who tried to overthrow the Olympians (there are a few hints that other subjects, such as chariots and Athenian soldiers, appeared as well).[57] No detailed representation of the *peplos* survives (though the cloth depicted in the center of the Parthenon's east frieze is probably it, Fig. 151), but it must have been an especially grand version of the sort of richly figured garments worn by women in many vase-paintings, by Athena herself in a late statue in Dresden, and (their paint now mostly faded) by Acropolis *korai* (the *kore* dedicated by Euthydikos in the 480s, for example, does not wear a *peplos*, but her dress was originally decorated with chariots and riders in red and black [Fig. 19]).[58] At all events, the presentation of the *peplos* was the highlight of the

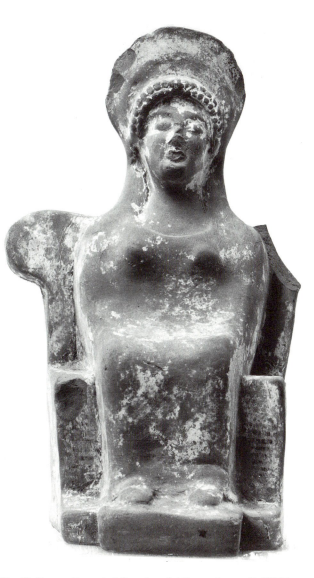

Fig. 18. Terracotta seated figurine of Athena, Acropolis 10895, c. 500. Courtesy Acropolis Museum.

Panathenaic festival but, as we shall see, the statue and its clothing (and it could wear other garments besides the *peplos*) figured in other holidays as well.

Whether the Athena Polias sat down or not, other Athenas from the Acropolis certainly did: there are, for example, those terracotta statuettes [Fig. 18], a fragmentary marble goddess who is possibly Athena,[59] and a headless, badly weathered marble Athena possibly seen by Pausanias and traditionally attributed to Endoios [Fig. 99].[60] Still, most Acropolis Athenas were on their feet.

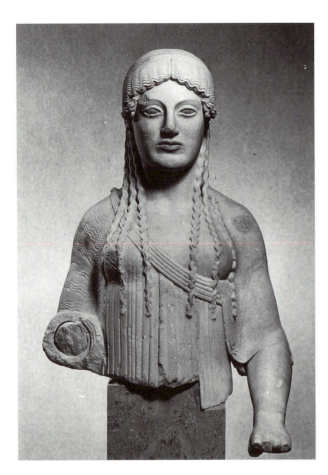

Fig. 19. Euthydikos *kore*, Acropolis 686, c. 490. Courtesy Acropolis Museum.

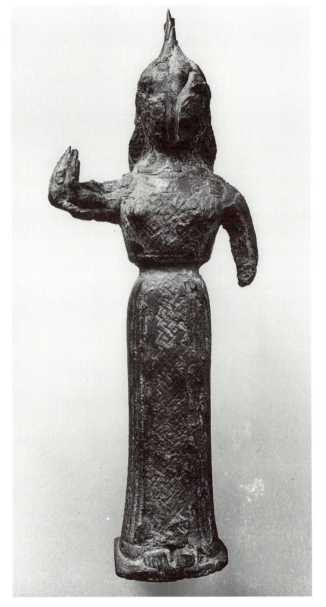

Fig. 20. Bronze Palladion from Acropolis, Athens 6457, c. 575–550. Courtesy DAI-Athens (Neg. Nr. NM 5119).

The Palladion

That was certainly the pose of the statue known as the Palladion – the statue of Pallas Athena that purportedly had once been the cult image of the goddess at Troy but that was captured by Argives and ultimately filched by the Athenians.[61] The Trojan Palladion stood not on the Acropolis, however, but in the law court named after it in the southeastern part of the city, where cases of involuntary homicide were heard.[62] Despite the fact that the statue was there in Athens for all to see, there was no hard-and-fast way to represent the Palladion in Athenian art – vase-paintings differ greatly in the details. But the statue itself showed the goddess standing rigidly erect and immobile, both feet together (or with the left only slightly advanced), probably with the right arm upraised brandishing her spear and the left holding her shield aloft. Statues of the Palladion type – loose interpretations of the original rather than exact copies – were

certainly to be found among the dedications of the Acropolis. A bronze statuette offered sometime in the second quarter of the sixth century apparently begins the series [Fig. 20];[63] a Palladion of gold and ivory was inventoried among the treasures stored in the Parthenon in 398/7 and after; and three bronze Palladia were intentionally melted down in the 330s to make new statues.[64] Interestingly, on one of the north metopes of the Parthenon the Trojan Palladion itself was shown in a narrative context: Helen seeks refuge at it as her husband,

Menelaos, charges from the neighboring relief [Figs. 134, 135].[65] But the Palladion almost certainly appeared elsewhere on the north metopes – there was undoubtedly a panel showing the theft of the statue from Troy and perhaps even the Rape of Cassandra at the foot of the statue – and one wonders whether this extraordinary cluster of images of an image had anything to do with an ancient, or at least pre-Periklean, shrine, consisting of a *naiskos* and round altar, whose traces have recently been identified within the north colonnade of the Parthenon [Fig. 21].[66] The architects of the Parthenon assiduously respected this earlier *naiskos* – they essentially built this part of their temple around it – and one cannot help but wonder whether a venerable statue of the Palladion type stood within it. The depiction of the statue of Athena in several of the metopes above would thus have served as an allusion, a reference, to a real statue of Athena housed below them and as a pointer for all those approaching the temple on this side – X more or less marks the spot.

The Athena Promakhos Type

When Athena is given a more active pose, striding mightily forward with one foot as she raises her spear and shield or *aigis*-bearing arm, the image ceases to be a Palladion and becomes an Athena Promakhos (Champion, Fighter in the Forefront). The line between the two types is sometimes difficult to draw, and one scholar's Palladion can be another's Promakhos.[67] Still, Athena Promakhos is recognizable from the particularly aggressive and combative pose she frequently strikes in the gods' battle against the giants, her greatest victory, and it is an imaginary giant that Athena must be threatening in a series of bronze Promakhos figurines from the late Archaic and Early Classical Acropolis, such as the one dedicated by Meleso around 480–470 [Fig. 22]. The Gigantomachy was not only woven into every *peplos* presented to Athena Polias, but was also depicted frequently on Attic vases from the mid-sixth century on [Fig. 31] and, very prominently, in a marble pediment that decorated the late-sixth-century temple in which the sacred olivewood statue was kept (the *Archaios Neos*, or Old Temple of Athena Polias, a predecessor of the Erechtheion) [Figs. 96, 97]. A similar Athena (though moving to the left) is always found on large prize amphorae awarded full of olive oil to victorious athletes at the Panathenaic Games (such vases were often offered as dedications to Athena on the Acropolis)

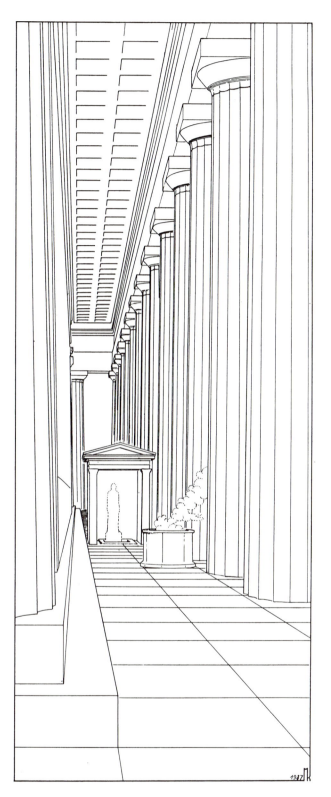

Fig. 21. Pre-Periklean *naiskos* (little temple) preserved in north flank of Parthenon. Drawing by M. Korres, used by permission.

[Fig. 23], and although it is not clear whether the vase-paintings are merely conventional representations of the goddess or renderings of a particularly important statue set up outdoors on the citadel in the 560s, the pose of the Panathenaic Athena – left leg advanced, shield and spear raised and ready – is clearly related to the Promakhos type.[68]

The Bronze Athena

Nearly a dozen bronze statuettes of Athena from the Acropolis dating to the late Archaic and Early Classical periods belong to the Promakhos category (though they vary markedly in details among themselves). But, paradoxically, the only statue of Athena that we know was referred to as "the Promakhos" in our ancient sources – it is so called only once, and very late[69] – does not rightly deserve the epithet at all (so much for modern scholarly conventions). This was the colossal and presumably state-of-the-art "Bronze Athena" (its official title) created by Pheidias. It stood in the open, probably around nine meters tall, on a large elaborate base about

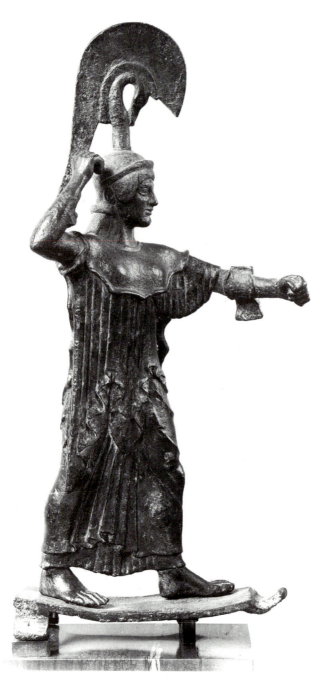

Fig. 22. Athena Promakhos, dedicated by Meleso, c. 480–470 (NM 6447 and *IG* I³ 540). Courtesy DAI-Athens (Neg. Nr. NM 4742)

Fig. 23. Burgon amphora (BM B 130), c. 560. Courtesy British Museum.

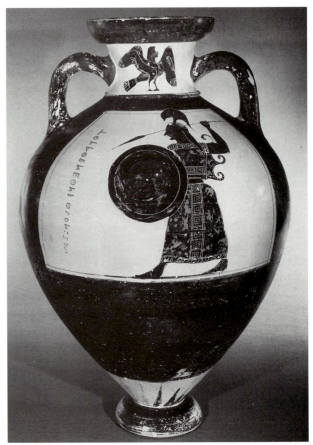

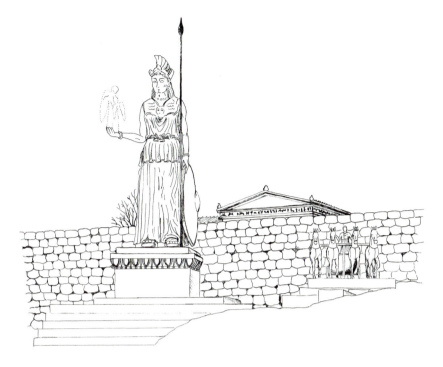

Fig. 24. Reconstruction of the Bronze Athena (Promakhos). The (restored) chariot group commemorating an early Athenian victory over Boiotia and Chalkis is seen at right. Drawing by D. Scavera.

forty meters east of the later Propylaia [Fig. 3, no. 7; Fig. 24].[70] There are no really informative representations or definite copies of this work, though a public accounting of material and labor costs inscribed on a marble slab and put on display on the Acropolis sometime in the mid- or late 450s provides some useful technical details (for example, that there was some detailing in silver).[71] The inscription also indicates that the making of the statue took nine years (the work is often dated between 465 and 456, but a date wholly within the decade between 460 and 450 is also possible). Pausanias notes that the decoration of Athena's shield included a battle of Lapiths and centaurs and that sailors coming into port from Sounion could see the sun glisten off the tops of the statue's spear and helmet crest.[72] A few Athenian coins of the Roman period, though too small and sketchy to be of much help, suggest the statue held an owl or *Nike* (Victory) in her right hand; others do not.[73] At all events, there was apparently nothing aggressive about the Bronze Athena. She stood at ease rather than charged into action like a true Promakhos, and the quiet pose of the brightly polished goddess, probably resting on her shield rather than lifting it, surrounded on her base by trophies taken from the Persians in various campaigns, might have suggested to the Athenians that, while they should remain on their guard, they had nonetheless prevailed over their great foe.

The Athena Parthenos

If our picture of the great Bronze Athena is accurate, and especially if she carried a *Nike* in her hand, the statue would have been almost a twin in metal of the statue Pheidias later created in gold and ivory for the Periklean Parthenon: the Athena Parthenos – Athena the Virgin – dated by inscriptions and inference to the years between 447 and 438.[74] We will return to the Athena Parthenos more than once. Here it is enough to indicate that, this time, the appearance of the statue seems reasonably well known from literary descriptions, a vase-painting of Athena based on the statue dating only a few decades after its dedication, and a wide assortment of late Classical, Hellenistic and Roman reliefs, statues, medallions, intaglios, and coins [cf. Figs. 25, 26, 40b, 199].[75] The Athena, perhaps some ten meters tall, stood on a base decorated with the creation of Pandora.[76] Her flesh of ivory, her eyes of ivory and precious stones, her *peplos* and equipment of removable gold (plates of the gold and ivory, weighing nearly a ton, were fixed upon a wooden core), she was fully armed with elaborate helmet, *aigis* (with gorgoneion), spear, and shield. The monumental shield, itself nearly five meters in diameter, was decorated inside with a painted or inlaid battle of gods and giants and outside with a relief battle of Greeks and Amazons revolving around another gorgoneion (in the second century AD a cottage industry developed copy-

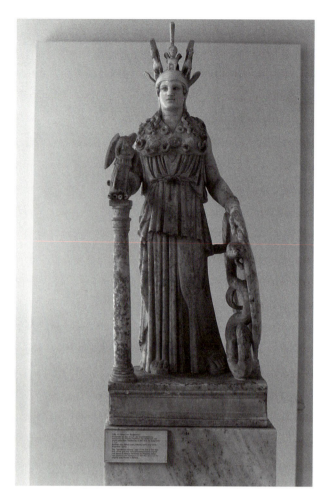

Fig. 25. Varvakeion Athena (NM 129), Roman copy of Athena Parthenos. Photo: author.

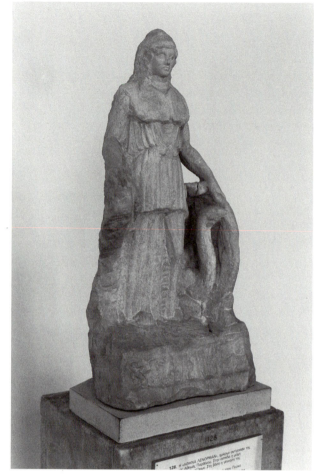

Fig. 26. Lenormant Athena (NM 128), unfinished Roman copy of Athena Parthenos. Photo: author.

ing excerpts from this struggle at full scale in marble) [Fig. 27]. A great snake – "the guardian of the Acropolis" and the incarnation of Erichthonios – coiled beside Athena in the concavity of her shield (at least that is where the snake was located in the time of Roman copyists and Pausanias).[77] And the goddess definitely held a gold-and-ivory Victory (*Nike*), itself about 1.85 meters tall and carrying a gold wreath, in her right hand. Originally the Nike-bearing arm may have lacked artificial support, though later copies and coins suggest that at some point a column or tree-trunk was added for security's sake.[78] At any rate, it was from this magnificent and rich statue that the Parthenon probably took its popular name, and it was to house and protect the Athena Parthenos (and to store Athena's wealth) that the Parthenon was possibly conceived in the first place. That is why Pheidias, a sculptor, is said to have been in

charge of the project, not its architects, and that is why special measures were taken to illuminate the temple interior and enhance its mystery: windows were cut in the east wall of the main room to provide more light than the door could alone [Figs. 127, 130], and a rectangular pool of water was eventually placed in front of the image, capturing its reflection and reflecting shimmering light back upon it.[79]

We are not sure how much of the Athena Parthenos that Pausanias saw in the second century AD (or that Roman copies like Fig. 25 replicate) was original and how much restored. The Parthenon is known to have suffered damage several times in antiquity, and the statue itself is said to have been stripped of her gold at the start of the third century; in addition, at least one repair may have taken place during the reign of the emperor Hadrian, a couple of decades before Pausanias's

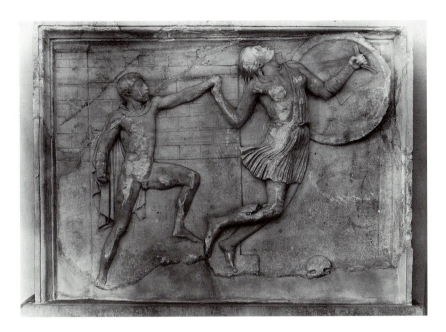

Fig. 27. Peiraieus relief (Roman in date), excerpting scene from shield of Athena Parthenos (cf. Fig. 155). Courtesy DAI-Athens (Neg. Nr. Pir 150)

visit.[80] But, clearly, there had never been a statue like this on the Acropolis before. It is still not certain whether the Parthenos belonged a larger category of Virgin Athenas (a "Parthenos class") or whether the Pheidian Parthenos had been preceded on the Acropolis by any earlier Parthenos – if a Palladion-like statue did not stand in the *naiskos* preserved in the temple's north colonnade [Fig. 21], perhaps a Parthenos did. It is unlikely, however, that the Pheidian statue was ever the object of an official cult in Classical antiquity: no public rituals or offerings were ever directed specifically to this statue (at least not until very late in its history).[81] Though there are, certainly, a few inscribed dedications addressed to (Athena) Parthenos – the earliest is no earlier than around 500 [Fig. 32][82] – the epithet is probably simply descriptive (like *potnia* or *glaukopis*, "flashing-eyed") rather than a cult title. There is no mention, anywhere, of any Priestess of Athena Parthenos (as there is of Athena Polias or Athena Nike, for example). And there is no altar of Athena Parthenos. Now, if the gold-and-ivory Athena Parthenos was not offered dedications or honored with sacrifices – if, in short, it was not worshipped – it was not, technically, a cult statue, and if it was not a cult statue, then the Parthenon was not, technically, a temple. The implications of that are far-reaching, and the Parthenon should perhaps be considered not so much a temple to Athena as a temple to Athens, a storehouse of its wealth, a marble essay on its greatness.

Other Acropolis Athenas

The Athena Parthenos and possibly the Bronze Athena (Promakhos) were *Nikephoroi* (Victory-Bearers), but they were not Athena Nike herself. The cult and shrine of that goddess – Pausanias (who may not have actually seen the cult statue) calls her "Wingless Victory," reflecting a popular confusion between Athena and the personification[83] – were located on the ancient bastion jutting out before the Propylaia from at least the early sixth century on [Fig. 181]. Originally set into a poros limestone base (two blocks of which remain), the statue survived the Persian Wars and seems to have then occupied, first, a plain *naiskos* of around 445 [Fig. 125] and then an elegant Ionic temple begun in 424/3 [Fig. 182]. We are told that the statue held a pomegranate in her right hand and a helmet in her left (the many-seeded fruit was a symbol of fertility and the abundance victory brings, while the helmet, since it was not in place on the goddess' head, symbolized the peace and security won by military success). Though the statue was probably slightly under life-size, we know little about it – not even whether it was standing or seated or made of wood or stone.[84]

In vase-painting Athena often doffs her helmet,[85] and so might have one of the most famous statues on the Acropolis: the Athena apparently dedicated by Athenians who settled the island of Lemnos around 450 (this is the last statue Pausanias notes before leaving the Acropolis, and so might have stood within the Propylaia).[86] The Athena Lemnia, another work by Pheidias (and the

one Pausanias considered his masterpiece),[87] has long been recognized in a fine head in Bologna and a torso in Dresden, Roman copies both [Fig. 28]. But although there may well have been a mid-fifth-century, even a Pheidian, statue that looked like this, there is nothing to prove it was the Athena Lemnia.[88] There is, in fact, practically nothing to go on except our ancient sources' insistence that the statue was beautiful, which is not much. We would rather know what she was made of, or whether she stood up or sat down, or whether she was in full armor, or whether she held her helmet or wore it, but we do not.

Fig. 29. Angelitos's Athena (Acropolis 140), c. 470. Photo: author.

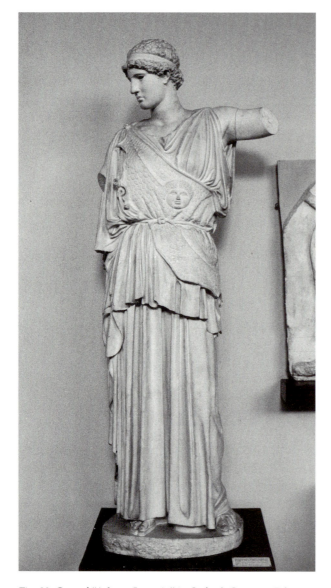

Fig. 28. Cast of "Athena Lemnia" in Oxford. Courtesy John Boardman and the Cast Gallery, Ashmolean Museum,

The inventory of Acropolis Athenas is hardly exhausted, and some images actually survive. There is, for example, the small marble statue of the goddess made by Euenor and dedicated by Angelitos around 470 [Fig. 29] which, in its quiet mood and non-aggressive stance, seems to predict qualities of other Classical Athenas, including the Bronze Athena (Promakhos).[89] And there were, of course, an assortment of Athenas shown in narrative contexts, not only in the pediments and metopes of the Parthenon, but also in action groups set up on the ground. Early in his tour of the Acropolis, for example, Pausanias saw a composition of Athena beating Marsyas for daring to pick up the flutes she had tossed away, an Athena rising from the head of Zeus,

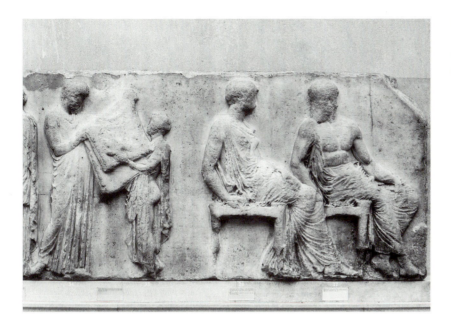

Fig. 30. Handling of the *peplos* and Athena and Hephaistos, east frieze of Parthenon. Courtesy Trustees of the British Museum.

and a group of Athena displaying her olive tree and Poseidon his sea-wave – the latter two groups obviously reiterating the subjects of the Parthenon pediments.[90] But perhaps one of the most remarkable of all Acropolis Athenas is the one depicted sitting quietly on a stool beside her colleague Hephaistos on the east frieze of the Parthenon [Fig. 30]. She has no shield or helmet (though holes drilled into the stone prove she cradled a bronze spear in her right arm). She has taken her *aigis* off (it lies in her lap, a snake or two from its fringe writhing over her left arm). And she is seemingly unfazed by all the commotion that fills the rest of the frieze [cf. Figs. 145, 153–9]. This is Athena at ease, and there is no point searching for an appropriate epithet for her here. She is the same goddess as Athena Polias, Parthenos, Promakhos, or Nike, and yet in iconography and mood she could not be more different.

Four Myths

Besides playing an important supporting role in the careers of many heroes, Athena is, of course, the principal character in a large mythological corpus of her own. As far as the art, cults, and ideology of the Acropolis are concerned, four stories are particularly significant: the myth of her birth, the story of her role in the battle of the gods against the giants, her contest with Poseidon for patronage rights to Athens, and the myth of her relationship to Erichthonios/Erechtheus.[91] As is the case with most Greek myths, these stories are known in sev-

eral versions, not all of them reconcilable in detail. Myth is not dogma.

All versions of the myth of Athena's birth, however, agree that she was born miraculously from the head of Zeus and had no mother in the conventional sense. Still, her conception was not exactly immaculate, either. Hesiod (*Theogony*, 886–900) tells the tale:

Zeus, king of the gods, took Metis as his first wife,
she who knew more than gods and men.
But when she was about to give birth to the bright-
 eyed goddess,
Athena, then he, deceiving her mind with treachery
and wily words put her inside his belly,
as Earth and starry Heaven advised.
They counseled this, so that none but Zeus
should ever be king of the gods who live forever.
For from her it was destined that wise children be
 born:
first, the bright-eyed girl, Tritogeneia,
her father's equal in strength and wise counsel.
But next she would bear a son, with overbearing
 heart,
to rule as king over both gods and men.
But Zeus put in her his belly first,
so that the goddess might ponder for him both
 good and evil.

So Metis apparently grew large with child in Zeus's belly, and the gestation period lasted while Zeus mar-

ried a series of other goddesses (first Themis, last Hera) until, somehow, Athena passed from Metis's womb to Zeus's stomach to his skull and popped out fully formed:

> Zeus himself, from his own head, gave birth to
> bright-eyed Tritogeneia,
> the terrible one, rousing the battle din, leader of
> armies,
> Unwearied *Potnia*, who delights in war-noise,
> wars, and battles . . .
>
> (924–926)

Elsewhere Hesiod, Stesikhoros, a *Homeric Hymn to Athena*, and other sources add the details that Athena was born beside the banks of the river Triton (perhaps a rationalization of her perplexing epithet, Tritogeneia, "Triton-born"),[92] that she leaped from Zeus's head doing an armed dance (the *pyrrhike*), shaking her shield and raising her spear, that Metis, despite being swallowed up in Zeus's belly, nonetheless fashioned the armor Athena was born wearing, that the immortal gods looked upon the birth with awe, and that Olympos shook, the earth cried out, and the sea heaved. It is, one notes, Athena's militarism and ferocity that these accounts emphasize, not her wisdom or craftiness, and there is nothing allegorical about the goddess of *metis* emerging from Zeus's brain: for the early Greeks the seat of wisdom was located elsewhere, in the diaphragm.[93] At all events, Greek art – vase-paintings above all, but possibly the East Pediment of the Parthenon, too [Fig. 145] – informs us that Hephaistos, Athena's future colleague as patron of craft and industry (and a god whose own reputation for cunning was as old as Homer), split Zeus's laboring head open with his axe to allow the mighty, already mature goddess to escape.[94] For Hephaistos, god of *tekhne*, to practice obstetrics in this way may be fitting, but there is a chronological problem: according to the *Theogony* (927–929), an angry Hera, jealous of the child Zeus brought forth by himself, conceived Hephaistos all on her own, without intercourse, and gave birth to him only after Athena appeared (Hephaistos's lameness is a sign of Hera's inferiority as a single parent). Again, it is not always possible to reconcile the variants of Greek myths, but the anachronisms and contradictions probably did not bother the average Greek very much.

Even if Hephaistos did help, we should still think of Athena as fighting her way out of Zeus's head: she was,

after all, born shaking her spear and terrifying the cosmos. Sometime afterward (with mythological time it is hard to tell how long) she put her martial arts to good use against the giants, sons of Gaia, who attempted to overthrow the Olympian gods. Though literary references to the giants appear as early as Homer and Hesiod, the most complete account is found in the *Library* attributed to Apollodoros (probably written in the first century AD). This mythological compendium tells how the gods (according to an oracle) could not defeat the giants, huge and fearful, hairy and scaly, without the aid of a mortal, how Athena enlisted Herakles as their ally, and how, at Phlegra or Pallene (in the Chalkidike peninsula of northern Greece), the gods took on the giants one on one. Zeus, with help from his son Herakles, killed their ringleader Porphyrion; Herakles, following Athena's advice, disposed of Alkyoneus; Athena herself killed Enkelados by throwing Sicily at him and then flayed Pallas and used his skin as armor; Hephaistos threw red-hot iron at Mimas; and so on.[95]

Although the myth would be a popular subject for artists elsewhere in Greece, nowhere was it more popular (or more important) than on the Athenian Acropolis. Indeed, the city's greatest festival, the Panathenaia, which culminated in the presentation of the new *peplos* to the ancient olivewood statue of Athena Polias, may have celebrated not Athena's birth (as is usually assumed) but the gods' victory over the giants: the Gigantomachy, again, was woven into the *peplos* as its principal decoration. It was also in this battle, in which Athena played so important a role, that she earned the epithet "Nike."[96] The earliest indisputable representations of the Gigantomachy, in fact, decorate a series of large black-figure vases dedicated on the Acropolis beginning around 560–550 [Fig. 31],[97] not far from the traditional date of a major reorganization of the Panathenaia (566). And, again, by the end of the sixth century, the battle filled one pediment of the *Archaios Neos* on the north side of the Acropolis: the aggressive figure of Athena, holding her *aigis* outstretched, striding mightily over a fallen giant, stood (according to one reconstruction) to the right of a central group of Zeus riding in a frontal chariot [Figs. 96, 97].[98] At least one smaller Archaic pediment (or freestanding narrative group) and several Archaic marble reliefs depicted excerpts from the battle.[99] The Gigantomachy was a recurrent theme on the Classical Acropolis, too. By the end of the fifth century, the visitor to the Acropolis would have seen Athena and the other gods defeating the giants over and

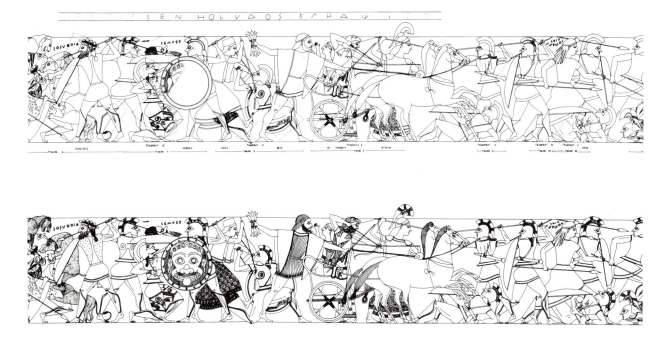

Fig. 31. Reconstructions of portion of Gigantomachy on fragmentary Black-figure dinos by Lydos, c. 550 (Acropolis 607). After Moore 1979, figs. 1 and 2, used by permission.

over again – in relief on the east metopes of the Parthenon [Figs. 136, 137] (where, in metope 4, a flying Nike crowns a fighting Athena – the same Nike the Athena Parthenos, presumably after the battle, holds in her hand), inlaid on the inside of the shield of the Athena Parthenos, and, inside the Classical Erechtheion, woven onto the woolen *peplos* that dressed the ancient statue of Athena Polias. And if all the *peploi*, large and small, periodically presented to Athena Polias were stored or displayed like tapestries in the Erechtheion, the visitor would have been presented with scores of variations on the theme at once. This array of Gigantomachies received a particularly grandiose addition around 200, when, as we shall see, a Hellenistic king of Pergamon dedicated a huge group of one-meter-tall mythological combatants, including the giants, against the wall of the Acropolis southeast of the Parthenon [cf. Fig. 219]. Gigantomachies were thus added constantly to the narrative inventory of the Acropolis, the theme undergoing nearly constant reinterpretation in a variety of media. No better example exists of how a particular theme endures over time – of how the imagery of the Classical Acropolis echoes the imagery of the Archaic or the Hellenistic the Classical – or how the same theme

could be seen in different versions, in different inflections, at any one time. The spectator's experience of the place would have reverberated with different tellings of the same tales, over and over.

The victory over the giants assured the gods' domination of the cosmos, but Athena's victory over her own uncle, Poseidon, god of the sea and earthquake, assured her right to Athens and guaranteed her preeminence in the self-representation of the city. The famous contest between the two gods, it was said, took place on the Acropolis during the reign of Kekrops, the first king of the city who, born miraculously from Earth, was part man and part snake. But the variants of the myth do not agree whether Kekrops or the Olympian gods judged the contest (Kekrops serving merely as chief witness), or whether the prize was supposed to go to the divinity who merely won a race from Mt. Olympos to the Acropolis, or to the god who was judged to have created on the rock the better gift or the more eloquent token of their power, or to the god who won a popular vote of the Kekropidai, the primordial inhabitants of the land. The confusion on all these points is odd if the myth, as some think, is a fifth-century invention. But the earliest literary reference to the story is, in fact, Herodotos (c. 440),[100] and the earliest known representation of the contest was the west pediment of the Parthenon, completed in the 430s [Figs. 140, 143]. Even here it is not

clear exactly what version of the myth, or what point in the narrative, the pedimental sculptures depict.[101] The fullest description of the contest, however, is once again found much later, in Apollodoros (3.14.1):

> In [Kekrops's] time, they say, it seemed best to the gods to take possession of cities where each would receive his own honors. Therefore Poseidon came to Attica first, and striking his trident on the middle of the Acropolis, he produced the sea which they now call the Erechtheis. But after him came Athena and, making Kekrops witness to her claim of possession, planted an olive tree which can still be seen in the Pandroseion. When the two of them argued over the land, Zeus separated them and appointed as judges, not Kekrops and Kranaos, as some have said, nor Erysichthion, but the twelve gods. When they gave their verdict, the land was judged Athena's, since Kekrops testified that she was the first to plant the olive. Athena therefore named the city Athens after herself, and Poseidon, furious, flooded the Thriasian plain and placed Attica under water.

The olive tree, the salt spring, and the marks of Poseidon's tridents were some of the most venerable and sacred spots on the rock (though Pausanias was not terribly impressed with the spring),[102] and they were certainly regarded as marvelous signs of the primeval contest (the tree, burned by the Persians in 480, was said to have miraculously sprouted a cubit-long shoot overnight, a sign of continued divine favor).[103] But the earliest Classical traditions seem to agree that they were merely tokens of priority, and that the inherent value of the olive and the salt sea – or, rather, their value as symbols of Athenian agricultural or naval power (which would be judged to be better for Athens?) – was not the point. If Apollodorus is right that Poseidon did indeed reach the Acropolis first, then he was robbed, or else his claim was disallowed because no one saw him arrive – something that Athena made sure did not happen to her by enlisting Kekrops as her witness (the goddess of *metis* in action again). In any case, the west pediment seems to have shown Athena arriving first, dashing for Kekrops (shown in the left angle of the pediment) to claim her victory after the olive tree has sprouted, with Poseidon about the hurl his trident just seconds too late.

Despite his imminent loss, Poseidon (if we can fairly judge from a famous seventeenth-century drawing of the pediment done by someone we call Jacques Carrey) seized the center of the composition, and Athena was, slightly, in the background [Fig. 140]. The focus seems to have been on the god, and the question arises why this should be so on the temple of the goddess. It is true that the two divinities fought on the same side at Troy and, obviously, against the giants. Poseidon's name (*po-se-da-o*) appears with "Lady Athena" (*a-ta-na-po-ti-ni-ja*) on that Linear B tablet from Knossos.[104] They often appear together (with no apparent hostility) on sixth-century Athenian vases. And, as we have seen, they shared an association with horses. Nonetheless, in myth they are more often antagonists than allies. Athena's protegé Perseus, again, decapitated Medousa, yet Medousa had been Poseidon's lover,[105] and Athena wore her head as a trophy on her *aigis* or shield (or both) – a constant, bristling reminder. In the *Odyssey*, Poseidon's wrath drives much of the plot in opposition to Athena, and torments her most simpatico hero. Even the fabulous myth Plato makes up in the *Kritias* pits Athens, the city of Athena, against Atlantis, the city of Poseidon.

But no god as powerful as Poseidon could be ignored, and the centrality of the sea-god in the west pediment may be, after a fashion, an expression of gratitude to the divinity who, told by Zeus to stop his floods, held no grudges and still granted Athens naval supremacy, ensuring their victory over the Persians in the waters of Salamis in 480. It may be, in fact, that a cult of Poseidon was first installed on the Acropolis in the 470s to thank (or appease) him.[106] Thus, the myth of the contest of Athena and Poseidon may actually have been invented in the fifth century as a way of expressing the immense significance of Salamis and the importance of the maritime empire Athens built in its aftermath, and of acknowledging the god who, despite his quarrels with Athena, had nonetheless looked favorably upon her city. There is no way to be sure about all this, and the possibility that Poseidon was the subject of an Acropolis cult before the Persian Wars remains.[107] But whatever their relationship before Salamis, by the end of the fifth century at least Poseidon and Athena Polias (as well as several other divine figures) shared the same temple on the north side of the Acropolis: the Classical temple popularly referred to as the Erechtheion though officially known, presumably like its late Archaic predecessor, as the *Archaios Neos*, the Old Temple of Athena [Fig. 173].[108]

The temple takes its nickname[109] from Erechtheus, a hero (and, according to mythological genealogies, the sixth king of Athens) with whom Poseidon shared an

altar and priest and whose very identity Poseidon seems to have absorbed. Around 450 (long before the construction of the Erechtheion), two brothers dedicated a marble basin to "Poseidon Erechtheus" (as if the names were hyphenated, or as if the god had taken on the hero's name as an epithet).[110] But Erechtheus is himself a shadowy figure. Herodotos says it was during his kingship that the Athenians first took that name (*Athenaioi*) for themselves, and he is said to have fought an early war against Eleusis and its ally Eumolpos, the son of Poseidon, who tried to avenge his father's loss to Athena by invading Athens: the battle was evidently represented in a statue group Pausanias saw near the Erechtheion and the war may even have been alluded to in the angles of the west pediment.[111] Compelled to sacrifice a daughter for the public good (other daughters are said to have voluntarily sacrificed themselves as well, and here were lessons for all good Athenians), Erechtheus slew Eumolpos, but was in turn killed by Poseidon (who only then subsumed his identity). The myth represents a continuation of Athena's rivalry with Poseidon by other means, through heroic proxies, and the fusion of Poseidon-Erechtheus in cult may have been another fifth-century attempt at reconciliation.

Erechtheus's identity also seems to have been fused or confused with the even more mysterious Athenian king Erichthonios (the similarity in names, if they are not simply variants, obviously contributed to the confusion). The careers of the two kings are (as later mythologies reconstructed them) distinct and, according to Apollodorus, Erichthonios, the fourth Athenian king, was even Erechtheus's grandfather. But there can be no doubt that at some point early in the tradition Erechtheus and Erichthonios were one and the same: their names mean essentially the same thing ("Very Earthy" or "Very Earth-Born"), they are said to have married the same woman (Praxithea), and they share the remarkable circumstance of being the virgin Athena's foster child.[112]

On the one hand, Homer (*Iliad* 2.546–51) says that the grain-bearing earth bore great-hearted Erechtheus and that Athena raised him, installing him in her own temple on the Acropolis where he himself became the object of cult and annual sacrifices (the rock of Athena, then, was also the hill of Erechtheus). On the other hand, later literary sources and vase-paintings substitute Erichthonios – he does not seem to have taken mythological shape before the early fifth century – and it is as if Erechtheus's infancy and youth were taken from him and given over to that other hero, a supposedly earlier

king.[113] But Erechtheus seems always to have been first in the hearts and minds of the Athenians (which is why they could call themselves "Erechtheidai" but never "Erichthoniadai").[114] And his story may even have been the subject of a portion of the sculptured frieze of the Erechtheion [cf. Fig. 179].

The fullest version of the tale is told once again in Apollodoros. According to some, he says, Erichthonios was the son of Hephaistos and Athena:

> Athena once came to Hephaistos, wanting him to forge her new weapons. But he, having been abandoned by Aphrodite, was filled with desire for Athena and chased her. She ran away. But when with great effort (for he was lame) he got near her, he tried to make love with her. She, being chaste and a virgin, would not yield, but he ejaculated on the leg of the goddess. In disgust she wiped off the sperm with some wool and threw it on the ground. As she fled and the sperm hit the ground, Erichthonios was born. She brought him up without the knowledge of the other gods, wishing to make him immortal, and putting him in a basket she gave him to Pandrosos, the daughter of Kekrops, forbidding her to open the basket. But the sisters of Pandrosos [Aglauros and Herse] opened it out of curiosity and saw a snake coiled around the baby. Some say they were killed by the snake itself, but others say that they were driven mad by Athena's anger and threw themselves down from the Acropolis. But having been reared in the sacred precinct [presumably on the north side of the Acropolis] by Athena herself, Erichthonios drove out Amphictyon and became king of Athens. And he set up the *xoanon* [wooden image] of Athena on the Acropolis, instituted the Panathenaic festival, and married Praxithea, a nymph, by whom his son, Pandion, was born.[115]

To put all this another way, Hephaistos, Hera's lame fatherless son, sired Erechtheus/Erichthonios, and Athena, Zeus' mighty motherless daughter, raised him as her own. In myth this passes for parentage. Thus the hero, though "autochthonous" (that is, "born of the earth"), was at the same time the child of the gods, and by extension so were his "descendants" – the Athenians themselves, the "sons of Hephaistos" (as Aeschylus calls them)[116] and of Athena, too. Autochthonous and of Olympian descent at once, the Athenians, ever resourceful, had it both ways.[117]

Myth was central to the self-definition and self-repre-sentation of any Greek city-state, and the proper under-standing of the Acropolis and its complex of buildings and images in large measure depends upon the use, power, and resilience of the myths of the birth of Athena, the Gigantomachy, the contest with Poseidon for the possession of the land, and the birth of Erechtheus/ Erichthonios. Taken together, the myths confirm and validate Athena's role as a mighty warrior-goddess and deserving patron and protector of Athens – as, in fact, the "mother" of her country.[118] More specifically, they also reinforced the principal reality of Athenian society and its principal patriotic boast. The reality was patriarchy, the boast was autochthony (the claim that the Athenians were indigenous to Attica, sprung from the very soil they inhabited). In a later chapter focussing on a single mythological image from the Classical Acropolis – the birth of Pandora, depicted on the base of the Athena Parthenos [Fig. 132] – we will suggest how deeply one reinforced the other, and how intense was the interaction of myth and society in ancient Athens.

THE ACROPOLIS IN
ATHENIAN LIFE AND LITERATURE

Parthenos, on the Acropolis Telesinos of Kettos dedicated this statue. Pleased, may you give him reason to dedicate another.

Inscription on a base for a bronze votive offering, around 500 [Fig. 32].[1]

Piety is the skill by which men and gods engage in commerce.

Plato, *Euthyphro*, 14E

It is not easy to draw a detailed, coherent picture of what went on upon the ancient Acropolis on an average day (assuming there was such a thing as "an average day" in the first place). The evidence, such as it is, is scanty and piecemeal. It comes from a wide variety of sources (literature, anecdotes, artifacts, inscriptions). And it comes from a wide variety of periods (in what follows we shall concentrate on the evidence from the Archaic and Classical eras). The complex of sanctuaries that was the Acropolis did not operate in exactly the same way in all of them.

Still, religious conservatism being what it is, many things probably stayed fairly constant from century to century. The sacrifice of an animal, the offering of a honeycake or piece of fruit, the dedication of a votive terracotta or bronze statuette – these were formulaic acts performed in much the same way for a thousand years or more, and an Athenian of, say, the Archaic period would not have found either the private or public rituals of the Hellenistic or Roman Acropolis unfamiliar. This is not to say that there were *never* any changes in the nature of cult on the citadel. New festivals were sometimes introduced and old ones sometimes declined or even disappeared altogether.[2] And from time to time there were shifts in dedicatory patterns, too. To take a case in point, it seems from the archaeological record to have been far more common for private individuals like Telesinos to dedicate bronze votives upon marble bases in the sixth and early fifth centuries [Fig. 32] than it was in the second half of the fifth century, during the Periklean building program. There are different ways to account for this. Perhaps it is just our sample that is faulty, skewed by unusual circumstances of preservation and loss.[3] But perhaps private dedications using marble bases were discouraged during, say, the 440s or 430s (since their carving, transportation, and erection would have drained at least some resources from – and even interfered with – the huge construction projects then under way). Or perhaps, after the Parthenon was built, gold and silver objects (such as gold wreaths and silver offering bowls) simply became the dedications of choice instead of bronze-and-marble ones. Of course, the Peloponnesian War (431–404) might have had something to do with changes in dedicatory patterns. But such changes occur at other times, too, and though it is hard to imagine it may, after all, simply be that individual

Fig. 32. Telesinos base (Acropolis 6505), c. 500–480. The inscription is addressed to Athena Parthenos. Photo: author.

have received any dedications specifically naming her until the fourth century, and this implies a certain change in emphasis – perhaps even the rise of a separate official cult (spun off the cult of Athena Polias, perhaps) where none had technically existed before.[7] Conversely, Athena Hygieia lost influence in the course of the Classical period: there were apparently no private dedications to her from the Acropolis after 420/19, when the sanctuary of the healing god Asklepios was founded on the south slope [Fig. 192] and quickly became the focus of Athenians concerned with their health. In this case, Athena seems to have yielded one of her ancient roles to another, newly imported god.[8] In short, votive practice and ritual remained familiar but it did not necessarily remain fixed. The history of worship on the Acropolis was to some degree dynamic.

The Acropolis in Athenian Literature

In trying to form some sense of what roles the Acropolis played in everyday Athenian life, we would walk down the path of conjecture with a lighter step if only Greek literature mentioned the place, or described the activities that regularly took place upon it and its slopes, more often than it does. It is true that in the prose histories of Herodotos of Halikarnassos (who lived for a time in Athens) and Thucydides (a native Athenian) there are a few detailed descriptions of events that took place on the citadel – its destruction by the Persians in 480, for example[9] – and that these include some important (if often controversial) topographical references. When in a famous passage Thucydides warns his reader that he should not judge cities such as Sparta and Athens by their physical remains alone – by that measure Athens would seem to have been twice as great as it in fact was – the brand new monuments of the Periklean Acropolis are surely those he has in mind.[10] It is true as well that the speeches of fourth-century Athenian orators sometimes mention monuments on the summit of the rock: Demosthenes, for example, refers to the Bronze Athena (Promakhos) just inside the Propylaia [Fig. 24]. So does the much later itinerant speechifier Aelius Aristides (second century AD).[11] There is also some suggestion in these political speeches and set pieces of what the Acropolis meant to the Athenians in a larger sense. For Demosthenes the Bronze Athena exemplified the Athenian victory over the Persians – it was the eternal symbol of Athenian greatness – and the beauty of the Propylaia

Athenians made relatively few private offerings to Athena in the second half of the fifth century, at precisely the time Perikles's program expressed the goddess's greatest glory on behalf of the entire polis. Certain kinds of personal dedications, that is, may have faded before the grandiose, patriotic offerings of the state.[4]

At all events, there were other notable shifts in dedications and cult on the Acropolis. Statues of women or maidens (*korai*), for example, were particularly popular dedications in the sixth century [cf. Figs. 91, 100, 101]; statues of youths and men became dominant by the fourth.[5] Votive reliefs dedicated to Athena were common around the turn from the fifth to the fourth century,[6] and then declined in popularity. Athena Ergane, though she must have always loomed large in the minds of the Athenian craftsmen who depicted her as early as the sixth century [Fig. 14], is nonetheless not known to

and the Parthenon, set up (he says, intriguingly) in honor of the people, is a legacy of undying glory from an earlier age, the achievements of men who should be emulated.[12] For Aelius Aristides the Acropolis was logically the center of the cosmos (since it was the center of Athens and Athens was the center of Greece and Greece the center of the world) and was, with its natural beauty complemented by the beauty of its wealth and art, itself like a beautiful statue.[13] Around the same time the satirist Lucian painted an imaginative picture of self-styled philosophers scaling the Acropolis from every conceivable angle.[14] And, of course, there are the long description of the Acropolis given by Pausanias (Appendix A) and the delightful (if not very accurate) description of the Periklean building program given by Plutarch in his biography of Perikles (Appendix B). Yet, oddly, in Thucydides's reconstruction of the funeral oration that Perikles himself gave at the end of the first year of the Peloponnesian War – a speech that focusses on the greatness of Athens, the Athenian love of "the beautiful" and the intellect, and the mighty monuments of its empire – there is no explicit mention of the Acropolis or what must have been his pride and joy: the recently completed Parthenon [Fig. 126].[15]

Greek art is not much concerned with the representation of sites or landscapes (either real or imagined), so it is not surprising that there is no extant Archaic or Classical depiction of the Acropolis (though one may have after a fashion appeared on the shield of the statue of Athena Parthenos [Fig. 161] and though there are some sketchy and abbreviated renderings of the citadel, from both north and south, on Roman Imperial coins).[16] But what we miss most, perhaps, are the words of poets and dramatists – passages that might convey what it was like to actually experience the place, to participate in a sacrifice, a dedication, or a festival on the summit or slopes, or simply to look around at its thick forest of monuments. There is no Archaic or Classical passage that "represents" the Acropolis in panorama or detail,[17] or that describes any real reaction to the buildings or images the Athenians had placed upon the Acropolis – no expression of awe or wonder or pride, no account of how the viewer perceived or understood, say, the pedimental sculptures of the Parthenon (the way the chorus stands, rapt, before the sculptures of the Temple of Apollo at Delphi in Euripides's *Ion*).[18] As it is, references to the Acropolis in Archaic and Classical poetry are limited at best.

The site happens to make its first literary appearance as early as it possibly could, in the epics of Homer.

But the *Iliad* (in which Athenians play no great role) barely mentions "the well-built citadel, the home of great-hearted Erechtheus" and Athena's "rich temple" in a few lines from the famous catalogue of Greek contingents at Troy, and in the *Odyssey* there is even less about the place.[19] In the 470s Pindar was reputedly fined by his native Thebes for extolling Athens too much in his poetry – "bright, violet-crowned, famous, bulwark of Greece, renowned Athens, divine city," he gushed – but only one reference to the city's "much-traversed fragrant center (literally, *omphalos*, or navel)" might refer to the Acropolis itself, and even that is doubtful.[20] Homer (in whose day the Acropolis did not merit much attention) and Pindar (who probably wrote his praise of Athens when its citadel was in ruins) were not Athenians, of course. But on the whole the Acropolis does not figure prominently in Athenian verse, either.

Solon, the great early-sixth-century law-giver who is also the earliest known Athenian poet, is the first Athenian to mention Athena, but his preserved lines do not mention her rock. Archaic Athenian poetry after Solon is poorly preserved, but what little there is ignores the Acropolis as well. And so, with some notable exceptions, does Classical Athenian tragedy and comedy. Now, it is true, Athenian dramatic poetry (like Homeric epic) typically deals with myths and sagas that took place elsewhere – the Thebes of Oedipus or the Argos of Agamemnon, for example – and in those stories the Acropolis usually has no logical or dramatic role to play. It is also true that Greek literature (like Greek art) is, as a whole, not noted for its descriptions of landscapes, sites, or buildings. But it is still remarkable that in all of fifth-century Athenian tragedy and comedy, where Athena appears far more often than any other deity, there is no poetic panorama, no taking stock, of her special place.

There are, in fact, only two or three allusions to the great chryselephantine statue of the goddess that Pheidias made for the Parthenon [cf. Fig. 25], and they are all found in Aristophanes: in *Knights* (1168–76), the comedian refers farcically to her ivory hand and finger as fit for making buns, in *Birds* (670) a pretty flutist dressed in gold is (probably) compared to the Parthenos, and in *Lysistrata* (344) the chorus of women appeal to the goddess "of the golden crest."[21] Even in later prose descriptions of the statue there is nothing like the awe-struck wonder we find in authors who stood before Pheidias's other great chryselephantine work, the statue of Zeus at Olympia (one of the seven wonders of the ancient world).[22] Whereas that statue, we are told, added some-

thing to traditional religion, the Athena Parthenos primarily personified Athenian wealth. The only time Perikles is said to have alluded to it was for the forty talents of removable gold plates it wore, as if it were first and foremost a colossal financial reserve – a safety deposit box in the shape of the city's patron goddess.[23]

All there is in Athenian drama are brief notations and scant allusions to a few buildings, monuments, and caves on the summit and slopes. Aristophanes's *Wasps* mentions the Odeion of Perikles on the south slope, for example, and his *Ploutos* (Wealth) mentions in passing the treasure house of Athena known as the *Opisthodomos*, a troublesome term that refers either to a portion of the late Archaic Old Temple of Athena Polias rebuilt after the Persian Wars and in Aristophanes's day still standing between the Erechtheion and the Parthenon [Fig. 3, no. 11, Fig. 93], or else to the western part of the Parthenon itself [Fig. 127] (this is a controversial matter we will need to take up again).[24] It has often been thought that a famous passage in the same comedy describes the healing process known as "incubation" as it occurred in the Sanctuary of Asklepios on the south slope [Figs. 192, 193], but although something like what Aristophanes describes must indeed have taken place there, the setting of the famous scene is possibly another sanctuary of Asklepios altogether (at Zea, on the Attic coast).[25] Even those Classical plays that do refer to the Acropolis, its topography, its monuments, or its rituals with relative frequency – they are mostly plays of Euripides – do not give much of a sense of what the place was actually *like*, or how it functioned as a sanctuary. Euripides's *Ion* refers often enough to the "Long Rocks" at the northwest slope of the Acropolis (where Apollo had his way with Erechtheus' daughter Kreousa and where she later abandoned her infant son), it notes the Cave of Pan nearby [Fig. 7], and it mentions Athena's sacred olive tree on the summit: the Acropolis looms so large in the background, in fact, that it has been called the "star" or "hero" of the play, even though the action takes place entirely at Delphi. Euripides's *Hippolytos* mentions a shrine of Aphrodite built "beside the Acropolis" (on its south slope) by Phaidra in memory of her doomed stepson. His *Herakleidai* refers to the singing and dancing of youths and maidens that took place on the Acropolis – "the windy hill," Euripides calls it – throughout the night before the Panathenaic procession (the *pannykhis*, or "All-Nighter").[26] It is likely, too, that Euripides alluded to the construction of the Erechtheion [Fig. 173], then rising on the north side of the summit of the rock, in his

fragmentary *Erechtheus* (datable to the late 420s). The drama told a foundation myth, and at its end Athena ordered the construction of a shrine on the Acropolis (whose centrality in the city was also affirmed), established the cult of Poseidon- Erechtheus (one focus of the Classical temple), and even made Praxithea, Erechtheus's widow, the first priestess of Athena Polias, whose olive-wood statue was kept in the building.[27] A fragment of the play also mentions the olive tree of Athena and a golden gorgoneion somewhere on the citadel.[28] But although the Acropolis thus figured in many plays, the only fully extant Athenian play that is *set* entirely on the Acropolis is the *Lysistrata* of Aristophanes (produced in 411), in which the women of Athens seize the citadel and stage their famous sex-strike in an attempt to end the Peloponnesian War. The scenery of the play probably represented the Propylaia (the background to the action), and there are plenty of references to the building itself. As the chorus of old men get ready to attack the Acropolis they invoke the goddess Nike for help in setting up a victor's trophy, and there may be a general allusion here not only to the Athena Nike bastion itself (on the right of anyone approaching the Propylaia) [Fig. 181] but also specifically to the Nike parapet [Fig. 185], where winged Nikai busily erect trophies (the parapet seems to have been begun, though not finished, by 411). The play alludes to the three great statues of Athena within the gates without explicitly naming them: the "holy (wooden) image" must be the Athena Polias, the "goddess of the gold crest" is surely the Athena Parthenos, and it is the helmet of the Bronze Athena (Promakhos) that one of Lysistrata's women, pretending to be pregnant, slips under her dress in an unsuccessful ruse. And there are references to a few other Acropolis sites or their contents besides: the treasure of Athena (the bulk of which was kept in the Parthenon, though Aristophanes does not specifically mention the building that was, among other things, the Athenian Fort Knox), the Cave of Pan, the Klepsydra fountain at the northwest corner of the Acropolis, and ropes and pulleys possibly used in the construction of the still unfinished (and in the play unnamed) Erechtheion.[29] At the end of the comedy, the famous sex-strike is over, peace between Athens and Sparta is made, the Propylaia are opened again, and everyone happily enters the Acropolis for feasting and banqueting (a normal ritual activity in most Greek sanctuaries). But if the locale is comically functional – there is, after all, the irony that Athenian women who intend to arouse the sexual desire of their

men for political purposes withdraw to the sanctuary of the goddess famed for her indomitable chastity, as if they could become *parthenoi* again – the Acropolis is hardly the subject of the play, and we are given no guided tour.[30] For all we are told of what actually lay inside the gates, at the end of the play we might as well still be locked out.

All in all, then, Classical Athenian literary references to the Acropolis are rare, nondescriptive, and basically topographical. But, of course, the Athenians *knew* what the Acropolis looked like and what was atop it, and they knew what it was like to visit the place. And so the best explanation for the relative dearth of descriptions of the Acropolis in Athenian literature is the obvious one: there was no need. The Athenians took the place and its contents for granted. As they watched the *Ion* or *Hippolytos* or *Lysistrata* performed in the Theater of Dionysos on the south slope of the Acropolis [Fig. 209], they had, after all, the rock and the monuments and temples on the summit and slopes over their shoulders or in the corners of their eyes, and they had their past and recent experiences of the place in mind. For most Athenians, those experiences were gained most memorably at festivals.

The Religious Festivals of the Acropolis

Pausanias, who must have grown weary inspecting and describing all the temples, monuments, and votives the Athenians set up, refers more than once to their conspicuous, even excessive, religious zeal.[31] But fifth-century Athenians were themselves well aware of their particularly strong devotion to state religion. In an anonymous pamphlet probably written in the early 420s, a cranky reactionary known as the "Old Oligarch" noted that the Athenians celebrated many more festivals than anyone else (his complaint was that the rich were expected to pay for many of them, and that the holidays were bad for business). But what the Old Oligarch complained about was material, at almost exactly the same time, for one of Perikles's boasts. In his Funeral Oration of 430, the great democrat bragged: "we [Athenians] sacrifice throughout the year."[32] For him (and probably for most Athenians) public festivals and sacrifices, besides being expressions of community, were forms of competition and recreation, a release from labor (they were also the principal means by which average Athenians included roast meat in their diet). And, in fact, Classical Athenians broke the monot-

ony of their daily lives by enjoying more religious festivals than any other Greek *polis*. In the fifth and fourth centuries, at least 120 days out of the year – about one day out of every three – were holidays.[33]

Though more of those days were actually devoted to Demeter, Kore (Persephone), and Dionysos than to either Athena or Zeus,[34] the Acropolis was without question the religious focus of the city. Most of the major festivals of Athens were at least partly played out on the summit of the rock or on its slopes, or used the Acropolis as a starting point (so, while there were "average days" on the Acropolis, there were not all that many of them). The procession that seems to have been the central feature of the women's festival known as the *Skira*, for example, set out from the Acropolis: though the holiday was apparently sacred to Demeter, the procession was led by the priestess of Athena Polias and the priest of Poseidon-Erechtheus, those divinities who competed for the Acropolis and whose cults were central upon it.[35] And even in the course of the long celebration of the Eleusinian Mysteries, which were also sacred to Demeter and Kore and in which Athena essentially played no role, an official had at one point to ascend the Acropolis and inform the priestess of Athena Polias that the "Holy Things" had arrived in town – an obvious, respectful bow to the authority of the goddess of the rock.[36]

The majority of Acropolis festivals had, in fact, little to do directly with Athena herself, and several of the most important celebrated male gods. Asklepios, for example, was honored by two annual festivals, the *Epidauria* and the *Asklepieia*, spaced six months apart, which were inserted in the sacred calendar in the midst of two other great civic festivals (the Eleusinian Mysteries and the City Dionysia). The *Epidauria* commemorated the arrival of the cult of Asklepios from Epidauros in 420/19, while the *Asklepieia* marked the consecration of the god's sanctuary on the south slope [Fig. 192]. The rites included the usual procession of offering-bearers and a large sacrifice and common meal in the healing god's honor. The second most important Athenian festival belonged to Dionysos: the City (or Great) Dionysia. This festival of parades, sacrifices, and dramatic competitions was played out, of course, primarily in the sanctuary and Theater of Dionysos Eleuthereus on the south slope (his cult was early on transferred there from the village of Eleutherai in rural northern Attica) [Fig. 3, no. 21; Fig. 209]. In the Classical period the festival proper, generally held in early spring, was preceded by two days of preliminary activities, such as the announce-

ment, in the Odeion of Perikles beside the theater, of what plays would be performed and the selection of judges of the dramatic contest (the names of the candidates had been sealed in jars stored atop the Acropolis). The first day of the actual festival was devoted to a grandiose procession of finely-dressed citizens, *metoikoi* (non-Athenian residents of the city), and colonists carrying *phalloi* or leading cattle that were sacrificed in the theater and devoured that night in a massive public feast (in 333, long after the heyday of Athenian tragedy, 240 bulls were sacrificed and roasted, as if the Athenians compensated themselves for a decline in the quality of their dramatic poetry with beef). The days of drama then began, but not before a procession of 400 youths (in the glory days of Athens's empire) carried jars and sacks of silver tribute to the theater for all to see and to remind the Athenians (and their foreign guests) of their imperial wealth, and not before a procession of war-orphans, raised to adulthood by the state and now equipped with armor of their own, filled the Athenians with pride and patriotism. After these more or less profane spectacles (little "religious feeling," as we might conceive of it, would have been invested in them), three days were filled with tragedies and satyr-plays and one day with five comedies. The festival concluded with a day that reviewed the management of events.[37]

If Asklepios and Dionysos were the focus of major festivals on the south slope, and if Apollo had an impressive cave-shrine at the northwest corner of the Acropolis [Fig. 7], the only male divinity to receive significant public attention on the summit of the Acropolis was Zeus Polieus – Zeus of the City, the counterpart of his daughter Athena Polias (indeed, he may have been called Polieus only because she was called Polias first). His sanctuary was probably located to the northeast of the Parthenon, where a squared-off but irregular mass of limestone marks the highest point of the Acropolis and where there are cuttings in the bedrock for a small gateway, precinct, and shrine [Fig. 3, no. 14; Fig. 164]. It was here that the midsummer *Dipolieia* (Festival of Zeus Polieus) with its central ritual, the *bouphonia* (ox-slaying), took place, a ritual so peculiar and primitive that even fifth-century Athenians thought it bizarre. According to the evidence of ancient reports and vase-paintings, a procession of Athenians (including girls carrying water-jars, or *hydriai*, and youths carrying barley, wheat, and a knife) drove a group of oxen up the Acropolis to the sanctuary of Zeus. Heaps of grain were placed atop an altar or bronze table in the shrine, ostensibly as an offer-

ing to Zeus but really as bait for the oxen, and the animals were allowed to circulate until one of them did what came naturally and ate the grain. At that point, a man quickly seized a bronze double-axe stored in the shrine and brought it down upon the neck of the "offending" beast. The ox-slayer himself then threw down the axe and fled, tainted by the blood of his victim. Those who remained skinned the ox with the sacrificial knife, cut up the meat, roasted it, and ate. There followed a trial in the Town Hall (*Prytaneion*) below the Acropolis to indict the murderer of the ox, but since the ox-slayer himself had escaped, charges were ultimately filed against the double-axe or the sacrificial knife, one of which (our sources disagree which one) was found guilty and thrown into the sea as punishment. As if to placate the victim, taxidermists filled the hide of the ox and the stuffed animal stood in Zeus's shrine until the next *Dipolieia*. Certainly by the Classical period most Athenians would have winked at all this: Aristophanes went further, ridiculing the *Dipolieia* and *bouphonia* as archaic nonsense.[38] The irony is that looming above the sanctuary of Zeus Polieus, in full view of the participants of the *bouphonia*, was the east pediment of the Parthenon, where Hephaistos, probably wielding a double-axe like the ox-slayer on the ground, had with a mighty blow just split open the head of Zeus [Figs. 136, 145].[39] If fifth-century Athenians no longer took the ancient *bouphonia* seriously, how seriously did they take the myth displayed in marble high above them? Ritual behavior, in any case, mattered more than original justification and belief – Greek religion *was* ritual behavior.[40] And the *Dipolieia*, which almost certainly ranks among the oldest festivals of Athens (the double-axe may have been an actual Mycenaean relic), endured, for all of its absurdity, for centuries.[41]

A variety of goddesses other than Athena were worshipped on the Acropolis and its slopes, though not all were the focus of major festivals or processions. A precinct of Artemis (another virgin goddess, or *parthenos*), for example, is located just to right of anyone who passes through the Propylaia, above a rock-cut wall marked with cuttings for dedications [Fig. 3, no. 5; Fig. 170]. There was once a colonnaded hall (or stoa) in the precinct; there were statues of Artemis (including one by Praxiteles); and it is likely that young Athenian girls (perhaps ten years old) performed the rite known as the *arkteia* here (as elsewhere in Attica), mimicking little she-bears and dancing around the altar of the goddess of the wild.[42] But there was no actual temple of Artemis, and

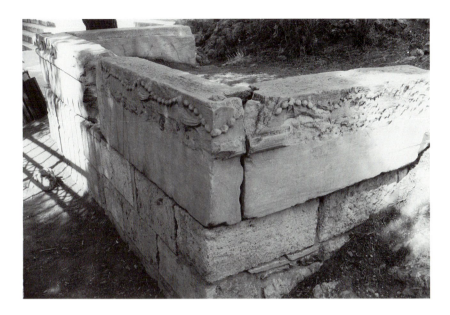

Fig. 33. Remains of Temple of
Aphrodite Pandemos. Photo: author.

the Acropolis shrine seems fully dependent upon the greater sanctuary of Artemis at Brauron in eastern Attica [Fig. 1], where the ancient wooden cult statue was always kept and where the main festival of Artemis Brauronia took place.[43] On the south slope Themis (the goddess of What Was Right, of law and order, who also "dismisses and convenes the assemblies of men"[44]) had a small temple, next to the later shrine of the Egyptian import, Isis [Fig. 3, no. 29]. Ge Kourotrophos (Earth, Nurse of Youth) shared a shrine just below the Nike Temple bastion with Demeter Khloe (Goddess of the Green). Though the great festival of Demeter was, of course, the Eleusinian Mysteries, Demeter Khloe was honored at her shrine on the southwest slope by the sacrifice of a ram on the first day of the festival of Apollo known as the *Thargelia*.[45]

But it has been said that if Athena was the preeminent goddess of the summit of the rock, the preeminent goddess of its slopes was Aphrodite, and there she was either the focus or witness of two other major Acropolis festivals: the *Aphrodisia* and the *Arrhephoria*. In a shrine located directly below the Nike Temple bastion (there is a rock-cut bedding for a building whose remains are currently located further to the west) [Fig. 3, no. 31], Aphrodite Pandemos, a civic goddess of "all the people," was worshipped together with Peitho (Persuasion), the personification of a quality essential for the well-being of a democratic state (as well as for romantic success). Though what is left of the architecture is early Hellenistic – these are the remains of the temple Pausanias saw

[Fig. 33] – the cult of Aphrodite and Peitho was said to have been established by Theseus (a favorite of Aphrodite) when he unified Attica and needed their help. The summer festival known as the *Aphrodisia* involved the sacrifice of Aphrodite's sacred bird, the dove (doves are carved in relief upon the entablature of the temple), as well as a procession that culminated in the ritual bathing of the cult statues of Aphrodite and Peitho.[46]

On the north slope of the Acropolis, Aphrodite seems to have been the goddess par excellence. In the late sixth and early fifth centuries the entire slope was apparently transformed into an open-air and exclusively sacred precinct, and its curtains of rock are, in fact, marked by nearly a hundred cuttings or niches for the deposition of votive objects. There must have been a wide variety of cults located along the length of the slope, though their identities are mostly lost to us. But in a great fold of rock below and to the east of the Erechtheion was the wide and deep precinct of Aphrodite and her son Eros, a curving, theater-like hollow with over twenty niches for the deposition of votive plaques, figurines, and other offerings [Fig. 3, no. 18; Fig. 34].[47] This shrine was at least as old as the mid-fifth century (when two inscriptions to Eros and Aphrodite were carved into the rock) but it is probably far older than that, and it may have been a satellite of another sanctuary, located near the Ilissos River, sacred to Aphrodite of the Gardens. It was there that Aphrodite's cult statue stood.

But it was here, beneath the Acropolis, that the goddess may have witnessed one of the rock's most enig-

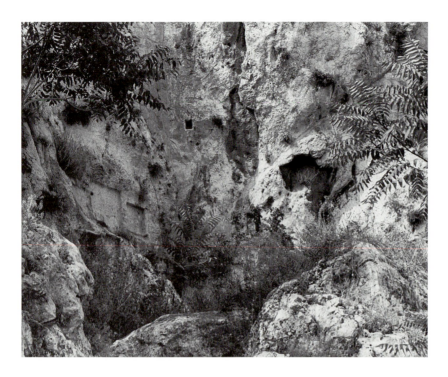

Fig. 34. Sanctuary of Aphrodite and Eros, north slope. Photo: author.

matic festivals: the *Arrhephoria*. The rite takes its name from two (or four) young girls, seven to eleven years old and of noble birth, known as the *Arrhephoroi* (the word could mean "Carriers of Sacred, or Unspoken, Things"). Each year the chief religious official of Athens (the so-called *Archon Basileus*, or Royal Archon) selected the girls from candidates nominated by the people. They dressed in white robes and lived atop the Acropolis for some unspecified length of time, possibly in a large structure (complete with a playground for ball games) built against the north wall of the citadel, west of the Erechtheion [Fig. 3, no. 8]. Their basic duties were probably to assist in the daily maintenance of the cult of Athena Polias; they may even be shown with her priestess on the Parthenon frieze [Fig. 151, left]. More important, they somehow assisted at the workers' festival known as the *Chalkeia* (sacred to Hephaistos, Athena's colleague as god of craftsmanship), when the loom for the weaving of Athena's *peplos* was set up, possibly in their house on the Acropolis (most of the work, though, was apparently done by other aristocratic maidens or women known as the *Ergastinai*). But most important, the *Arrhephoroi* played the principal role in the strange nocturnal rite named after them. According to a difficult passage in Pausanias (1.27.3), the Priestess of Athena Polias gave them covered baskets holding secret objects or *arrheta* (neither the priestess nor the girls knew what

the objects were, and we are not told who did), and the *Arrhephoroi* then carried them down an underground passage "in a precinct in the city [the phrase Pausanias uses here can also mean 'on the Acropolis'] not far from the Sanctuary of Aphrodite in the Gardens." The girls deposited the mysterious objects below and were given others to take back up. They were then dismissed from service and new *Arrhephoroi* took their place on the Acropolis.

It is usually assumed that the *Arrhephoroi* began their trek atop the Acropolis itself, descending part-way through a deep natural cleft inside the north citadel wall that in the Mycenaean period led down to a spring [Fig. 57]. In this view the girls emerged from the underground passage through a deep cave high on the north slope [Fig. 35], and then passed to or through the sanctuary of Aphrodite and Eros below. But it is not certain that that was their route, or that the Acropolis was the site of the entire ritual, or that the shrine of Aphrodite and Eros should be equated with the Sanctuary of Aphrodite in the Gardens, or even that Aphrodite was directly involved in the rite – her sanctuary, according to Pausanias, was not the final destination of the *Arrhephoroi*, it was just nearby.[48] Since we do not know what things the *Arrhephoroi* carried on their heads or even what their precise goal was, it is difficult to say what the ritual signified. Some scholars, maintaining that the

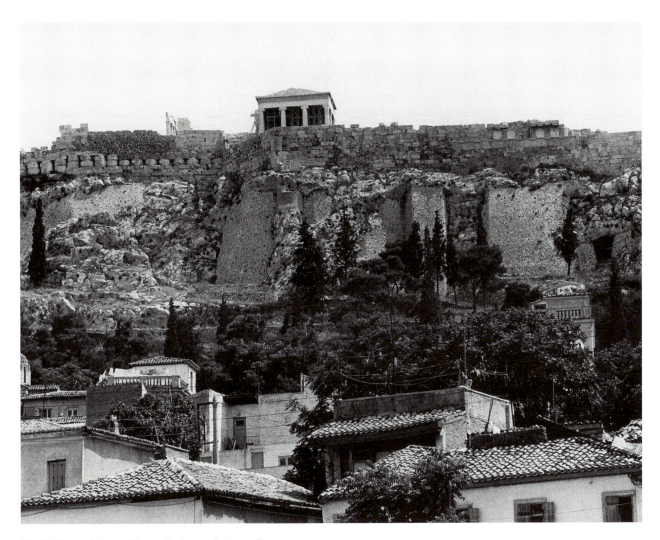

Fig. 35. View of Acropolis, north slope. Photo: author.

Arrhephoroi literally moved from the summit of a virgin goddess to the precinct of a goddess of love and fertility, suggest the ceremony represented the coming of age or sexual maturation of the girls. Others suggest that the ritual was a corrective reenactment of the myth of the disobedient daughters of Kekrops, Aglauros and Herse, the two girls who (unlike their good sister Pandrosos) had looked where they were forbidden to look (in the basket with the baby Erichthonios and his guardian snakes) and perished.[49] On the other hand, the *Arrhephoria* may in origin have been a fertility ritual, guaranteeing the coming of nurturing dew (that is what both Pandrosos and Herse mean, and some have translated *Arrhephoroi* as "Dew-Bearers") and thus the health of Athens' olive trees (hence the possible involvement of Aphrodite, the garden goddess). But whatever it meant,

Pausanias implies the *Arrhephoria* began and ended on the Acropolis, and the possibility remains that the ritual spatially, if cryptically, linked slope and summit and their principal goddesses. Aphrodite and Athena may at first glance seem an odd pair. But the ancient Athenian would not have thought them incompatible. For the state to prosper it had to enjoy the benefits of both goddesses, and the necessary link was reinforced in many other ways.[50]

Athena herself, of course, was the focus of a number of festivals of the Acropolis. Our knowledge of the *Synoikia*, the publicly funded festival celebrating Theseus' legendary unification of Attica (the *synoikismos*), is poor – Thucydides believed Theseus himself instituted it[51] – but we know it included a great feast and we can reasonably surmise that some of the festivities took place on Athena's citadel. There is no question about the

rituals known as the *Kallynteria* and *Plynteria*, which focussed upon the ancient olivewood statue of Athena Polias and its house. During the *Kallynteria*, the annual Festival of Spring Cleaning (or Beautifying) held during the month of Thargelion (April/May), the Temple of Athena Polias (later, the Erechtheion) was swept out and spruced up and (probably) the eternal, olive-oil burning lamp of Athena was refilled and relit. During the *Plynteria* (the Festival of Washing) a few days later, women of the Praxiergidai clan stripped the cult statue of its gold ornaments and *peplos* and wrapped it up. What happened next, we are not sure. There was, as usual, a procession, but the popular notion that the Praxiergidai actually carried the image to Phaleron accompanied by young Athenian horsemen (*epheboi*), sponged it off in the sea, and brought it back to the Acropolis, has in fact little to commend it. At all events, the festival would have been grand but solemn, for with the statue unadorned, hidden, or even absent from the Acropolis, this was not a happy day (we are told that the Athenians refused to undertake anything of import during the *Plynteria*). But even inauspicious days must come to an end, and the procession returned in the evening by torchlight. Inside the cleaned temple or in one of its porches, in view of the people, the Praxiergidai dressed the statue in a freshened *peplos* (perhaps that is what had been washed in the sea) and put its gold jewellery, *aigis*, owl and so forth back on. If the statue had been taken away, it was then put it back in its place.[52]

The *peplos* of Athena Polias was clearly one of the most sacred items on the Acropolis – at least the Athenians invested a lot of prestige in it – and the presentation of a new one, begun nine months before at the *Chalkeia*, was the central event of the annual *Panathenaia*, "the one sacred to all Athenians," the greatest Attic festival of all. The origins of the festival are lost in mythological time – most sources say Erichthonios established it, some say Theseus[53] – but there is no question that for the Athenians the holiday was virtually as old as Athens itself.[54] Actually, the Panathenaia, held in the last days of the first month of the Athenian year – Hekatombaion (corresponding to our late July and early August) – was celebrated in two forms. The annual or "Lesser" Panathenaia, the one of remote antiquity, may have lasted two or three days. It probably began with a torch race and all-night celebration of youths and maidens on the Acropolis (the *pannykhis* alluded to by Euripides), which was followed at sunrise by a long procession of Athenians and sacrificial animals from the Dipylon Gate at the northwest entrance to the city, through the Kerameikos and Agora along the main thoroughfare known as the Panathenaic Way, up the slopes of the Acropolis, to the altar of Athena Polias on the summit of the rock – a total distance of over a kilometer [Fig. 2].

The day of the procession was Hekatombaion 28, but there is some disagreement over the significance of the date. It is often thought to be the birthday of Athena (and perhaps also the day her olivewood cult statue fell from heaven). If so, the Panathenaia can be regarded as an elaborate birthday party that culminated, appropriately, at an altar a stone's throw away from the east pediment of the Parthenon, where her birth was grandly displayed [Fig. 3 no. 12; Fig. 145]. But one normally reliable ancient source claims that Athena was born not on the twenty-eighth day of the month, but on the third (that would explain her common epithet, Tritogeneia, "Third Born").[55] And even if the twenty-eighth was, in fact, considered Athena's birthday, the festival may still have been inspired by the goddess's great victory in the battle against the giants – which is why it was appropriate to weave excerpts from that myth, and not the birth of Athena, into the *peplos* itself.[56] Indeed, the Panathenaia always had a clearly martial character: the day of the procession was the only day of the year that the Athenians could bear arms en masse, and so the festival was a display of Athenian military might. On what may be the earliest representation of the Panathenaia, on a black-figure cup of the mid-sixth century, armed hoplites (foot soldiers) are among the participants.[57] At all events, there was almost certainly more to the annual Panathenaia in its early days than just a procession, the presentation of a robe, and the sacrifice of animals. There were probably also contests of various sorts (tribal or clan-sponsored chariot races, for example, or group competitions in such dances as the *pyrrikhe* – the sort of armed dance Athena herself supposedly performed both after she was born and after her victory over the giants).[58] Just how organized or official these games might have been we do not know.

Not long before the middle of the sixth century, on the model of the already ancient Olympic Games (traditionally founded in 776) and in emulation of quadrennial athletic festivals recently established at the panhellenic sanctuaries of Delphi, Isthmia, and Nemea, *agones* (competitions) – footraces, boxing, wrestling, the pentathlon, and so on, open to all Greeks – were formally added to the Panathenaia, and thus the Greater Panathenaia, held every four years, was born. The traditional (though not

absolutely certain) date for the reorganization and expansion of the festival is 566/5, when Hippokleides, a member of the important Philaidai family, was chief magistrate (or *archon*) of Athens.[59] This does not mean Hippokleides should get the credit for overhauling the Panathenaia: the only source that gives credit to anybody gives it to Peisistratos, a war-hero who would be (but who in 566/5 was not yet) tyrant. But whether Peisistratos was responsible for establishing the Greater Panathenaia or not, he and his sons, Hippias and Hipparkhos, certainly left their mark upon it. After Peisistratos succeeded in establishing a secure tyranny in Athens (around 546), he turned the festival into a glamorous cultural as well as athletic affair by adding musical performances or contests in the flute or kithara.[60] Perhaps a few years after his father's death in 527, Hipparkhos reportedly first brought the epics of Homer to Athens and directed competing Panathenaic rhapsodes – professional singers of epic – to recite the poems in order, one picking up where another left off.[61] This cannot mean that the Athenians had never heard the *Iliad* or *Odyssey* before (on the contrary, the story implies rhapsodes had recited the epics before in Athens but had done so haphazardly). What it does apparently mean is that Hipparkhos imported a standard text of Homer to Athens, or established such a text, and perhaps also prohibited rhapsodic performances of any epics except Homer's.[62] The installation of Homer at the Panathenaia was in any case not simply a declaration of Athenian good taste. It was literary expropriation of the first order, an assertion of cultural supremacy, an act of cultural imperialism: Homer now belonged to the Athenians.

The nature of the Greater Panathenaia was not, then, fixed in 566/5, and the evolution of the festival hardly ended with the Peisistratids. Events, procedures, and categories of participants may have been added, changed, or shuffled fairly often, and not all the alterations were minor. It now appears, for example, that in the early fifth century a particularly remarkable feature was added to the Greater Panathenaic procession and a monumental change made in the nature of the cloth brought to Athena Polias on the summit of the Acropolis. In the aftermath of the Persian Wars, perhaps in the Greater Panathenaia of 474 or 470, a ship – a trireme that had acquitted itself admirably in the decisive battle of Salamis in 480, perhaps – was lifted out of the water and set on a wheeled undercarriage. At that Greater Panathenaia, and then every four years afterward until the festival ceased to be celebrated, the ship's yardarm was fitted with a huge

peplos (4–8m on a side) that, like the much smaller one dedicated at the annual Panathenaia, was decorated with scenes from the Gigantomachy: it was another, bigger "story-cloth," and the theme was once again victory. However, unlike the *peplos* used to dress the wooden statue of Athena Polias (made by the *Arrhephoroi* and the *Ergastinai*), the colossal sail-*peplos* was made by men, and by professionals who competed for the commission at that (we may even know the names of the men who wove the very first one – Akesas and Helikon). A *peplos* as big as a sail was obviously too large to drape upon the little statue of Athena Polias. More than likely, after the ship was drawn through the streets of Athens by a team of oxen and docked at the foot of the Acropolis (where it remained on view until the next Greater Panathenaia), the cloth was eventually struck, folded, and carried up the citadel, where it was deposited in the shrine of Athena Polias or hung like a tapestry on its walls (could it eventually have been displayed somehow on the broad and otherwise strangely blank south wall of the Erechtheion, Fig. 173?). In short, beginning in the 470s, there were *two* Panathenaic *peploi*: one of human scale presented each year to Athena Polias at the Lesser Panathenaia, and one of colossal size, ship-born, offered only every four years at the Greater Panathenaia.[63]

That, anyway, is a plausible interpretation of the complex literary evidence for the Greater Panathenaia. Hard archaeological and epigraphical evidence is also bountiful, and it starts early. There is, for example, a mid-sixth-century inscription from the Acropolis that records the names of a handful of Athenian religious officials (the *hieropoioi*, or Doers of Sacred Things) who "made the *dromos*" and "for the first time established the *agon* for the flashing-eyed maiden." *Agon* can mean either "contest" or "public ceremony," while *dromos* can mean either "race competition" or "roadway/racetrack" (the original track is usually thought to have run along part of the Panathenaic Way in the Classical Agora, though a location northeast of the Acropolis, in what now appears to have the Archaic Agora, is perhaps more likely). But the phrase "for the first time" apparently ties the inscription to Hippokleides, 566/5, and all that.[64]

The date of the *dromos* and *agon* referred to in the inscription would in that case be close to the date of the earliest extant "Panathenaic amphora" – the so-called Burgon amphora in the British Museum [Fig. 23].[65] Such large vases were specially commissioned by the Athenian state to be presented to the victors (and runners-up) in the Panathenaic athletic contests. It would, it is true,

be an extraordinary stroke of luck to have an amphora awarded at the very first Panathenaic competitions, but on stylistic grounds the Burgon vase cannot be very far from 566/5. At all events, from the very first (and until they go out of style in the second century), these prize vases, always painted in the black figure style, bore on one side the image of Athena in her Promakhos pose (or else dancing her own *pyrrikhe*) with the inscription "[I am] from the games at Athens" written vertically in front of her; on all but the earliest Panathenaics Athena is framed by two columns surmounted by cocks.[66] The other side bore a representation of an athletic event, presumably the one for which the vase was awarded.[67] Hundreds of these vases were made for each festival, and a potter's shop that won a Panathenaic commission was a busy place literally for years. According to an important inscription listing the prizes at an early-fourth-century Greater Panathenaia, for example, the winner of the *stadion* (a roughly 200-yard sprint) in the "youth" division (there were also age-brackets for boys and men) received sixty of them, while the second-place finisher received twelve, and the total number of vases for all the athletic events combined probably exceeded fourteen hundred.[68] But the pots were not the real prize: it was the oil they contained, collected from Athens's sacred olive trees (the descendants of the one the goddess planted on the Acropolis during her contest with Poseidon). Though dimensions vary, the typical Panathenaic amphora can hold 38 or 39 liters of oil,[69] so the victorious youth in that fourth-century *stadion* would have been well supplied indeed. And since we are told that the prize oil was kept on the Acropolis before distribution, the sacred citadel must have been equipped with substantial storage facilities.[70] Sanctuaries had their utilitarian side.

Winners in the equestrian events (such as the horse-race, chariot-race, and the *apobates*, in which armed warriors leapt down from charging chariots and then either finished the race on foot or ran their chariots down and jumped back on) also received Panathenaics filled with olive oil. But oil was not the only prize at the festival. Around 480 or 470, for example, the leader of a victorious men's chorus evidently received a bronze tripod (he in turn mounted it on an inscribed marble base and dedicated it on the Acropolis). Tripods were also awarded the victors in the mock cavalry battle known as the *anthippasia* (held at the Greater Panathenaia at least from the third century on), and perhaps such prizes – venerable symbols of victory that began to be dedicated on the

Acropolis in the eighth century [cf. Fig. 64] – were awarded for other contests as well.[71] According to Aristotle and that early-fourth-century Panathenaic inscription, winners in the various musical contests won prizes of gold and silver: the champion kithara-singer, for example, received a gold crown worth 1,000 *drakhmai* (a *drakhma* was an Attic silver coin weighing about 4.3 grams) and 500 *drakhmai* in cash. The three victorious teams of Pyrrhic dancers (boys', youths', and mens') won coins and bulls. Bulls and money also went to the winners of a torch race and a boat race held in the sea off Phaleron (the winners of the regatta also received free meals), and the victors in the curious team event called the *euandria* (Manly Excellence) – it seems to have been a male beauty pageant with a test of strength thrown in – won cash and a bull, too.[72] The Greater Panathenaia was clearly no place for amateurs.

From the late fifth century on, a board of ten men known as the *athlothetai* (Commissioners of the Games), selected by lot, planned and managed the quadrennial festival, arranging for the weaving of the great sail-*peplos*, awarding the contracts for the prize vases, collecting and distributing the olive oil, and so on.[73] It is also possible to reconstruct a likely calendar of events, though this, too, might have changed from festival to festival. In its heyday the Greater Panathenaia seems to have lasted eight days (Hekatombaion 23 through 30, with the days measured from sunset to sunset).[74] Most musical, rhapsodic, athletic, equestrian, and tribal contests took place over the first five days (if the *Iliad* and *Odyssey* were really performed from start to finish, that alone would have required several days at least, even with the recitations overlapping other events). The torch race that lit the altar of Athena, the night-time *pannykhis* celebration, the procession, and the sacrifice filled up the sixth day (Hekatombaion 28). More events (such as the naval regatta and the *apobates* competition) took place on the seventh day, and the awarding of prizes and celebrations were scheduled for the eighth.[75]

As thrilling and spectacular as such events as the *apobates* and regatta were, and as culturally enriching as the musical and Homeric competitions must have been, the highpoint of the Greater Panathenaia remained the procession, and in the fifth century, at least, we have a good idea who participated: the *athlothetai* themselves, other sacred officials and priests, marshalls, musicians, highborn Athenian youths and maidens (many would already have been exhausted from partying on the Acropolis the night before), *kanephoroi* (noble virgins – *parthenoi*, like

Athena herself – who carried baskets of grain hiding knives, both for use in the sacrifice), *diphrophoroi* (maidens of lesser class who carried stools and perhaps also sunshades for the noble basket-carriers), *thallophoroi* (old men chosen for their good looks who carried branches of olive), and hoplites with shields and spears.[76] Since mounted youths (*epheboi*) figured prominently in other Athenian sacred processions and since horsemen figure prominently on the Parthenon frieze (taking up nearly half its length) [Figs. 147, 153], it is almost universally assumed that the Athenian cavalry formed a major component of the Panathenaic parade as well, despite the fact that there is not a single literary or historical source explicitly saying so and that the Parthenon frieze, as we shall see, is a poor guide to the procession as we know it from other sources (using the frieze as evidence for the procession only leads to trouble).[77] Horsemen or no, there must have been men to round up and drive the sacrificial animals, and there must been some to lead the oxen that drew the Panathenaic ship-on-wheels. One class of non-Athenians played a significant role in the procession: *metoikoi*, resident aliens, whose sons carried metal trays full of honeycakes (*skaphephoroi*) and whose daughters paraded balancing water-jars, again for use in the sacrifice, on their heads (*hydriaphoroi*). Even manumitted slaves and barbarians carrying oak branches are said to have joined the march. Athenian colonies (and, at the height of its empire in the fifth century, Athenian subjects or allies) participated in the Greater Panathenaia by sending a cow and a suit of armor, presumably to be displayed in the procession. In fact, the Panathenaic procession was fundamentally a grand, colorful display – a display of Athenian youth, Athenian beauty, Athenian classes, Athenian hegemony, and Athenian wealth. (Many participants probably carried previously dedicated objects – gold or silver *phialai* [offering bowls] and *oinochoai* [wine jugs], silver *hydriai*, silver trays, ivory lyres, bronze incense burners – removed for the occasion from Athena's treasure stored in the Parthenon.) The procession was from our point of view as much profane and ideological as it was sacred – it was, in effect, a dynamic representation, a moving picture, of the greatness and unity of Athens itself – but the distinction would not have crossed the Athenian mind.

We know, too, how the day of the procession ended: with mass slaughter. One cow, we are told, was killed on the altar of Athena Nike; one ewe (or more) may have been sacrificed to Pandora (or Pandrosos).[78] At least a hundred cows (a *hekatomb*, hence the name of the month) were then sacrificed, one by one, upon the altar of Athena Polias, their fat burned as an offering to the goddess. The practice of Archaic and Classical Greek state religion was often a long, noisy, and violent affair: it is hard to avoid the conclusion that the sculptured groups of lions savaging bovines placed in the pediments of sixth-century temples on the Acropolis (and elsewhere) reflected the sacrificial brutality taking place in front of them [cf. Fig. 80].[79] At all events, on the main day of the Panathenaia the city must have echoed with the bellowing of the cattle and the ritual screaming of attendant women,[80] thick smoke and smells must have drifted over it, and the altar of Athena and the Acropolis rock must have run with blood for hours. Afterward, the meat was roasted and distributed to the people of Athens, not on the Acropolis but down in the Kerameikos, through which the procession and cattle had passed earlier in the day. If Aristophanes is any indication, the Athenians then gorged themselves, their stomachs rumbling, on Panathenaic steaks and stew.[81] The food was literally divine.

Virtually everyone in Athens must have been, somehow, a participant in the Lesser and Greater Panathenaia – a marcher, a spectator, a member of an audience, a recipient of meat – and the new *peplos* itself was evidently a big draw: a conventional character in later Athenian (and then Roman) comedy was the naive country girl who only visited the big city to see the new robe.[82] But few Panathenaic events actually took place on the Acropolis itself, and it was probably only at the end of the procession, during the presentation of the *peplos* and the sacrifice, and perhaps during the awards ceremonies, that large numbers of Athenians actually stood on the summit of the rock.

Athenians, of course, had the opportunity to ascend the citadel in the course of other annual state festivals, such as the *Dipolieia* or *Plynteria*. And they were apparently encouraged to go up on a monthly basis as well. The first day of every month – *Noumenia* (New Moon Day) – was a public holiday, when the citizenry was expected to shop, exercise, eat, put frankincense on the statues of the gods throughout Athens, and climb the Acropolis to make personal offerings and pray for blessings both upon the city and themselves (this may have been the same day as the so-called *Epimenia*, when Athenians left a honeycake for the guardian snake of the Acropolis, the avatar of Erichthonios).[83] There were also occasions in the private life of an Athenian – personal holidays – when a visit to the Acropolis was expected.

We are told, for example, that before a bride was married (and most Athenian marriages seem to have occurred in the winter month of Gamelion, corresponding to late December and early January), her parents took her up the Acropolis for a pre-nuptial ceremony and sacrifice known as the *proteleia*. After the marriage, in an equally obscure ritual, the newlyweds were in turn visited and blessed by the priestess of Athena Polias carrying or possibly wearing the sacred *aigis* of the ancient image – and thus identifying with the goddess herself.[84]

The summit of the Acropolis, then, was the setting for public festivals and private ceremonies throughout the year. If we count the festivals that took place on the slopes (some of them lengthy, like the City Dionysia), the Acropolis was the focus of civic religious activity for a good part – perhaps as much as a sixth – of the year. Still, on most days, nothing special – at least nothing public or official – went on, and so the question is: who was (or had the right to be) on the Acropolis then?

Who Would Have Been on the Acropolis on an Average Day?

The question is much easier to ask than answer. Any answer we give can only be incomplete, partly because the same answer might not apply to every era. There were times, for example, when the Acropolis had some extraordinary occupants. It has been suggested that the sixth-century tyrants Peisistratos and his sons Hippias and Hipparkhos dwelled atop the citadel for most of their rule. That is unlikely (as we shall see) but Hippias and his family certainly holed themselves up upon it before being forced into exile in 510.[85] Just over a century later, at the end of the Peloponnesian War in 404, the defeated Athenians suffered the humiliation of having a Spartan military governor and garrison stationed on the Acropolis. And toward the close of the fourth century, the Athenians, turned sycophants, invited the Macedonian potentate Demetrios Poliorketes ("Besieger"), their liberator in another struggle, to live in the back of the Parthenon, as if he were Athena's little brother (they would be sorry).[86]

Occasionally the Acropolis was the setting for civic activities that normally took place elsewhere. For example, the five hundred members of the Athenian Council, or *boule*, normally met in their own building in the Agora, yet we are told that meetings of the *boule* from time to time were also held on the Acropolis.[87] And there were days when large numbers of Athenians, for reasons we do not know, gathered upon the Acropolis to eat. One of the regular responsibilities of the priestess of Athena Polias, we gather from an inscription, was to prepare a magnificent feast, though we do not know why or when.[88]

But unusual occupants, gatherings, or circumstances aside, it is still likely that on most days of the year a fairly large contingent of officials, priests and priestesses, assistants, public servants, maintenance workers, guards, and so on could be found on the summit of the Acropolis, with many more on its slopes. Every year, for example, ten men were chosen from the richest Athenian class to serve on the Board of the Treasurers of Athena – the *tamiai*, they were called.[89] These "religious civil servants" were ultimately responsible to the Athenian *boule*, they served from Panathenaia to Panathenaia, and their principal task was to keep track of the vast numbers of dedications and ritual objects belonging to Athena that were displayed or stored on the Acropolis (in the Parthenon and elsewhere). The Athenians were inveterate record-keepers, and each year from 434 to around 300 the *tamiai* published on inscribed stone slabs (*stelai*) lists of the objects in the enormous treasury of Athena: about two hundred fragments of these inventories, displayed on the Acropolis itself, survive [Fig. 36].[90] The Athenians, however, were not always fastidious record-keepers, and only the most valuable holdings were normally inventoried. There are also enough inconsistencies from year to year to indicate that the lists were selective as well as incomplete: something listed one year might be omitted the next. At all events, the inventory was probably taken just after the Panathenaic procession, when the participants returned the gold and silver bowls, trays, *hydriai*, *oinochoai*, and other precious items from the treasure they had carried through the streets and back up the citadel. After inscribing the stones, the *tamiai* handed over their duties to the next board in a ceremony that presumably took place on the Acropolis.

But the *tamiai* were not just glorified auditors and bookkeepers. As guardians of Athena's wealth, they expended the funds necessary for building projects on the Acropolis. They were, in essence, the principal financial officers of Athena – the Acropolis's CEOs. Very likely they were also responsible for upholding the regulations and enforcing the taboos of the Acropolis. The dung of sacrificial victims had to be discarded in just the right way. No goats or dogs were allowed (ancient dogs would have regarded altars, statues, and *stelai* with the

Fig. 36. Inventory of the Treasurers of Parthenon (*IG* I³ 296–299, for the years 430–426, EM 6788). Photo: author.

same anticipation as ours do fire hydrants),[91] and neither were births or deaths or those who had engaged in recent sexual intercourse without purification. The *tamiai* were also charged with protecting the Acropolis's various temples, buildings, and grounds, with ensuring the maintenance and security of the sanctuary, with planning for the positioning and care of its monuments, large and small, and with the religious administration of the sanctuary in general. Since the *tamiai* oversaw not only the treasure of Athena but also day-to-day activities on the Acropolis, it is likely that at least some of the members of the board could be found up there most days, perhaps on a rotating basis. On other, special days they were required to be there or be fined. At all events, we infer that when in the late seventh century an ex-Olympic champion named Kylon attempted to capture the Acropolis and seize power, he found members of an early Board of the Treasurers of Athena (known then as the *naukraroi*) already up there. And, we know, the *tamiai* took their responsibilities to the sanctuary seriously: when the Persians attacked the Acropolis in 480 with overwhelming numbers, the *tamiai* were among its few doomed defenders.[92]

There were several other financial boards at work on the Classical citadel. After 454, when the treasury of the Delian League (formed by the Athenians and their allies as a defense against further Persian aggression) was moved from Delos to (probably) the Acropolis and the League became the Athenian Empire, the treasurers known as the *Hellenotamiai* (Treasurers of the Greeks) did their business on the Acropolis, too, assessing, managing, and inventorying the tribute paid Athens by its subject states. Sophocles was elected to this instrument of empire in 443/2 (he was chairman of the board), just a couple of years, perhaps, before he won first prize in the tragic competition at the City Dionysia for a trilogy including the *Antigone*.[93] In 434/3, yet another board of ten was established to administer the holdings and cults of "the other gods." Their treasures were stored in the controversial place known in inscriptions as the *Opisthodomos*. Whatever this was, the decree establishing the Treasurers of the Other Gods instructs them to keep their holdings on the left side of it, while the Treasurers of Athena kept theirs on the right.[94]

We have no idea whether any of these various treasurers or their secretaries actually lived upon the Acropolis, or merely commuted to it, as if it were their office (which it was). The only people we know lived atop the Acropolis were the annually-appointed *Arrhephoroi*,

though they may not have lived there for very much of the year (Pausanias says only that they lived there "for some time"). It is in any case difficult to believe that the Athenians would have left little girls up there all alone. Theoretically, Greek priests and priestesses were expected to live in the sanctuaries of the gods they served. Practice was another matter, of course, but if the Acropolis operated like other Greek sanctuaries, it is likely that one or more priestesses made their homes on the citadel, too. The priestess of Athena Polias, appointed for life from among the mature women of the ancient and distinguished Eteoboutadai clan, may have lived there with two priestly assistants.[95] She could be widowed (like her mythological antecedent Praxithea, Erechtheus's wife, the very first priestess of Athena Polias) or married, though she could not engage her husband in conjugal relations in the sanctuary itself.[96] Other possible residents were the priestess of Pandrosos (chosen from the ranks of the important Salaminioi clan) and the priestess of Athena Nike, whose office was established or redefined around the middle of the fifth century. Like the priestess of Athena Polias, she served for life, but unlike her she was chosen by lot from all Athenian women, not from one ancient aristocratic family (we happen to know that the first woman to serve was named Myrrhine). In other words, this was a democracy's priestess. And while the priestess of Athena Polias must have been compensated for her service in some way,[97] the priestess of Athena Nike was contractually paid a salary of fifty *drakhmai* a year and received the legs and hides of animals sacrificed at public festivals besides.[98] The evidence we have does not allow us to say conclusively that any of these priestesses lived on the Acropolis (nor can we say exactly where on the citadel they would have dwelled). But, residents or no, they were responsible for the daily maintenance and activities of the cults under their charge, and so could be expected to be on the rock on a regular basis.

They had plenty of company. On most days the Acropolis was criss-crossed with a variety of other religious functionaries: the so-called *zakoroi* (temple-attendants or sacristans), a possibly large group of young women who assisted the priestesses in their duties; one or more boys who helped in sacrifices and in dedications (such "temple boys" were regular features of Greek sanctuaries – in Euripides's play named after him, Ion has lived virtually his whole life in the precinct of Apollo at Delphi – and a temple boy may in fact be represented handing over the *peplos* in the east frieze of the

Fig. 37. Cuttings in Acropolis bedrock for placement of *stelai*. Photo: author.

Parthenon, though the nature of the action and gender of the child are highly controversial [Fig. 151]); the group of popularly elected officials known as the *hieropoioi*, who were in essence the commissioners of sacrifice but who were also in charge of several festivals, including the annual Panathenaia;[99] menial laborers who swept the sanctuaries or polished the silver and bronze; and maintenance workers who kept buildings and monuments in repair. Finally, there were porters and police. The Acropolis was a very rich as well as a very sacred place, and the safety of its treasures must have been of no small concern. Aristotle lets us know that a regular force of fifty policemen was stationed on the Acropolis in the years following the Persian Wars. Since its defenses were probably badly damaged by the Persians who sacked it in 480 (and since an inscription indicates that the holes in the wall were not all filled even by 450 or so), this makes good sense.[100] But it is inconceivable that the Acropolis was left unprotected in any period.

The existence of a police force obviously implies the threat of theft or vandalism: there was clearly a need for vigilance. Yet fifty policemen is a lot, and so large a force also suggests the need for crowd-control. The guards, in other words, may have closely monitored visitors while not excluding them. Indeed, another important function of the Acropolis throughout its history suggests that it was meant to be accessible to those Athenians who could read: it was, in effect, an open-air hall of records, a place of information and reference.

The Acropolis rock is scarred with hundreds of cuttings for monuments of various sorts [Fig. 37], and while many of them held private dedications, many others were filled with upright stone and bronze *stelai* inscribed with official texts of almost infinite variety (there were whitewashed wooden boards, too, though these, written on with charcoal, would have been displayed indoors). There were legal inscriptions, such as the early law-codes of Drakon and Solon.[101] There were documents relating to the management of festivals (such as the early inscriptions dealing with the Panathenaic *dromos* and *agon*). There were decrees regulating conduct, sacrifices, and rites in the sanctuary (such as the handsomely inscribed "Hekatompedon Decrees," dated to 485/4, which deal with the *tamiai*, priestesses, sacrificers, and so on [Fig. 38]). There was at least one bronze plaque recording the dedications of the *tamiai* themselves. There were financial decrees regulating state expenditures, such as one recording the accounts of the treasurers of Athena for the year 410/9, complete with a relief of Athena, her olive tree, and a figure who is probably Erechtheus but possibly a personification of the Athenian people, or *demos* [Fig. 39]. There were inscriptions announcing alliances and treaties or publishing details of military, colonial, or foreign policy. One decree outlines the obligations of settlers on the island of Salamis (dated to the late sixth century, this is the oldest official Athenian decree). Another inscription outlines the terms of a peace treaty with Chalkis on the once-rebellious island

Fig. 38. So-called Hekatompedon Decree (*IG* I³ 4, EM 6794), 485/4. Photo: author.

of Euboia (446/5). Another describes the decision and procedures necessary to establish a colony at a place called Brea (c. 445). Others document the preparations for the ill-fated expedition against Sicily in 415. Another, with an illustrative relief showing Zeus, Hera, and Athena, commemorates a treaty probably negotiated with Korkyra (Corfu) in 375/4. There were dozens of so-called *proxeny* ("public guest-friendship") decrees honoring citizens of other states who rendered important services to Athens or assisted Athenians abroad [Fig. 40], sometimes granting them Athenian privileges and rights (the *proxenos* Herakleides of Klazomenai, for example, was given the right to own land and a house in Athens). There was a list of Plataians who were granted Athenian citizenship for their loyalty and courage in the Persian Wars. There were, in fact, lists of all kinds – lists of victors in the Panathenaic contests and their prizes, lists of casualties in war, inventories of the treasures of Athena and the Other Gods [Fig. 41], lists of the treasures of Artemis not even kept on the Acropolis but at Brauron, lists of the tribute Athens assessed the members of its empire [Fig. 113], lists of expenses incurred in the creation of statues such as Pheidias's Bronze Athena (Promakhos) and his Athena Parthenos and in the construction of buildings such as the Parthenon, Propylaia, and Erechtheion, lists of what the city of Athens needed to borrow from the treasuries of Athena Polias, Athena Nike, and the other gods and what it owed in interest, lists of public benefactors, and lists of public debtors. There was a list of the Peisistratid

Fig. 39. Document Relief from Acropolis recording accounts of Treasurers of Athena in 410/9 (*IG* I³ 375). Louvre MA 831. Courtesy Musée du Louvre.

Fig. 40. a. Proxeny decree honoring Philiskos of Sestos for services rendered to Athens (*IG* II² 133, NM 1474). 355/4.
b. (*below*) Detail showing horseman, Athena Parthenos, Philiskos. Photos: author.

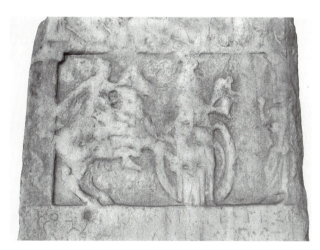

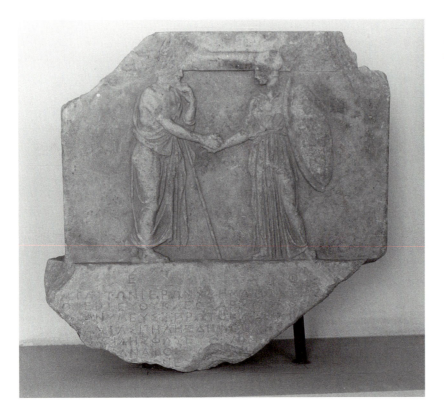

Fig. 41. Inventory of the treasures of Athena and the Other Gods for 398/7 (*IG* II[2] 1392, NM 1479), with relief of Athena and Erechtheus. Photo: author.

tyrants and their children so that their crimes would be remembered, and there were inscriptions publishing the names of traitors and enemies of the state: a famous bronze stele revoked the rights of one Arthmios of Zeleia, an early-fifth-century *proxenos* who was accused of being an agent for the Persians.[102]

The Acropolis, then, was a kind of public archive in bronze and stone, and an archive presumes a readership. In fact, it is difficult to say just what percentage of the population of Athens could read and write. Certainly the Athenian state did not promote mass literacy as a matter of public policy – there were no public schools, for example – and it is now the consensus that fully literate Athenians were very much in the minority, to be found primarily among the ranks of upper-class males. It is also true that the lines at the top of the tallest inscribed stones could not have been easily made out by Athenians standing on the ground no matter how literate they were: anyone wanting to read from top to bottom the marble block listing the first payments of tribute to the Athenian Empire (it was 3.66m, or 12 ft, high) needed a ladder [Fig. 113].[103]

The publication of so many documents on the Acropolis clearly does not prove that they *were* read, only that they were *available* to be read, and the principle of

publication may have mattered more than the actual practice of reading (it is the same with the *Congressional Record* of the United States). Even so, the fact that so many Acropolis inscriptions were formulaic lists, where the reader for the most part just needed to make out names and amounts in a familiar format repeated from year to year, suggests that the records were theoretically accessible to people with even rudimentary literate skills – there are, after all, degrees of literacy.[104] The essential question remains, however: just how accessible to the average Athenian was the Acropolis itself?

Could Athenians Visit the Acropolis Whenever They Wanted?

Whether average Athenians *could* ascend the Acropolis on average days to consult its documents and enter its shrines, and whether they actually *did* so, are two different things. Conventional wisdom holds that since the altar of a divinity was typically located outside its temple, there was no reason to go in, and consequently that access to sanctuaries and especially the interiors of temples in ancient Greece was normally restricted or tightly controlled.[105] In some cases there is no doubt about it. At Delphi, for example, those who wished to consult the

oracle of Apollo had to purchase a very expensive cake, offer it, and sacrifice at least one goat or sheep before they could enter the temple, and they had only nine days out of the year to choose from at that.[106] But what was true at Delphi was not necessarily true elsewhere. There is, in fact, plenty of evidence to suggest that whether you could enter a temple or not depended on where you were, who you were, and what day it was.

When the women of the chorus in Euripides's *Ion* ask whether they can walk into the Temple of Apollo and are told by the temple boy that they cannot without the obligatory cake and sacrifice, or when Pausanias points out that it is not customary to enter the sanctuary of Necessity and Force at Corinth or that it is forbidden to enter the sanctuary of Ourania at Sikyon,[107] the implication is that there were Greek temples and shrines where access was free and simple: one just had to find out the local regulations first. At Olympia, for example, the rules may have been liberal. The fact that barriers screened off the great cult statue in the Temple of Zeus suggests that visitors were regularly allowed to enter the cella (though not get too close to the god), and Herodotos, at least, is said to have enchanted audiences gathered in the back porch of the temple with readings of his history.[108] So, too, in the *Fourth Mime* of the third-century poet Herodas, two lower-class women arrive at a temple of Asklepios with a sacrificial cock. It is early and the building is still closed, and a crowd of pilgrims has formed. When the door is finally opened, the women (and apparently everyone else) enter freely, no questions asked. On the Acropolis, we hear of at least one instance where questions *were* asked. In 510, the Spartans, led by King Kleomenes, helped expel the Peisistratid tyrants but seized the Acropolis on behalf of the Athenian oligarchs they supported. Herodotos (5.72) says that

> when [Kleomenes] went up to the Acropolis intending to capture it, he went to the temple of the goddess on the pretext of addressing her. But the priestess, rising from her throne before he had passed through the doors, said, "O Lakedaimonian stranger, go back and do not enter the shrine: it is unlawful for Dorians to enter here."

That did not stop Kleomenes,[109] but the story (even if apocryphal) suggests several important things. First, the priestess of Athena Polias was normally stationed at the entrance to the temple, monitoring traffic. Second, it was generally possible to enter the temple and directly approach the venerable cult-statue of Athena Polias if you belonged to the right class of people. And third, the right class of people consisted of Athenians and the larger ethnic group to which they belonged, the Ionians. Had Kleomenes been one of them, he would presumably have met no interference and could have walked right in.

We have no parallel anecdotes concerning access to the temples of the Acropolis in the fifth century. But there is plenty of evidence (besides the existence of a police force) that the security of the Acropolis and its shrines was a major concern. Around 450–445 a decree gave Kallikrates (one of the two architects of the Parthenon, according to Plutarch) sixty days to shore up the (western?) defenses of the Acropolis and ordered three archers to guard the entrance to the citadel, not only to frustrate thieves but also to keep runaway slaves from finding asylum in the sanctuary.[110] Thucydides indicates that the whole Acropolis could be closed up and put off limits, and Aristotle mentions the keys.[111] The plot of Aristophanes's *Lysistrata* depends upon the ability of the women to bolt the Acropolis's doors,[112] and in fact the five passageways of the Propylaia [Fig. 166] that Aristophanes had in mind had doors or grills that could be locked, presumably by the sort of gatekeepers and "Acro-guards" whose names are listed in a series of inscriptions of the Roman Imperial period.[113] An inscription of the 450s indicates that the temple then holding the statue of Athena Polias was to be sealed for the month of Thargelion: the keys were entrusted to the Praxiergidai, the women who tended the image during the *Plynteria* (the implication, then, is that the temple was *not* closed the other months of the year).[114] We know, too, that the Parthenon itself could be sealed: the spaces between the columns of its *pronaos* and *opisthodomos* (east and west porches) were fenced off with lattices or grills (the cuttings for them are still there [Fig. 129]), the door of the large western room (the one with four interior columns [Figs. 127, 128]) was reinforced with iron bars, and the key to the door of the main room of the Parthenon (the *hekatompedos neos*) is mentioned in an inscription or two.[115] Finally, one of the so-called Kallias Decrees says the Treasurers of Athena and the Treasurers of the Other Gods were jointly responsible for opening, closing, and sealing what it calls the *Opisthodomos*.[116]

The evidence for and allusions to doors, grills, seals, and keys are enough to prove that the managers of the Acropolis had the capacity to lock the place and its shrines up tight, and there are other hints of limitations and restrictions at certain times. The Hekatompedon

Decrees [Fig. 38], for example, instruct the *tamiai* to open up the rooms or buildings known as *oikemata* ("little houses," possibly treasuries) at least three times a month for public viewing: the implication is that the *oikemata* were closed and the treasures they contained out of sight the rest of the month. A line of Aristophanes calls the whole great rock of the Acropolis "untrodden" (*abaton*), which, though it is but one word in a comedy, suggests that hordes did not normally trample the summit.[117] And we are told that the laws of Drakon and Solon were once transferred from the Acropolis to the Prytaneion and Agora down below so that all could see them.[118]

It is, in fact, obvious that documents on display in the lower city were more accessible to the average Athenian than documents kept on the Acropolis: it was simply easier to visit the flat Agora than to hike up the steep rock. It is also quite likely that most Athenians did not climb the citadel on a daily basis: on most days there was no need. But this does not mean that they could not have climbed the rock if they wanted to, and on the average day it is likely that they would have found the gateway and most temple doors open to them had they decided to ascend. And if the laws of Drakon and Solon were eventually taken down from the heights, other laws and documents on the Acropolis were still frequently consulted: one fourth-century orator dashed up, apparently without hindrance, just to look for the name of an adversary on the list of public debtors, and there is nothing in the story to suggest his research trip raised eyebrows.[119] Pausanias himself gives no indication that he had any trouble entering the Acropolis or any of its temples (when he has such trouble elsewhere he tells us so) and, though his visit took place in the second century AD when antiquarian interest in the Acropolis was already high, there is no reason to believe such tours of the sanctuary were impossible or irregular earlier. In fact, over three centuries before Pausanias, Polemon and Heliodoros wrote extensive studies of the dedications and works of art on the Acropolis, and the research necessary for these lost treatises (Polemon's was, we are told, four books long, Heliodoros's fifteen) implies unimpeded access at least as early as the second century.

But, of course, the Acropolis was primarily a place of worship, and free access to the sanctuary was necessary for the performance of the rites of popular or private religion. Despite the conventional wisdom, some temples contained sacrificial altars within them: altars of Boutes, Poseidon-Erechtheus, and Hephaistos were located inside the Erechtheion [Fig. 174], for example,

and so anyone wishing to offer anything to those deities needed to enter. Above all, it was normally necessary for Greek worshippers to see the cult-statue of the god or goddess to whom they were offering their prayers. This could have been accomplished with the suppliant standing outside the temple, peering through its colonnade and its opened inner door, addressing the image at a distance. But prayers were judged most effective, we think, the closer the suppliant was to the god or goddess. And while it is unlikely that worshippers were allowed to get too close to the hundreds of precious objects stored on shelves or in boxes within temples – perhaps this was one of the duties of the *zakoroi* – they may well have been allowed to approach the statue and even kneel before it.[120]

To say, then, that the Parthenon and Erechtheion *could* be locked up does not mean that they always *were*. The treasure-packed west room of the Parthenon was probably usually off limits [Fig. 128]. So, possibly, were the treasure-filled aisles between the interior colonnade and inner walls of the room of the Athena Parthenos [Fig. 127], though by innovatively extending the interior colonnade *behind* the statue of the Athena Parthenos the architects of the Parthenon seem to have created a path for spectators to circumnavigate it. At all events, the gold and silver items stored on the shelves in the side aisles would have glistened impressively in the light let in through the two perfectly aligned windows in the Parthenon's east cella wall [Fig. 130], while the Parthenos itself would have seemed activated by shimmering light bouncing off the rectangular reflecting pool placed before it. This rich, sparkling, grandiose interior invited – it almost demanded – visits. Even if the movement of the pilgrim was restricted (as it may have been most days), it is hard to believe such a space and such a statue [Fig. 132] could have been designed with the intention of preventing people from ever experiencing them, more or less, up close.[121]

All in all, it is reasonable to conclude that average Athenians could have ascended the Acropolis on an average day, and that the monuments and temples on the summit were generally open to them. While some rooms or spaces were undoubtedly off-limits some of the time, most doors were shut and locks locked only at night, to guard against thieves. Whether average Athenians actually made the trip in large numbers on non-festival days is, however, another matter: typically the religious officials, functionaries, and guards of the Acropolis may well have outnumbered worshippers and

sightseers. To be sure, most Athenians would probably not have ventured up the hill unless they had a specific purpose. On rare occasions that would have been to check the contents of an inscription. Most of the time it would have been to worship – which is to say, make an offering.

Who Dedicated What on the Acropolis, and Why?

Greek priestesses and priests were not clergy in our sense of the term. They possessed no special training or knowledge (which is why they could often be chosen by lot, which is also why Isokrates could say that "priesthood is for anybody").[122] They did not pronounce dogma or keep sacred books. Since there was neither Church nor orthodoxy, they did not give sermons or moral instruction to congregations on Sundays. Thus, they were not "holy men" or "holy women" but religious bureaucrats who oversaw behavior – it is, again, formal behavior, not individual belief, that defined Greek religion – and, except on days of civic festivals, the average Greek did not need them to act as intermediaries to their gods or even to perform the essential rituals of their lives.[123] What state priests did on a grand scale on public holidays, the average Greek could do on a smaller scale, on his or her own.

The standard Greek act of worship was a highly stylized sequence of prayer, sacrifice, libation, and dedication. These elements were found, of course, in various combinations depending upon the ritual. A sacrifice (either of an animal or, bloodlessly, of an offering such as a cake or piece of fruit) could be accompanied by a libation (that is, the pouring of a liquid such as wine upon an altar or the ground), though the one did not require the other. A prayer was usually said while the libation was poured. And a dedication – that is, the presentation and deposit of an offering, or *anathema* – could (but did not have to) conclude the service.

We are explicitly told that sacrifices were made for three simple reasons: to honor the gods, to thank the gods, and to ask the gods for something in return.[124] These were also the principal reasons for dedicating an object (though, in fact, it is a rare dedication that was made solely to express faith or belief in the gods, with no ulterior motives). Many dedications, it is true, were probably meant to perpetuate the act of worship itself: a small bronze sheep offered on the Acropolis by one Peisis around 550, for example, might be a representation of the

animal he had sacrificed, something for the divinity to keep long after the fat and meat had been consumed, as a remembrance.[125] So, too, the Moschophoros would continue to bring his calf to the sacrificial altar as long as the group stood on the citadel [Fig. 71]. But most dedications seem to have been made to keep one end of a bargain. For all intents and purposes, Greek prayers were typically not requests for spiritual healing, forgiveness, or moral improvement but for material gain: they were supplications in the form "if you grant me X, I will present Y to you." And so a dedication was usually made only *after* such a prayer was answered, to redeem the vow – hence the term "votive." Around 500, for example, a certain Kynarbos dedicated on the Acropolis two bronze statuettes on a single marble base explicitly to keep a promise made by his two daughters Aristomakhe and Arkhestrate (we do not know what they received from the goddess in exchange).[126]

Because the Greek prayer was in the nature of a proposition, the wording of the consequent dedication often has all the religious feeling or spirituality of a legal contract: it is the record of a business transaction between mortal and divine materialists.[127] When Telesinos presented his bronze statue to Athena to thank her for some bit of good fortune, he unabashedly asked her for more at the same time, and promised another votive should she look down with favor upon him again [Fig. 32]. Many other examples from the Acropolis indicate that a dedication made to thank the goddess for some recent benefit was also meant to ensure the goddess's favor or protection in the future. The sometimes blatant commercialism of it all embarrassed no one. For Greek piety itself was, as Plato's Socrates states, "the science of asking and giving," the art by which men and gods bartered with one another.[128]

Many dedications on the Acropolis were indeed tokens of commercial and economic success, and sometimes the change in fortune could be dramatic. A certain Anthemion, we are told, dedicated a statue group of a man leading a horse to commemorate his leap from the lowest economic (and thus social and political) rung of citizenship (*thetes*) to the rank of the *hippeis* ("cavalrymen" or "knights," the next-to-highest class).[129] Far more common were dedications that represented, in tangible form, percentages of earnings. Acropolis inscriptions regularly characterize such offerings as *dekatai* ("tenth-parts" or "tithes") or *aparkhai* ("firstfruits"). That is, frequently an Athenian would, to fulfill a vow, dedicate an object worth one-tenth of his total

income over a given period or some respectable proportion of an inheritance, gift, or windfall. The splendid bronze statuette of Athena Promakhos that Meleso dedicated around 480 or later was, for example, a *dekate* (the information is inscribed on its base) [Fig. 22].[130] And around 450, a certain Menandros dedicated something (it is lost) to Potnia Athena as an *aparkhe* to redeem an earlier vow, to thank the goddess, and to ask that she now preserve his wealth.[131]

Economic self-interest was not, of course, the only reason for dedicating objects on the Acropolis. Some dedicants were actually moved by true spirituality: in the fourth century, a woman named Meneia offered a votive to Athena after seeing the goddess in a dream.[132] Other dedications marked transitions from one phase of life to another,[133] or commemorated the completion of certain duties, or commemorated a lifetime of accomplishment. It has recently been suggested, for example, that the so-called Family Sacrifice relief [Fig. 42] was dedicated to mark the formal introduction of the two boys who are shown (and possibly the girl as well) into the *phratry* or kinship-group of the father.[134] And it is sometimes thought that Archaic *korai* [cf. Fig. 100] were dedicated to Athena by aristocratic families upon the release of their daughters from their year of service as *Arrhephoroi* (while that cannot be the explanation for all *korai*, it might account for some of them). Whatever the case in the sixth century, statues explicitly of *Arrhephoroi* become popular in the third.[135] Similarly, priestesses, *tamiai*, or other officials who left their posts could have their service memorialized with a dedication: a statue of Lysimakhe, priestess of Athena Polias for over six decades, may have been of this sort [cf. Fig. 205]. So may have the statue of a scribe or treasurer [possibly Fig. 43] dedicated by one Alkimachos in honor of his father Chairion, a sixth-century *tamias*.[136] There were as well honorific portraits of some of Athens's greatest leaders – a statue of Perikles [Fig. 44], for example, or a painting of Themistokles, commissioned by his children and hung in the Parthenon.[137] Other dedications seem to have commemorated life or survival itself. In the early fourth century, one Lysimakhos dedicated an image to Athena (he uses the epithets Pallas Tritogeneia) to thank her for saving him "from great dangers."[138] What dangers Lysimakhos faced the inscription does not say, but a number of Acropolis dedications commemorated success in battle and were paid for out of enemy spoils. Around the middle of the fifth century, for example, the newly created corps of Athenian cavalry (a force of 300

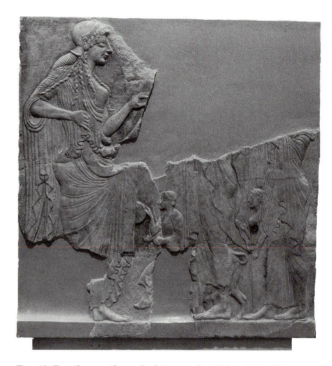

Fig. 42. Family sacrifice relief (Acropolis 581), c. 500–490. Photo: author.

aristocratic or at least well-to-do *hippeis*) set up a bronze statue of a man leading a horse at the entrance to the citadel to celebrate its first victory.[139] Athletic and musical victories as well as military ones were memorialized with dedications: around 500 someone possibly named Sostratos dedicated a full-size four-horse chariot in bronze to celebrate a victory of his stables at some competition or other. Around the same time a kitharode named Alkibios dedicated a bronze statue (cast by Nesiotes) to celebrate (we presume) a musical victory in the Greater Panathenaia, and it was perhaps a couple of decades later that the leader of that victorious lyric chorus dedicated his prize tripod on a marble base. Around 450 one Pronapes set up another bronze chariot to honor victories at Nemea, Isthmia, and the Greater Panathenaia.[140] And champions in the footraces and other contests held at the Greater Panathenaia seem to have made a habit of dedicating prize amphorai on the Acropolis (after draining them of their olive oil). Sometimes private dedications were overt political gestures: in 480, when aristocratic Athenians were apparently still reluctant to put their faith in the fleet at Salamis (for the oars were in the hands of commoners) and preferred to face the Persians on land, the great conservative Kimon grandly marched through Athens, scaled the Acropolis,

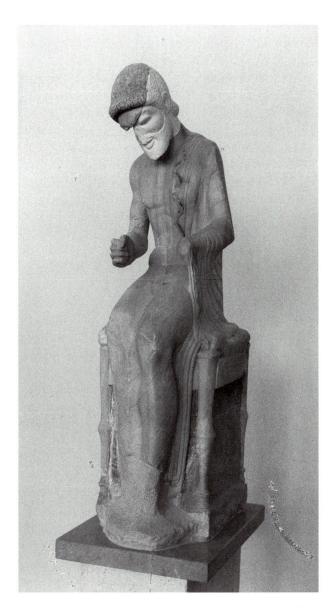

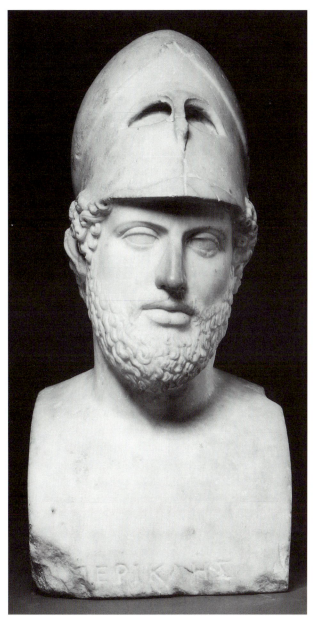

Fig. 43. Scribe or treasurer (Acropolis 629), c. 510. Photo: author.

Fig. 44. Portrait of Perikles, Roman copy after full-length original by Kresilas (?). Courtesy Trustees of the British Museum.

and dedicated his horse's bridle to Athena, symbolically approving the naval strategy and urging the holdouts to do likewise.[141] And not quite three centuries later, around 200, King Attalos I of the rising Hellenistic kingdom of Pergamon visited Athens and possibly dedicated on the Acropolis a huge group of under life-size Giants, Amazons, Persians, and Gauls [Figs. 218, 219].[142] His purpose was not merely to thank Athena or to ingratiate himself with the Athenians but also (as we shall see) to argue that Pergamon was the logical and worthy successor to Athens as the cultural leader of the Greeks, the new defender of civilization against the forces of barbarity.

The Attalid dedication was more political rhetoric than pious votive.

The specific motives for making a dedication, then, varied greatly, and the range of dedicants was just as broad. The Athenian state itself, of course, made more than its share of offerings, and they could be particularly grandiose and expensive: for example, a monument commemorating a victory won over the Boiotians and Chalkidians in 506 that was very likely the first public dedication of the recently established Athenian democracy, or booty seized from the Persians at Plataia eventually stored in the Erechtheion,[143] or the Bronze Athena (Promakhos), the very transfiguration of Persian spoils [Fig. 24], or the so-called Golden Nikai, six-foot-tall echoes of the Nike hovering in the palm of the hand of the Athena Parthenos [Fig. 25], made to celebrate fifth- and fourth-century naval victories and to store, in figured form, the bullion that was Athena's share of the captured wealth,[144] or golden crowns presented to Athena in the name of the people at each Panathenaia. Moreover, the Classical treasuries of the Acropolis contained the offerings of other states – particularly panoplies and gold wreaths presented by Athens's colonies and allies. Prestigious aristocratic clans may have been responsible for constructing the small sixth-century buildings (oikemata) mentioned in the Hekatompedon Decrees to serve as the storehouses of dedications made by their members. And throughout the history of the Acropolis, high-born or high-placed individuals, men and women alike, dedicated many of the richest single offerings: large-scale marble or bronze statues, for example, or precious objects such as the gold olive-wreath presented by one Gelon, son of Tlesonides, and the silver phiale presented by Lysimakhe, mother of Telemakhos – both objects are listed in the Parthenon inventories of 398/7 – or the gold tiara on a wooden mount dedicated before 395/4 by Aspasia, possibly Perikles's famous lover.[145]

The same accounts list offerings by resident aliens (Arkhias and Dorkas, both metoikoi in the Peiraieus, dedicated a chryselephantine Palladion and a gold ring, respectively).[146] The Acropolis was primarily a local sanctuary, but dedications by foreigners were not unknown even in the fifth and fourth centuries, long before it received the attention of Hellenistic kings and Roman emperors. Around 480–470, the great athlete Phayllos of Kroton (who fought alongside the Athenians at Salamis) dedicated a marble statue, for example, and two sisters from Argos dedicated a bronze a little before 450.[147]

Lysander, the great Spartan general and conqueror of Athens in 404, dedicated a gold wreath that was inventoried in 398/7 (the offering was undoubtedly a political gesture symbolic of his victory). Roxane, the Bactrian wife of Alexander the Great, presented Athena a gold rhyton and neckbands listed in the Parthenon inventories of the late fourth century.[148] And while there are no known dedications by slaves – one of the functions of the Acropolis police, after all, was to keep them off the citadel – there were dedications by freedmen: their offerings of choice were apparently silver phialai.[149]

It is noteworthy that a healthy percentage of dedications made before the mid-fifth century were made jointly, and that later dedicants could add votives to bases already holding one (sons expanding upon the dedications of fathers, for example).[150] But in many ways the most interesting group of dedicants are the members of the Athenian business or middle class, and it again included women as well as men. Early in the fifth century, for example, a woman named Lysilla dedicated a small bronze discus to Athena as aparkhen (the "first-fruits" of what we do not know) and another woman named Smikythe commissioned a stone carver to make a marble basin to dedicate to Athena. This was a common kind of offering on the Acropolis (as at other Greek sanctuaries) and was probably intended to hold lustral or holy water with which pilgrims purified themselves before entering the gateway and the various sacred precincts within. The basin itself is lost, but thanks to an inscription carved on its surviving pedestal, we know not only the name and gender of the dedicant, but also her occupation: Smikythe was a plyntria, a washer-woman or laundress. Around the same time, another woman of more modest means offered a less imposing gift: a small bronze shield, only a few inches across but with a central gorgoneion (it is thus Athena's shield), with the words "Phrygia, the bread seller, dedicated me" inscribed around its rim [Fig. 45].[151] And in the fourth century, Melinna, whose occupation we do not know but who says she was proud of raising her children at the same time she pursued a career, offered Athena Ergane the "first fruit" of the goods she had acquired through expertise and hard work.[152]

The best represented class of craftsmen-dedicants on the Acropolis were, however, the makers of painted pottery. Around 500, for example, a potter whose name apparently ended in ——aios (Pamphaios is one possibility) dedicated a relief of himself holding two wine cups in his left hand [Fig. 46]; the inscription written around

Fig. 45. Small votive shield dedicated by Phrygia the Bread-seller c. 500 (NM 6837). Courtesy National Archaeological Museum, Athens

Fig. 46. Relief (Acropolis 1332) dedicated by potter Pamphaios (?), carved by Endoios (?), c. 500. Photo: author.

the edge states the relief is a tithe (*dekaten*), presumably one-tenth of the income of his shop.[153] Some of Athens' finest potters and vase-painters – Nearchos, Euphronios, Andokides, Brygos, and probably Smikros and Onesimos, to name a few – could afford to hire some of the leading sculptors of their day (masters like Antenor and Endoios) to create marbles or bronzes as *dekatai* or *aparkhai* [Fig. 101], and they often dedicated examples of their own ceramic handiwork, sometimes placing them atop marble bases, besides.[154] Many of these vases bore pictures of potters themselves: the earliest Athenian image of a potter's shop, in fact, appears on a black-figure fragment from the Acropolis of around 530,[155] and over the next century a handful of other vases (and one incised relief) from the Acropolis show potters and painters in action – once in the presence of Athena herself [Fig. 14] and once juxtaposed with a scene of sacrifice, implying that the potter had offered the animal as a tithe or "first fruit" and left behind the vase as both a remembrance of his profession and a perpetuation of his act.[156]

It is, of course, no surprise to find so many offerings from potters and painters on the Acropolis – this was, after all, the sanctuary of the goddess of their craft – but it is still remarkable how well and how often artisans, mer-chants, and businesspeople of all sorts are represented in the extant dedications. The roster from the late sixth and early fifth centuries alone is extensive. The panel-painter Eumares is known from a dedicatory inscription, if not from any surviving work. There is a herald named Oino-bios. There are fullers named Simon and Mneson. There are Smikros the tanner and Mekhanion the scribe. There are a shipbuilder and an architect (or carpenter) whose names have not survived. And there is Isolokhos (or Naulokhos), a fisherman (apparently) who dedicated a *kore* (possibly to Poseidon rather than Athena) as the "first fruits" of what must have been a very rich catch.[157] The dedications of successful craftsmen, businessmen (and women), and other professionals continued to fill up the place in the later fifth and fourth centuries, too: around 330, for example, a metalsmith named Kittos dedicated a

silver *phiale* which he presumably made himself.[158] And it has even been suggested that the dedications of courtesans – who inscribed only their first names, without those of their fathers – were to be found among the treasures of Athena in the Classical period (there are parallels elsewhere but the point is arguable).[159] What we can say for sure is that the members of the Athenian working class who made such dedications were not merely thanking Athena for her favor, but were also seeking or declaring status, and even seeking business: it is easy to see the dedications of potters and painters in particular as advertisements, as parts of a "marketing strategy." Many of the businesspeople were clearly prosperous entrepreneurs: to be able to afford *korai* of bronze and marble – prestige symbols normally associated with the aristocracy – Isolokhos (if he really was a fisherman) must have had more than one line in the sea and Nearchos the potter must have been the proprietor of a flourishing shop.[160] And if Smikythe the washerwoman was the same Smikythe who, along with one or two other women, offered a bronze statue to the goddess on another occasion,[161] her establishment, too, must have thrived.

Still, we mistake the nature of the Acropolis if we regard it only as the field for opulent votive displays of the state, the aristocratic élite, the nouveaux-riches, or even the bourgeoisie. There must have been any number of shopkeepers at the foot of the Acropolis eager to sell small terracotta figurines or plaques or other relatively inexpensive dedications to those needing one before making the climb. And we mostly lack what may have been the most common offerings of all: the poorest ones – the crudely fashioned clay or wooden image (which mimicked more costly statues in marble or bronze), the bread or honeycake, the piece of fruit, the natural found-object. The trouble with perishable objects is that they tend to perish, but their absence from the archaeological record of the Acropolis should not exclude the poor from our picture of the place. On an average day, virtually every level of Athenian society was represented by the dedications on display. This is not the same thing as saying that Athenians of every class were represented *in* those dedications – in those statues, reliefs, and so on. Even in the late fifth century, at the height of Athenian democracy, the iconography of the Acropolis is overwhelmingly an iconography of the élite: the members of the lowest level of free society (the landless, the common laborer, the poor) are rarely visible. This is especially true, paradoxically, on works approved by a vote of the full citizen assembly: it is

horsemen (*hippeis*), with their aristocratic bearing and connotations, who dominate the Parthenon frieze, for example [cf. Fig. 153], not the poor but politically powerful free men (*thetes*) who rowed the ships of the fleet (by far the most important branch of the Athenian armed forces).[162] Still, despite the infrequent appearance of the poor in its ennobling, elevating, and perhaps wish-fulfilling imagery, the Acropolis belonged to all Athenians, no matter what their class, status, or gender (indeed, in the inventories of the treasures stored in the Erechtheion and Asklepieion women dedicants outnumber men).[163] Athena and the other gods who were worshipped on the summit and slopes gratefully received dedications no matter who gave them, no matter what they were, no matter what the cost.

Early in the second century Polemon filled four (lost) books with descriptions of the dedications on the Acropolis. And Pausanias, touring the site three and a half centuries later, gives the impression that all the objects he saw – statues and everything else – were votive offerings.[164] Though not every object Pausanias saw was in fact a dedication, it will be clear by now that the variety of dedications on the Acropolis and its slopes – offerings not only to Athena but also to Zeus, Poseidon, Aphrodite, Artemis, Asklepios, and so on – was almost limitless, and that the gods appreciated just about any gift. Marble and bronze statues and figurines came in a great variety of sizes and shapes (maidens, athletes, scribes, divinities, horses, riders, cattle, owls, snakes, and so on). There were gold and silver figurines and terracotta ones; there were marble basins and bronze ones; there were marble reliefs and bronze ones; there were bronze vases and gold vases and silver vases; there were black-figure vases and red-figure vases (the cup was by far the most popular shape, followed by the skyphos and krater) and Panathenaic vases and terracotta relief vases; there were panel-paintings and painted or molded clay plaques; there were bronze tripods and utensils and knives and axes and mirrors and helmets and shields; there were bronze and silver incense-burners, trays, and plaques; there were gold wreaths and crowns and small shields of gold; there were glass objects; there were baskets and wooden and bronze boxes and stools and thrones; there were *peploi* and other garments and leather goods; there were large nails of gold and silver, gold rings and coins (some foreign), at least one gold nugget, and musical instruments of gold or ivory; there were wheels, armor, and weapons of iron; and there was even an alphabet of gold.[165] And

on the south slope Asklepios received many hundreds of dedications specially appropriate to his cult: models of genitalia and other body parts in gold, silver, marble, and terracotta offered by the inflicted seeking a cure or by those who had been healed.

Virtually every corner of the Acropolis must, in other words, have been crammed full of dedications – votives set directly upon the earth or bedrock [Fig. 37], or placed upon pillars, columns, or bases [Fig. 32], or stored on wooden shelves or in boxes inside the rooms of the Parthenon, Erechtheion and other buildings or deposited in their porches or hung on their walls [cf. Fig. 128][166] or from their ceilings, or pegged onto rafters and lintels, or leaned against doorjambs, or hung from the branches of Athena's sacred olive tree [Fig. 175], or or set upon offering tables or altars or at the foot of cult statues (a much sought-after spot). We even hear that one Glyke, daughter of Archestratos, placed gold earrings and rings upon the base of the Athena Parthenos [Fig. 132].[167] Votives could thus be placed just about anywhere, inside or out, and it must have been hard to walk through the Acropolis or enter a temple without bumping into or stepping on something or knocking something over. And yet the disposition of offerings cannot have been completely unregulated. It is possible that certain kinds of offerings tended to be set up in one part of the sanctuary and not in another: for example, in the Archaic period there may have been a particularly thick concentration of *korai* on the north side of the Acropolis, in the vicinity of the *Archaios Neos* [Fig. 109].[168] But any substantial work – a large-scale statue or group, a bronze votive set atop a marble base, and so on – required authorization from the *tamiai* or priestesses before it could be set up, and the right spot had to be found, assigned, and prepared. Smaller but rich offerings – gold wreaths, for example – were undoubtedly

given special treatment and deposited, after they were tagged for purposes of identification, along with the other expensive treasures of Athena in the cupboards that lined the walls of the rooms of the Erechtheion or Parthenon. Lesser offerings – a red-figure cup, say, or a small bronze figurine or terracotta plaque [cf. Fig. 17] – were probably carried up and deposited without any special arrangement, dispensation, or accounting at all. It was probably one function of the *zakoroi* to oversee the deposition of the more portable dedications and to make sure everything found its proper place – to group all the gold crowns or silver *phialai* or terracotta figurines together, for example. From time to time it was their responsibility to relieve overcrowding by clearing fallen statues or damaged or decaying objects, or by taking the most common ones from tables, altars, or shelves, and to pile them up in some corner of the sanctuary, store them in chests or boxes, or even bury them underground. And periodically, under the direction of the *tamiai*, prominent metalsmiths such as Nikokrates of Kolonos were hired to consolidate the collection by melting down old votives in bronze, silver, or gold and recasting them into new ones.[169]

If, then, Greek piety was the art by which mortals and divinities bargained and traded with one another, the Acropolis was one of the ancient world's most elaborate bazaars. Bursting at the seams with every conceivable kind of votive, the flat-topped Classical Acropolis [Fig. 4] must have resembled a colossal offering table, overflowing with *anathemata* (which is what even the temples and buildings could be called).[170] At the same time, the Acropolis was the sum total of all the dedications placed upon it, those tangible expressions of the Athenians' intense commerce with their gods, the historical record of Athenian piety. It was, in a sense, one colossal dedication itself.[171]

THE NARRATIVE

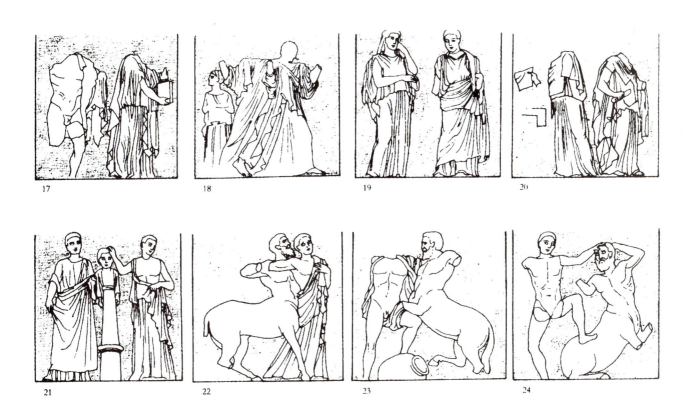

17 18 19 20

21 22 23 24

CHAPTER FOUR

THE STRONG HOUSE OF ERECHTHEUS
THE ACROPOLIS IN THE BRONZE AGE

And so after she spoke flashing-eyed Athena went
across the barren sea, and left lovely Skheria,
and she reached Marathon and Athens of the wide ways
and entered the strong-built house of Erechtheus.

Odyssey 7.78–81

The Neolithic Acropolis

Just beyond the southeast corner of the Classical Agora, where the Panathenaic Way begins to ascend the Acropolis's northwest shoulder, there lay the Eleusinion, the sanctuary of Demeter and Kore [Fig. 2]. During the excavation of this area in 1938 there came to light a marble statuette, 13.9 centimeters (a little over 7 in) long and almost as wide, of a full-figured woman lying rather nonchalantly on her side [Fig. 47].[1] Her head, much of her arms, and her feet are missing, but what is left of her is twisted in a complex and remarkably successful pose: the knees are sharply bent and drawn up under her, the right hip mounds above the corpulent belly, the upper body is turned at right angles to the waist. The head of the figure originally rose straight up from its shoulders, and the arms met across the torso.

The statuette was a stray find (that is, it was not found in any stratified context or with anything else that would help pin down its date or function). Still, there is no mistaking it. It is the kind of statuette – female, fat, with an emphasis on legs, vagina (it is incised), buttocks, and torso – characteristic of the Neolithic (New Stone Age) cultures of the Aegean and the Near East.[2] Whomever it represents – it is hard to suppress the automatic reflex of calling it a "Mother goddess" or "Earth

Mother" but we must make the effort[3] – it can be dated on stylistic grounds to the Middle Neolithic period (which in Greece covered, roughly, the fifth millennium). It is at all events considerably earlier than the very few other Neolithic figurines in marble and terracotta that have come to light in the vicinity of the Acropolis and Agora. It is thus the oldest Athenian work of art extant, and one of the oldest Athenian artifacts of any kind.

The owner or owners of the marble statuette were not, however, the earliest inhabitants of Attica. While there is as yet no sign that Palaeolithic (Old Stone Age) peoples had ever hunted or gathered in this part of Greece (as they had, for example, in Thessaly and the Peloponnesos), practitioners of Neolithic culture – farmers, shepherds, builders, pottery-makers – had already appeared in the sixth millennium (the Early Neolithic period) near the coast of northeastern Attica (at Nea Makri and the Cave of Pan near Marathon) [Fig. 1]. There is no evidence that the Acropolis, the Agora, or any other spot within the bounds of the later city of Athens was settled this early, and even the Middle Neolithic period is sparsely represented there. Besides the marble statuette, there are only the sunken traces, on the south slope of the Acropolis behind the Hellenistic Stoa of Eumenes

67

Fig. 47. Neolithic figurine from area of Eleusinion, 5000–4000. Agora Museum S 1097. Photo: American School of Classical Studies at Athens: Agora Excavations

[Fig. 48], of what may have been a more-or-less rectangular hut – though one archaeologist's hut is another's refuse pit – with a good assortment of Middle Neolithic potsherds preserved in the debris.[4]

Of course, what we have from the Middle Neolithic south slope was not all there was. We must keep in mind that the prehistoric Acropolis (both Neolithic and Bronze Age) was in a real sense a victim of the citadel's later success. Even if the Acropolis and its slopes had been thickly occupied in the Neolithic period, even if there had existed on the summit something like the heavily fortified settlements found at contemporary Sesklo and Dimini in Thessaly,[5] Bronze Age, Archaic, and Classical digging, filling, building, and rebuilding would have destroyed virtually every trace of it. It is in fact hard to imagine the Neolithic inhabitants of Athens not availing themselves of the natural defenses the mighty Acropolis rock had to offer – defense was certainly on the minds of their contemporaries in the north – and it is hard to imagine the summit of the Neolithic Acropolis with no huts at all. The mostly small-stone, mudbrick, and wood architecture of Neolithic Athenians just did not stand much of a chance against millennia of disturbance, demolition, and construction.

The vases of Neolithic Athenians, however, are another matter. Pots break, but no one goes out of his way to pulverize the pieces (which is why potsherds are so essential to the archaeological record of most ancient sites). Had there been a flourishing settlement of pottery-users atop the Acropolis or its slopes in the Middle Neolithic period, we would expect to find at least some ceramic record of them, either still on the Acropolis itself or in dumps of debris below. But the record (aside from the hut or pit on the south slope) is not there. The tentative conclusion is that the Acropolis, like the rest of Athens, did not boast much of a population until the Late Neolithic period (the fourth millennium). Even then it may still have continued to be less significant a place than sites in eastern Attica.

Late Neolithic potsherds were also found in some quantity in the hut or pit on the south slope, but most of the Late Neolithic pottery we have from the Acropolis – and it is very late, or Final, Neolithic – turned up in twenty shallow wells sunk into the northwest slope, clustering around the water-rich area of the later Klepsydra fountain (the wells had to be dug only three or four meters deep before water rose to fill the shaft) [Figs. 7 and 48]. These wells obviously served villagers who lived nearby – water is heavy, it sloshes and spills, and it is not a good idea to carry it very far – and so we must imagine clusters of Late Neolithic houses above the area of the Classical Agora, on the north and northwest slopes of the Acropolis (perhaps built in the shelter of the Acropolis caves), as well as on the south slope (where there are also natural springs and inhabitable caves). But there was more to Late (and Final) Neolithic Athens than the Acropolis. Just before 3100, for example, a male in his early thirties – his crushed skeleton survives – was buried with two crude pots in a rock-cut tomb across the flatland of the later Agora, at the foot of

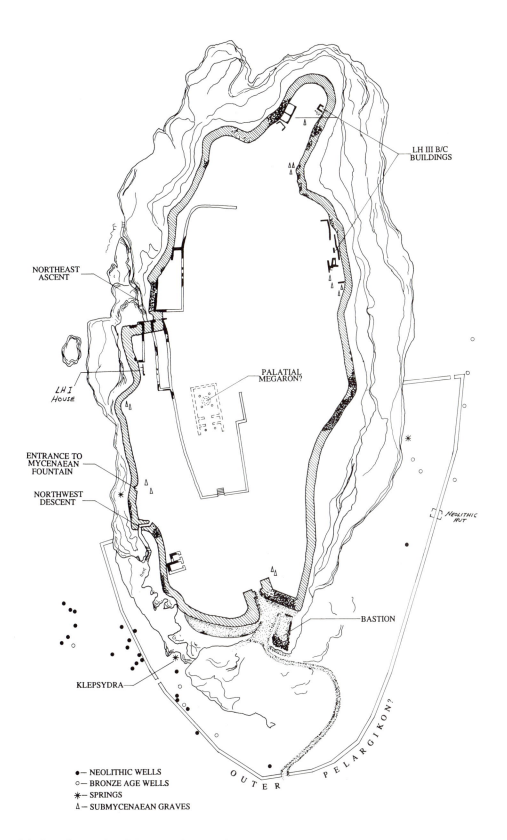

LH III B/C
BUILDINGS

NORTHEAST
ASCENT

PALATIAL
MEGARON?

LH I
House

ENTRANCE TO
MYCENAEAN
FOUNTAIN

NORTHWEST
DESCENT

Neolithic
Hut

BASTION

KLEPSYDRA

O U T E R P E L A R G I K O N ?

●— NEOLITHIC WELLS
○— BRONZE AGE WELLS
✳— SPRINGS
△— SUBMYCENAEAN GRAVES

Fig. 48. Plan of the Late Bronze Age (Mycenaean) Acropolis.
Modified from Travlos 1971, fig. 67, and Mountjoy 1995, fig.
52, by I. Gelbrich.

the low hill known as Kolonos Agoraios [cf. Fig. 92]. He is the earliest known Athenian, and he could well have lived in a small village considerably removed from the wells on the northwest slope.[6] Whether there was another settlement back on the summit of the Acropolis – one dominated by the strong house (*megaron*) of some Neolithic "big man" or chieftain and his family – we can only surmise: if Late Neolithic Athenians acted like other Late Neolithic inhabitants of Greece, we would expect that an emerging élite marked its importance architecturally. But to assume that the Late Neolithic inhabitants of the various little hamlets that were probably dispersed around the Acropolis and across the Agora considered themselves the residents of a single community, or that they were subject to a central authority, is to take the scanty evidence we have further than we should. We should recall, too, that *Athenai* (Athens) is not a plural noun for nothing.[7]

The Early and Middle Bronze Ages

There is no reason to believe that Athens was any more important after the beginning of the Bronze Age around 3100 than it had been in the Neolithic period.[8] The Early Bronze Age (or Early Helladic period, as the third millennium, more or less, is known on the mainland) is barely represented on the Acropolis – some material was found above near the Erechtheion, some below in fill on the north slope and in caves on the south slope – and even in the Agora there are very few potsherds of the period (and they are found mixed in with more plentiful later material).[9] Though the population of Early Helladic Athens may have been fairly widespread, with houses scattered from the south slope of the Acropolis to various other parts of the later city, there are no wells of the period at all in the vicinity of the Klepsydra: the northwest shoulder of the Acropolis, whose water had been fully exploited in the preceding Neolithic period, seems to have been virtually abandoned.

The Early Helladic period was an era of burgeoning commerce and contact across the Aegean, and so it is no surprise that Attica's most significant sites are located on its east and south coasts – at Tsepi near Marathon, Raphina (apparently a center of metal-working, the activity that most easily distinguishes the new age from the Neolithic), Askitario (a large settlement defended by fortification walls), Thorikos (near Mt. Laureion, exploited at least this early for its silver, lead, and copper ores), Aghios Kosmas (on a promontory extending into the

Saronic Gulf), and Palaia Kokkinia in the Peiraieus [Fig. 1]. These communities looked to the sea rather than inland, and as a group they have solid material connections with the contemporary seagoing cultures of the Cycladic islands.[10] In any case, the center of the most vital cultural and economic activities of Attica in the Early Bronze age was clearly its extensive coastline, and a site even a few miles from the sea, like the Acropolis, was not likely to be in the maritime mainstream.

The Neolithic and Early Bronze Age occupants of Athens and the Acropolis were by definition Athenians, but they were not necessarily "Greeks." Greekness is defined linguistically – the language, again, belongs to the so-called Indo-European family – and the first Greek-speakers (or the people whose language would develop into what we know as Greek) probably arrived only in the last phase of the Early Bronze Age, after a violent wave of destruction hit Aghios Kosmas and important sites in the Peloponessos around 2200 or so. But the "coming of the Greeks" – where they came from, how they reached their final destinations, when, and over how long a time – is a difficult problem, and a number of theories (such as one that Indo-Europeans actually inhabited Attica as early as the Neolithic period and another that the practitioners of the first monumental culture that can be called Greek – the Mycenaeans – arrived in a single, swift wave from the north only in the late seventeenth and early sixteenth centuries) merit consideration.[11] But the consensus is still that Attica, like other parts of the mainland, received its first Greeks (or Proto-Greeks) at the end of the third millennium. The newcomers may have arrived gradually. They may not always have been welcomed peacefully. And they may have imposed themselves upon the pre-Greek inhabitants of the land before, inevitably, intermingling with them. But despite their extensive propaganda of autochthony,[12] historical Athenians were not indigenous or aboriginal after all: they simply forgot (or repressed the memory of) their ancient arrival.

Whether or not the full Hellenization of Athens took place in the course of the Middle Helladic Period (c. 2050–1600), the record of habitation on the Acropolis now becomes relatively extensive. Middle Helladic pottery (above all the characteristically soapy-to-the-touch fabric known as "Minyan ware" and the geometrically decorated "Matt-Painted ware") is found in some quantity both on the Acropolis summit and the north slope (there are even a few fragments of imported Cycladic vases),[13] as well as over virtually the entire area of the Classical Agora (which now appears to have had at least one street laid out on its

west side). Moreover, water-seekers finally returned (after about a thousand years) to the northwest shoulder of the Acropolis, where five new wells were dug. Though there are no traces of any houses atop the Acropolis itself at this time, houses there must have been – the area of the Erechtheion was likely the center of habitation – and there were at least five Middle Helladic graves dug along the north and west edges of the summit (they held the remains of children and nothing else).[14] Habitation seems to have been relatively thick on the south slope of the Acropolis, too: there are traces of a few Middle Helladic houses, wells, pits, and graves, and even (near the later Odeion of Herodes Atticus) the remains of what appears to have been a large funerary mound or tumulus with multiple burials.[15] All in all, Middle Helladic Athens seems to have been a more populous and significant place than the Neolithic and Early Helladic town had ever been. Economic and cultural conditions had evidently changed to favor an inland site, though one still accessible to the sea.[16] Close enough to exploit maritime commerce, yet far enough away to escape unforeseen attack, Athens surged in importance, and so, inevitably, did its Acropolis.

The Late Bronze Age

We cannot assume, however, that the Acropolis had become the focus of anything like a unified Middle Helladic "state" – that whatever authority controlled the citadel held political dominion over the rest of Attica as well, that the Acropolis had become the practical and symbolic center of power. When the Late Helladic, or Mycenaean, period began around 1600,[17] Attica undoubtedly still consisted of a number of small, separate "principalities" (for lack of a better word) and it probably remained so until the middle of the thirteenth century. A low acropolis at Kiapha Thiti (near Vari in southern Attica, Fig. 1) was fortified as early as the Middle Helladic III period – long before the Athenian Acropolis – and this suggests the presence of a local, independent power to reckon with.[18] So, too, at Marathon and metal-rich Thorikos in eastern Attica, early Mycenaean "lords" built large stone *tholoi* (beehive tombs) to contain their remains and rich mortuary treasures, and the presumption is that these and other impressive tombs (such as a later *tholos* constructed at Menidi, less than ten miles north of Athens, or an elaborate and richly-appointed chamber tomb at Spata) represent the existence at those sites of autonomous élites who expressed their local sovereignty and prestige in grandiose repositories for the dead. If so, the pattern of monumental tombs in Late Helladic Attica suggests that political power remained decentralized for centuries.[19] Oddly, no trace of a *tholos* has been found in Athens itself (odd, given the abundance of convenient hillsides – on the Pnyx, Areopagos, or Kolonos Agoraios, for example – into which such tombs could have been and for architectural reasons had to have been built). But unless we assume that the lord or lords of Athens were especially backward they must have built a comparable *tholos* or two somewhere in the vicinity, perhaps even on the south slope of the Acropolis, where the later construction of, say, the Theater of Dionysos or the Odeion of Herodes Atticus might have destroyed every trace [Fig. 3]. It is also possible that we have at least one piece of such a tomb after all: the large and curious *lithos*, or oath-stone, set before (appropriately) the Royal Stoa in the Classical Agora [cf. Fig. 92] looks like a reused lintel block from a Mycenaean royal tomb.[20] At any rate, there is still no reason to believe that the prestige of the putative lord or "king" of early Mycenaean Athens was any higher than that of the lord of Marathon or Thorikos or any of the other dozen or so Attic sites known to have been occupied at the time; he may not even have been first among equals.

It is fair to assume, however, that Athens itself was subject to a single authority in the early Mycenaean period, and that that authority dwelled on the Acropolis. Habitation of the citadel was continuous from the Middle Helladic period on, though physical evidence for the occupation of the summit in the first phase of the Late Helladic period (LH I, c. 1600–1500) is limited to a few potsherds and, possibly, the scraps of a wall of a room with a packed white-clay floor located north of the Classical Erechtheion [Fig. 48].[21] These stones have the distinction of being the earliest nonfunerary architectural remains on the top of the rock. Coincidence or no, they are not far removed from the date one ancient chronographer[22] reckoned for the beginning of the reign of Kekrops, the first Athenian king (1581/0), nor are they very far from the traditional site of Kekrops's tomb (partly beneath the western wall of the Erechtheion) [Figs. 174, 175]. But a palace can hardly be reconstructed upon them, and from what we can tell the sixteenth-century Acropolis (and Athens as a whole) remained a modest place by the standards then being set at Mycenae itself, which was in the midst of its glorious and gold-filled Shaft Grave period.

There is nothing architectural from the next phase of habitation on the Acropolis (Late Helladic II, c. 1500–1390).[23] Still, there are sherds belonging to a style

Fig. 49. Fragment of stone vase carved in relief with scene of bull-jumping. After Mayer 1892, 81.

of pottery associated with palatial structures elsewhere in the Aegean, and so there is the possibility that a ruling family of some sort commanded the summit from a large mansion like those known at other contemporary mainland sites. Some of the pottery, decorated with octopodes and other marine motifs, demonstrates the influence of Minoan Crete (where such pottery was invented).[24] And although the Marine Style pottery found on the Acropolis was locally made, there may have been at least one direct Minoan import to the citadel: a relief stone vase (perhaps originally covered with gold foil), carved with a quintessentially Minoan scene of a youth leaping over a bull [Fig. 49]. Like the Marine Style pottery, this fragment is tantalizing evidence for developing Athenian tastes and participation in a broader Aegean aesthetic and iconography.[25]

The pace of Athenian cultural development seems to have quickened in the late fifteenth or early fourteenth century. Before 1400 or so, the Mycenaean town may actually have concentrated on the sunny south slope of the Acropolis and to the southeast, in the Ilissos district, rather than on the cooler north or northwest (interestingly, the archaeological evidence coincides fairly well with a vague Athenian memory of a time before the legendary King Theseus when the city consisted solely of the Acropolis and the territory below it to the south).[26] But during the Late Helladic IIIA period (essentially the fourteenth century, c. 1390–1300) Athens seems to have spread outward from the slopes in several directions, and a large Mycenaean cemetery arose for the first time in what is now the Classical Agora [Fig. 2]: the civic center

of Classical Athens was in the Mycenaean era primarily a burial ground. There are nearly fifty known Mycenaean tombs in the area, and the largest and most spectacular is a monumental chamber tomb cut into the northeast slope of the Areopagos. It was found missing its occupant but full of pottery, gold ornaments, a bronze lamp and mirror, ivory pins and barrettes, and two ivory cylindrical boxes (*pyxides*), the larger one carved in relief with a violent scene of griffins savaging deer, the force of their furious charge blowing over a small tree below [Fig. 50]. Who carved the pyxis, we do not know: there has been a general reluctance to ascribe it to an Athenian artist (which is not unreasonable given the absence of local parallels) and it is perhaps an import from the Argolid.[27] Who owned the pyxis, we do not know, either. Though no human bones were found in the tomb, the barrettes and other finds suggest the original occupant was a woman. The sheer size of her tomb suggests, too, that whoever she was, she was no ordinary Athenian: she was wealthy, even "noble," though not necessarily "royal."

If she lived anywhere on the Acropolis or its slopes, no traces of her house have come to light. In fact, there is (after the Late Helladic I house north of the Erechtheion) no surviving architecture at all on the Acropolis until early in Late Helladic IIIB (c. 1300–1190). By the first half of the thirteenth century – around 1270, to pick a date – a cluster of five artificial terraces, of varying sizes and heights and supported by neatly built walls as high as two or three meters, had been constructed on the north side of the summit to provide level ground on which to build a major complex [Fig. 48].[28] Stretches of the retaining walls are preserved here and there [Fig. 51]. In fact, two parallel walls running beneath the Erechtheion could not have escaped the notice of its Classical builders and must have enhanced the site's associations with Athens's primeval and heroic past. Two or three of the terraces overlooked a deep, narrow cleft in the rock to the northeast of the Erechtheion that, when steps were cut and others added with small stone slabs, provided a steep path to the summit and gave access to corridors between the terraces. A similar stairway – narrow, partly built, partly rock-cut – is found at the northwest corner of the citadel and led down to the great caves on this side (and no farther): perhaps the grottoes later sacred to Zeus, Apollo, and Pan were sacred even then [Fig. 7]. But neither the "northeast ascent" nor the "northwest descent" was the principal means by which Athenians climbed the citadel. Most traffic would have taken the gentler, apparently wide-

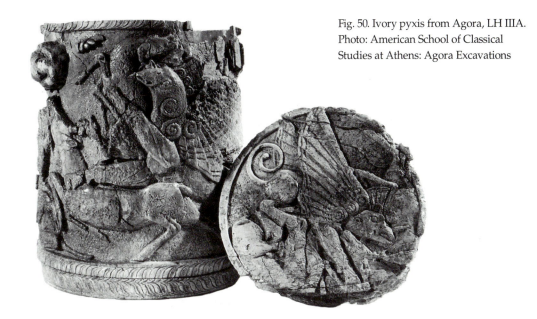

Fig. 50. Ivory pyxis from Agora, LH IIIA. Photo: American School of Classical Studies at Athens: Agora Excavations

open course of the west slope, and it was in that direction that the largest of the terraces (about 100m long and 25–35m wide) extended. Its western edge is apparently marked by a very shallow foundation trench cut into the bedrock (it runs north-south just east of the cutting for the statue of the Bronze Athena, about 40m east of the Propylaia), and its general form can be inferred from other remains.[29] Though the terrace survived far into historical times (the foundations of a great Archaic temple [Fig. 82] were sunk into it and even Classical planners seem to have taken its lines into account), virtually nothing of its fill survives. Still, there can be no doubt that it and the other, smaller terraces nearby were originally built to support a palace.

Mycenaean civilization was a palatial civilization, characterized by fortified citadels that were more than just the residences of royal families. They were administrative, economic, religious, and military installations, centers for the collection, manufacture, and distribution of goods of all sorts, foci of official bureaucracies and of cult activities, and places of refuge for the general populace in times of peril. Yet if the Athenian royal family did not build a palace for itself until the thirteenth century (LH IIIB), it would have lagged seriously behind Mycenaean royalty elsewhere. Extensive palaces had been built at Mycenae, Tiryns, and Thebes at least a century earlier (LH IIIA), long before the generally accepted date for the Acropolis terraces and palace. Moreover, when the Athenians did build a palace, they at first left it undefended. They may have (justifiably) relied on the

rock's natural bulges and scarps for protection, and the retaining walls of the various terraces supporting the palace may have had something of a defensive character, too. Still, there was not yet anything like the massive "Cyclopean" walls – high, wide, and built of roughly dressed limestone boulders, huge but of no standard size, with the cracks between them filled with smaller stones and clay – that had been raised around Mycenae, Tiryns, and other citadels in the early fourteenth century.[30] On the face of it, the social, economic, and political development of Mycenaean Athens seems to have been comparatively slow, and the Acropolis did not begin to look like a Mycenaean citadel until other Mycenaean citadels had already grown old.

Nothing of the Acropolis palace itself survives except, probably, a single limestone column-base [Fig. 52] – the column itself would have been of wood – and pieces of several sandstone steps from an apparently monumental stairway.[31] These few stones are not much to go on (and it does not help that none of them was found in its original location). But assuming that the Mycenaean palace atop the Acropolis broadly resembled the far better preserved palaces at Mycenae, Tiryns, and Pylos (which are themselves similar in many respects) it is not hard to envision what it would have looked like. A broad ramp probably led up from the west slope to a courtyard before the retaining wall of the largest terrace. A stairway cut into the west terrace wall led up to the central block of the palace, which may have included, more or less on the same axis, a gateway (or *pylon*), then another court, and

Fig. 51. Blocks from retaining wall of Mycenaean palatial terrace, 13th century. Photo: author.

Fig. 52. Limestone column base, probably from Mycenaean palace. Photo: author.

on the other side a *megaron* [Fig. 48]. This was the royal hall proper, consisting of a columnar porch, a vestibule, and a large throne room equipped with a round central hearth framed by four columns, and decorated with colorful frescoes of, perhaps, hunts and battles, the kinds of activities in which the Mycenaean élite displayed their valor, prowess, and authority. This was the official and ceremonial heart of the palace. It was here that the Mycenaean ruler of Athens held court and exercised his authority, and it was here, no doubt, that Mycenaean bards sang epic tales of heroes, early representatives of an oral poetic tradition that would centuries later emerge as the *Iliad* and *Odyssey*. The *megaron* would have been imbedded in a larger fabric of corridors and smaller subsidiary rooms, and there may well have been a second story. Moreover, if the Athenian palace was like those at Tiryns or Pylos, there would have been another, smaller *megaron* in a nearby wing – a "queen's *megaron*," it is often called, though it may well have belonged not to the king's consort but to another powerful official of the realm. Some of the terraces would have held workshops and utilitarian areas for potters, lapidaries, bronzeworkers, and other manufacturers, storerooms for such equipment as armor and chariots, granaries for the produce of the Attic plain, and magazines loaded with great terracotta jars filled with wine and olive oil.[32] On the lesser terraces or below the summit in wings that have not been preserved there were, perhaps, additional houses for the élite. And somewhere (on analogy with a complex recently explored at Mycenae) there might have been a cult center with a processional way, a house for priests, altars, and a shrine for the goddess of the rock – perhaps *a-ta-na-po-ti-ni-ja*, the venerable Lady of Atana herself, who would have looked in Athenian imagery very like the armed goddess depicted at Mycenae [Figs.10–12] and who may even have been portrayed in a simple olive-wood sculpture that survived the centuries to become the sacrosanct cult statue of Athena Polias (for what it is worth, *Odyssey* 7.79–81 implies that the goddess dwelt in the palace of the Mycenaean king). Zeus, too, was probably worshipped in the religious complex: it is not impossible that the strangely primitive *bouphonia*, the murder of an ox sacred to Zeus with a double-axe, goes back at least this far. Nor is it impossible that there was already established a kind of Proto-Panathenaic festival celebrating Athens and its devotion to its patron goddess.[33]

However we imagine it, the Acropolis palace had stood perhaps for only a generation or so when, toward the end of the thirteenth century (late Late Helladic IIIB) – around the same time that the citadels at Tiryns and Mycenae had their already impressive fortifications extended – the decision was finally made to throw a massive Cyclopean wall around the entire brow of the citadel. Some 760 meters long, up to 10 meters high, and ranging from about 3.5 to 6 meters thick, the wall fortified an area far larger (about 25,000 sq m, or about six acres) than that covered by the known palatial terraces themselves [Fig. 48]. Actually, the circuit did not so

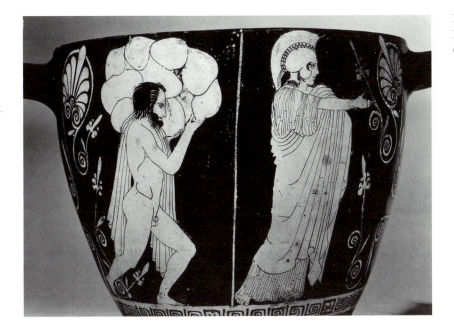

Fig. 53. Red-figure skyphos by Penelope Painter (Louvre G 372), c. 440. Courtesy Musée du Louvre.

much shield and hide the royal compound inside as lift it high above the level of any attack: it is likely that most of the Cyclopean wall was not freestanding, but was back-filled with earth to form a flat terrace almost flush with the top of the wall itself.[34] In any case, the decision to fortify, once made, was quickly put into effect: it is as if the Athenian royals had no time to lose. And there can be little doubt that they had the advantage of modelling their defenses upon what they had seen at other citadels – above all, at Mycenae and Tiryns.

Later Athenian tradition held that the Acropolis walls were built not by Cyclopes but by the people known as the Pelasgians (supposedly the original, pre-Greek inhabitants of Attica, whom the Athenians hired but then cheated out of their reward).[35] A vase painted after the middle of the fifth century has often been taken as evidence for a rival tradition that a boulder-bearing giant or giants built the Acropolis wall under the direction of Athena herself [Fig. 53] – they were presumably in servitude to her after their defeat in the Gigantomachy – but the tradition is recorded nowhere else, and the vase is open to other interpretations.[36] However Classical Athenians mythologized its construction, it is likely, given the expertness of technique and the fact that the wall was built all at once without the phases seen elsewhere, that Mycenaean Athenians hired (or were offered the services of) practiced architects from Tiryns or Mycenae to do the job.

Classical Athenians could make myths about it because this Cyclopean or Pelasgian circuit wall remained

the principal defense of the Acropolis until the fifth century, nearly 800 years after it was first built. Remnants are still to be seen in several spots on the Acropolis. A trench left open below the southwest corner of the Parthenon allows the modern visitor to peer down at part of a forty-meter-long stretch lying far below the present surface (the southwest corner of the Parthenon's own deep foundations actually touch upon the wall). Large portions of the wall are visible above ground in the southeast corner of the citadel (beside the museum), and bits and pieces are found at several places along the north side of the citadel. But the most impressive surviving stretch stands at the west, abutting the Classical Propylaia [Fig. 54]. This massive wall, over sixteen meters long, has stood continuously in view since its construction, and later architects (such as Mnesikles, architect of the Propylaia) seem not only to have taken it into account during their own projects but also to have left it more or less intact, presumably as a memorial to Athens's legendary or heroic past. Evidence at the southeast corner of the Propylaia suggests it still stood ten meters high in the fifth century (even today it is nearly 3.5m high). This is also the straightest, thickest stretch of Cyclopean masonry on the Acropolis, and that suggests it formed part of a major defensive installation on the west side of the citadel.

About four or five meters to the west, in fact, are the remains of a rough, irregular construction (about 16m long on the south and just under 10m wide on the west) that was in the fifth century encased within the smooth

Fig. 54. Stretch of Cyclopean fortification wall adjacent to Classical Propylaia, late 13th century. Photo: author.

bastion built to support the Classical Temple of Athena Nike [Figs. 55, 181]. It can be no coincidence that Athena, goddess of victory, rested atop this bulwark protecting her Bronze Age citadel, and the presence of a large niche, complete with a small supporting column, built into the lowest courses of the bastion's west face suggests some sacred character even for the Bronze Age monument (traces of burning suggest the niche may have been a shrine).[37] But it is not clear how tall the Mycenaean bastion was originally and as a matter of fact it is not likely to have been a true bastion at all – if by that we mean a tower structurally bound to the Cyclopean fortification wall.

Scholars have in the past variously imagined a monumental Mycenaean entrance, with a high, thick tower somehow attached to the Cyclopean wall and thus forming an intergral part of a mighty system of rock-cut stairs, gateways, and constricting courts that would have impressed any visiting embassy and neutralized the momentum of any assaulting army (soldiers standing on the bastion, for example, would have had a clear shot at the unshielded right side of potential attackers down below). The whole thing would have resembled the famous Lion Gate built a little while before at Mycenae itself.[38]

The problem is that there is no evidence that the bastion was ever structurally bound to the Cyclopean circuit. In fact, it seems to be located too far below the Cyclopean wall to make sense as part of a single entrance system.[39] As a result, it is best to detach the bas-

tion from any monumental installation in the west citadel wall itself. Rather than being an integral part of the fabric of the entrance, the bastion seems instead to have been an independent or freestanding structure below it on the west slope [Fig. 56]. Now, it is not impossible that the bastion was built somewhat earlier than the massive Cyclopean circuit above: it may, in other words, have been originally built to overlook and secure the normal approach to a still undefended palace on the summit. After the construction of the circuit wall, it may have been retained as part guard-post, part terrace. But its value in a full-scale attack on the Acropolis would have been minimal or even detrimental: such an isolated bastion/terrace would have been indefensible in time of war and would quickly have become a staging post for besiegers of the citadel itself.[40] It is interesting to note, by the way, that even in Archaic and Classical times the Nike bastion technically lay outside the Acropolis's main line of defense.

Whatever the arrangement on the west slope, the construction of the Cyclopean wall around the summit apparently blocked the old northeast ascent that had led up between the palatial terraces. A stairway may have been built within the thickness of the wall at this point, but it is not clear whether the summit was here still accessible from down below, and it is usually thought that a cluster of small, rickety houses was soon built over the lower end of the ascent, as if their humble occupants huddled for safety in the fold of the Acropolis rock.[41] The northwest descent to the caves, however, cer-

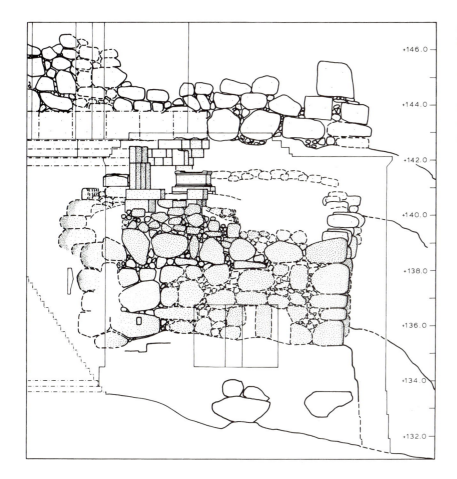

Fig. 55. West elevation of early Nike bastion, with Mycenaean remains. After Mark 1993, fig. 16, used by permission.

Fig. 56. Tentative reconstruction of entrance to Mycenaean Acropolis. Drawing by I. Gelbrich.

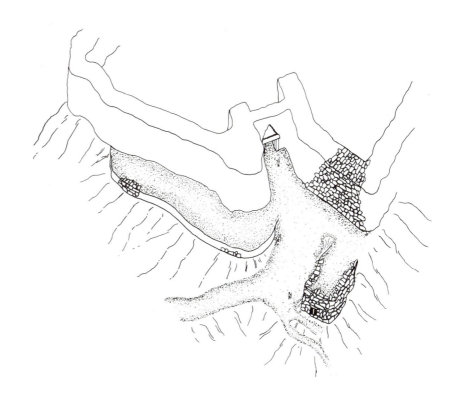

tainly remained open: it in effect became a secondary entrance and was itself protected by a fortified zone at the base of the Acropolis known in our sources variously as the Pelasgikon or Pelargikon (The Place of Storks), an outerwork that at the very least defended the plateau below the caves of the northwest slope but that may well have defended the entire western half of the citadel, from the descent all the way around to the middle of the south slope [Fig. 48].[42] Still, the northwest descent did not guarantee access to what the rulers of the Acropolis apparently needed very badly at the end of Late Helladic IIIB: water. And not far east (at the northwest corner of the later House of the Arrhephoroi), their architects engineered one of the most ambitious (if ultimately unsuccessful) installations found at any Mycenaean citadel: a subterranean fountain or well [Fig. 57].

At some point – all we can say is that it was before the thirteenth century – erosion and earthquake broke off a huge slab of rock from the north face of the Acropolis: after sliding a few meters down the slope it came to rest vertically on the bed of relatively soft marl that extends under the hard limestone of the citadel. The action opened up a fissure some thirty-five meters long (east to west) and one to three meters wide between the detached slab and the main Acropolis mass, but the crown of the wayward rock leaned back against the Acropolis, so that the cleft was virtually sealed at the top. The late Mycenaean architects of the Acropolis, in fact, actually built part of the north Cyclopean wall atop the slab that had fallen away, and not upon the Acropolis's solid core. It is unclear whether they did so because they knew, before beginning work on the wall, of a small but potentially useful crack left between the slab and the Acropolis mass, just inside the line of the Cyclopean wall, or because they did not originally distinguish between slab and mass and only discovered the opening when the wall was under construction. In any case the crack, they discovered, opened into the fissure that, once cleared of earth and debris, descended some thirty meters deep. Aware of water's habit of seeping down the limestone and collecting at the base of the Acropolis, the builders constructed a narrow staircase eight flights long: the two at the top, where air circulated freely and moisture was less of a problem, had wooden steps slatted into cuttings in the rock, while the lower six had steps of schist slabs supported by stone rubble walls or bedrock. At the bottom, in the natural substratum of marl, they dug a shaft eight or nine meters deep, and they must have met with almost immediate success

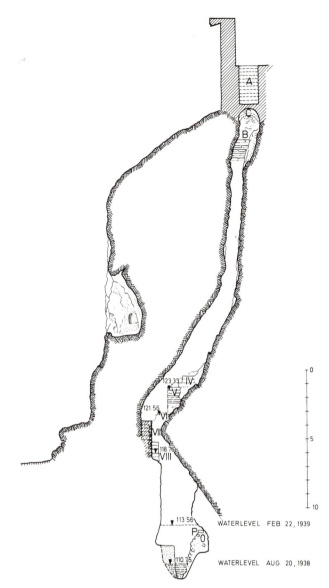

Fig. 57. Section of Mycenaean Fountain, north slope. After *Hesperia* 8 (1939), pl. 12. Used by permission of American School of Classical Studies.

(during the excavation of the fountain in the 1930s, water collected faster than it could be pumped out). The servants or slaves who fetched water for the élite atop the citadel had to lower their jugs, buckets, or sewn skins on long ropes while standing on the lowest landing, and they had no easy task lugging the water back up again. But a constant and plentiful supply of water, accessible from within the fortifications of the Mycenaean Acropolis but invisible to anyone outside the citadel, was nonetheless secured – briefly.

For all the ingenuity and effort expended upon it, the Mycenaean fountain ultimately failed. In the opinion of its excavator, its practical life ended no more than twenty-five years after it was built, when the lower flights of the stairway for some reason collapsed (earthquake and rot are likely culprits, but so is too-hasty construction).[43] Little distinction can be made between the potsherds that found their way into the rubble walls of the stairway during construction, the pots that were accidentally dropped down the well or that shattered against the fissure's rocky walls during the years when people fetched water, and the large amount of broken pottery that was intentionally tossed down the cleft when the fountain was abandoned. In other words, construction, use, and destruction happened within (archaeologically speaking) a very short time: to judge from the ceramic evidence, that was essentially the turn from the thirteenth to twelfth centuries. In still other words, the fountain was apparently dug at the very end of the LH IIIB period (perhaps around 1200, virtually at the same time the Cyclopean wall itself was built) and was abandoned early in LH IIIC (perhaps around 1180 or 1175, when, incidentally, debris also buried the original surface of the northeast ascent). Interestingly, no effort was made to rebuild the installation. The lords of the Acropolis, who presumably ordered its rapid construction in the first place because of an urgent need for water, could within a relatively brief time afford to leave a copious supply at the foot of the citadel untapped and put the fissure to another, inglorious use. For the rest of the twelfth century and then some, the fissure served as the citadel dump. Most of the rubbish thrown into it was broken household pottery (the bulk of it belongs to the advanced stages of LH IIIC, datable to the early eleventh century), though there was also an assortment of human and animal terracotta figurines and stone objects such as whorls, weights, and mortars.[44] Beneath the weight of such garbage, the Mycenaean fountain itself was eventually forgotten.[45]

If the architectural development of the Late Helladic Acropolis lagged behind that of citadels elsewhere, and if its remains are sparse compared to what is left at Mycenae or Tiryns, there is still enough – Cyclopean walls, bastion, terraces and fountain – to suggest that, for at least a few decades around 1200, the Acropolis was as physically imposing and formidable as any palatial citadel in Mycenaean Greece, a citadel that, when it was remembered in the Homeric tradition as the "strong-built house of Erechtheus," was remembered not in detail but well. Any Athenian commoner living in the shadow of the Acropolis would looked upon those walls as monuments to the status and power of the ruling élite. Any potential attacker, standing at the foot of the citadel and gazing up at armed defenders perched seventy or eighty meters above his head, would have thought twice about his chance of success. But two questions remain: first, how *important* a place was the Acropolis (and Athens) at the end of the thirteenth century (LH IIIB), and second, what happened to it in the twelfth and early eleventh centuries (LH IIIC, c. 1190–1065), at the end of the Mycenaean era? Was it in fact as impregnable as it must have looked?

Although there is always the possibility that lost evidence would document a gradual architectural evolution on the summit rather than the swift, comprehensive building program we imagine, the full monumental "Mycenaeanization" of the Acropolis seems as sudden as Athena's emergence from the head of Zeus. It looks as if the decisions to build a palace and then to fortify it were conscious attempts to make the Acropolis politically, economically, culturally, and symbolically dominant in Attica as a whole. By the middle of the thirteenth century, in other words, there could be no doubt which Mycenaean lord was the strongest in Attica: the one who dwelled atop the citadel of Athens. This is not quite the same thing as saying that all of Attica was by now fully unified, and that the lord of the Acropolis ruled it. Hard evidence for that is wanting, and there may still have been princes elsewhere (at Menidi, for example, where there is a fine LH IIIB *tholos* tomb). It is also a bit of a mystery why the Acropolis should have been the *only* significant citadel in Late Bronze Age Attica: why not also Thorikos, for example, which had started out the Mycenaean period more impressively and continued rich in the metal ores of nearby Mt. Laureion? Whatever the answer to that question, the voice of legend nags. Thucydides records the tradition that Theseus abolished all local Attic assemblies, established a single government in Athens, and bestowed Athenian citizenship upon all; and Plutarch states that he (and not Erichthonios, who is more often given the credit) established the Panathenaia festival and even named the state Athens.[46] If there is any historical basis to the story at all (and of course there may not be), LH IIIB is the likely time for Theseus's unification of Athens – the so-called *synoikismos*. Coincidentally, the chronographer of the Parian Marble dated the event to 1259/8 – the mid-point of the era.[47]

Whether Attica was fully unified or not, the preeminence of the ruler of Athens in late thirteenth- and early twelfth-century Attica cannot be seriously questioned. How he ranked among Mycenaean lords in general is another matter. Whatever the extent of the kingdom he ruled from his palace on the Acropolis, it is unlikely that he was the equal of his peers at Mycenae, Tiryns, or Pylos. Homer is Homer, and myth is myth, and neither should be confused with documentary evidence. But it is still hard to ignore Athens's minor role in the allied Greek expedition against Troy (the fifty ships the Athenians bring, under the inconsequential Menestheus, are half the number brought by Agamemnon),[48] or the bit parts that Athenian heroes (despite Theseus) tend to play in Greek saga. The Athenian economy was, to be sure, healthy enough: agricultural production (especially of olive oil) would have been strong, and the metals mined on Laureion (if the hypothetical *synoikismos* did indeed bring it under Athenian control) would have been an important source of capital.[49] And yet Athenian foreign trade at the height of the Mycenaean period – a period when Mycenaeans elsewhere enjoyed far-flung contacts – seems to have been modest,[50] and materially the place seems, on the whole, provincial. The graves in the Agora (after the LH IIIA Tomb of the Ivory Pyxis, Fig. 50) do not document notable wealth, and Athenian potters do not seem to have kept up with major ceramic developments until the mid-thirteenth century, when they began to take their cues from the principal centers of the Argolid. Even then their pottery was run-of-the-mill, and their LH IIIB pictorial repertoire was derivative, uninspired, and limited mostly to birds and fish and, once, a robed man [Fig. 58]. Still, it may be significant that Athens is, besides the Argolid, the only mainland site in the late thirteenth century to produce a substantial number of pots with pictures on them. The Argolid connection seems strong, and it may be no coincidence that this was also the time of palace- and fortification-building on the Acropolis.

The construction of the Cyclopean walls [Fig. 54] and north fountain [Fig. 57] at the end of LH IIIB surely formed a response to a perceived threat. The Athenians would not have surrounded the Acropolis with such massive defenses unless its palace needed protection from something, and they would not have built the fountain unless a secure water supply was of paramount concern. The Athenians feared a siege: that much is clear. But it is not clear who they thought might mount it. And it is not even clear whether their response was formu-

Fig. 58. Mycenaean pictorial pottery from Acropolis. After Vermeule and Karageorghis 1982, IX.90, X.48, and IX.14.

lated locally or as part of a broad pan-Mycenaean strategy orchestrated elsewhere. One possibility, of course, is simply that the rulers of Athens, marshalling burgeoning resources and acting independently, employed architects who used techniques and designs that were in general use throughout the Mycenaean world, or who were specifically chosen to replicate (and rival) the impressive architecture of the Argolid. But the monumentalization of the Acropolis was apparently so sudden, and the similarities of its defenses and fountain with analogous structures at Mycenae and Tiryns so striking, that it has the look of something that was not the result of an organic or internal Athenian process but that was imposed upon it from the outside. The impetus, in other words, may have come not from a local hero such as Erechtheus or Theseus but from the kings of Mycenae and Tiryns, who sent builders to Athens and *made* it, once and for all, the dominant site of Attica. The decision to fortify the Acropolis would have been, in this view, part of a grand defensive scheme devised in the Argolid, the undisputed center of power in Late Bronze Age Greece: as part of a coalition of Mycenaean states, the Acropolis's role could have been

to protect the east flank of central Greece.[51] One trouble with this scenario is that it assumes an extraordinary level of coordination among several palatial kingdoms, not to mention the perception of a monolithic foe. But whether Athens was a fully autonomous state or had its strategic role dictated to it by mightier realms, the defenses of the Acropolis and the construction of the fountain suggest the Athenians felt the same kinds of pressures and perils as the Mycenaeans of the Argolid, who extended their own fortifications and built their own hidden waterworks at the same time. The stones that document the might and resourcefulness of LH IIIB Athens also document its anxiety.

The End of the Bronze Age Acropolis

Even after the Trojan affair, Thucydides says,

> Greece still experienced migrations and settlement, so that it did not know the kind of peace that would have allowed it to grow strong. The long return of the Greeks from Ilion caused many problems, and there was political discord in most cities – those who were driven out founded new ones. The Boiotians of today in the sixtieth year after the capture of Ilion were forced out of Arne by the Thessalians and settled the land that is now Boiotia, but that was previously called Kadmeis (a part of the Boiotian people had previously been in that land, and some of them fought at Troy). In the eightieth year [after Troy] the Dorians, along with the Herakleidai, took possession of the Peloponnesos.[52]

Thucydides is describing what we tend to call the end of the Mycenaean Age, and he is describing a protracted period of instability, population shifts, and strife. There is no question that he is right about the unsettled circumstances Greece began to experience even before the end of LH IIIB. And there is no question that when we speak of "the end" of the Greek Bronze Age as if it happened at a single stroke, we speak too hastily. In all likelihood, the Mycenaeans themselves already saw trouble coming by the middle of the thirteenth century (which is why they built or expanded their mighty citadel walls in the first place). But what the archaeological record (and the legendary one, too) suggests instead of a single wave of disaster is an uneven pattern of destruction, movement, and abandonment that lasted nearly two

centuries, that had no single cause, and that took unequal tolls on different parts of Greece. While Thebes and Pylos suffered destruction during or at the end of LH IIIB, for example, Mycenae and Tiryns each endured several disasters in the course of the late thirteenth and twelfth centuries, and neither citadel suffered total desolation or annihilation. In fact, the nature of the LH IIIC period has recently undergone significant re-evaluation. While palatial society and its complex economies certainly collapsed in the course of the twelfth century, while monumental building programs were a thing of the past, and while there were both a substantial decline in the number of settlements and increased signs of regionalism, the era was far from culturally stagnant or moribund: the remains at such sites as Tiryns and Lefkandi on Euboia, for example, are rich and extensive.[53] The twelfth was still very much a Mycenaean century and if society was no longer predominantly "palatial," and if the Greeks no longer inhabited many of the sites they had before, they were still "Mycenaeans" by any reasonable definition.[54] The "death" of Bronze Age Greece was slow, it was not everywhere equally painful, and it was not over until the middle of the eleventh century.

As for the causes of this long transformation (a better word than "decline" or "death") many theories have been offered: climatological change, catastrophic drought, earthquakes and other natural disasters; the collapse of palatial systems and economies under the weight of their own specialization, their over-extended bureaucracies, and even their excessive building programs; a breakdown in foreign trade; repercussions from crises in other parts of the eastern Mediterranean; uprisings of subject populations and civil wars; wars between kingdoms (such as those remembered in the Greek tragic tales of Thebes and Argos); the adoption of new weapons and armor and the rise of new military tactics favoring massed infantry over chariotry; and, infamously, the so-called Return of the Herakleidai and the Dorian Invasion (datable, by some ancient calculations, to precisely 1104).[55] The Herakleidai, according to myth, were the descendants of Herakles, whose own sons had been expelled from the Peloponnesos after his death; with their supposed return a couple of generations after the Trojan War, they repossessed lands and states that were ancestrally theirs. Thucydides considered the Return of the Herakleidai and the Dorian Invasion the same phenomenon. Herakles became in any case the Dorian hero par excellence, and the various tales of

the invasion of the Dorians – remembered as semi-bar-baric tribal Greeks from the north who descended upon Mycenaean Greece and violently destroyed its states – were and still are used to explain certain linguistic features of historical Greece (namely, that the Greeks of most of the Peloponnesos spoke the Doric dialect). Whether the Dorians are actually detectable in the archaeological record of the end of the Bronze Age;[56] whether they were really massed invaders and efficient sackers of citadels or merely trickled down in disorganized but peaceful fashion, family by family, after the citadels had fallen to others; whether they had already lived in the Mycenaean world as the subjects of the Mycenaean élite and merely inherited what was left after the disintegration of a palatial society that had been superimposed upon them; whether they precipitated the collapse of the Mycenaean civilization or merely benefitted from it – all of this is not our concern here.[57] It is obvious enough that the Mycenaean rulers of Athens and elsewhere built their LH IIIB fortifications to defend themselves against potential human attackers and not natural disasters, even if it is far from obvious where they imagined the threat to lie, or whether the peril was internal, external, or both. But it also needs to be stressed that the destruction of sites is not necessarily to be equated with the destruction of cultures. Undeniably, there was violence at the end of the Bronze Age. But it is doubtful that such violence was by itself the cause of the end of the Bronze Age rather than just a symptom of it. And the Dorian Invasion, in all likelihood, was simply a convenient way for later Greek tradition to account for it all.

According to the testimony of legend, the defenses of the Acropolis held and the citadel was never taken by force. Athenian mythology records that the royal house of Pylos (the Neleids) took refuge in Athens after the fall of its kingdom to the Dorians, and that two of their number, Melanthos and then his son Kodros, even became king. Melanthos, we are told, successfully fought off Boiotians on the western Attic frontier, and Kodros saved Athens from the Dorians themselves. Our sources differ as to whether he purposefully sacrificed himself in accordance with an oracle or fell in battle against invaders who had reached the Ilissos stream, but they agree his death deflected the Dorian Invasion and preserved Athens from destruction.[58] For what it is worth, ancient calculations placed Kodros's death at 1069, not very far from the date now suggested for the end of the Bronze Age (1065).[59]

The archaeological evidence from the Acropolis, as far as it goes, does not contradict the legend. If the Mycenaean fountain was built in anticipation of a siege, its quick abandonment might suggest that the threat soon passed: its water, and the protection the fissure provided, were not needed anymore. Moreover, there is no record of any stratum of burnt debris – no ash in the fill of the fountain, no signs of burning on the Cyclopean walls, no mud bricks or Linear B tablets baked hard accidentally in a general conflagration – that would indicate that the citadel suffered serious damage at any time during LH IIIB or LH IIIC. The absence of any overt sign of violence (together with the linguistic fact that historical Athenians spoke Attic-Ionic, and not Doric, Greek) has generally proved persuasive: the Acropolis, unlike Pylos, Mycenae, Tiryns, or Thebes, was not destroyed at the end of the Bronze Age – not by Dorians or anyone else.

It needs to be said, however, that pure Mycenaean deposits in which to look for burnt debris are (with the exception of the fountain) rare, that the later use and reuse of the Acropolis – the centuries of ancient demolition, clearing, and building – were far more destructive of Mycenaean remains than any Bronze Age army could have hoped to be, and that the tales of the successful defense of Athens from Dorian "aliens" fit in almost too neatly with Classical Athenian chauvinism and claims of autochthony – claims that the Athenians alone of the Greeks were ethnically pure, indigenous to their land, uncontaminated by foreigners (the fact that Melanthos and Kodros came from Pylos did not faze them) – to be taken at face value. Did Athenian history at the end of the Bronze Age inspire the ideology of autochthony, or did the Classical ideology of autochthony shape legendary accounts of events at the end of the Bronze Age?[60]

The archaeological evidence (or lack of evidence) may, in short, be less than conclusive. Consider those few humble houses usually thought to have been built over the bottom of the old northeast ascent at the end of LH IIIB and abandoned early in LH IIIC [Fig. 48]. Their fate has often been interpreted positively, as a sign that the threat that compelled poor folk to find flimsy emergency housing in the shadow of the Acropolis walls soon passed, and that the occupants could leave the protective folds of the rock for better housing elsewhere. But that is not the only way to look at it. Perhaps the occupants, forced to flee so abruptly that they left pots and pans on their floors, took refuge within the walls, were unable to return, or perished.[61] And even the abandonment of the Mycenaean fountain could be taken as a sign not of the

passing of a threat, but of its success (did the fountain collapse from natural causes, or was it scuttled by hostile occupiers?). It is thus necessary to raise the possibility that a violent and damaging attack on the Acropolis occurred but is simply not detectable in the meager archaeological record, and that memory of it was suppressed by later Athenians who had an abiding interest in promoting the continuity and purity of their descent.

At all events, even if it did ward off destruction, Athens did not escape the transformation that befell most of the Mycenaean world in the course of LH IIIC, and here transformation does look more like cultural decline. One indicator is that there are only a few tombs in the Agora that can be dated to the twelfth century, as if the population that had used that ground for burial sharply decreased or moved elsewhere.[62] Other areas, it is true, apparently gained inhabitants: the earliest graves of the important Attic cemetery of the Kerameikos are dug, late in LH IIIC, some 800 meters northwest of the Agora in the area of the Dipylon Gate and Pompeion (the staging place for later civic processions such as the Panathenaia) [Fig. 2], and there are even a few LH IIIC graves to the south of the Acropolis, which suggests there was a hamlet there, too.[63] On the south slope itself, one LH IIIC chamber tomb, cut into the rock behind the east end of the later Stoa of Eumenes, contained the bronze greaves, knives, and tools of one of Mycenaean Athens's last warriors.[64]

But the finds from the twelfth- and early eleventh-century Acropolis and its environs are hardly indicative of a major, centralized settlement. The great amount of potsherds and rubbish tossed down into the north fountain proves the summit itself continued to be occupied well into LH IIIC. So, most likely, do new waterworks dug on the northwest slope in the area of the Klepsydra soon after the collapse of Mycenaean fountain to serve, logically, as its replacements.[65] The line of the mysterious Pelargikon (the lower citadel's line of defense) is uncertain at this point: perhaps the wall protected the Klepsydra installation [Fig. 48]. But if it did not, the military or political atmosphere that necessitated the construction of the north fountain out of sight deep within the rock [Fig. 57] had changed dramatically, and those who fetched water outside the walls had relatively little to fear. Whether the water was drunk by a royal élite worthy of the name still commanding the summit of the citadel is doubtful.

Whatever the condition of the palace in LH IIIC, clusters of modest stone and mud-brick houses were built at several points within and against the Cyclopean

wall: traces survive in the southeast corner of the citadel, along the south wall (near the southeast corner of the Parthenon), and, perhaps, in the areas of the Classical Propylaia and the House of the Arrhephoroi [Fig. 48].[66] Finally, early in LH IIIC someone seems to have wrapped up an assortment of thirty-three bronze objects (swords and knives, lots of tools, several mirrors, and a bowl) and placed them in a hole he had dug in the mudbrick wall of one of the houses built against the south Cyclopean wall. It is an open question whether the owner acted in an emergency, hiding the hoard to prevent its seizure by, say, hostile forces attacking the Acropolis, or whether he was simply a Mycenaean bronzesmith who stored the metal as scrap to be melted down later.[67] What is clear is that no one returned to dig the hoard out again.

Our picture of the Acropolis at the end of the Bronze Age is, then, woefully fragmentary and defective. There was probably a sizable settlement atop the citadel in the twelfth and early eleventh centuries – the bountiful LH IIIC trash thrown into the fissure above the Mycenaean fountain had to come from somewhere, and the warrior buried on the south slope may have been an inhabitant. But it is extremely unlikely that by the end of LH IIIC the settlement still focussed upon a working palace or even a diminished royal family: the story of Kodros, for what it is worth, suggests Athens survived only at the cost of its monarchy. Moreover, it is likely that, however unified Mycenaean Attica might have been at the height of Athenian power, it suffered political and economic fragmentation once more at the end of the era. During LH IIIC, for example, Perati, a thriving settlement of refugees (not necessarily Athenian) on the Attic east coast [Fig. 1], was a richer and better connected place by far.[68] The existence of Perati – a town that, unlike LH IIIC Athens, seems to have had extensive contacts with other parts of the Aegean and Mediterranean world – seems to represent a significant shift in both population and cultural energy, and it, not Athens or the Acropolis, may been the most vital site in Attica for about a century (the situation is reminiscent of the Early Bronze Age, when eastern coastal sites were the dominant ones in Attica). As for Athens itself, there is no compelling reason to believe that it was at the end of LH IIIC much more than a collection of small hamlets broadly scattered atop and around the Acropolis.[69]

So, in the end, it did not matter whether the Mycenaean Acropolis fell violently at one blow or not: the palatial state it once controlled collapsed anyway. The

Mycenaean world was an intricate and fragile fabric of political and economic interconnections. When the fabric was, for whatever reasons, torn, when the other citadels of the Mycenaean world fell, when the interdependence of the states was shattered, Athens was deprived of its partners and inspirations, and the Acropolis's brief history as a Mycenaean center of power came to a relatively precipitous end. And there is (for once) eloquent testimony to its transformation: for the first time since the Middle Helladic period, the Acropolis became a place for the dead. In the second half of the eleventh century, Athenians residing atop the rock, contrary to the usual Mycenaean practice of separating houses and tombs, buried their dead around the perimeter of the summit, within the old fortification walls: fourteen graves are known, all miserably furnished or completely unfurnished, all but one the graves of children.[70] The once-formidable palatial citadel had now become, at least at its edges, a poor cemetery. But we are now in another age – the Submycenaean (1065–1000) – and on the Acropolis it is very dark indeed.

SANCTUARY AND CITADEL
THE CHARACTER OF THE ACROPOLIS, 1065–600

And next came the men who held Athens, well-built citadel,
community of great-hearted Erechtheus, whom once Athena
raised, daughter of Zeus, and the grain-giving ploughland bore,
and she settled him in Athens, in her own rich temple.
There Athenian youths offer him up bulls and rams
as the years come and go.
These men Menestheus led, the son of Peteös. . . .

Iliad 2.546–552

There is nothing very remarkable about these late-eighth-century potsherds [Fig. 59]: women sit on stools, men stand with scabbards, and they all bring their hands to their heads in conventional gestures of mourning. It is the sort of lament often seen on the great grave-markers of the Late Geometric period (760–700), vases like the colossal ones created by the Dipylon Master and others to stand as memorials over the burials of the Athenian élite [Fig. 60].[1] And, to judge from the mourning men and women, it looks like the vases to which these fragments originally belonged (probably large mixing bowls, or kraters) marked graves, too. These sherds, then, are unremarkable – unremarkable in every way but one. They were not found in any of the principal burial grounds of Geometric Athens. They were found (along with fragments of other obviously funerary vases) where graves and funerary vases ought not to have been: in the soil of the Athenian Acropolis, the sacred ground of the goddess Athena, ground whose sanctity (in the historical period at least) could not be violated by death or burial.[2] These small sherds thus pose some large questions: How sacrosanct was that ground in the eighth century – the period that is usually thought to witness the birth of the Greek *polis* (city-state) itself? What function or functions did the Acropolis serve then? What, in fact, was the character of the place during that long, half-lit period bracketed on one side by the monumentality of the Mycenaean Acropolis [cf. Fig. 54] and on the other by the monumentality of the Archaic, sixth-century Acropolis [cf. Fig. 83]? Our topic, then, is the Acropolis in the so-called "Dark (or Iron) Age" (1065–760) and then some (760–600).

Now, it has been said that "the Acropolis of Athens has always had one of two characters. Either it has been the citadel, the stronghold, the place of refuge that could be defended in time of danger, or it has been a sanctuary, the dwelling place of the gods."[3] And it is now almost taken for granted that the Acropolis lost its military character and became a full-fledged sanctuary (a

Fig. 59. Fragments of Late Geometric pottery from Acropolis. After Graef and Langlotz 1909, pl. 8 (nos. 256 and 251) and 10 (no. 298).

Fig. 60. Funerary amphora by Dipylon Master, c. 760–750 (NM 804). Photo: author.

thoroughly and exclusively sacred precinct) only in the second quarter of the sixth century – around the year 566, to be more precise.[4] These are premises that need testing. As we have seen, there is no question that the Acropolis was, for a short time in the Late Bronze Age, a heavily fortified citadel comparable to those better preserved at Mycenae and Tiryns, its Cyclopean walls protecting a palace located in the area between the Classical Erechtheion and Parthenon [Fig. 48]. Similarly, there is no question that, from the early sixth century on, the Acropolis was a major sanctuary. The west slope acquired its first broad ceremonial entrance ramp [cf. Fig. 181], and the summit its first great stone temple [Fig. 83] and its first great marble dedications [Fig. 71], in the years around 575–550, and as a sanctuary the Acropolis would thereafter thrive for nearly a thousand years. But there is not much evidence for the character of the place in the era in between. What was the Acropolis from the late eleventh through the seventh centuries – citadel, sanctuary, or both? Was it much of anything at all? The questions are hard to answer because in large measure the Dark Age Acropolis, like the Bronze Age one before it, was a casualty of centuries of later building, destruction, landscaping, and rebuilding. The wonder, in fact, is not that there is so little evidence left from this period, but that there is any evidence left at all. Admittedly, the evidence is not spectacular. Still, it is more diverse than we might at first expect.

The Evidence of Literature, Myth, and History

But first there is literary, mythological, and even histori-
cal evidence to consider, though for us as for the Greeks
myth and the history blend together. This kind of evi-
dence for the early Acropolis begins, appropriately
enough, with Homer himself, who, again, refers to the
place only twice:[5] first, the brief Athenian entry in the
Iliad's long Catalogue of Ships (see above) and, second,
Odyssey 7.78–81:

And so after she spoke flashing-eyed Athena went
across the barren sea, and left lovely Skheria,
and she reached Marathon and Athens of the wide
 ways
and entered the strong-built house of Erechtheus.

The relevance of these passages to the topography of the
early Acropolis is hotly debated. For some, these lines,
which purport to describe the Acropolis in the heroic
Bronze Age, actually do so: that is, they remember a
Mycenaean Acropolis with a royal palace and a closely
associated shrine of Athena. For others, they describe the
Acropolis in the eighth century – Homer's "own day," it
is often thought. For still others, the passages are post-
Homeric interpolations meant to pander specifically to a
sixth-century Athenian audience, and so have nothing
to do with the character of either the Mycenaean or Dark
Age citadel. Certainly, it is hard to reconcile the differ-
ent conceptions of the building Athena and Erechtheus
are imagined to share on the Acropolis: in the *Iliad*, the
hero Erechtheus shares Athena's temple; in the *Odyssey*,
the goddess seems to share the hero's palace.[6] All in all,
the two passages are too vague and problematic to be of
much use – except that, taken together, they suggest a
dual character for the place. They suggest that the early
Acropolis was both Erechtheus's citadel and Athena's
sanctuary, that these functions were not mutually exclu-
sive after all. Whether these passages are rooted in any
historical reality or not, the situation they describe may
not be far from the truth.

Homer has nothing more to say about the Acropo-
lis. Local Athenian tradition, as we have seen, remem-
bered what happened to it after the Trojan War, at the
end of the age of heroes, and that was nothing much. At
a time when other Mycenaean citadels were supposedly
suffering Dorian-induced disasters, the Acropolis,
though threatened, escaped violent destruction through
the leadership of Melanthos and the sacrifice of the
noble Kodros. According to the testimony of legend,
then, the rock's mighty defenses held, and the citadel
was never taken by force. Although there exists a fanci-
ful list of thirteen more Athenian kings after Kodros,
taking the Melanthid dynasty down through the Dark
Age to the year 753/2 (when the kings were replaced by
"decennial archons," chief officials who served for ten
years), there is another tradition that the institution of
kingship was abolished in honor of his sacrifice. At all
events, Kodros is the last king about whom Attic tradi-
tion remembers much of anything at all.[7]

Thucydides's comments on the nature of the early
Acropolis are about as vague as Homer's. It is not clear
which era – the Bronze Age or the Dark – he is talking
about when he says that Athenians in his day still called
the Acropolis simply "the *polis*" because they vaguely
remembered a time when they used to live upon it, and
that, in the days before Theseus and his unification of
Attica (the *synoikismos*), the city of Athens essentially
consisted of the Acropolis and the grounds to the south.[8]
There were several times in the prehistory of Athens
when this seems to have been true, and Attica may have
been "unified" more than once. One *synoikismos* – a
political event that would have undoubtedly promoted
the centrality of the Acropolis – may have taken place in
the late Mycenaean period, another somewhere between
900 and 700.[9]

None of this is particularly helpful for reconstruct-
ing what the Acropolis actually looked like between the
end of the Mycenaean era and the beginning of the sixth
century. But Thucydides (along with Herodotos just
before him and Plutarch long after) also describes the
first recorded act in Athenian political history, one whose
setting was the Acropolis itself: an attempted coup d'é-
tat. Perhaps in 632/1 (an Olympic year), an ex-Olympic
champion and aristocrat named Kylon, with the support
of his father-in-law (the tyrant of nearby Megara), seized
the Acropolis in an effort to establish his own tyranny.
Thucydides (1.126) says that it took a while for all the
Athenians to learn what had happened – the implication
is that the inhabitants of the city did not all live densely
packed around the foot of the citadel, where they would
have found out fast – but when they did they besieged
Kylon and his men and waited them out. Growing bored
with the siege, the Athenians left the matter in the hands
of their chief magistrates, the *archons* (appointed annu-
ally now), and went back to their homes in the country-
side – important details, if true, suggesting not only the
existence of political procedures for the management of

crises but also the consolidation of city and country that is usually thought fundamental to the idea of the *polis* itself.[10] According to Thucydides, Kylon himself escaped, but his accomplices, suffering from hunger and thirst, "took their places as suppliants in front of the altar on the Acropolis" and some were even found dying (sacrilegiously, of course) in the temple or sanctuary (*hieron*). According to Herodotos (5.71), Kylon himself took refuge at the statue of the goddess before being led away under false pretenses and slain. So, if we can trust the combined accounts of these fifth-century historians,[11] there was on the late seventh-century Acropolis an altar, a temple, and a statue of Athena – and by this Herodotos could only have meant the ancient olivewood image of Athena Polias, always the holiest on the rock.

And that is about all our literary, mythological, and historical sources have to tell us about the Acropolis in the four centuries after the end of the Bronze Age. Art and archaeology tell us a little more.

The Archaeological Evidence

The Dark Age

Whether the legend of Kodros has any historical basis, whether the absence of destruction deposits from the late Mycenaean Acropolis tells the whole story, whether the Acropolis saw any of the violence that befell other Mycenaean citadels at the end of the Bronze Age, there is no question that the massive Cyclopean wall of the citadel [Fig. 54] survived the end of the era more or less intact, and that it would have been the most formidable and striking feature of the Acropolis throughout the Dark Age (and beyond) – a colossal and still very functional relic. What happened to the palace within the circuit, we do not know. But it is hard to believe that the successors of the last Mycenaean Athenians would not have availed themselves of the protection the mighty citadel walls still afforded. In fact, in the second half of the eleventh century – the so–called Submycenaean period (c. 1065–1000) – there seems to have been a small settlement atop the rock. The evidence is limited: it consists not of houses, but of fourteen small, miserably furnished, slab-lined cist graves discovered during the massive excavations of the late nineteenth century (four were located west and north of the Erechtheion, four in the area of the Acropolis Museum, four southeast of the Parthenon, and two more south of the Propylaia, all virtually in the shadow of the old Cyclopean wall) [Fig. 48].[12] All but one of these Submycenaean graves were the graves of

children, with one burial per cist (the old Mycenaean practice had been to build family-style, reusable chamber tombs – a practice that assumes a certain level of social stability and that in these far more impoverished and uncertain times might have been regarded as too much of an economic and social investment).[13] We may surmise that the Submycenaean settlement covered some of the high ground at the center, or even occupied the ruins – if they were in ruin – of the old Mycenaean palace. And it could be that this Acropolis hamlet was ruled by a someone we might call a petty chief or boss-man (*basileus*), whose house doubled as the focus of ritual, communal dining, and worship: if the ancient olivewood statue of Athena Polias was really Mycenaean in origin, it was now probably kept in his house.[14] But all we know for sure is that the once mighty palatial citadel had now become, at its margins, a poor cemetery and that the pottery its inhabitants used was wretchedly made and decoratively bankrupt. There is, moreover, no reason to believe that the settlement atop the Acropolis was even the major population center of Submycenaean Athens.[15] If anything, Athens seems now to have been a cluster of separate hamlets or homesteads scattered south and north of the Acropolis, with the greatest concentration lying to the northwest, near an extensive Submycenaean cemetery found in the Kerameikos.[16]

The evidence is even more scarce in the tenth century. This is the so-called Protogeometric period, and Athens was among the cultural trendsetters of the Aegean,[17] its painted pots suddenly the finest of the day – austere expressions of order, *symmetria*, and analytical clarity [Fig. 61]. Yet there is hardly any of this kind of pottery from atop the Acropolis itself: one or two fragments of apparently very early Protogeometric date were found in the late nineteenth-century excavations (only one piece, belonging to a krater, has compass-drawn semicircles, the characteristic motif of the new style),[18] and a few pieces were tossed down into the dump of the old Mycenaean fountain. There is more Early Protogeometric from the water-rich area of the later Klepsydra spring-house down below on the northwest slope – water jars and cups, mostly.[19] But visits to the Klepsydra area seem to have ceased by the middle of the tenth century, and it is possible that the north slope of the Acropolis – the more shaded slope – would not be regularly utilized again for four hundred years.[20] On the southwest slope, two graves represent the transition from Submycenaean to Protogeometric[21] and five Protogeometric tombs were found near the Odeion of Herodes Atticus.[22] Further south, perhaps along the sides of an

Fig. 61. Protogeometric amphora (Kerameikos 1073). Courtesy DAI-Athens (Neg. Ker. 4245)

ancient road leading down from the Acropolis to the sea, there was another Protogeometric cemetery, in use until the middle of the tenth century.[23] But there is no proof that any of the occupants of these graves had lived atop the Acropolis itself and, all in all, there is so little Protogeometric material from the summit that it is hard to say there was a major settlement or sanctuary up there. On the basis of the published evidence, then, it is easy to imagine the Protogeometric Acropolis a virtual "ghost-citadel" – a nearly empty fortress to flee to in case of trouble, perhaps, but the home of only a modest population at most. But sometimes the published evidence does not tell the whole story, and the Protogeometric settlement on the summit may have been larger and more dynamic than the archaeological record indicates.

This may be so because the picture of a nearly deserted Acropolis around 950 or so does not jibe with the prosperity that Athens seems to have otherwise enjoyed in the tenth, and then in the ninth and early eighth centuries – the Early and Middle Geometric peri-

ods (900–760). There is not much question that some levels of the Athenian economy, at least as measured by its ceramic output and the wealth of some of the graves in the Agora and elsewhere, flourished in the Geometric period. But there is still practically nothing to look at from the Acropolis itself; there is one large sherd from the summit that might be Early Geometric.[24] We have to concede yet again that it may not be good practice to measure the character of the Early and Middle Geometric Acropolis (as of the Protogeometric) by the archaeological record: the later churning up of the site has surely bent the yardstick all out of shape. Still, it is unlikely that the churning could have been so selective as to wipe out virtually the entire archaeological record of the tenth-, ninth-, and early eighth-century Acropolis (had one existed) but not that of the late eighth-century Acropolis. For after 750 or so – in the Late Geometric period – things dramatically change, and the Acropolis suddenly takes on the appearance of an important site: it is, by comparison with what had gone before, artifact-rich.[25]

The Late Geometric Period

Just a few days' excavation in October 1888 brought to light about 1,000 fragments of pottery said to belong to the Late Geometric "Dipylon Class" (significantly, much of this material is said to have been found in *Perserschutt* – Persian debris – buried after the sack of the Acropolis in 480).[26] Fewer than a hundred sherds have ever been published, and so the evidence is incomplete. But it is fair to say that the bulk of the Geometric pottery found atop the Acropolis belongs to the last decades of the eighth century. And it may therefore seem fair to conclude that Late Geometric Athenians began using or depositing vases on the summit in virtually unprecedented numbers. But here we must come to uneasy terms with those troublesome sherds with funerary imagery [Fig. 59] – sherds from vases that presumably should not have been set on the Acropolis had the place become a sanctuary.

There are at least four possible explanations for their presence on the Acropolis:

1. In the middle of the eighth century, the Acropolis, at least in part, was still what it had been in the Submycenaean era – a hamlet and cemetery – and was not yet an exclusively sacred zone. There were graves on the summit, and the sherds belonged to vases that marked them.

2. The vases were dedications at the primeval cult-place known as the Tomb of Kekrops, the first Athenian

Fig. 62. a. Sherd with part of name "Antenor," c. 700 b. Fragmentary terracotta plaque with woman, horse, and threshing fork, c. 700. c. Sherd with part of name "Antenor," probably the dedicant, c. 650. d. Sherd with part of word *anetheken* ("dedicated"), c. 650. After Graef and Langlotz 1909, pl. 11 (no. 309), 10 (no. 286), and 13 (nos. 368a and 380).

king (located in Classical times under the southwest corner of the Erechtheion) [Figs. 174, 175]. The rediscovery of earlier tombs, and the interpretation of them as the graves of legendary heroes worthy of new dedications, was characteristic of life in many parts of Late Geometric Greece, including Attica.[27] Perhaps these funerary vases did not stand atop actual Late Geometric graves but were considered appropriate offerings at the supposed tomb of the legendary king.

3. The vases were won as prizes in athletic contests or games held at elaborate aristocratic funerals below the Acropolis, and were then dedicated on the summit as thank-offerings to Athena.

Finally, 4. The vases were not originally placed atop the Acropolis at all, but were accidentally transported there during some large landscaping project later in antiquity. That is, the sherds were mixed up in fill brought up from the slopes below (where there were Late Geometric graves that later builders might have disturbed). Their presence atop the Acropolis would in this case tell us nothing about the character of the Late Geometric Acropolis: they are there because of some post-Geometric earthmoving. They are archaeological red herrings, and are no problem at all.

Since it eliminates all difficulties at a stroke, the fourth explanation is perhaps the easiest to accept.[28] Still, the second and third seem preferable to me, and only

the first is out of the question. It is difficult to believe that there could have been burials on the summit around or after 750 or so because the evidence that the Acropolis had become a full-fledged sanctuary by then is fairly conclusive.

Even if some of it arrived accidentally at some later date, the bulk of the Late Geometric pottery found atop the Acropolis is consistent with votive use, and the presence of a few sherds from what seems to have a large (poorly published) pot brought from Crete suggests the site may have even been visited by reverent foreign visitors or traders. There are, as well, fragments of other kinds of ceramic dedications. There is, for example, a small painted terracotta group of four yoked horses. There are several pieces of painted terracotta plaques from the end of the century. One [Fig. 62b], pierced with a suspension hole for hanging on a wall or from a branch, bears parts of a woman with a wreath, a winnowing fork, and a horse (one wonders whether it is early evidence for the *Skira*, a festival celebrated by women). And there are fragments of painted clay boxes, too.[29] There is one sherd [Fig. 62a], dating to the end of the eighth century, that probably bears part of the name ANTENOR (and this would not be the last time an Antenor dedicated something on the Acropolis).[30] And yet this is probably not the earliest example of writing from the site. That distinction belongs to a small piece of

Fig. 63. Stone inscription from Acropolis, 8th century (*IG* I³ 1418, Epigraphical Museum 5365). Photo: author.

stone with parts of two lines, possibly hexameters, engraved *boustrophedon* style (that is, one line reads in one direction, the next in the other, turning across the surface of the stone the way an ox plows a field) [Fig. 63]. The inscription is impossible to understand and it is just as hard to date, but it is generally thought to belong to the eighth century. If so, it is the earliest extant Greek stone inscription. At all events, it heralds the wealth of inscriptions that would be set up on the Acropolis from the Archaic period on down.[31]

But pots, plaques, boxes, and stone inscriptions were not the most prestigious objects deposited on the Late Geometric Acropolis. After 750 or so, there is, quite suddenly, a wealth of bronze where there had been, quite simply, no bronze objects before. Above all, there are hammered tripod-cauldrons (an Athenian specialty).[32] Typically, such tripods were awarded as prizes in competitions of various sorts and were then dedicated in sanctuaries. The competitions could be athletic or equestrian, of course, but they did not have to be: the Late Geometric epic poet Hesiod says he won a tripod in a poetry contest held at the funeral of a "king" and then dedicated it to the Muses of Helikon.[33] And on one Late Geometric Athenian bowl it seems clear that tripods, painted on the exterior, were the prizes for the dance contest pictured within.[34] Early on, the tripod became the symbol, as well as the actual fruit, of victory:

a potsherd from the Acropolis itself suggests the symbolic value of the object at the site [Fig. 59, lower right]. In any case, some seventy fragments of tripod legs and ring-handles are known from the Acropolis, and there is a host of bronze figurines that stood upon the rims and helped support the handles or stood upon the handles themselves. Most of these figures are male and some originally held spears, shields, or the reins of horses [Fig. 64], but there was at least one female figure and even mythological creatures like the Minotaur [Fig. 65].[35] There are also a few bronzes that could have been independent figurines rather than tripod attachments.[36] And, finally, there are horses: sixteen of them (plus one more that seems to be a Lakonian import), the majority handle-attachments but a few that were meant to stand by themselves on their own little platforms [Fig. 66].[37]

Now, there was throughout eighth-century Greece a tremendous increase in cult activity – cults spread over Late Geometric Attica, too, at such places as Marathon, Menidi, and Kiapha Thiti – and an increasing proportion of available wealth (usually in the form of bronze artifacts) was dedicated to the gods almost everywhere. The phenomenon is usually linked to the rise of the *polis* – the city-state – itself. Emerging *poleis*, it is thought, established or promoted the elaboration of sanctuaries as a means of self–definition, as a means of centering *polis*-life and religious structures, and of marking civic bound-

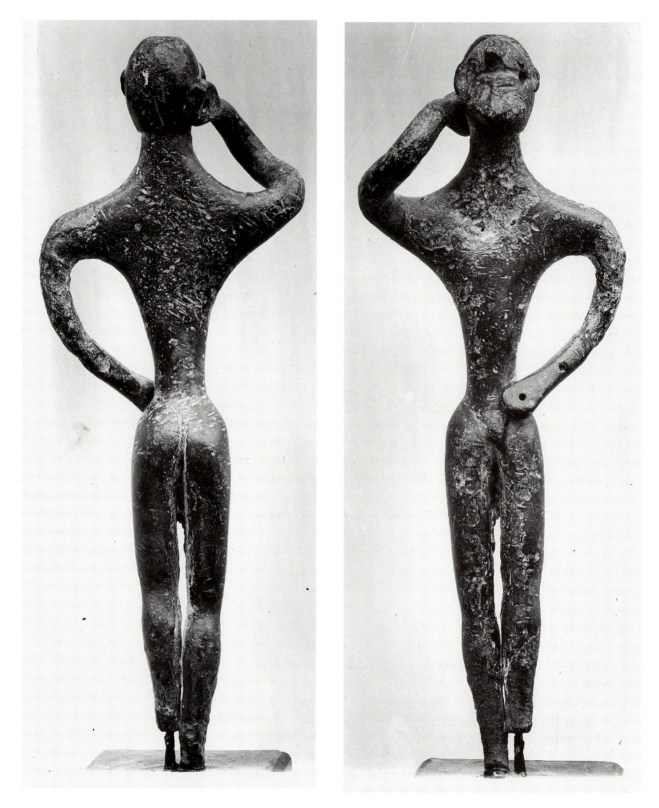

Fig. 64. Bronze figurine from tripod dedicated on Acropolis (NM 6616), late 8th century. Courtesy DAI-Athens (Neg. Nr. NM 3407)

aries. At the same time, the sanctuary became the center of such self-aggrandizing élite displays as the dedication of large bronze tripods and figurines (which are in this period almost without exception found in sanctuaries as votives).[38] Perhaps the Acropolis tripods were dedicated by the winners of aristocratic family competitions or funeral games or, just possibly, by the victors in embryonic Panathenaic contests held in honor of Athena.[39] But the deposition of tripods and figurines on the late eighth-century Acropolis – and it is important to note that no other Attic site can compare to it in the wealth of its bronzes – makes perfect sense in terms of the emerging *polis*. The Acropolis had become, without much archaeologically visible preparation, the major sanctuary of Attica – its religious focus, its symbolic center, and the center of its symbols. It had become a display.

Whether it acquired a new temple, or its first temple, at the same time is another matter. A temple, it is true, was not the critical feature of a Greek sanctuary: the altar was the essential thing.[40] Still, the construction of temples – corporate efforts that required some degree of planning, financing, and organization – is another supposed symptom of the emerging *polis*, and it is not difficult to imagine a modest Geometric temple on the rock – it would have stood on the north side, in the vicinity of the old Mycenaean palace or the later Erechtheion – even though there is no hard evidence for one (or for any other major architectural activity on the eighth-century Acropolis).[41] In any event, the Acropolis

Fig. 65. Bronze minotaur from Acropolis (NM 6678), late 8th century. Courtesy National Archaeological Museum, Athens.

Fig. 66. Bronze horse from Acropolis (NM 6543), late 8th century. Courtesy National Archaeological Museum, Athens.

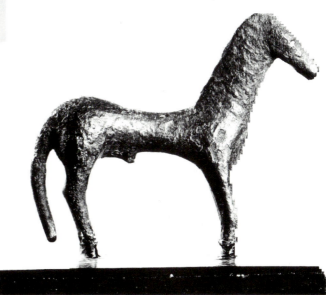

seems to have become the major focus of conspicuous material investment by the Athenian élite at the same time that Attica as a whole experienced a great increase in the number of settlements and cemeteries: in the late eighth century the Attic countryside was apparently filled in with communities, "internally colonized."[42] In short, the Late Geometric Acropolis – with its hypothetical first Temple of Athena Polias – looks like the religious focus of an expanding city-state taking promising shape.

The Seventh Century

The problem is that the political and economic shape of Athens after 700 does not look so good. In the seventh century Attica seems to have experienced not continued expansion along eighth-century lines, but depopulation, discontinuity, and decline. There are far fewer known Attic cemeteries in the seventh century than there had been in the eighth, and there are far fewer settlements, too. Yet, if the population of Athens and Attica seems to have shrunk, there seems, at the same time, to have been a minor "religious boom" in the countryside, especially at hilltop sanctuaries (like one on Mt. Hymettos) not associated with any settlements – a phenomenon that might suggest a decentralization of Athenian religious life, a diminution of the prestige of the Acropolis (only recently earned), even a desire to invest in religious activities outside the bonds or patterns of the community.[43]

The history of Attica in the seventh century is generally regarded as unusual or eccentric compared to other *poleis*, largely because the archaeological record of the Acropolis is generally regarded as thin and unimpressive. As a result, some scholars have concluded that the Late Geometric Athenian progress toward true *polis*-dom was only temporary, that it was stunted by some natural, economic, or military disaster around 700 or so. It is the relative poverty, cultural quiescence, and insularity of seventh-century Athens that these scholars focus on. There is the sense that in this era Athens lacked the political machinery or formal constitution (*politeia*) that should have characterized a developed Archaic *polis*, and that political power and the offices of magistrates were not yet concentrated upon a single civic space or agora.[44] Some even believe that around 700 the reactionary Athenian aristocracy – the *Eupatridai* (as they would be called), the Well-Born, the heads of Athens's chief families – were able to abort the birth of the Attic *polis*. In this view Attica was returned to a state of affairs more like that of the Dark Age (where personal loyalties and family ties were the basis of power), with a true Athenian *polis* not conceived again until the early sixth century.[45]

That may be, but there are some things about seventh-century Athens that can be interpreted more positively: the establishment of the annual archonship in 684/3, for example (the first "eponymous archon," the chief executive who gave his name to the year, was, incidentally, Kreon); the fact that the first Athenian athletes to win Olympic victories won them in 696, 692, 644, 640, and 636;[46] that Athens did not feel the need to send out colonies (as other hard-pressed city-states did) until the very end of the seventh-century (when it occupied Sigeion at the entrance to the Hellespont); that "the people" and their politically-obliged archons thwarted Kylon's tyranny; or even that around 621/0 Drakon supposedly set down in writing, on wooden objects called *axones* displayed on the Acropolis, the first Athenian law code, an act that (despite its reputation for harshness) implies some consolidation or definition of the Athenian political community.[47] But the difficulties in assessing the early history of the Athenian *polis*, its territorial boundaries, and its emerging constitution are acute, and rather than engage that broad argument directly it is best to return to the Acropolis, to see exactly what there is, or what there is not, to justify the common assumption that the character of the place, like Attica generally, was in the seventh century somehow different and less impressive than it had been in the eighth.

First, it is true that in a number of respects the Acropolis now seems modest, if not odd, compared to sanctuaries elsewhere in Greece – even compared to itself in the previous century. Pottery, for example, is very scarce: the site has yielded only a little more than a hundred seventh-century sherds (compared to the thousands of Late Geometric sherds known).[48] There are only eight or nine seventh-century bronze tripod fragments to set against the seventy-odd pieces from the eighth.[49] While bronze *fibulae* (safety-pins) were dedicated in large numbers at other seventh-century sanctuaries, only one was found on the Acropolis (which is especially remarkable given the role of clothing in several Acropolis rituals) [cf. Fig. 151].[50] The seventh-century Acropolis also seems peculiarly isolated. East Greek material is rare, and imports from farther east – the Near East and Egypt – are even rarer. There is, for example, only one Egyptian object from the early Acropolis (a bronze figurine of the infant Horus) and that could well be eighth century.[51] Finally, there is a conspicuous absence of mar-

ble statuary of the sort that began to adorn other sanctuaries of the Aegean in the seventh century – no early statues of youths (kouroi) or maidens (korai) here. In short, the Acropolis material just does not look like the richer stuff found in major sanctuaries elsewhere.

Still, if seventh-century pottery from the Acropolis is not plentiful, the leading practioners of the so-called Protoattic style – the Ram Jug Painter and the Polyphemos Painter, for example – are represented among the sherds,[52] and the pots that were deposited were surely votives (one amphora was apparently dedicated by another Antenor, Figs. 62c, d).[53] One terracotta fragment appears to come from a house or temple model like better known examples found at Argos and Perachora.[54] Though they may be less common in the seventh century, bronze votives – human figurines, horses, and other animals – still appear; there are even a few surviving terracotta heads and masks.[55] The dedication of tripods continues (even if the numbers are not so great) and elaborate wooden chests covered with figured bronze sheets are deposited, too [Fig. 67].[56] There are even a handful of griffin protomes from the sort of Orientalizing cauldrons now in vogue elsewhere (the inventories of wealth stored in the Classical Parthenon refer several times to griffins and one wonders whether they could have been "heirlooms," the remains of seventh-century cauldrons venerated for their antiquity).[57] Inscriptions on marble continue as well. One, on a fragmentary base, records the dedication of a tithe (dekaten) to Athena. Another, a flat roof tile, has two letters (BU) cut into it (in both cases the marble appears to be Naxian, not coincidentally the material of the earliest monumental Greek sculpture).[58] From the last decades of the seventh century there come a few painted architectural terracottas that, if they did not adorn a temple or shrine, indicate the existence of several small sacred buildings on the summit (antecedents of the treasury-like structures that would stand there in the sixth century, perhaps; cf. Fig. 83).[59] And if there are no marble statues yet, there are several curious marble plaques, incised with the smiling faces of sphinxes, and at least two marble lamps, adorned with human and animal heads, from perhaps the end of the century [Fig. 68].[60]

All in all, then, we must be careful to distinguish changes in the sheer quantity of archaeological material from the Acropolis from changes in its patterns of use, from changes in its character. Though accidents of preservation may (as always) come into play, there is a steep drop in the number of potsherds and bronzes from

the place after 700. The Acropolis lacks some objects found in abundance elsewhere, and there seems to have been relatively little diversion of material wealth to this sanctuary, at least compared to contemporary Samos, Delphi, or Olympia. Athenian Eupatrids evidently did not use the Acropolis as a stage for conspicuous consumption and display to the same degree as aristocrats used sanctuaries elsewhere. But the range of objects remains broad, and certainly the Athenians did not stop dedicating pottery and bronzes on the summit. That is, even if the degree of investment declined, even if the sanctuary seems modest or idiosyncratic by seventh-century standards, the sacred nature of the site, fully established in the Late Geometric period, remained: it was even powerful enough to begin to attract lesser shrines to its slopes.[61] The peculiar trajectory of the evidence from the Acropolis may have a lot to do with the rising and falling fortunes of the Athenian polis as a whole. But there is nothing to suggest that the character of the Acropolis itself had in any way changed.

There are, at all events, at least two good reasons for believing the sacred character of the Acropolis was enhanced rather than diminished in the seventh century: these are a pair of crudely fashioned, poros-limestone column bases once embedded in the great sixth-century foundations south of the Erechtheion [Fig. 82], bases that probably represent the remains of a temple built between 700 and 650 on the probable spot of the old Mycenaean palace, on a level field perhaps still defined by Mycenaean terrace walls.[62] While the temple to which these column-bases belonged – the second Temple of Athena Polias, if there had been a Late Geometric predecessor – is difficult to reconstruct (it is not even clear whether the columns they supported stood in the porch of the temple or inside it) and while it was probably not monumental (the real advances in Greek temple architecture were being made elsewhere), the bases are eloquent testimony to the continuing sacred function of the Acropolis and to continued interest in elaborating its sacred role (and perhaps to Athens's desire to establish itself as the peer of other emerging polities, with a temple of its own). However one approached it in the seventh-century – from the west slope of the Acropolis or from the northeast, via the old Mycenaean ascent leading up from what now seems to have been Athens's original civic center, the Archaic Agora [Fig. 2][63] – this would have been the temple in which the holy olivewood statue of Athena Polias stood. This might have been the building illuminated by those

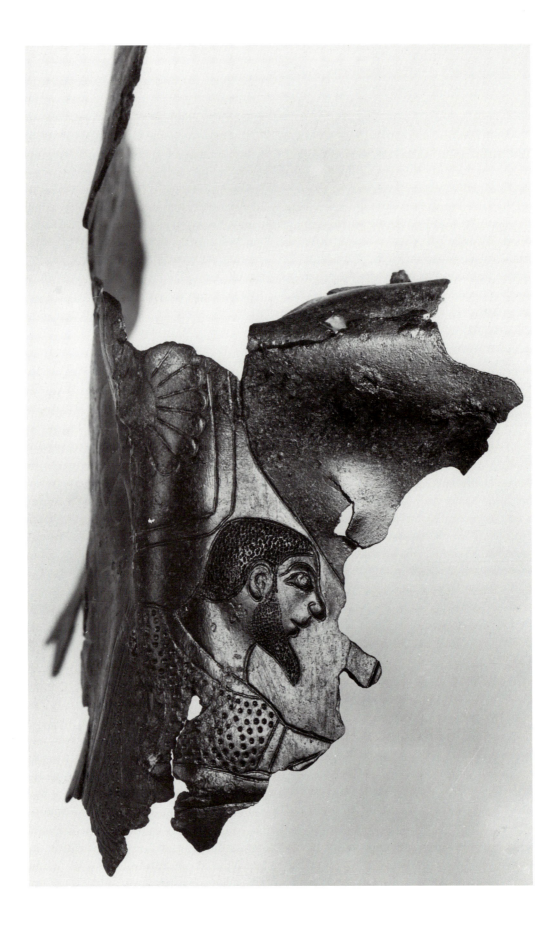

late seventh-century marble lamps [Fig. 68] and decorated by those curious marble plaques with incised sphinxes (were they roof ornaments?). This would have been the temple in which Kylon or his men sought refuge. And this would certainly have been the goal of seventh-century Panathenaic processions. It is tempting to think that a large vase by the Nettos Painter (he worked in Athens not long after the Kylon affair) showing women in procession between two Doric columns alludes to this building [Fig. 69]. But there is no better place to put a curious seventh-century bronze disk with a standing, encircled Gorgon [Fig. 70]. It was, perhaps, an *akroterion* (roof-ornament); perhaps it was a pedimental decoration.[64] But it is certainly the first in a long line of Acropolis Gorgons, an image that initiates a

Fig. 68. Marble lamp with the heads of women and rams, end of 7th century (Acropolis 190). Photo: author.

Fig. 69. Foot of Black-figure skyphos krater by Nettos Painter, end of 7th century (NM 16384). Photo: author.

Opposite: Fig. 67. Bronze sheet from wooden chest (?), 7th century (NM 6963). Courtesy DAI-Athens (Neg. Nr. 71/266).

Fig. 70. Bronze disk with cut-out figure of Gorgon, from 7th century Temple of Athena Polias (?). (NM 13050). Courtesy National Archaeological Museum, Athens.

strong association on this site between Athena and Medousa and an iconographic tradition that would endure at least until the Hellenistic period, when a great gilded-bronze gorgoneion (possibly reflected in the so-called Medousa Rondanini [Fig. 223]) was nailed to the south Acropolis wall.

It remains to emphasize that for Kylon, anyway, the seventh-century Acropolis was a citadel – a stronghold that needed taking if power was to be grabbed – as well as a sanctuary. And, of course, the Acropolis's strategic significance never ceased (at least not until it was officially declared an archaeological site in 1834 AD). One of the legacies of geology, which drove the rock above the center of a large plain and gave it its sheer sides [Fig. 4], and of the Mycenaean period, which left behind those great Cyclopean walls [Fig. 54], was that the Acropolis could never *not* be a place of defense or military value. It is thus not really true that the Acropolis was throughout its history either one or the other, or that it was first "set aside as the principal sanctuary of the city goddess Athena"[65] only in the second quarter of the sixth century.

What happened then was the more glamorous intensification of patterns of use that had long been established. The sixth-century Acropolis differed from the seventh- or eighth-century Acropolis not in kind (or sacred character) but in degree. Nor is it true that it lost its military character even then. No one doubts that the sacred monumentalization of the Acropolis took off after 575; no one doubts that at least one large peripteral temple was constructed on the summit [cf. Fig. 83], or that the place became a gallery for large-scale élite and ideological displays. But, as we shall see often enough, the sanctuary of Athena was never completely demilitarized. It would always continue to be a center of power, a place of defense, a last bastion.[66] The character of the Acropolis was, at least from the eighth century on, mixed, and it probably had always been so. It was, in short, what it appears to be in the *Iliad* and *Odyssey*: both fortress (the stronghold of Erechtheus) and sanctuary (the shrine of Athena). And that is one of the things that makes the Acropolis one of the most unusual Greek places of all.[67]

TYRANNY, DEMOCRACY, AND THE ARCHAIC ACROPOLIS, 600–480

Our *polis* will never perish by the decree of Zeus, nor through the will of the blessed gods;
For such is our great-hearted guardian, daughter of a mighty sire, Pallas Athena, who stretches
her hands over us.

Solon, 3.1–4.

The Historical Background

When all there is in the historical record is a string of a few shadowy events – the Kylonian conspiracy in 632/1, the recording of laws by Drakon in 621/0, the reforms of Solon in 594 – the temptation to link them all causally, to assume that one thing led directly to the other, is nearly irresistible. But knowing as little as we do about the late seventh and early sixth centuries in Athens, it is risky to assume they really are all connected: the Drakonian code may have been set down in response to the Kylonian affair, but then it is curious that the reaction was delayed a decade, and the association is not, after all, a necessary or obvious one.[1] And when the primary sources for the history of early sixth-century Athens are the sometimes defensive, sometimes self-congratulatory first-person poems written by a leading player in that history – Solon himself – we had better be wary. His poetry and his legislative acts may have been closely connected, but the language of even political poems can be imaginative and metaphorical (and how readily would an historian accept the accuracy and objectivity of the autobiography of a modern politician without verification from other sources?).[2]

Even so, it is clear that something was rotten in the state of turn-of-the-century Athens. Whether it was by 600 or so a fully developed *polis* or one whose evolution

was in some sort of arrest, Athens experienced severe social, economic, and political stress, and whatever political mechanisms were in place could not handle it. The crisis pitted rich against poor, Eupatrids against commoners, and it seems to have been fundamentally agrarian in nature. The fourth-century document known as the *Constitution of Athens* (conventionally attributed to Aristotle) couches its summary of the situation in the terminology of its own day, but the general picture is probably fairly accurate:

[After the Kylonian affair] there was strife for a long time between the nobles and the commoners. For the whole political structure at Athens was oligarchic; in particular, the poor together with their wives and children were in bondage to the rich. They were called *pelatai* [dependents or clients] and *hektemoroi* [sixth-parters], for it was on that percentage-basis that they worked the lands of the wealthy. All the land was now owned by a few, and if they failed to pay what they owed, they and their children could be sold into slavery. All debts were contracted upon the person of the debtor, until Solon's day; he was the first to become the champion of the people. The most difficult and hateful feature of the regime for the

masses was their enslavement. But they had other grievances as well, since for all intents and purposes they had no role at all in public affairs.

Constitution of Athens 2

With the majority enslaved to a minority, with some Athenians even sold abroad as slaves, the crisis turned violent, and even the nobles realized that something had to be done. The sides came together long enough to choose Solon as mediator: in 594 he became archon, and the Athenians "put the constitution into his hands" (*Constitution of Athens* 5.1).

Solon is credited by later sources with a wide variety of political and economic acts, including a reform of weights, measures, and coinage, a prohibition against all agricultural exports except olive oil, legislation setting limits on the amount of land an individual might own, a law encouraging fathers to teach their sons a trade, the institution of a Council of Four Hundred (with 100 members drawn from each of the four ancient "Ionian tribes" into which the Athenian populace was traditionally divided), and a horizontal division of the citizenry into four classes based on wealth rather than birth, with different political offices open to members of different classes. The treasurers of Athena (*tamiai*), for example, were selected from the highest class – the *pentakosiomedimnoi*, those whose lands produced at least 500 measures of grain a year – while the lowest class, the *thetes*, or laborers, could only participate in the public assembly and law courts.

How many of the reforms credited to Solon are genuine is a matter of considerable dispute, but there is little doubt that his principal target was the problem of debt and enslavement.[3] Again, the *Constitution of Athens* (6.1):

> After having been given full power to act, Solon freed the people by prohibiting, in the present and for the future, loans taken out on the person of the debtor. He made laws, and effected the cancellation of debts, both public and private, a measure that is called the *seisachtheia*, which means "the shaking-off of burdens."

And there is Solon's own broad evaluation of his (moderate) actions, with a metaphor that has him, like Pallas Athena in another of his poems, protect all the Athenians:

> I gave the people just as much privilege as sufficed, neither removing any of their prerogatives nor giving them too many;

> And as for those who already wielded power and were admired for their wealth, I arranged that nothing shameful should come to them.
> But I stood there holding my mighty shield over both sides, allowing neither an unjust victory.

Constitution of Athens 12.1–5

At the heart of his reforms was a belief in justice, the necessity for civic order, and the construction of an inclusive state in which individual responsibility was fundamental to the sense of public community. His laws were inscribed on revolving wooden contraptions called *axones* and were displayed early on in a building (the Prytaneion) below the northeast end of the Acropolis, in the area of the Archaic Agora [Fig. 2], where all could see them (at some point, however, the *axones* were to be found on the Acropolis). These laws, Solon declared, were binding for a hundred years and to give them a chance to work he left town on a decade-long foreign tour.

Perhaps he should have stayed put, though it is easy to see why he left. Moderation makes enemies right and left, and Solon himself admits it was hard to please everyone: in one poem Solon presents a striking image of himself as a wolf cornered by a pack of dogs. But in his absence the dogs apparently had their day. The agrarian crisis seems to have been defused, it is true, and whatever economic reforms Solon actually instituted seem to have worked: Athens began to prosper. But the *polis* that Solon had re-created was no utopia: the new political machinery did not run smoothly, and civil strife continued. Twice during Solon's absence (in 590/89 and 586/5), power struggles led to *anarchiai* (literally, "years without archons") and a certain Damasias, selected archon in 582/1, illegally stayed in office for over two years before being forcibly removed.[4] If, as is often assumed, one of the motives for Solon's extraordinary appointment in 594 was to avoid the kind of tyranny that had befallen other Greek states and that had already threatened Athens once before, the danger clearly had not passed. In the years following his reforms, increasingly complex factional politics set the stage for the emergence of a tyranny that stuck, and Solon, back in Athens, was powerless to prevent it.

In the second quarter of the sixth century, Athenian political wars were waged by powerful families and parties whose bases of support were located in the Attic geographical regions contained in their names: the Men of the Plain (led by Lykourgos), the Men of the Coast (led by Megakles of the Alkmeonidai family), and the

Men of (or beyond) the Hills (led by Peisistratos of Brauron in east Attica, a war-hero and younger cousin of Solon, who in one poem even seems to warn the Athenians about him). This was "the histrionic period"[5] of Athenian history: Solon himself had feigned madness to deliver one of his early poems and Peisistratos, weary of jockeying for position with Lykourgos and Megakles, twice used theatrics to grab or consolidate power. In 561/0 he appeared before the people in the Agora – the Archaic Agora, to the east of the Acropolis [Fig. 2] – displayed wounds he said he had received from his enemies, and asked for and received a band of club-bearers for protection. With this bodyguard he seized the Acropolis. The *coup d'état* quickly collapsed, however, and Peisistratos was sent packing back beyond the hills to Brauron. Solon may have died the following year (560/59), and things continued to go so badly that even Megakles the Alkmeonid recognized the need to come to terms with his popular rival. Probably in 557/6 Megakles offered to support his tyranny if Peisistratos would marry his daughter, and the deal was struck. Herodotos (1.60) tells the famous story that a second tyranny came as a result of a plot to have Peisistratos ride into town on a chariot beside a tall, beautiful country girl dressed up as Athena (Phye was her name), so that the people would think he was being installed as ruler upon the Acropolis by the goddess herself. Herodotos cannot believe the Athenians could have been so gullible as to fall for this lame-brained scheme, but he probably missed the point. The tyranny was already his when Peisistratos took his famous ride and the parade through town was a public ceremony – and a kind of interactive theater – through which the tyranny was announced and couched in an iconography the people could understand (one of Athena's most familiar mythic roles was as the friend of heroes such as Herakles, whom she led to immortality upon Mt. Olympos; cf. Fig. 85). The parade gave the people the chance to show their enthusiastic approval for the new regime (or at least to flatter it).[6] Peisistratos's second tyranny, however, did not last much longer than the first. Megakles withdrew his support when he learned that his son-in-law failed to consummate his marriage in the customary manner, and Peisistratos was forced into exile, this time farther afield. For ten years he gathered resources, mercenaries, and allies (in Thessaly, Thebes, Naxos, and Eretria), and in 546/5 the histrionic era of Athenian politics neared its end when Peisistratos and his army landed unopposed at Marathon on the east Attic coast, won the battle of Pallene (between Pentelikon and Hymettos, Fig. 1), and captured the city. One more bit of play-acting secured his rule once and for all. According to the story, Peisistratos mustered the people, telling them to gather with their weapons at either the Anakeion (the sanctuary of the Diskouroi) or the nearby Theseion (our sources differ), and then faked a weak speaking voice. The Athenians complained they could not hear him, and "asked him to go to the Propylaion, so that they all might hear. At that point, while he continued to speak softly and they strained to hear his words, his mercenaries advanced, collected the arms, and brought them down to the Sanctuary of Aglauros."[7] The Sanctuary of Aglauros has been identified below the huge grotto on the east side of the Acropolis [Fig. 8],[8] and both the Anakeion and Theseion are thought to be have been located off the northeast flank of the citadel, in the vicinity of the Archaic Agora [Fig. 2]. But the location of the Propylaion (Gateway) of the anecdote is uncertain. It was, possibly, the old Mycenaean postern gate at the top of the rock-cut northeast ascent [cf. Fig. 48], which, again, may have been in working order in the sixth century.[9] Still, the topography of the area seems much too narrow and steep to accommodate a large civic gathering. An alternative is that Peisistratos moved his low-level oratory to the west slope of the Acropolis, with its broader approach and more impressive gateway [Fig. 83], where there was more room and where the thievery of Peisistratos's henchmen all the way around the other end of the Acropolis would have gone completely unnoticed.

At all events, the third time was the charm, and the Peisistratid tyranny remained secure and, apparently, popular. Resistance was mild or nonexistent: Athenians of all political stripes easily preferred Peisistratos's authority to the chaos of the first half of the century, and our sources are nearly unanimous that he respected the Solonian constitution and won support from nobles and commoners alike. In fact, he ruled so moderately, efficiently, and in the public interest that his reign was later characterized as a "Golden Age."[10] The regime was so benevolent that when Peisistratos died of old age in 528/7, the tyranny fell to his eldest son Hippias with barely a hint of opposition (indeed, in 525/4, Kleisthenes, son of Megakles and leader of the Alkmeonidai, even collaborated by serving as eponymous archon). For years Hippias, with the support of his younger brother Hipparkhos, evidently ruled wisely and well, and Thucydides (6.54) could conclude of both father and sons that "these tyrants to the greatest extent made a

practice of excellence and intelligence, and exacting from the Athenians only a twentieth of their incomes as taxes they beautified their city, concluded their wars, and performed the proper religious sacrifices."

In 514 all that changed. A personal dispute between Hipparkhos and two noble lovers, Aristogeiton and Harmodios, resulted in a plot to assassinate both Peisistratids at the start of the procession of that year's Greater Panathenaia. Hipparkhos was slashed to death. Aristogeiton and Harmodios were caught and executed. And though Hippias, the real tyrant, escaped harm, he grew paranoid and harsh. After a few years of agitation against the tyranny and one disastrous attempt to create an anti-Peisistratid stronghold at Leipsydrion, below Mt. Parnes, Kleisthenes and the Alkmeonidai, with the connivance of Delphi, enlisted powerful allies. In 510 (another Greater Panathenaic year) King Kleomenes of Sparta invaded and Hippias and his family took refuge behind the Acropolis's still functioning Mycenaean wall [Fig. 54].[11] There is no telling how long the seige would have lasted, and its success was not a foregone conclusion. But the capture of some Peisistratid children outside the walls ensured victory for their opponents. In exchange for their safe return, Hippias agreed to withdraw to Sigeion and eventually found refuge at the court of Darius, King of Persia.

The tyranny was over, but vicious party politics of the sort that had set the stage for Peisistratos in the first place immediately ensued. First the conservative aristocrat Isagoras got the upper hand over Kleisthenes; then Kleisthenes, losing ground, enlisted the aid of the people by promising them a greater role in government; then Isagoras countered with an invitation to the Spartans to intervene again; Kleomenes came back and with Isagoras took the Acropolis. But the Athenians this time rose up in revolt and beseiged the Acropolis themselves. Recognizing the hopelessness of their position, Kleomenes and Isagoras departed. Kleisthenes and the idea of the new form of government he had promised the people (first and foremost out of political expediency) had triumphed.

"Democracy" had in some measure been prepared for by Solon's reforms and even by the Peisistratid tyranny, which not only respected the rule of law but also levelled the field upon which nobles and commoners both stood. Still, Kleisthenes's reforms, passed in 508/7 by the Solonian Council of 400, restructured the Attic state, breaking many bonds with the past. The citizenry was now divided into ten tribes instead of four,

each with its own "eponymous hero" (Erechtheus, Kekrops, Pandion, Aias, and so on). Fifty citizens from each tribe, chosen by lot, formed a new Council of 500 (the old Council of 400, in other words, voted itself out of existence by ratifying Kleisthenes's proposals). Attica itself was divided into *demes* (local, self-administering townships) that were in turn grouped into thirty *trittyes*, artificial units linking communities in different parts of Attica, compelling their association for the common good (three *trittyes* – one each from city, coast, and interior – made up a tribe). Theoretically, every Athenian citizen was a demesman who had the same rights as every other demesman, and it did not matter what part of Attica he came from. This was embryonic democracy or, as it was called, *isonomia* (equality under the law), and the Athenians quickly invented two new heroes to symbolize it. Harmodios and Aristogeiton, the lovers who had killed Hipparkhos in 514, were promoted in story and song as the Tyrannicides. Now, they were not tyrant-killers but brother-of-the-tyrant-killers, and everyone knew it. But better Athenians be given the credit for the overthrow of the Peisistratids than the Spartans.

Oddly, Kleisthenes is not heard of again. But the Spartan king Kleomenes is: in 506 (the year of yet another Greater Panathenaia) he vengefully led an army from the Peloponnesos against Athens and enlisted the Boiotians and Chalkidians as allies. Kleomenes's own forces broke with him, however, and the Athenians easily handled the Boiotians and Chalkidians themselves, defeating both foes on the same day. Free men are better warriors than those oppressed by tyrants, Herodotos notes,[12] and after the turn of the century the Athenians had abundant opportunities to prove him right – not against other Greeks, but against Persians.

The Moschophoros and Company

Sometime probably in the 560s, a man whose name seems to have been Rhonbos, the son of a man whose name seems to have been Palos, hired a sculptor to carve out of a block of grayish marble quarried on Mt. Hymettos a five-and-a-half-foot-tall statue of a powerfully built, enigmatically smiling, bearded man carrying a sacrificial calf over his shoulders – a Moschophoros, or Calf-Bearer [Fig. 71]. The man steps forward with his left leg – below the waist it is the pose of an Archaic *kouros* [cf. Fig. 102] – and he wears only a tight cap and a thin, practically transparent cloak. The nudity is conventional and idealizing; the clinging mantle is a small concession

to reality, a sign that mature men did not normally walk stark naked down the streets of Archaic Athens (they did not leave themselves frontally exposed, either). In any case, it is the intimacy of the relationship between man and beast that strikes us most. The calf tilts its head gently toward the man's, touching his head with its ear, as if it were a willing, trusting victim. Their large eyes are on exactly the same level, as if they were contemplating the same reality or focussing on the same spectator, fixed where their gazes meet. They are formally unified by the X-pattern created over the chest by the man's arms and the calf's legs. The alert expression of the man would have been enhanced by once-inlaid eyes, the brilliance of the entire composition by vivid color (the cloak would undoubtedly have been brightly painted, and the calf itself was originally painted bluish green). This is, quite simply, the finest Athenian marble sculpture of its time, and upon delivery Rhonbos must have proudly dedicated it on the Acropolis, probably in the open somewhere in the eastern area of the summit.[13]

There is still a lot about the statue that we do not know. We are, in fact, not even sure of the first letters of the names of the dedicant and his father: the inscription on the base of the statue is damaged, and "Rhonbos" and "Palos" are just the best guesses. And while the Moschophoros was surely intended to represent or stand for Rhonbos himself – the dedicant would thus bring the calf to the altar forever – just who Rhonbos, son of Palos, was, we do not know. We presume he belonged to the upper echelon of Archaic Athenian society. Perhaps he was one of Solon's new *pentakosiomedimnoi*: he was certainly wealthy enough to afford a life-size marble statue. Whom he hired, we do not know either, though the sculptor's style has often been detected in several other important Athenian sculptures of the middle of the sixth century, both architectural [Pl. III] and free-standing (one of these works is signed by a sculptor who was named, or who immodestly named himself, Phaidimos – "Brilliant"). What prompted the dedication of the Moschophoros, we can only guess. It was probably a thank-offering for Rhonbos's economic status or success (as a farmer or cattleman, perhaps), or for some athletic victory (oxen were awarded as prizes in some competitions), and was possibly a marble memorial of an actual sacrifice. But although the inscription on the base of the statue seems to say "Rhonbos, son of Palos, dedicated [me or it]," it does not say to whom. Athena is usually assumed to have been the recipient, but we think that the goddess would normally have received female ani-

Fig. 71. Moschophoros (Acropolis 624), c. 570–560, h. 1.65m. Photo: author.

mals as sacrifices (heifers are led to the altar on the later Parthenon frieze, for example [Fig. 157]), and this calf is clearly male (its testicles fall over the man's left shoulder).[14] So perhaps the putative sacrifice, and thus this dedication, would have been to Erechtheus, to whom bulls (and rams) were sacrificed,[15] or, more likely, to Zeus Polieus, the object of the ancient *bouphonia*, whose sanctuary was located in the eastern end of the Acropolis, not very far from where the statue was found [Fig. 3, no. 14].[16] But despite all we do not know about the statue, the Moschophoros looms large in the history of art and cult on the Acropolis. For if it was not the first, it

was certainly among the first life-size statues ever dedicated there, and along with a series of other works and buildings it testifies to the monumentalization of the sanctuary in the course of the second quarter of the sixth century.

Between 575 and 550, the Acropolis, which had been for so long the modest sanctuary of a provincial *polis*, became a grandiose spectacle of the first order, the visible expression of a city that was now entering the first rank in Greece, the place where the Athenians increasingly reminded themselves, and formulated through their art and architecture, what it was to be Athenian. The roster of dedications, images, and stelai set up at this time include, in addition to the Moschophoros:

- A bronze palladion – an upright Athena, feet close together, right arm raised to hold or brandish a lost spear, left arm lowered, bearing a missing shield [Fig. 20].[17]
- An inscribed bronze plaque (a rare thing) recording the dedication of a number of bronze objects to Athena by her treasurers, the *tamiai*.[18]
- The fragmentary *dromos* inscription, commemorating the laying out of a new racetrack used for events during the Panathenaia or the establishment of new *agones* (competitions) held in honor of the "grey (or bright)-eyed maiden," by officials with names like Krates, Thrasykles, Aristodikos, and Antenor. It may thus date to 566/5, the year of the founding of the Greater Panathenaia.[19]
- A marble relief, possibly an independent votive, possibly an architectural sculpture, showing four frontal, high-relief horses pulling a (lost) chariot and charioteer (undoubtedly Zeus or a hero) [Fig. 72].[20]
- A fragmentary basin (*perirrhanterion*) of Naxian marble originally supported by six small figures of standing draped women, or *korai* [Fig. 73]. Filled with holy water for purification, the basin would have stood at an entrance to the sanctuary or to a shrine within it.[21]
- Two elegant, freestanding life-size *korai* also of Naxian marble and in the Naxian style. Either itinerant Naxian sculptors could bring their own marble to Athens to carve for local patrons, or Athenians sailed to Naxos to purchase *korai* to dedicate back on the Acropolis.[22]
- Other *korai* of marble apparently quarried on the Cycladic islands.[23]
- One local Attic *kore*, made of Pentelic marble, carved flat and broad, with a pomegranate in one hand and a wreath in the other. The back of the statue is not as

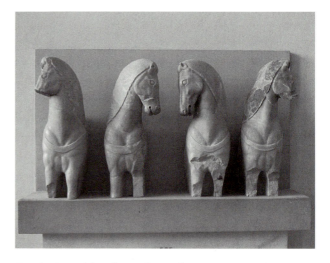

Fig. 72. Frontal four-horse chariot from votive or architectural relief (Acropolis 575–80), c. 570–550. Photo: author.

well finished as the front, which suggests the sculptor knew where it was going before he carved it – against a precinct or temple wall, for example, where the back would not be as easily seen [Fig. 74].[24]

- A marble sphinx, originally set atop a high pillar.[25]
- A tall Doric column supporting a (lost) bronze bowl dedicated jointly by two young members of the Alkmeonidai family to commemorate athletic victories.[26]
- Two reliefs, one with the three Graces (Charites) or nymphs, the other with Hermes holding pan-pipes.[27]
- A small, fragmentary terracotta model of a temple with a tiled roof.[28]

Fig. 73. Marble *perirrhanterion* (Acropolis 592), c. 575–550. Photo: author.

The Peisistratid Acropolis

This impressive list of major sculptures, inscriptions, and ceramics represents the first great concentration of votive activity on the Archaic Acropolis. Although no item (with the possible exception of the *dromos* inscription) can be dated with much precision, every work on it fits somewhere between 575 and 550 (there is very little, and nothing of great artistic significance, that can be securely dated to the first quarter of the century – what we might call the "Solonian era").[30] The picture we can draw of the Acropolis in the 560s and 550s, then, is of a suddenly busy and increasingly rich place, acquiring the accoutrements of a major sanctuary, with Athenians (especially *pentakosiomedimnoi* like, perhaps, Rhonbos son of Palos) beginning to compete with one another for the gods' (and their fellow Athenians') attention through the wealth of their dedications.

Around the same time, the Acropolis witnessed easily its greatest burst of architectural activity since the Mycenaean period. Although there is some modest evidence for a Solonian structure atop the citadel,[31] there was nothing to compare with what happened now. For starters, the west face of the citadel was made over. A straight ramp some eighty meters long and over ten meters wide, probably made of packed earth and clay and supported on the north by a retaining wall of polygonal masonry, was built up the west slope [Figs. 83, 181].[32] It is hard to believe that the Athenians would have built such a monumental approach without at least refurbishing its goal – the old Mycenaean entrance that after 600 years still functioned as the major gateway to the Acropolis – but hard evidence for such a renovation is lacking.[33]

On the other hand, there is good evidence that the old Mycenaean bastion or terrace to the right of the ramp was remodelled at approximately the same time [Fig. 55]. Whatever its function had been in the centuries after the end of the Bronze Age, it was now transformed into the sanctuary of Athena, Goddess of Victory. The crown of the bastion was rebuilt, and a poros-limestone altar set up atop it. The one surviving block from the altar is inscribed (in five short lines) "Altar of Athena Nike. Patro[k]ledes set it up" [Fig. 75].[34] We do not know who this Patrokledes was, nor who was responsible for the new (and possibly marble) cult statue of Athena Nike dedicated nearby: it no longer survives, though we are told it held a pomegranate in one hand and a helmet in the other. Some evidence – in the form of two stone blocks from the statue's base – suggests it was a seated

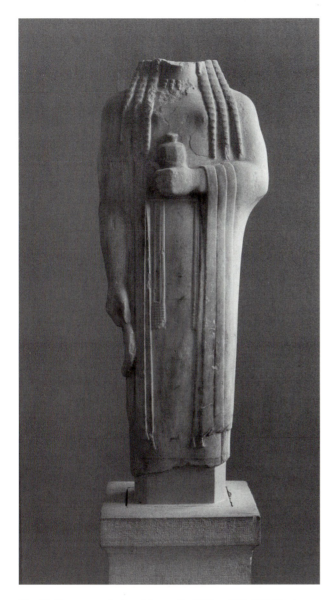

Fig. 74. Pomegranate *kore* (Acropolis 593), c. 560–550. Photo: author.

- And lots of splendid black-figure vases, large and small, with such scenes as: divine marriages; the Departure of Amphiaraos; the Introduction of Herakles to the gods on Mt. Olympos; dancers celebrating Theseus's victory over the Minotaur; heroic if unidentifiable battles; Achilles harnessing his horses; or the gods fighting the giants (the earliest examples of this subject) – vases painted by the leading vase-painters of this generation (Sophilos, the C Painter, Kleitias, the Painter of Acropolis 606, Nearchos, and Lydos [Fig. 31]).[29]

Fig. 75. Block from early 6th-century altar of Athena Nike. After Mark 1993, fig. 4.

or enthroned under-life-sized figure about a meter high. And since Greek cult statues were normally found inside temples, it is likely that the statue of Athena Nike was, too. In fact, there are amidst the wealth of isolated architectural bits and pieces from the sixth-century Acropolis a number of blocks that date to roughly the same time as the monumentalization of the Nike bastion and that could have belonged to a modest house for the statue [cf. Fig. 84].[35]

In any case, the monumentalization of the west slope in the years around 560 left no doubt as to which would be the principal approach to the Acropolis from now on (which is why it was probably here that Peisistratos mustered the Athenians, only to deceive them, in 546). It is also a sign that the center of Athenian civic gravity, long situated to the east of the citadel in the Archaic Agora [Fig. 2], would eventually shift to the flat area below the Acropolis to the northwest: the New or Classical Agora, previously the site of private homesteads and burial plots [Fig. 92]. Whatever and wherever the *dromos* mentioned in the inscription really was,[36] the breadth of the new Acropolis ramp – really the termination of the Panathenaic Way – was clearly meant to accommodate the Panathenaic procession, made even grander after the establishment of the Greater Panathenaia in 566. The conclusion that the construction of the ramp and the revamping of the Nike bastion both

had something to do with the reorganization of the Panathenaic festival is inescapable.[37]

Other festivals seem to have stimulated architectural activity on other Acropolis slopes before or around the middle of the sixth century. Low on the northwest slope, where the Acropolis gradually descends into what would become the Classical Agora, a thick wall of Acropolis limestone was built to define a new precinct sacred to Demeter and Kore (Persephone) – the Eleusinion in the City, as it was officially known [Fig. 2]. This shrine, set beside the Panathenaic Way, formally confirmed the ties that bound Athens to the ancient (indeed, originally Mycenaean) sanctuary at Eleusis, the principal shrine of the goddesses, in western Attica [Fig. 1]; according to the orthodox view, Eleusis was incorporated within the Athenian *polis* by force during the seventh or early sixth century.[38] Before the Great Eleusinian Mysteries began, mounted ephebes brought "the Holy Things" (whatever they were) from Eleusis to Athens in round baskets and deposited them in the Eleusinion (at which point an official climbed the Acropolis to inform the priestess of Athena Polias of their arrival in town). Four days later, a great pilgrimage took the sacred objects back to Eleusis and the Mysteries proceeded.[39]

On the south slope, another connection between city and countryside was made with the establishment of a sanctuary with a great future: the shrine of Dionysos Eleuthereus, the god of Classical Attic drama [Fig. 3, no. 22]. By far the most popular divinity represented on sixth-century Athenian vases – more popular even than Athena herself – Dionysos was worshipped in various places in the city (a shrine called the Lenaion seems to have been established in the Agora in the early fifth century, for example). The sanctuary on the south slope, however, represented the transfer of a rural cult, together with the crude and primitive image of the god, from the site of Eleutherai at the northern boundary of Attica. The statue, which to judge from one source may have been essentially a wooden pillar with a mask attached,[40] was housed in a modest rectangular temple (probably with two columns *in antis*) located south of the later theater. There remain only some foundations and, probably, a badly eroded piece of a small limestone pediment with figures of maenads and satyrs (the usual members of the god's entourage).[41] The stones and the relief seem to date around 550 or a little later.

The really big architectural event, however, took place atop the Acropolis within the old Mycenaean circuit. Somewhere on the summit, sometime in the second quar-

Fig. 76. Doric column capitals from monumental temple of c. 560 (the so-called Hekatompedon, or Bluebeard temple). Photo: author.

ter of the century, the Athenians built the first truly monumental temple to their goddess.[42] By Archaic standards, the new temple was actually not particularly big: a roughly contemporary Temple of Hera on Samos was around six times as large. But it was still the most impressive structure to have been built on the Acropolis in nearly seven hundred years and, depending on where it stood, it either replaced or overshadowed the seventh-century shrine on the north side of the rock (the Temple of Athena Polias). There is enough architecture and architectural sculpture left for us to tell that the temple belonged to the Doric order [Fig. 76]; that it was about forty-one meters long (perhaps a few meters longer) and about twenty meters wide; that it had a continuous colonnade (or *peripteros*) around a rectangular cella; that it was built mostly of limestone; and that it was adorned with brightly painted limestone pediments, Hymettian marble simas (gutters) engraved with lotus-palmette and other patterns, carved metopes, and *akroteria* in the form of sphinxes, palmettes and perhaps even two *korai* [Fig. 77].[43]

How to put all the pieces together is just one of the many controversial things about this building, but one plausible (though by no means certain) reconstruction goes like this. The temple had six columns in its facades and twelve or thirteen along the sides (counting the corner columns twice). The metopes of the temple (at least some of them in marble) had bands of incised and painted leaf-patterns, and some were probably adorned with figures – low-relief marble reclining lions and leopards and possibly a gorgon [Fig. 78] and that deeper

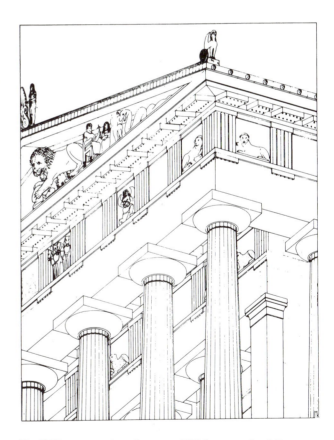

Fig. 77. Reconstruction of corner of "Hekatompedon." Drawing by M. Korres, used by permission.

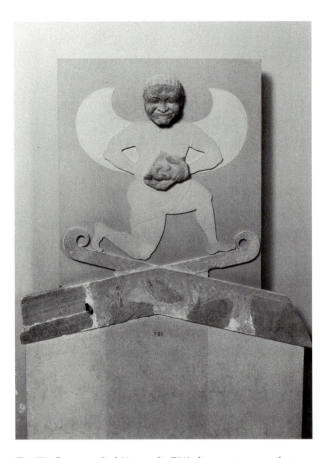

Fig. 78. Gorgon relief (Acropolis 701), from metope or akroterion. Photo: author.

Fig. 79. Sculptures from angles of "Hekatompedon" pediment: Herakles and Sea-god (left) and "Bluebeard." Photo: author.

relief with a frontal four-horse chariot driven by Zeus or a hero [Fig. 72] (the gorgon, though, could have been an *akroterion* rather than a metope and the quadriga could have belonged to an independent votive).[44] The center of one pediment – let us call it the east [Fig. 86a] – was filled with a group of two lions (one male, one female) savaging a bull crumpled beneath them, its blood pouring from its wounds. The ferociousness of the group must have been in some sense "apotropaic," meant to ward off evil from the temple and transfix the spectator, reminding him to tread the Acropolis carefully and reverently, for the divine world is full of raw, elemental forces. The left angle, on the other hand, was filled with a mythological group: Herakles wrestling a fish-tailed creature (Triton or Nereus) [Fig. 79]. In the right angle, there was an even stranger fantasy, also brightly painted in blue, green, red, and white, this time with intertwining snaky tails, wings, three heads, and three bodies with little snakes originally sprouting from them, each part holding a bird, what looks like a wave, and a sheaf of wheat (or flame) in its hands [Plate III]. Who this "Bluebeard" really is, no one knows. Recent suggestions include one that he is Zeus's monstrous foe Typhon; another that he is Herakles's triple-bodied foe Geryon; another that he is a cosmic composite of Okeanos, Pontos, and Aither; and yet another that he is a benign allegory of Attic political union, the personification of the

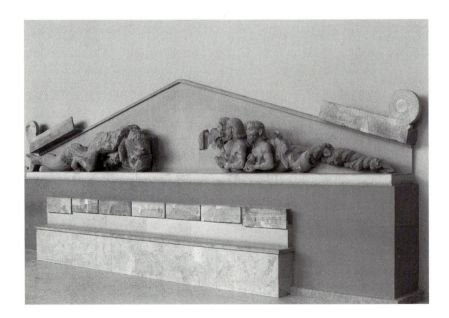

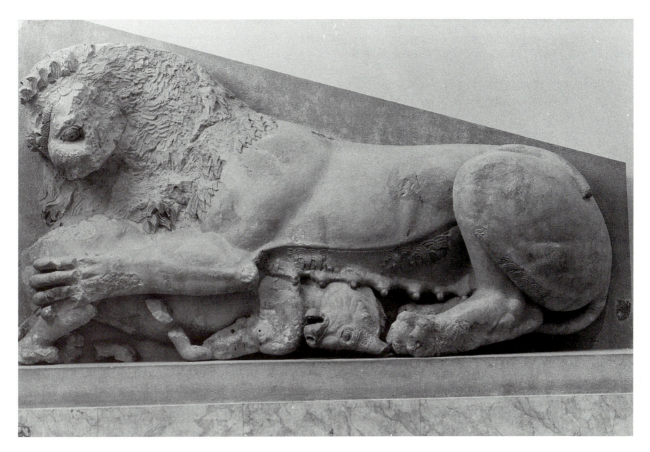

Fig. 80. Pedimental group of lioness savaging bull,
"Hekatompedon" pediment, c. 560. Photo: author.

three parties of the Hill (hence, the bird), the Coast (the watery wave), and the Plain (the wheat) – in other words, Bluebeard is the early sixth-century "body politic."[45] Whoever he is, there is nothing obviously threatening about him – he makes a rather harmless-looking Typhon or Geryon – but his identity would presumably have been clarified by another figure, very poorly preserved, that stood between him and the lions (Zeus? Herakles?). One of the most interesting things to be said about Bluebeard is that his snaky-tails might have recalled the similarly serpentine physique of the earth-born kings of early Attica: one, Kekrops, would later appear in the west pediment of the Classical Parthenon [Fig. 143], and although his legs are fully human there, he had a snake right beside him, a reminiscence of his chthonic origins.[46] The other ("west") pediment of the Archaic temple also had two lions at its center (though only the lioness, on the right, crumpled a bull, terrified and bellowing, beneath her) [Fig. 80], while the angles were filled with, at the very least, two

great sinuous snakes [Fig. 81]. This is another unmistakable reference to Athenian mythology, alluding this time to the sacred snake of the Acropolis rock – the same snake that would later find a place beside the Athena Parthenos, the snake that Pausanias thought was Erichthonios [cf. Fig. 25].

Stylistically, both the architecture and sculpture of the building date to the years around 560. Bluebeard, again, has certain affinities with the Moschophoros [Fig 71] and is often attributed to the same sculptor; though it is impossible to say which work came first, it is possible that the sculptor attracted the attention of the Acropolis administration after first executing Rhonbos's private commission. But what is really controversial is the temple's original location and function, specifically its relationship to the large rectangular foundations just south of the Classical Erechtheion, known as the Dörpfeld foundations after their late-nineteenth-century discoverer [Fig. 82]. These, all agree, are the only visible sixth-century temple foundations preserved on the Acropolis and, all agree once again, they supported a late sixth-century temple sacred to Athena Polias – the

Fig. 81. Snake from angle of "Hekatompedon" pediment. Photo: author.

Fig. 82. Dörpfeld Foundations. Alison Frantz Collection, Courtesy American School of Classical Studies.

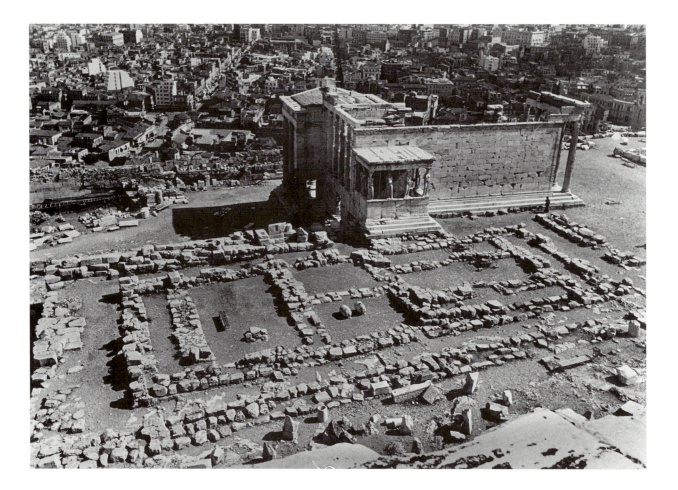

Archaios Neos, the Old Temple of Athena Polias.[47] There is plenty of architecture and sculpture from this temple, too [cf. Fig. 96]. The question is whether these same Dörpfeld foundations, or those foundations in an earlier incarnation, had also supported the *early* sixth-century temple represented by the lions and monsters and snakes and so on – let us call it the "Bluebeard temple" – or whether those sculptures adorned *another* temple site on the south side of the Acropolis, beneath the present Parthenon. The debate hinges not only on the archaeological evidence but also on a couple of lines in one of the Hekatompedon Decrees [Fig. 38], inscribed early in the fifth century to regulate certain kinds of behavior on the Acropolis. The inscription was carved on a marble metope taken from the Bluebeard temple itself (that temple had therefore been dismantled by the time the decree was carved) and it clearly distinguishes the *Neos* (that is, the *Archaios Neos*, the late sixth-century temple then standing on the Dörpfeld foundations) from something or some place known as the Hekatompedon (the "Hundred Footer"), a name that, as we shall see, would later be applied to the main room of the Classical Parthenon (*hekatompedos neos*) on the south site [Fig. 127] and even to the entire building.

All this evidence has been read in two principal ways:

Theory A [Fig. 83a]. The modest seventh-century Temple of Athena Polias (probably the second temple on the site, the one represented by the two old column-bases imbedded within the Dörpfeld foundations, Fig. 82) remained in use on the north side of Acropolis only until the second quarter of the sixth century, when a new, larger temple – the Bluebeard temple – replaced it on (or on the site of) the Dörpfeld foundations. This, then, would have been the third Temple of Athena Polias. It remained the only major temple on the summit and its old olivewood statue (perhaps refurbished by the sculptor Endoios later in the century) remained the only major cult statue of the goddess. The south side of the Acropolis (the site of the later Parthenon) was throughout the sixth century occupied by an open precinct that was in some dimension one hundred feet long (hence, the nickname Hekatompedon), though in this precinct there could have been a number of small buildings or shrines. The Bluebeard temple was dismantled in the last quarter of the sixth century to make room for the fourth Temple of Athena Polias, the *Archaios Neos*, thus freeing up marble slabs, eventually, for the stonecutter of the Hekatompedon Decrees.[48]

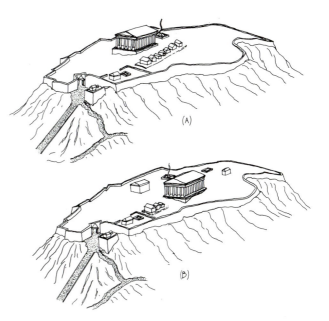

Fig. 83. a. Reconstruction of mid-6th-century Acropolis, with "Bluebeard temple" on north site. After Schneider and Höcker 1990, fig. 62. b. Reconstruction of mid-6th-century Acropolis, with "Bluebeard temple" on south (Parthenon) site. Drawings by I. Gelbrich.

Theory B [Fig. 83b]. The modest seventh-century Temple of Athena Polias remained in use until the last quarter of the sixth century, when it was finally replaced by the *Archaios Neos* on brand-new Dörpfeld foundations (in which case the *Archaios Neos* would have been the third Temple of Athena Polias, not the fourth). In the meantime, in the second quarter of the sixth century, the grand Bluebeard temple was built on the south Acropolis site. It was dedicated not to Athena Polias but to Athena Parthenos – it was, in a famous metaphor, the "grandfather" of the Periklean Parthenon – and it was in some dimension one hundred feet long (so the epithet *hekatompedon* was passed down from one architectural generation to another, even though the dimensions of later structures on the same spot no longer exactly fit the adjective). That is, if the Bluebeard temple stood on the Parthenon site, it was popularly known as the Hekatompedon, and it stood there until the end of the Archaic period, when it was dismantled in favor of another project, its marble metopes thus becoming available to the inscriber of the Hekatompedon Decrees.[49]

There are difficulties whichever scenario one chooses. One problem with Theory A, for example, is that the Dörpfeld foundations were worked with a tool

111

known as the claw chisel, while the architecture and sculpture of the Bluebeard temple were not – a technical discrepancy sufficient, in the minds of many, to disassociate them completely. One problem with Theory B, on the other hand, is that the word *hekatompedon* in the inscription may refer not to a single building at all, but to an area *in which* there were buildings. There are now, in fact, reports that the remains of Archaic buildings have been located beneath the floor of the Classical Parthenon, but it is not yet clear what kind of buildings they were, or how large. As a result, the jury is still out.[50]

There are plenty of other complications. One is the possibility that around the same time that the Bluebeard temple was built, a great new statue of a militant, striding, spear-brandishing Athena – a "Promakhos" reflected on Panathenaic prize-amphoras beginning in the 560s [Fig. 23] – was set up somewhere on the Acropolis, even, perhaps, inside the Bluebeard temple, as its cult statue (which would therefore mean it could not have been the temple of Athena Polias, represented as she was in the olivewood image). But the idea that the Panathenaic Athena could in fact represent a cult statue is now generally dismissed, and there is no certainty that it represents a large new statue at all.[51]

More significant are the complications presented by poros-limestone architecture and fragments of terracotta roofs, on a much smaller scale, belonging to more than half a dozen buildings (given labels like A, Aa, B, C, D, and E) set up on Acropolis from the second quarter of the sixth century until well into the fifth century [Fig. 84]. This is "floating" material: it is next to impossible to tie any of the roofs to any of the limestone architecture, and we are unable to anchor much, if any, of the evidence to definite spots on the ground.[52] There are, as well, a series of small painted-limestone pediments that must have decorated at least some of these small buildings, pediments like one, polychrome and in very low relief, showing Herakles combatting the Hydra, or another, from the right side of a relief pediment, showing Herakles wrestling Triton (thus a small-scale reprise of the myth occupying one corner of the east pediment of the Bluebeard temple, Fig. 79), everything painted dark red.[53]

Two small pediments (both much and probably inaccurately restored) present special problems. One is the so-called "Introduction pediment" [Fig. 85], which has generally been understood to show Athena (her figure is lost) leading Herakles to godhead upon Mt. Olympos, where he is received by Zeus, Hera (seated

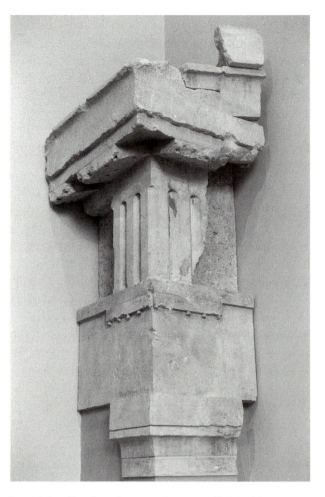

Fig. 84. Small-scale architecture from so-called Building A, c. 550. Photo: author.

frontally), and other divinities. But not everyone sees it that way: according to one (less likely) interpretation, Herakles is shown entering the underworld (the "Zeus" would be Hades, the "Hera" Persephone) to seize the hell-hound Kerberos and so complete one of his labors. Moreover, it has been suggested that the figures of the Introduction pediment (whatever it represented) did not adorn a separate small-scale building at all, but were inserted instead into the west pediment of the Bluebeard temple, on the right, between the great lioness and the snake (whose coiling length, largely restored in any case, would thus have to be dramatically reduced). Other small figures once thought to belong to the left side of the introduction scene (a bearded male wrapped in a long mantle, for example) have also been inserted (on paper) between the snake and lion on the other side of the west pediment, in a group representing the Birth

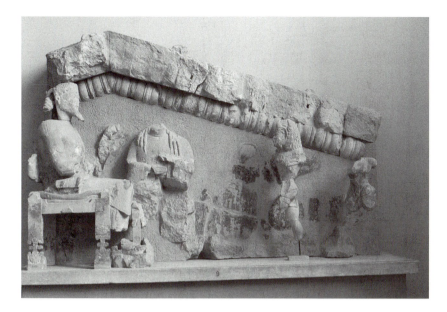

Fig. 85. Introduction Pediment (Acropolis 9), c. 550. Photo: author.

of Athena – a particularly appropriate narrative for an Acropolis pediment, and one that would nicely anticipate the subject of the east pediment of the Periklean Parthenon [Fig. 86b; cf. Fig. 145], especially if the Bluebeard temple stood on the Parthenon site. The snakes, the mythological groups, the lions, and, at the center of recent reconstructions, a gigantic gorgon, would all be at widely different scales, but the mix would not have disturbed an early sixth-century spectator (there are precedents elsewhere). The addition of mythological narratives to a pediment that would otherwise be occupied solely by animals (unlike the other pediment, which had Herakles, Triton-Nereus, and Bluebeard himself) makes some sense, but gnawing technicalities (for example, the depth of the relief of the Introduction pediment does not match that of the lions or snakes) put the theory in doubt.[54]

Finally, there is a much-restored pediment with several freestanding female figures (one appears to have raised her left arm to support something resting on her cushioned head), a male figure (carved in relief) striding in front of a precinct wall enclosing an olive tree incised into the background, and, at center, a large building with a "hipped" roof (that is, with a sloping side where a pediment would otherwise be) at both ends [Fig. 87].[55] Once commonly thought to represent the myth of Achilles's slaying of the Trojan prince Troilos at the fountainhouse (a myth that has no obvious relevance to the Acropolis), the Olive Tree pediment is increasingly recognized as a representation of the Acrop-

olis itself: the olive is Athena's sacred tree, the building is the legendary Temple of Athena mentioned in the *Iliad* (though its form might have imitated a real early Archaic shrine),[56] and the figures (there were more of them originally than there are now) are characters from Athens's mythological past, figures crucial to Acropolis cult on the north side of the rock (say, Pandrosos and the other daughters of Kekrops, and even Erechtheus, who dwelled in Athena's "own rich temple").[57] Or, if the scene is not mythological, then perhaps it is a generalized image of the Panathenaic procession nearing its conclusion at the temple of the goddess – a remarkable idealization of Athenian sacred life whose only real sculptural parallel would appear on the Parthenon over a century later [cf. Fig. 158]. The female figure would in that case be a *hydriaphoros* (a female water-jar carrier of the sort that took part in the historical procession, steadying the vase on her head; cf. Fig. 155),[58] or a *diphrophoros* (the two young women carrying objects on the east frieze of the Parthenon have similar pads on their heads [Fig. 151]), or even one of the *Arrhephoroi*, perhaps even bearing the sacred *peplos* itself.[59]

Some, however, would restore the figure not as a *hydriaphoros* or other processional participant but as a Karyatid, a column in female form, standing in support of the building beside the olive tree – a small-scale predecessor of the Karyatids of the Classical Erechtheion [Fig. 177]. A restoration of this kind is unlikely. But that does not mean that real Karyatids could not have stood on the sixth-century Acropolis. *Korai* may have already

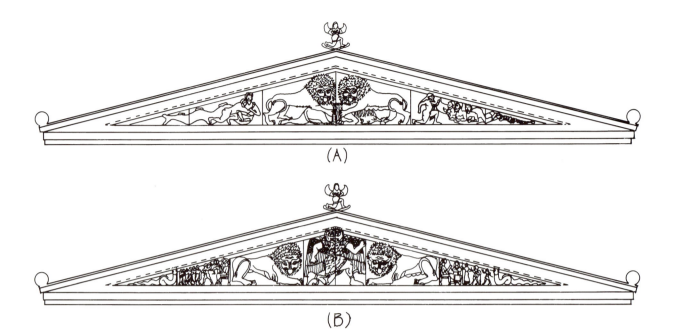

Fig. 86. a. Reconstruction of "east" pediment of Bluebeard
temple according to W.-H. Schuchhardt. b. Reconstruction of
"west" pediment of Bluebeard temple according to I. Beyer.
Drawings by I. Gelbrich, after Beyer 1974, fig. 10.

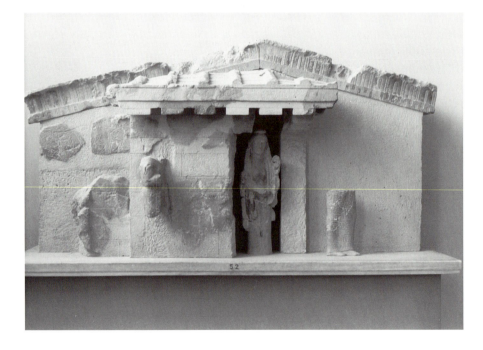

Fig. 87. Olive-Tree Pediment
(Acropolis 52), c. 550. Photo:
author.

played an architectural function on the Acropolis (as *akroteria* on the roof of the Bluebeard temple, for example; cf. Fig. 77). Karyatids are well-known in sixth-century Ionic architecture elsewhere (at Delphi, for instance), and we even have one from the Acropolis itself. Long considered just another in the long line of generic marble maidens offered as votives to Athena, the so-called Lyons *kore* [Fig. 88], carved a decade or so after the Olive Tree pediment, has several distinguishing features (besides her powerful, almost masculine physique) that suggest an architectural role. For example, the upper surface of the cylindrical hat (*polos*) she wears – itself unusual for Acroplis *korai*[60] – is worked to receive another stone block. And her diagonal mantle (*himation*) covers her left shoulder, not the right, as was *de rigueur* for freestanding *korai* [cf. Fig. 100]. The best explanation is that the Lyons *kore* was one of a symmetrical pair of Karyatids, with the other figure – a mirror image – wearing the *himation* over the right shoulder, as was normal.[61] The building in whose facade the matched pair stood could not have been very large, but the existence of actual Karyatids on the sixth-century Acropolis, in addition to the possible representation of them in the Olive Tree pediment, establishes some measure of continuity of architectural conception between the Archaic sanctuary and the Classical. At all events, whether the pediment showed Karyatids or not, it (like the west pediment of the Classical Parthenon [Fig. 143]) probably referred to the actual topography of the contemporary Acropolis – the tree can hardly have been read as anything but Athena's sacred olive – and the Erechtheion's Karyatids must now be considered Classical expressions of an architectural tradition that had already been established there in the Archaic period.

Besides mentioning the *neos* and the *hekatompedon* itself, the Hekatompedon Decrees [Fig. 38] also refer to "the *oikemata* in the *hekatompedon*," which the treasurers of Athena (the *tamiai*) were required to open for public viewing three times a month. *Oikema* means "chamber" or "house" but, most often, the word refers to a freestanding structure rather than a room. Though the topography of the Acropolis had dramatically changed by the time the Hekatompedon Decrees were inscribed in 485/4 – the buildings with the Olive Tree and Hydra pediments and so on might not have been still standing – the odds are still good that *oikema* was the official name for at least some of the small poros structures built on the Acropolis in the second and third quarters of the sixth century. And if these *oikemata* stood in the

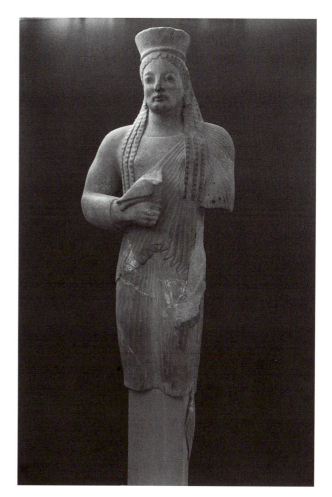

Fig. 88. The Lyons *kore* (Acropolis 269), c. 540. Photo: author.

Hekatompedon, as the inscription says, then the Hekatompedon itself was not a building but a large open-air precinct on the south side of the Acropolis (and that, again, would suggest that the Bluebeard temple stood on, or on the site of, the Dörpfeld foundations, Fig. 83a).[62]

But what, exactly, were the *oikemata*? We can infer from the inscription that they contained the property of Athena, the goddess's – and the city's – accumulated wealth, resources managed by the *tamiai* but periodically opened, by law, for inspection. And so scholars have tended to consider all the small poros buildings from the Archaic Acropolis as "treasuries," storehouses of rich offerings like those built at such panhellenic sanctuaries as Olympia and Delphi by city-states wishing to impress the gods (and other city-states) with the wealth of their dedications. The Acropolis was not, however, a panhellenic sanctuary, and if the *oikemata* were treasuries they

were likely set up by leading Athenian families (the Alkmeonidai, the Philaidai, the Eteoboutadai, and so on) in emulation of Olympic or Delphic practice. If the Acropolis was not a panhellenic sanctuary, a focus of the entire Greek world, Athenians aristocrats could still make it look like one. And yet not all of the small poros buildings on the sixth-century Acropolis were necessarily located in the Hekatompedon, nor did they all necessarily have the same function. Perhaps one or two were small shrines or *naiskoi* (little temples) sacred to Athena or other divinities. Some of the architecture assigned to Building A [Fig. 84], for example, may have belonged to the first Temple of Athena Nike.[63] Perhaps others were ritual dining rooms built by and reserved for Athens's most prominent clans (there are, again, parallels for such rooms elsewhere and in one reconstruction the northwest wing of the Classical Propylaia – which, coincidentally, Pausanias calls an *oikema* – was equipped with dining-couches, Figs. 166, 167).[64] But whatever they were, such small-scale, richly decorated structures were added to the summit with some regularity throughout the Archaic period. Building C and the Olive Tree pediment date around 550 (or only a little later). Building Aa can be dated to the third quarter of the century, and the structure with the Lyons "*kore*" was built (to judge from the style of the statue) around 540. A building (unlettered) with a painted rather than carved pediment (one fragment shows a lioness) seems to date to the third quarter of the century,[65] while an unusual terracotta *akroterion* in the form of a seated goddess decorated a small building that seems to have been built (or refurbished) around 530 or 520.[66] *Oikemata* would be built well into the fifth century, adorning the spaces around or between larger temples.[67] But the earliest date to the second quarter of the sixth century (Building A, for example, and the Red Triton, Hydra, Olive Tree, and Introduction pediments, not that they all belonged together). And that, again, was the period of the Acropolis's transformation into a major sanctuary. It remains to be seen who, or what, was responsible for the transformation.

The works of art and architecture dedicated on the Acropolis between 575 and 550 constitute the leading economic indicator of an emerging Athens. The rise of Athenian prosperity (partly the result of the Solonian reforms taking hold, partly of military successes against neighboring cities) undoubtedly encouraged the reorganization of the Panathenaea as a kind of declaration of Athens's new preeminence.[68] The establishment of the

Greater Panathenaea in turn stimulated the monumentalization and glorification of the Acropolis, the arena in which the culminating events of the festival – the presentation of the *peplos* and the massive sacrifice – took place. In short, the redefinition of Athenian religious and civic life represented by the new festival necessitated the reshaping of sacred and civic space, above all to accommodate the grand procession and provide a suitable architectural backdrop for its climax. The economic, political, religious, architectural, and artistic phenomena are inseparable.

The year 566/5 – the year of the first Greater Panathenaia – thus attracts everything to it like an electromagnet. The *dromos* inscription, the dedication of the first great marble statues (clearly meant to adorn the sacred space) [Fig. 71], the potting of the first Panathenaic prize-amphorae [Fig. 23], the dedications of vases with the earliest representations of the Gigantomachy (the battle that may have been the *aition*, or mythological occasion, for the holiday and that decorated the *peplos* presented to Athena) [Fig. 31], the establishment of the Athena Nike sanctuary, the construction of the west ramp [Fig. 181], even the construction of what may have been the first monumental Altar of Athena, where scores of sacrificial cattle would meet their end[69] – all of this logically clusters around the new festival. And so it is almost impossible not to think of the Bluebeard temple, wherever it stood [Fig. 83], as a new "Panathenaic Temple," either completed in time for the celebration of 566/5, or begun at the time, as the centerpiece of an extensive building program that included the ramp and the Nike sanctuary. And since one source – though, it is true, only one[70] – says that Peisistratos was responsible for the Greater Panathenaia (despite the fact that the wealthy and high living Hippokleides was archon in 566/5), it is tempting to see him at the center of this constellation of cultural and architectural activity, as the shaper of broad public policies that at least temporarily transcended the partisanship of the parties of Plain, Coast, and Hills to elaborate and elevate the setting of everyone's patron goddess, Athena Polias.

But although Peisistratos rose to prominence in the 560s (largely as the result of his successful military expedition against the harbor of nearby Megara), and although he *might* have proposed its construction (as well as the reorganization of the Panathenaia), the Bluebeard temple cannot have been a product of his *tyranny*. He did not even attempt his first *coup d'état* until five years after the first Greater Panathenaia, and the familiar

temptation to attribute automatically any great building to a great man should in this case be resisted.[71] If we date its inauguration or completion correctly to the 560s, the Bluebeard temple, no matter who proposed it, must have been literally a Panathenaic project, one that united the city and required the marshalling of public resources to an unprecedented degree. Similarly, Peisistratos probably did not have time to initiate much of anything in 561/0 and 557/6, the years of his first two (short-lived) tyrannies. Opportunities for grand public works would only have come after his final victory of 546/5, by which time the Bluebeard temple had already been standing for some years.

So it remains to be seen whether there is anything else on the Acropolis or its slopes that can be securely credited to the reign of the father (546–527) or the sons (527–510). Did the Peisistratids leave any physical marks on the rock at all? The answer is: not many that we can see. There is no question that, just as they elaborated the Greater Panathenaia in the course of their rule, adding Homeric recitations and other features, the Peisistratids fostered the City Dionysia, the principal dramatic festival of Athens. Even Thespis and the performance of the first tragedy is traditionally dated betweem 535 and 533, while Peisistratos himself still ruled. But the temple and cult of Dionysos Eleuthereus may already have been established on the south slope before the tyranny, the traditional date for Thespis's first production is unreliable, and the Peisistratids may simply have enhanced developments that had already been set in motion.[72] On the north slope, the open-air sanctuary of Aphrodite and Eros [Fig. 34] was probably in operation by the sixth century, but no dedications are attested there before the mid-fifth, and so any association with the Peisistratids is tenuous at best.[73] There are, perhaps, better grounds for attributing to Peisistratos himself the founding of the Eleusinion in the City low on the northwest slope of the Acropolis [Fig. 2]: the tyranny's association with Eleusis itself seems secure, and the new shrine in Athens seems another attempt to unify the cultic life of city and country, something that both Peisistratos and his sons would have encouraged.[74] If some of the *oikemata* atop the Acropolis were contributions of major Athenian families, it is reasonable to expect that the Peisistratids had a hand in building one, too, perhaps even before 546. In fact, it is tempting to read Peisistratid propaganda in the imagery of many of the painted limestone pediments from the sixth century citadel, both large and small – especially to read the figure of Herakles as Pei-

sistratos's mythological alter-ego. For example, when in the east pediment of the Bluebeard temple the hero wrestles the sea-monster [Fig. 79], it is Peisistratos's amphibious attack against the port-city of Megara that is being alluded to, and when Athena escorts Herakles to Olympos in the Introduction pediment [Fig. 85], it is the charade of 557/6 (when Peisistratos and long tall Phye, dressed as Athena, drove up to the Acropolis) that is the subtext. But, again, the Bluebeard temple seems to date to a time before Peisistratos could have inserted so blatant a reference to his own importance. Moreover, the earliest Attic vases showing the Herakles's apotheosis on Mt. Olympos seem older even than Peisistratos's first coup, so the Introduction Pediment need not have any special link to his second. Finally, no Acropolis temple or *oikema* can be definitively linked to him (or to any one else). As a result, the admittedly seductive notion that whenever we see Herakles in Athenian art of the second and third quarters of the century we are to think "Peisistratos" probably takes the evidence too far.[75]

On the other hand, it is conceivable that Peisistratos had something to do with the erection of a single huge Ionic column (its capital was 2.5m wide) to mark the grave of King Kekrops just north of the *Archaios Neos* and Dörpfeld foundations [cf. Fig. 109] – one autocrat bowing in the direction of a legendary predecessor, perhaps.[76] And the one shrine on the Acropolis that is almost universally attributed to Peisistratos is the sanctuary of Artemis Brauronia, adjacent to the Classical Propylaia on the southeast [Fig. 3, no. 5; Fig. 170]. In its developed form the sanctuary dates to the Classical period. But the cult was clearly transferred to the Acropolis from Artemis's major sanctuary at Brauron in eastern Attica [Fig. 1], and since Brauron was, according to some traditions, Peisistratos's hometown it is usually assumed that the transfer was made during the tyranny – yet another religio-political integration of city and countryside. Still, we are not sure what the Acropolis Brauronion looked like in the sixth century: it may have been no more than a modest enclosure with an altar and light pavilion.[77] And the paltry archaeological evidence that there is – two lean, crouching (or cowering?) marble hounds [Fig. 89] that are rather optimistically thought to have been set up in the precinct of Artemis, goddess of animals and the hunt, around 520, and a single late sixth-century ritual vase of a kind specifically associated with her cult – suggest that the Brauronion was in fact established not by Peisistratos himself but by his sons.[78]

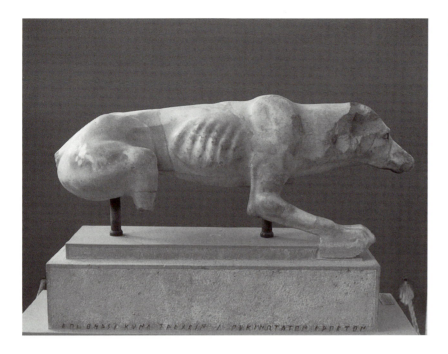

Fig. 89. Hound, possibly from Sanctuary of Artemis (Acropolis 143), c. 520. Photo: author.

Fig. 90. The Rampin Rider (Acropolis 590; head in Louvre), c. 550. Photo: author.

There is, moreover, no trace of any Peisistratid in the record of dedications from the Acropolis, though some have supposed that a pair of marble horsemen dated around 550 or so – the so-called Rampin Rider [Fig. 90] and a far more fragmentary sidekick – are images of Hippias (Horseman) and Hipparkhos (Horse Leader).[79] In fact, it is sometimes claimed that there was a general falling-off of dedicatory activity on the Acropolis during the third quarter of the century (roughly the years of Peisistratos's own reign). Those who think so also tend to think that Peisistratos lived atop the Acropolis in a mansion or palace, protected by the old Mycenaean fortification wall and by bodyguards and mercenaries who had their barracks on the summit nearby – a situation that would have naturally discouraged normal visits and private offerings.[80]

The idea is not unthinkable (the Acropolis, after all, had once been the home of Mycenaean kings and Dark Age "big men").[81] It is just, all things considered, unlikely. There were additions (some of them splendid) to the corpus of Acropolis *oikemata* and dedications in the years of Peisistratos's tyranny: several small buildings represented by parts of different terracotta roofs,[82] for example, or the small building that had the Lyons *kore* as a Karyatid [Fig. 88], or a smiling sphinx (Acropolis 632), originally set atop a high column (540–530), or *korai* such as Acropolis 671, 678, and 679 (the Peplos *kore*) [Fig. 91], all dated around 530. Moreover, virtually

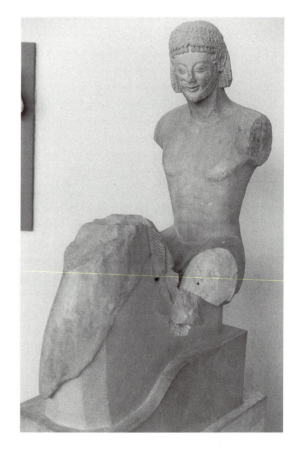

118

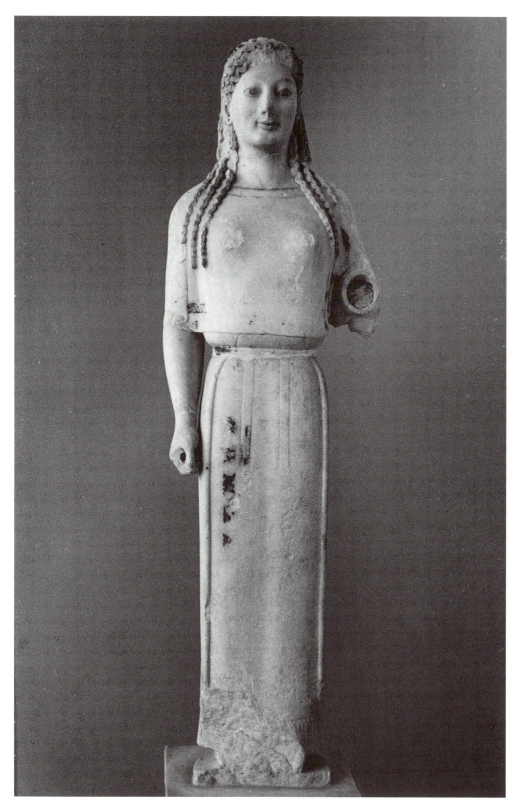

Fig. 91. The Peplos *kore* (Acropolis 679), c. 530. Photo: author.

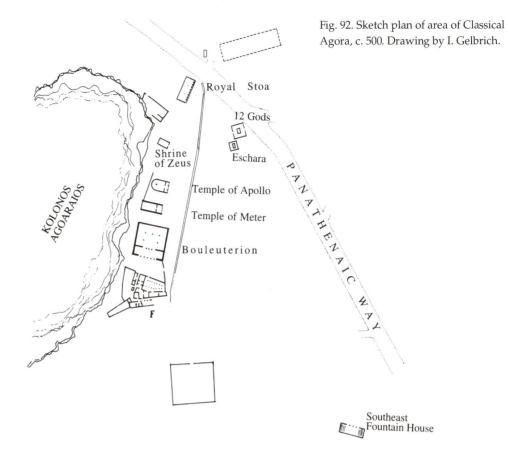

Fig. 92. Sketch plan of area of Classical Agora, c. 500. Drawing by I. Gelbrich.

everything we are told about Peisistratos indicates that he maintained the Solonian "constitution," that (despite his position) he played by the same rules as everyone else, that he acted more like a citizen than a tyrant, and that his benevolent, cautious rule was even considered a step on the road to democracy. The author of the *Constitution of Athens* labels him, in fact, *demotikotatos* – a dedicated champion of the people.[83] This does not sound like someone who needed to withdraw behind the walls of a lofty, garrisoned citadel for his own protection, and had he done so we would surely have heard about it in our sources.[84]

If, in fact, Peisistratos and his sons built themselves a mansion at all, it was probably a large, irregular residential complex at the southwest corner of what would become the Classical Agora: so-called Building F, built after 550 [Fig. 92]. How and when the area northwest of the Acropolis was removed from private tenure and transformed into a new civic space – a civic arena for shrines, processions, athletic competitions, military training, and even theatrical performances – is a matter of debate, and the Archaic Agora east of the Acropolis

[Fig. 2] still functioned as the principal civic center during the tyranny. Still, Peisistratos or his sons sharpened the definition of the roughly triangular area (bounded on the east by the Panathenaic Way) by constructing Building F at one angle, by building a popular fountain-house at the southeast angle (c. 525), and by dedicating in 522/1 the Altar of the Twelve Gods, the spot from which distances in Attica were measured, at the third (north).[85] This area was not yet a true agora: Building F was a private villa, not a public hall, and the open lands adjacent to it may have more of a Peisistratid than an Athenian garden. But under the Peisistratids the nature of the area was changing, and the way was being prepared. It may seem ironic that the center of later democratic Athens was essentially laid out by tyrants, but it is in keeping with Peisistratos's reputation as "a man of the people." The Peisistratids also lavished resources and attention upon the area southeast of the Acropolis [Fig. 2], where, seeking the kind of prestige other Greek tyrants enjoyed, they began a colossal new temple for Olympian Zeus and established a Sanctuary of Apollo Pythios nearby.[86] And so, when Thucydides (6.54.5) says

that the tyrants "beautified their city," it is probably not the Acropolis summit (still the focus of aristocratic display) but the lower city – the areas of the later Classical Agora and the Olympieion – that he had in mind.

The Acropolis, the Democracy, and the Persians, 510–480

This picture of relative Peisistratid inactivity atop the Acropolis itself comes into even sharper focus when the *Archaios Neos* is removed from the list of their public works (where it is most often found) and placed in the column of the active young democracy established by Kleisthenes.

Between 508 and 490, the democracy deliberately and thoroughly put its stamp upon the religious spaces of Athens, using architecture and art to remake the city and shape a new civic identity. Its tactics were diverse. Sometimes it rebuilt structures constructed during the tyranny or especially associated with it. One of the small buildings erected on the Acropolis during Peisistratos's reign, for example, had its roof replaced in the years just before 500.[87] Low on the northwest slope of the Acropolis the Eleusinion was enlarged and given a new temple around 500 or 490: if the shrine had once been considered Peisistratid, it could be no longer.[88] On the south slope, the first simple orchestra and seating of the Theater of Dionysos, just north of the older temple, were probably laid out at the end of the sixth century [Fig. 109] and this, not the Peisistratid years of 535–533, could be the date of the production of the earliest tragedies; here, then, is another revision of a site often linked to the tyrants. The most eloquent expression of the change from tyranny to democracy, however, was the conversion (around 500) of Building F at the southwest angle of the Classical Agora [Fig. 92]: the mansion of the autocratic Peisistratids, with a little remodeling, apparently became the main office and dining hall for the chief officials of the new government, the constitutionally elected nine archons.[89]

Rather than completing the huge Temple of Olympian Zeus begun by self-aggrandizing Peisistratids, however, the democracy made a political point by leaving it conspicuously unfinished: its unworked blocks and column-drums must have quickly seemed like fossils from the bygone age of tyrants, the remains of an architectural dinosaur. The decision not to complete the temple was the architectural equivalent of the democracy's publication, on a bronze stele set up on the

Acropolis, of a list of the names of the Peisistratids and their crimes.[90] But the democracy also built entirely new buildings to accommodate new civic bodies or old institutions given new prominence. Next to Building F, for example, a Bouleuterion (the home of the new Kleisthenic Council of 500) was built [Fig. 92]. And at the northwest angle of the Agora a new stoa (colonnaded hall) for the office of the Archon Basileus, the chief religious official of Athens, was constructed (the Stoa Basileios, or Royal Stoa, it was called).[91] Thus, it was now that the area northwest of the Acropolis, first given shape by the Peisistratids, first became a true Agora, lined by public buildings and defined by boundary stones. And around the same time (c. 500) and not far away, on the limestone hill known as the Pnyx directly west of the Acropolis [Fig. 2], the first meeting place for the Athenian general assembly was also built, an open-air arena where thousands of citizens would decide the affairs of state.

But it was a new temple on the Acropolis – the *Archaios Neos* – that was the clearest and most grandiose proclamation of the new order in Athens, especially if the Bluebeard temple (which had itself declared Athens's improved economic and cultural status earlier in the century) had to be dismantled to accommodate it, and especially if that temple had in any way been associated with Peisistratos.[92] There has never been any doubt that a new Temple of Athena Polias was constructed on the Dörpfeld foundations [Fig. 82] in the last quarter of the sixth century. It is increasingly accepted, however, that it was built at the very end of the century, after the expulsion of Hippias, after the *isonomia* of Kleisthenes had stabilized, and it may be no accident that it was more or less aligned with the Pnyx, as if the assembly-place and the temple formed the secular-sacred axis of the new democracy.[93] It is impossible to say exactly when construction on the temple began, but 506 – a Greater Panathenaic year, and the year of the first great military victory of the young democracy (against the Chalkidians and Boiotians) – would have been a nice choice.

Assuming that the *Archaios Neos* [Fig. 93] succeeded the Bluebeard temple on the north side of the Acropolis, the new temple was in some ways still conceived as an elaboration of the old rather than as a repudiation of it: expressions of continuity in the sphere of the sacred have political value, too. Its dimensions (43.44m × 21.34m) were probably more or less the same as the Bluebeard temple's. The ratio of columns in its peristyle (6 × 12) may have imitated that of its predecessor as well. And the fact that

Fig. 93. Plan of the *Archaios Neos*, last decade of 6th century. After Travlos 1971, fig. 196. Reproduced by per mission of Deutsches Archäologisches Institut Zentrale, Berlin, and E. Wasmuth Verlag.

the temple had only one step, instead of the normal three, suggests its architect was following an older precedent.[94] Like the Bluebeard temple it was Doric and limestone, though it, too, had plenty of marble features and trim – roof tiles, plain metopes, possibly one *akrotē- rion* in the form of a Nike, and simas with ram- and lion- headed waterspouts, one [Fig. 94] apparently carved by the same hand as the marble hound supposedly from the Brauronion [Fig. 89].[95] The plan of the temple within the colonnade was, however, unusual. The cella was divided in two by a solid crosswall creating, in effect, a "double temple" – the first of several built on the Archaic and Classical Acropolis (cf. Figs. 107, 127, and 174] . There was one large square room on the east (this was surely the room of Athena Polias, the home of the olivewood icon), while the western half of the cella con-

Fig. 94. Marble lion's-head waterspout, from *Archaios Neos*. Photo: author.

tained three smaller rooms presumably devoted to other cults (since the cults of Hephaistos, Poseidon-Erechtheus, and the hero Boutes were accommodated in the *Archaios Neos*'s Classical successor, the Erechtheion, it is not hard to imagine them installed here, too).[96]

Around the top of the cella walls, or at least above its porches, there was apparently a continuous sculptured frieze – not a Doric feature, but an Ionic one. The Acropolis has yielded up several fragments of marble reliefs that are about the right size (1.2m high) for such a frieze and whose figures – a charioteer [Fig. 95], a bearded figure wearing a traveler's hat (Hermes?), someone seated on a stool – seem stylistically about the right date as well. There is, it is true, no proof that these slabs adorned the *Archaios Neos*. But certain technical features are identical to those used in the building and it is hard to think where else they could have belonged on the *fin-de-siécle* Acropolis.[97] If they did indeed decorate the *Archaios Neos*, then this temple looked forward as well as back, for the presence of an Ionic frieze on a fundamentally Doric building, as well as the choice of its subject matter (a procession with charioteers, gods, and seated figures), anticipated the Periklean Parthenon [cf. Figs. 150, 156].

The two pediments of the building also present a combination of the conservative and the innovative. They are, for example, Parian marble – the first Acropolis pediments not carved of limestone. But the center of one composition (probably located on the east, over the main entrance) was filled with a very poorly preserved group of two lions savaging a bull, a deliberately old-fashioned and apotropaic subject whose reference to the limestone animal groups of the Bluebeard temple [Fig. 80] could not have been missed. We have no idea how the angles of this pediment were filled, though here, too, one might expect mythological groups, perhaps on a much smaller scale. The other pediment, however, was devoted to a single subject: the battle of the gods and the giants, in which Athena, over life-size and carved fully in the round, and Zeus (possibly placed centrally in a frontal horse-drawn chariot, perhaps with his son Herakles at his side) played the leading roles, with fallen giants at the same scale successfully filling the difficult angles [Figs. 96, 97].[98] The Gigantomachy was, of course, a natural choice: it was this victory that the Panathenaia probably celebrated, that was depicted on many vases dedicated on the summit ever since the 560s [Fig. 31], and that adorned the *peplos* worn by the cult statue of Athena Polias herself inside this very temple. The pedi-

Fig. 95. Relief of Charioteer, possibly from Ionic frieze of the *Archaios Neos*. Photo: author.

ment was thus a monumental marble statement of a theme long popular in the iconography of the Acropolis. But in this great battle, in which the gods defended their young Olympian regime against darker forces, the Athenians might also have seen a mythological prefiguration for, and divine justification of, their own recent victory over the Chalkidians and Boiotians, the first external threat to the new democracy.

In any case, the Athena herself is a remarkable figure [Plate IV]. Striding mightily forward, her (lost) right arm brandishing a spear, she is in a way the reverse of the Panathenaic Athena seen on prize-amphorae [Fig. 23]. But she is more ornate: her helmet, for example, was ringed with the protomes (foreparts) of animals (the coiled snakes are restorations), and there were many bronze attachments. She is also much more dynamic, using her *aigis*, stretched over her left arm, as her shield, bearing down mightily over a fallen foe. This was the democracy's Athena, and if the Gigantomachy filled the west pediment of the *Archaios Neos*, it was this Athena that must have first captured the imagination of anyone just entering the Acropolis and at once have become the grand focus of an iconographic constellation, a point of reference for other smaller-scale images and sequels seen on the summit. There is, for example, a badly shattered relief of c. 500–490 that excerpts and compresses the

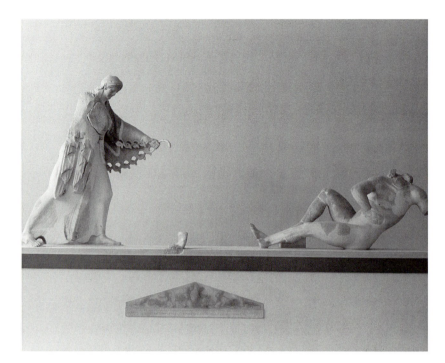

Fig. 96. Athena and Giant, from west pediment of *Archaios Neos* (c. 500). Photo: author.

Fig. 97. Restoration of Gigantomachy Pediment based on M. B. Moore 1995, fig. 7. Drawing by D. Scavera.

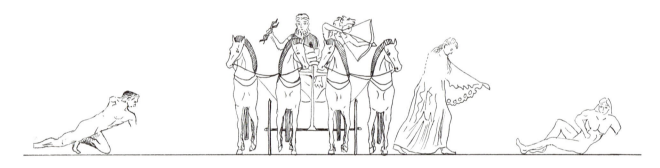

larger composition, and there are fragments of a group showing Athena fighting a giant in much the same pose, perhaps from the pediment of an *oikema* or shrine set up on the Acropolis at the end of the century.[99]

That smaller but still impressive buildings were constructed on the Acropolis in the early years of the democracy seems clear from a series of terracotta antefixes and roof tiles datable to the years around 500, as well as from the remains of so-called Building B, bigger than the average *oikema*, with three columns in its facade and a curving (apsidal) back wall, that probably stood on the spot of the northwest wing of the Classical Propylaia [Fig. 109, no. 110]; pieces of Building B were even built into the foundations of the Propylaia. We do not know what function it served, and its precise date is also unknown, though a date after 510 is likely.[100] It is also likely that a trapezoidal, two-chambered cistern, located

just to the northeast of the later Propylaia (under the remains of the Classical "Northwest Building," Fig. 3, no. 4; Fig. 109) was built at the same time as Building B, perhaps as part of the young democracy's scheme for extensively reworking the west end of the citadel.[101]

It could be, too, that in the years around 500 the young democracy financed at least one more project. At the west entrance of the Acropolis, in front of and aligned with the ancient gateway (still basically Mycenaean) and flush against the old Cyclopean wall [Fig. 54], the Athenians cut a wide forecourt out of bedrock, adding poros-limestone steps, marble benches, and behind them a dado of at least eighteen marble metopes taken from the now-dismantled Bluebeard temple [Fig. 98].[102] The forecourt, in other words, was a kind of theatral area, where Athenians could gather before entering the Acropolis or watch the end of the Panathenaic

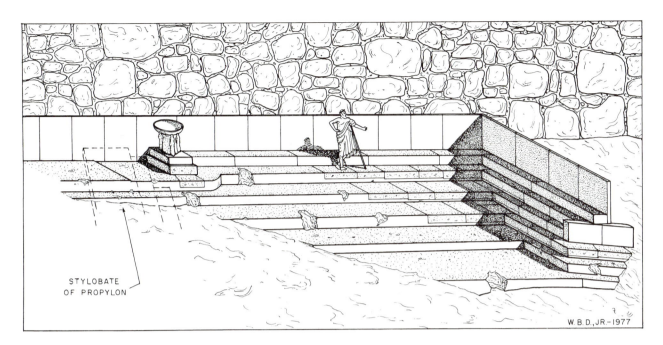

Fig. 98. Reconstruction of entrance forecourt, built c. 500.
Drawing by W. B. Dinsmoor, Jr., used by permission.

procession. But it was also a place for the display of dedications. Built into the north end of the top step is a particularly conspicuous, almost square base. It supported something important and strategically placed: a tripod, perhaps, or an image of Hekate (a goddess of the uncanny whose images were often found at crossroads), but, more likely, a *perirrhanterion*, a basin for holy water, where pilgrims could cleanse themselves before entering the sanctuary.[103]

At all events, the Acropolis in the year 500 would have looked very different from the one Peisistratos seized for good in 546. Even apart from the architectural changes, the votive inventory had boomed. The burst of dedicatory activity on the Acropolis actually began during Hippias's reign, but it continued strong under the democracy. In and around the *Archaios Neos* and all over the Acropolis were statues and votives of all sorts: black- and red-figure vases (sometimes set out in the open, upon stone pedestals); terracotta figurines and painted and relief plaques [Figs. 17, 18]; bronze statuettes, including a series of small bronze warlike Athenas; marble basins; marble reliefs, such as the one showing Athena receiving the sacrifice of a pig from an Athenian family [Fig. 42]; and marble statues of seated goddesses (the best known being the Athena evidently carved around 525 by Endoios, Fig. 99). But the largest contin-

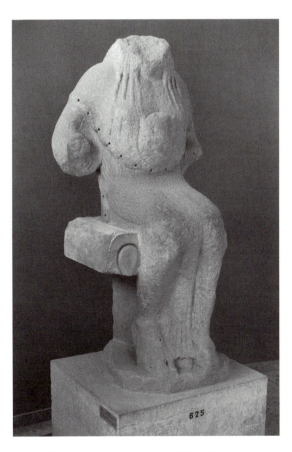

Fig. 99. Seated Athena (Acropolis 625), c. 525, possibly by Endoios. Photo: author.

gent in the marble census of the late Archaic Acropolis consisted of the standing, draped, and usually offering-bearing figures known as *korai*, which first began to appear on the citadel in the 560s and 550s [cf. Fig. 74]. By the end of the Archaic period, some seventy-five of them (or more) occupied the Acropolis [cf. Fig. 100]. Traditionally, *korai* have been considered generic maidens – embodiments of an aristocratic ideal beauty, anonymous girls meant simply to adorn the sanctuary space and so please Athena. Less often, they have been interpreted as images of *Arrhephoroi*, or as priestesses, nymphs, or the daughters of Athens's early kings, or even as the generic expressions of the success and prosperity of members of Athens's thriving business class (as opposed to the aristocracy).[104] But whatever the motive that led to their dedication, it is likely that at least some *korai* were images of goddesses, their identity clinched by now-missing attributes. For example, the Peplos *kore* (a later work by the sculptor of the Rampin Horseman, Fig. 90) has a hole pierced through her right hand [Fig. 91]. It held something (undoubtedly in bronze): if it was an arrow, she is the huntress Artemis; if a spear, she is Athena. So, too, the colossal *kore* carved by Antenor around 520 and dedicated by Nearchos (probably the owner of a successful potter's workshop) almost certainly wore a crested helmet on her head [Fig. 101]; thus she, like some other Acropolis "*korai*" with supporting metal rods (so-called *meniskoi*) sticking out of their heads, represents Athena herself, not unlike the helmeted but otherwise unarmed goddess on the relief with the sacrifice of the pig [Fig. 42].[105]

Though *korai* – generic or specific, large or small, Attic or imported, fine or merely competent – dominated the sculptured population of the Archaic Acropolis, there was no shortage of male figures, either. After all, the Moschophoros [Fig. 71] was probably the first great marble dedication on the Acropolis, and male figures in both bronze and marble continued to be considered appropriate dedications even in this sanctuary of a virgin goddess (though it needs to be stressed that the Acropolis in fact contained shrines and altars to gods such as Zeus Polieus). There is a minor debate whether a true *kouros* – the male counterpart of the *kore*, nude and without attributes or offerings – ever stood on the Acropolis, but if Acropolis 665 [Fig. 102] and, later, Acropolis 692 (Fig. 112) do not conform precisely to the canon, they come pretty close.[106] There are plenty of other males in any case: marble and bronze athletes, for example; a large bronze warrior (only his helmetless,

bearded head survives), which might date to the 490s;[107] a marble draped youth;[108] and several seated scribes, all dating to the end of the century, who might represent officials of Kleisthenes's new order [Fig. 43].[109] The most common male images, however, were horsemen, beginning with the Rampin Rider and his companion [Fig. 90] but, interestingly, continuing well past 510 [Fig. 103].[110] The prestige of the equestrian statue – the aristocratic image *par excellence* – did not diminish after the institution of the democracy.

In fact, there seems to be no great difference between the kinds of offerings made on the Acropolis before the watershed of 510 and those made after. Athena was the same goddess, even if the government of her city had changed, and there were still aristocrats willing and able to dedicate the kinds of images they always had, *isonomia* or no. Nonetheless, three phenomena detectable in the dedications of the democracy's first decade or two deserve special note. First, there is the debut in Acropolis marble sculpture of Theseus, the local hero, who, through both art and literature, is elevated to near-Heraklean stature after 510, and who becomes something of the emblem of the democracy.[111] Theseus had appeared on Athenian vases before, and Peisistratos himself evidently made considerable efforts to enhance his reputation and improve his image.[112] But the earliest extant marble figure of Theseus from the Acropolis, dated around 500, shows him fighting (probably) the brigand Prokrustes [Fig. 104]. Like Theseus's other labors (which became very popular in vase-painting at this time and may have been depicted in other Acropolis sculptures), this was perhaps a projection into myth of the obstacles the new democracy had recently overcome.[113]

Second, there is in the last decade of the century a wave of dedications by nonaristocratic Athenians. Craftsmen and laborers had, to be sure, offered works to Athena Ergane long before the establishment of the democracy. But the bulk of dedications by *banausoi* – "mechanics," workers, artisans who worked with their hands – date after 510. There are, for example, Simon the fuller (who dedicated a *kore* perched on a column around 510–500 as a tithe); Smikros the tanner; Phrygia the baker, who dedicated that miniature shield with gorgoneion around 500 [Fig. 45]; and Smikythe the washerwoman, who dedicated a marble basin around 500 or 490. And there are, above all, offerings by potters and vase-painters. Again, these were not the first potters and painters to make dedications to Athena, and it is not as if

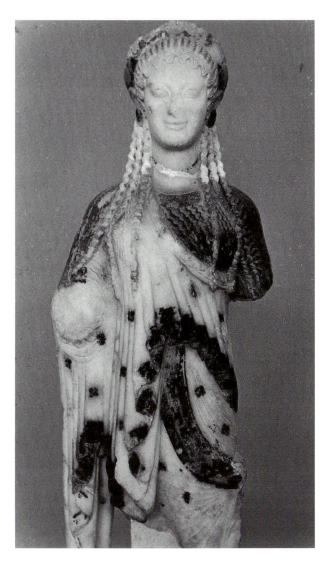

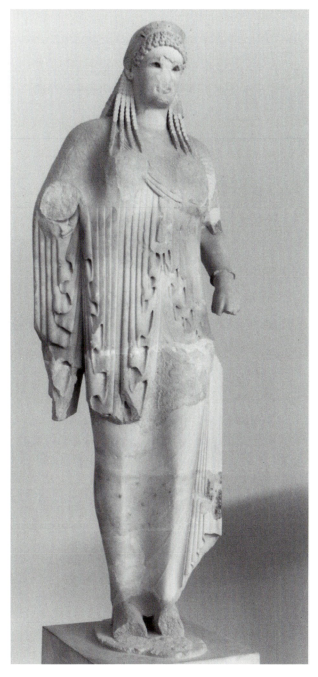

Fig. 100. *Kore* (Acropolis 675), c. 510–500. Photo: author.

Fig. 101. *Kore* (Athena? Acropolis 681), dedicated by Nearchos
and made by Antenor, 520–510. Photo: author.

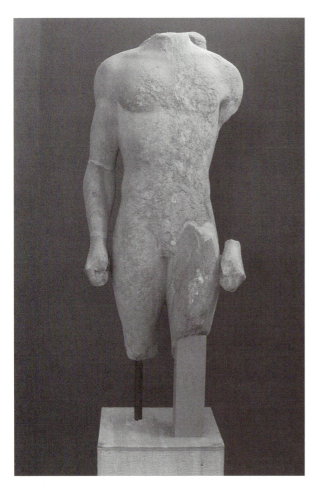

Fig. 102. *Kouros* (Acropolis 665), c. 540. Photo: author.

Bottom left: Fig. 103. Rider (Acropolis 700), c. 500. Photo: author.

Bottom right: Fig. 104. Theseus grappling with villain (Prokrustes?) (Acropolis 145 and 370), c. 500. Photo: author.

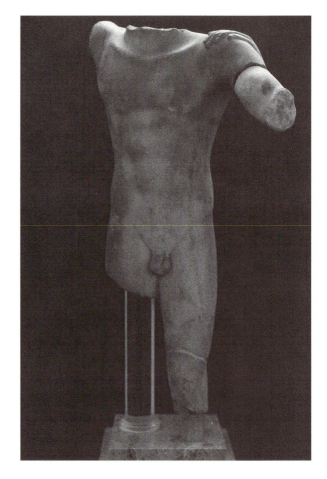

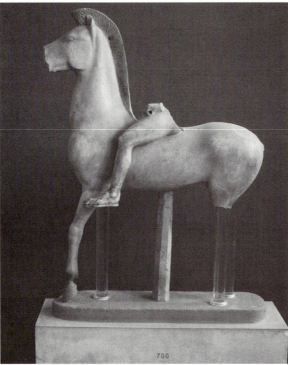

these craftsmen had suddenly become captains of industry. But in the last years of the century their numbers swell: Euphronios, Onesimos, and Brygos, for example, or Pamphaios, who may have dedicated the so-called Potter Relief showing the manufacturer with new cups in hand [Fig. 46], or Euergides, the potter who probably dedicated the red-figure cup showing Athena Ergane seated amidst craftsmen (a vase-painter, a metalworker) [Fig. 14].[114] Dedicants and dedications like these would naturally have been encouraged by the new atmosphere of *isonomia:* the offerings of the working or business class could more easily take their places beside those of the nobility.

Finally, there are the offerings of the democracy itself – the first dedications made not by individual Athenians, but by the Athenian people (the *demos*) as a whole. Around the time the democracy set up its very first decrees on the Acropolis (an inscription imposing military obligations on the Athenian settlers of Salamis,[115] for example, or the lost bronze stele listing the names and crimes of the Peisistratids), the Athenians reportedly set up a bronze lioness in honor of Leaina (She-Lion), the mistress of Aristogeiton who did not betray the conspiracy against Hippias and Hipparkhos and was tortured to death as punishment.[116] The bronze does not survive, and the story sounds apocryphal. But there are no such doubts about the first great Athenian public dedication: a monument set up at the entrance of the Acropolis to commemorate the newborn democracy's stunning victory over the Boiotians and Chalkidians in 506. According to Herodotos (5.77), the Athenians put 700 Boiotian (and an unspecified number of Chalkidian) captives in chains and eventually ransomed the prisoners for two minae (200 *drakhmai*) each. They then displayed the chains on walls "opposite the *megaron* that faces west" and with a tenth of the ransom dedicated a four-horse chariot of bronze, which Herodotos saw "on your left as you first enter the *propylaia*." The historian then accurately quotes the inscription on the chariot's marble base (which happens to survive):

> Having overpowered the Boiotian and Chalkidian
> peoples in the deeds of war, the sons of the
> Athenians
> Quelled their insolence in gloomy iron bonds,
> And from a tenth of their ransom dedicated
> these horses to Pallas.

What exactly Herodotos means by *"propylaia,"* "the *megaron* that faces west," and "the walls opposite it" are

troublesome points we will deal with later. But the bronze chariot he saw was actually an Early Classical replacement for a late Archaic monument [cf. Fig. 24]. The base of the original dedication also survives, though it is Eleusinian limestone instead of marble and the order of the couplets of the inscription are reversed.[117] What necessitated the restoration in the first place was the capture and destruction of the Acropolis by the Persians in 480: the fires the Persians set, Herodotos notes, scorched the walls on which the chains of the Boiotian prisoners were hung, and the original bronze chariot, like so many other dedications, was presumably taken away and melted down. Thus, a monument commemorating the democracy's first great victory was itself destroyed just two decades later in the democracy's first great defeat.

The End of the Archaic Acropolis

In the early years of the fifth century, the young democracy, intoxicated by its success, entered the realm of foreign affairs and quickly got in over its head. Across the Aegean, the kindred Greeks of Ionia (who traced their ancestry back to Ion, Erechtheus's grandson, conceived by Kreousa and Apollo in a cave on the northwest slope of the Acropolis, Fig. 7) had for decades lived under Persian domination and were now hatching plans for a rebellion. Spurned first by the more powerful Spartans, the Ionians turned to Athens for help and got it in the form of twenty manned ships. But an initial, modest allied success was followed by a major Ionian defeat, and the Athenians, realizing now that the Persians were tougher than they thought, sailed back home. A few years later Miletos, the glory of Ionia, was sacked and the uprising quelled. Darius, the Great King of Persia, who may not have even heard of Athens before the end of the sixth century,[118] did not intend to let its interference in his affairs go unpunished. In 492 one expedition failed in a storm. Two years later, the Persians came again, this time guided by the decrepit Hippias, still hoping to be restored to power. Hippias directed the Persians to Marathon, where his father had landed over fifty years before on the way to his third tyranny. But this time, at a shrine of Herakles, the Athenians, led by Kallimachos and Miltiades, and 600 men from Plataia were waiting. On a mid-August day in 490, just a few weeks after celebration of another Greater Panathenaia, the badly outnumbered Athenians charged the Persian lines at a run, broke their ranks, and cut them to pieces, killing 6,400 and losing only 192.

The victory could only have seemed miraculous, divinely inspired. Indeed, Athena, Herakles, and Theseus were seen fighting on the Athenian side that day and the long-distance runner Philippides, dispatched to Sparta before the battle to ask for help (the Spartan answer was unhelpful), reported that on his return trip he was accosted on a Peloponnesian mountainside by Pan, a normally peaceful god who, after chastising the Athenians for ignoring him, still promised to favor them, presumably by striking the Persians with the power of "panic."[119]

The commemoration of Marathon on the Acropolis began almost immediately after the battle. In the cluster of caves on the northwest shoulder of the Acropolis [Fig. 7] the Athenians gratefully established a shrine to Pan (whom they really do appear to have neglected before) and founded annual sacrifices and a torch race in his honor: the walls of the caves have numerous rock-cut niches for votives.[120] It is possible that a bronze group of Theseus and the Marathonian Bull (or, more likely, just the bull) was dedicated by the *deme* of Marathon after the victory (according to legend, the hero captured the bull, previously caught by Herakles but let go, on the Marathon plain, drove it to the Acropolis, and sacrificed it on the altar of Athena, so a statue of the animal would have clearly alluded to the battle in which Theseus had just assisted the Athenians defeat the Persians).[121] And shortly after the battle, the so-called Nike of Kallimachos was dedicated [Fig. 105]. This winged figure, marble with a necklace of bronze and perched atop a tall, inscribed Ionic column, was represented as if descending from heaven to proclaim the news of the victory at Marathon. Lots of words on the base are missing and are variously restored, but one plausible reading of the inscription suggests that the dedication had a more complicated history than that:

> Kallimachos of Aphidna dedicated me to Athena,
> the messenger of the immortals who have their
> homes on Olympos,
> since he was victorious as polemarch in the Athen-
> ian games.
> And at Marathon fighting bravely he won fairest
> fame
> for the men of Athens, and a memorial of his own
> excellence.

The best interpretation is that Kallimachos, the Athenian *polemarch* or chief of staff in 490, had just won a contest at the Panathenaic games before leading his forces to Marathon, where he fell on the beach as one of the 192 Athenian casualties, and that the dedication, vowed before Marathon, was made posthumously in his name to honor both his athletic and military victories. It remains debatable whether the winged figure is, in fact, Nike or Iris, the female messenger of the gods. There is a contemporary bronze *kerykeion* (or herald's staff) from the Acropolis (it is, incidentally, tipped with two heads of Pan) and if the marble figure held it, she is certainly Iris.[122] But whoever she is, Kallimachos's memorial was set into a cutting in a natural rise of bedrock a few meters north of the northeast corner of the Classical Parthenon,[123] and its height and position there would have enhanced the impression that the figure had flown down from the skies.

Not long after the dedication, the Athenians began to provide it with an impressive architectural backdrop. Beginning perhaps in 489/8, when Aristides was archon,[124] the Athenians cleared the irregular south side of the Acropolis of the temple or *oikemata* that stood there [cf. Fig. 83] and levelled it with a massive podium, in places eleven meters deep, consisting of about 8,000 two-ton blocks of Peiraieus limestone [Fig. 106]. This is the foundation for the first great building that we know beyond doubt occupied this side of the summit, and the first one to be built completely of marble.[125] This was the Older Parthenon, a temple that can itself be considered an expression of the Athenian self-confidence engendered by Marathon [Fig. 107].

In the decade after Marathon, then, the democracy essentially revised and expanded the building program initiated by the construction of the *Archaios Neos* (and Building B, the cistern, and the stepped entrance court) less than two decades before [Fig. 109]. The individual projects, whether very late sixth-century or early fifth, should be seen as parts of an elaborate and continuously evolving plan to remake the Acropolis. Soon after Marathon, for example, the Athenians also decided to replace the old Mycenaean gateway with a new one, razing some of the Cyclopean defenses in the process. The construction of this Older Propylon (so-called to distinguish it from the Classical Propylaia built by Mnesikles) truncated the northern part of the entrance court, which now ended at the square "tripod base" [Fig. 98]. Mostly marble, Doric, and nearly 20 meters wide and 16.5 meters deep, the Older Propylon had four columns in its east and west facades, six columns flanking the route through the interior, and an interior cross wall pierced by five doorways (the central one a little wider

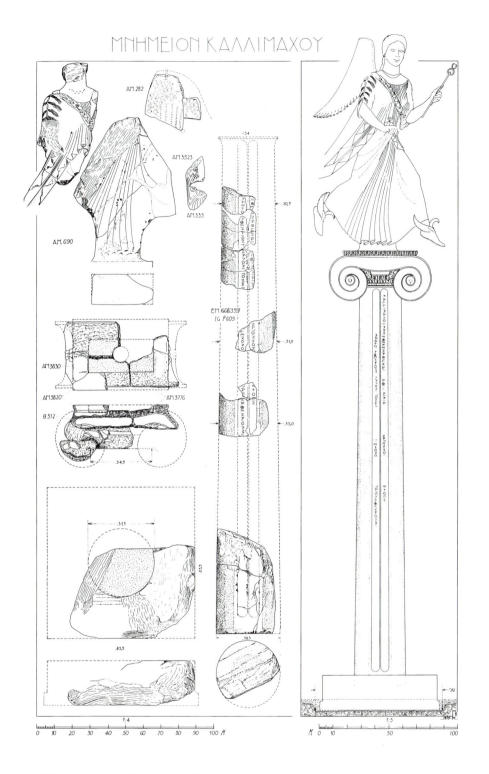

Fig. 105. Monument of Kallimachos. Reconstruction by M.
Korres, used by permission.

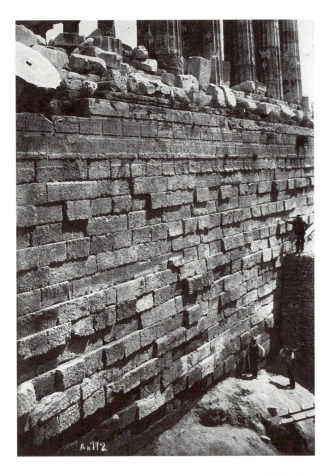

Fig. 106. Foundations of Periklean Parthenon, originally built for Older Parthenon, 489–480. Courtesy DAI-Athens (Neg. Akr. 112).

Fig. 107. Plan, Older Parthenon, 489–480. Drawing by M. Korres, used by permission.

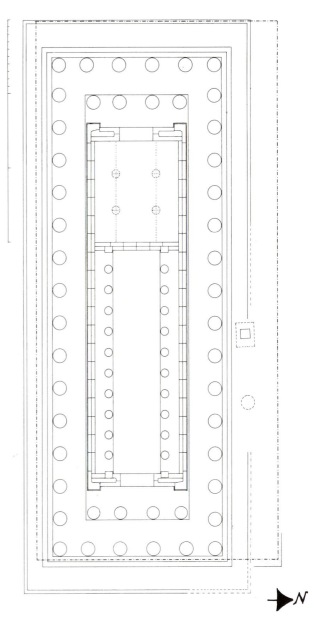

than the others) [Fig. 108]. Significantly, the axis of the Propylon, running southwest to northeast, would have directed the visitor not toward the new marble temple under construction on the south side of the summit but toward the north side and the *Archaios Neos* – an indication, perhaps, not only that it was still the holier building but also that it was a project of the democracy [Fig. 109]. In any case, there seems to have been a short pause in construction, and even though work soon resumed, the Older Propylon was never finished.[126]

Neither was the Older Parthenon. There are hundreds of pieces left from this rich new structure (including a piece of a single half-finished column capital that

was judged unsuitable and abandoned because of a crack) [Fig. 110].[127] They are built into the fabric of later walls, or lie about the summit of the Acropolis, or are embedded within its successor, the Classical Parthenon. And there is enough left to indicate it would have had six columns in its facades and sixteen along its flanks, and a cella divided (like that of the earlier *Archaios Neos* and the later Periklean Parthenon) into two separate but unequal rooms: an almost square one on the west, and another, about 100 feet long – a successor *hekatompedon* – on the east [Fig. 107]. This Doric structure would also have had at least one major Ionic feature (a large moulding at the base of its cella walls),[128] and in this

132

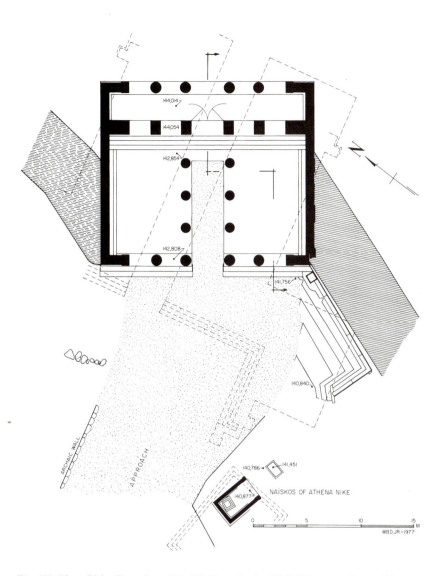

Fig. 108. Plan, Older Propylon, 489–480. Drawing by W. B. Dinsmoor, Jr., used by permission.

combination of orders it also anticipates its even greater successor, the Parthenon of Perikles.

The Older Parthenon was almost certainly conceived as a monumental expression of thanks to Athena for the exhilarating victory over the Persians – the position of the "Nike/Iris" of Kallimachos near its northeast corner reinforced the point – and monumental it was. At 26.19 meters wide and 69.81 long, it was at the time the largest temple ever begun on the Greek mainland (with the exception of the aborted Peisistratid Olympieion). It was only a few meters wider than the *Archaios Neos* but it was half again as long, and it was to be built entirely of Pentelic marble besides. Though its west facade stood

just behind the line of the west facade of the limestone *Archaios Neos* [Fig. 107], as if it were reluctant to impinge upon the more sacred status of the temple in which the icon of Athena Polias was kept, and though we do not know what sorts of architectural sculptures were planned for it (though one might reasonably expect pediments depicting episodes from Athena's mythological career) or what sort of statue would have stood within it, it would have been clear to anyone entering the Acropolis from the Old Propylon which of the two buildings was in fact grander. But the Older Parthenon is a temple of "would have beens." For in 480, while it was under construction – an enormous wooden scaffolding

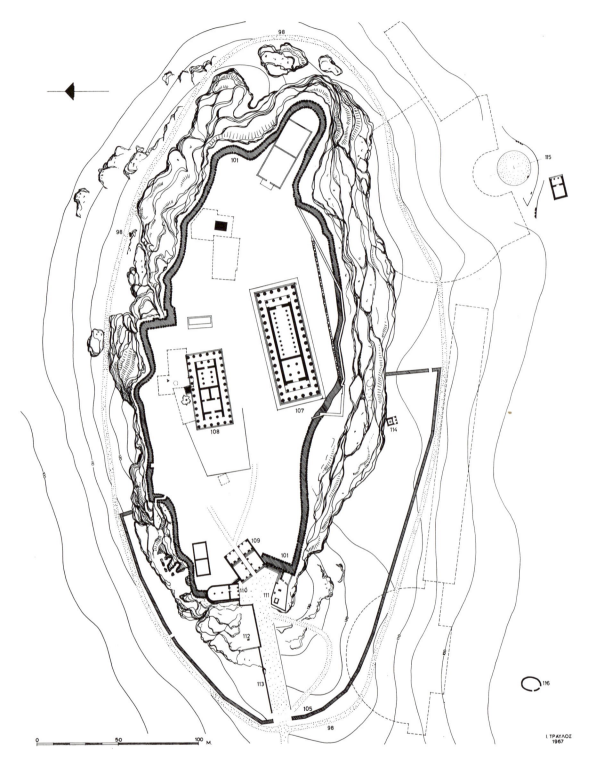

Fig. 109. Plan of the Acropolis in 480. After Travlos 1971, fig. 71.
Reproduced by permission of Deutsches Archäologisches
Institut Zentrale, Berlin.

107 Older Parthenon

108 *Archaios Neos* (Dörpfeld Foundations)

109 Older Propylon

110 Building B

111 Nike bastion

113 West ramp

114 Spring house

115 Temple and early Theater of Dionysos

Fig. 110. Unfinished column-capital from Older Parthenon. Photo: author.

had been erected but only the lower blocks of the cella walls and the two or three lowest (and still unfluted) drums of its columns had been set in place [Fig. 111] – the Persians returned with a vengeance.[129]

Xerxes himself, son of Darius and the new Great King, led them. For several years he had planned the campaign, cutting canals, building bridges, and gathering a huge army and fleet for a coordinated invasion around the northern rim of the Aegean, and this time the target was not just Athens, but Greece itself. The Greeks, united for once, decided to make a stand at Thermopylai, the pass to central Greece, while their navy attempted to hold off the Persian armada at Cape Artemiseion at the northern tip of Euboia. The Greeks held their own at sea, but Thermopylai, despite the heroism of 300 Spartans, fell by treachery, and the allied navy was forced to withdraw. The defense of Attica was futile, the destruction of Athens assured. The population of Athens, led now by Themistokles, was evacuated to

Aigina, Salamis, and Troizen. Even the sacred snake of the Acropolis, the priestess of Athena Polias reported, slithered off the rock – a depressing omen. It is inconceivable that the Athenians would have left the sacrosanct olivewood statue of Athena Polias behind (and there is even a tale that the statue's gold gorgoneion was lost during its transportation to the sea).[130] But it is unclear how much of the goddess's treasury – the wealth of the *polis* – they were able to remove.

In fact, a small contingent of Athenians – priests, *tamiai*, and old patriots, the stubborn and the pious – remained to defend the Acropolis against overwhelming odds, believing, perhaps, that when an oracle hastily issued at Delphi had said "a wooden wall" would prove safe for the Athenians, it meant a stockade and not the wooden ships of the Athenian fleet. They were wrong. They refused to negotiate with unnamed Peisistratid refugees still in the Great King's company, but the timbers they used to plug the gaps in the unfinished Older Propylon and the adjoining Cyclopean walls (the wood was probably cannibalized from the scaffolding of the Older Parthenon) went up in smoke, ignited by flaming arrows shot by archers on the Areopagos. The defenders rolled "round stones" down the west slope when Persians soldiers tried to ascend, and still the Acropolis held. But the Athenians made the crucial mistake of concentrating their defense on the west and (it

Fig. 111. The state of the Older Parthenon in 480, before Persian sack. Drawing by M. Korres, used by permission.

135

now appears) north, believing that the other sides of the Acropolis were too sheer and rugged for anyone to climb.[131] In a famous passage, Herodotos (8.53) describes how the siege finally ended:

> Toward the front of the Acropolis, opposite the gates and the ascent, where no guard was stationed and where no one expected that any man could climb up, there beside the Sanctuary of Aglauros, the daughter of Kekrops, some Persians made their way up, though the place was steep. When the Athenians saw them upon the Acropolis, some hurled themselves down from the wall and were killed, but others took refuge within the *megaron*. The Persians who had ascended the rock then ran to the gates [or doors] and opening them murdered the suppliants. When all lay dead, they pillaged the temple and set all of the Acropolis on fire.

Since the Sanctuary of Aglauros has now been found below the huge grotto on the east side of the rock [Fig. 8], this was the side the small band of Persians managed to scale. It is at first surprising that Herodotos would call this end of the Acropolis "the front," when the major entrance had always been on the west. But "the front" of the typical Greek temple was its east facade (the cult statue thus faced east, too). And since the earliest public buildings of Athens were located east of the Acropolis, Herodotos' choice of words seems less odd: the "front" of the Acropolis would be the side that faced Athens' oldest civic center – the Archaic Agora [Fig. 2].[132] At all events, the *Archaios Neos* was largely demolished, its contents seized or burned, its columns pulled down – one can easily imagine the sculptures from the Gigantomachy pediment [Fig. 96] crashing to the ground and piles of Athena's sacred *peploi*, accumulated over many years of Panathenaiai, being tossed onto a bonfire. The Great Altar of Athena to the east must also have been torn down. What had been built of the Older Propylon was destroyed. Burning scaffolding scorched the podium, column drums, and wall blocks of the Older Parthenon: the tremendous heat fractured virtually every stone that had been set in place.[133] The sanctuary of Athena Nike was razed: the altar set up by Patrokledes [Fig. 75] and the base of the statue of the goddess were damaged beyond repair, and the top of

the bastion itself was levelled.[134] The late Archaic cistern at the northwest corner of the citadel was demolished so that future Athenian defenders would be deprived of drinking water.[135] A "mystery building" adorned with at least one high-relief metope with an Amazon on horseback – one of the first Athenian sculptured metopes and certainly the earliest Athenian sculptured Amazon – may also have been a victim of the sack, its sculptures thrown down the south slope.[136] So, too, very few dedications escaped the fury of the Persians:[137] vases and terracottas were smashed, reliefs were pushed over and shattered, bronzes (such as the chariot of the Boiotian-Chalkidian dedication) were pried off their bases and carried off to be melted down, and marble statues were mutilated and pulled down from the pedestals on which they stood. The Antenor *kore* [Fig. 101], for example, was pulled from her column and broke in two, and the Monument of Kallimachos [Fig. 105], symbol of the Persian defeat at Marathon, must have been savaged with particular glee.

There is simply no telling how many medium- and large-scale marble and bronze statues there were in all on the Acropolis when the Persians came – hundreds, probably. Since the very first ones were dedicated in the second quarter of the sixth century – these presumably still stood where they had been set, or perhaps had been shifted to new locations as major construction projects necessitated – several new generations of sculptures had grown up around the temples and buildings on the summit. Even in the few years just before the sack, the marble population of the Acropolis had continued to expand impressively with the dedication of such works as the thickset *kore* offered by one Euthydikos, son of Thaliarchos (one of the very last examples of her genre, she seems more somber now) [Fig. 19], or the statue of a young athlete crowning himself in victory (Acropolis 302), or the statue of a standing youth (Acropolis 692, a near-*kouros*) [Fig. 112].[138] But only eight or nine decades separated the earliest monumental votives [cf. Fig. 71] from the latest and, despite changes in style, and despite the fact that the surfaces of some were fresh and brightly painted while others were by now dull and faded, they co-existed easily. The history of Archaic Athenian art was essentially compressed into this one place, and it was this accumulated achievement that in just a few hours' time fell victim to the Persian massacre of images.

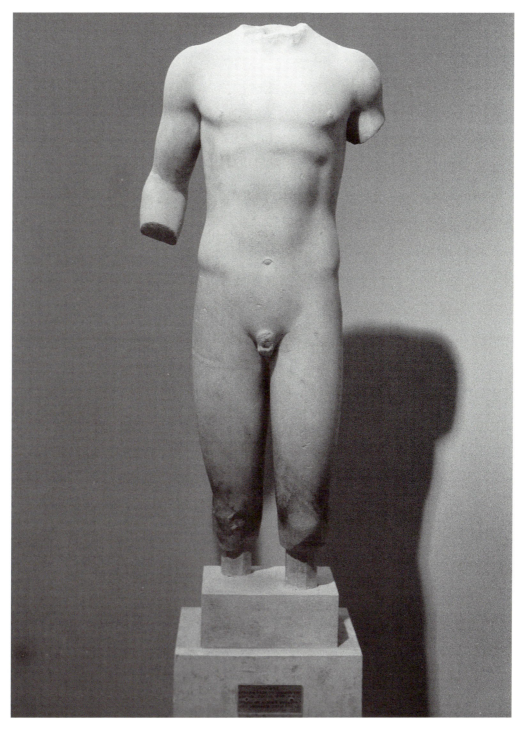

Fig. 112. Youth (Acropolis 692), c. 490. Photo: author.

THE EARLY CLASSICAL ACROPOLIS, 479–450

> . . . and having defeated the barbarians in war, I will not raze any of the cities that fought against them, and I will rebuild none of the temples that have been burned and cast down, but I will leave them as a monument to men hereafter, a memorial of the impiety of the barbarians.
> From the "Oath of Plataia" (Diodoros 11.29.3)

The Historical Background

Everything turned out all right. The devastation of the Acropolis in 480 was in short order followed by a stunning Greek naval victory (engineered by Themistokles) in the straits of Salamis. Xerxes, who sat upon a portable throne (or silver-footed stool) and watched, thought it prudent to head home, taking with him what was left of his fleet and spoils seized from the Acropolis and Agora.[1] Mardonios, commander of the Persian army, decided to withdraw to Thessaly for the winter. It is not clear how many Athenians made their way back to Attica during the military off-season, but the lull came to an end in 479 when Mardonios once again descended upon a defenseless Athens and burned or tore down what had been left standing the first time.[2] Soon after that, however, an allied Greek army led by the Spartans routed the Persians at Plataia, killing them by the thousands and driving them from the Greek mainland once and for all (only fifty-two Athenians were lost). In the course of the battle the Athenians stripped the golden cuirass from the body of Masistios, the Persian cavalry commander, and allegedly took the sword or dagger of the dead Mardonios from his own hand. Both were put on display in the votive collections of the Acropolis, where they were still to be seen six centuries later.[3]

After Plataia, Athens and Sparta were clearly the preeminent powers in Greece and the leaders of an ongoing campaign to rid the entire Aegean of Persians. But troubles with its own two kings (one, Pausanias, was a loose cannon), the unrest of its own subject population (the Helots), a devastating earthquake in 464, and an inherent reluctance to take to the sea, all convinced the Spartans to withdraw from the conduct of the war, and they left matters in the hands of the Athenians. This presumably pleased Themistokles, who presciently considered the Spartans a greater threat than the Persians and who had in 479 managed to stall them long enough for the Athenians, hurriedly and against Spartan wishes, to rebuild their city walls from all available materials, including marble sculptures destroyed by the Persians.[4]

It would have been easy for the Athenians themselves to turn inward or isolationist in 479. Their city and Acropolis, after all, were in ruins, with only a few houses used by the Persian occupiers left intact: they had enough to attend to at home. Instead, they crafted a brilliant foreign policy with stunning speed, energy, and imagination. Knowing that they still had more to fear from the Persians than other Greeks did, the Athenians decided that the best defense was a good offense and in 478/7 Athens, under the leadership of the highly respected Aristides (a general at Marathon, archon in

489/8, and commander of Athenian forces at Plataia), became the principal partner in a new alliance of Greeks from the islands and the Aegean Rim. Created to carry on the war against the Persians, the league conducted its business on the central and sacred island of Delos, and ostensibly each member state had an equal say in the shaping of policy. But Aristides determined what each state should contribute to the league treasury (he became famous for the fairness of his assessment) and the management of the revenues was from the start placed in the hands of new *Athenian* bureaucrats, the *Hellenotamiai* (the Treasurers of the Greeks).[5] Athens also supplied the Delian League's military leaders, and by far the most important was Kimon, son of Miltiades (the hero of Marathon), a political conservative noted for his aristocratic bearing, his long, thick, curly hair, his Spartan sympathies (he named one of his sons Lakedaimonios), and his *noblesse oblige*. Acting in the name of the league he defeated a Persian garrison at Eion (an outpost in Thrace) in 476 and shortly thereafter took the central Aegean island of Skyros from pirates (there he supposedly found the bones of Theseus and returned them to Athens, to great acclaim). The league compelled one city (Karystos on Euboia) to join and forcibly prevented another (Naxos) from seceding, though it is unclear what Kimon had to do with that. And then around 466, after steadily advancing against the Persians in Caria and Lycia, Kimon met them at the mouth of the Eurymedon River on the south coast of Asia Minor. Victory was total and richly profitable: the enemy fleet was completely destroyed and the Persian camp yielded vast spoils. It could be that the defeat finally convinced Xerxes, near the end of his life, to make peace with Athens, and that a treaty was formally negotiated in 465 by Kallias, Kimon's brother-in-law.[6] But Kimon's domestic agenda began to face increasingly stiff opposition at home, and his downfall came swiftly. Around 462 he convinced the Athenian assembly to send him and an army to help the Spartans put down a revolt of Helots, but when they got there the Spartans (fearing that the Athenians, who had freed so many from the Persian yoke, might favor the oppressed) sent them home again. This was regarded as a national humiliation and Kimon paid the price: in 461 he was ostracized (that is, exiled for ten years by a majority vote of at least 6,000 citizens who inscribed his and the names of other likely candidates on potsherds, or *ostraka*).

Kimon's absence did not stop the Delian League from expanding its membership and pursuing its goals. If a "Peace of Kallias" had indeed been negotiated in 465,

it was more of an uneasy armed truce, and hostilities soon broke out once more. In the early 450s Athens and the league launched a major campaign to help Egypt secure its independence from Persia and met with some initial successes. But in the summer of 454, large land and naval forces suffered a devastating defeat in the Nile Delta: the fleet was lost, and thousands of men perished or were captured. A few years later, Kimon, who had been recalled early from exile, led one last campaign, to Cyprus. The expedition was successful but Kimon died in the effort (c. 450), and the Delian League's campaign against the Persians came to an end.

In effect, though, the Delian League itself had already ceased to exist. In 454, apparently after the disaster in Egypt, the league treasury – some 5,000 talents' worth[7] – was removed to Athens (presumably to the Acropolis itself, though no source explicitly says so) ostensibly for safekeeping. At that point what originally (if only theoretically) had been conceived as a voluntary alliance of autonomous states became for all intents and purposes an Athenian Empire – in a sense, a grand protection racket. In 454/3 a huge marble block set up on the Acropolis was inscribed with the first list of the tribute the "allies" annually brought to Athens for the cost of their own defense [Fig. 113]. What was listed for this and succeeding years was actually the percentage (one-sixtieth) of each payment that was reserved for Athena herself, as *aparkhai* (first-fruits): for example, the first tribute list records 600 *drakhmai* from the Samothracians, so Samothrace was assessed 36,000 *drakhmai* (or six talents) in all. Reassessments were typically made quadrennially in the years of Greater Panathenaiai, and more inscribed stelai were set up as needed to publish the accounts [cf. Fig. 197]. Other mid-fifth-century decrees stipulated that Athenian coinage, weights, and measures were to be adopted throughout the alliance. Still others commanded, under pain of prosecution, that each allied state (as well as Athenian colonies) supply a sacrificial cow and a bronze panoply for the Greater Panathenaia (as well as a *phallos* for the City or Great Dionysia) and send representatives to march in the procession.[8] And at the Great Dionysia, when the theater was full of Athenians and non-Athenians alike, the tribute of the imperial cities was brought into the orchestra as a demonstration of the city's wealth and power. After 454, in other words, the Greater Panathenaia and Great Dionysia were imperial as well as civic/sacred displays.[9]

The famous irony is that imperialist Athens was increasingly democratic at home. The popular leader

Themistokles had been ostracized around 471 but in the 460s the democratic party, led now by Ephialtes and his younger associate Perikles, was ascendant, undermining the opposition whenever possible and taking special aim at Kimon, the darling of the conservatives. Ephialtes (who accepted the Themistoklean view that there was more to fear from Sparta than from Persia) had unsuccessfully opposed Kimon's efforts to go to the aid of the Spartans in 462, but took advantage of his absence (or subsequent ignominy) to restrict severely the prerogatives of the principal conservative institution in Athens – the Council of the Areopagos, which had traditionally enjoyed an undefined but powerful oversight of the laws. In 462/1 Ephialtes passed reforms that stripped the Areopagos of most of its influence and transferred many of its functions to the popular assembly and Council of 500: from now on the Areopagos was principally a homicide court. Ironically, it soon had Ephialtes's own case on its docket: he was assassinated, apparently by an extremist unhappy with his reforms. The leadership of the democrats thus fell to Perikles, whose principal constitutional accomplishments in these years were his institution of pay for jury duty (thus even the poorest Athenian could serve) and the opening up of the archonship (the highest Athenian office) to all but the lowest economic class. Although Perikles also passed a law (in 451/0) defining Athenian citizenship more narrowly, the roots of Athenian democracy grew deeper, and its health seems reflected in a new flowering of state documents – governmental paperwork in marble. Public inscriptions on stone were uncommon before 460; there was a flood of them afterward. Many were set up on the Acropolis [cf. Fig. 113], where they would in theory be accessible to all, testifying to the democracy's obligation to document and justify its actions and open its "books" before the people (and the gods). Many inscriptions, in fact, include a formulaic line stating that they were set up "so that all (who wish to) may know." The liberal democracy of Aristides and Perikles virtually required or encouraged an unprecedented freedom of information, and even for those Athenians who could not read – and that may have been the majority of them – the inscriptions on the Acropolis still served as public signs or markers of actions democratically taken.[10]

Finally, these years of radical change at home and abroad witnessed an Athenian cultural efflorescence as well. Though tragedies had been written and victories awarded at the Great Dionysia for two or three decades at least, this is the first great era of Attic drama. Aeschy-

Fig. 113. Portion of first Athenian Tribute List, 454/3 (*IG* I³ 259 and EM 13444). Courtesy Epigraphical Museum, Athens.

lus, who as a youth had seen the downfall of the tyranny and the establishment of Kleisthenes' *isonomia*, and who as an adult had fought at Marathon and probably Salamis and Plataia as well, actually won his first tragic competition between the wars in 484. But his earliest extant work, *Persians*, was performed in 472: the young Perikles was *khoregos*, or producer. His latest play (*Prometheus Bound*, if it is really his) was written around 456. And it is as if his experience of the wars and their rhythm of success, disaster, and triumph had clarified his own tragic vision. The arena for the tragic competitions was, again, the Theater of Dionysos on the south slope of the Acropolis [Fig. 3, no. 21; Fig. 191], and Aeschylus emerged victorious from it thirteen times. But in 468 he lost one, to the young Sophocles, then making his debut as a tragic poet. At roughly the same time, the famed Stoa Poikile (Painted Colonnade) was built and decorated at the north end of the Agora [Fig. 2]. Its masterpiece (by Mikon and Panainos) was the "Battle of Marathon," and portrayed in the painting (along with Athena, Herakles,

and Theseus and other heroes) were Kallimachos and Miltiades. Another portrait of Miltiades, this time over-life-size and in bronze, appeared in the company of gods and heroes in a great group of sculptures made by the young Pheidias for the Athenians at Delphi and paid for, we are told, out of the spoils taken from the Persians at Marathon (the presence of images of Miltiades in both the Stoa Poikile and the Marathon Monument suggests that Kimon, his son, had a hand in the commissions).[11] Thus, the creative maturity of the first great Athenian tragedian, the early career of the second, the creation of the most famous of all ancient paintings, and the early career of Pheidias, all coincided with the expansion of Athenian hegemony across the Aegean and the widening of democracy at home. And yet, though the years between 480 and 450 saw an explosion of Athenian energies and activity in virtually every political and cultural sphere, there is a widespread notion that the Athenians were for three decades content (or obligated) to leave the Acropolis more or less a ruin, that from the date of the Persian destruction until the start of the Periklean building program they paid virtually no attention to it at all.

The notion is served by the Oath of Plataia, said to have been sworn by the Greeks before the critical battle of 479, committing themselves to fight to the death, to remain loyal to their commanders and allies, and not to rebuild any temple that the Persians destroyed, leaving their ruins as memorials of barbarian impiety.[12] The problem with the oath is that it is known in several significantly different versions and that its authenticity was called into question as early as the fourth century (one admittedly biased source says flatly that it was an Athenian fabrication, adding cynically that the Battle of Marathon was not as important as the Athenians said it was, either).[13] It is, in fact, difficult to see why the Spartans, say, should have uttered the part about not rebuilding their temples, since the Persians never got to destroy anything in the Peloponnesos. On the other hand, it is hard to imagine why the Athenians or anyone else would have made the whole thing up. Perhaps the story of the oath simply reflects a local ban the Athenians imposed on themselves.

The Topography of the Early Classical Acropolis

There may never be a completely satisfactory verdict on the historicity of the Oath of Plataia, though the archaeological record of the post-war Acropolis, as a matter of fact, reveals no major violation of it. But the important point is that even if the oath is genuine, it did not prevent the Athenians from carrying out significant projects on the citadel. It just kept them from rebuilding the temples (above all, the *Archaios Neos*, the Older Parthenon, and the shrine of Athena Nike, Fig. 109) razed by the Persians. Although it is often thought that the Athenian recovery from the disastrous events of 480/79 must have been slow, and that the record of building and dedicatory activity on the Acropolis in the Early Classical period is poor not only because of the oath but also because of general economic weakness, there was in fact a surprising amount of architectural and artistic activity on the post-Persian, pre-Periklean Acropolis after all.

But first things first. The Acropolis was a mess when the Athenians returned in 479 – littered with fallen architecture, burnt timbers, smashed pottery and terracottas, bases robbed of their bronzes, and broken marble sculptures. And there is no question that the Athenians eventually swept up much of the rubble and buried it in the ground. For example, fourteen statues (including the "Nike" of Kallimachos, Fig. 105, and the upper part of the Antenor *kore*, Fig. 101) were deposited in a mass grave northwest of the later Erechtheion, where they were exhumed in February 1886 AD. But it is possible that these statues were interred not immediately but a decade or more after the sack, when a new north citadel wall was built. Moreover, deposits of pure, homogeneous *Perserschutt* (Persian debris) are in fact hard to come by. It is likely that some pockets were disturbed during later building projects on the citadel and that pre- and post-Persian material got mixed up that way. But it is also clear that it took time, even decades, to bury all of the *Perserschutt*, and some pieces (such as the Moschophoros [Fig. 71] and the head of Athena from the Gigantomachy pediment [Plate IV, Fig. 96] would even be buried with Classical material.[14] Moreover, some works that were on the Acropolis when the Persians came were never buried at all (at least not in antiquity). During his tour of the Acropolis, Pausanias saw a bronze lioness that the Persians evidently missed or ignored, as well as a seated Athena by the Archaic sculptor Endoios – the badly weathered Acropolis 625 [Fig. 99] may be it – and a number of other expressly Archaic statues of Athena (of what material Pausanias does not say) which still had all their limbs but were blackened by Persian flames.[15] All this means there was no single clean sweep of the citadel in 479 or 478. But perhaps there was no hurry, either. While it is unlikely that debris was left unburied as a matter of public policy,

141

the sight of fallen architecture and broken statues littering their Acropolis would nonetheless have had a powerful moral and political effect upon the Athenians in the 470s and after, inciting them against the impious barbarians who had ravaged their sanctuary. The rubble left exposed fed Athenian grievances and was thus its own kind of war memorial.[16]

A memorial of another sort was at some point built into the north Acropolis wall [Fig. 35]. The Persians seem to have knocked down long stretches of the old Cyclopean fortifications of the Acropolis, walls that had, with only minor revisions or repairs, defended the citadel for some seven hundred years [cf. Figs. 48, 83].[17] The refortification of the Acropolis would have been, one might suppose, a major priority of the post-Persian period. But here, too, the Athenians seem to have taken their time. The Athenians, we know, frantically rebuilt the *city* wall in 479 while Themistokles diverted the Spartans' attention. But it was not until the aftermath of the Battle of Eurymedon (c. 466) that a new south wall for the Acropolis itself was built (or, more precisely, begun): one source indicates that the vast Persian spoils were publicly sold to finance the construction, another that Kimon did the job himself, as one of his many acts of civic largesse.[18] No ancient source links the north wall to anyone. But militarily it does not make much sense to fortify only one side of a citadel at a time, and for this and other reasons some sections of the north wall (though not all of it) should probably be credited to Kimon, too.[19] The north is certainly the more interesting wall, not only because it has more angles and facets than the straighter south wall, but also because it puts on display scores of pieces from the two major temples destroyed by the Persians. At the top of the fortification northwest of the Erechtheion, triglyphs, metopes, architrave blocks, and other parts of the *Archaios Neos* were built into a stretch of wall that is roughly as long as the temple from which they came (since the cache of fourteen statues destroyed by the Persians was found in fill behind this part of the wall, the date of its deposit must be the same as the date of this section of the wall itself). And twenty-nine unfluted column drums (as well as scores of other blocks) from the Older Parthenon were showcased in several courses in the wall to the north and east of the Erechtheion. Old ruins were thus conspicuously displayed in a new wall built precisely to prevent such destruction in the future, and this transformation of the late Archaic temples razed by Persians into an extraordinary Early Classical war memorial – a looming

reminder of the impiety of the barbarians – is certainly in keeping with the spirit of Oath of Plataia.

There are hints here and there of a number of lesser but still significant architectural projects carried out within and without the new Early Classical circuit. On the northwest slope of the Acropolis, for example, below the cluster of sacred caves [Fig. 7], a rectangular fountain house was built in the 460s over the natural spring known as the Klepsydra, and beside it on the north a paved court was laid out to collect water dripping down from the rocks above [Fig. 114].[20] Somewhere in Athens, some kind of large public work was begun around 455: a fragmentary inscription lists eight years of financial accounts down to 446/5, but there is not enough information to identify the project.[21] Back atop the Acropolis, there is some slight evidence that old *oikemata* such as Buildings B, C, and E were repaired (since they were presumably not temples, their restoration would not have violated the Oath of Plataia) and that new ones were built.[22] In fact, there are a fair number of architectural terracottas – roof tiles, antefixes, simas – dating to the years between 480 and 450, and though we cannot place them on any specific building, they had to decorate something.[23] At least one utilitarian structure seems to have been built in the southeast corner of the Acropolis, in the hairpin turn of the old Mycenaean circuit: this so-called Building V would eventually be replaced by a larger, open-air complex known as Building IV, usually identified as either the sacred precinct of the Attic hero Pandion or a workshop [Fig. 3, no. 16; Fig. 162].[24] Other such workshops or service courts may have been built elsewhere. Particularly tantalizing is clear evidence, in the north gallery of the Periklean Parthenon, for a small shrine consisting of a small *naiskos*, statue, and altar that was built sometime before the Parthenon and that continued to function even after the Parthenon was built over and around it [Fig. 21].[25] The precise age and identity of the shrine are open questions but it is at least as old as the Early Classical period (if it was any older it would had to have been restored after the Persian sack) and, whatever its function, the *naiskos* was too important, its deity too venerable, to be razed or moved, even by the architects of Perikles. Could it originally have been built as a home for an even older image – a Palladion, say – made homeless by the Persian sack?

The major problems concerning the topography of the Early Classical Acropolis revolve around the fates of the three principal structures destroyed by the Persians in 480/479: the Older Propylon, the Older Parthenon, and the *Archaios Neos* [Fig. 109]. The Nike bastion was almost

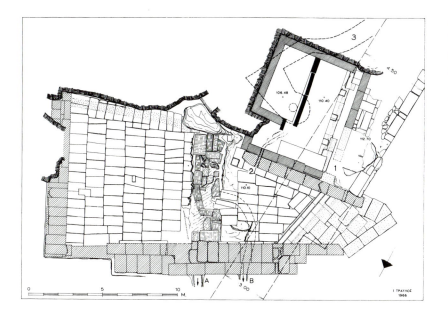

Fig. 114. Plan of Klepsydra Fountain house, c. 460s. After Travlos 1971, fig. 427. Reproduced by permission of Deutsches Archäologisches Institut Zentrale, Berlin, and E. Wasmuth Verlag.

certainly left in ruins down to the middle of the century, with perhaps only a simple altar left as the center of the cult.[26] But if the Acropolis began to get new walls on the south and north in the 460s, logically some attention should also have been paid to the entrance nearby on the west. The standard view is that at some point the Older Propylon (Fig. 108, still unfinished in 480 when the Persians came) was, in fact, repaired and rebuilt, though along slightly different lines and with both new and reused material (since a gateway is a secular rather than sacred structure, its reconstruction would not have violated the Oath of Plataia). The date of the restoration, like the date of the north wall, is debatable, but the best guess is that it occurred in the 460s, during the "Kimonian" era.[27] As for the Older Parthenon, under the terms of the Oath it could not have been rebuilt (or finished), and it was not. Indeed, it seems to have been cannibalized for building material from at least the 460s on down. Not only were scores of unfinished column-drums and other blocks built into the memorial of the north wall [Fig. 35], but drums would also be reused in the foundations of the so-called Workshop of Pheidias built south of the Periklean Parthenon in the 440s.[28] The vast podium [Fig. 106] originally built for the Older Parthenon supported only its ruins throughout the Early Classical period, and if we did not have the Oath of Plataia we would have had to invent something like it to explain why.[29]

The most difficult question concerning the Early Classical Acropolis is, what happened on the north side of the summit? This question entails several others.

Where was the wooden statue of Athena Polias kept after its return? Where was the treasury of Athena stored? And what was the *Opisthodomos*, perhaps the most exasperating term relating to the fifth-century Acropolis? The word (meaning literally "the room behind") is usually applied to the back porch of the typical Greek temple cella: a shallow space, with columns, separated from the main room by a solid wall. As far as official Athenian documents are concerned, however, the term *Opisthodomos* first appears in a decree of 434/3 and whatever it was, the treasury of Athena was to be kept on the right-hand side of it and the newly established "treasury of the other gods" was to be kept on the left.[30] It is important to stress that there is no mention of the *Opisthodomos* in any source earlier than 434. Still, the consensus is that the word refers to the western part (the back rooms *and* porch) of the *Archaios Neos* destroyed by the Persians [Figs. 93, 115]. The Athenians clearly had to keep the statue and (diminished) wealth of the goddess somewhere after 479, and in this view the rear part of the temple cella was restored soon after the Athenian return to accommodate them both (and since the east part of the cella and the colonnade were left in ruins, it could be argued in a pinch that the spirit, if not the letter, of the Oath of Plataia was still respected – the *whole* temple was not restored). This makeshift *Opisthodomos*, the theory goes, stood in the middle of the Acropolis until at least the middle of the fourth century – that is, long after the Classical Erechtheion was built just to its north and the Parthenon to its south [Fig. 3 no. 11].

But the theory rests primarily on ambiguous epigraphic and literary rather than archaeological grounds. There is no physical evidence for the rebuilding of any part of the *Archaios Neos*, and it might have made more sense to restore the east part of the cella anyway (since that was the original home of the statue of Athena Polias). And for anyone entering the late fifth- and fourth-century Acropolis, its (presumably still charred) Archaic limestone walls would have seemed out of place in the center of a sanctuary of freshly-cut Pentelic marble: the rebuilt structure would have obscured or blocked many views of the elegant Karyatid porch of the Erechtheion besides [Fig. 177]. Although the ancient references to the place remain hard to interpret, it seems more economical to consider the *Opisthodomos* the grand, western section of the Periklean Parthenon (architecturally complete by 438) – the room behind the room with the statue of Athena Parthenos, a room whose doors were reinforced with iron bars and whose columnar porch was screened with metal grills obviously meant to protect considerable wealth within [Figs. 127, 128]. There is no reference to the *Opisthodomos* before 434/3, in other words, because it did not exist until the Periklean Parthenon was built. If so, the *Archaios Neos*, in a strict construction of the Oath of Plataia, was left a total ruin throughout the Early Classical period, with collapsed colonnade, fallen entablature (much of it quarried for use in the north citadel wall), and blackened (though perhaps more or less intact) cella walls.[31]

After 479 the treasure of Athena could have been kept in restored or new *oikemata* on the summit. But we still need to find a home for the venerable statue of Athena Polias itself. And here Herodotos and an inscription or two come into play. Herodotos (born in Halikarnassos in the 490s or 480s) was drawn to Athens, now the undisputed center of Greek intellectual life, around 447, when, coincidentally, construction of the Parthenon began. He lived in Athens, however, only until 444/3, when he left to participate in the founding of the Athenian colony at Thurii in south Italy, and he is not known to have returned to the mother city before his death (probably in the early 420s).[32] Thus, the Acropolis he knew himself was essentially the Acropolis as the Early Classical period had left it and as Perikles had just begun to remake it. It is not always clear, when he refers to the topography of the Acropolis at the time of the Persian Wars (the subject of his history), whether he is relying on second-hand and not necessarily consistent accounts of what was there before 480, or whether he is interpreting events on the basis of the monuments and buildings that were there, or were being built there, in his own day (the 440s).

Still, Herodotos twice mentions monuments that he clearly saw for himself. First, after briefly chronicling the Athenian campaign of 506 against the Boiotians and Chalkidians, he notes that the chains of prisoners of war still hung in his day "on walls scorched all over by the flames of the Medes, opposite the *megaron* that is turned toward the west" (5.77). He then notes the victory monument (a four-horse chariot in bronze) paid for with ransom and, before recording the dedicatory inscription, says the monument "stands on the left hand side of one first entering the gates (*propylaia*) on the Acropolis." Here, Herodotos's gateway must be the restored Old Propylon (it had five interior doorways or gates, so the plural form *propylaia* is apt) [Fig. 108], since its Classical successor was not begun until 437. His use of the word *megaron* is notoriously problematic (the word itself is Homeric, meaning "great room" or "hall"), but most likely he means the west part of the ruined *Archaios Neos* (if so, it is significant that he does *not* use the term *Opisthodomos*). As for the walls on which the prisoners' chains were hung, it is anyone's guess, but plausible candidates are the walls of blackened *oikemata* or the interior face of the west Cyclopean fortification [Fig. 109].[33]

If Herodotos does not use the term *Opisthodomos* (or, for that matter, *Archaios Neos* or *Hekatompedon*), in a second passage describing the Acropolis he himself knew he notes the existence of "a *neos* (temple) of Erechtheus, called the Earthborn, and in it there are the olive tree and salt sea that, according to the Athenian story, Poseidon and Athena created as evidence when they competed for the land" (8.55). Though burned by the Persians "along with the rest of the shrine," the olive tree, Herodotos goes on to say, miraculously put forth a cubit-long shoot overnight – a sign (though Herodotos does not say so) of Athena's continued favor even in the face of disaster.[34]

The sanctuary of Erechtheus that Herodotos saw in the 440s cannot have been the Classical building we know as the Erechtheion [Figs. 173, 175] – it had not been built yet – and he does not place his shrine with any topographical precision: he just says it is "on the Acropolis." Still, what he saw was almost certainly an Early Classical predecessor on the site of the later temple, just to the north of the foundations of the *Archaios Neos* [cf. Fig. 109]. This had probably always been a sacred zone, with the supposed tomb of Erechtheus, the crevice of

Athena's sacred snake (or Erichthonios), the tomb of Kekrops, and a shrine to his good daughter Pandrosos close by the olive tree and salt sea created by Athena and Poseidon during their competition, and it undoubtedly suffered in the Persian destruction, as Herodotos implies. But the area was perhaps still architecturally inchoate when the Persians came, so the incorporation of a number of previously existing (even primeval) shrines and perhaps one or two new ones into one composite precinct after 479 – an Early Classical or even Kimonian "Pre-Erechtheion" – might not have been covered by the Oath of Plataia.[35] At all events, it has long been suspected that there was a Pre-Erechtheion of some sort on the spot of the Classical temple.[36] And recent investigations have offered a better idea of what it looked like [Fig. 115]. On the west there was an L-shaped Ionic stoa defining the open-air Pandroseion, with Athena's olive tree and an enclosed Kekropeion at its eastern edge (this area remained essentially unchanged even after the Classical Erechtheion was built). East of the stoa of the Pandroseion there was another, smaller stoa and then a modest *naiskos* facing east.[37] The whole area may have long been popularly known as "the Erechtheion," but the small temple was undoubtedly the new home for the ancient wooden statue of Athena Polias, and when it finally came time to build the Classical building, the new temple rose directly around and above it.[38]

Besides Herodotos, there are one, possibly two, likely references to the Pre-Erechtheion, both of them inscriptional. A marble document of around 460 regulating the practice of the Eleusinian Mysteries mentions sacred monies to be managed on the Acropolis and one very damaged line can be restored as placing funds "in the temple."[39] Around 460, the only functioning temple on the Acropolis (assuming the *Archaios Neos* was unrestored and out of business) would have been the new Pre-Erechtheion. A little more certain reference is contained in an inscription (datable to the 450s) detailing the settlement of an apparent dispute between the city and the Praxiergidai, that ancient family whose women had always had the honor of dressing the statue of Athena Polias during the *Plynteria*. The badly damaged inscription indicates that "the temple" (presumably the working one, the *naiskos* of the Pre-Erechtheion) was to be sealed during Thargelion (the month of the *Kallynteria* and *Plynteria*) and the keys entrusted to the Praxiergidai.[40] Perhaps in the aftermath of the Persian sack, the temporary disruption of Acropolis cults, and the reconfiguration of the area north of the destroyed

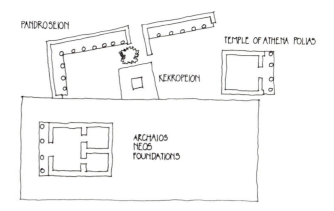

Fig. 115. Tentative sketch plan (not to scale) of Erechtheion area in the Early Classical period, c. 460 (the "Pre-Erechtheion"). Drawing by I. Gelbrich.

Archaios Neos, the ancestral prerogatives of the Praxiergidai needed to be reconfirmed.

All in all, then, the record of architectural activity on the Early Classical Acropolis is not as poor as is usually thought. Certainly, the *Archaios Neos,* the Older Parthenon, and the sanctuary of Athena Nike were not rebuilt, and the Oath of Plataia still seems the best explanation for that. But the rebuilding of old *oikemata* and the building of new ones, the reconstruction of the Old Propylon and the possible construction of one or more utilitarian structures, the layout of the Pre-Erechtheion and its associated shrines, and the initial construction of massive new citadel walls, all suggest that Athens was not too weak economically between 479 and 450 (or at least between 466 – the profitable year of Eurymedon – and 450) to carry out significant projects, and that the sanctuary of Athena was by no means ignored.[41]

Early Classical Sculpture on the Acropolis

The sculptural record of the Acropolis between 479 and 450 reads much the same way. The Oath of Plataia covered temples, not dedications, and whether it is a forgery or not, there was no taboo against restoring statues vandalized by the Persians. It is not clear how many private dedications were repaired or replaced after 480/79. Sometime around 480, for example, Theodoros, the son of Onesimos (possibly the vase-painter), added a new line to an inscribed base set up some years earlier by his father, but we cannot say for sure that the addition took place after the sack rather than before, or whether he replaced the

bronze statuettes his father had dedicated or merely added his own to the array.⁴² Still, there is no question that monuments – even public ones – could be restored after 479. The deme of Marathon had apparently dedicated a bronze statue of the Marathonian Bull, captured by Theseus, on the Acropolis by the 480s (if not earlier), and so the monument Pausanias saw in the second century AD was probably a post-Persian replacement in marble: parts of the beast may even survive.⁴³ More significant was the restoration of the great bronze four-horse chariot originally set up to commemorate the Athenian victory over Boiotia and Chalkis in 506, but carried off or melted down by the Persians in 480. It was, as we have seen, a replacement (complete with a new dedicatory inscription that reversed the order of the couplets in the original) that Herodotos saw "on the left-hand side as you go into the *propylaia* on the Acropolis," and the renewal of the old monument was likely inspired by another decisive Athenian victory over the Boiotians around 457. We do not know where the original monument was set up, but the one Herodotos saw just outside the gates in the 440s was probably moved inside during the construction of the Classical Propylaia in the 430s. At any rate, Pausanias saw it on his way out of the citadel, and a cutting in the rock near the site of the Bronze Athena (Promakhos) likely marks the peripatetic monument's final position [cf. Fig. 24].⁴⁴

The renewal of private and public monuments damaged or destroyed by the Persians (as well as the survival of a few Archaic statues) established some measure of continuity between the Archaic Acropolis and the Early Classical one: the *tabula* was not completely *rasa*. At the same time, there is a possibility that the engrained Archaic habit of dedicating *korai* on the Acropolis briefly survived the destruction. The so-called "Propylaia *kore*" is the last of its species [Fig. 116], but whether it was made just before the sack or just after is debatable. If it is pre-Persian, it lay around the Acropolis until the 430s, when it was unceremoniously tossed into the foundations of the Classical Propylaia (hence its nickname). But its severe style (especially the thick rims around the eyes, the squared chin, and the heavy and simple dress) suggests a date in the early 470s (in which case the statue was ultimately removed from its pedestal by Athenians), and only the suspect notion that *korai* production for some reason had to shut down completely in 480/79 supports the earlier date.⁴⁵

Most Archaic statuary on the Acropolis had the good fortune (if we can call it that) of being destroyed more or less at a single blow and of being buried over a relatively

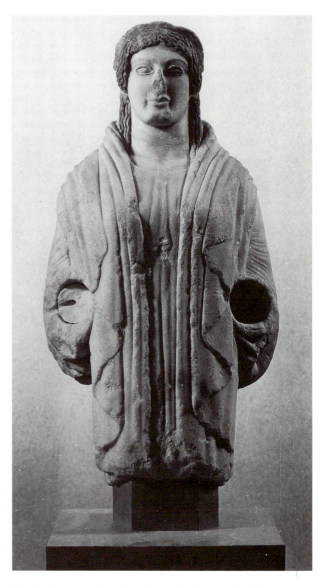

Fig. 116. The Propylaia *kore* (Acropolis 688), c. 480. Courtesy Acropolis Museum.

short period of time; that is why we have so much of it. Early Classical (and later) statues dedicated on the Acropolis had a far more erratic fate, suffering uncoordinated damage and destruction, in smelter or lime-kiln, one by one, over a much longer period of time; that is why we do not have so many of them. But we have enough (and hear about enough) to indicate that the Athenians were virtually as energetic in their dedication of bronzes and marbles on the Early Classical Acropolis as they had been in the Archaic period, and that the range of dedications was almost as broad – gods and goddesses, horsemen, athletes, warriors, heroes, and so on.

The early 470s, in fact, probably saw the dedication of two of the most famous of all Acropolis marble sculptures: the Kritios Boy [Fig. 117], so called because of a purported stylistic resemblance to the Tyrannicides by Kritios and Nesiotes set up in the Agora in 477/6, and the Blond Boy (yellow paint still clung to his hair when he came out of the ground) [Fig. 118]. Although these works have regularly been classified as Persian victims, there is in fact no compelling reason to think they were on the Acropolis in 480. They were not found in *Perserschutt*. Their style, pose, and somber, introverted mood are supremely Early Classical (by distributing their weight unevenly or bending their heads thoughtfully down and to the side, they break away from the rigid frontality and empty-headedness of Archaic *kouroi*). Moreover, their relatively fresh state of preservation can be explained by removal and burial during the massive Periklean relandscaping of the Acropolis, just a few decades after their dedication.[46] At all events, both boys have usually been considered generic athletes, dedications commemorating victories by Athenian youths in some games or other. And, in fact, there are bronze votive statuettes from the Acropolis dating from the 470s that show such victorious athletes in action – for example, a twisting diskos-thrower, set diagonally on his plinth to enhance the spatial, dynamic effect [Fig. 119].[47] But it is perhaps more likely (particularly because of their unusual hairstyles) that the Kritios Boy represents the young Theseus, and the Blond Boy (a later work by the author of the pre-Persian Euthydikos *kore* [Fig. 19]) a young Apollo.[48]

The Propylaia *kore* and images of Athena aside, female figures do not seem to have played as much of a votive role on the post-Persian Acropolis as they had done before. At least in bronze, marble, and relief, the tide appears to have turned decisively in favor of the male. There is, for example, the elaborately coiffed head of a bronze youth who, when he had his body, must have seemed a cousin of the taller Kritios Boy [Fig. 120].[49] Somewhere on the Acropolis a marble relief with a youth whose hairstyle is also "Kritian" but who had a fringe of curls inserted in bronze was dedicated in the 470s.[50] Kritios and Nesiotes themselves produced a bronze statue of Epikharinos (a *hoplitodromos*, or armed runner) dedicated on the Acropolis around 470 or so (Pausanias saw it on his tour).[51] And someone apparently named Strombikhos dedicated a now-headless Herm around the same time.[52] A little later, in the 460s, a half-life-size marble youth, his hair tied in a fillet signifying an athletic victory, appeared,[53] and a powerful life-size archer, wearing a skin-tight cuirass (its lower edge is carved, its upper edge was painted on), drew his bow against some unseen enemy.[54]

Statue groups were set up as well. Around mid-century, for example, though possibly later, the *hippeis* (the cavalry or "knights" of Athens, an equestrian upperclass) dedicated near the entrance of the Acropolis a group of a man on foot leading a horse. The inscription survives:

The horsemen [dedicated this] from [the spoils of] the
enemy; the commanders of the horse were
Lakedaimonios, Xenophon, and Pronapes.
Lykios, son of Myron, from Eleutherai made it.[55]

Lakedaimonios was the son of Kimon, and he and Xenophon would later serve as generals in the Peloponnesian War. Pronapes was apparently more distinguished for athletic success: at least, his horses seem to have won chariotry events at the Nemean and Isthmian games, as well as at the Panathenaia. Around 450, somewhere on the Acropolis, he commemorated his string of victories by dedicating a life-size bronze quadriga, with a charioteer in the car, a groom standing to the left of it, and an image of himself on foot beside it on the right.[56]

As for Lykios, the sculptor of the *hippeis* dedication, he is also credited with a bronze statue of a boy holding a *perirrhanterion* (in this case probably a sprinkler for holy water), which Pausanias saw after passing through the Propylaia but before reaching the sanctuary of Artemis Brauronia. But that was probably a work of his later career (in the 430s),[57] and it was Lykios's father, Myron, who was better represented on the Early Classical Acropolis. In his description of the sights of Boiotia, Pausanias notes in passing the existence of a statue of Erechtheus by Myron back in Athens, but whether this is the same figure as the Erechtheus who fought Eumolpos (or Immarados) in the large bronze group Pausanias saw on the Acropolis itself, he does not explicitly state.[58] For Pausanias, Myron's "Erechtheus" was the "most worth seeing" of all his works. But to judge from its ancient press his most famous statue was a bronze heifer whose naturalism was repeatedly praised in epigrams (it supposedly fooled shepherds and bulls alike). Myron's cow *might* have stood on the Acropolis – a bronze sacrifice perpetually ambling toward the altar of Athena, a monumental version of the numerous little bronze cattle and sheep offered on the Acropolis since the Archaic period.[59] Still, Pausanias does not mention it, which, given its fame, makes one wonder.[60] But he cer-

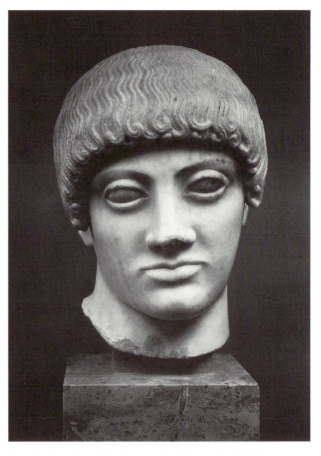

Fig. 118. The Blond Boy (Acropolis 689), c. 479–475. Photo: Courtesy DAI-Athens.

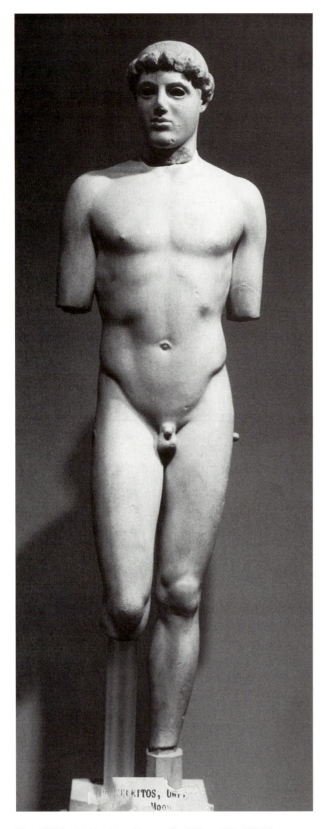

Fig. 117. The Kritios Boy (Acropolis 698), c. 479–475. Photo: author.

tainly saw another work by Myron on his tour of the citadel: a group of Perseus holding aloft the head of Medousa (the gorgon who had appeared in the iconography of the Acropolis since the seventh century [Fig. 70] and whose head was regularly affixed to the shield and *aigis* of Athena [Fig. 25]).[61] The group was apparently located right next to Lykios's "Boy with *Perirrhanterion*," so the work of the son was displayed beside that of the father – a nice touch. Pausanias also saw a group of "Athena striking Marsyas the Silenos" for picking up the flutes she had thrown down in disgust (they made her cheeks puff out unprettily when she played them). Pausanias does not say who made this work. But since another ancient source attributes "a satyr admiring the flutes and a Minerva [Athena]" to Myron (though without locating them, without indicating that the goddess was angry, and without even explicitly stating that the satyr and the Athena belonged to the same group), and since a mid-fifth-century Athenian vase shows such

148

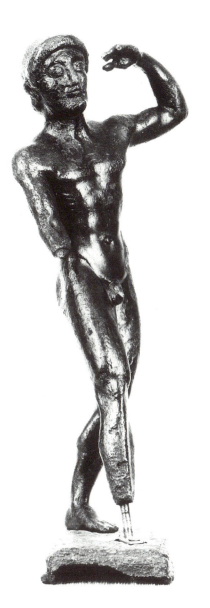

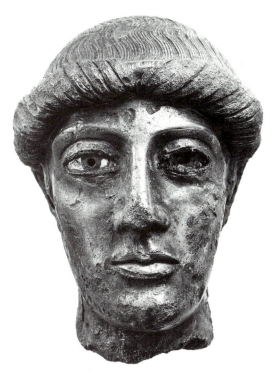

Fig. 120. Bronze Head of Youth (NM 6590). Courtesy DAI-Athens (Neg. NM 4947).

Fig. 119. Bronze Statuette of Diskos-thrower, c. 470s (NM 6615). Courtesy National Archaeological Museum, Athens.

a composition and assorted Roman copies seem to have belonged to one, it is often thought that Myron was responsible for the narrative on the Acropolis as well. The connection requires a moderately long leap of faith, but there it is.[62]

If generic female images or statues of mortal women were not particularly well represented on the Early Classical Acropolis, goddesses were another matter. For example, Aphrodite, the dominant goddess of the Acropolis slopes, was the subject of a bronze cast by Myron's contemporary Kalamis and dedicated on the summit by Kallias (Kimon's wealthy brother-in-law) around or before 450. Pausanias saw it in the vicinity of the Classical Propylaia, its inscribed base survives, and it could well have been the same work as Kalamis's *Sosandra* (Savior of Men) which the humorist Lucian (second century AD) also saw near the entrance of the Acropolis. For his reconstruction – on paper – of the perfectly beautiful woman, Lucian borrowed the Sosandra's modesty, inscrutable smile, and simple dress, though not her covered head.[63] But, of course, the most familiar goddess on the Early Classical Acropolis was Athena herself, and she was depicted in marble, in marble relief, and in bronze, on scales both small and spectacular.

Images of Athena

As we have seen, it is likely that at least some of the rigid, ornate, and enigmatically smiling *korai* that stood on the Archaic Acropolis [e. g., Fig. 101] represented Athena, so the dedication of standing marble images of the goddess was nothing new. What is different now is her mood, stance, and wardrobe, and the differences are all evident in a work – at half life-size it is really little

more than a statuette – made by Euenor and dedicated by Angelitos to Potnia Athena around 470 [Fig. 29].[64] Angelitos's Athena stood atop a fairly tall column and the sight was impressive enough for contemporary red-figure vase-painters to depict it (or something very like it) on the surfaces of their pots. The goddess wears thick sandals, an *aigis* with a scowling gorgoneion and holes for the attachment of a fringe of bronze snakes, and beneath that a simple belted *peplos*. The left leg is straight and hidden beneath heavy parallel folds, but the right leg is bent forward and relaxed – the position of the legs is not unlike that of the Kritios Boy [Fig. 117] – and presses against the cloth to reveal the form beneath. With her left hand placed firmly on her hip, and with her right hand raised to hold a spear, the goddess seems to have turned her probably helmeted head gently to one side, as if to acknowledge someone unseen or to think upon herself. So the goddess stands at ease, but she stands (or stood) contemplatively, which is something Archaic *korai* cannot do.

Athena adopts much the same pose, but in reverse, on a curious relief (usually considered a votive) placed on the Acropolis around 460 [Fig. 121].[65] Standing before a plain background once painted dark blue, her helmet crest protruding over a once-brightly-painted moulding, the goddess, wearing a belted *peplos* whose folds this time defy gravity and fall diagonally, places her right hand on her hip and cradles the end of her spear in her raised left arm. But this Athena – barefoot, as if on holy ground, and without her *aigis*, as if there were no longer any need for full battle gear – leans heavily upon her weapon and looks down at a rectangular object fixed upright on the ground (the groundline, incidentally, does not quite extend all the way across the relief). This mysterious slab is the key to the image. It looks like a pillar or stele, but that in itself does not help much. Boundary stones, for example, can look like this, and so Athena could be inspecting the limits of her own sanctuary: perhaps the relief itself was such a marker, self-reflexively representing the goddess looking at it. On the other hand, Athena could be reading an inscription (letters might have been painted on), perhaps even a list of Athenian casualties, like one set up around 460/59 with the names of those from the Erechtheid tribe who had died on campaign in the eastern Mediterranean.[66] Indeed, a mournfulness has often been detected in this image, as if Athena, lowering her head in sympathy, were in lament – if not for Athenian war dead, then perhaps for her sanctuary, ruined by the Persians. Yet others

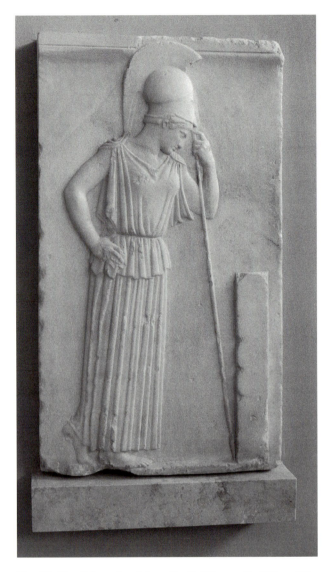

Fig. 121. The "Mourning Athena" relief (Acropolis 695), c. 460. Photo: author.

see no such sadness at all. For some, this is not a melancholy goddess, but one who is carefully checking an inventory of her treasury. For others, the slab is an abstract rendering of the Acropolis fortification wall, rebuilt after Eurymedon: Athena is inspecting her new defenses. For still others, the slab is a *terma* (goal or turning post) in a stadium or palaistra: in that case, Athena presides over a competition, and the relief would be the dedication of a victor who won a race under the auspices of the goddess. But even if the "Mourning Athena" does not really mourn, there is no question about her thoughtfulness and contemplative mood, and it is this that makes her quintessentially Classical.

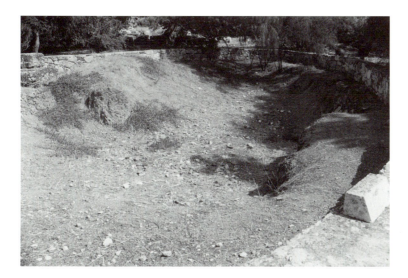

Fig. 122. Area of bronze-casting installation, south slope. Photo: author.

Athenas of various shapes and sizes were also found in bronze: it was probably in the 470s, for example, that Meleso dedicated her small figurine of Warlike Athena on the summit [Fig. 22], an Early Classical representative of a well-established Archaic type.[67] On a grander scale, there was the bronze Athena made by Pheidias and dedicated by Athenians sent to settle the island of Lemnos around 451. Though it is, as we have seen, uncertain whether this statue is reflected in Roman copies of what still appears to have been a splendid fifth-century type, with her *aigis* slung over her right shoulder, her head bare, the goddess existentially contemplating her helmet in her outstretched right hand [Fig. 28], it is clear that "the Lemnia," whatever it looked like, was renowned for its beauty: Lucian took the outline of her face, the softness of her cheeks, and her well-proportioned nose as features for his Perfectly Beautiful Woman.[68]

Pausanias saw the Athena Lemnia as he ended his tour of the Acropolis, and he called it "the most worth seeing" of all of Pheidias's works. The praise may well have been warranted – Lucian agrees with it – but it is still surprising, not only because Pausanias had seen the great gold-and-ivory statue of Athena Parthenos inside the Periklean Parthenon but also because another colossal Pheidian work apparently stood close by the Lemnia and must have towered over it. This was the huge statue officially known as the "Bronze Athena" (and by misleading modern convention as the "Athena Promakhos") [Fig. 24]. Pausanias twice says the statue was paid for from the spoils of Marathon, but Demosthenes (a much earlier witness) says more broadly that "it was dedicated as a monument to victory in the war

against the barbarians, with the Greeks supplying the funds."[69] It is often inferred from Demosthenes that the money for the statue (like that used to build the south Acropolis wall) came from Eurymedon, with the members of the Delian League volunteering a share of the captured riches. But Demosthenes does not specifically say so, and neither does a heavily restored inscription – only six letters survive – on two marble blocks that were once thought to belong to the base of the pedestal of the statue: "The Athenians dedicated [this] from [the spoils taken from] the Medes."[70] The inscription probably does not belong to the statue after all. But it is still possible that the Bronze Athena was created not to commemorate a specific battle, but rather the long history of Athenian success against the Persians and thus the city's freedom – an Early Classical "Statue of Liberty."

Another, much longer inscription listing the costs of labor (both wages for Pheidias's workers and salaries for the public commissioners in charge) and raw materials (copper and tin for the bronze, goat's hair to mix with clay for the core and mold, coals and firewood for the smelter, lead, and silver for ornamental details) suggests that the project cost around eighty-three talents in all and took nine years to complete.[71] Since this inscription was carved at the end of the project and can itself be dated (though subjectively, by the style of its letters) to around 455–450, work on the statue – it was probably cast in an installation on the south slope of the Acropolis itself [Fig. 122][72] – could have started at any point between, say, 465 (that is, just after Eurymedon, when Kimon was at his height, and perhaps in the wake of the

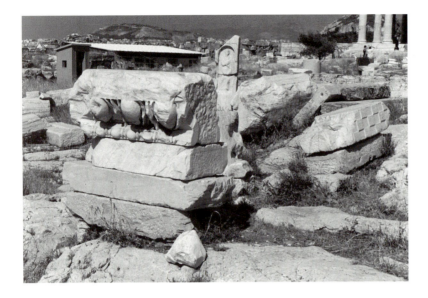

Fig. 123. Fragments from base of Bronze Athena (Roman repair). Photo: author.

first Peace of Kallias) and 460 (in the wake of Kimon's ostracism). But whether the Bronze Athena was a product of Kimonian patronage or an early commission of Periklean democracy, perhaps Pausanias and Demosthenes were both right about its sources of funding, and the Bronze Athena should be understood as commemorating the sum total of major Athenian victories from 490 onward. The victory at Marathon was surely implicit in the symbolism of the statue, and it may not be coincidental that around the same time that the Bronze Athena was created the Athenians set up a new, monumental marble monument at Marathon itself to commemorate the victory.[73] But any dedicatory inscription (like the one no longer associated with it) would surely have been inclusive.

Wherever the money came from, the Bronze Athena stood as the very transfiguration of enemy spoils – as Persian wealth recast into the brightly polished image of the goddess who had assured Athenian victory. Athena had always stretched her protective hands over her city (as Solon said so long before), but this Athena, though on guard at the entrance of her sanctuary, probably stood at rest, leaning on her shield rather than brandishing it, not aiming her spear but allowing it to rest in the crook of her arm. It stood tall: thirty feet tall, if a bronze Athena seen by a Byzantine historian in Constantinople in the early thirteenth century was *the* Bronze Athena, possibly much taller if it was not the same statue, but in any case tall enough for its helmet crest and spearpoint to rise above its architectural surroundings and reflect

light seen by sailors coming into port from Sounion.[74] It stood on an elegantly moulded pedestal of Pentelic marble and dark Eleusinian limestone [Fig. 123] set into a large cutting (about 5.465m by 5.58m) in the rock just in front of the ancient terrace-wall west of the *Archaios Neos* [Fig. 3, no. 7].[75] This location, and the fact that the base was not set flush against the terrace-wall but was rotated slightly away from it, is surely significant: the Bronze Athena stood almost exactly on axis with the ruins of the old temple, yet it turned to the southwest, toward Salamis – the site of a victory to rank with Marathon and Eurymedon. If the goddess did not hold a Nike – an obvious enough symbol of victory – in one hand, then she may have held an owl; and owls, it was said, were seen before both Marathon and Salamis, omens of Athena's favor.[76] Thus, the Bronze Athena, strategically placed to dominate the view of anyone entering the Early Classical Acropolis, stood at a kind of intersection of history, topography, and allusion, at a symbolic nexus of destruction, victory, and renewal. Aligned with the holiest temple destroyed by the Persians, directing her lofty gaze toward the waters where the Persians met disaster, the statue was cast from the fruits of victory (or a series of victories) to be, in Demosthenes's words, "the goddess's own *aristeion*," her own prize of valor.[77] The Bronze Athena was, in short, Pheidias's (and Athens's) first great essay on the course and meaning of the Persian Wars, and no one passing through the Old Propylon could have missed the colossal, gleaming message [Fig. 24]. Like a phoenix rising from the ashes of the

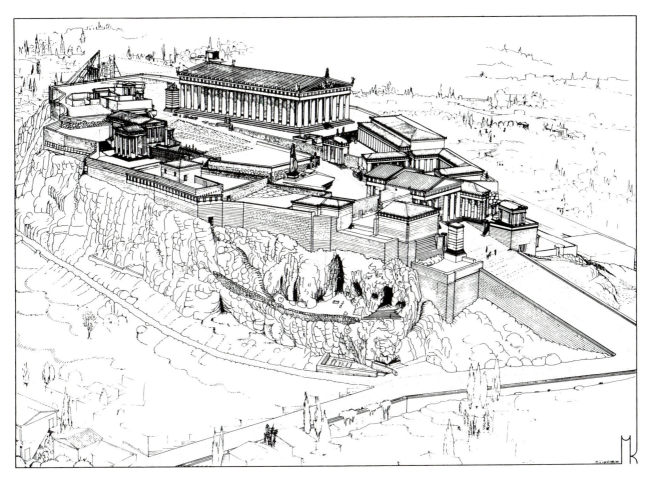

Fig. 124. Reconstruction of the Athenian Acropolis. Drawing by M. Korres, used by permission.

Acropolis, it embodied a material splendor and political symbolism that would culminate just a decade or two later, when the restored Boiotian/Chalkidian monument, commemorating the democracy's very first military success, was finally moved to a spot just beside it and when, under the auspices of Perikles, the entire Acropolis was transformed into a vast and intricate dissertation on Victory itself [Fig. 124].

A GUIDE TO THE HIGH CLASSICAL ACROPOLIS, 450–400

But as the works rose, overwhelming in size yet also inimitable in form and grace, with the craftsmen striving to surpass their craft in the beauty of their workmanship, the most wondrous thing of all was the speed of their work. For while it was thought that each one of these works would take many successive generations to reach an end, all of them were completed at the height of a single administration. . . . For which reason the works of Perikles are to be especially wondered at, being made in so short a time, for all time. For in beauty each one was then immediately ancient, yet each seems fresh and newly-made even now. Thus a kind of newness always blooms over them, preserving their appearance untouched by time, as if his works were infused with an ever-fresh breath and ageless soul.

Plutarch, *Life of Perikles* 13.1–5

Historical Background

At the start of the year 447/6 Perikles was easily the dominant (though not unchallenged) political figure in Athens, and his position would only grow stronger. The wheels of the democracy he had helped engineer (limited though it was) were running smoothly. The number of citizens – and that meant free adult males born of both an Athenian father and an Athenian mother – ranged healthily somewhere between 40,000 and 45,000 (as it is, they constituted only a minority of the population of Attica, which of course included women and children as well as slaves and resident aliens).[1] Athens, center of an empire on land and sea, had accumulated power and wealth unprecedented in Greece. And construction of the Parthenon, the building that would come to symbolize the greatness of Periklean Athens, had just begun.

By the fall of 404, Athens had been utterly defeated in the Peloponnesian War. It had lost its fleet, its empire, and its tribute, and facing starvation it had unconditionally surrendered to Spartan besiegers the preceding spring. The number of adult male citizens had plummeted toward 20,000. The democracy had been overthrown and a junta known as the Thirty Tyrants, installed under pressure from the victorious Spartan admiral Lysander, now ruled, cancelling laws, eliminating rights, confiscating property, and putting 1,500 of their opponents to death within a matter of months. The Parthenon [Plate V, Fig. 126] had been finished nearly thirty years before, the Temple of Athena Nike [Fig. 182] nearly twenty, and with the recent completion of the Erechtheion in 406/5 [Fig. 173] the making of the Classical Acropolis as a whole was almost done. But, humiliatingly, the sanctuary-citadel was no longer in Athenian hands. The Thirty Tyrants needed foreign reinforcements, and Lysander duly sent them 700 troops under the authority of a Spartan *harmost* (military governor) named Kallibios: he made the Acropolis his garrison,

apparently using the Odeion of Perikles on the south slope [Fig. 3, no. 20] as his barracks.[2] For the third time in just over a century, Spartans had essentially taken the Acropolis. The first time they did so to overthrow the comparatively benevolent Peisistratid tyranny (510), the second time to abet Isagoras in his political struggle with Kleisthenes (508/7). They did so now to defend a gang of murderers.

Few heroes of Athenian tragedy ever suffered so complete – and none so complex – a reversal of fortune as did Classical Athens itself between 447 and 404. But serious troubles were, in fact, already brewing at the start of the period. Athens had been waging an intermittent conflict with Sparta and her allies for about a decade, and the year 446 did not begin well at all. In short order Athens lost Boiotia and its land empire and faced a rebellion by the island of Euboia from its maritime empire. As if that were not bad enough, the army of the Spartan King Pleistoanax invaded and ravaged western Attica. The situation was so severe that work on the Parthenon, begun just the year before, was temporarily suspended.[3] But Perikles deftly persuaded (or bribed) Pleistoanax to leave Attic soil, thoroughly crushed the Euboian revolt, and then (in 445) negotiated a peace treaty with Sparta and her allies that was supposed to last thirty years. It lasted fourteen. Yet it was in those years that the Parthenon, Propylaia and other works were built, and it was in those years that Perikles reached the peak of his authority and prestige. In 444/3 he forced the ostracism of his strongest opponent (the conservative Thucydides, son of Melesias, and by marriage a relative of Kimon) and won election as one of ten Athenian *strategoi* (generals) every year thereafter until his death. *Strategos* was the only major constitutional office Perikles ever held (he was never *archon*, for example), but it did not matter. In the famous words of that other Thucydides, the historian, "in name there was democracy, but in fact political power was exercised by the first man."[4]

The Thirty Years' Peace came undone when Athens intervened in a dispute between Corinth (a powerful but insecure Spartan ally) and its old colony Korkyra (Corfu), began the siege of Poteidaia (another Corinthian colony that was nonetheless a member of the Athenian Empire and in 432 wanted out), and issued a decree (proposed by Perikles in 433 or 432) that Megara, a long-time foe and Corinthian ally, be excluded from the Athenian Agora and the harbors of the empire – an economic death-penalty. There were some attempts to resolve these disputes diplomatically but in the spring

of 431 Sparta's ally Thebes launched a surprise attack on Athens's ally Plataia and the Peloponnesian War was on. Korkyra, Poteidaia, the Megarian decree, and Plataia may have lit the fuse, but in Thucydides's opinion "the real cause, though the one least noted, is, I think, that the Athenians, growing powerful, scared the Spartans and forced them into war."[5]

The Athenians had apparently been convinced for several years that the Peloponnesians would be coming. They were ready, and the Acropolis loomed large in their preparations. As early as 434/3, for example, the assembly passed the two financial measures known as the Kallias Decrees. After noting the presence on the Acropolis of "3,000 talents belonging to Athena" that the assembly had sometime earlier voted to transfer to the citadel, the decrees provided for the management of the "treasures of the other gods" brought from temples in rural Attica and the lower city to the Acropolis for safekeeping (they were to be kept on the left side of the *Opisthodomos*, whatever it was). They called for the completion of some things "made of worked stone" (almost certainly marble statues and very likely the last of the Parthenon pedimental sculptures) and the first of the so-called Golden Nikai, which were essentially bank deposits in divine form (six-foot-tall statues, replicas of the Nike held by the Athena Parthenos [cf. Fig. 132], covered with two talents of gold plates apiece). The decrees apparently suspended work on the Propylaia (it was, in fact, never finished) and provided funds for the final arrangement and securing of the Acropolis itself (the architect of the Propylaia – unnamed in the decrees though we know him to be Mnesikles – was put in charge).[6] The Kallias Decrees, in short, represent precisely the sort of measures a city anticipating armed conflict and imminent invasion might take.

In 431, on the brink of war, Perikles himself went before the people to assess their resources in men and money, and his accounting, paraphrased by Thucydides, must have put them at ease. Apart from the usual sources of revenue (meaning silver from the mines at Laureion, harbor fees, and so on), they received, he said, 600 talents annually from their allies. They still had 6,000 talents of coined silver on the Acropolis, and while Perikles would not have needed to remind anyone that this was after sixteen years of his costly building program, Thucydides adds parenthetically that there had once been 9,700 talents in all but that the Poteidaia campaign and the cost of the Propylaia and "other public buildings" had drawn down the reserve (presumably

one of those "other buildings" was the Parthenon and it is surprising that it goes unmentioned). There were, Perikles went on, at least 500 additional talents in the form of private and public dedications in silver and gold, sacred vessels and equipment, and Persian booty (the Golden Nikai mentioned in the Kallias Decrees must have been among the treasures he had in mind). Other temples still had assets, too, and if worst came to worst they could even strip the statue of Athena Parthenos of the forty (or forty-four) talents of removable gold plates that covered her (though this gold, he warned, they would be obligated to restore).[7] It could be significant that Perikles did not list the gold adorning the ancient statue of Athena Polias (jewelry, *aigis*, owl, *phiale*) among the assets of the state. Perhaps that gold was not enough, relatively speaking, to matter. Or perhaps the statue was too holy to touch even in emergencies. If so, that tells us something about the relative sanctity of the Polias and the Parthenos: only one was inviolable.

Soon after this public audit, in the spring of 431, King Archidamos of Sparta led his army into Attica, and Perikles did nothing to stop him. His strategy was to sacrifice the land to Spartan invasions, to counterattack the Peloponnesian coast by sea, and to move the rural Athenian population within the walls of the city and to the space between the Long Walls that joined it to the Peiraieus – walls that essentially turned Athens into an island. Since Athens's fleet ruled the waves and could import whatever it needed, an island was logically a safe place to be. Despite severe overcrowding in the city – space was so limited that some Athenians had to be housed for a time in temples and shrines, though not on the Acropolis or in the Eleusinion[8] – the strategy might have worked had Perikles been there to manage it. But in 430 something even mightier than a Spartan army invaded Attica, and the crowded conditions meant it struck hard. For two years an epidemic (typhus? smallpox? a mystery plague out of Africa?) decimated Athens and the Peiraieus, killing perhaps a third of the population, including, in the fall of 429, Perikles himself. In 427/6 the plague struck again, and as if that was not bad enough Attica was rocked by a series of earthquakes: one was powerful enough to damage the Propylaia and knock columns in both Parthenon facades 2cm off line.[9] But even natural disasters and the loss of Perikles did not derail the war effort and, in fact, during the first ten years of the struggle Athens won at least as often as it lost: a particularly important victory occurred at Sphacteria (Pylos) in 425 and was commemorated by a bronze Nike

set up on the Acropolis.[10] Still, the Archidamian War (as the first phase of the conflict is known) ended in stalemate and mutual exhaustion, and in 421 Athens and Sparta negotiated the so-called Peace of Nikias.

The treaty was so defective that Sparta's most powerful allies refused to sign on, and this time the peace, meant to last fifty years, broke down after only six. In the summer of 415, a great Athenian expeditionary force departed for Sicily to prevent the island from falling completely under the domination of its preeminent city, Syracuse, and in 414 the Spartans responded by sending a general to command the Syracusans. In 413 the Spartans resumed their annual invasions of Attica and the Sicilian expedition ended in catastrophe: the Athenian fleet was destroyed, and nearly all of the 45,000 Athenians and allies who had sailed west were killed or sold into slavery. Major building activity on the Acropolis was now apparently suspended for several years. But, remarkably, the Athenians fought on for nearly a decade more – even though their tributaries revolted one after another; even though their old enemy, Persia, began to subsidize the Spartans; even though in 407/6 they were forced to melt down, in addition to other dedications, eight Golden Nikai from the Acropolis reserves (yielding sixteen talents worth of gold coins). After 410, in fact, Athens turned the tide and was actually on the verge of winning the war.[11] But when a smashing victory was won in 406/5 off the islands of Arginusai in the eastern Aegean, the Athenians snatched disaster from its jaws: thousands of shipwrecked and badly needed seamen were abandoned because of a sudden storm and the commanders of the fleet were (illegally) condemned to death for failing to rescue them. In the same year misfortune struck the Acropolis, too: we are told "the old temple of Athena" somehow caught on fire, though it is not absolutely clear which building is meant.[12] Yet the Athenian treasury in the last months of the war seems to have been in surprisingly good shape. Soon after "the great meltdown" of 407/6, the treasury began to be replenished (the growth in dedications can be detected in the Parthenon inventories as early as 406/5),[13] and the Athena Parthenos never seems to have been in danger of losing her gold. But in late summer 405, at the mouth of the Aigospotamoi River in the Hellespont, the Spartan admiral Lysander caught the Athenian fleet by surprise and annihilated the city's last great fighting force. His siege of a helpless Athens ensued, and terms of surrender were accepted the next spring (404). What was left of the Athenian empire disintegrated, and flute-girls

played as the Long Walls linking Athens to the sea were torn down.[14]

The course of the war naturally had an impact on the Athenian democracy and it, too, suffered upheavals and disasters. After Perikles's death, Athenian politics were dominated by a long list of radical democrats and oligarchs (moderates of any stripe were few). There was, for example, Kleon, a democratic warmonger with an unremittingly bad press whose death in battle in 421 encouraged the making of peace, and Nikias, the moderate conservative who made it, only to be butchered later in Sicily, the victim of a campaign he had strongly opposed. There were demagogues named Hyperbolos (really) and Kleophon, a lyre-maker who was a leading imperialist and the leading democrat during the last years of the war. There were sly oligarchs like Theramenes and ruthless ones like Socrates's friend and Plato's older cousin Kritias, who is irrefutable proof that intellectuals can be violent thugs. And there was, above all, the brilliant but unstable Alkibiades, who could be democrat or oligarch depending on how the wind blew, who was the driving force behind the Sicilian expedition, who went over to the Spartans and back again, and who was finally put to death by Persians. The political intrigues in which such men engaged were largely tied to the fortunes of war, and a series of regimes with numbers in their names rose and fell. In the aftermath of the Sicilian disaster, for example, an oligarchy overthrew the discredited democracy and established a Council of Four Hundred to rule the state and dismantle many of the provisions of the democratic constitution, such as pay for government service (411). Vicious extremists, the Four Hundred were in turn overthrown by a more moderate and inclusive oligarchy, the Five Thousand, led by Theramenes. But they themselves lasted only a matter of months. In 410 the success of the Athenian fleet, its ships manned by commoners (the *thetes*), led to the restoration of the radical democracy. This endured until the end of the war, when the Thirty Tyrants, led by Kritias and Theramenes, took over with Lysander's blessing and the muscle of Kallibios's 700 Spartans (disgracefully, the Thirty melted down two of the last Golden Nikai to pay the foreigners garrisoned on the Acropolis).[15] But Theramenes himself quickly fell victim to the Thirty's reign of terror, and the junta did not survive him very long. Exiled democrats and patriots led by Thrasyboulos defeated the forces of the oligarchs in the streets of the Peiraieus, killing Kritias in the process. The Spartan king Pausanias then outmaneuvered his rival Lysander,

entered Attica, and negotiated a general reconciliation. In the fall of 403 the democracy was restored once more.

Athens thus experienced all the history it could handle in the second half of the fifth century, and that makes the development of its Acropolis all the more remarkable. For despite plague and disasters, despite interruptions necessitated by the costs of military campaigns and the vicissitudes of politics, the Acropolis continued to be adorned with splendid buildings, sculptures, and dedications during and even after the Peloponnesian War, as it had been before, in the brief age of Perikles himself.

The Periklean Building Program

It is usually thought that the Oath of Plataia (assuming it is genuine) was negated by the bilateral Peace of Kallias (assuming *it* is genuine): that is, the Athenians were freed from their vow not to rebuild the temples destroyed by the Persians when their war with the Persians officially came to an end. The odds are that both the oath and the peace are authentic, but the date of the Peace of Kallias is, as we have noted before, still in dispute. It is possible that a peace was first negotiated in 465, but if so the result was only a tense, uneasy truce that soon broke down. Architectural projects (such as new citadel walls) were undertaken on the Acropolis in the 460s and 450s, but, again, the *Archaios Neos* (Old Temple of Athena), the Older Parthenon, and the bastion and shrine of Athena Nike were not at that time rebuilt. Thus, even if the Oath of Plataia was no longer considered binding after 465, the Athenians for whatever reasons – practical, philosophical, or moral – acted as if its "temple provision" were still in effect.

It is possible, too, that an oath said to have been sworn by all the Greeks who fought at Plataia had to be reconsidered by all the Greeks who fought at Plataia, not just the Athenians, and that a more satisfactory renegotiation or renewal of the Peace of Kallias around 450 or 449 gave Perikles the opportunity to seek a panhellenic annulment of the oath.[16] At some point, we are told, Perikles did indeed officially invite all the Greeks to meet in congress at Athens to discuss the rebuilding of the temples that the Persians had cast down, the sacrifices that they owed the gods, and ways of keeping the peace and guaranteeing freedom of the seas. Now, both the authenticity and date of this so-called Congress Decree are (surprise!) debatable, but its authenticity holds up to examination and a date of around 449 makes

some sense.[17] In any case, we are also told that the Spartans recognized the invitation for what it was – an unsubtle attempt on Perikles's part to get the Greeks to acknowledge Athenian leadership – and prevented the congress from ever taking place. But Perikles did not let this rejection stand in his way and, Oath of Plataia or no, he quickly brought his proposals for the remaking of the Acropolis before the assembly, probably late in 449.[18]

The standard ancient account of the Periklean building program is found in Plutarch's *Life of Perikles*. This description is lively but not completely reliable (see Appendix B). It seems to have been shaped by the conditions and procedures of Plutarch's own era (the early second century AD) rather than of mid-fifth-century Athens. Plutarch greatly overstates Pheidias's role in the program (making him the director of all the projects when, we know, Pheidias left Athens long before the program came to an end). And the financing of the program was far more complex than Plutarch knew. Yet Plutarch's list of the projects that Perikles initiated both on and off the citadel remains fundamental. These are, in the order Plutarch gives them: the Parthenon (built, Plutarch informs us, by Iktinos and Kallikrates), the Hall of Mysteries at Eleusis (built by Koroibos, Metagenes, and Xenokles), the middle Long Wall linking Athens to the Peiraieus (by Kallikrates), the Odeion (architect unnamed), the Propylaia (by Mnesikles), and the statue of Athena Parthenos (by Pheidias).

It is difficult to know precisely the extent of Perikles's vision for Athens, but his program was certainly not limited to the six projects on Plutarch's list. Other ancient sources credit Perikles with building a grain warehouse in the Peiraieus and a gymnasium (the Lykeion) at Athens,[19] and we know from an inscription that in the 430s Perikles and his sons offered to finance a new springhouse somewhere in the city (the assembly, though commending them for their generosity, decided to use imperial tribute instead).[20] These works probably failed to make the list because of their relatively modest or utilitarian nature. But Plutarch omits even a few Acropolis projects that were almost certainly Periklean initiatives (the completion of the citadel walls, for example, or the remodelling of the sanctuary of Artemis Brauronia) and a few that were probably Periklean (one or both phases of the Classical sanctuary of Athena Nike, the remodelling of the sanctuary of Zeus Polieus, and even the construction of the Erechtheion, which may have been conceived or begun by 431).

On the other hand, just because something may have been built or initiated in Athens during Perikles's period of dominance does not guarantee that he had anything to do with it. A distinction should be made between works that are "Periklean" because Perikles actually proposed them and works that are "Periklean" merely because they were under construction during the period of his greatest political influence. For example, an unknown public work of some magnitude begun around 455 while Perikles was ascending the ranks of Athenian politics and apparently still under construction in 446/5, just after the building program got under way, is "Periklean" only in the latter sense.[21] So, too, a number of "Periklean" temples built in the Attic countryside in the 440s and 430s – Poseidon at Sounion or Ares at Acharnai, for example – have no known connection with Perikles himself. As for the sculpture-rich Temple of Hephaistos and Athena (or Hephaisteion) overlooking the northwest corner of the Classical Agora [Fig. 2], opinion has always been divided. Some date it precisely to 449 (which makes it just fit into the Periklean program). But dates as early as 460 and 454 have been offered for at least the inception of the project, and the fact that its completion was apparently long delayed and its sculptural decoration created in stages over several decades suggests that the Periklean building program (which paid little attention to the Agora anyway) bypassed it altogether, that it was an overlapping but separate project, even that laborers and resources were diverted from it to the Periklean Acropolis as required.[22]

It remains to emphasize that, for all the monumental achievements of the last half of the fifth century, not everything on the High Classical Acropolis was High Classical in origin. For example, the late Archaic monument commemorating the young Athenian democracy's victory over the Boiotians and Chalkidians, restored in the Early Classical period, greeted visitors to the High Classical citadel [Fig. 24]. The formidable Bronze Athena (Promakhos) was no less dominant a feature of the Periklean Acropolis than of the Early Classical one; expropriated (or co-opted) by Periklean planners, the bronze, together with the chryselephantine Athena inside the Parthenon, bracketed the experience of the visitor with colossal, myth-bearing images of the goddess who assured victory and thus Athenian freedom and democracy.[23] Column-drums from the Older Parthenon and triglyphs and metopes from the *Archaios Neos* had already been put on display in the war memorial built into the north Acropolis wall [Fig. 35]. But, more than this, Periklean architects consciously incorpo-

rated Archaic and even Mycenaean remains into their designs.[24] Mnesikles bevelled one corner of his Propylaia so that the Cyclopean wall, then eight centuries old, could fit snugly against it [Fig. 54]: his new gateway thus functioned in sharp juxtaposition with, but in acknowledgment of, a Mycenaean relic. Similarly, the remains of the old Mycenaean bastion [Fig. 55] were purposefully exposed through "windows" in the Nike Temple bastion [Fig. 181]. The architect of the Erechtheion (built over and around a variety of earlier sacred spots and shrines) perched the Karyatid porch conspicuously atop the north foundation wall of the *Archaios Neos*, which also served as a precinct wall for the Classical sanctuary of Pandrosos [Figs. 82 and 3, no. 10]. The Periklean Parthenon literally stood atop massive Archaic foundations [Fig. 106], accommodated a pre-existing *naiskos* and altar within its north *pteron* [Fig. 21] and was in its very material largely a reincarnation of the Older Parthenon. And if the western section of the *Archaios Neos* really was repaired after the Persian destruction and lived out a long life as the controversial *Opisthodomos* of the inscriptions, then a renovated Archaic limestone building occupied the very center of the marble High (and even Late) Classical Acropolis [Fig. 3, no. 11]. But whether the *Opisthodomos* was there or not (and I do not think it was, at least not after the construction of the Erechtheion), the intent was clearly to weave the past into the fabric of the Periklean age, to acknowledge precedents and reveal, almost everywhere, the history of the place. Now, to some degree every "new" Acropolis had assimilated relics of past Acropolises, so that its long history was always in evidence.[25] But the Periklean Acropolis especially acknowledged and revelled in its own archaeology, in its sense of its own past. It was a landscape of memory.

Finally, we should note that the High Classical Acropolis was by no means "finished" at Perikles's death in 429. As far as we know Perikles devised no long-range masterplan to govern development of the sanctuary after him, and there are at least a few later Classical additions – the parapet of the Temple of Athena Nike [Figs. 185–87], for example, or the Chalkotheke, probably the last major Classical addition to the summit [Fig. 189] – that may not have figured in Perikles's original design.

At this point it will be useful to survey in roughly chronological order (so far as we can determine it) the principal structures built atop the High Classical Acropolis[26] from the initiation of the Periklean program around 450/49 to the end of the fifth century and actually a little

beyond, into the early fourth century (the few Hellenistic and Roman contributions were by comparison mere afterthoughts or embellishments, with no significant effect on the plan or flow of the sanctuary). The survey concludes with a brief review of the major Classical monuments on the south slope. The principal materials, dimensions, sculptural adornments, inscriptional evidence, bibliography, and the like for each monument are tabulated in the catalogue of Appendix C.

THE SUMMIT

The Citadel Walls
(Appendix C, no.1)

The walls of the Classical Acropolis were built in sections or stages over the course of four or five decades. The south citadel wall (now mostly sheathed by Medieval stonework and buttresses) [Fig. 4] is, again, said to have been built by Kimon after Eurymedon (c. 466). The walls on the east and north (with its "war memorial" of Older Parthenon column-drums and *Archaios Neos* entablature) [Fig. 35] may have been begun at the same time, or possibly even earlier in the 470s (Pausanias, who says all the walls except the south were built by the legendary Pelasgians Agrolas and Hyperbios, was presumably misled by the Mycenaean wall still abutting the Propylaia [Fig. 54]).[27] Yet it is now accepted that the upper half of the south wall, and at least an upper section in the western portion of the north wall (a section that is structurally bound to and built over the foundations of the so-called Northwest Building [Figs. 3, no. 4, and 171]), are in fact Periklean, and are as late as the 430s.

Given the long and complex history of the walls, it is unlikely that a single architect was in charge of the entire fortification. Our literary sources provide no names (the mythical Agrolas and Hyperbios do not count). But an inscription datable to the early 440s (*IG* I[3] 45) records a decree calling for the construction of a wall on (or below) the Acropolis meant to keep undesirables like runaway slaves and sneak-thieves out of the sanctuary, and Kallikrates (co-architect of the Parthenon, according to Plutarch) was put in charge. The wall in question cannot have been a major project (Kallikrates was given only sixty days to do the job and is instructed to carry it out as economically as possible), but it seems to have corrected a noticeable weakness in the Acropolis defenses. Perhaps Kallikrates – whom we today might

call a contractor rather than an architect – was chosen because of some prior involvement in the construction of the grander north or south walls. At any rate, his experience as wall-builder apparently led to his commission for the construction of the middle Long Wall linking Athens to the Peiraieus (c. 445–443), one of the projects in Plutarch's list. Since a western section of the north citadel wall was built as part of the same project as the Propylaia and Northwest Building, it can be tentatively attributed to the same architect: Mnesikles.

The Sanctuary of Athena Nike
(First Classical Phase, Appendix C, no. 2)

After the Persian destruction of 480/79 the old bastion of Athena Nike was left in ruins, presumably in accordance with the Oath of Plataia. Worship of the goddess would have continued, but the cult was evidently under the jurisdiction of another priestess – the priestess of Athena Polias, no doubt – as it probably had been even before the sack. At some point, however, the Athenian popular assembly issued a decree establishing a separate office of "priestess of Athena Nike" (she was to be chosen democratically by lot from all Athenian women and was to be paid fifty *drakhmai* a year, plus the legs and

hides of sacrificial victims). The decree also commissioned Kallikrates to design a new temple, an altar, and doors for the sanctuary.[28]

Now, the date of this "Nike Temple Decree" happens to be extremely controversial, and the debate hinges on a small but significant detail: the way the mason carved the letter sigma into the marble slab. The sigma used on the decree has three strokes or bars (ϟ), and this three-barred sigma, it used to be thought, was obsolete by 445, when it was replaced (at a stroke) by a sigma with four bars (Σ). It is now increasingly clear, however, that the transition to the new form of sigma was gradual rather than instantaneous and that three-barred sigmas could still be inscribed into the 420s and even later.[29] What all this means is that the Nike Temple Decree *could* date to the early 440s, but it does not *have* to. And that complicates our conception of events on the Nike bastion considerably.

As I. Mark has argued,[30] the Nike sanctuary was apparently remodelled twice in the course of the fifth century. The first project shored up the old bastion with a new, irregularly shaped precinct/retaining wall entered through a double door on the northeast side [Fig. 125]. Within the sanctuary, a simple poros-limestone *naiskos* was built facing east: it lacked columns and, as far as we can tell, architectural sculpture.[31] Below its floor was a

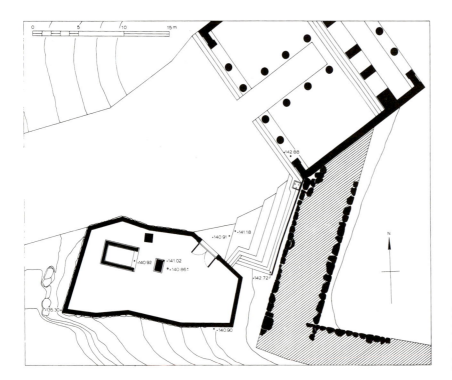

Fig. 125. Plan of Sanctuary of Athena Nike, First Classical Phase, early 440s (?). After Mark 1993, fig. 12; used by permission.

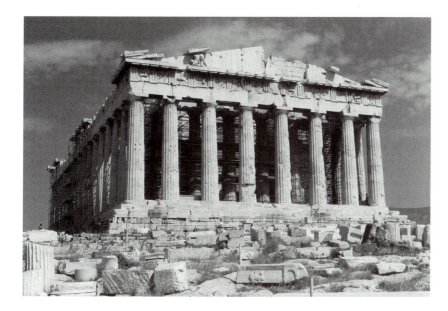

Fig. 126. The Parthenon, from the west. Photo: author.

repository containing an assortment of crude terracotta figurines – a so-called "foundation deposit" sanctifying the new shrine. The repository was actually built of two blocks from the old base of the Archaic cult statue, thus maintaining a link between the new sanctuary and the old. The image itself, like that of Athena Polias, was apparently evacuated in 480 when the Athenians fled the Persians. It is unclear where the statue resided in the post-war period – the bastion, again, was a ruin – but it was almost certainly reinstalled in the new *naiskos*. Finally, two altars (not just one, as ordered in the Nike Temple Decree) were eventually set up – one on axis with the *naiskos* to the east, the other (a single square block set above the original sixth-century altar of Patrokledes, Fig. 75) to the northeast.

Now, if the Nike Temple Decree with its three-barred sigma dates to the early 440s, then Kallikrates must be credited with this first (and early Periklean) phase of the sanctuary. If the decree dates to the 420s, however, then Kallikrates was responsible for the sanctuary in its final, far more sumptuous form [Figs. 180–82]. No literary evidence, it is true, directly links any stage of the sanctuary of Athena Nike to Perikles's program. But if the first Classical phase really does date to the early 440s, it would have been contemporary with the first years of work on the Parthenon – Kallikrates is, again, named as one of its builders – and so would have been an early, if modest, element in the broader, coordinated Periklean initiative to renew the ritual and sacred spaces of the Acropolis.

The Parthenon
(Appendix C, no. 3)

How the Parthenon [Plate V, Fig. 126] got that name is unclear. Surprisingly, we are not sure what (besides the generic *ho neos*, "the temple") the building was officially called in the fifth century. The Periklean architects Mnesikles and Kallikrates are said (by a late source) to have nicknamed it *Hekatompedos* (the Hundred Footer) in a lost treatise on Athens, but the surviving building accounts of what we call the Parthenon give no name at all: the evidence is so sparse it is almost as if this spectacular addition to the Acropolis originally *had* no name.[32] The term Parthenon seems to have come into general use only in the fourth century (the first time the term certainly refers to the entire building is in Demosthenes). But even then the building could still be called the *Hekatompedos* (or *Hekatompedon*), and in any case both names seem to be popular sobriquets rather than official titles. Even later authors can seem a little unsure about what to call it: "the temple they name the Parthenon" is how Pausanias introduces the building, while Plutarch, hedging his bets, calls it the *Hekatompedon Parthenon*.[33]

In fact, the terms *parthenon* and *hekatompedon* are both applied to the Periklean building in fifth-century inscriptions, but there, in the opinion of most scholars, they refer only to parts of the structure, rather than to the whole thing [Fig. 127]. Beginning in 434/3 the Treasurers of Athena routinely published inscribed inventories listing the sacred property – the gold, silver, and other precious goods, the booty, the furniture, the dedi-

cations – stored in the building's *pronaos* (the east, or front, porch), its *hekatompedon* (the large eastern room, just over 100 Attic feet long, which contained the statue of Athena Parthenos), and its *parthenon* (apparently the smaller but still imposing western room, with four tall interior Ionic columns, Fig. 128);[34] other inscriptions inventory the holdings of the *opisthodomos*, which, if it was not a separate structure altogether (the rebuilt western half of the *Archaios Neos* destroyed by the Persians), would be the back (western) porch of the Periklean building. In this view *parthenon*, which originally designated only one room of the building, in time came to be applied to the entire structure. The implication is that Pheidias's great gold-and-ivory statue of Athena [Fig. 25] owed her name to the terminology developed for the temple: the goddess was called Athena Parthenos because her image stood in the Parthenon.

This interpretation of the nomenclature presents certain problems. For example, Athena had attracted the epithet *parthenos* long before the construction of the Periklean building [cf. Fig. 32],[35] and it is unclear why the western chamber of the Periklean temple should have been called the *parthenon* in the first place. The word means "[Room] of the Virgin (or Virgins)." But although some have supposed that the maidens referred to were the *Arrhephoroi* (who some think began weaving the Panathenaic *peplos* here) or even the daughters of Kekrops (who might have enjoyed an eons-old cult on this spot), there is no evidence that this was so. The room with the four columns, with its high ceiling and windowless walls (and, in the fifth century at least, jampacked with treasure besides) [Fig. 128], was surely not an ideal place to work a loom, and the *Arrhephoroi* had their own house elsewhere on the Acropolis, anyway [Fig. 3, no. 8]. So, too, a recent notion that the room was built over the tombs of Erechtheus's sacrificed daughters has nothing to commend it. On the other hand, there is some evidence that the western room of the building (together with the west porch) was in fact the *opisthodomos* of the inscriptions. We are told that in the winter of 304/3 the Athenians, to their everlasting discredit, allowed the Macedonian nabob Demetrios Poliorketes to lodge (together with a number of female companions) "in the *opisthodomos* of the Parthenon." The shallow and partly exposed west porch (*opisthodomos* in the normal terminology of Greek temples) was no place for a potentate like Demetrios to reside and hold his orgies (especially not in winter), and the story only makes sense if he and his entourage occupied the spa-

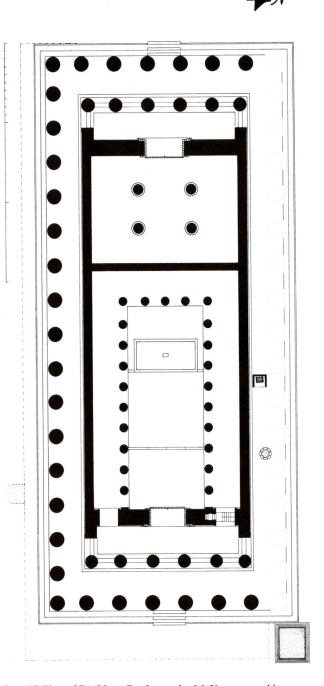

Fig. 127. Plan of Periklean Parthenon by M. Korres; used by permission.

cious and closed room behind. The anecdote implies that the usual nomenclature for the parts of a Greek temple was adjusted to apply to the entire (and unusual) western section of the Periklean building, room and porch together.[36] As for the *hekatompedon*, it was likely an inherited term, a legacy of two or three generations of precincts or buildings on the south side of the Acropolis: the Older Parthenon [Fig. 111], had it been finished, might have been called the same thing (its large eastern room was also about 100 Attic feet long). And it may even be that the term serendipitously designated an actual (if rounded off) dimension of the Periklean structure (the interior length of the east room, or even the width of the stylobate). But by the fifth century, one hundred feet was no longer a spectacular architectural dimension, and it is thus likely that the term *hekatompedon*, besides linking the new building to its architectural heritage, primarily bestowed a certain grandeur upon it: that is, the word was a traditional epithet connoting not so much length as venerability.[37] As for the *parthenon*, no inscription mentioning it antedates Pheidias's creation of the Athena Parthenos itself, and it is hard to see why any other room but the one in which the gold-and-ivory statue of Athena Parthenos stood should ever have been called the "Room of the Virgin." In short, it looks as if the Periklean building came to be called "the Parthenon" because that was the epithet of the goddess whose great image loomed within it. The building did not give its name to the statue, the statue gave its name to the building (first to the eastern part, then to the whole thing).

But there are serious difficulties with this view, too. For example, the inventories of the treasures stored in the *parthenon* and *hekatompedon* were inscribed on separate blocks, indicating that they were distinct rooms and not just alternative names for the same thing.[38] The problems of nomenclature may not be entirely resolvable, and readers may wish to follow the orthodox view that the spaces of the Parthenon were as a rule called, from east to west: *pronaos* (front or east porch), *hekatompedon*, *parthenon*, and *opisthodomos* (back or west porch). It may be, too, that our problems have something to do with the unusual nature of the building itself. For however much the Parthenon looks like a temple [Fig. 126], it did not exactly function like one. Certainly, it was surrounded by a colonnade like a normal Greek temple (even if its peristyle of forty-six columns – eight in the facades, seventeen along the flanks, counting corner columns twice – is unusually grand). It had a cella like a Greek temple (even if it had two large and unconnected rooms

Fig. 128. Reconstruction of west room of the Parthenon. Drawing by I. Gelbrich, after D. Harris 1995, fig. 1.

set between proportionally shallow porches, instead of the usual one room between deep porches – in this respect it was like its predecessor, the Older Parthenon, and other "double temples" built on the Acropolis [cf. Figs. 93, 107, 174]). It housed a statue of a divinity, like a normal Greek temple (even if this one was exceptionally large and costly). It was adorned with narrative sculptures, like many Greek temples. It could even be called, generically, a *neos* ("temple"). And yet the Parthenon was almost certainly not a temple – at least not in the usual sense of the word. No ancient source ever refers to the "Temple of Athena Parthenos." Signficantly, we hear nothing of any "priestess of Athena Parthenos." There is no evidence for an altar – the *sine qua non* of cult – in front of the building. The principal altar on the Acropolis was always the one on the north side of the rock [Fig. 3, no. 12], the one sacred to Athena Polias, whose olivewood statue was the principal object of worship and whose possessions and dedications could even be stored inside the Parthenon. Sometimes, it is true,

divinities could share altars, but so far as we know no Periklean-era sacrifices or dedications were ever made to Athena Parthenos. And while visitors must have marvelled at Pheidias's great gold-and-ivory statue, no one ever worshipped her (at least not until the fourth or fifth century AD, by which time the far more ancient and sacrosanct statue of Athena Polias may no longer have existed).[39] In short, the Parthenon was not the focus of Classical cult. It looked like a temple without actually being one.[40]

It functioned instead as a treasury, as a votive, and as a symbol. In effect, the Parthenon was the central bank of Athens, where a large percentage of Athena's (and thus the city's) material assets was stored, and where its single greatest treasure, the statue of Athena Parthenos itself [Fig. 132], wore robes plated with some forty talents worth of gold – the very gold Perikles said could be removed and spent if the (mis)fortunes of war required. The cella of the building, in fact, had the character of a strongbox: the spaces between the columns of both the east and west porches were screened by grilles [Figs. 127, 129] and the great doors to the west and east rooms – the east door was slightly narrower but both were richly decorated with such ornaments as the heads of lions, rams, gorgons, and poppies – could be locked.[41] Even before the finishing touches had been put to the Parthenon, the Athenians had deposited considerable holdings within it. In the *pronaos*, the inventories of 434/3 inform us, there were one gold *phiale*, 113 silver *phialai*, six silver cups and drinking horns, a silver lamp, and a small, gilded, wooden cup in a case. In the *hekatompedon* there were (in addition to the statue of Athena Parthenos) three gold *phialai*, a gold *kore* on a stele, and a silver sprinkling vessel. And in the *parthenon* there were one gold crown, five gold *phialai*, unmarked gold, a gold cup with a silver base, two large and expensive nails (!) made of silver and gold, a silver and gold mask, a group of silver *phialai*, six gilded Persian swords, twelve gold corn stalks, three gilded wooden boxes of various types, one gilded *thymiaterion* (censer), another gold *kore* on a stele, a gorgoneion, a worm, a horse, a griffin, a griffin's head, a lion's head, a flowery wreath, a snake (all of these of gold leaf), a gold-plated helmet, thirteen gilded wooden shields, eight couches made on Chios, ten couches made at Miletos, assorted knives, breastplates, shields, thrones, stools, and campstools, a gold lyre, ivory lyres, lyres of unspecified material, an ivory table, three bronze helmets, and three couches with silver feet.[42] The holdings increased year by year,

Fig. 129. Detail of columns of Parthenon *pronaos*, with cuttings from iron grilles. Photo: author.

even during the Peloponnesian War. For example, by 418/7 (a year of peace) the *hekatompedon* alone boasted not only the three gold *phialai* (here said to weigh 2,544 *drakhmai*), the gilt *kore* on the stele, and the silver sprinkler mentioned in the inventory of 434/3, but also a pair of gold crowns; the gold crown (weighing 60 *drakhmai*) held by the figure of Nike perched on the hand of the Athena Parthenos; eight silver *phialai* averaging 100 *drakhmai* apiece; a silver drinking cup; another silver drinking cup, this one weighing 200 *drakhmai* and belonging to Zeus Polieus; eight more gold crowns of various weights; four gold vessels of various weights; another crown of gold; a silver vessel; a silver *thymiaterion* weighing 1,000 *drakhmai*; and three more gold crowns (these last crowns, one of them weighing an impressive 1,250 *drakhmai*, were added to the treasure in the year of inventory). The vases, crowns, and other items recorded as being in the *hekatompedon* were proba-

Fig. 130. Reconstruction of *pronaos* of Parthenon. Drawing by M. Korres, used by permission.

bly stored on shelves set against the walls of the room and their aisles would have been partly illuminated by light let in from two large windows that were set high into the east wall of the cella [Fig. 127, 130].[43] All told, the *hekatompedon* treasures of 418/7 were worth a relatively modest ten talents. But, like the gold of the Athena Parthenos, they were potentially expendable assets, and while the Athena Parthenos managed to survive the Peloponnesian War intact, all but a few of the objects inventoried here were in fact melted down at the war's end to help pay the bills.[44]

The Parthenon, then, was a vast, spectacular treasury, but a treasury nonetheless, a monumental Periklean version of the kind of sculpture-filled storehouses (*oikemata*) that we think dotted the Acropolis (and perhaps particularly the south side – the Parthenon side – of the Acropolis) in the Archaic period [cf. Fig. 83a]. It was

at the same time a votive, a dedication to Athena, as well as a renewal of the Older Parthenon, the late Archaic temple built as a thank-offering to the goddess for the Athenian victory at Marathon in 490. It is not clear whether the Older Parthenon would have been any more of a "temple" in the conventional sense of the word than the Periklean Parthenon was, but there is no question that the architects of the Classical building were highly conscious of its aborted predecessor: its remains, much still scorched by Persian fire, had, after all, stood on the south side of the Acropolis for over thirty years, and while scores of unfinished column-drums were built into the north citadel wall [Fig. 35] scores more still lay about the summit. These remains constituted both an enormous challenge to the Periklean architects and an opportunity.

The plan of the Periklean Parthenon [Fig. 127] essentially represents a noticeable widening (by two columns)

and a slight lengthening (by one column) of the plan of the Older Parthenon (which would have had a peristyle of 6 × 16) [Fig. 108]. In other respects, it is a variation, an elaboration, of the Older Parthenon (it, too, was to have two great rooms within it and it, too, included Ionic features). The Classical building rests, for the most part, on the massive Peiraieus limestone platform that was to support the Archaic one [Fig. 106]. But while the Older Parthenon was set symmetrically atop the podium, the new building was shifted to the west and north. More bedrock had to be prepared and additional foundations laid for a width of almost five meters on the north (this expansion, again, had to preserve the older shrine just to the north of the Older Parthenon – the small *naiskos* and its circular altar – and incorporate it into the space between the north colonnade and cella wall [Fig. 21]). On the other hand, the eastern edge of the podium is left unoccupied for a width of 4.26 meters, and the southern edge for 1.68 meters. Much of the stepped platform (or *krepidoma*) of the Older Parthenon was encased within the Periklean one – the old steps can be seen through the cracks in the new ones – and most of its unfinished column drums and column capitals were cut for re-use in the Periklean building (with the result that although the later columns were taller, their diameter was exactly the same as the earlier columns).[45] Of course, the recycling of so much material was primarily cost-effective, and any economy in a building estimated to have cost 700 or 800 talents would have been advisable. But the re-use of Older Parthenon stones had, perhaps, a symbolic value as well. The fabric of the Classical temple was largely made up of material from the embryonic building destroyed by the Persians in 480 [Fig. 111], and so in a sense the new Parthenon was a reconstruction, even a reincarnation, of the old. Thus, the Periklean building could be considered both a monument to Marathon, like its predecessor, and to all those victories won over the Persians after their desecration of the Acropolis in 480.[46] In the fourth century, in fact, it could be said that the Parthenon was built not from imperial tribute (as Plutarch much later implies) but from the spoils taken from the barbarians, and this may not be far off the truth. At the same time, the Periklean Parthenon was more broadly a monument to the wealth and power of Periklean Athens, and thus it was also (somewhat surprisingly) said that the building was an *anathema*, a votive offering, not in honor of Athena but of her glory-seeking, democratic, imperial city. It was a dedication by the *demos* (people) to the *demos*.[47]

Plutarch says the architects were Iktinos (who probably was not an Athenian) and Kallikrates (who probably was). Vitruvius says that Iktinos and a certain Karpion wrote a book about the project (probably a technical manual dealing with matters of engineering and proportion, but also, perhaps, with such unusual features as the windows and staircase, leading to the ceiling, built into the east cella wall) [Fig. 127]. About Karpion we hear absolutely nothing more anywhere, and one suspects that the name is a mistake for Kallikrates (who, as we have noted, is elsewhere said to have co-authored a book with Mnesikles).[48] Iktinos ("The Kite," presumably a nickname) is said to have been the architect of the Temple of Apollo at Bassai and one of the architects of the Periklean Telesterion at Eleusis, and Kallikrates, we know, was in charge of several Periklean projects on the Acropolis and off (for example, the Long Wall to Peiraieus). How they divided up work on the Parthenon we do not know for sure, but to judge from the other works attributed to him (including, possibly, the modest first phase of the Classical Nike sanctuary, Fig. 125) Kallikrates was probably the building's "general contractor," the one charged with organizing the enormous, practical effort of construction, while Iktinos was more likely the actual designer of the Parthenon, its "true" architect, the one most responsible for its originality.[49]

What Iktinos designed was the largest and most sumptuous building that had ever been constructed on the Greek mainland,[50] a structure surely meant to surpass in size and grandeur the purely Doric Temple of Zeus at Olympia (finished less than a decade before) and so to seize the architectural field for Athens (the fact that the Parthenon's exterior columns are 10.43m high – almost exactly the same height as those of the Temple of Zeus – cannot be coincidental).[51] It is now clear that the unique plan of the Parthenon – there is no other such octastyle peripteral Doric temple in Greece – underwent many changes and adjustments as work progressed (not an unparalleled course of events on the Acropolis), and the ability to make such adjustments in so vast an undertaking must have been part of Iktinos's genius. But the finished product is remarkable above all for the harmony of its carefully calculated proportions and for its so-called "refinements." Critical dimensions of the Parthenon, for example, are governed by a ratio of 9 to 4: that is the proportion of the length of the stylobate (the top step) to its width, and of the width of the stylobate to the height of the order (the column and entablature

together), and of the axial spacing (the distance between the centers of two neighboring columns) to the lowest diameter of a single column. It is a fair assumption that Iktinos (and Karpion, whoever he was) outlined the principles behind this proportioning in the book that Vitruvius had available to him.

The book would presumably have also discussed the techniques and explained the purposes of the many kinds of "refinements" that characterized the Parthenon. These consisted of a series of slight but intentional deviations from the straight and perpendicular, from the horizontal and vertical. The peristyle columns do not stand perfectly straight, but tilt inward (extrapolated infinitely upward, the lines of the flank columns would meet at a point approximately 2,000 meters above the floor of the building, those of the facade columns about 4,800 meters above the floor) [Fig. 131]; the side walls of the cella tilted inward, too. The column shafts do not taper perfectly, but swell out slightly at the center (*entasis*). The corner columns of the peristyle are a little thicker than the others. The metopes tilt outward, the triglyphs in. The stylobate itself curves noticeably upward along both the facades and the flanks, and the curve was carried up through the peristyle to the entablature. Now refinements such as these were nothing new (*entasis* is far more pronounced in some sixth-century Doric temples, for example, and the upward curvature of the stylobate, which also first appears in sixth-century temple architecture, had been planned for the Older Parthenon – it actually starts in the foundations, Fig. 106). Refinements were utilized in other Periklean buildings on the Acropolis as well (the columns of the Propylaia, for example, incline even more than the Parthenon's). But the Parthenon presents an extraordinarily rich combination of refinements and represents the climax of the practice.[52]

To create such subtle deviations from the purely horizontal and vertical meant that virtually every block had to be cut, on the spot, to its own distinct specifications. This was normal Greek architectural practice anyway. But the Parthenon's wealth of refinements demanded even more painstaking work than usual and thus the building, so economical in the re-using of Older Parthenon marble, was extravagant in their use. Basically, there could have been only one justification for the greater expense they required: appearances. The refinements were intended to make the Parthenon look good. It is true that the curvature of the stylobate has a practical function: it drains off rainwater. But there is no such prosaic explanation for *entasis* or the tilting of the columns,

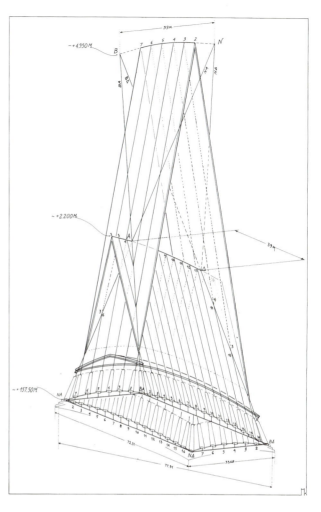

Fig. 131. Exaggerated rendering of upward curvature and inclination of columns of Parthenon. Drawing by M. Korres, used by permission.

and it has been far more common to think of the refinements as either "corrective" or "aesthetic" devices.

That the refinements corrected, or compensated for, unwanted effects in a perfectly "straight" or regular temple is an idea as old as antiquity itself. Vitruvius, who (it is important to remember) had many ancient architectural manuals on his bookshelf besides Iktinos's, clearly believed that refinements generally counteracted "optical deceptions." A perfectly straight stylobate, he thought, would appear to sag if not given a slight curve; a corner column silhouetted against the sky would appear too weak unless thickened; architectural members high up on a temple should tilt so that they will appear plumb, and so on.[53] Whether the optical illusions and corrective effects Vitruvius describes in fact

occur – whether, for example, a long straight line will really appear to sag and only an upward curvature can make it look straight – is not the point. The point is that Vitruvius, himself an architect, apparently followed a long tradition in believing they did. The Vitruvian explanation, we should also note, assumes that buildings like the Parthenon were *meant* to look absolutely straight and precisely perpendicular.

What the refinements were supposed to do, and what they in fact do, are, however, two different things. And most modern scholars (with a little ancient literary support) have found them at least to some degree aesthetic or expressive. The theory is that a building (especially one as large as the Parthenon) displaying absolutely straight lines and precise right angles and perfectly evenly spaced columns and so on will appear dull, stiff, and mechanical. The refinements mitigate that static effect by introducing nuance. Even if they are only intuitively sensed, they create subtle, unexpected variations, and variations create visual interest. In other words, the refinements enliven the building by establishing a tension between what one assumes is or should be there (say, a straight line or taper) and what one actually sees (a curve or swelling). The resulting tension intrigues the eye by offering it deviations from normal visual experience. Whatever their original purpose, the effect of the refinements is very much in the eye of the beholder: the experience is subjective. For some, the curvature of the stylobate seems to lighten the Parthenon, making it seem as if it were ready to lift off the rock [Fig. 126]. For others, or from a different angle [Fig. 136], the curvature creates an impression of weightiness, as if the building were conforming itself to the shape of the summit or hugging the ground, or were being pulled down at the corners by the forces of gravity. Similarly, the *entasis* of a column makes it appear to "feel" or respond to the weight it supports, as if it were somehow a living mass, a body under pressure.[54] But however we read them, the refinements give the Parthenon an extraordinarily "plastic" or sculptural quality. The curves, the inclinations, the swellings seem the result of an architect "modelling" the building the way a sculptor models a statue. The Parthenon has in fact been called "a sculptor's temple," and in one overarching sense (if we can trust Plutarch) this is literally true: Iktinos the architect labored under the supervision of Pheidias the sculptor, supposedly the overseer of the entire Periklean building program.

Pheidias's role on the Acropolis was surely not as comprehensive as Plutarch implies (the Propylaia, for

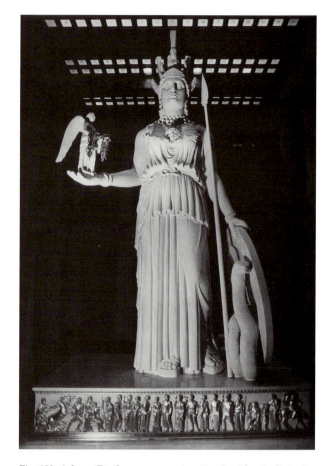

Fig. 132. Athena Parthenos, reconstruction by Alan LeQuire in Nashville, Tennessee (1990). Photo G. Layda for the Metropolitan Government of Nashville and Davidson County. Courtesy Wesley Paine and the Nashville Parthenon.

example, was built when Pheidias was no longer in Athens). But in the case of the Parthenon it was apparently the sculptor's conception of the building that mattered most, and Pheidias apparently conceived of it above all as an appropriately lavish container for his chryselephantine Athena Parthenos – a statue, it should be noted, that cost at least as much as the Parthenon itself, and maybe a lot more [Fig. 132]. It was probably to accommodate Pheidias's enormous statue – to give it more elbow room, as it were – that Iktinos widened his building so markedly over its predecessor, and it was to give the statue a more interesting backdrop that Iktinos introduced the first important change in Doric interior design in over a century. He extended the interior double-decker columns of the cella (normally set in two parallel rows) around the back of the statue [Fig. 127], so that the Athena was virtually surrounded by its own

two-storeyed colonnade (10 × 5), a colonnade that was purely decorative in function (it played no supporting role) and that was meant simply to enrich the setting of the rich statue.[55] So, too, changes made to the cella during construction were apparently driven by changes in sculptural decoration. It is conceivable that Pheidias originally planned to set Doric metopes over the columns of the *pronaos* and *opisthodomos* (as in the Early Classical Temple of Zeus at Olympia) but then, while the building was under way, changed his mind, deciding on a long, continuous Ionic frieze (not only at the top of the exterior cella wall but also within the *pronaos*, Fig. 130) instead. This necessitated subtle alterations and adjustments in the plan of the cella (such as a deepening of the *pronaos* by 16cm and a 6-cm reduction in the diameter of its columns).[56] The construction of the Parthenon was thus a cooperative and continually revised effort. Kallikrates had his role. Iktinos had a greater, creative one. But it was Pheidias's evolving vision that in the end governed what they built.

Although the only Parthenon sculpture we know Pheidias created himself was the statue of Athena Parthenos, it is generally assumed that he was also the "master" of the rest of the sculptural program of the building – the metopes, the frieze, the pediments, even the great marble Nikai that probably perched on the four corners of the roof [Fig. 133], just as one perched in the hand of the Athena within [Fig. 132]. Pheidias could not have executed very much (if any) of this marble sculpture himself. Before 438 he was too busy with the Athena Parthenos. After 438, Pheidias was in Olympia creating the gold-and-ivory statue of Zeus (incidentally, the only other Parthenon artist whose name we definitely know was an assistant and turncoat named Menon, but Pheidias's big-time pupils Agorakritos and Alkamenes are often thought to have been responsible for the execution of the pediments and frieze in his absence).[57] It is nonetheless possible (though not provable) that the conception or design of the overall program was his, that he was responsible for assembling and training the sculptors necessary to do the job, that he (in consultation with Perikles or the citizen assembly) decided upon the subject matter of the various parts of the program, even that he made the sketches for the metopes and frieze and the clay models for the pediments and akroteria.

The Metopes. The sadly damaged and corroded west metopes [Fig. 126] represented duels between Greeks (nude or nearly so, on foot) and Amazons (elab-

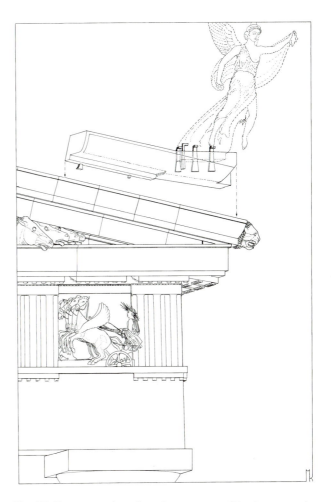

Fig. 133. Reconstruction of northeast corner of Parthenon roof. Drawing by M. Korres, used by permission.

orately dressed, some on horseback). Greeks fought Amazons – formidable women-warriors from the east, or at least from beyond the boundaries of the civilized (i.e., Greek) world – on more than one mythological occasion, and an Amazonomachy had already filled at least some of the metopes of an enigmatic building built on the Acropolis (or its south slope) around 480.[58] But the battle represented in the west metopes was fought to repel an Amazonian (and hence foreign) invasion of Athens itself. The same story – specifically the Amazons' attack on the Acropolis – was depicted on the exterior of the shield of the Athena Parthenos [Fig. 161], and the allusion to the Persian invasion of 480 would have been lost on no one: in their oriental garb and hats, the Amazons even looked like Persians. The mostly indecipherable north metopes [Fig. 134] – like those on the west and east sides they were mutilated systematically by

Fig. 134. Parthenon, north metopes. From Boardman and Finn 1985, 234 (after Carrey drawings). Used by permission.

Christians, randomly by Moslems – evidently depicted a series of separate episodes from the Trojan War (yet another struggle pitting west against east), particularly from the night of the sack of Troy. The main narrative was set between two metopes giving it a cosmic setting (a common Parthenon motif): north 1 represented Helios rising in his chariot, north 29 showed Selene plunging below the horizon on horseback.[59] The most easily readable reliefs in between showed Menelaos, in one metope, rushing toward Helen in the next [Fig. 135]: Helen seeks refuge at an archaistic statue of Athena (the Trojan Palladion) while Aphrodite and a tiny Eros head off her enraged husband and, across the intervening triglyph, try to talk him out of doing her harm (again,

the Palladion may possibly have alluded to the statue kept in the old *naiskos* preserved in the north colonnade of the Parthenon, Fig. 21). The three westernmost metopes on the north depicted other gods and goddesses who had an interest in the Trojan proceedings: north 32, the best preserved (the Christians thought it was an Annunciation and left it alone), shows a formidable goddess seated on a rock, talking things over with a standing goddess. One is probably Athena herself and is thus one of the many Athenas or representations of Athena that the visitor would see on and within the Parthenon (for example, the Palladion in Fig. 135, possibly the statue in south 21, Fig. 139, and of course the Athena Parthenos herself, Fig. 132). The east metopes

Fig. 135. Parthenon, north metope 25. Courtesy DAI-Athens (Ng. Akr. 2308)

[Figs. 136, 137] depicted the Battle of the Gods against the Giants, who tried to take Olympos and overthrow the cosmic order. The story, of course, had already had a long history on the Acropolis [cf. Figs. 31, 96], it had been woven into all the Panathenaic *peploi* that had been (and would ever be) presented to Athena Polias, and it was shown on the inside of the shield of the Athena Parthenos. These metopes are in such bad shape that the identification of many figures is guesswork, but Athena (crowned by Nike) was certainly shown in east 4 and Zeus, near the center, in east 8. Herakles, the hero whose presence was essential for the triumph of the gods, was perhaps shown in east 11, where he would have occupied a position symmetrical to Athena's in east 4.[60] Helios, also shown rising around the corner on north 1 [Fig. 134], drove his four-horse chariot in the other direction on east 14 [Fig. 133]. The south metopes were the least conspicuous of the four sets – most Acropolis traffic passed down the north side of the Parthenon. But perhaps because of their position – it is often assumed they were harder for post-antique occupants of the Acropolis to hack away at – and certainly because of Lord Elgin (who began removing many of them to England in 1801) they are the best preserved of the lot [Figs. 138, 139]. Most of the metopes (south 1 through 12 and 22 through 32) showed the Greek Lapiths fighting the centaurs, whose drunken violence disrupted the wedding of their king Peirithoos (best friend of Theseus, hero of Athens, who may be the Greek in south 32) to Hippodameia, by some accounts the daughter of the Athenian hero

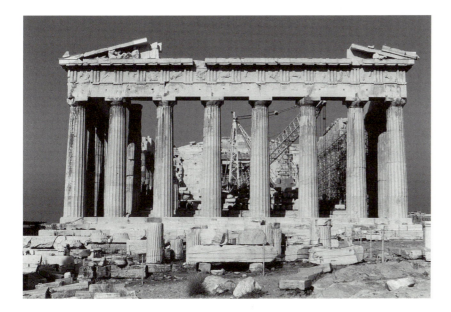

Fig. 136. Parthenon, east facade (in the foreground are the remains of the later Temple of Roma and Augustus). Photo: author.

1 2 3 4

5 6 7 8

9 10 11 12

13 14

Fig. 137. Parthenon, east metopes. After Boardman and Finn 1985, 235. Used by permission.

Fig. 138. Parthenon, south metope 27 (British Museum). Photo: author.

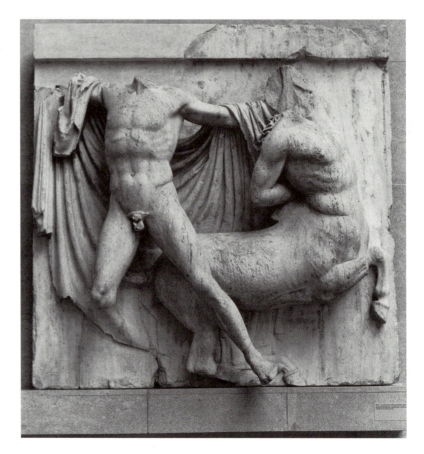

Boutes, who had an altar on the north side of the Acropolis. The myth had appeared in Greek wall- and vase-painting before, but this is the first Athenian treatment of the story in stone. A few metopes show centaurs carrying off women from the wedding feast. Most show individual duels. And this is no rout: the centaurs (who occasionally use wine jugs as weapons) win their share of battles, and some Lapiths fall and die.

The central eight or nine metopes (south 13 through 20 or 21) are, however, an enigma: they were blown off the building in 1687 and were thus not there to be taken by Elgin. Fortunately, all the south metopes had been drawn thirteen years before the explosion by a journeyman artist named (apparently) Jacques Carrey [cf. Fig. 139]. And since centaurs are absent from the missing metopes it is apparent that they did not represent the same story, or the same stage of the story, as the others (centaurs are absent from south 21, too, but here two women, one of whom is apparently disheveled with her breasts exposed, may have been shown escaping to the protection of a cult statue). In recent years important fragments of these "intrusive" metopes have been identified, but nothing that clinches their interpretation.[61] Perhaps, it has been suggested, they depicted the story of early Athenian kings or heroes – Daidalos, for example whose tragic flight with his son Ikaros might be the subject of south 15 and 16 (the fallen youth in south 16 has in this reading flown too close to the chariot-borne Helios in south 15). Still, such stories are either unrelated to the flanking centauromachy or can be related to it only by straining oneself. It is less taxing to see in these metopes the story of the lust, violence, and madness of Ixion, who was at the same time the father of Peirithoos and grandfather of the centaurs, antagonists in the battle raging to the left and right. In this view south 13–20 filled in the narrative background for the centauromachy: they would be in the nature of a mythological "flashback." Such an interpretation is particularly appealing to the modern eye, attuned as it is to the cinema (it has been doubted for that very reason, but fifth-century Athenians would have been familiar with similar debriefings in the choral odes of tragedies).[62] On the other hand, these eight or nine metopes might have depicted legends or rituals concerning important images of Athena, in which case they would have had clear associations with metopes depicting Athena and her statues on the north. South 15 and 16 might depict the story of the arrival in Athens of the Palladion when, we are told, an Athenian youth was trampled by a chariot team (the Palladion itself was,

Fig. 139. Parthenon, south metopes. From Boardman and Finn 1985, 236–237 (after Carrey drawings). Used by permission.

again, shown at Troy on the other side of the building, in north 25 [Fig. 135]). South 19 seems to have represented the spinning of cloth, south 20 the removal of a robe or *peplos* in a roll from a loom, and south 21 (which, again, might belong to the Centauromachy) the disrobing of a stiff, old-fashioned cult-statue (the Athena Polias?) in anticipation of the presentation of a new dress: the central events of the *Plynteria* and *Panathenaia* come readily to mind [cf. Fig. 151].[63]

In any case, the south metopes (the only ones preserved well enough to allow more than superficial analysis) vary greatly in form and style. Some panels have projecting bands of stone as groundlines for their figures, some do not. The faces of some centaurs resemble grotesque masks (south 31); others are handsome and idealized (south 4) or even grandfatherly (south 29). One or two compositions (for example, south 10, in the Louvre) are disasters; many (for example, south 30) are merely mediocre; a few are masterpieces (the composition of south 27 [Fig. 138] depends upon the crossing of two powerfully oblique figures, creating a "V" often thought to characterize Pheidian design as a whole). The usual explanation is that the metopes were the first Parthenon sculptures to be executed (they had to be, since they needed to be inserted as the building rose) and that Pheidias had not yet had the time in the mid-440s to homogenize the styles of his various teams and so gave his sculptors their heads (if, however, Pheidias supplied the sketches, he might fairly be blamed for the awkwardness of some compositions). But the unevenness of the south metopes, as well as the apparently intrusive subject matter of south 13–20/21, may also have had something to do with Pheidias's rethinking of the Parthenon's sculptural program. Perhaps some of these metopes were originally carved for placement above the *pronaos* and *opisthodomos* and were moved to the south side, where they would be less obvious, after the decision was made to go with an Ionic frieze atop the cella wall instead. The Parthenon, as we have seen, was full of re-used material, and the economic recycling of metopes that had originally been designed for another location on this very building – perhaps above all the middle south metopes, whose presence seems iconographically forced – would not have violated the spirit of the project.[64]

The Pediments. Pausanias does not mention the Parthenon's metopes, perhaps because they were overshadowed in his eyes by the building's huge pediments – 28.8 meters wide, 3.4 meters high at their center, each one filled to the brim with about twenty-five over-life-size and often dramatically posed marble figures. These works he does mention, and fortunately he also identifies their subjects. Now, even without Pausanias's testimony we would eventually have been able to figure out that the west pediment [Fig. 126] depicted the contest between Athena and Poseidon for patronage rights to Athens. There is no earlier representation of the myth to compare it to, but we have Carrey's drawing, made when many of the sculptures were still in place [Fig. 140]; we possess large fragments of the central figures [Fig. 141]; and there are a couple of slightly later vase-paintings that seem partly or indirectly dependent on the Parthenon's version. But without Pausanias's testimony that the east pediment [Fig. 136] depicted the Birth of Athena, we would have had no idea what was shown up there: the central sculptures had apparently been removed (none too gently) over a thousand years before Carrey arrived [Fig. 142], when Christians transformed the Parthenon into a church and built an apse on this side; the figures they left in the angles are by themselves not enough to help.

The west pediment [Fig. 126] was the first to be seen by the ancient visitor to the Acropolis, though one would have to have viewed it above the mass of monuments, walls, and shrines that cluttered the field of vision of anyone passing through the Propylaia, obscuring much of the Parthenon itself [cf. Fig. 124]. The pediment still loomed over all, its drama enlivened by colorfully painted and even partly gilded figures, some with bronze additions or attributes, all set off by the red background of the pedimental back wall. Appropriately, the location of the depicted myth was the Acropolis itself – specifically the area now covered by the Erechtheion [Fig. 3, no. 9]. But, as we have noted before, it is not clear which version of the myth of the contest between Athena and Poseidon, or what point in their dispute, was shown: the moment Athena and Poseidon actually create their tokens (the olive tree, the salt sea), or the moment Zeus hurls his thunderbolt to prevent his daughter and brother from coming to blows, or even the moment when Poseidon, denied the victory, floods the Attic plain in anger.[65] It is thus not clear whether Athena and Poseidon are to be thought of as leaping down from their braking, rearing chariots (Athena's driven by Nike, Poseidon's by his wife Amphitrite) after their race to the citadel, or whether, having swept in from either side, they are now recoiling from the force of their own miracles (the eruption of the olive from the pedimental floor or the blow of Poseidon's trident), or whether they are

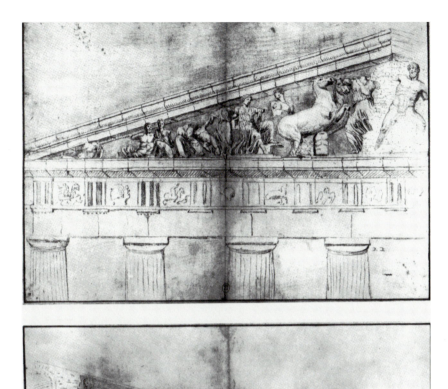

Fig. 140. Drawings by J. Carrey (?) of Parthenon west pediment. After Omont 1898, pls. II and III.

Fig. 141. Torso of Poseidon, from Parthenon west pediment (Acropolis 885 and British Museum). Photo: author.

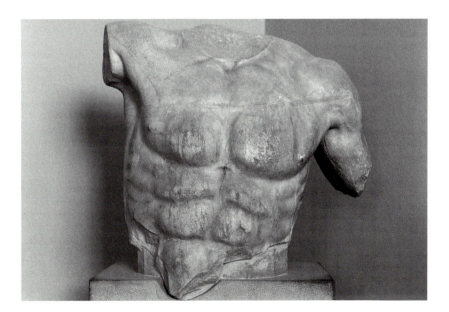

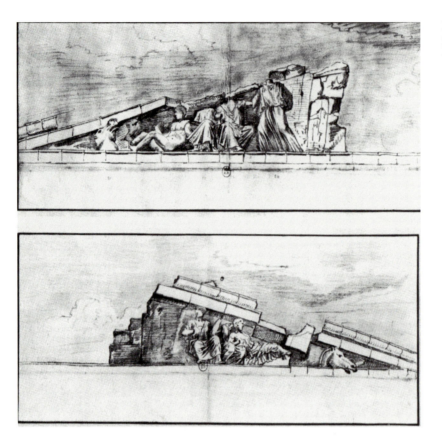

Fig. 142. Drawings by J. Carrey (?) of Parthenon east pediment. After Omont 1898, pl. I.

taken violently aback by the shock of Zeus's intervention.[66] What is clear is the explosiveness of the composition, as the figures of Athena and Poseidon cross in a great "Pheidian V" – Poseidon actually overlaps Athena and thus seizes the foreground in what may be an acknowledgment of the power of the sea-god, in whose province the Athenian navy had been so successful since Salamis – and the agitated figures to the left and right react to the violence of the center. The figures in the angles represent the royal population of Athens before it *was* Athens – mortals (or at least heroes) rather than gods [Fig. 143]. The semi-reclining figure near the north angle is surely the autochthonous Kekrops, king at the time of the contest and chief witness according to some accounts; he is identified by the snake coiled on the ground beside him. The young woman wrapping her arm around his shoulder should therefore be one of his daughters, probably the good Pandrosos (father and daughter had adjacent shrines on the north side of Acropolis, in the Erechtheion complex). Logically, Herse and Aglauros should be there, too, and the boy between them could be either Erichthonios or Kekrops's rather insignificant son Erysichthon. Hermes appeared behind Athena's Nike-

driven chariot, and a strange, legless but perhaps originally snaky-tailed male figure (another autochthonous Attic hero like Kekrops?) rose from the pedimental floor to support Athena's horses. The identities of the figures in the other wing, behind Iris, Poseidon's chariot (his team was supported by a Triton),[67] and its charioteer Amphitrite (who apparently used a toothy sea-monster as a running board) are more problematic. That they are Attic heroes and heroines (or nymphs) of some sort seems indisputable. But some see in them the family of Erechtheus (whose cultic identity had by the mid-fifth century fused with Poseidon's, hence his position on the sea-god's side of the pediment), while others (preferring to place Erechtheus, Athena's foster-child, on her side of the pediment) see in them Poseidon's son Eumolpos and his Eleusinian entourage, and find in the contest between their "parents" a foretelling of Eumolpos's future invasion of Athens and battle with Erechtheus.[68] Whoever the figures in the wings are, the prominence of women and children is noteworthy. As for the reclining figures in the very angles, they are often identified as local river-deities: the one on the north, whose anatomy is genuinely fluid, is usually identified as the Ilissos, though the Kephissos

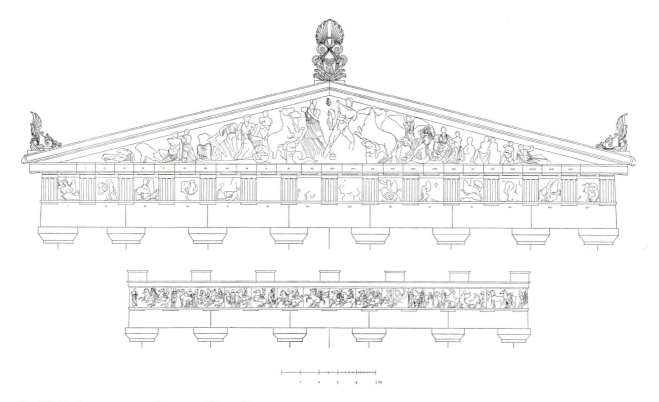

Fig. 143. Parthenon, west pediment and frieze. Reconstructions from Berger 1977, Falttafel III. Used by permission.

Fig. 144. Marble fragments of olive tree encoiled by snake (Acropolis 6510). Photo: author.

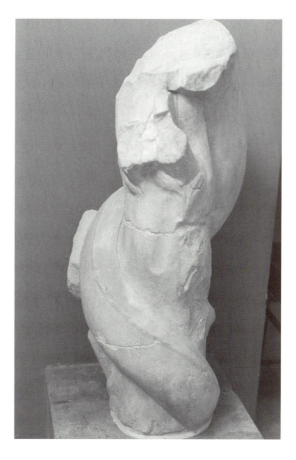

(which runs to the north of the Acropolis, Fig. 1) would perhaps make better sense geographically. In any case, the identification of these figures as personifications would mean that features of the plain below appear in a locale otherwise depicting the Acropolis summit, but the topographical compression would not have disturbed anybody: this, after all, was myth, and it was all Attica. The analysis of the west pediment is further complicated by post-Periklean repairs or additions. Athena's newly sprouted olive tree almost certainly stood against the pedimental wall at the center of the composition, but marble fragments usually thought to come from the tree are in fact Roman in date and the best preserved piece, with a snake coiling around a tree-trunk [Fig. 144], was not even found on the Acropolis. The original tree might have been bronze (so might Zeus's thunderbolt, if it was there at all).[69]

The problems presented by the west pediment are nothing, however, compared to those presented by the east [Figs. 136, 142, 145]. There are the usual disputes

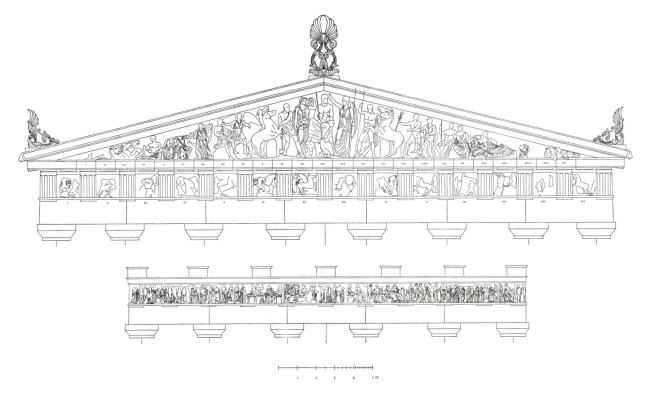

Fig. 145. Parthenon, east pediment and frieze. Reconstructions from Berger 1977, Falttafel II. Used by permission.

over the identity of most of the figures preserved in the angles. Is the powerful male nude reclining on an animal skin near the south angle Dionysos or Herakles? (The consensus favors Dionysos – who would then be looking down toward his theater on the south slope – even though a beardless and naked Dionysos would be at this time unique). On the other side, is the woman in whose lap the sensuous Aphrodite lies Dione (her mother according to Homer), Themis, or Artemis? (Artemis is an appealing choice, since she appears beside Aphrodite on the east frieze below.) There are disagreements over the relevance of such impressive pieces as the so-called Laborde head in the Louvre or the torso known as H (Acropolis 880). But the major debate hinges (naturally) on what has been almost totally lost: the nature of the center. Given the subject of the pediment, Zeus and Athena obviously appeared here. Hera did, too (there are two pieces of a colossal, stately *peplos*-wearing figure that may belong to her; cf. Fig. 146). But we do not know whether Zeus was standing or enthroned (as he almost always is in other images of the the birth), or whether Athena appeared on his right or left, or whether the central triad was flanked by recoiling figures (Hephaistos,

with his axe, and Poseidon, perhaps a little concerned about his future competition, would make sense) and rearing horses or chariot-teams (as in the west pediment) or by heavy groups of more gods. The basic question is whether the central composition was dynamic and V-shaped, like the west pediment, with Athena, having exploded from Zeus's head, rushing outward from the center, with the shock waves of her birth rippling through the attendant divinities on either side, or whether it was more static, dominated by the three sedate, standing, and more-or-less frontal figures of Athena, Zeus, and Hera. Recent analyses favor the static option [Fig. 146], though that would mean Pheidias radically abandoned the long established tradition of showing Zeus seated at the birth only to mimic rather conservatively the compositional scheme at the center of the east pediment of the earlier Temple of Zeus at Olympia.[70]

Unlike the contest with Poseidon, the birth of Athena had appeared on Athenian vases before; like the contest, the birth had probably not appeared in earlier sculpture.[71] The birth itself took place on Olympos, in the presence of divinities (there are no mortals or heroes

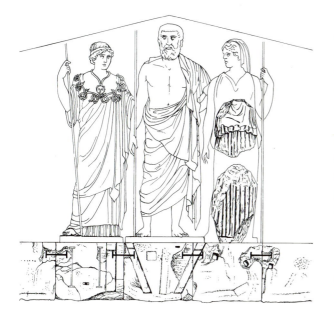

Fig. 146. Reconstruction of center of east pediment by K. Iliakis. From Palagia 1993, pl. 20. Used by permission.

here, unless the reclining nude is Herakles after all), and probably there was some favorable equation intended between the mountain of the gods and the mountain of the Athenians: the Acropolis, the scene of the other pediment. Here, however, the birth is given a heavenly rather than an earthly frame (another of several in the Parthenon sculptural program). In the south angle Helios (Sun), flat on his back, rises in his chariot: the real pedimental floor becomes an imagined horizon. (Like all the pedimental statues, incidentally, Helios and his horses were carved on the ground, but these figures evidently had to be recut when actually installed so that they would better fit their allotted space – another midcourse correction or adjustment so typical of the making of the Parthenon in general.)[72] In the other corner, Selene (Moon) drives her tired team – it has just traversed the night sky – below the horizon-floor; two of her horses stick their muzzles out of the frame of pediment, gasping for one last breath before descending [Fig. 136]. Helios and Selene are, in fact, the only extant figures whose identity is beyond dispute, and the event taking place between them is thus of cosmic significance. It is dawn. There is a new order on Olympos. The coming of Athena has changed the world.

The Frieze. The Acropolis had already had a fairly strong dose of the Ionic architectural order before the building of the Parthenon, and the insertion of an Ionic

sculptural form onto an otherwise Doric building was not unprecedented.[73] Still, as we have noted, the original design of the Parthenon may not have called for a continuous frieze; the decision to place one around the top of the cella's north and south walls and over the columns of the *pronaos* and *opisthodomos* was made only after construction was well under way [Figs. 127, 147].[74] It should not be regarded as heresy to wonder whether the decision was the right one. As a public monument – as an image obligated to speak readily and comprehensibly to a broad civic audience – the Parthenon frieze, as brilliantly executed as it is, was not a complete success, simply because it was not easily seen. Now, light was not a big problem: though the frieze was tucked up behind the peristyle, high atop the cella walls, just beneath the coffers of the ceiling, and though the light reaching it was thus indirect or diffused (its strength varied depending upon the side of the building and time of day), enough bounced off the fresh-cut white marble stylobate, walls, and columns for adequate illumination. Moreover, steps were taken to enhance the visibility of the frieze: the relief is only about five centimeters (two inches) deep, but it is cut a little deeper at the top than at the bottom, and the half-life-size figures (set against a rich blue background) were colorfully painted and enlivened by bronze additions (the reins and bridles of horses, for example, or accessories such as spears and wreaths, or, in one case, sandal straps).

The real problem was not lighting but position [Fig. 148]. In one sense, the closer one got to the frieze, the harder it was to see. The flanks and porches of the Parthenon are comparatively shallow: anyone wishing to view the frieze from within the peristyle – it stood about twelve meters above the floor – had to crane his neck uncomfortably, and even then the figures (no matter how well lit) would be extremely foreshortened and the compositions difficult to make out. One scholar has calculated that the best place to view the frieze was from a "zone or belt of observation," only a few feet wide, running all around the terrace of the Parthenon about thirty feet (a little over nine meters) distant from the stylobate – much farther away than that and the top of the frieze would be cut off by the entablature of the building.[75] Even for someone standing in this optimum zone, however, painted or bronze details might have made little impression and only small portions of the frieze would have been visible at any one time, since the columns of the peristyle rhythmically interrupted each and every view of the work. Now, Pheidias seems to

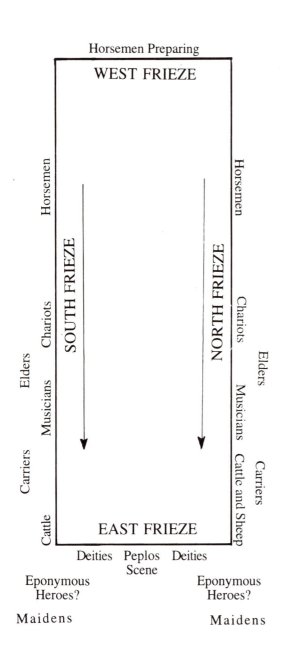

Horsemen Preparing

WEST FRIEZE

Horsemen

SOUTH FRIEZE

Chariots

Elders

Musicians

Carriers

Cattle

EAST FRIEZE

Horsemen

NORTH FRIEZE

Chariots

Elders

Musicians

Carriers

Cattle and Sheep

Deities Peplos Deities
Scene

Eponymous Eponymous
Heroes? Heroes?

Maidens Maidens

Fig. 147. Plan of Parthenon frieze. Drawing by I. Gelbrich.

Fig. 148. Reconstruction of west peristyle. Drawing by D. Scavera.

have recognized the problem and designed the frieze so that the spectator could pause at certain significant spots – on axis with the eastern door of the cella, for example – and so "frame" particularly dramatic, unified, or significant passages of the frieze between two columns [Figs. 149, 151]. Still, the only way to see the whole frieze was to move all around the building – the direction and momentum of the stone figures helped carry the flesh-and-blood spectator along – and so each viewer essentially created his own experience of the work.[76] This can be considered a positive thing – ancient interactive sculpture, as it were. But the Parthenon program may have sent mixed directional messages: the generally west-to-east direction of the figures in the north frieze was countered by the generally east-to-west direction of the

figures in the more conspicuous north metopes [Fig. 134] (was this counterpoint or neutralizing contradiction?).[77] Few viewers would have kept religiously to the narrow "zone of observation" in any case; few would have been motivated to follow the frieze all around the building in a single visit; and only ancient art historians are likely to have paused consistently to frame just the right figures between just the right columns. Most ancient visitors had more important things to do. Given all the other monuments in their sight (and in their way) typical visitors to the Acropolis would have had only an obscured, fragmented, and thus discontinuous experience of the continuous frieze. It is not really fair to use Pausanias, who does not mention the frieze, as an indication of just how inconspicuous it was: after all, Pausanias does not mention the metopes, either. Still, while he could not possibly have missed the metopes, he may well have missed the frieze. So, probably, did many others.

But this could be the wrong way of looking at it. Perhaps the frieze was not really a public monument after all, at least not in the sense that its principal concern was to be entirely and immediately perceptible to the Athenian populace walking below. Perhaps the frieze was more in the nature of a votive relief – a spectacularly grandiose version of the kind of reliefs that had long been dedicated by private citizens on the Acropolis, as in other sanctuaries [cf. Fig. 42], but with the entire Athenian *demos* acting as dedicator instead of an individual or family.[78] In that case, the "success" of the frieze did not depend so much on how conspicuous it might have been, or how legible its individual figures or general composition were. For its intended audience was not the Athenian on the ground, but Athena on Olympos, the ultimate and ideal spectator, the recipient of the grandest votive of them all – the Parthenon itself.

Most of the frieze (especially the north and south sides, where the figures overlap the seams between the slabs as if they were not there, Fig. 153) was carved in place by sculptors standing on scaffolding. The west and east sides, where the figures generally stay clear of the seams [cf. Fig. 152], may have been roughed out on the ground, then hoisted into place before finishing. At all events, all 119 frieze blocks, carved or not, had to be in place by 438 for architectural reasons, and theoretically the sculptors could have continued carving them down to 432.[79] It is possible, too, to detect in the details many "hands" at work: one horse's mane is treated differently from another's. Still, the overall effect of the frieze (as opposed to the earlier metopes) is one of remarkable styl-

Fig. 149. Reconstruction of center of east frieze seen through peristyle. After Stillwell 1969, pl. 69.14.

istic unity: the faces of the youths on the frieze, for example, all look very much alike, and a number of horses repeat identical (or nearly identical) poses or patterns, as if the same cartoons (sketches transferable to the stone) were used over and over.[80] No matter how the labor was apportioned, Pheidias had by now molded his frieze sculptors into a single, homogeneous team: it was the business of any one of them to know well what the others were doing, and how they were doing it, and blend in.

The interpretation of the frieze is perhaps the most difficult and frustrating problem in the study of Classical art, which is painfully ironic since we have about 80 percent of it (some 420 out of 524 feet), plus Carrey's (occasionally ambiguous) drawings to fill in many of the gaps (would we not be so perplexed if less of the frieze had survived?). Students of the frieze agree that it depicts a procession. They agree that the procession is "bifurcated," or divided into two streams: the longer stream starts at the southwest corner of the cella, runs north along the west side [Plate VI], turns the northwest corner, and then runs east along the north side before turning the northeast corner; the second, shorter stream begins at the southwest corner, runs east along the south side of the cella, and then turns the southeast corner. The two streams, all agree, converge on the east side [Fig. 147]. It is also agreed that the gods are depicted in two groups on the east frieze [Figs. 145, below, and 150]. And they agree that between the gods something is going on involving a piece of cloth [Fig. 151]. But they agree on little else. Even a bare rundown of the cast of characters cannot avoid controversy. Still, it will be useful to give one here, and to reserve discussion of the frieze's meaning and place in the Parthenon's sculptural program for the next chapter.

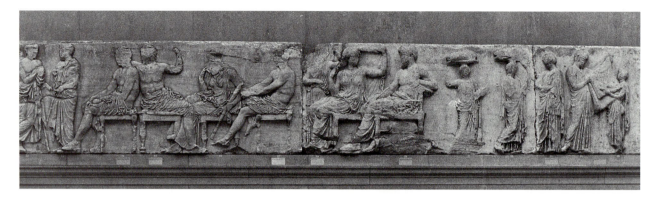

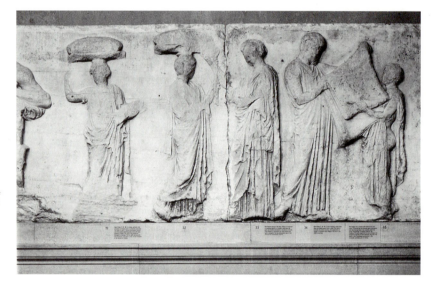

Fig. 150. The south side of east frieze with two Eponymous heroes (?), the seated gods Hermes, Dionysos, Demeter, Ares, Nike (or Iris, standing), Hera, and Zeus, and *peplos* scene. (British Museum). Photo: author.

Fig. 151. The central scene of the east frieze. Courtesy Trustees of the British Museum.

On the west frieze there are twenty-six horsemen, two young attendants, and two marshalls; eleven riders are still unmounted. Near the center, in another powerful **V**-shaped composition, one of only two bearded horsemen on the entire frieze tries to tame a magnificent, fiercely rearing steed who seems a relief version of the horses in the west pediment [Fig. 152; cf. Fig. 143].[81] So here the cavalcade is just getting under way (it has been often and rightly said that the general mood of the frieze as a whole is one of preparation and anticipation rather than of culmination or climax). The parade is in full swing on the north side, where there are sixty horsemen on saddleless mounts (they seem arranged in ten ranks, but the number of riders in each rank varies) [Fig. 153]. One horseman wears full armor, most others just tunics and cloaks, a few so-called Thracian caps; some are nearly nude. The procession continues with eleven, mostly charging, four-horse chariots with drivers and *apobatai* – armed soldiers whose sport consisted of jumping off moving chariots and racing to the finish line (their

brand of chariotry undoubtedly recalled that of Poseidon and Athena in the west pediment). A few grooms and marshals appear among them. Then come the pedestrians: first sixteen elders, casually conversing or adjusting their hair [Fig. 154]; then four musicians playing the kithara and four more playing flutes; then four youths carrying *hydriai* [Fig. 155] and three more carrying *skaphai* (trough-like trays for honeycombs and cakes); and then attendants leading four sacrifical sheep and four sacrificial cows. Once past the riders and chariots, the number four (and its multiple sixteen) stands out.

The south frieze seems to have closely mirrored the north, though the numerology is different (ten is the magic number here). There are again sixty horsemen, this time arranged in ten ranks of precisely six riders each, all the members of each rank wearing identical, distinctive garb (everyone in the first rank wears Thracian caps, chitons, and high boots, for example);[82] then ten chariots (not eleven, as on the north side) with drivers and *apobatai* (none of whom have yet leapt to the ground)

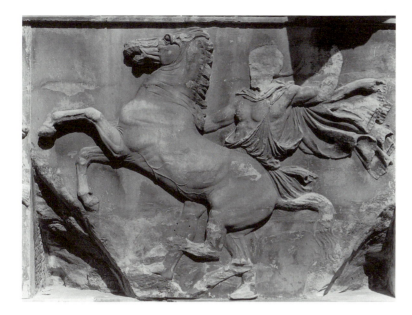

Fig. 152. Horse-taming scene, center of west frieze. Alison Frantz Collection. Courtesy American School of Classical Studies.

Fig. 153. Horsemen, north frieze (British Museum). Photo: author.

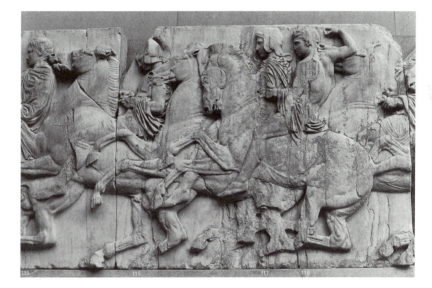

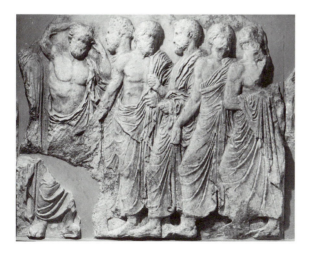

Fig. 154. Elders, north frieze. Courtesy Acropolis Museum.

Fig. 155. Youths carrying *hydriai*, north frieze. Acropolis Museum. Photo: author.

Fig. 156. *Apobatai*, south frieze (British Museum). Photo: author.

[Fig. 156]; then more elders and, probably, musicians, *hydriaphoroi* and *skaphephoroi*; then attendants leading ten sacrificial cows (and no sheep) [Fig. 157]. On the east side, the two streams approach one another. At the very south end, a marshal gestures for the figures on the south frieze to turn the corner and follow him. Then comes a group of sixteen thickly-draped women, most carrying something (*phialai*, *oinochoai*, an object with a flaring base that could be an incense-burner or *thymiaterion*). This group is roughly balanced on the other end of the east frieze by thirteen more women and four more marshals [Fig. 158]; many of these women also carry *phialai*, *oinochoai*, and a *thymiaterion*, but at least one has handed over an offering basket (*kanoun*) to a marshal. She is a *kanephoros*, a high-born maiden (a *parthenos* like Athena herself) who had the honor of leading sacrificial processions, and so, probably, are many more of the maidens in the east frieze, recognizable as *kanephoroi* by the costumes they wear.[83] These are, incidentally, the first women we have seen on the frieze, and the objects they carry are almost certainly some of the gold and silver vessels listed in the inventories of the Parthenon treasures, loaned out for the occasion. Next, moving toward the center from both left and right, come two groups of apparently non-processional male figures mostly leaning on staffs (since they occupy the full height of the frieze even as they lean, their scale seems a little larger than the other males on the frieze) [Fig. 159]. Whether there are actually nine or ten of them (one could be a standard marshal), and

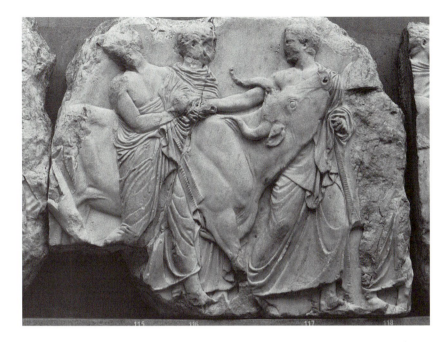

Fig. 157. Youths leading sacrificial cattle, south frieze (British Museum). Photo: author.

Fig. 158. Maidens and marshals, east frieze (Louvre MA 738). Courtesy Musée du Louvre.

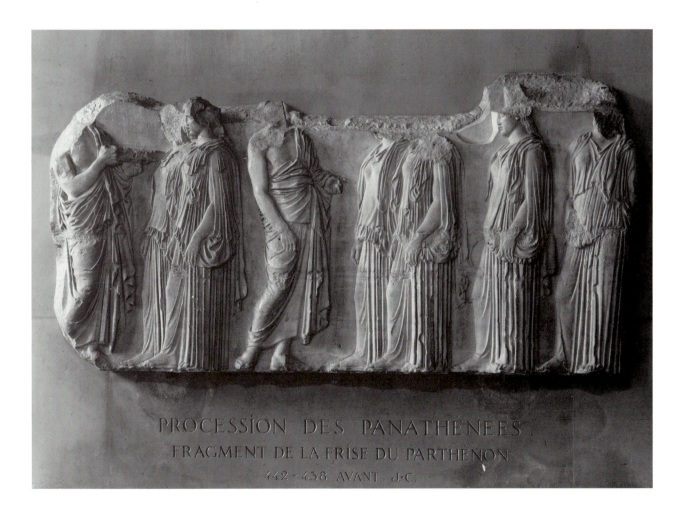

PROCESSION DES PANATHÉNÉES
FRAGMENT DE LA FRISE DU PARTHÉNON
442-438 AVANT J.C.

Fig. 159. Male figures (Eponymous heroes?), east frieze (British Museum). Photo: author.

whether they are the Eponymous Heroes of the Athenian tribes [cf. the Erechtheus of Fig. 41], or generic magistrates, or generic Athenian elders (the fathers or brothers of the nearby maidens or *kanephoroi*) are matters of dispute. If they are the Eponymous Heroes – and it should be noted that Pheidias had already made a group of them for the sanctuary of Apollo at Delphi[84] – they would form a neat transition to the next level of being, for there is no question that the Olympian gods come next, again in two groups (six seated and a quasi-Olympian – Iris or Nike – standing on the left, six seated and another quasi-Olympian – Eros – standing on the right) [Figs. 145, 150].[85] It is not clear whether the gods are to be thought of as watching the procession from their home on Olympos, or from the Acropolis itself, or even in the Agora (where there was an Altar of the Twelve Gods beside the Panathenaic Way, Fig. 92). But between Hera and Zeus (on the left, Fig. 150) and Athena and Hephaistos (on the right, Fig. 30), perfectly aligned with

the east doorway below and behind, we are probably back on the Acropolis, and find the most controversial passage of all [Fig. 151]. Here there are five smaller (hence mortal) figures. Two young women carrying something (cushioned stools?) on their heads and other things in their hands (a footstool, a lamp?) are greeted by a taller matronly woman, who helps one girl with her load. She stands back to back with a bearded male, dressed in a long robe, who appears to be folding up a piece of cloth with the help of a child. Who these people are and what they are doing – even the gender of the child – are crucial to the interpretation of the frieze as a whole, and every point is fiercely disputed. But most scholars, seeing a grandiose, sacrificial procession on the frieze and a piece of cloth at its center, and remembering the importance of the Panathenaia in Athenian life, believe the frieze depicts the Panathenaic procession and preparations for delivering the *peplos* to Athena Polias. As we shall see, they may be only partly right.

The Athena Parthenos. We have already had occasion to describe Pheidias's gold-and-ivory goddess [Figs. 25, 26, 132], which, some think, was created first in a temporary *ergasterion* or workshop south of the Parthenon, only to be reassembled and installed in the *hekatompedos neos* in time for dedication at the Greater Panathenaia of 438. Although in his description of the Parthenon Pausanias fails to attribute the Athena Parthenos to Pheidias (which is a little curious, since he is careful to note several other originals by the master elsewhere on the summit), the statue Pausanias saw in the 150s AD was not exactly the one Pheidias made, anyway (it had likely undergone one, maybe two, repairs or restorations in the meantime).[86] But the point to emphasize here is that the statue combined on her person, armor, and base many of the myths and leitmotifs the spectator had already encountered elsewhere on the building. Inlaid or painted on the ivory of the interior of her shield was the Battle of Gods and Giants, which the visitor entering the cella had just seen distributed over the fourteen east metopes of the Parthenon [Figs. 136, 137]. The Gigantomachy (to judge, riskily, from a later Athenian vase-painting of the subject) may have been arranged in concentric rings, and Helios may have been shown driving his team above the (here curved) horizon as he did in the east pediment [Fig. 145] and (probably) in both north metope 1 [Fig. 134] and east metope 14 [Fig. 133]. The exterior of the shield carried a circular Amazonomachy – the subject of the west metopes – revolving around a gorgoneion (which also appeared in the center of Athena's *aigis*). Roman-era copies of the shield, both large-scale and small, excerpt many of the duels between Greeks and Amazons [Figs. 27, 160], and some suggest that the Amazonomachy was played out on rising terrain around and even atop the walls of a citadel [Fig. 161].[87] In other words, this is the Amazons' attack on the Acropolis itself, though the background of the shield probably represented a topographically imaginative panorama. In any case, the parallel with the Persian attack of 480 was unmistakable, though here, in a mythological, wish-fulfilling reversal of reality, the Greek defenders emerged victorious. The fable that Pheidias slyly inserted portraits of Perikles and himself among the Greek defenders (and was for that reason thrown in jail, where he died) is probably a Hellenistic invention.[88] On the edges of Athena's sandals there was a Centauromachy, the subject of the south metopes [cf. Fig. 139], but no copy even hints at its appearance. At all events, three of the four battles represented on the Parthenon metopes reappeared on the

Fig. 160. Lenormant Athena (Athens NM 128), detail of shield. Photo: author.

Athena Parthenos (only the Trojan saga of the north metopes was not reprised). So, too, the large snake coiled up inside Athena's shield – Pausanias tentatively identified it as Erichthonios – was not the first the visitor would have noted: there was another beside Kekrops, and perhaps yet another wrapped around the olive tree of Athena, in the west pediment [Fig. 143]. Nike, whose gold-and-ivory figure the goddess literally held in the palm of her hand [Fig. 132], had also been seen before: she drove Athena's chariot in the west pediment; she may have appeared in the lost center of the east pediment (she is often found in images of Athena's birth) and on the east frieze; she certainly appeared hovering beside Athena in east metope 4; and, again, four marble Nikai probably alit on the corners of the roof of the Parthenon, as *akroteria* [Fig. 133]. Only the myth on the base of the statue – the creation of Pandora in the company of

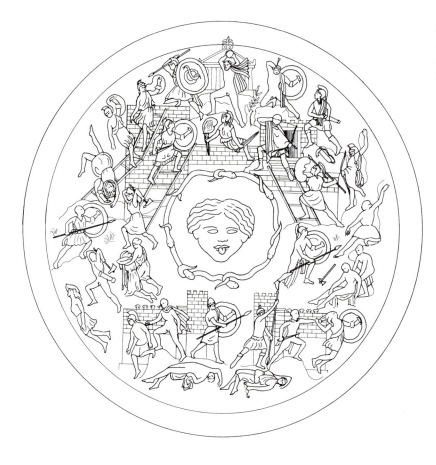

Fig. 161. Reconstruction of the Amazonomachy on the exterior of the Shield of Athena Parthenos. Drawing by E. B. Harrison (1981), used by permission.

twenty divinities [Figs. 26, 132] – seems to have had no iconographic preparation elsewhere on the building. In fact, however, the base was related to the east pediment by the theme of birth itself, and to that pediment, the east frieze, and the east metopes by the theme of divine assembly. The choice of this myth – which is the Greek explanation for the existence of evil and suffering in the world – is still a surprising one, and for that reason deserves separate treatment elsewhere (Chapter 10). All in all, though, the statue of Athena Parthenos stood as a kind of reiteration or summary of Parthenon myth and theme. Through its images the visitors' experience of the building's exterior and interior was unified, and through its images the messages of the Parthenon's sculptural program were drilled into them one last time.

Building IV
(Appendix C, no. 4)

In the Athenian Agora Pausanias saw a monument with statues of the Eponymous Heroes, after whom the ten Attic tribes were named.[89] One of the represented heroes was Pandion, and though Pausanias was unsure which Pandion this was – the son of Erichthonios, or the son of King Kekrops the Second (this Pandion was the father of Aigeus, father of Theseus) – he mentions in passing that there was another statue of Pandion on the Acropolis. Despite his note that the Acropolis statue was "well worth seeing," Pausanias does not mention this image or any precinct sacred to the early king in his tour of the Acropolis itself. Still, a handful of late Classical inscriptions (the earliest dates to the end of the fifth century) confirm that there was a *heroon*, or hero shrine, of Pandion somewhere on the citadel.

Tucked into the southeast angle of the Acropolis are the overlapping remains of two large but simple structures known as Buildings IV and V [Fig. 162]. Building V appears to be Early Classical in date, and was torn down to make room for Building IV, built almost directly atop it. The date of the demolition of Building V and the construction of Building IV are hard to determine with precision, but since Building IV, like its predecessor, was nestled within a hairpin turn of the old Mycenaean fortification wall its construction apparently

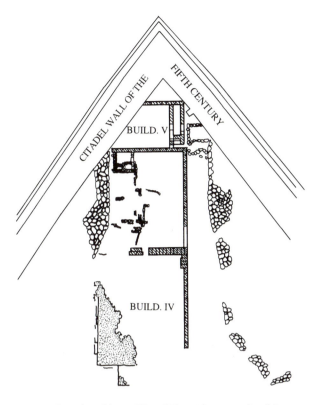

Fig. 162. Plan of Buildings IV and V, southeast angle of Acropolis. Drawing by I. Gelbrich, after Stevens 1946, fig. 22.

antedates the nearby stretch of the Classical citadel wall. Since this part of the wall could be as late as the 430s, Building IV could still date to the Periklean era – say, to the 440s. Interestingly, such works as the Moschophoros [Fig. 71] and the head of the Athena from the pediment of the *Archaios Neos* [Fig. 96], victims of the Persians in 480, were found in the fill of its foundations, and so may have lain about the Acropolis for decades before burial.

Building IV actually consisted of two parts [Fig. 3, no. 16]. The larger one (on the northwest, about 56m from the east side of the Parthenon) was an open-air precinct entered via a columnar porch. Behind it, with a doorway of its own, was a slightly smaller, less-well-built room that seems to have been a service court or *ergasterion* (workshop), and indeed large amounts of marble chips were found in the area when excavated. While there can be no certainty, it is likely that the open-air precinct was a *heroon* and, though it is unclear why Pandion should have merited so large a sanctuary, it is possible that it belonged to him (with, presumably, the statue of the hero Pausanias saw). The strictly utilitarian room behind it was perhaps a workplace for masons and

sculptors, including those employed in the Periklean building program (more than one *ergasterion* are, in fact, mentioned in the building accounts of the Parthenon).[90]

The Great Steps West of the Parthenon (Appendix C, no. 5)

Pausanias may have scaled the broad flight of steps cut out of bedrock west of the Parthenon [Fig. 163], but he does not mention them (and neither does any other ancient source). There were originally sixteen steps in the flight, and the upper steps were laid in poros limestone. The number of steps actually cut out of the rock varies from a maximum of nine toward the southern end to two at the north. The north end of the steps abutted a long east-west wall running from the Sanctuary of Artemis Brauronia most of the way down the north flank of the Parthenon, where it served as a retaining wall for the Parthenon terrace [Fig. 3]. This wall also served as the northern boundary, and the steps the eastern boundary, of a trapezoidal court defined on the west by the back wall of the Artemis Brauronia sanctuary and on the south by the Acropolis citadel wall (later by the Chalkotheke). There was a simple propylon in the north wall of this precinct.

The flight of steps is precisely parallel with, and led up to a level platform or terrace in front of, the west facade of the Parthenon [Fig. 126]. Like the steps of the Parthenon, the rock-cut steps reveal an intentional upward curvature, a refinement clearly meant to harmonize its lines with the curving horizontals of the Parthenon for anyone standing in the trapezoidal court. All this leaves little doubt that the steps were cut and laid with the Parthenon in mind, and that the project was part of the general Periklean building-program.

The treads of the rock-cut steps are covered with thirty-eight cuttings for stelai of various sizes and dates, and the missing poros steps were undoubtedly cut for more. As well as giving access to the west side of the Parthenon, then, the flight of steps served as a gallery for votive display, which it remained for the rest of antiquity. A monument with seven life-size bronze statues was inserted atop the ninth step at the southern end of the flight (just above the northeast corner of the Chalkotheke), evidently in the Hellenistic period. At the northern end of the steps a large, nearly square (c. 8 × 7m) foundation supported a different sort of monument: a small precinct or shrine, perhaps. It was in his visit to this general area that Pausanias (1.24.3) appar-

Fig. 163. Rock-cut steps west of Parthenon. Photo: author.

ently saw something to do with Athena Ergane and a shrine shared by a *daimon* (spirit) of some sort, but his text at this point is corrupt, and the identification of the foundation (which in its latest form seems Roman) with anything Pausanias mentions is merely possible.

The Sanctuary of Zeus Polieus (Appendix C, no. 6)

Although we know the central event of the ancient festival of Zeus Polieus (the *Dipolieia*) in some detail, the literary evidence concerning the appearance of his sanctuary is meager, and the sparse archaeological evidence open to interpretation. Accounts of the *bouphonia* (in which oxen were driven, or else allowed to roam, around a bronze offering table before the sacrifice) suggest that the rite required a large but enclosed space, and Pausanias's itinerary indicates that it was near the northeast corner of the Parthenon [Fig. 3, no. 14]: it was

in that vicinity that he saw a statue of Zeus by Leokhares, another statue of Zeus Polieus, and the altar of Zeus Polieus (possibly the bronze sacrificial table of the *bouphonia*). Neither Pausanias nor any other source mentions a temple for the god, and it may be significant that a silver goblet dedicated to Zeus Polieus (and silver *phialai* dedicated to Zeus without epithet) were stored in the Parthenon. But starting about ten meters northeast of the Parthenon's northeast corner, and then extending to the east and north, is a complex of rock-cut walls, shallow trenches, and holes (plus a few poros foundation-blocks) that have almost universally been interpreted as traces of Zeus's precinct [Fig. 164]. The area includes the highest point on the Acropolis rock (over 156m above sea level), a fitting location for the worship of Zeus, great lord of the sky.

The conventional interpretation of the rock-cuttings is that the sanctuary (which must go back to a very early period) had in its final form two connected parts

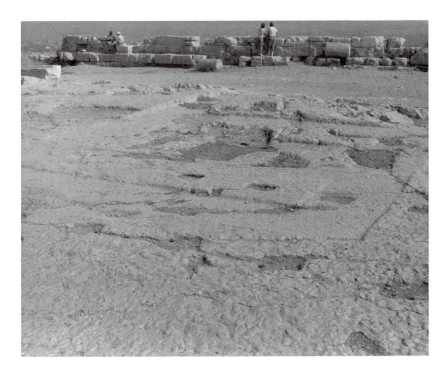

Fig. 164. Area of Sanctuary of Zeus Polieus. Photo: author.

Fig. 165. Plan of Sanctuary of Zeus Polieus. Drawing by I. Gelbrich, after Stevens 1946, fig. 17.

[Fig. 165]: on the west a large, slightly trapezoidal, open-air precinct with a doorway near its southwest corner, and a large adjoining polygonal precinct on the northeast (the precincts were linked by a door in the middle of a shared wall). In the southern portion of the northeast precinct there was a small shrine (facing atypically north) and a long offering table. In the cella of the shrine was a rectangular rock-cut pit. This modest building partly overlapped the western portions of five nearly parallel rows of small rectangular cuttings in the rock (fifty-five cuttings remain). These holes, it has been suggested, held the wooden posts of wattle fences and a barnlike structure for the stabling of oxen. Since construction of the shrine erased some of the post-holes, it is later than the original installation, which may have been remodelled to suit the new building.

The possibility that oxen were stabled behind rustic fences for any length of time on the mostly marble Periklean Acropolis makes one pause (which is not to say it did not happen). Still, the traditional reconstruction of the paltry remains is largely hypothetical. It is possible, in fact, that the western precinct was much larger than has usually been thought, extending north all the way to the citadel wall and west almost to the Great Altar of Athena (covering a huge area approximately 42m × 35m) [Fig. 3, no. 14]. It is worth remembering, too, that a large herd of cattle was brought up the Acropolis and sacri-

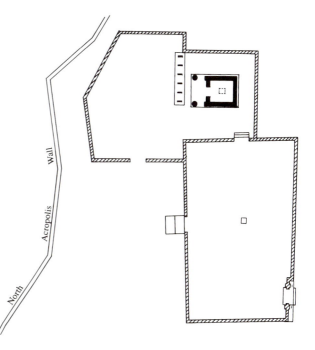

ficed on that very altar on Hekatombaion 28 (at the Pana-thenaia), and one wonders whether the west precinct served as their corral (and had little or nothing to do with Zeus and the *bouphonia*). Moreover, the small shrine of Zeus Polieus (if such it was) may not have stood in a fully walled precinct of its own, but may simply have been set off from the rest of the Acropolis by the east wall of the west precinct and another wall to the south. As a result, it is unclear how or if the west and east "precincts" were related in function or in cult.

It is difficult to date rock cuttings *per se*, but there are indications that the west precinct was originally laid out with the late Archaic Older Parthenon in mind, and that its southern wall was cut back and rotated slightly to the north (resulting in its trapezoidal plan) when the Periklean Parthenon was built in order to maintain the same distance between the precinct and temple. It is also likely that the flat, broad, rock-cut expanse to the south and east of the west precinct was levelled during the Periklean period as part of a general relandscaping of the Acropolis. The remodelling of the entire area north-east of the Parthenon – which must have included the sanctuary of Zeus Polieus somewhere – may then be dated to the third quarter of the fifth century.

The Great Altar of Athena
(Appendix C, no. 7)

Pausanias does not mention the Great Altar of Athena in his description of the Acropolis. He certainly could not have missed such a venerable and important struc-ture – one monumental enough to accommodate the sac-rifice of a large herd of cattle during the Panathenaia. The altar of Athena was at least as old as the seventh century, and it was large even then (according to Thucy-dides, there was room enough for Kylon's supporters to take refuge before it around 632). But its history undoubtedly goes back to the eighth century and beyond. Though monumental and ritually significant, the altar Pausanias saw might still have had a conven-tional or relatively unprepossessing character, which could explain why he passed by in silence.[91]

A cutting in the bedrock about twelve meters east of the foundations of the *Archaios Neos* (and only slightly off the axis of that temple) probably marks the site of the altar [Fig. 3, no. 12]]; the cutting itself preserves the cor-ners of a rectangular structure about 8.5 meters deep (east-west). In the sixth century the altar probably con-sisted of a broad flight of steps leading up to the sacrifi-cial platform itself, and it is likely that the form was much the same in the fifth century. Attempts to assign some of the "floating" architecture and architectural sculpture from the Archaic Acropolis to the sixth-cen-tury altar, and some late fifth-century mouldings to the Classical structure, are purely speculative, as is a sug-gestion that the base of the Classical altar was decorated with a marble frieze carved in a style derived from the Parthenon frieze and representing the Birth of Pandora, the same subject as the base of the Athena Parthenos itself (the fragments of this frieze were found in the Agora).[92] The Archaic altar must have been severely damaged during the Persian sack and it must have been repaired to some extent in the Early Classical period: the cult of Athena Polias still needed to be served. But the possibility that the altar was completely remodelled dur-ing the Periklean remaking of the Acropolis is also strong.

The Propylaia
(Appendix C, no. 8)

The name Propylaia ("Gateways") is plural not because this unusually complex building has several elements (and was originally designed to have even more) but because five doors of different sizes pierced the cross-wall of its central hall (the "Propylaia" proper) [Fig. 166].[93] It is this cross-wall that marks the entrance to the sanctuary of Athena. Technically, then, the Propylaia sits astride the boundary of the sacred precinct, and most of the complex – the large western portion of the central hall, the northwest wing, the southwest wing – actually lies outside it, in secular space.

The Propylaia is not just topographically liminal: it is also both termination and prelude. Mnesikles designed the building, first, to provide a monumental setting for the end for the Panathenaic Way and, second, to prepare the visitor for what would be found within the gates. Mnesikles (or someone working with him) essentially doubled the width (to about 21m) of the old ramp leading straight up the west slope – the last great stretch of the sacred road leading up from the Agora. And the Propylaia, looming over the ramp, embracing it with its wings, would have afforded an appropriate space for spectators to await the arrival on the summit of the Panathenaic procession (a function served earlier by the late Archaic stepped entrance court, Fig. 98). It would also have introduced the pilgrim to many of the features he would see within the sanctuary, especially in

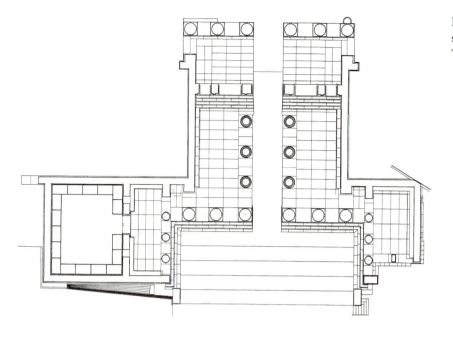

Fig. 166. Plan of the Propylaia of Mnesikles, 437–432. Drawing by T. Tanoulas, used by permission.

the Parthenon. The roughly east-west axis of the Propylaia is virtually parallel to the axis of the Parthenon, so that the visitor's path through one building established a spatial alignment with the other. The dimensions of the deep west portion of the central hall are close to those of the Parthenon's west room. The Propylaia shares some of the same proportions as the Parthenon (the ratio of column height to lower column diameter, for example) and it possesses some of the same optical refinements, too (for example, inward inclination and *entasis* of columns and upward curvature in the architrave, though here the stylobate is level). Like the Parthenon, the Propylaia combines architectural orders: the exterior is Doric [Plate VIII], but because of the sharply rising ground on which the building is set Ionic columns (which have a greater height relative to their diameter) were required within the west part of the central hall, three on each side of the four-meter-wide central rock-cut passageway (this was the road taken by the sacrificial animals in the Panathenaiac procession; the four other, smaller doors in the cross-wall were approached by a flight of five steps, and were thus meant for human traffic). The close visual relationship between the Parthenon and Propylaia can be explained not only by Mnesikles's conscious desire to harmonize his gateway with the great temple within, but also by the identity of the labor force: the workmen who had completed the architecture of the Parthenon in 438 were simply transferred to Mnesikles's project the next year, and they

brought a honed technique and a Parthenonian style with them.

One of the tasks Mnesikles set for himself was to unify an area that had been previously marked by several discrete late Archaic structures: the Older Propylon (repaired after the Persian sack of 480), the stepped entrance court, and, probably, the apsidal Building B [Fig. 109]. The Propylaia might even be considered a reinterpretation and regularization of those earlier buildings: the central gatehouse, for example, represents an enlargement and clockwise rotation of the Older Propylon, and the northwest wing [Fig. 167] a squaring and realignment of Building B, linking it with and setting it at right angles to the main hall.[94] But Mnesikles's initial design was even more grandiose than this. He intended (perhaps in a second architectural campaign) to attach great halls to the Propylaia on both the northeast and southeast sides, and door-jambs (or antae), a spur wall at the northeast corner of the northwest wing, and cuttings for rafters and ridge beams in the walls of the Propylaia suggest his plans reached a fairly advanced stage. Both halls would have been accessible only from the east (that is, from within the sanctuary of Athena), with no direct access from the interior of the Propylaia itself. Although plans for these halls were eventually scrapped, it is clear that Mnesikles originally conceived of the Propylaia as a massive juxtaposition of five rectangles (central gatehouse, western wings, eastern halls).

He may not, however, have originally conceived of

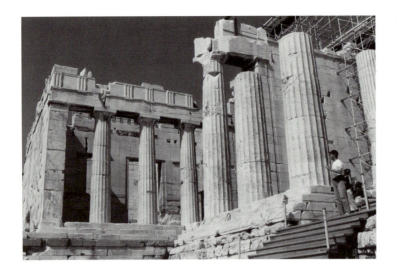

Fig. 167. The northwest wing of the Propylaia (the Pinakotheke). Photo: author.

the complex as perfectly symmetrical. A few details suggest the eastern halls would not have been exactly the same size.[95] And while it is often supposed that Mnesikles initially intended the southwest wing to be a mirror image of the northwest, as built it is a very different structure. Certainly the columnar facade of the southwest wing echoes the one across the way, so that it is easy for a visitor at the top of the ramp to think himself flanked by symmetrical wings. But the impression is false: the southwest wing is just a small open space defined by its short colonnade, a large "double anta" at the northwest corner, two walls, and (on the west) a single pier. At any rate, perfect symmetry between the southwest and northwest wings would have required dismantling much of the still-impressive stretch of Cyclopean masonry south of the Propylaia [Fig. 54]. But this Mycenaean wall was not touched and, in fact, the southeast corner of the southwest wing was bevelled to fit snugly against it. Thus, if there had been some early plan to build a larger wing here, it went nowhere. Nonetheless, there are indications that whatever the original design, the southwest wing was in fact adjusted several times (perhaps after the central gatehouse and northwest wing were complete) to take the rebuilding of the adjacent Nike temple bastion into account.[96] It was by no means uncommon for Greek architects to alter the designs of their buildings as construction proceeded and problems or opportunities arose – as we have seen, the Parthenon displays such changes-in-progress, too. The fact remains that the Propylaia Mnesikles ended up building was substantially different from the Propylaia he originally had in mind in 437.

Changing the design of a building in the course of construction is one thing. Not finishing what *was* built is another, and it is clear that the Propylaia was never completed. Protective, working surfaces on the steps and floor of the building were never removed and, most conspicuously, scores of lifting bosses (lumps of stone left on blocks to aid in their positioning during construction) were never chiselled off [Fig. 168]. Most of these lifting bosses are found on the east walls of the northwest and southwest wings and on the north and south walls of the central gatehouse – on the "back" of the Propylaia, as it were. But there are a few even on the west wall of the northwest wing and elsewhere, where they would have been quite obvious to anyone ascending the Acropolis. Not even the new broad ramp leading up to the Propylaia was finished in the Classical period.[97]

The usual explanation for the scaling-down of Mnesikles's original, multi-winged plan for the Propylaia is religious conservatism; the usual explanation for its unfinished state is economic belt-tightening. Neither explanation by itself is totally satisfactory. It is true that building the putative southeast wing would have meant razing a large portion of the surviving Mycenaean wall [Fig. 54] and expropriating the western portion of the Sanctuary of Artemis Brauronia (at least as that sanctuary was eventually defined, Fig. 169). It is possible, too, that the Athenians might have resisted tearing down so conspicuous a memory of their heroic, Bronze Age past as the Mycenaean wall, and that the officials of the cult of Artemis might have opposed the loss of some of their precinct. But in fact it is not clear that the nearly religious awe or veneration in which the Cyclopean wall was held would alone have saved it from destruction (the Athenians had no problem tearing down other parts

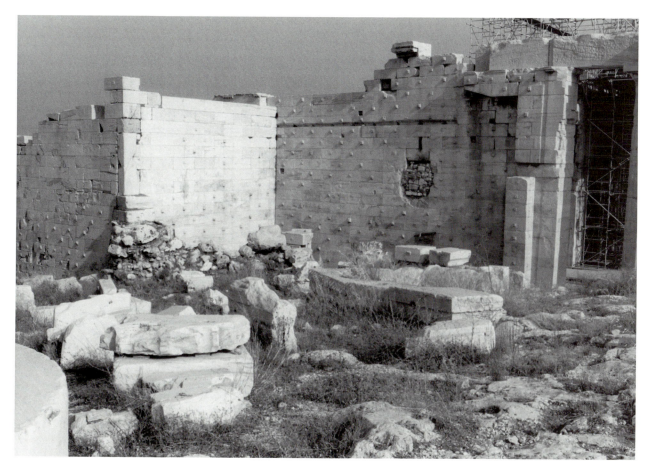

Fig. 168. Propylaia from southeast, over the precinct of Artemis Brauronia. Blocks from the base of Strongylion's bronze Trojan Horse are in middle ground, just right of center. Photo: author.

of the Mycenaean fortification on the Acropolis), and it is not even clear how far west the Artemis sanctuary extended in 437 (the Classical Brauroneion was most likely developed with the Mnesiklean Propylaia in mind, not vice versa). Besides, there was no organized "church" in ancient Athens, and the priesthood of Artemis would not by itself have had the clout to oppose Mnesikles's original design. It was the democratic assembly that exercised such power and the assembly, under Perikles's influence, had presumably approved Mnesikles's plan by 437. There are, it is true, hints that just before the Peloponnesian War broke out an Athenian "religious right" began to strenuously defend traditional religion and state cults.[98] But, more likely, it was simple economics that dictated the decision not to build the eastern halls and not to remove the lifting bosses and protective surfaces from the walls and floor. As early as

434/3, when the Kallias Decrees were passed, the Athenians knew that war with Sparta was inevitable: resources needed to be husbanded, and work on the Acropolis needed to be wrapped up. In 433/2, the date of the last building account of the Propylaia, it was. On the other hand, frugality does not explain why the finishing touches were not applied to the Propylaia later: a city that in the last quarter of the fifth century could afford to build the Nike temple, the Nike parapet, and the Erechtheion could surely have afforded to return to the gateway and shave off a few unsightly lumps of stone from its walls. Here religion might enter the picture after all: during the war years Athens could afford to build temples, but the Propylaia, essentially a secular structure, may not have merited additional expense.[99]

The Propylaia did more than just channel traffic into the sanctuary of Athena, and its parts served a variety of functions. Besides optically balancing the northwest wing, the southwest wing served as a waiting area and provided access to the Nike sanctuary [Fig. 180]. The

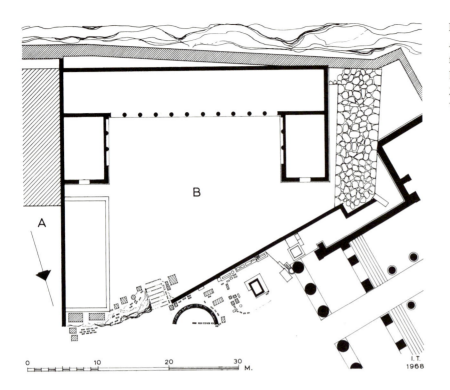

Fig. 169. Plan of the Sanctuary of Artemis Brauronia. After Travlos 1971, fig. 169. Reproduced by permission of Deutsches Archäologisches Institut Zentrale, Berlin and E. Wasmuth Verlag.

unrealized eastern halls would likely have served as dining rooms for ritual feasts, and this was almost certainly a function of the northwest wing [Fig. 167]: one reconstruction places seventeen couches for reclining banquetters around the interior of the inner room [Fig. 166], and it may be no coincidence that after 434/3 (when the northwest wing might have been essentially complete) inscriptions happen to list couches among the inventories of the Parthenon.[100] Pausanias does not mention any couches in the northwest wing on his visit, but he does say it was full of paintings (including one or two mythological scenes by the great Early Classical artist Polygnotos and a portrait of Alkibiades). How many of the paintings he saw in this "building (oikema) with pictures" were already there in the late fifth century we do not know, but they must have been portable panel paintings rather than murals (this is the only explanation for the presence of work by Polygnotos, who was not around in the 430s to fresco walls). Windows in the south wall of the room would have helped illuminate the art.

Although it contained a picture gallery for the pleasure of both pilgrims and sacred diners, and although dedicatory statues would be set up within it and votives hung from its walls, the Propylaia lacked architectural sculpture of its own. Its many metopes and its three pediments (a third was required because of the build-ing's split-level plan) were empty, and akroteria, if planned, were never executed.[101] And yet the Propylaia was not a visually dull building. The contrasting use of dark Eleusinian limestone for prominent features (such as orthostate blocks) and details enlivened and varied its surfaces (this stone is also used decoratively in the Erechtheion, which may point to a connection between the two buildings), and it did not lack ornament. Its famous ceiling was, according to Pausanias, unsurpassed even in his day: the marble coffers were decorated with gold or gilded stars against a blue background, and outlined (and unfinished) floral patterns are still preserved on the lower surface of the east cornice.[102]

Though the Propylaia is not likely to have cost the 1,000 talents a fourth-century orator says it did (much less the 2,012 talents cited by another source), the building was noted (and even criticized) for its magnificence. Indeed, it was far more extravagant a structure than its basic function called for. Temples were expected to be rich and costly, gatehouses were not, and so the beauty and expense of the Propylaia was in its way an even stronger assertion of the grandeur of Periklean Athens than the Parthenon itself. It is perhaps for this reason that in his various encomia to the Periklean era the fourth-century orator Demosthenes lists the Propylaia first, and the Parthenon second, or cites the Propylaia

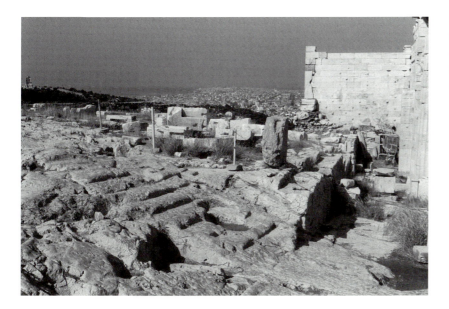

Fig. 170. View, Sanctuary of Artemis Brauronia, rock-cut north precinct wall. (The upright block of dark Eleusinian limestone atop the wall may have formed part of the base of the Bronze Athena). Photo: author.

without mentioning the Parthenon at all. And with this even Demosthenes's political opponent, Aeschines, agrees: when in one speech he urges the Athenians to recall the great achievements of their ancestors, it is the Propylaia, and not the Parthenon, that he singles out.[103]

The Sanctuary of Artemis Brauronia (Appendix C, no. 9).

The worship of Artemis Brauronia atop Athena's rock almost certainly goes back to the days of the Peisistratids, who came from the coastal town of Brauron in east Attica (it is probably not coincidental that Athena and Artemis, two virgin goddesses, are sometimes seen side by side in Archaic vase-painting).[104] What Artemis's precinct looked like in the sixth century we do not know, and the course of its development in the Classical period is uncertain as well.

In its developed form, the sanctuary of Artemis Brauronia occupied the quadrilateral area between the "Chalkotheke court" on the east, the Mycenaean fortification wall on the west, and the citadel wall on the south [Figs. 3, no. 5, 169]. The northern boundary of the precinct was formed by a vertical scarp cut out of bedrock that originally supported additional courses of poros-limestone blocks above [Fig. 170]. Towards the eastern end of the rock-cut wall are eight low steps (about 2m wide), again cut out of bedrock, that formed the entrance to the sanctuary. This northern precinct wall is almost exactly parallel to the axis of the Mnesik-

lean Propylaia (as well as to the line of the wall that forms the northern boundary of Chalkotheke court), and this has always suggested that the layout of the entire sanctuary was contemporary with the construction of the Propylaia, and so datable to the 430s.

Most of the preserved remains (rock-cut beddings for walls, limestone foundations) are found in the eastern portion of the precinct, and they reveal as many as three building phases. The first phase saw the construction of the east precinct wall itself, running from the northern edge of the sanctuary all the way to the south citadel wall, and a simple Doric stoa extending at least fifteen meters west from the south end of the east precinct wall. In the second phase, the stoa was rebuilt and a modest east wing (c. 8.25m × 5.50m) begun. (Earlier reconstructions envision a double-winged stoa over 38m long, but evidence for this length and a west wing is sparse.) In the final phase, the incipient east wing was replaced by a new wing extending all the way to the northern edge of the sanctuary. (Earlier reconstructions hypothesize not a longer wing but a second, separate stoa.) The rock-cut entrance belongs to this third phase. Although it has been claimed that the east precinct wall and south stoa are structurally bound to the south Acropolis wall (and so must have been Periklean or even Kimonian), recent investigations have indicated that no such binding exists. Thus, the best clue to the chronology of the sanctuary remains the parallelism of the rock-cut north wall and the axis of the Propylaia: the one was designed with the other in mind. This suggests (though

it does not prove) a Periklean date for at least the third phase of the precinct, and perhaps Mnesiklean involvement in the design as well.

The principal sanctuary of Artemis Brauronia was at Brauron itself, and perhaps for this reason the sanctuary on the Acropolis seems to have lacked a true temple: it was in essence an urban satellite of the rural sanctuary. By the middle of the fourth century the Acropolis precinct seems to have boasted a statue of Artemis, probably in bronze, by the Late Classical sculptor Praxiteles,[105] and there were likely older images as well. Though the east wing and south stoa presumably contained a wealth of offerings to the goddess (women's robes may have been especially common gifts), many gold and silver objects dedicated to her (for example, a gold ring on a plaque dedicated by one Kleinomakhe before 398/7) were stored in the Periklean Parthenon.[106] And yet a series of fourth-century inscriptions found on the Acropolis inventorying Artemis's treasures (in cloth, gold, silver, and bronze), mentioning three statues of the goddess (an old one, a marble one, and a standing one), and even referring to buildings named "the Old Temple" and "the Parthenon," are probably copies of inscriptions on display at (and dealing with) Brauron itself. That is, the statues and votives and "Parthenon" referred to were to be found there, not atop the Acropolis.[107]

At all events, like the great steps west of Parthenon, the precinct of Artemis Brauronia was an important arena for the display of votives and statues: scores of cuttings for stelai and other, larger monuments are found north of the rock-cut precinct wall and in the area of the stepped entrance to the sanctuary [Fig. 37]. Within the precinct itself stood a huge bronze rendering of the Wooden or Trojan Horse – life-size Greeks peeked out of it – made by Strongylion and dedicated by Khairedemos son of Euangelos around 420 [cf. Fig. 168].

The Northwest Building
(Appendix C, no. 10)

Until recently the Northwest Building [Fig. 3, no. 4, and Fig. 171] was considered an Early Classical structure, dated anywhere between 479 and 450. But recent investigations have suggested that it (along with the stretch of the north Acropolis wall to which it is structurally bonded) was begun at the same time as the Propylaia of Mnesikles (that is, 437–432) and that it should therefore be considered an element of the Periklean program.[108]

The building was probably designed by Mnesikles

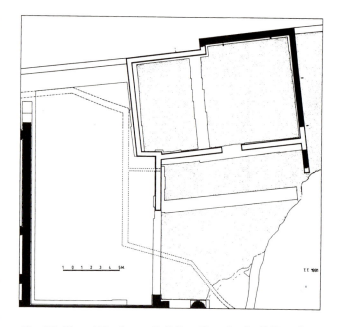

Fig. 171. Plan of Northwest Building. Drawing by T. Tanoulas, used by permission.

himself, who realized that he would not immediately be able to complete the northeast wing he had conceived for the Propylaia. Originally, it was to contain two rooms of unequal size (the larger one, about 9m wide and 11m deep, was to be on the east) entered via a portico on the south. It is possible that the building was originally intended as a banquet hall (its plan resembles ritual dining rooms elsewhere in Greece). But the substructure was never finished, and the superstructure was not completed as designed. The original plan seems to have been abruptly abandoned when Mnesikles went ahead with his plans for the Propylaia's northeast wing and even laid down the foundations of its eastern wall, which sliced into the area assigned to the Northwest Building. Though the Propylaia's northeast hall was itself soon aborted, the change in plan forced the conversion of the Northwest Building into an open-air courtyard, which may ultimately have functioned as a service court or storage area. It was probably the approaching Peloponnesian War, and specifically the provisions of the Kallias Decrees (which called upon the architect of the Propylaia to put the Acropolis in order), that necessitated the curtailment of both projects. At all events, the Northwest Building, the contiguous western portion of the north citadel wall (their foundations are, again, structurally bound together), and the Propylaia are now all considered projects of Mnesikles.

The Shrine of Athena Hygieia
(Appendix C, no. 11)

During the construction of the Propylaia, Perikles's favorite workman fell from a great height and, though near death, was cured by Perikles himself: Athena appeared to him in a dream and told him what medicine to use (the herb came to be known as *parthenion*). Perikles then dedicated a bronze statue to Athena Hygieia (Health) to commemorate the miracle, not far from an earlier altar. This tale (told in both Plutarch and Pliny) is colorful, but probably not very accurate.

Set against the southeast column of the east porch of Propylaia is a roughly semicircular inscribed base for a bronze statue [Fig. 172]. The inscription reads "The Athenians to Athena Hygieia. Pyrrhos the Athenian made it." The dowel-holes atop the base indicate that Pyrrhos's statue stood with her right foot advanced, her left hand holding an upright spear, and her left foot raising its heel and just touching the base with its toes – a pose reminiscent of the "Mourning Athena" [Fig. 121].

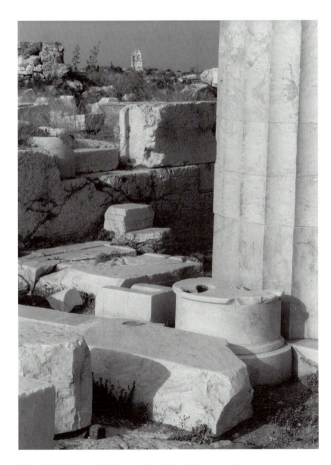

Fig. 172. Shrine of Athena Hygieia. Photo: author.

Approximately 3.6 meters east of this base are the remains of a nearly square platform and altar, and this is probably "the earlier altar" of Plutarch's anecdote.

The cult of Athena Hygieia is, in fact, at least as old as the late Archaic period: the potter-painter Euphronios, for example, apparently made a dedication to the goddess toward the end of his distinguished career (c. 475).[109] If the cult had originally been centered in this area of the Acropolis, the construction of the Propylaia and the north wall of the precinct of Artemis Brauronia would likely have necessitated a reorganization of its (unwalled) space. The altar is in fact aligned more or less parallel to the north wall of the Brauroneion and to the axis of the Propylaia, and the setting of the statue base itself against the Propylaia's southeast column suggests that the dedication dates sometime after work on the Propylaia prematurely ceased in 432. Although the inscription states that the dedication was offered by the Athenians as a whole, not Perikles alone, it is of course possible that he was responsible and receded democratically behind "the people," making the dedication on their behalf. But the forms of the inscribed letters suggest a date after 430, and despite Plutarch's and Pliny's anecdotes it is thus likely that the dedication was made to thank Athena not for a single miraculous cure but for a respite from the great plague. If so, Perikles, who died of the plague in its first year (429), cannot have been involved, and the shrine of Athena Hygieia can only be considered a small posthumous appendage to his building program.

We know that Athena Hygieia received state sacrifices at the annual Panathenaia (at least in the fourth century), but no private dedications to her can be dated after 420/19, when the cult of that other healing god, Asklepios, was introduced to Athens and a new sanctuary founded on the south slope of the Acropolis [Fig. 3, no. 25]. Pausanias saw a statue of Hygieia herself (Asklepios's daughter) very near that of Athena Hygieia.

Building III
(The House of the Arrhephoroi? Appendix C, no. 12)

Midway between the Erechtheion and the Northwest Building, behind that part of the north citadel wall built with triglyphs, metopes, and architrave blocks from the *Archaios Neos* to memorialize the Persian sack of 480, are the thick foundations of what must have been a fairly impressive, virtually square structure with a single room

and columnar porch facing south – Building III [Fig. 3, no. 8].[110] The foundations just touch, but are not structurally bonded to, the north wall, and so probably date after its construction. No remains of the superstructure are known. Adjacent to Building III on the west was an oblong, open-air court which on its north side incorporated an entrance to the cleft in the rock leading down to the Mycenaean fountain [Fig. 57] – the path possibly taken by the young girls known as the *Arrhephoroi* during the mysterious night-time festival named after them (*Arrhephoria*). Almost from the time of its discovery, and almost by default, Building III has been identified as the House of the Arrhephoroi, who, we are told, lived for some unspecified length of time atop the Acropolis not far from the Pandroseion in service to Athena and who somehow helped with the weaving of the *peplos* presented to Athena Polias at the Panathenaia (perhaps working on it in this very building). We are also told that the *Arrhephoroi* had a ball court atop the Acropolis and that there was a statue of a young boy (said to have been the orator Isokrates) playing field hockey in it. The setting of Building III and its adjacent court fit what we know of the *Arrhephoroi*, their enigmatic passage, and their playground, but the evidence remains circumstantial. Some believe Building III was too monumental a structure to house a few little girls (though it is possible the venerable priestess of Athena Polias lived there, too, in a supervisory role) and have proposed other identifications: the Sanctuary of Aphrodite in the Gardens, for example, or even the Erechtheion.[111] Neither theory has yet won general acceptance.

Building III was almost certainly built in the second half of the fifth century, but nothing definitely connects it to (or disassociates it from) the Periklean building program.

The Erechtheion
(The Last Temple of Athena Polias, Appendix C, no. 13)

Two ancient sources (and only two) mention a building on the Acropolis specifically called the "Erechtheion," and both are relatively late. One source (whom we call Plutarch) has virtually nothing to say about it. The other, Pausanias, has a lot to say, but is notoriously confusing. The relevant passage (see Appendix A) begins with a discussion of the Erechtheion itself, a "double building" with a variety of altars both outside (Zeus Hypatos) and in (Poseidon-Erechtheus, Boutes, and Hephaistos), with

paintings of the Boutadai family hanging on the walls, with a sea-water well (or cistern) that makes the sound of waves when a south wind blows, and with the form (*skhema*) of Poseidon's trident somewhere "on the rock" (presumably bedrock).[112] Next, without giving any clear indication that he has yet left the Erechtheion, Pausanias mentions the ancient olivewood cult statue of Athena Polias and the golden lamp of Athena Polias (with its eternal flame) made by the late fifth-century sculptor Kallimachos. It is only after noting the statue and lamp of the goddess that Pausanias first explicitly mentions the Temple of Athena Polias, and he does so in passing – he is interested in its contents, not its architecture – without giving it his usual introduction (such as "there is also a Temple of Athena Polias"). Finally, he mentions the sacred olive tree of Athena and the Temple of Pandrosos, which he says adjoins the Temple of Athena Polias. At all events, the descriptions of the Erechtheion, the Temple of Athena Polias, and their holdings run together in a way that is peculiar and vague even for Pausanias.

Ever since the seventeenth century AD it has been assumed that throughout this long and difficult passage Pausanias is in fact describing a single complex: namely, the elegant, Ionic, asymmetrical marble structure standing across from the Parthenon on the north side of the Acropolis, the building with the six maidens serving as columns in its south porch – Karyatids that Pausanias unhelpfully does not mention anywhere [Plate VII, Fig. 173]. Now, this building was without question the Classical Temple of Athena Polias. It succeeded the modest complex built on the site in the Early Classical period – the Pre-Erechtheion [Fig. 115] – but was ultimately regarded as the replacement for the grander late Archaic temple that, before its destruction by the Persians in 480, had stood just to the south [Figs. 82, 93]. This, then, was the new abode of the sacrosanct cult statue of Athena Polias and so was officially known in inscriptions as "the temple on the Acropolis in which the ancient image is," or simply the *Archaios Neos*, "the ancient temple," ancient (that is, venerable) because of the antiquity of the wooden statue within it. But the consensus is that this building, the most sacred on the summit of the rock, was much more than a reliquary for the image of Athena Polias. It was a multi-purpose temple with a variety of sacred places and cults, including that of Poseidon-Erechtheus [Fig. 174]. According to the popular view, Athena and the god-hero were so closely associated in myth and cult that "Erechtheion," which

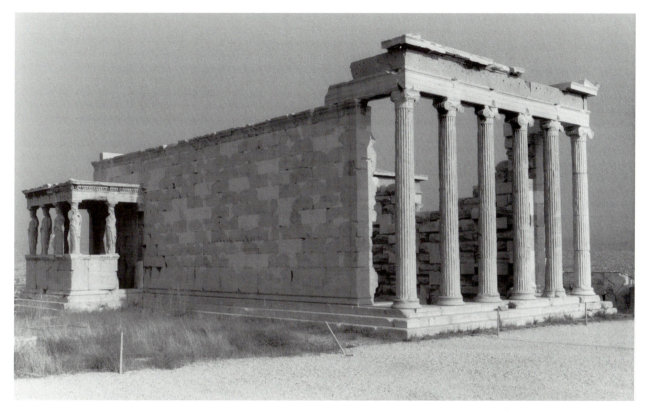

Fig. 173. View of Erechtheion from southeast.
Photo: author.

Fig. 174. Plan of Erechtheion. After Travlos 1971,
fig. 280. Reproduced by permission of Deutsches
Archäologisches Institut Zentrale, Berlin, and E.
Wasmuth Verlag.

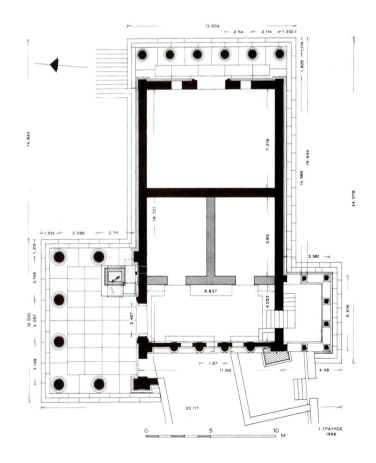

may have originally designated only a portion of the complex, became a nickname for the whole thing (just as *parthenon* might have been first applied only to one room of the Periklean building and only later came to designate it all). In short, Pausanias does not distinguish the Erechtheion from the Temple of Athena Polias because it would not have occurred to him to do so: they were one and the same building.

This view has recently come under repeated fire, and critics have pointed out genuine weaknesses in the traditional identification of the Erechtheion of our (two) sources with the "Karyatid temple" standing on the Acropolis rock. For one thing, if the Erechtheion and the Temple of Athena Polias are the same building, Pausanias's route through it would have been remarkably circuitous and back-tracking: certain difficulties are removed if we assume Pausanias's text originally described two separate buildings but has been corrupted and poorly transmitted. For another, Pausanias's description of a salt sea that makes the sound of waves when the wind blows is hard to reconcile with the ravaged interior of the Karyatid temple (though a cistern was constructed in the western part of the building in the medieval period, the existence of a Classical predecessor there is entirely conjectural).[113] A more likely candidate for so primeval (and drafty) a place, K. Jeppesen has argued, is the old Mycenaean fountain and crevice on the north side of the Acropolis [Fig. 57] – perhaps the great split in the rock was thought to be the "mark" of Poseidon's trident. As a consequence Jeppesen has suggested that the so-called House of the Arrhephoroi (Fig. 3, no. 8), from which the fissure was accessible, was in fact the Erechtheion of Pausanias's account. On the other hand, this identification does not correspond with the general direction of Pausanias's tour of the Acropolis (he went counterclockwise, visiting the Parthenon, then the Erechtheion, then, if it was separate structure, the Temple of Athena Polias). And so J. Mansfield has suggested the real Erechtheion was what has usually been identified as the shrine of Zeus Polieus in the eastern part of the summit [Figs. 164, 165] (for him, the rows of "postholes" cut in the rock are the real marks of Poseidon's trident, though why there are fifty-five holes instead of three is left unexplained).[114]

Despite some legitimate concerns, there are still good (if admittedly circumstantial) reasons for maintaining the traditional identification of Pausanias's Erechtheion and the last Temple of Athena Polias (the Karyatid temple, Fig. 173). After all, the idea that Erechtheus and Athena shared the same space goes back

at least as far as Homer (e.g. *Iliad* 2.546–51) and the close connection was continually reinforced in the imagery of the Acropolis: Erechtheus (probably) stands beside the goddess and her sacred olive tree on one document relief and nonchalantly shakes her hand on another [Figs. 39, 41][115] while a painting of Erechtheus driving his chariot even hung on the wall behind the statue of Athena Polias in her temple.[116] In his fragmentary play *Erechtheus,* possibly written when the Karyatid temple was under construction, Euripides explicitly associates the establishment of the cult of Poseidon-Erechtheus with the establishment of the priesthood of Athena Polias;[117] he even makes Praxithea, Erechtheus' widow, the first priestess of the goddess. Historically, the priest of Poseidon-Erechtheus and the priestess of Athena Polias were both chosen from the ranks of the Eteoboutadai, the same clan whose portraits, Pausanias says (1.26.5), hung in the Erechtheion. The sacred snake of Athena is by one source said to live in the Temple of Athena Polias, by another source in the sanctuary of Erechtheus, which, if it does not prove the identity of the two, might suggest that the temple of the goddess and the precinct of the hero somehow intersected.[118] More significantly, perhaps, we have the testimony of Strabo (9.1.16), who (though he does not have much to say about the Acropolis) says he saw Athena's eternal lamp in the Temple of Athena Polias (Pausanias, again, mentions the lamp after introducing the Erechtheion but before specifically mentioning the Temple). And, above all, we have Herodotos, who, as we have seen, notes (8.55) that by the middle of the fifth century there was already on the Acropolis a sanctuary of Earthborn Erechtheus that included the olive tree of Athena as well as Poseidon's salt sea – the Pre-Erechtheion [Fig. 115]. That is, an Early Classical shrine named after Erechtheus had within it the sacred tree that Pausanias would centuries later see in the Pandroseion adjacent to the Polias temple. If an early fifth-century temple of Erechtheus could have included Athena's famous token, there is no reason a late fifth-century Temple of Athena Polias could not have included the cult of Erechtheus.

The main block (or cella) of the Erechtheion (as I shall continue to call the Karyatid temple) had on the east a porch with six Ionic columns (nearly 6.6m tall) set prostyle (that is, in front of the antae of the cella walls); the columns lean slightly inward toward the east wall, an "optical refinement" of the sort so common in the Doric Parthenon across the way. The western wall of the cella, on the other hand, had two levels: below, a base-

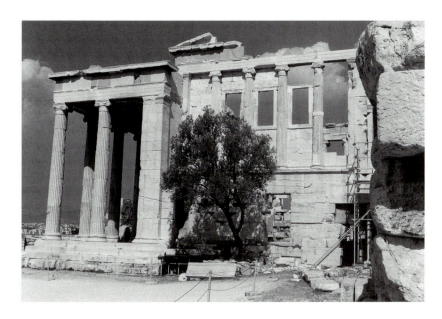

Fig. 175. Erechtheion from the west.
Photo: author.

ment of ashlar masonry pierced by a doorway, and above, a storey with four Ionic half-columns set between antae [Fig. 175]. Between the half-columns were five tall windows, four grilled, one (the southernmost) open; these windows, once considered elements of the original building, are Roman additions, inserted when the building underwent massive renovations early in the reign of the emperor Augustus (in the 20s).[119] Five much smaller, wedge-shaped "slit windows," however, were cut into the bottom of the north and south cella walls as part of the original design, possibly to help illuminate special chthonic cult places within.[120]

The interior of the building has been gutted, so its plan is largely conjectural [Fig. 174]. It is clear enough that the cella was divided into at least two large rooms by a solid north-south wall. (There was no commerce between the rooms, and this is what Pausanias may have meant by calling the Erechtheion "a double building;" of course, the wall dividing the two rooms of the Parthenon [Fig. 127] was solid, too.) The slightly smaller eastern room was almost certainly the location of the statue of Athena Polias, as well as many of the gold wreaths, gold and silver vases, votive armor, and other treasures inventoried in fourth-century inscriptions: two windows flanking the door would have let natural light in upon the statue and its precious goods (just as the two large windows in the Parthenon's east cella wall [Fig. 130] let light into the interior, illuminating the treasures of Athena and, indirectly, the statue of Athena Parthenos). The western room (whose floor was over 3m

lower than that of the east) was probably further subdivided into three compartments. An antechamber full of its own cult places (possibly the salt sea and trident marks of Poseidon, a rocky cleft in which Athena's sacred snake, the avatar of Ericthonios, was said to live, a rock-cut shaft and a shelf and tall niche in its southwest corner) provided access to two smaller rooms set side by side. These were possibly devoted to the cults of the local hero Boutes (the Plowman, who in some accounts is Erechtheus's brother and the priest of both Athena and Poseidon, as well as the founder of the priestly Eteoboutadai family) and Hephaistos (the father of Erechtheus/Erichthonios). As plausible as it is conjectural, this plan for the cella imitates the cella of the late Archaic *Archaios Neos*, whose foundations, again, lay just to the south [Fig. 93].

Without actually naming the temple, the Roman architect Vitruvius singles out the Erechtheion for "transferring to its sides what is normally found in front," and he is clearly talking about the building's north and south porches. A splendidly ornamented doorway on the north side of the western antechamber connected it with a great porch [Fig. 176], supported by six tall Ionic columns, that actually extends about three meters beyond the western wall of the cella proper (to the east of the north porch was a rectangular paved courtyard; a broad flight of stairs led up to the level of the east facade). Beneath the marble floor in the southeastern part of the north porch is a small "crypt,"[121] and an opening left in the pavement reveals a cluster of irregular fissures and indentations in the

bedrock below. Though often thought to be the marks of Poseidon's trident, the fissures were most likely considered scars left by the thunderbolt of Zeus, which put a dramatic end to the contest waged by Athena and Poseidon over rights to Athens [cf. Fig. 143]. Framing the hole in the floor was an altarlike structure; we are told in inscriptions of an altar in the north porch sacred to an obscure character known as "the Thyekhoos" (Pourer of Offerings), and this most likely was it. But almost directly above the hole, high above in the marble ceiling and roof of the north porch, there is another, elegantly crafted rectangular opening, a kind of skylight. That there was some kind of metaphysical connection between the markings in the rocky crypt below and the bright heavens above seems inescapable.

South of the western antechamber, though on a higher level and connected to it by a stairway, is the famous Porch of the Karyatids, answering (on a smaller scale) the six columns of the north porch with its six (not quite evenly spaced) maidens [Fig. 177]. The Karyatid porch could also be entered from the outside by a small stairway at its northeast corner, though this is unlikely to have been a common point of entry. Like most of the south wall of the cella, the porch rests upon the foundations of the late sixth-century *Archaios Neos* and so, if the plan of the cella of the Erechtheion truly emulated that of the old temple, there was a tangible as well as a formal connection between the two, with the substructure of the Archaic temple literally helping to support the Classical (just as the Periklean Parthenon stands largely upon the foundations of the late Archaic Older Parthenon, Fig. 106), with the Classical temple serving as a kind of recreation or reincarnation of the Archaic. Tucked under the Karyatid porch was also a portion of the Kekropion, the hero-shrine (and supposedly the tomb) of the legendary king in whose time the contest between Athena and Poseidon and the creation of their tokens (the olive tree and trident marks) took place. Perhaps the Karyatids themselves, with their *phialai* or libation-bowls, were to be thought of as participants in the cult of Kekrops. In any case, the Kekropion extended at an angle to the west, beyond the porch, and a tall stele may have marked its location in the Classical period, as a great Ionic column seems to have done in the Archaic.[122]

To the west of the temple lay the quadrilateral enclosure known as the Pandroseion [Fig. 3, no. 10], the shrine to the one obedient daughter of Kekrops. The priestess of Pandrosos, incidentally, was also priestess of Aglauros, whose sanctuary was located on the east slope of the

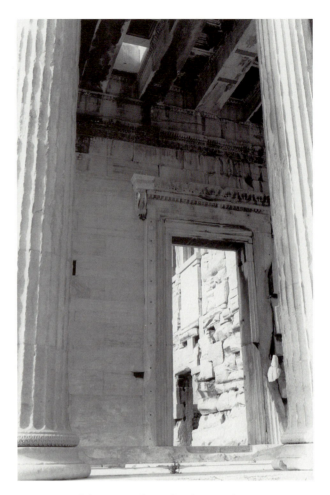

Fig. 176. Erechtheion, north porch. Photo: author.

Acropolis below that massive cave [Fig. 8],[123] so that summit and slope were in some sense related by cult. At all events, the principal features of the Pandroseion were a small Ionic stoa that ran obliquely from the southwest corner of the Erechtheion's north porch, the sacred olive tree of Athena, and, in the shade of the tree, an altar to Zeus Herkeios (Zeus of the Court). The door in the lower storey of the west wall of the Erechtheion [Fig. 175] provided direct access between the Pandroseion and the Erechtheion's interior; another doorway directly connected the Pandroseion to the north porch of the Erechtheion. Thus the Pandroseion should be considered an appendage to the temple, part of the same great complex. And complex is just what the Erechtheion was: its irregular, even radical plan was dictated by the need to incorporate within it a variety of pre-existing but previously discrete cult places spread over the uneven terrain of the north side of the Acropolis [Fig. 115] and to com-

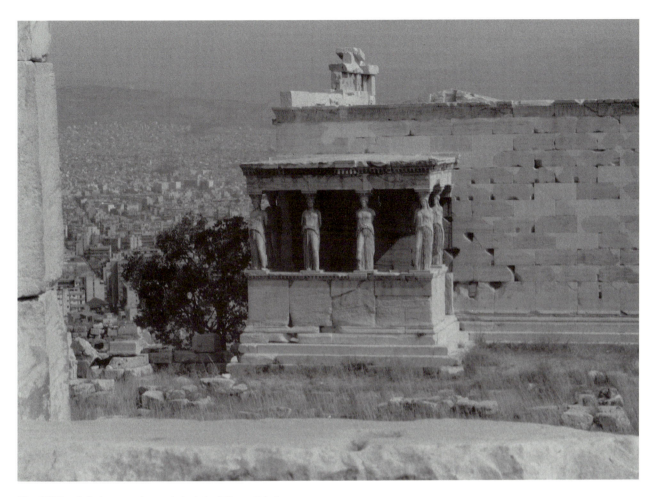

Fig. 177. Erechtheion, south porch (original Karyatids in Acropolis Museum and British Museum). Photo: author.

bine them all as a new incarnation of the destroyed *Archaios Neos*. Again, the Periklean Parthenon had preserved within it a pre-existing shrine and altar [Fig. 21] so the notion of accommodating the old in the new was not original with the Erechtheion architect – it almost seems a Periklean principle. At all events, the Erechtheion was not a temple devoted to a single divinity, but an assemblage of shrines devoted to many deities, heroes, and a heroine. It was a *composition* of shrines, a sanctuary within a sanctuary.

The name of the architect of this unprecedented building is unknown. We do know that a certain Philokles and an Arkhilokhos were each given one-year contracts to help bring the project to completion after an interruption. We even know the names of the workmen who fluted the columns of the east porch: Laossos of Alopeke, for example, and Phalakros of Paiania, and their slaves Parmaean and Karion and Thargelios and Gerys. (Slaves,

incidentally, make up about 20% of all Erechtheion workmen whose names we know, *metoikoi* over 50%.) But Philokles and Arkhilokhos were most likely just site supervisors or master craftsmen, hired to oversee the finishing touches on a building whose architecture was already largely complete.[124] As the original designer of the temple scholars have proposed such better-known architects as Kallikrates and Mnesikles. Kallikrates, a contractor, a builder of walls and modest shrines, seems not have been as subtle or sophisticated a designer as the Erechtheion required.[125] But there are, in fact, a number of similarities between the temple and Mnesikles's Propylaia: the general asymmetry of the buildings, for example; the way they incorporate various "blocks" into one complex; the split-level nature of the designs, necessitated by the irregular ground, with floors and colonnades at different levels; the use of Eleusinian limestone for details or, more technically, the use in the north porch of a "double

anta" that seems modelled on the double anta of the Propylaia's southwest wing; and the fact that the Erechtheion, like the Propylaia, has column-drums apparently belonging to the interior order of the Older Propylon built into its foundations.[126] Certainly, the Athenians could have found no better architect for the Erechtheion than the genius of the Propylaia. On the other hand, there are also a number of technical similarities with the final stage of the Ionic Temple of Athena Nike, built in the 420s: the same use of a rare kind of dowel, for example, or the use of the same formulae in decorative mouldings, or the "optical refinement" of inward-leaning columns (unknown in any other Ionic building). These correspondences need not mean that the same architect designed both temples, only that the same well-trained labor force worked on both and brought their special skills and techniques from one to the other.[127] Still, one wonders whether Mnesikles figured in the Nike Temple project, too.

Neither "the Erechtheion" nor "the temple in which is the ancient image" is mentioned in the Kallias Decrees (dated to 434/3 and concerned with putting the Acropolis in order), and neither is mentioned in Plutarch's list of Periklean building projects. This has always suggested that the temple was never part of the Periklean program, that Perikles essentially ignored the more sacred cult of Athena Polias in favor of the more ideological and imperial Athena Parthenos [Fig. 132], and that he was content to leave the ancient olivewood statue in the modest Early Classical shrine on the north side of the rock [Fig. 115]. Indeed, the inception of the Erechtheion has typically been dated to 421, eight years after Perikles's death (the Peace of Nikias, it is thought, would have been the most propitious moment after the start of the Peloponnesian War for the beginning of so large and expensive a project on the Acropolis). Still, there is no hard evidence for the date of the ground-breaking. The concluding lines of Euripides's fragmentary *Erechtheus*, in which Athena directs Praxithea to build a shrine for the hero, have been taken to allude to construction already under way in the late 420s (the accepted date of the play), even before the peace. And some now believe that, despite its absence from Plutarch's list, the Erechtheion had been projected or even begun long before that, in the 430s – and so during the Periklean regime after all.[128] If so, it is necessary to split some hairs, for it is difficult to imagine the Athenians initiating a major project after 434/3, when the assembly had just passed an injunction (in the form of the Kallias Decrees) to wrap everything up in anticipation of conflict, even to the point of leaving the Propylaia unfin-

ished. One possible scenario is that the Erechtheion was first planned in the mid-430s but that construction did not progress very far (if at all) before the outbreak of war, and that full-scale work did not really begin until the late 420s (hence its absence from Plutarch's list). Most of the edifice would have been built by 413 when, probably, the Sicilian disaster and fiscal exigencies brought the project to a halt. Work on the temple was definitely resumed, inscriptions inform us, in 409, when a commission was appointed to report on the state of the building (that is when Philokles was appointed "site architect;" Arkhilokhos took over the next year). Perhaps the confidence-building and very profitable victories won by Alkibiades at Kyzikos and the Hellespont in 410 provided the inspiration (and some of the funds). There is some questionable evidence that an accidental fire on the night of a full moon caused one last delay,[129] but if so the temple was essentially completed soon after, in 406/5 – essentially completed, because even here a few details (some rosettes in the architrave above the Karyatids and a portion of the egg-and-dart moulding below them on the west side of the porch) were never carved.

The Erechtheion had three pediments (east, west, and north porch); all were empty. There is no evidence for any *akroteria*. The sculptural adornment of the building was thus limited to the maidens of the south porch and a continuous Ionic frieze. The Karyatids [Fig. 177] are appropriately stocky and powerful (they do the work of columns, after all) and although at first glance they seem to differ only in the distribution of their weight (three stand with the right, three with the left leg relaxed), a closer look reveals that they all vary in the treatment of their drapery and coiffures. They were carved and set in place during the first phase of construction and so may be dated to around 420. Inscriptions refer to them as *korai* and the choice of words may not be coincidental: these maidens, who, like Archaic *korai* [cf. Fig. 100], wear their hair long in spiralling locks and originally held a *phiale* in their right hand and tugged at their dress with their left, might have been considered public or state replacements for the private votives destroyed by the Persians in 480, or even for Karyatids that once stood in Archaic buildings on the Acropolis [Fig. 88].[130] At the same time, the Karyatids face south, toward the Parthenon, and in profile view they look like fully three-dimensional versions of the offering-bearing maidens of the Parthenon's east frieze [Fig. 158]. The style of Agorakritos or Alkamenes has sometimes been detected in the statues (Alkamenes's slightly earlier "Prokne" [Fig. 178] looks a lot like a Karyatid that has

stepped down from the building and entered a myth). But chains of attribution are only as strong as their weakest links. And while the Karyatids may well have been the product of a single workshop under the direction of a known "master" responsible for the model or prototype – and Alkamenes is not a bad candidate – it is likely that the individual statues were carved by artists whose names we would not recognize. That, indeed, is the case with the Ionic frieze that ran around the top of the exterior of the cella and the north porch.

The Erechtheion frieze (carved in the second major campaign, between 409–406) displays a technique that was never again attempted for architectural sculpture [Fig. 179]: separately carved, high-relief marble figures or groups pegged (by means of iron dowels) to a background of dark bluish Eleusinian limestone (on the Parthenon frieze the background was painted blue).[131] Though no figure is still *in situ*, over a hundred marble fragments of the frieze remain; some are Roman replacements (or additions), attached when extensive repairs were made (especially to the western part of the building) during the reign of Augustus. A few female figures (at least one with her breast exposed) run to the left or the right. Other women stand or crouch or sit on chairs or rocks. A youth kneels at the feet of a man caught in a strikingly contorted pose (he resembles the twisting Itys of Alkamenes's Prokne group [Fig. 178]). A figure of uncertain gender rises from a throne. A seated Apollo holds an *omphalos* in his lap (this piece is of Roman date). A seated woman holds a young boy in hers. Inscriptions tell us of other figures: a youth writing something down, for example, or wagons and mules. Most of the preserved figures are posed fairly quietly, and there is not much that helps identify the undoubtedly mythological content of the frieze. A recently published fragment with a Corinthian helmet lying on a rocky outcropping suggests that Athena, shown seated with her armor at her side, appeared at least once.[132] The woman with the boy in her lap also naturally makes one think of (or hope for) Athena and Erechtheus/Erichthonios, but there were other such mother-child groups, so the identification is weakened. No doubt there were several different subjects (the frieze on the north porch was at a different level and on a slightly larger scale than the rest, and so might have called for separate treatment).

An important inscription of 408/7 identifies some of the artisans who worked on the frieze (a large percentage, again, were *metoikoi*) and tells us what they were paid (the going rate was 60 *drakhmai* per figure, human or animal):

Fig. 178. The Prokne and Itys of Alkamenes (Acropolis 1358), c. 430–420. The head has now been removed. Photo: author.

207

Fig. 179. Erechtheion frieze (Acropolis Museum). The third figure from right (a seated Apollo) is a Roman replacement or addition. Photo: author.

Phryomachos of Kephisia, the youth beside the breast-plate. 60 *drakhmai*.

Praxias resident at Melite, the horse and the man seen behind it who is turning it. 120 *drakhmai*.

Antiphanes of Kerameis, the chariot and the youth and the pair of horses being yoked. 240 *drakhmai*.

Phyromachos of Kephisia, the man leading the horse. 60 *drakhmai*.

Mynnion resident at Agryle, the horse and the man striking it; he afterwards added the pillar. 127 *drakhmai*.

Soklos resident at Alopeke, the man holding the bridle. 60 *drakhmai*.

Phyromachos of Kephisia, the man leading on his staff beside the altar. 60 *drakhmai*.

Iasos of Kollytos, the woman embraced by the girl. 80 *drakhmai*.[133]

Without the inscription we would never have heard of Phyromachos and his fellows, who evidently were assigned different figures in a single scene of harnessing four horses to a chariot.[134] But not even the carver of the inscription specifically identifies the figures. They are described generically ("the man leading the horse," "the woman embraced by the girl"): it is as if even he did not know who they were. But the prevalence of horses and chariot in this passage and the predominance of women in the extant fragments raises the possibility that at least some of the frieze represented the career and family of Erechtheus himself. He (and not Athena) was in some

accounts the inventor of the chariot, and the only major myth dealing with him (besides the story of his birth) involves his sacrifice of his own daughters to save the city from its foes (the story was told in Euripides's *Erechtheus*, which, as we have seen, may have other connections with the Erechtheion). This story, which has recently been read into the Parthenon frieze, was more likely depicted or alluded to here instead.[135]

Although not as sculpturally loaded as the Parthenon or the Temple of Athena Nike, the Erechtheion was a remarkably luxurious building. Mouldings or bands carved with lotus-palmette chains, egg-and-darts, leaf-and-darts, bead-and-reels, guilloches, rosettes (carved or gilt bronze), and other patterns were everywhere – around the frame of the north door [Fig. 176]; around the windows of the east wall; around the aperture in the ceiling of the north porch; around and in the ceiling coffers; or atop the cella walls (the contrast between the lush decoration at the top of the south wall and the vast plainness of the wall beneath [Fig. 173] is startling). Column capitals even had gilding and were inlaid with multicolored beads of glass. This, in short, was an exceptionally rich jewel-box of a temple, and yet for all its external elegance it was still a place of mystery and curiosities within – a place unparalleled for its asymmetry (in a culture where symmetry was a metaphor for rationality), a place of strange thunderbolt- and trident-marks, of holes left in the roof and floor, of a salt-water sea, of tombs, of snake-inhabited crevices and underground crypts, and of a statue that had fallen down from heaven.

It may seem remarkable that temples as different as

the Ionic Erechtheion and the (mostly) Doric Parthenon could stand just forty meters apart on the summit of the Acropolis [Fig. 124]. And indeed for some the Erechtheion has seemed in some measure an eccentric, even critical, response to the Periklean building, a reassertion of the primacy of the oldest cult places of Athens that had been neglected during the years of Perikles's dominance. In this view the building represents a late fifth-century resurgence of fundamentalism or even the irrationality of religious belief in the face of the symmetrical, colonnaded Parthenon's promotion of its own imperial Athena [Fig. 132] and Periklean rationalism. Naturally, this view is weakened if the Erechtheion was in fact designed as early as the 430s. And in any case the Erechtheion and the Parthenon should not be regarded as architectural antagonists: the buildings do not clash. We need instead to stress the role they together played in the spatial and iconographic composition that was, finally, the Classical Acropolis. The Karyatids, looking a lot like Parthenon sculptures themselves, acknowledge the Parthenon and direct our attention to it. In turn, the Erechtheion gave spectacular shape to the north-side cult places that the Parthenon itself had already alluded to in its sculpture: there in the west pediment, after all, was Athena's olive and Poseidon's trident and Kekrops and possibly even Zeus's thunderbolt [Fig. 143], now all incorporated within the confines of the admittedly unorthodox new building across the way. Erechtheus himself probably appeared in the west pediment. Boutes, the object of an Erechtheion cult, may have appeared on one of the lost Parthenon south metopes.[136] And, of course, the object of the Panathenaic procession – and the recipient of the *peplos* placed in the middle of the Parthenon's east frieze [Fig. 151] – was not the gold-and-ivory Athena Parthenos, but Athena Polias, the ancient wooden statue that had always been housed on the north side of the rock.[137] The building of the Erechtheion only made that side more glamorous and worthy of the Parthenon's allusions. Different the two buildings certainly are, but they are also complementary.

The Sanctuary of Athena Nike (Final Classical Phase, Appendix C, no. 14)

If there had been a modest early Periklean remodelling of the old Bronze Age bastion [Fig. 125], less than two decades later plans were made to rebuild the sanctuary of Athena Nike completely, monumentalizing it in keep-

ing with the spirit of the other major works of the Periklean Acropolis. The entire bastion received a new sheath of limestone that straightened its lines (it was now trapezoidal in plan, widening toward the east) and increased the area and raised the level of the sanctuary above [Figs. 180, 181]. Near the base of the bastion's west face two rectangular niches were left open to reveal the Mycenaean core (with its own niche) within [cf. Fig. 55], and another irregular opening may have been left in the north face of the bastion – all Classical windows onto the Bronze Age past. The limestone sheathing is crowned by a moulding of Pentelic marble, the same material used for the little but elegant and profusely adorned Temple of Athena Nike itself [Plate IX, Fig. 182].

This Ionic structure, with four columns in front and four in back (that is, tetrastyle amphiprostyle), is set flush against the western edge of the bastion and was built with some of the same kind of architectural refinements that distinguish the Parthenon and other Periklean buildings (the north and south walls of the cella, for example, lean inward slightly and the columns lean back). A new altar was built less than two meters to the east of the temple, and the entire sanctuary was paved in marble. The precinct, which lies outside the Acropolis fortification wall and thus technically outside the confines of the sanctuary of Athena Polias on the summit, could be entered either from the east, via the southwest wing of the Propylaia, or from the north, up a small stairway leading from the new long and broad Classical ramp (c. 80m × 20m) that had been built up the west slope to the Mnesiklean Propylaia. An inscription dealing with the Nike temple project mentions an architect but gives no name.[138]

Whoever he was, he certainly worked with Mnesikles's new gateway to the Acropolis in mind (indeed, if the architect was not Kallikrates, then it is conceivable he was Mnesikles himself).[139] The Propylaia is the earlier of the two buildings, and it is clear that one of the Nike architect's tasks in remodelling the bastion was to bring its level up to (or near) that of the gateway. But if the new bastion plainly acknowledged the existence of the great Mnesiklean structure, it is also now apparent, as we have noted, that the design of the southwest wing of the Propylaia was itself revised several times to accommodate the rebuilding of the Nike precinct and permit easy passage between the two. It is thus likely that the very latest work on the Propylaia and the earliest stages of the rebuilding of the Nike bastion overlapped. This would mean: (a) that the monumentalization of the bastion had already begun (or at least had been antici-

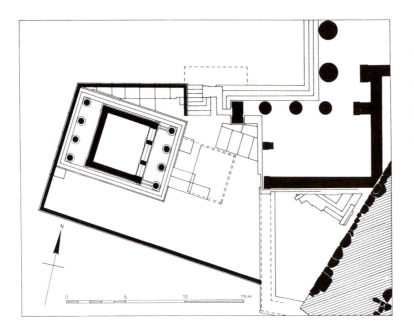

Fig. 180. Plan, Nike Temple bastion, second Classical phase. After Mark 1993, fig. 17, used by permission.

Fig. 181. Nike Temple bastion, with windows onto the Mycenaean core left on its west face. (Visible in the foreground is the polygonal retaining wall for the mid-6th-century ramp leading up to the summit). Photo: author.

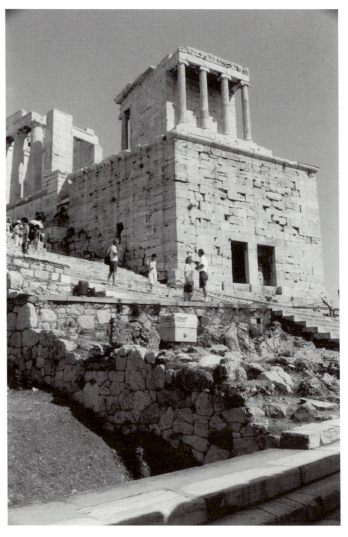

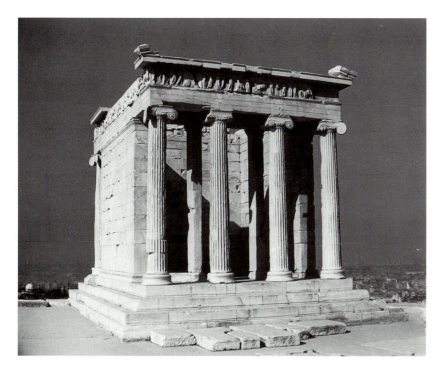

Fig. 182. Temple of Athena Nike, from east. Courtesy Acropolis Museum.

Fig. 183. Sculptural Program of Temple of Athena Nike. After C. Smith's plan, Stewart 1990, pl. 414.

pated) by 432, the year work on the Propylaia prematurely came to a halt, or (b) that the southwest wing as it stands was a late feature of the Propylaia, contemporary with the rebuilding of the Nike bastion in the 420s.[140] In the case of first scenario, the new, grander sanctuary of Athena Nike should be considered part of Perikles's own vision for the Acropolis, and this despite the fact that Plutarch does not list it among the projects of the Periklean building program and that the Temple of Athena Nike itself does not seem to have been built until 425 or so (the same crisis that led to the premature termination of the Propylaia would have caused the delay). That is, if work on the bastion in fact began before 432, the new temple may in some sense still be considered "Periklean," even though he did not live to see it.

Upon completion of the temple, the old Archaic cult-statue of Athena Nike, which had been taken from the Acropolis before the Persian sack of 480 and spent the Early Classical period we know not where, was installed inside on a marble base, possibly decorated with a relief frieze (there is a fragmentary Nike that might belong). The exterior of the small temple was decorated with what might be, pound for pound, the richest sculptural program of the Classical Acropolis [Fig. 183], and it is no surprise that the principal theme of the decoration was victory (*nike*) itself. The theme was expressed mythologically, allegorically, and histori-

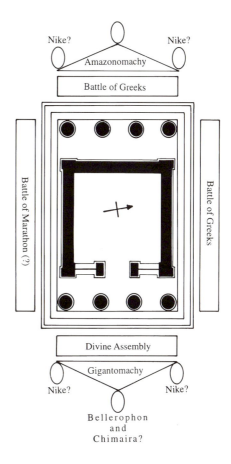

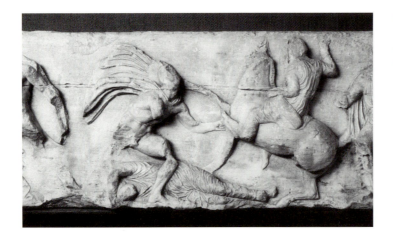

Fig. 184. South frieze (detail), Temple of Athena Nike: Battle of Marathon (?). Courtesy Trustees of the British Museum.

cally,[141] and it started at the top, in the bronze *akroteria* of the roof. At the center (at least on the east side) Bellerophon, the hero who had captured Pegasos with Athena's golden bridle, defeated the Chimaira: the message, clearly, is that Athena favors the brave. Probably flanking this mythical scene at the corners were Nikai, the personifications of victory itself. Just below the roof, the victory of the gods over the giants filled one pediment, and the victory of the Athenians over the Amazons filled the other. Below that, in the continuous friezes running round the temple, there is both myth and, exceptionally, history (or history mythologized). The battles on the north and west are problematic but most agree that they showed, remarkably, Athenians fighting other Greeks.[142] The question is whether the fights are historical or mythological. Possibly they depicted recent struggles between Athenians and their Peloponnesian foes; that is, these are fifth-century battles. But it has recently been argued that the west frieze depicts Athenians fighting to recover the bodies of the seven heroes who fought against Thebes, while the north showed the Athenians defeating the forces of Eurystheus, king of Argos – mythological antecedents for Athens's more recent battles against the Thebans and Argives. Whatever the case on the north and west, the battle on the south [Fig. 184] is almost certainly the quite historical, but by the end of the fifth century almost legendary, Marathon.[143] In the Classical Athenian mind, the line between history and myth was not clear, and Marathon existed easily in both realms (the Marathon dead were, in fact, worshipped as heroes).

On the east frieze [Fig. 182], a host of standing and seated divinities (and probably a hero or two as well) gather around a central group of a fully-armed Athena and another, lost figure (possibly Nike herself again).[144] Poseidon sits on a rock (Cape Sounion?) to Athena's right, Zeus on his throne to the proper left of the missing figure. The gods are mostly quiet, and most are posed frontally. They thus face the shrines located to the east, on the Acropolis summit, though Aphrodite and Peitho, at the south end of the frieze, loom above their sanctuary – the shrine of Aphrodite Pandemos – almost directly below [Fig. 3, no. 31]. What the assembly has to do with the battles on the other sides is unclear, though the simplest explanation is that the gods have come together to honor Athena as guarantor of the victories depicted around the corners: the battles are manifestations of her province and power. It is also worth noting that divine assemblies had been juxtaposed to heroic battles in architectural sculpture as early as the sixth century,[145] and that a few figures rush in from the south and north ends, supplying a slender formal (if not thematic) connection to the dynamic battles on those sides of the temple.

The sculptural program of the Nike temple was in its way a variation of or comment upon the Parthenon's. Bellerophon's Pegasos was seen again (twice) on the helmet of the Athena Parthenos. The probable use of Nikai as corner *akroteria* mimicked their use on the Parthenon [Fig. 133]. The combination of Amazonomachy and Gigantomachy on the pediments repeats the same "back-to-back" relationship between those myths on the outside and inside of the shield of the Athena Parthenos and on the west and east metopes of the Parthenon. Certain passages in the battle friezes seem to have quoted portions of the shield of the Athena Parthenos; the battle on the south frieze even recalls that the Parthenon itself was considered a monument to Marathon. And the east frieze

repeats a theme of the Parthenon's east pediment, east frieze, and the base of the Athena Parthenos: the divine assembly. Carved in response to the Parthenon program, the Nike temple sculptures, rising above the visitor as he first ascended the Acropolis, fittingly introduced or prefigured what he would find on the summit. Indeed, as R. Rhodes has suggested, the Nike bastion is to the Acropolis what the chryselephantine Nike is to the statue of Athena Parthenos [Figs. 25, 132]. The Acropolis, with the bastion projecting like an arm from its west slope, seems to extend Victory to the city of Athens in the same way that the Athena Parthenos, with her outstretched right hand, presented Nike to the visitor inside the Parthenon.[146]

The Nike Parapet
(Appendix C, no. 15)

The Nike bastion juts out sharply from the Acropolis [Fig. 181]. Its summit is high, exposed, and none too spacious; its sides are sheer and steep. It is a perilous place, and the dangers would have increased when people in some numbers gathered around the altar on days of sacrifice. What was needed was something to keep visitors from falling off. And so, sometime after the completion of the Nike temple, a waist-high marble parapet or balustrade was built along the three edges of the bastion. There was in addition a short return beside the small stairway on the east, and the whole thing was about 100 feet long [Fig. 180]. The balustrade itself was framed below by the projecting marble crown of the bastion and by a moulding above; for added security, a bronze grille was set into its upper surface. Between the mouldings, on the outer face, ran a continuous figured frieze about nine-tenths of a meter high (the height of the frieze plus the upper moulding is almost exactly the same height as the Parthenon frieze). Though it was not visible to anyone standing within the Nike sanctuary itself, the parapet frieze was the architectural sculpture closest to the pilgrim who climbed the great ramp leading to the (sculptureless) Propylaia.[147] Looming above the visitor on the right, the parapet would certainly have been among the first figured works to catch the eye. In this sense it was (along with the sculptures of the Nike temple itself) the visitor's introduction to the iconography of the Classical Acropolis – the initial statement of its theme of victory.

The frieze was filled with approximately fifty figures (more, if the south frieze extended past the line of the Nike temple's east facade towards the relic of the Cyclo-

pean wall). Because Athena Nike herself, seated on a rocky throne, seems to have appeared once on each side of the parapet (near the center on the west, and on the westernmost slabs of the north and south sides) [Fig. 185], the parapet frieze had no single goal (as the Parthenon frieze did) and its composition was thus diffuse. Instead of forming a continuous progression around the top of the bastion, each side of the parapet was discrete and self-contained; taken together, they were purposefully repetitive. Thus, to someone standing below the northwest corner of the bastion on the way up the Acropolis ramp [Fig. 181], two Athenas would have been visible simultaneously, and the theme of victory would have been clear. For around the Athenas, who merely sat and watched, were flocks of winged Nikai who approached the goddess (one held a helmet in her hand) or stood on tiptoe to trim battle trophies, or casually untied their sandals [Fig. 186], or pushed and pulled cattle to the sacrifice [Fig. 187], all with the grace or grand gestures of ballerinas at the *barre*.

It is worth noting that a fourth-century inscription detailing the massive Panathenaic sacrifice says that one of the most beautiful cows brought to the Acropolis was to be sacrificed on the altar of Athena Nike.[148] But the gender of only one of the animals preserved on the Nike parapet is clear: it is male, and male animals were not normally sacrificed to a goddess. The Nike parapet, then, probably does not represent sacrifices *to* Athena. It represents sacrifices that Athena herself observes or supervises. Possibly this is the kind of sacrifice made by warriors before battle, here undertaken by divine figures on the Athenians' behalf. In this view the Nike parapet, telescoping time, represents both the requisite sacrifice before battle and the erection of trophies afterwards: victory is sought, assured, and won at once.[149] But more likely the sacrifice is not to the gods at all but to dead Athenian heroes – heroes like those defending Athens in history and myth on the friezes of the Nike Temple above, heroes like those who fell at Marathon [Fig. 184].[150]

The trophies the Nikai build are variously hung with hoplite armor, naval equipment (apparently), and Persian spoils, and the differences may be significant. It could be, for example, that there was some relation between the sides of the parapet and the sides of the frieze on the Nike temple above: the Persian trophies, for example, seem confined to the south side of the parapet, corresponding to the battle of Marathon depicted in the south temple frieze. Still, those trophies may also commemorate victories more recent than Marathon.

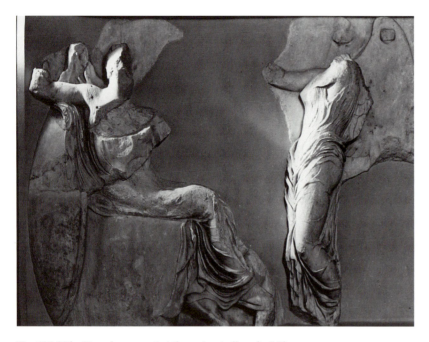

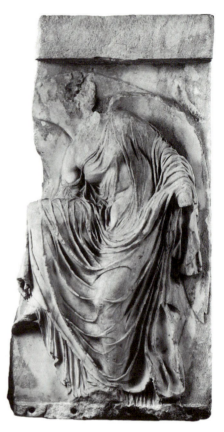

Fig. 185. Nike Temple parapet: Athena (seated) and a Nike.
Courtesy Acropolis Museum.

Fig. 186. Nike Temple parapet: Nike unbinding her sandal.
Courtesy Acropolis Museum.

Although the parapet is often thought to have been carved around 420, when it would have put an elegant Athenian spin on the Peace of Nikias, circumstantial and stylistic evidence suggests a date closer to 415 or even 410, when Athenian spirits, crushed by the failure of the Sicilian expedition just a few years before, were rapidly reviving. Near the beginning of Aristophanes's *Lysistrata* (produced in 411),[151] the chorus of old men – they are veterans of Marathon – stand before the Propylaia and appeal to Lady Nike for a trophy of victory over the women who have seized the Acropolis (possibly an allusion to the carving of the parapet then under way). So, too, the Athenians won a string of victories over the Peloponnesians in the eastern Aegean and Hellespont between 411 and 407 (Alkibiades won most of them) and so frustrated the designs of the Persians (who subsidized Sparta) in the area. The display of Persian spoils hanging on trophies on the parapet may well refer to these late successes against their ancient foes as well as to Marathon, conflating recent and ancient history. Finally, though dating sculptures on the basis of style alone is, to say the least, an inexact science, some figures on the parapet seem earlier than the Erechtheion frieze

(Fig. 179, dated c. 409–406), while others seem about the same date, or even later.

One artist probably designed the frieze, but the work was turned over to a fairly large and heterogeneous team of sculptors. Six distinct "hands" have, in fact, been identified, and two artists with very different styles could even work on the same slab (one might carve drapery in thick, deep, flourishing folds, for example, while the other might carve flimsier, revealing material with sharp, shallow furrows) [Fig. 187]. It has been nearly impossible to resist identifying these Nike Masters A, B and so on with known sculptors of the last quarter of the fifth century – Agorakritos (A), Paionios (B), and Kallimachos (E), for example – but the temptation should probably be avoided. It is possible that some of the sculptors had already worked on the Nike temple pediments and friezes or even the Parthenon frieze or, at least, knew them well. The famous Nike unbinding her sandal before treading upon sacred ground [Fig. 186], for example, seems a variation of the Aphrodite who bends over, placing her foot on a rock, near the south end of the Nike temple's east frieze [Fig. 182]. And the artist who carved the Nike bracing her foot on a rock as she

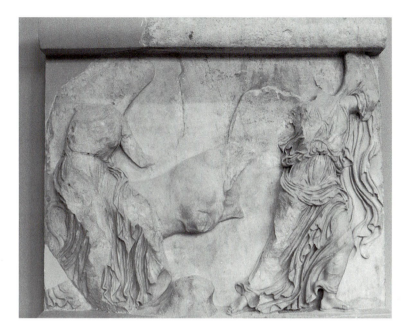

Fig. 187. Nike Temple parapet: Nikai restraining sacrificial bull. Photo: author.

Fig. 188. Parthenon south frieze, detail: youth restraining heifer. Courtesy Trustees of the British Museum.

tries to control a recalcitrant if diminutive bull [Fig. 187] or another Nike leading a bull from the south side[152] seems to have known (could he, earlier in his career, have carved?) a passage on the Parthenon's south frieze, where a youth similarly restrains a heifer [Fig. 188]. Still, as in the case of the Erechtheion frieze, a list of the sculptors of the parapet would likely be filled with the names of complete unknowns.

At all events, the parapet frieze is an allegorical coda to the mythological-historical sculptural program of the Nike temple itself [Fig. 183]. There, gods fight giants and Greeks (or Athenians) fight Amazons, other Greeks, and Persians. Here, dozens of personifications either perform the necessary sacrifices before battle or sacrifice to honor the Athenian heroes of battles past. By building trophies they celebrate the victories such sacrifices and honors guaranteed. If the victories and heroes are not those depicted on the temple above, then the Athenians were here engaging in sculptural wish-fulfillment, using superhuman figures to assure their success in the last years of a war they were destined to lose.

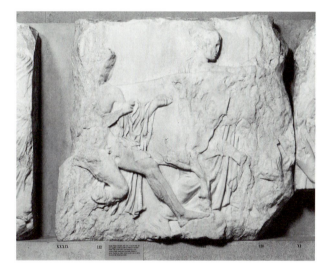

The Chalkotheke
(Appendix C, no. 16)

Once routinely considered a Periklean project datable to the third quarter of the fifth century, the Chalkotheke [Fig. 3, no. 6; Fig. 189] has also been dated to the post-Periklean era, perhaps as late as the early fourth century (there is no literary evidence for it and the earliest inscription certainly mentioning the building by name belongs to 371/0). The function of the building was essentially utilitarian. As the name implies, it was a storehouse for bronze (and iron) objects, above all armor and weapons (shields, greaves, spears, and so on), chariot wheels and axles, and even catapults and naval equipment. In addition to military matériel, however, the Chalkotheke stored a variety of miscellaneous objects (for example, empty bronze chests, iron pebbles, twenty-one gold letters of the alphabet,[153] even the key to the east room of the Parthenon, the so-called

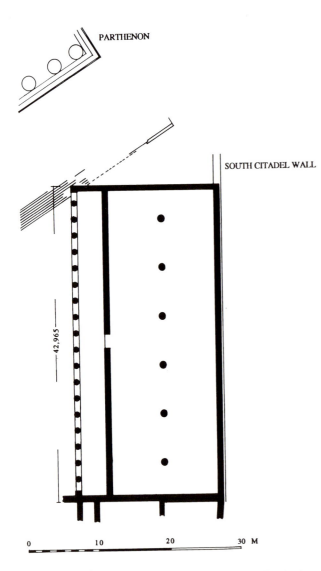

SOUTH CITADEL WALL

42,965

0 10 20 30 M

Fig. 189. Plan of the Chalkotheke. Drawing by. I. Gelbrich after La Follette 1986, fig. 3.

defined the building on the north. Once thought to be a later addition, it is now apparent that this portico was contemporary with the hall behind it and may have displayed the building's more impressive holdings (such as spoils of war). The northeast corner of the porch sliced into the impressive flight of steps previously cut into bedrock west of the Parthenon (these steps [Fig. 163] and the portico thus defined two sides of a trapedoizal court in the shadow of the great Classical temple), and on the west the building shared a party wall with the Sanctuary of Artemis Brauronia (which appears to be earlier). The north side of the Chalkotheke court was defined by a long, probably Periklean wall, with propylon, that extended eastward past the rock-cut steps to act as a terrace wall for the Parthenon. Despite its size, the Chalkotheke was built economically (this, together with the inscriptions and inferences from some historical evidence, argues against a Periklean date). The presence on the late Classical Acropolis of what seems to have been primarily an arsenal confirms the citadel's enduring military character even after the fifth-century monumentalization of its cult-centers. At the same time, like the nearby Bronze Athena and even the Parthenon itself, it symbolized Athenian military might. In any case, the Chalkotheke, if it truly dates to the 380s or 370s, was the last great Classical addition to the summit of the rock.

THE SOUTH SLOPE

The Odeion of Perikles
(Appendix C, no. 19)

Major state-sponsored activity on the north slope of the Acropolis seems to have been virtually nonexistent in the second half of the fifth century,[155] and on the south slope it seems to have been limited to a single, if huge, building: the so-called Odeion, or Music Hall, the earliest in Athens [Fig. 3, no. 20; Fig. 190]. Although Vitruvius states that the Odeion was built by Themistokles (who, he says, roofed it with the yards and masts of Persian ships), most scholars follow Plutarch, who says the building was a replica of Xerxes's pavilion and credits Perikles with the project (Perikles is even said to have acted as building supervisor).[156] Perikles evidently built the Odeion to accommodate the several kithara and flute competitions held during the Panathenaia – *mousikoi agones* that he probably reorganized and that are probably alluded to in the Parthenon frieze.[157] But the Odeion served as more than a concert hall. It soon became (if

hekatompedon) as well as stuff that can only be considered junk (such as broken iron objects). Unlike the treasures stored in other Classical buildings on the Acropolis (or even in the Archaic *oikemata*, some of which may have once stood in the vicinity, cf. Fig. 83a), much of the material kept inside the Chalkotheke does not seem to have been votive in character.

The building consisted of a large oblong room, its roof supported by perhaps six interior columns, set against the south wall of the Acropolis (its back wall actually used the upper, Periklean part of the south wall as a footing and therefore postdates it).[154] A portico with eighteen columns (probably Doric and set *in antis*)

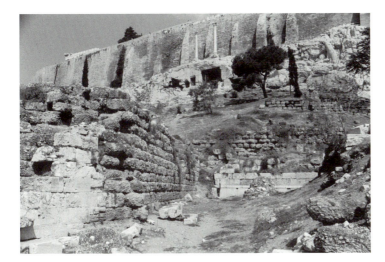

Fig. 190. View, area of Odeion of Perikles. Photo: author.

Perikles did not originally intend it to be) the setting for the annual event known as the *Proagon* ("Before the Contest"), where Athenian dramatists, accompanied by their actors and choruses, introduced to the people the plays they would be seeing a few days later in the nearby Theater of Dionysos during the City Dionysia (it was here, at the *Proagon* of 406, that Sophocles famously appeared in black to mourn the death of Euripides).[158] According to a line in Aristophanes, the Odeion could also be used as a court and some sources suggest philosophers taught there, too. In the sad days of 404/3, it was even transformed into a military headquarters: the Spartan garrison called in to prop up the Thirty Tyrants was probably stationed here, and after the Thirty were deposed the Athenian cavalry and their horses were for a time quartered inside.

Built into and against the rising rock of the south slope, the Odeion was almost square and had eight to ten rows of interior columns supporting a steep, pyramidal wooden roof – the peak evoked comic comparisons to the pointy-headed Perikles. It is not certain whether the building had solid exterior walls (with entrances on the west, east and, probably, the south) or whether it was instead an open columnar pavilion reminiscent of Persian hypostyle halls (which would have made the quartering of horses a little easier). There were, presumably, seats inside, but the precise arrangement is unknown and the forest of interior columns must have obscured many views (on the other hand, anyone who had followed the course of the Parthenon frieze from outside the temple's peristyle [Fig. 149] would have been used to that).

In 86 the Athenians themselves burned down the Odeion to deny the Roman general Sulla the use of its precious and plentiful supply of wood for his siege of the Acropolis. The Odeion that Vitruvius, Pausanias, and Plutarch knew (and whose scanty remains we mostly see) was thus the one rebuilt along the original design a few decades later by Ariobarzanes II, King of Cappadocia.[159] It is uncertain whether the original timber really did come from the spars and masts of Persian ships (presumably those captured at Salamis) – the wood would have had to be preserved for thirty years or more before Perikles' architects could use them. And it is unclear how much the building really resembled the famous tent of Xerxes captured at Plataia.[160] But the stories told in our sources are enough to suggest that the Odeion, like the Parthenon, was in the Athenian mind closely associated with the Persian Wars. In its way, it was another victory monument.

The Periklean Sanctuary and Theater of Dionysos

The relationship between the Odeion, where Athenian dramas were previewed, and the Theater of Dionysos just to the west, where they were actually performed (and had been since the end of the sixth century), was obviously close [Fig. 3, no. 21]. But in the second half of the fifth century the Odeion seems to have been the more impressive place architecturally. It is difficult to believe that the Periklean program would have created so vast a building as the Odeion without paying at least some attention to the Theater next door, and there is the possibility of some kind of Periklean refitting. As far as the larger Sanctuary of Dionysos is concerned, however, Perikles was content to leave the small and simple

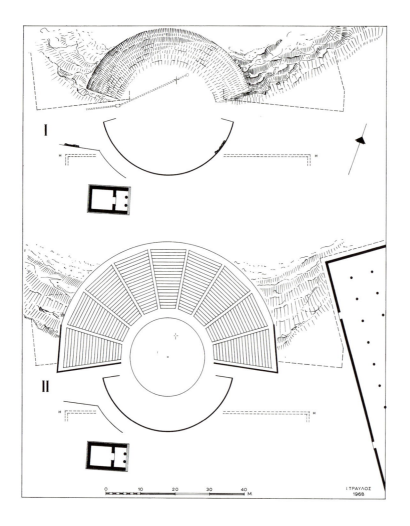

Fig. 191. Plans of early Theaters of Dionysos. After Travlos 1971, fig. 677. Reproduced by permission of DAI-Zentrale, Berlin, and E. Wasmuth Verlag.

Archaic temple of the god the focus of cult [Fig. 109, no. 115], though perhaps some sort of Periklean structure was built nearby to house a new chryselephantine statue of Dionysos said to have been made by Alkamenes (who may have learned the technique while working as Pheidias's apprentice on the Athena Parthenos).

The (perplexing) archaeological and literary evidence suggests that in the second half of the fifth century – the heyday of Sophocles, Euripides, and Aristophanes – the Theater of Dionysos (like the temple just to the south) remained a surprisingly modest place [Fig. 191]. It had three distinct parts: a flat, circular *orchestra* ("dancing place," where the actors and chorus performed); behind this a low, broad wooden *skene* (the stage building, which provided an all-purpose architectural setting as well as a place for the actors to change their costumes); and, fanning out above the *orchestra*, the *theatron* ("the seeing place"), where the mass of Athenians sat on concentric rows of wooden bleachers set into

the rising, natural curve of the south slope (the front row was reserved for dignitaries, such as the priest of Dionysos and victorious generals, and may have been of stone). In short, below the marble shrines of the Acropolis summit, nestled into the bowl of the slope, fifth-century Athenians watched the greatest dramas of antiquity in a simple, open-air theater that exploited but did not seriously alter the hillside. But the best ancient poets knew that they could create more with words than architects could with wood or marble, that they built monuments more lasting than stone. It is significant that the Theater of Dionysos was not enlarged and rebuilt fully in stone – and a new, larger Temple of Dionysos was not constructed – until the fourth century, when Athenian tragedy at least had declined: the monumentalization of the theater almost seems compensation for the fall-off in Athenian dramatic energy. In the second half of the fifth century, however, the play, not the theater, was still the thing.[161]

The Sanctuary of Asklepios and Hygieia (Appendix C, no. 20)

In 420/19, with the last major outbreak of the plague six years past and the recently negotiated Peace of Nikias allowing greater freedom of travel within Greece, a wealthy Athenian citizen named Telemakhos, apparently acting on his own, sailed to the Peloponnesian site of Epidauros, the preeminent sanctuary of the healing god Asklepios, and on the eighteenth day of the month of Boedromion brought the god (and his daughter Hygieia, "Health") back with him. Precisely what form the god took is unclear.[162] Though some sources say that the great Sophocles himself received Asklepios's snake – his avatar – in his own house and fed it eggs (did the author of the *Antigone* really believe a reptile was Asklepios incarnate?), the god was more likely housed temporarily in the Eleusinion north of the Acropolis [Fig. 2] until Telemakhos could construct a suitable shrine. There is no question that the sanctuary he built (and no doubt served and administered as chief priest) was located west of the

Theater of Dionysos, between the Peripatos (the belt-line pathway that ran all around the Acropolis) and the steep rocky face of the citadel [Fig. 3, no. 25; Figs. 192, 193]. But there is some debate over the exact location, extent and appearance of the earliest sanctuary. The remains we see today – the so-called Doric stoa on the north side and the temple and altar on the marble pavement – date principally to the fourth and early third centuries, while the smaller south stoa and propylon date to the Roman Imperial period.

The sanctuary that Telemakhos built over the eight or nine years following Asklepios's arrival in Athens must have included a modest temple or *naiskos* for the cult-statue as well as a sacrificial altar. It probably also included a curious stone-lined hole in the ground called the *bothros*, which was incorporated later into the Doric stoa and covered with a stone canopy or baldacchino. The *bothros* could have been a reservoir, a sacrificial pit, or a home for snakes. Water was an essential part of the healing cult – plenty was needed to treat women who

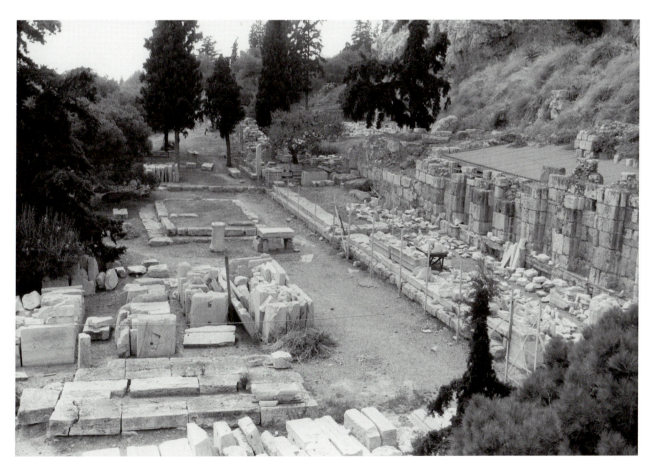

Fig. 192. View of Asklepieion from east. Photo: author.

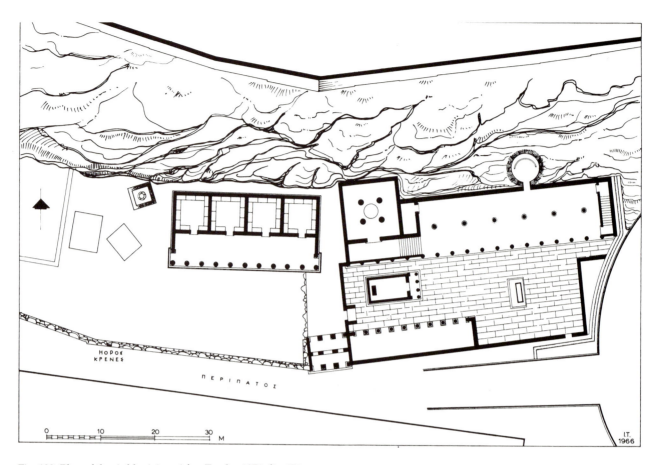

HOΡOΣ
KPENEΣ

ΠΕΡΙΠΑΤΟΣ

0 10 20 30
⊢┼┼┼┼┼─────┼─────┤ M

I.T.
1966

Fig. 193. Plan of the Asklepieion. After Travlos 1971, fig. 171. Reproduced by permission of DAI-Zentrale, Berlin, and E. Wasmuth Verlag.

had trouble nursing or men with kidney stones, for example – and so Telemakhos incorporated into his sanctuary a natural grotto and spring in the cliff (it was later entered through a short tunnel in the back wall of the Doric stoa). A few years into the project, Telemakhos built a wooden propylon to serve as a formal entrance to the precinct: the gateway was pictured in relief at the top of the so-called Telemakhos Monument, an inscribed pillar set up by the founder around 400 to commemorate his good works (and, it has been suggested, to correct the popular belief that it was Sophocles who introduced Asklepios to Athens).[163] In short, the fifth-century Asklepieion probably occupied the same terrace as the later one; so little of it is left because the original structures, like the propylon, were of wood.

To the west of this area, however, there was another large building – the so-called Ionic stoa – that is often thought to have formed part of Telekmakhos's original installation [Fig. 3, no. 26; Fig. 193]. The building con-

sisted of four rooms large enough (6m square) for the dining of priests, suppliants, or pilgrims (it is less likely, though possible, that the rooms were used for the ritual "incubation" of Asklepios's patrons). This interpretation of the stoa is not universal, however, and some would disassociate it from the Asklepieion altogether. Yet the archaeological date for the building – c. 420 or so (the columnar porch was actually added a decade or two later) – accords too well with Telemakhos's foundation and elaboration of the sanctuary to be coincidence. From the inscription on the Telemakhos Monument we know, too, that early on in the history of the sanctuary there was a territorial dispute with the priestly family known as the Kerykes, and since the Ionic stoa was built astride an old precinct wall it may have been the source of the argument.[164] It was probably its construction, in fact, that led to the clearer definition of the boundaries of yet another sacred zone a little farther to the west – the South Slope Spring, as it is known, originally sacred to nymphs and then to Pan. This spring (rather, the spring house built over it) originally dates to the late sixth century. Its sacred territory was not officially marked off,

220

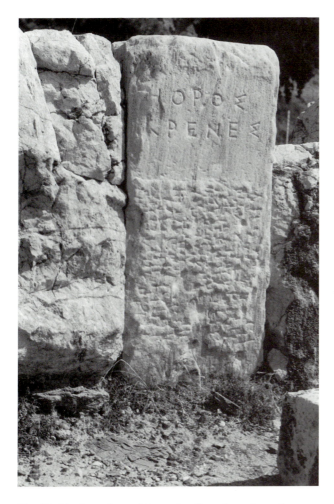

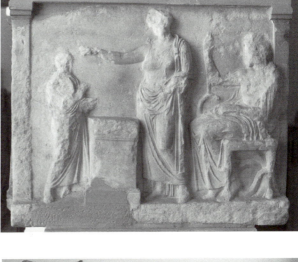

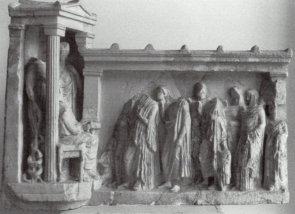

Fig. 194. The boundary of the spring (*horos krenes*), south slope. Photo: author.

Right top: Fig. 195. Votive relief from Asklepieion: Asklepios and Hygieia bless a worshipper (NM 1338), c. 400. Photo: author.

Right bottom: Fig. 196. Votive relief from Asklepieion: Epione, Asklepios, and daughter receive worshippers (NM 1377), c. 350. Photo: author.

however, until the last quarter of the fifth century – the era of Telemakhos's beneficence – when a marble boundary stone inscribed with the words *horos krenes* ("boundary of the spring") was set up along the Peripatos [Fig. 194].[165]

Remarkably, then, the initiative of a private citizen in the late fifth century reshaped, directly or indirectly, a roughly eighty-meter-long strip along the south slope of the Acropolis. Votive reliefs depicting Asklepios and Hygieia blessing worshippers were dedicated in the sanctuary by 400 or so [Fig. 195]. But the state would not assume official control over the Asklepieion and its treasures until around 350, and the takeover would be marked by a boom in splendid votive reliefs and other dedications [Fig. 196] and by the translation of wooden architecture into stone. Still, for nearly three-quarters of a century an unofficial healing-cult served ailing Athenians in the shadow of the public state-cults of the Acropolis summit. The sanctuary's impact on Athenian life seems to have been immediate and sacred patterns atop the Acropolis itself did not go untouched. For after 420 no private dedication is ever made again to Athena Hygieia, whose shrine still stood just inside the Propylaia [Fig. 172]. One of the goddess's cultic roles was apparently usurped at a stroke by the popular newcomer Telemakhos brought to town.

THE PARTHENON FRIEZE, NIKE, AND THEMATIC UNITY ON THE CLASSICAL ACROPOLIS

There is nothing [in images] that is unintelligible. To understand Pindar's poems we have to rack our brains. That does not apply to the Parthenon frieze.

Ernst Robert Curtius, arguing that philologists
have a tougher time than art historians.[1]

The researches of many commentators have already thrown much darkness on this subject, and it is probable that, if they continue, we shall soon know nothing at all about it.

Mark Twain (allegedly), in another context.

The Problem of the Parthenon Frieze

Either the Parthenon frieze [Fig. 147] represents the Panathenaic procession, or it does not. Either the frieze is an idealized rendering of a contemporary and recurring event, or it is not. These have been the traditional terms of the long debate over the subject and meaning of the one element of the Parthenon sculptural program that is relatively well-preserved. But the traditional terms of the debate turn out to be inadequate, and E. R. Curtius's opinion that understanding the frieze is easy is about as wrong as it could possibly be.

But let us assume for the moment that the parade of horsemen [Figs. 152–53], chariots [Fig. 156] and pedestrians [Figs. 154–55, 157–58] is indeed the Panathenaic procession (as the prominence of the Panathenaia in Athenian civic and religious life and in Athenian political history, as well as the centrality of the cloth-handling scene in the east frieze [Fig. 151], have not unreasonably led the majority of scholars to conclude).[2] The question

then becomes, which, or what kind of, Panathenaic procession is it – mythological, historical, or generic?

We instinctively, reflexively, think myth. After all, we *expect* to find myth and heroes in Greek architectural sculpture. That is what the rest of the Parthenon sculptures represent. That is what Greek architectural sculpture had almost always represented. And there are now two comprehensive mythological interpretations to choose from. The first makes this the very first Panathenaia, the one founded by Erechtheus/Erichthonios (who in one tradition also invented the chariot, shown so often in the north and south friezes). The participants are thus the heroes and heroines – the legendary population – of early Athens. So, in the central scene on the east, the cloth is the inaugural *peplos*, the small child is Erechtheus/Erichthonios himself, the man King Kekrops, the woman Ge (Earth, from whom the child sprung), and the stool-bearers two of Kekrops's daughters.[3] But there is nothing that clinches the mythological

222

identity of any of the figures – no attribute (such as, say, a snake beside Kekrops) that would decide the issue – and there is a general reluctance to assign specific names to more than a few of the 360 figures on the frieze who are clearly not gods.

According to a new and provocative mythological reading, however, the frieze depicts not only the legendary first Panathenaia, but also, in a kind of narrative "flashback," the mythological occasion or explanation for its establishment.[4] In this reading the central scene in the east frieze [Fig. 151], far from representing the benign handling of the first *peplos* by Kekrops and the boy Erechtheus/Erichthonios, in fact represents an adult King Erechtheus, aided by his wife Praxithea, tragically preparing to sacrifice their youngest daughter – the small child at Erechtheus's side – to save the city from the invading forces of Poseidon's son Eumolpos. The cloth is not the Panathenaic *peplos* but a shroud in which the littlest daughter will be ceremoniously wrapped before having her throat slit. Her two older sisters approach their mother not with chairs and a footstool but with shrouds of their own on sacrificial tables: in accordance with a sisterly vow, they will patriotically submit themselves to the knife as well. The central scene, then, presents a different, earlier, mythological moment from that shown in the rest of frieze. For there, on the north, south, and west friezes (and even on the north and south ends of the east frieze itself), we see (once again) the very first Panathenaia, held not to honor Athena's birthday or her role in the Gigantomachy but to commemorate the heroic death of Erechtheus (who in the meantime had been destroyed by Poseidon) and the noble sacrifice (and self-sacrifice) of his daughters. The horsemen, chariot-borne warriors, and pedestrians who occupy so much of the frieze represent the heroic Athenians who, having just triumphed over Eumolpos, now participate in the inaugural procession.

Now it is likely that Erechtheus, and conceivable that Eumolpos, appeared somewhere in the Parthenon's west pediment [Fig. 143].[5] In this new interpretation, the story of their continuation of Athena and Poseidon's *agon* (contest) over Athens was foretold in the pediment only to be developed further on the frieze. Still, there are more than the usual number of problems with the theory. The tragic tale itself *may* have been known before the Parthenon was begun, but that is not certain. The first known literary treatment of the myth is Euripides' fragmentary play, *Erechtheus*, written a decade or more *after* the frieze was finished (so the play cannot fairly be used as if it were the source of the sculpture). In crucial details the story might even have been Euripides's invention (he is notorious for putting his own peculiar spin on myths). There is no extant representation of the story in pre- (or, for that matter, post-) Periklean art, either: it is difficult to believe that Pheidias would have inserted at the center of the frieze a myth that is found, as far as we can tell, absolutely nowhere else in Athenian art. And without a standard iconography to guide them, and without even a sacrificial altar to indicate the setting or a sacrificial knife to indicate the action, how could spectators have been expected to recognize the central scene as the solemn prelude to grisly human sacrifice?[6] It is, perhaps, not so hard to explain the presence of the gods on either side of the unhappy family [Figs. 150, 30]: with their backs turned to the central passage, they can be read as belonging to the depiction of the first Panathenaia rather than to the earlier scene of impending human sacrifice (where they should not be present at all). Still, the juxtaposition between what is supposedly a very tragic royal family and two groups of very blasé gods to left and right is jarring, to say the least. Everything about the frieze, in fact, is casual and relaxed: there is no hint of grief or torment over the bloody deaths of patriotic innocents. Moreover, the bearded man (whoever he is) seems to be folding up the cloth, not unfolding it (how, then, could he be about to cover his child with it before the sacrifice?). As for the two young women to the left of "Praxithea," they may simply be carrying cushioned stools, not tables laden with shrouds (there are no visible folds as there are in the shroud/*peplos*). They would thus be standard-issue processional *diphrophoroi*, familiar and expected sights in Athenian festivals. Alternatively, they might be *Arrhephoroi*.[7] But in any case they are not Erechtheids. Furthermore, the interpretation of the procession as the very first, mythological Panathenaia held to honor the memory of Erechtheus and his daughters does not jibe with the tradition that Erechtheus (or his *doppelgänger* Erichthonios) established the festival himself,[8] with Homer's and even Euripides's indications that bulls and rams were sacrificed to Erechtheus and the Erechtheids (not the heifers and ewes depicted on the frieze),[9] or with the numerology of the south frieze, where the clear organization of the horsemen into ten ranks suggests a Panathenaia held after Kleisthenes' quite historical establishment of the ten Attic tribes.[10] Absolutely crucial to this mythological interpretation of the frieze, however, is the gender of the small child handling the cloth [Fig. 151]. If this is the

saga of the Erechtheids, the child must be a girl, and indeed the so-called Venus-rings on the child's neck have often been taken as female indicators. But there are statues of boys with such rings, too – they are signs of well–fed plumpness not gender – and the garment the child on the frieze wears is probably a *himation*, worn in this fashion (without an undergarment) exclusively by males. Now, even if the small child *is* a girl,[11] we are still not required to accept the mythological reading of the work: she seems about the right age for a *Arrhephoros*, who could be as young as seven. But if the child is in fact a boy, the interpretation of the frieze as a representation of the Erechtheus story simply collapses.[12]

If the frieze does not depict legend, there would appear to be only two choices left: either it depicts an historical procession – that is, the procession of a particular year – or it depicts a "generic" procession, one that stands for any and all such processions without representing a specific one, a generalized and idealized procession.

The problem with an historical reading of the frieze is that such a thing had never appeared in Greek architectural sculpture before and a lack of precedent makes cowards of us all. We might, however, take courage in the fact that historical events had appeared in *paint* before, on a large scale and on a public building not far from the Acropolis: probably in the 450s, Mikon and Panainos depicted the Battle of Marathon within the Stoa Poikile in the Agora [Fig. 2].[13] One cannot deny Pheidias the same capacity for innovation so recently displayed by the painters of the Stoa Poikile or, for that matter, the designers of the Temple of Athena Nike, whose Ionic frieze, carved only two decades after the Parthenon's, was filled on three sides by depictions of (probably) historical battles, including Marathon itself [Fig. 184]. Marathon was the defining event of fifth-century Athenian history: it was the greatest of all Athenian victories, one that quickly acquired quasi-legendary status as proof of the virtuousness of the democracy and the favor of the gods. And Marathon, John Boardman has argued, is implicit in the Parthenon frieze as well. The year 490 was a Greater Panathenaic year, and in Boardman's view the Parthenon frieze represents the procession that happened to take place just six weeks before the critical battle – a procession in which the warriors who fought at Marathon surely took part. He has counted the numbers of horsemen, *apobatai*, marshals, and grooms in the cavalcade and chariotry portions of the frieze and come up with a total of 192, which is precisely the number of Athenians who fell at Marathon and who in fact came to be worshipped as heroes thereafter. The frieze, then, not only represents a particular procession, but retrospectively idealizes and heroizes the Marathonian dead besides.

Now, a Marathonian connection for the frieze is appealing in several ways. In the Stoa Poikile the painting of the battle was juxtaposed with paintings of an Amazonomachy and the Sack of Troy, two of the myths depicted in the Parthenon's own sculptural program (west metopes, exterior of the shield of the Athena Parthenos, north metopes). The association between this history and those legends – and with it the blurring of the boundaries between history and legend – was thus already well established in Athenian art, and it would have been natural for Pheidias, as designer of the Parthenon program, to rely upon and develop the connection (especially if his earlier creation, the Bronze Athena [Fig. 24], really had been paid for out of the spoils of Marathon).[14] The topography of the Acropolis itself had Marathon connections: Pan, the goat-god who favored the Athenians in the battle, had his cult in a cave on the northwest slope [Fig. 7]. Moreover, as we have seen, the Parthenon itself was in some measure a restoration of a temple (the Older Parthenon) begun in the heady days after the battle as a thank-offering to Athena for the victory. And such fourth-century Athenians as Demosthenes even conceived of the Periklean building as a war memorial, financed out of Persian spoils.[15] The Marathon theme, then, would have resonated with bell-like clarity on the Parthenon frieze (and it would have rung even more loudly after the carving of the Nike Temple's south frieze) – had it only been there. But it probably was not. Boardman's theory relies on an arbitrary muster of processional figures (why count the grooms and marshals but not the charioteers?) and his numbers may not quite add up, either. Portions of the relevant sections of the frieze are missing, so we cannot be sure of an exact count (I come up with 190, two short of what is required). More importantly, perhaps, we have to ask who in antiquity would have taken the trouble to count the figures so high above their heads between the peristyle columns in reflected light and who, having counted, would instantly have drawn the connection between, on the one hand, the horsemen and the chariot-borne *apobatai* and, on the other, Marathon, where the Athenians, to a man, fought on foot?[16]

So, by a process of elimination, we seem to be left with the standard interpretation of the Parthenon frieze as a generic image of a recurring, contemporary

event – the sort of Panathenaic procession with which the inhabitants of Athens in the second half of the fifth century were intimately familiar, since they either participated in it or observed it from the sidelines. In this reading the figures represent the idealized inhabitants of Perikles's city, male and female, young and old. Real Athenians (and even some resident aliens who served as *skaphephoroi*) would have looked up at the frieze, seen themselves, and been pleased at how well they looked [cf. Figs. 153, 154, 158]. The frieze, in other words, is a flattering Athenian self-portrait, with the Athenians represented as uniformly handsome, uniformly pious, and uniformly contemplative, with the plane of their idealized humanity fusing easily with the higher plane of the so-called Eponymous Heroes and the even higher plane of the gods on the east frieze [Figs. 150, 159] (the difference between the Athenians and the heroes and the gods is not one of kind but merely of degree). In this reading, the *peplos* scene [Fig. 151] represents a young temple-boy helping the Archon Basileus (the city's chief religious magistrate) with the sacred robe; the matronly woman is either the Priestess of Athena Polias or the Basilinna, the wife of the Archon Basileus, who played an important role in Athenian civic religion; and the two younger females approaching her are *diphrophoroi* (chair-bearers) of a sort commonly found in sacred processions or even the *Arrhephoroi* (though these girls do seem a little too old for that). Such an interpretation still makes the Parthenon frieze an anomaly: no earlier work of architectural sculpture had ever represented a contemporary event and contemporary Greeks – a human present rather than a heroic past – even in an idealized fashion. But votive reliefs had done so [Fig. 42][17] and no earlier work of architectural sculpture had ever approached the Parthenon frieze in scale, either. The building's sculptural program is full of original, even radical, choices (the decision to carve all 92 exterior metopes, for example, or the unprecedented choice of the contest between Athena and Poseidon for the west pediment, and so on). The decision to fill the frieze with a generic procession could have been simply one more stroke of originality.

The basic reading of the frieze as an idealized Panathenaic procession, depicting the Athenians not as they were but as they wished to see themselves, permits a large number of variants, some of which actually cut across the boundaries between myth, history, and genre – boundaries that the Greeks bothered about less than we do anyway. For example, even some scholars who reject a comprehensive mythological or historical reading of the frieze are still prepared to find a hero or portrait among the mortal crowd. The bearded horse-tamer in the center of the west frieze has been identified as Theseus [Fig. 152] – his breaking of the horse would be an allegory for his *synoikismos*, his legendary unification of Athens – while the Archon Basileus in the center of the east frieze [Fig. 151] has (improbably) been identified as none other than Perikles himself.[18] Other scholars more plausibly suggest that the figures in the *peplos* scene, though idealized mortals and not figures of legend, may nonetheless be *reenacting* the heroic foundation of the Panathenaia, with the young women standing in for the daughters of Kekrops, the Archon Basileus for Kekrops (his royal ancestor), and the boy for Erechtheus/Erichthonios.[19]

Some scholars who accept the generic character of the frieze nonetheless also raise issues of time and place. One, relying on the numerology of the frieze, accepts the south frieze as a generalized Periklean-era procession (again, its organization around the number 10 refers to the ten tribes into which the Athenian populace had been divided ever since Kleisthenes's reforms) but believes that the north frieze (where the number four plays so large a role) alludes to the Panathenaic procession of pre-Kleisthenic times, when the population was organized into four tribes: in this reading the frieze, though generic, in a way summarizes the history of the procession and the political history of Athens.[20] Another scholar sees two distinct (if still generic) processions, with two distinct directions and goals, instead of one: the north side depicts a procession in honor of both Athena Polias and Pandrosos (the four cows would be sacrificed to Athena, the four sheep to Pandrosos), while the south side depicts a procession in honor of Athena Parthenos (the recipient of the ten cows) – this despite the fact that the two streams come together as one on the east side [Fig. 145, below], and despite the fact that there is no evidence that Athena Parthenos was ever the object of cult in the first place.[21] Some scholars, believing that the Classical temperament would have insisted on the dramatic "unity of place," set all the action of the frieze in the Agora. Others more flexibly distribute the action over different parts of Athens, from the Dipylon Gate (where the procession began and where the riders shown in the west frieze [Pl. VI] would have mounted their horses), through the Classical Agora (where, for example, the *apobates* competition [Fig. 156] may have taken place), to the summit of the Acropolis itself (where the sacrifices were made and the *peplos* was presented).

To follow the frieze around the building would have been to take an imaginative journey through Athens [Fig. 2].[22] Finally, there are interpretations that accept the generalized Panathenaic character of the frieze but emphasize its political messages. Style, it can be argued, is often a political rather than purely aesthetic choice, and the stylistic homogeneity of the detached or introspective figures on the frieze [Fig. 153] is an attempt to emphasize the equality of the Athenian populace under Perikles. Those who look alike, the argument goes, not only think alike and act alike but are alike under the democracy.[23] According to yet another generic theory, the frieze represents the Panathenaia all right, but in doing so deliberately synthesizes the iconographies and conventions of the art of Athens's Ionian subjects and allies. Equestrian and processional subjects and chariot races had already been depicted in the sculpture of East Greek temples, for example, and Pheidias incorporated such images here to argue for the ideological unity and ethnic kinship of the entire empire. Athens's subject-allies, visiting the Acropolis, would have been reassured by the inclusive nature of the image.[24]

The generic reading of the frieze is, then, a broad umbrella covering a large cluster of interpretations. Still, the assumption fundamental to them all – that the frieze basically represents a contemporary but generic Panathenaic procession of idealized mortals – is hardly unassailable. Again, we need not be bothered by the fact that such a subject would be unprecedented in Greek architectural sculpture: there is a lot about the Parthenon that is unprecedented. Rather, the problem is that if the Parthenon frieze was really intended to represent an idealized but still recognizable Periklean-era procession, it does a poor job of it. There are people and things missing from the frieze that we know from literary sources should be there: representatives of Athens's imperial allies, female water-jar carriers (the *hydriaphoroi* on the frieze are male [Fig. 155]), *thallophoroi* ("twig-carriers" chosen from among the best-looking Athenian elders),[25] and, most conspicuous by their absence, the force of armed hoplites that marched, and the large ship-on-wheels that rolled (with the huge tapestry-*peplos* rigged as its sail), down the Panathenaic Way. Artistic license can explain away some of this: the depiction of a full-size ship in a relief only a meter high would have wreaked havoc upon the scale of the frieze (either the ship or the figures would have had to be jarringly miniaturized). Or perhaps, in a telescoping of time and place, the pilgrim, following the course of the procession down

the side of the Parthenon [Fig. 147], imaginatively mimicking its progress from the Dipylon Gate to the Acropolis summit, was at some point toward the eastern end of the cella supposed to think of the ship as already docked at the foot of the citadel and therefore absent from the festivities depicted as taking place atop it. Or perhaps this is not the quadrennial Great Panathenaia at all, but the annual festival, when the ship did not roll and Athena Polias was presented the human-sized robe-*peplos*. Still, the missing persons are harder to explain. There were 160 meters of frieze: could the great Pheidias (or whoever designed the frieze) find no room for any hoplites at all? Then, too, there are things present on the frieze that were almost certainly not there in the course of the actual procession. *Apobatai* [Fig. 156] may have participated in the parade, but they could not have actually engaged in their dramatic sport, as they do on the frieze, without trampling pedestrians and causing bloody mayhem. Indeed, the *apobates* competition probably took place the day *after* the procession,[26] so in this respect at least there can be no unity of time in the frieze. Finally, there are participants for whom there is no independent evidence – the male *hydriaphoroi*, for example, and, remarkably, even the horsemen [Figs. 152, 153]. Although the cavalcade occupies nearly half of the total length of the frieze and equestrian events certainly loomed large in Panathenaic contests held in the days before the climactic parade, there is not a single ancient source that states unequivocally that horsemen participated in the Panathenaic procession itself.[27] Now, no one expects the frieze to be a completely accurate, documentary record of the event: this is sculpture, not videotape. But there are so many discrepancies between what the frieze shows and what the procession is known to have included that either (a) the frieze, as a depiction of a Panathenaic procession, is a failure, or (b) it does not represent a Panathenaic procession at all.

So let us now assume that the frieze does not depict a Panathenaic procession of any kind. What, then, is going on? According to one theory, it is a *symbolic* representation. Just as the Periklean Parthenon was a kind of restoration of the Older Parthenon destroyed by the Persians, so the figures on the frieze are renewals, in relief, of the Archaic statues and votives that fell victim to barbarian impiety in 480 – dedications that Athenians over the age of fifty might well have remembered seeing in their youth and whose loss they would have lamented still. The prominent maidens of the east frieze [Fig. 158],

for example, are in this view really Archaic *korai* [Fig. 100] put in fashionable Classical clothes; the youths leading cattle [Fig. 157] are evocations of works like the Moschophoros [Fig. 71]; the horsemen are restorations of Archaic equestrian statues [Figs. 90, 103]; even the *peplos* in the east frieze [Fig. 151] is a symbolic replacement for all those *peploi* that, stored in the *Archaios Neos* [Fig. 82], went up in smoke. The frieze, then, depicts an ideal procession, but it is a parade of restored monuments, not people.[28] And according to another kind of symbolic theory, the Parthenon frieze has less to do with actual Athenian processions than with the stereotyped parades of subjects and tribute-bearers carved on the palatial facades of Persian kings: either the frieze, with its freely posed, introspective, and individualistic figures [cf. Figs. 154, 155], is a democratic critique of rigid Persian totalitarianism, or, conversely, it is sympathetic to it, with Pheidias co-opting Persian iconography in order to assert the new dominance of Periklean Athens over its empire and the rest of Greece (the frieze would then present Athens as a new Persia – an unlikely tactic).[29]

The Parthenon frieze simply cannot accommodate all these divergent, even contradictory interpretations. Now, ambiguity is good and great works of art should have more than one level of meaning and all that (I shall argue as much in the next chapter), but they should not mean just *anything*. Still, there is one more kind of interpretation to consider, one that goes a long way toward resolving the problems of the frieze, and it is this: the frieze does not represent a single event at all (mythological, historical or generic) but is a synopsis of many events, a collection of excerpts. The fact that *apobatai*, horsemen, and musicians prominently appear on the frieze, when their competitions took place on different days of the Panathenaia (as well as in different places), suggests that the frieze does not represent the *procession*, but selects or alludes to episodes from the whole multiday *festival*, and blends them artfully in processional form.[30] But perhaps even this theory is too limiting, and the frieze depicts not "the idea of the Panathenaia" but, as J. J. Pollitt suggests, "the idea of Religious Festival" itself – an idea fundamental to Athenian life and to Athenian self-representation in general (as Perikles himself noted with pride in his Funeral Oration, citing the many "contests and sacrifices" held throughout the year).[31] Lavish processions characterized several Athenian festivals besides the Panathenaia: the one held yearly at the start of the City Dionysia (with gorgeously dressed citizens, *metoikoi*, and colonists, and with sacrifi-

cial animals and attendants galore) was nearly as grand. Virtually every feature of the Parthenon frieze could be found in any number of Athenian holidays. The procession at the City Dionysia, for example, also boasted *skaphephoroi*, *hydriaphoroi*, and a *kanephoros* carrying a ritual golden basket. It is worth noting that imperial tribute was displayed in the theater in sacks and *hydriai* [Fig. 197], and it is worth wondering whether the youths on the frieze are carrying coins, not water, in their jars [Fig. 155], one talent – "a man's load" – per pot.[32] *Kanephoroi* [Fig. 158] and *diphrophoroi* were regular features of Athenian sacrificial processions and festivals in general. But if the girls carrying things on their heads on the left side of the central scene on the east [Fig. 151] are not *diphrophoroi*, then, again, they might be *Arrhephoroi* and their burdens the secret objects they transported by torchlight on the night of their own festival, the *Arrhephoria*.[33] Horsemen may or may not have ridden in the Panathenaic procession, but mounted *epheboi* (youths in military training) certainly served as escorts at such festivals as the *Eleusinia* and *Plynteria*. One of the more spectacular equestrian displays in Classical Athens was a mock cavalry battle known as the *anthippasia*, but this is not specifically attested as a Panathenaic event until the third century, and even then it was not uniquely Panathenaic.[34] The Panathenaic *apobates* competition was clearly the most important in Athens, but *apobatai* probably performed at other celebrations as well (such as the *Anthesteria*, a festival sacred to Dionysos).[35] So did flute-players and kitharists, who regularly attended sacrifices of all sorts. And whoever the staff-bearing men flanking the gods in the east frieze are [Fig. 159] – the Eponymous Heroes of the ten Attic tribes or archons or commissioners of sacrifice – their presence would be entirely appropriate as the overseers of Athenian political, cultural, and religious life in general.[36]

Now, I side with those who believe that the central scene in the east frieze [Fig. 151] is indeed "Panathenaic" and that the cloth really is a *peplos* (this may be why Athena, just to right, has placed her *aigis* in her lap: she is getting ready for a change of costume [Fig. 30]). But other Athenian rites involved garments, too (robes were regularly offered to Artemis Brauronia, certainly at Brauron and probably on the Acropolis), so even here other non-Panathenaic associations could have come to mind. The important point is that the Panathenaia, though given pride of place on the east frieze, is only one element in the rich panorama of Athenian sacred life – and thus of Athenian society – that the entire frieze

Fig. 197. Document relief from Acropolis relating to collection of imperial tribute, 426/5 (*IG* I³ 68, EM 6595). Bags of money and at least one *hydria* are depicted at the top of the stone. Courtesy Epigraphical Museum, Athens.

surveys. This is perhaps the best explanation for the presence of all the Olympians on the east [Fig. 145]: just as the Panathenaia itself probably celebrated a cosmic battle won by *all* the gods – the Gigantomachy, woven into the *peplos* – rather than simply Athena's birthday, so the frieze glorifies Athenian piety toward all the gods, not just Athena.[37] Though placed symmetrically about the *peplos* scene with Zeus, Athena nonetheless takes her place beside the other gods, just as her special holiday, the greatest Athenian holiday of them all, is subsumed under the abstraction Festival.

One important question remains, however: what does the Parthenon frieze – a distillation of the many processions, athletic and cultural contests, ritual presentations, and sacrifices that characterized Athenian life in the age of Perikles – have to do with the rest of the Parthenon's decidedly mythological sculptural program, or indeed with the imagery of the High Classical Acropolis as a whole?

Agon and Nike: Thematic Unity on the Acropolis

By the time Pheidias's gold-and-ivory Athena Parthenos was dedicated in 438, his Bronze Athena (Promakhos) had stood out in the open on the Acropolis for almost twenty years [Fig. 24]. It was complete, but it was not quite finished. For sometime after the dedication of the Athena Parthenos (and presumably after Pheidias's departure from Athens), Parrhasios (a painter and designer active around 400) and Mys (a metalworker and engraver) were commissioned to return to Pheidias's earlier work and add to the surface of its shield, among unnamed other things, a Battle of Lapiths and Centaurs – a myth that had been virtually nonexistent on the Acropolis before the Periklean era but that now decorated the Parthenon's south metopes [Fig. 139] as well as the sandals of the Athena Parthenos [Fig. 132].[38] There can be no doubt that the addition was made to harmonize the great older bronze statue, which had apparently lacked any mythological decoration, with the great new chryselephantine one, which was loaded with it. This High Classical modification of the Early Classical bronze is one indication that the Athenians themselves conceived of the Acropolis not as a random assemblage of distinct, unrelated monuments but as a continually evolving and expanding "text." Every new monument not only changed the Acropolis; it also had the potential to alter the way everything that had been

set there before was seen. The Acropolis was thus a composition where images could allude to other images, where images could even be *made* to respond to other images, and where unity was supplied by the moving spectator's recognition of thematic repetition, variation, or elaboration.

Another case in point: around 420 a certain Khairedemos, for reasons unknown, hired the sculptor Strongylion to create a bronze statue of the Wooden Horse, the deceit that finally allowed the Greeks to enter Troy. The work was a colossos: according to one estimate, it stood nearly six meters high, and at least four life-size Greeks (Menestheus, Teukros, the sons of Theseus) were shown peeking or perhaps even climbing out of it. Pausanias saw the statue within the precinct of Artemis Brauronia, and that is where inscribed blocks from its base still lie [Fig. 168].[39] In any case, as he set about his enormous task, Strongylion must have been aware that episodes from the Trojan War, including the sack, were represented not far away on the Parthenon's north metopes [Pl. V]. In other words, the immediate artistic environment of his creation already included an extensive if episodic treatment of the myth.[40] As far as we can tell, the Trojan Horse itself did not appear on the Parthenon metopes, and so Strongylion could have conceived of his monument as a complement to the earlier reliefs – as one more episode in the saga. But the sons of Theseus (Damophon and Akamas), whom Strongylion showed peeking out of his "Wooden Horse," almost certainly appeared again on the north metopes (they rescued their grandmother, Aithra, from the burning citadel). Thus, Strongylion's work essentially explained how the pair entered Troy in the first place, and their progress on the night of Troy's sack could be traced from monument to monument, from bronze to marble. More generally, it would have been difficult for any attentive visitor to move from the Brauroneion, with its colossal horse, to the north flank of the Parthenon, with its Trojan metopes, without making a connection: one's "reading" of the story of Troy extended from one Acropolis site to the other.

So, too, Pausanias saw (apparently near the northwest corner of the Parthenon) a statue group representing Athena's birth from the head of Zeus and another group (apparently near the northeast corner of the Parthenon) of Athena and Poseidon displaying their tokens (the olive tree, the salt sea) and awaiting the outcome of their competition.[41] Athena's birth and her contest with Poseidon were, of course, the subjects of the east and west pediments of the Parthenon [Figs. 143,

145], and so the statue groups "transported" each myth to the ground on the side of the Parthenon opposite its treatment in a pediment: the narratives of the Birth and the Contest in a sense criss-crossed the Parthenon terrace. We have no evidence for the date of the statue groups. But with their addition to the sanctuary the visitor was presented not so much different versions of the myths told in the pediments as different moments in the stories – one a preface, the other an epilogue. In the "Birth of Athena" group on the ground, Athena was apparently shown actually emerging from Zeus's head (in the pediment she stood, fully emerged, beside the god) and in the other group Athena and Poseidon were evidently standing quietly by, awaiting the final verdict (in the pediment their violent contest is still under way). So, the spectator who visited both ends of the Parthenon found in the pediments above and the monuments below a kind of mythological self-commentary.

The visitor who traversed the summit of the Classical Acropolis was enmeshed in a network – an Acropolis-wide web – of meaning and reference. The web expanded organically as each new monument found itself in some fashion linked to monuments already there, unavoidably participating in a kind of discourse (both iconographic and stylistic) with other images or sites. The spectator who noted the reclining figure of Kekrops near the north angle of the Parthenon's west pediment, the marble (or bronze) olive tree of Athena at its center, and the figure of Erechtheus somewhere in the pediment, had only to turn a little farther to the north to locate Kekrops's tomb, the "real" olive [Fig. 175], and, probably, one or more images of Erechtheus again (on the Erechtheion frieze [Fig. 179] or in the large bronze group Pausanias saw, in which he fought Eumolpos).[42] The spectator who noted the group of deities on the east frieze of the Temple of Athena Nike [Fig. 182] would find the leitmotif of "divine assembly" repeated on the Parthenon's east frieze [Fig. 145] and on the base of the Athena Parthenos [Fig. 132]. The theme of divine birth linked the base of the Parthenos with the Parthenon's east pediment (could the east frieze of the Nike temple have represented the birth of Athena as well?). The Erechtheion Karyatids [Fig. 177] seem like monumental versions of the maidens on the Parthenon east frieze [Fig. 158]. Sculptors working on the Nike parapet may have quoted passages on the Parthenon frieze [see Figs. 187, 188]; and so on. The perception of the intricacy of this topography of allusion depended upon the movement and short-term memory of the visitor, and few vis-

itors would have viewed one treatment of a given theme or myth without recalling and comparing others already seen and already in mind. The experience of the Acropolis (as of any Greek sanctuary) would thus have been a dynamic, cumulative, and extremely resonant one. The imagery of the Acropolis constantly alluded to itself: its unity was a natural product of intricately evolving lines of self-reference.

Any number of themes or leitmotifs can be traced upon the fifth-century Acropolis. Some were even architectural. The use of the Ionic order for the Nike Temple, inside the mostly Doric Propylaia, for the Erechtheion, and inside the mostly Doric Parthenon, for example, imposed a broad contrapuntal rhythm upon the place. Another particularly significant theme, as we have noted before, was the High Classical evocation, preservation, and renewal of Early Classical, Archaic, and even Mycenaean monuments and remains: in the fabric of the new Periklean Acropolis, there was the constant revelation and thus memorialization of past Acropolises [cf. Figs. 21, 181].

But if there was one strand that was most conspicuous in the sanctuary's web of allusion, if there was one theme that ran throughout the iconography of the Parthenon in particular and the Classical Acropolis as a whole, it was *nike* (victory) – Victory Personified, Victory Commemorated, and Victory Represented.

Victory Personified – Nike herself – was a very common sight. Statues of Nikai were certainly not new to the Classical sanctuary: assorted Archaic Nikai were already there when the Persians came in 480 and knocked them down [cf. Fig. 105]. But the Nike population boomed afterward. Pheidias' Bronze Athena (Promakhos) may have held a Nike in her hand. The chryselephantine Athena Parthenos certainly did [Fig. 132] – another possible thematic link between the two monumental goddesses of the Classical sanctuary. Nike appeared elsewhere in the sculptural program of the Parthenon: she hovered beside Athena in east metope 4 [Fig. 137], preparing to crown the goddess for her victory over the giants; she drove the goddess's chariot in the west pediment [Fig. 143]; she probably appeared in the east pediment [Fig. 145]; she may be the winged figure beside Hera in the east frieze (Iris, who also announces victory on occasion, is the other possibility) [Fig. 150]; and four Nikai probably alit on the corners of the Parthenon roof, as if bringing news of victory down from Olympos itself [Fig. 133]. On the brink of the Peloponnesian War there were at least eight "Golden Nikai"

stored in the Parthenon; more would be dedicated in the course of the war (two are recorded for the year 426/5, for example).[43] A bronze Nike was dedicated somewhere on the summit to commemorate the victory over the Spartans at Sphacteria (425).[44] Nike may have appeared beside Athena in the east frieze of the Temple of Athena Nike [Fig. 182]; more Nikai probably served as that temple's corner akroteria (in imitation of the Parthenon akroteria). And, of course, by the end of the fifth century there were Nikai galore on the Nike parapet [Figs. 185–187], participants in a procession that conditioned the visitor for the even greater processional frieze of the Parthenon. All in all, Victory Personified was as familiar a sight on the Classical Acropolis as the goddess of the place, Athena herself.

The Acropolis was also full of victory monuments – either war memorials set up by the state or memorials to competitive success enjoyed by individuals. The Bronze Athena itself, for example, commemorated Marathon (at least according to Pausanias) but it was also purposefully aligned so it could gaze toward Salamis (the site of yet another great victory over the Persians), and it was possibly paid for out of the spoils taken from the Persians at a number of battles, including Eurymedon. There was also the restored monument marking the victory of the early democracy over the Boiotians and Chalkidians in 506 [Fig. 24], and the group of man and horse dedicated at mid-century by the victorious cavalry (*hippeis*).[45]

But Nike was manifest on the Acropolis in other ways, and not every victory monument was military. The Classical sanctuary was loaded with the dedications of victorious athletes, musicians, and others – private citizens wishing to commemorate their public triumphs. Perhaps soon after construction of the Parthenon began, for example, the military commander Pronapes dedicated a chariot to commemorate his own athletic victories at Nemea, Isthmia, and the Panathenaia.[46] And possibly around 430, Kallias, son of Didymios, dedicated a bronze statue (now lost) upon a circular base inscribed with a laconic tabulation of his victories at the major athletic competitions of Greece [Fig. 198]:

Kallias son of Didymios dedicated this.
Victories:
Olympia.
Pythia [Delphi]: twice.
Isthmia: five times.
Nemea: four times.
Great Panathenaia.[47]

Fig. 198. Kallias base, Acropolis (*IG* I³ 893), c. 450. Photo: author.

And at some point a portrait of Alkibiades, commemorating an equestrian victory at Nemea, was hung on a wall of the Pinakotheke.⁴⁸

Victorious athletes were always well represented on the citadel (some Panathenaic champions even dedicated their prize amphorae after emptying them of their oil), but the thank-offerings of victorious musicians may have been common, too. Even tragedians may have commemorated their success in the Theater of Dionysos down below with dedications up above. Although it does not look much like a victory monument, with the mother about to kill her own fearfully contorted son, it has been suggested that the Prokne and Itys of Alkamenes [Fig. 178] marked the dramatic victory of a trilogy by Sophocles performed in the 420s.⁴⁹

But, of course, Nike was particularly manifest in the Acropolis's many representations of battles, battles that were deeply woven into the iconographic fabric of the sanctuary and that presented the visitor with assorted narrative threads to follow – battles between the gods and the giants (carved on Parthenon east metopes, painted or inlaid on the interior of the shield of the Athena Parthenos, possibly painted on the *peplos* in the east frieze, certainly woven into the many *peploi* displayed or stored inside the Erechtheion, and depicted in the Nike Temple east pediment), battles between Greeks and centaurs (Parthenon south metopes, sandals of Athena Parthenos, exterior of the shield of the Bronze Athena); battles between Athenians and Amazons (Parthenon west metopes, exterior of shield of Athena Parthenos, Nike Temple west pediment); battles between Greeks and Trojans (Parthenon north metopes and

Strongylion's Wooden Horse); and historical battles between Greeks and Greeks, and Greeks and Persians (Nike Temple friezes).

What is interesting about these battles, however, is that the issue is often yet to be decided: Acropolis monuments typically commemorate not the triumph but the conflict. On many of the Parthenon's south metopes, for example, centaurs are (or are about to be) victorious [Fig. 139]. On the west metopes, Greeks lose to the Amazons about as often as they defeat them. On the shield of the Athena Parthenos [Fig. 161] at least one defender of the Acropolis (the so-called Kapaneus, near the top) was badly wounded in the back. And even the outcome of the battle friezes on the Nike Temple is still in the balance [Fig. 184]. So, if the iconography of the Acropolis constitutes a paean to *Nike*, it is not simple-minded exultation or gloating: Athenians and Greeks will win the battles and the wars, but not without struggle and not without loss.

In fact, it may be the struggle, rather than the conquest, that is at the core of the Acropolis's imagery and ideology – not so much *Nike* but the even broader idea of *Agon* (conflict, contest, rivalry), an idea that encompasses not just warfare but also musical and athletic competition and even the kind of divine struggle depicted in the Parthenon's west pediment [Fig. 143].⁵⁰ The *agon* is one of Athena's many fields of operation:⁵¹ her sacred olive tree, the tangible sign of her defeat of Poseidon,⁵² was not only the Acropolis's first victory monument but was also, according to tradition, the mythical first olive tree, the one that engendered all others, including those whose oil was awarded in handsome black-figure containers to victors

in the Panathenaiac competitions [Fig. 23]. The mythical *agon* that determined the identity of Athens was thus directly tied to the actual *agones* held at the Panathenaia, the civic festival that best defined what it was to be Athenian. At all events, the breadth and intricacy of the conception of *agon* as both armed struggle and civic competition is perhaps symbolically represented in, of all places, the Periklean Odeion on the south slope [Fig. 3 no. 20, Fig. 190]. As the setting for both the musical contests of the Panathenaia and the preliminaries to the tragic competitions of the City Dionysia, this monumental hall, supposedly a replica of Xerxes's pavilion built with the spars of captured Persian ships, was one place where the significance of military victory and peaceful civic victory fused.

Containing and defeating the Persians had been the principal goals of Athenian foreign and strategic policy for thirty years before the construction of the Parthenon began, and it is a truism that the mythological battles depicted in the metopes, on the shield and sandals of the Athena Parthenos, and then on the shield of the Bronze Athena, are analogues or allegories for the historical victory over the evil Eastern empire.[53] All these myths had, of course, appeared in Greek art before, and Archaic Gigantomachies [Fig. 96], for example, obviously had nothing to do with the Persian Wars (which had not happened yet). Still, these old tales were invested with new meaning after 480, and the way the myths were told in art (as well as poetry) could be adjusted to accommodate historical events. For example, Amazonomachies in which the women-warriors actually attacked the Acropolis, as they did on the shield of the Athena Parthenos [Fig. 161], do not antedate the Persian sack of the Acropolis in 480, nor did the story (first told by Aeschylus) that the Amazons used the Areopagos as their base of operations (as Xerxes and the Persians in fact did). In other words, Classical Athenian art and literature made the Amazons of their ancient legends act like the Persians of their recent history, and in so doing converted myth into polemic.[54]

Now, it may be that the Athenians appreciated their own victories above all as concrete historical demonstrations of the universal truths or abstractions inherent in the myths – that piety will defeat impiety, that justice will triumph over injustice, that order will overcome chaos, that rationality will defeat bestial violence, that the west will triumph over the east and that the male will overcome the female (oppositions we shall take up again). But all those antitheses could be read into the history of the Persian Wars as well, and the implicit message of the metopes and *akroteria* of the Parthenon – that most grandiose of

victory monuments – as well as of the sculptural program of the Nike Temple, whose Marathon frieze was juxtaposed with the Gigantomachy and Amazonomachy of its pediments [Fig. 183], is that Athenian military success against Persia is to be ranked with those other great, even cosmic, victories, those assertions of moral right. The Athenians of the fifth century would have considered the inherited myths prefigurations and even justifications for their own recent struggles with the Persians – easterners who, after all, were garbed like Amazons and attacked the Acropolis like Amazons and acted barbarously, impiously, and unjustly like giants and centaurs.[55] There may even be in the north metopes [Fig. 134], where allied Greeks defeated a common eastern foe (the Trojans), an allusion to the necessity of the Delian League (by then really the Athenian Empire), an alliance ostensibly held together by animosity toward another common eastern enemy (the Persians)[56] but which would prove essential in future struggles against other common foes (such as Sparta and its league). In short, recent (and even anticipated) history injected new meaning into the old tales: the myths were not only ripe for expropriation, but could also be promoted as grounds for imminent action.

Now, time undoubtedly changed the temper of the imagery. In the midst of new wars, the implications of the old myths would correspondingly shift: the battles of the Parthenon metopes, in the 440s taken as allusions to the Athenian victory over the Persians, might in the late 430s and 420s also be taken as predictors of future Athenian success over the Spartans. So, too, the Acropolis's "victory text" was read quite differently in, say, 403 (in the bitterness of a defeat largely financed by the hated Persians themselves) than in 431 (on the brink of the Peloponnesian War, when its array of victories must have seemed reassuring and programmatic). Like a great work of literature, the Acropolis was subject to different readings at different times, in the shifting lights of history. Its text was also subject to emendation and, as we shall see, that was something that Hellenistic kings and Roman-era Athenians relied upon.

Still, the Acropolis always remained in large part a complex essay on competition and victory – it was a vast field of *Agon* and *Nike* – and it remains to be seen how the Parthenon frieze fits into the scheme.

The School of Hellas

Whatever else it is, the Parthenon frieze is a glorification of the Athenians themselves. The makers of the Classical

Acropolis depicted Athens as it wished to be seen, with its Acropolis (the setting of the west Parthenon pediment, Fig. 143) literally placed on the same plane as Olympos (the setting of the east, Fig. 145),[57] with its many victories analogous to divine and heroic victories. The makers of the frieze depicted the Athenians as they wished to be seen, as a people composed of perfect youths [Fig. 153], pure maidens (parthenoi) [Fig. 158], and handsome elders (among the youngest-looking old men in ancient art) [Fig. 154], as a people whose idealized nature is nearly godlike and whose relaxed, conversing gods [Figs. 30, 150] act like human beings, as a people who even exist and move in the same sculptural field as their gods. The divine and the mortal spheres intersect; divine and human images blend. There is no modesty here.

"Man," said Perikles's friend Protagoras, "is the measure of all things," and the Athenian, the frieze seems to argue, is the measure of all men. It is the character of the Athenians – their reverent virtue, their excellence or arete – that is the point of the frieze, and it is a character revealed once again through the sacrifices and agones of Athenian life and through the Athenian history and promise of military success.[58] One such agon is, of course, overt: the apobates competition [Fig. 156], an event that had its origin in the kind of chariot-warfare remembered in Homer's Iliad, where heroes are driven to the field of battle in chariots and dismount to fight. This kind of battle chariotry was obsolete long before the fifth century, but the Athenians regularly heard about it during the institutionalized recitations of Homer at the Panathenaia. Thus, the military and heroic character of the Classical sport would have been obvious.[59] Apparently only citizens – and only "the best men" among them at that – could act as apobatai in Periklean Athens and so on the frieze (as in reality) the finest Athenians display the same extraordinary skills that Homeric heroes possessed.[60] Other less militaristic competitions are implicit in the frieze: the flute-players and kitharists, as we have noted, might have recalled Panathenaic musical contests, and the male hydria-bearers [Fig. 155], if they did not allude to the display of imperial wealth at the City Dionysia, possibly brought to mind torch-races held the night before the Panathenaic procession (the prizes were hydriai).[61]

Still, the martial character of the frieze is pervasive. The center of the east frieze – the side that is most "Panathenaic" – represents, after all, preparations for the presentation of a representation of battle (the Gigantomachy of the peplos) [Fig. 151]. The Panathenaia was probably founded to celebrate Athena's role in the Gigantomachy, and the Panathenaic procession (which, again, could be read into the frieze along with others) was the only occasion when Athenians could bear arms within the city without arousing suspicion.[62]

Most significant, there is the cavalcade, by far the single longest (and therefore most conspicuous) passage of the entire frieze [Figs. 147, 153]. Just as many different religious events could be read into the frieze as a whole, so the cavalcade was no doubt subject to different readings. But while the horsemen might have called to mind the cadets (epheboi) who regularly escorted Athenian sacred processions or the entrants in Panathenaic (and various other Athenian) equestrian events, they would also (as J. J. Pollitt has argued) have evoked pride in a brand-new Periklean fighting force, a new instrument of Athenian nike. In the early 450s Athens had established a 300-man cavalry to guard Attica from attack, and all 300 hippeis seem to have come from Athens's wealthiest, aristocratic families. But sometime between 445 and 431, in an effort to strengthen the defense of the polis, Perikles more than tripled the size of this force, creating a new 1,000-man cavalry commanded by two hipparchs and divided into ten tribal squadrons (since members would have had to be recruited from a broader base than the traditional Athenian aristocracy, Perikles's cavalry was more democratically based than the old force of 300). Although the gaps in the frieze call for caution, the division of the horsemen on both the north and south friezes into ten ranks and the presence of only two bearded horsemen (who may be the hipparchs, Fig. 152] suggest that the Periklean expansion took place just early enough to inspire the designers of the cavalcade on the frieze.[63] Again, the frieze would in this case simply be an evocation of the new fighting force. Only a portion of the full 1,000-man cavalry could be represented; few of the riders bear weapons or wear armor; and action is not imminent.[64] Still, this is very likely an idealized image of the men who made up the new Periklean arm of military policy: the men whose skill, courage, and Olympian self-control will ensure that Athens in the future will win battles as significant as those depicted in the metopes. Shown in peaceful civic procession, they are the guarantors of future nikai.

All in all, the message of the Parthenon frieze, available to any who negotiated the difficult circumstances of its viewing, was not simply the piety of the Athenians, but their capacity for achievement, their special character, their sophrosyne (moderation, self-control) and virtue

among the Greeks, their elevated status (expressed above all through horsemanship, with its time-honored connotations of heroic valor and, ironically, aristocratic status).[65] It is much the same message as the one found in Perikles's Funeral Oration (431/0), that great statement of Athenian civic ideology delivered just a few years after completion of the frieze:

> Putting it all briefly, then, I say that our city is the school of Hellas, and that, so it seems to me, each and every man among us offers to it his own person with exceptional grace and readiness. That this is no mere boast but rather the reality of hard facts, the very power of our city, which we have gathered by means of such character traits as I have described, is the proof.[66]

The power of Athens depends on the *arete* of those depicted here. The Athenians are represented as worthy protegés and "children" of the goddess whose birth and *agon* with Poseidon were depicted in the Parthenon ped-

iments. The men on horseback and in chariots are worthy successors of the legendary heroes who defeated Amazons, Trojans and Centaurs and noble emulators of the gods who defeated the giants (who tried to scale Olympos as the Persians had scaled the Acropolis). The maidens on the east frieze [Fig. 158] – many of them *kanephoroi* and thus by definition well-born virgins (*parthenoi*) like the goddess of the rock – display the purity required to ensure the health and future of the Athenian people. On the frieze, then, the Athenians, male and female alike, are depicted as a chaste, reverent, agonistic, heroic, and vigilant folk: a people of timeless beauty whose lives are filled with sacrifices, processions, and *agones*; a people who had already won great *nikai* and who are prepared to win more; a people who have earned the favor of Athena and all the gods. A little later in his Funeral Oration, Perikles boasted that the Athenians did not need a Homer to sing their praises.[67] In the sculptural programs of the Periklean Acropolis, and especially in the Parthenon frieze, the Athenians did that well enough themselves.

PANDORA AND THE ATHENA PARTHENOS
MYTH, GENDER, AND PATRIARCHY ON THE CLASSICAL ACROPOLIS*

Chorus: What god, then, shall be our city's protector? For whom shall we weave the *peplos*?

Euelpides: Why not keep Athena as City-Goddess [*Polias*]?

Pisthetairos: How could a city be well-ordered where a woman-god stands in full armor, and Kleisthenes works the loom?

Aristophanes, *Birds*, 826–31

After passing by the west facade of the Periklean Parthenon, with Athena and Poseidon contending over the land of Attica in its pediment and Greeks battling Amazons in its metopes [Fig. 126]; after passing along the north or south flank of the building, with their scenes from the Trojan War [Fig. 135] or duels between Lapiths and centaurs [Fig. 138]; after catching glimpses of a half-lit grand procession high atop the cella walls [Pl. VI]; after reaching the east side of the building [Fig. 136] with its pediment showing the Birth of Athena, its metopes depicting the Battle of the Gods and the Giants, and, within, the culmination of the processional frieze, with the gods gathered at ease and the curious exchange of cloth [Figs. 145, 151], the ancient visitor would finally have seen Pheidias's great goddess through opened doors, filling the far end of the cella and framed by the interior double-colonnade: the huge gold-and-ivory Athena Parthenos [Fig. 132].

The Acropolis, as we have seen, was a highly resonant place. The images that filled and adorned it often depicted versions of the same myths or legends, varying them like musical themes, and the Athena Parthenos itself was essentially a grand recapitulation, an elaborate reprise.[1] Crowned with an elaborate helmet adorned with griffins, winged horses (*pegasoi*), and a sphinx, the statue was otherwise close to being a chryselephantine double of Pheidias's earlier Bronze Athena (Promakhos) that stood guard at the entrance of the Acropolis, just within the Propylaia [Fig. 24]. And it re-presented themes and myths the visitor had seen along the way – above all, the defeat of the hybristic enemies of order and justice (Amazons, giants, and centaurs) by the forces of civilization and *sophrosyne* (moderation, self-control), the latter the province of Athena herself, the goddess who literally held Victory (*Nike*) in the palm of her outstretched right hand.

But on the base of the colossal statue, right at tourist-level, carved in marble relief or, more likely, consisting of gilded bronze figures doweled onto a marble background,[2] was a story of another kind: the creation of Pandora – the clay image that, according to Greek myth, was the first mortal woman, the beautiful progenitor of all women, and the cause of evil in the world. It was a remarkable choice for the pedestal of the Athena

Parthenos, this monument to Athenian *nike*, this embodiment of Athens at the height of its power and prosperity. And Pausanias did not even attempt to explain it: he simply noted the subject of the pedestal in his guidebook and moved on.[3] Nonetheless, we have a little more information to go on. A century before Pausanias, the Roman polymath Pliny noted that twenty gods were represented at Pandora's *genesis* (he uses the Greek word for "birth" or "creation," so he may have been relying on another source).[4] One Hellenistic and one Roman copy of the Athena Parthenos – a three-meter-tall Athena from Pergamon [Figs. 199, 200] and the small, unfinished Lenormant statuette in Athens [Fig. 26] – give a very rough idea of how the figures were arranged, though the cast of characters is much reduced on both. And a couple of Roman-era reliefs have been thought to reproduce parts of the original, though there are grounds for reasonable doubt.[5] Altogether the evidence is not much, but that has not stopped some scholars from reconstructing the whole base, naming all twenty-one figures and putting them in their proper order.[6] Perhaps more significant than any speculative reconstruction of a work that no longer exists, however, is the recognition of ambiguity in the relationship between Pandora and the Parthenos itself, and the suggestion that the scene of her creation was on several different levels an important element in the ideological fabric of the Parthenon and the Periklean Acropolis as a whole.

The average Classical Greek, Athenian and non-Athenian alike, was undoubtedly familiar with the story of Pandora as the epic poet Hesiod related it, and he related it twice.[7] In the *Theogony* (probably the earlier of the two tales), Hesiod tells how Zeus, furious that Prometheus has stolen fire and given it to mortals (for the gift lessened the distance between gods and men), took his revenge by having Hephaistos make the likeness of a maiden (*parthenos*) out of earth and having Athena deck her out in a silvery dress, a veil, and a fabulous crown of gold. The other gods and mortal men (how *they* had come into existence Hesiod does not say) took one look and were stunned by this, the source of all mortal women – a "beautiful evil," in Hesiod's words, a trick for which men have no remedy and a great misery that drains their resources. With Woman comes Marriage and, Hesiod complains, men are damned if they do and damned if they don't. If they avoid women and marriage, they die mournfully old and alone. But even a dutiful wife is a wash: the good she brings to a marriage is enough to balance, but not outweigh, the evil.[8]

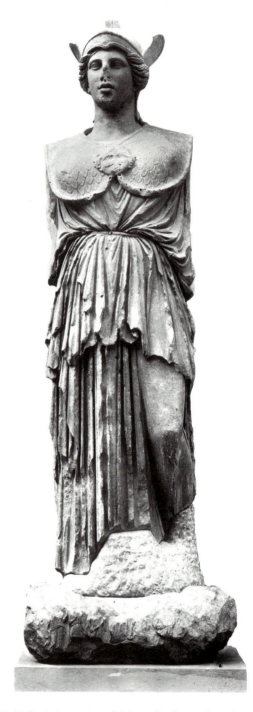

Fig. 199. Hellenistic version of Athena Parthenos from Pergamon. Berlin PM 1304. Courtesy Antikensammlung, Staatliche Museen zu Berlin, Preussischer Kulturbesitz.

Fig. 200. Detail of base of Athena Parthenos from Pergamon (cast). Courtesy John Boardman and the Cast Gallery, Ashmolean Museum.

In the *Theogony* the image-woman formed by Hephaistos and outfitted by Athena has no name. She does in Hesiod's second version of the story (told early on in the *Works and Days*), where more gods and goddesses participate in the creation. Again, Zeus, angry at Prometheus's theft of fire, ordains punishment for men:

"I will give men as the price of fire an evil, in
 which all
men will delight in their hearts, an evil they will
 warmly embrace."
Thus he spoke, and the father of gods and men
 laughed out loud.
He ordered far-famed Hephaistos at once
to mix earth with water, and to put into it human
 voice
and strength, but to give her a face like an immor-
 tal goddess,
the charming, lovely shape of a maiden
 [*parthenike*]. And he told
Athena to teach her women's work [*erga*], how to
 weave the intricate
loom. And he told Aphrodite to pour golden grace
 upon her head
and painful desire and cares that weaken limbs.
And he ordered Hermes, the messenger, Slayer of
 Argos,
to put into her the mind of a bitch and a treacher-
 ous nature.
Thus he commanded, and they obeyed lord Zeus,
 son of Kronos.
At once the famed Lame One moulded out of earth

the likeness of a modest maiden [*parthenos*] as the
 son of Kronos wished,
and the gray-eyed goddess Athena girded her and
 dressed her.
Around her body the divine Graces and Lady Peitho
put chains of gold, and her head
the fair-haired Hours wreathed with flowers of
 spring.
[And Pallas Athena fit all manner of adornment to
 her form.]
And the Messenger, Slayer of Argos, into her heart
 put
lies and wily words and a treacherous nature
according to the will of loud-thundering Zeus. And
 the
herald of the gods gave her voice, and he named
 the woman
Pandora, because all of the gods who live upon
 Olympos
gave her a gift, a sorrow to men who eat bread.
But when he finished this sheer trick, without rem-
 edy,
the father sent the famed Slayer of Argos, swift
 messenger of the gods,
to take her to Epimetheus as a gift. And
 Epimetheus
did not think how Prometheus had told him never
 to accept
a gift from Olympian Zeus, but to send it back,
lest it prove to be an evil for men.
But when he took the gift, when he had the evil, he
 understood.

237

Before this the races of men lived upon the earth
free from evils, free from hard work,
and without painful diseases that bring fates down
 upon men.
[For mortal men in the midst of evil quickly grow
 old.]
But the woman, lifting the great lid of the jar with
 her hands,
scattered them abroad, and wrought ruinous sor-
 rows for men.
Only Hope remained within the jar, in its unbreak-
 able home,
under the rim, and did not fly out the opening.
Before that could happen the lid of the jar stopped
 her
[by the will of *aigis*-bearing, cloud-gathering Zeus].
But the others, thousands of miseries, wander
 among men.
The earth is full of evils, and the sea is full.
Diseases, moving of themselves, visit men by day
and by night, bearing evils for men
in silence, since wise Zeus took from them their
 voices.
And so there is no way to escape the mind of Zeus.
 (*Works and Days*, 57–105)

Now, there were probably other vernacular tradi-
tions concerning Pandora that the fifth-century visitor to
the Acropolis would also have known – as we shall see,
there may even have been more than one Pandora. But
one of the things that still makes the myth seem such a
strange choice for the base of the Athena Parthenos is
that, after Hesiod, we hear practically nothing else about
her: Hesiod's Pandora, in other words, seems to have
remained the definitive one.[9] We know that sometime in
the mid- or late fifth-century Sophocles wrote a satyr-
play (that is, a burlesque with the members of the cho-
rus dressed up like satyrs) entitled *Pandora, or the
Hammerers*[10] – only a few unhelpful words come down to
us – but otherwise extant Archaic and Classical Greek
poetry does not really deal with her again.

Greek artists were hardly keen on her, either. There
is no certain representation of Pandora at all earlier than
the fifth century, and the number of extant examples
that date from before or around the time of the
Parthenon (say, before 450 or 440) can be counted on the
fingers of one hand.[11] On the best of them, she is not
even Pandora, exactly: on an Attic cup of around 460
Athena and Hephaistos, looking like adolescents them-

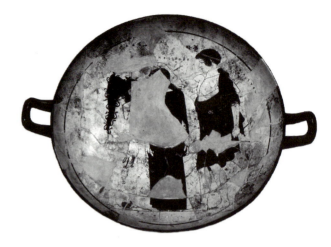

Fig. 201. White-ground cup by Tarquinia Painter, c. 460 (BM D
4). Courtesy British Museum.

selves, adorn their creation with crown and robe (it is a
peplos) precisely as they do in the *Theogony*, but the
image is labelled "Anesidora" [Fig. 201]. The name, writ-
ten above her in the field, means "She Who Sends Up
Gifts," and "Pandora" could mean roughly the same
thing – "She Who Gives All Gifts." But that is not what
Hesiod says it means: he goes out of his way to tell us
that she got the name because all the gods gave *her* a
gift.[12] Now, Hesiod's etymology might be novel or it
might be wrong, but it was authoritative, and most
Greeks would likely have accepted it: for them, the
name probably meant "She Who Was *Given* All Gifts."
The gift-giving was, in any case, the subject of at least
one other pre-Parthenon-era vase where a frontal
woman (whether she is Anesidora or Pandora the vase
does not say) receives a crown from Athena in the pres-
ence of a half-dozen other gods.[13]

As we can (barely) tell from the sketchy scenes on
the two later copies of the Athena Parthenos, the depic-
tion of the myth of Pandora on the base of the High Clas-
sical statue was drawn from the same iconographic
tradition seen on those Early Classical vases, with the
gifted creation disposed frontally and the gifting gods
aligned on either side. But there was another, non-Hes-
iodic tradition after all: a number of vases, some still
painted before the beginning of the Parthenon, show
Pandora rising from the earth, only half there, a chthonic
goddess like Gaia (Earth) herself. On a volute krater
made about 450, for example,[14] Zeus and Hermes stand
by while Epimetheus, hammer in hand, receives an elab-
orately crowned Pandora (labelled, this time) as she

emerges from the ground; Eros hovers overhead, anticipating their marriage [Fig. 202]. On a couple of other mid-century vases, satyrs wield hammers as a woman emerges from the earth, and though it is not certain that they all illustrate Sophocles's satyr-play, or even that all the women are Pandora (Persephone and Aphrodite are other possibilities),[15] they seem to reflect a tradition in which Pandora was released from the earth by hammering upon the ground – perhaps even a primordial tradition in which Pandora was herself an earth-goddess (or the name a cult epithet for Gaia) and thus really a "giver of all gifts" after all.[16] It may be that the Athenians, in fact, conflated two Pandoras: a primeval earth-goddess, on the one hand, and the first woman, the product of the Olympian gods, on the other. But there is nothing about Hesiod's Pandora that is very chthonic in either nature or function.[17] And, again, to judge from the traces on the bases of the Lenormant and Pergamon Athenas [Figs. 26, 200], it was the Hesiodic tradition – the tradition that inspired the iconography of passive, frontal woman and active, attendant divinities on either side – that Pheidias and his audience relied upon. This does not mean that Pheidias faithfully "illustrated" Hesiod: the twenty divinities on the base noted by Pliny are far more than even the *Works and Days* allows. Still, it is likely that across the floor or pool in front of the Athena Parthenos, on virtually the same level, the visitor to the Parthenon and a full frontal Pandora confronted each other [Fig. 132].

The relationship between what was depicted on the base of an ancient Greek cult-statue and the statue itself is not always obvious.[18] Still, it is difficult to avoid the conclusion that whatever Pandora, the first human woman and mother, was doing on the base of the Athena Parthenos, the motherless virgin goddess, Pheidias was attempting to say something about her gender – "the race of female women," as Hesiod puts it in the *Theogony*. The question, of course, is what? For some possible answers we need to address the broader implications of the mythological construction of gender, patriarchy, and autochthony on the Parthenon and the Acropolis.

It may from time to time have struck a few Athenians – the residents of a city that was essentially a "men's club" – as strange that their patron divinity was female. There is a hint of such temporary puzzlement in Aristophanes's comedy *Birds*, where the founders of Cloudcuckooland doubt that any state could be well-governed whose patron goddess dresses up like a man (and whose men act effeminately). They consequently

Fig. 202. Attic Red-figure volute krater, c. 450 (Oxford G 275). Courtesy Ashmolean Museum.

reject the androgynous Athena and, not surprisingly, choose a cock to be their patron deity: no gender confusion for them. For Aristophanes, nothing was sacred, but the point about comedy is that it is not to be taken too seriously. Athens, after all, was hardly the only Greek city with a patron goddess (Hera was the goddess of Samos and Argos, for example), and there was little that Classical Athenians could do about it, anyway. The association between the city and the goddess was simply too ancient and the identification between its ideology and mythology and her character, her paradigm, too complete.

Like any Greek *polis*, Athens was a bastion of male privilege: women were generally relegated to the background of society, in subordinate, passive positions. Though the women of Athens were the mothers, daughters, and sisters of citizens, they were not citizens themselves in any real sense of the term. They possessed no true political rights (they could not attend, much less vote, in the citizen assembly, for example), they could

not sit on juries in citizen courts, they did not control whatever property may have been attached to their name, they were not autonomous individuals before the law (they were always under the authority of a male guardian – usually father or husband – and so were perpetual minors), and their proper place was in the home, where their principal function was to raise children who nonetheless "belonged" entirely to the father. It has even been argued that the Greek word for "Athenians" (the masculine *Athenaioi*) grammatically excluded women from the *polis*: there is no exact feminine equivalent.[19] In fact, Attic Greek did have a word or two to designate the daughter or mother of a male citizen: *aste* and *politis*, for example, mean "citizen woman."[20] But such words are rare semantic necessities and no *aste* or *politis* was ever endowed with true political or civil rights of her own.

Now, there was in ancient Athens (as in most other places) a difference between theory and practice, between ideology and reality. The status of Athenian women was complicated, the rules may have differed from class to class, and their lives were not uniformly bleak. While women were certainly restricted in civic life, they were not locked up behind closed doors and they made their presence felt in both the private and public spheres. They were responsible for managing their households. They could work outside the home (as vendors, for example, cf. Fig. 45) and apparently even own businesses. They could accompany their fathers, husbands, and sons to sacrifices [Fig. 42] and make dedications to the gods in their own name (the proportion of women's dedications on the Archaic and Classical Acropolis is surprisingly high) [cf. Fig. 22].[21] To judge from a number of expensive votives we know were offered by women, they could prosper. They could leave their houses on holidays (there were even separate women's festivals, such as the *Thesmophoria*) and the course of the lives of the female élite was marked by public service or duties as *Arrhephoroi*, *arktoi*, and *kanephoroi* (who conspicuously led sacred processions; cf. Fig. 158).[22] They functioned as priestesses in major cults (those of Athena Polias and Athena Nike, for example) and the Basilinna, the wife of the Archon Basileus (whom some see in the dignified woman in the central scene of the Parthenon's east frieze, Fig. 151), played an important role in the cult of Dionysos.[23] Women could attend weddings and funerals. And (though this is controversial) they could probably attend the theater. If so, on more than one occasion they would have found male playwrights – needless to say, there was no other

kind – such as Sophocles, Euripides and Aristophanes challenging both the misogynistic traditions of Greek poetry and the basic Athenian presumption of female inferiority with such characters as the unbending Antigone, the noble Alcestis, and the formidably intelligent Lysistrata.[24]

It should also be noted that in 451/0, just a few years before construction of the Parthenon commenced, Perikles passed a law that redefined Athenian citizenship: one now had to have an Athenian "citizen woman" for a mother as well as an Athenian father to qualify.[25] The Periklean citizenship law has seemed to some to indicate a rise in the status of Athenian women in the middle of the century, and it has even been suggested that their new legal importance is reflected in the prominence of women on the east side of the Parthenon frieze [Fig. 158] or in the large number of female figures depicted in the west pediment [Fig. 143]. But like Greek drama (even with its share of powerful and sympathetic women), the public sculptures of the Parthenon had as their principal audience the men, not the women, of Athens, and on the east frieze it is as if the maidens, segregated from the rest of the procession and under the direction of men, are merely pretty exhibits on display. In any case the meaning and intent of the citizenship law is far from clear. Its passage may indicate an overabundance of citizens, the rising value of citizenship, or both. By reducing the number of citizens (and thus qualified heirs), the law also eased pressures on courts deciding issues of property and inheritance. But whatever its practical justifications and applications, the law was an illiberal device to restrict the franchise – to define and exclude – rather than to elevate women *per se*: it was meant to "purify" Athenian bloodlines and protect them from resident aliens or foreigners. And it is, in any case, hard to see a champion of women's rights in the Perikles whose famed Funeral Oration ends with an abrupt and grudging acknowledgment of the existence of war widows and an austere warning that the greatest glory for a woman is not to be talked about by men for good or ill.[26] The citizenship law, whatever its purpose, certainly was not enough to overturn the prevailing popular sentiment that women were by nature lustful, irrational, immoderate creatures who needed constant restraint, and that the stability of the state depended upon keeping them under strict control.[27]

Whatever the differences between theory and practice in Athenian attitudes toward women, the sculptural program of the Parthenon was a monument to theory.

Motherhood, for example, was conspicuously lacking in the east pediment of the Parthenon, with its Birth of Athena [Fig. 145]. Though the reconstruction of the center of the composition is, again, a matter of considerable dispute [cf. Fig. 146], Zeus, all agree, was certainly there. But Metis, the goddess who conceived Athena, certainly was not. There was no visual clue that she still putatively resided in Zeus's belly and, unseen, Metis did not exist. The well-known story, familiar from many vase-paintings, could therefore only have seemed to validate the superiority of the male and the claims of the father, especially in the light of a famous scene in the *Eumenides* of Aeschylus, performed in Athens about a decade before the Parthenon was begun.

Orestes is on trial for murdering his mother, Klytemnestra, the murderer of his father, Agamemnon (every family has its ups and downs). Acting as Orestes's advocate, and arguing that it is worse for the wife to kill the husband than for the son to kill the mother in revenge, Apollo, the quintessential male, announces the remarkable theory that the mother is no parent at all but just the incubator for the seed planted by the father ("the one who mounts"). Apollo literally points to Athena as proof:

> There can be a father without any mother. There
> she stands,
> the living witness, daughter of Olympian Zeus,
> she who was never fostered in the dark of the
> womb
> yet such a child as no goddess could bring to birth.

Apollo's science goes unchallenged and, as she casts the decisive vote acquitting Orestes, Athena gives her reason:

> There is no mother anywhere who gave me birth,
> and, but for marriage, I am always for the male
> with all my heart, and strongly on my father's side.
> (662–66, 736–38, trans. R. Lattimore)

This is the myth, science, and verdict of patriarchy. Athena is its defender. She is its basis and its verification (and the fact that Zeus gave birth to a perfect daughter, while Hera, by herself, could only engender the crippled Hephaistos,[28] again argues for the superior role of the male). Her father's daughter in every way (like the east pediment, the *Eumenides* omits any mention of Metis), Athena has not even passed through a woman's birth canal and, born fully formed, she has not even experienced childhood and its attendant weaknesses. The myth

and premise of her extraordinary birth – represented for all to see on the front of the Parthenon – reduces, even renounces, the natural role of women, and so elevates the masculine.

According to one ancient account, the contest between Athena and Poseidon (represented in the other pediment of the Parthenon) even explained and justified the existence of patriarchy itself. In this version of the myth both the men and the women of Kekrops's Athens voted on which divinity would be their patron. All the men voted for Poseidon, all the women for Athena, and since there was one more woman than man in the primeval city, Athena carried the day. Poseidon then flooded Athens in anger and could only be appeased by the punishment of the Athenian women: they were thus disenfranchised, their children would take their fathers' names, and they were no longer to be called Athenians.[29] There is no telling when this version of the myth became current: in outline the story might even have been Classical (which might explain the large number of women in the west pediment). But that this story – the foundation myth of Athenian patriarchy – exists at all suggests that sexual politics could be read in, or into, some of the most prominent images of the Classical Acropolis even in antiquity.

If patriarchy was one of the underpinnings of the ideology of the Acropolis, autochthony was another, and autochthony was, of course, embodied in the figure of Erechtheus/Ericthonios. Like Athena, the hero was born, as we have seen, in extraordinary circumstances, as the result of Hephaistos's premature ejaculation and the spontaneous generation of the lad from the sperm that the virgin Athena wiped off and threw upon on the earth. In other words, the birth of Erechtheus/Erichthonios was the paradigm for autochthony. But, in fact, many of Athens's other legendary Bronze Age kings – Kekrops, Kranaos, Amphictyon – were also autochthonous ("sprung from the earth itself"). And the notion (repeated over and over again in the speeches of Athenian orators such as Demosthenes and Lysias and in the dialogues of Plato) that the Athenians were, alone of all the Greeks, indigenous, native to the land they inhabit, lay at the heart of the Athenian contention that they were for that very reason homogeneous, legitimate, and inherently just. The same people, say both Thucydides and Thucydides's Perikles, had always occupied the land of Attica and they were, according to a messenger in Herodotos, the oldest race, the only Greeks who were not immigrants.[30] The Athenians thus considered themselves distinct from and superior to the

rest of the Greeks, whom they regarded as latecomers and invaders, populations mixed with foreigners.[31] The chauvinistic premises of autochthony are, first, that the Athenians were uncontaminated by "others" and, second, that they, like their paradoxical patron goddess, were uncontaminated by the (mortal) feminine: somehow, they were not the children of Pandora. Autochthony, then, established the purity and difference of the Athenians. Its myths were fundamental to Athenian narcissism, self-representation, and (since autochthony applied to all Athenians equally, disguising real differences of status and birth) even democracy.[32]

By worshipping Athena, a female goddess who was not of woman born, who is a (foster) mother without having experienced either intercourse or the pangs of childbirth herself, who androgynously carries the armaments of men [Fig. 132], who, when she chooses to take another form in the *Iliad* and *Odyssey*, usually becomes a man,[33] who in myth is virtually Zeus's "right-hand man," his enforcer, who embodies all those virtues and characteristics – *sophrosyne*, wisdom, rationality – that mortal women were supposed not to possess,[34] who, as she says in the *Eumenides*, sides with the male in almost all things, and who thus, in short, rises "above her sex,"[35] Athenian society negated Athena's sexuality and her gender. She is not just chaste, she is sexless, and her mythology, as well as Erechtheus/Erichthonios's, made the reproductive function of the female in general minor or even irrelevant. It could even be argued that in her adoption and legitimization of Erechtheus/Erichthonios and in her appointment of the daughters of Kekrops as nurses for the boy, Athena performs less as an Athenian "mother" than as an Athenian "father," more paternally than maternally. Hephaistos may be the lad's biological father, but Athena functions as his social and civic one.[36]

Now, other popular myths in the art of the Acropolis participated in the citadel's representation and assertion of patriarchy: the battle of the Greeks against the Amazons, for example [Fig. 161], where Theseus and the Athenians defended the Acropolis from alien warrior-women from the ends of the earth (their homeland was usually placed at the eastern end). Unlike the warrior-goddess Athena, Amazons were not virgins (*parthenoi*); they cut off their right breasts so they could pull their bows and arrows without obstruction (*amazon* might mean "breastless"); and their men stayed home and took care of the children. Their matriarchal society, in other words, was the inverse of the Athenian and they therefore had to be defeated at all costs.

But it needs to be stressed that the Parthenon's disputation on gender was but one expression of a broader intellectual or philosophical position. The fifth-century Athenian (like Greeks in general) saw or constructed the world in terms of polarities or oppositions – culture and nature, human and animal, rational and irrational, Greek and barbarian, and so on – in which the first terms of every pair (culture, human, rational, Greek) constituted the norm and the ideal. In such an intellectual context, it is not surprising that the imagery of the Parthenon addressed many of these other antitheses as well. For example, the battle of Lapiths and centaurs [Fig. 138] clearly presented the struggle between civilized humanity and instinctive bestiality. So, too, the victory of Theseus over the Amazons was not only the victory of normative patriarchy over abnormal matriarchy. It was also the victory of civilization over barbarity and disorder, of west over east, of Greece over "the other," of Athens over Persia (another theme that, as we have seen, penetrated virtually every corner of the Classical Acropolis).[37] Still, in fifth-century Athens there was perhaps no stronger cultural antithesis than that of male and female, and it would have been surprising had the images of the Classical Acropolis failed, somehow, to address it. And so it is time to return to Pandora, and to see how she fits in with the mythology and ideology of the place.

On one level, it is unlikely that the typical Athenian would have been disturbed upon finding the creation of Pandora on the base of the Athena Parthenos [Fig. 132]. As a matter of fact, the image would have called up many associations with images already seen on the Parthenon or with Acropolis cults or myths already familiar. The base depicted, for example, the extraordinary birth of a fully-formed female figure, just as the east pediment did: it would have been hard to miss the parallel. The gods attended the birth of Pandora, just as they did Athena's in the gable above, and just as the gods reacted to Athena's birth with awe and wonder, so (we are told in Hesiod) they marvelled at Pandora's. The assembly of divinities on the base was just one of a series on the Parthenon itself: the gods fought together against the giants on the east metopes [Fig. 137] and on the interior of Athena's shield; they relaxed together on the east frieze [Fig. 150]; they gathered together in the east pediment [Fig. 145]. And, as the Lenormant statuette seems to show [Fig. 26], the entire scene was given the same cosmic frame as the east pediment and perhaps the majority of the north metopes of the Parthenon [Fig.

134]: at one end of the base Helios rose in his chariot and at the other Selene descended on her horse. Pandora's birth, like Athena's, occurred at dawn, and was in tune with celestial forces, with the rational processes of the rotating cosmos.[38]

Pandora is one statue depicted on the base of another, and indeed she was not the only image of an image in the Parthenon's sculptural program (again, the Palladion, an image of Athena, was probably depicted several times on the north metopes and a statue – perhaps another Athena – appeared on south metope 21 as well [Figs. 135, 139]).[39] Though animate, she is artifact and artifice, a creation primarily of Hephaistos and Athena, the gods of rational production, artistry and craft – the gods of *tekhne* – who were both objects of cult on the Acropolis and who even sit together on the east frieze [Fig. 30]. She is made of earth (*gaia*) and water, a mixture especially associated with the craftsmen of Athens. Athena, again, is herself a coroplast [Fig. 15], and is the protector of pots and potters; she is the goddess of terracotta creations like Pandora and her famous *pithos* (jar).

The base, it should be admitted, did not actually depict Pandora's "birth" – as far as we can tell Hephaistos was not shown moulding her out of clay – but her provisioning. Athena was probably shown dressing her with a robe and allegorically teaching her the art of weaving. This robe could only have reminded our hypothetical spectator of the robe handled in the center of the Parthenon's east frieze [Fig. 151]: the *peplos* given to yet another statue – the old olivewood image of Athena Polias – at the Panathenaia. And the whole theme of "dressing" is one that reverberates throughout the Parthenon sculptural program: horsemen prepare themselves on the west frieze, an elder tends to his hair on the north [Fig. 154], Artemis adjusts her gown on the east [Fig. 145], and figures in some of the no-longer-quite-so-lost south metopes (19–21) seem to have been weaving, rolling a bolt of cloth, and even disrobing a statue [Fig. 139].[40]

Pandora is repeatedly described in Hesiod as *parthenos*, like the goddess of the temple itself (the maidens in procession in the east frieze were *parthenoi* as well) [Fig. 158]. And since she was formed of earth or clay she was, literally, autochthonous – another motherless creature, a child of the earth such as the Athenians fancied themselves. In the sense that she was the creation of Hephaistos and Athena, Pandora would have been "sister" to Erechtheus/Erichthonios, the product of another (even more unusual) collaboration, and Pausanias, at least, rec-

ognized him in the snake rearing inside the shield of the Athena Parthenos directly atop the scene of Pandora on the base.[41] The disastrous opening of her jar (admittedly not shown on the base) might have recalled the way the two disobedient daughters of Kekrops opened their forbidden basket, with fatal consequences. On the other hand, Athenians very well-versed in mythography might have known that in one version of the Erechtheus saga one of his own daughters was named Pandora: she may have been the one who nobly sacrificed herself to save the city from the forces of Eumolpos.[42] And after walking around the Acropolis most visitors would have been aware that Hermes, the Graces, Peitho, and Aphrodite, as well as Athena – deities who endow Pandora with various gifts in the *Works and Days* and who were probably all present on the base – were all worshipped on the Acropolis or its slopes.

The myth of Pandora explains why human beings must work to survive: she introduces *erga* to the world, and Athena, in her capacity as Athena Ergane, was goddess of work.[43] One source specifically (if problematically) links the two in cult: "if anyone sacrifices an ox [or cow] to Athena, it is necessary also to sacrifice a sheep to Pandora."[44] Finally, the scene of dressing and gift-giving on the base might have recalled activities before the traditional Greek wedding, when the bride was adorned in much the same way as Pandora, the first mortal bride and mother. It may even be that marriage was itself a theme of the Parthenon sculptures. After all, the Centauromachy of the south metopes [Fig. 139] erupted at a wedding feast; a broken marriage precipitated the Trojan War (north metopes, Fig. 134); Hera unveils herself like a bride before Zeus on the east frieze [Fig. 150]; and Athena and Hephaistos, paired in myth as the "parents" of Erechtheus/Erichthonios, are paired on the east frieze, too [Fig. 30]. Some Athenians, remembering that Athena was the goddess of good housekeeping in marriage, might also have recalled that it was King Kekrops, seen in the west pediment [Fig. 143], who supposedly instituted marriage as a way not simply to guarantee the future of the Athenian community but to control the promiscuity of women.[45]

While some of these associations and cross-references are admittedly arcane, others would have been fairly obvious even to the average spectator (whomever we envision the "average spectator" to be). Perhaps, after making a few of these connections, the viewer would not have bothered inquiring further why Pandora was there. After all, the scene depicted the gods giving gifts, just as

they had showered gifts upon Athens, and the image might have been construed simply as "a demonstration of pure [divine] beneficence"[46] and Pandora as a glamorous icon of delight. Indeed, the immediate, all-encompassing context of the scene – the Parthenon itself, that marble monument to Athenian glory – might, for most Periklean viewers, have filtered the range of possible meanings down to this: the gods have been good to Athens.

Still, images may also play against context and "average" viewers were not the only kind. There were undoubtedly others who not only understood the more recherché associations of the image but who also could not help remembering what happened after Pandora's creation in the Hesiodic account – who must have realized that if Woman brought the craft of weaving from Athena to humankind and (if a man was lucky) the comfort of a dutiful companion and heirs in old age, the other "gifts" she gave were no gifts at all. Now there is even in the misogynistic pre-Classical literary tradition the acknowledgment that women have the potential to be good – there is, after all, Penelope – and there is the grudging admission that women are necessary for the continuation of the human species and reproduction of its social realities[47] But if she is nothing else, Pandora – Woman – is a figure of terrible ambiguity: beautiful and necessary, dangerous and evil. She is, in Hesiod's account, the instrument of Zeus's revenge upon blameless men, a way of ensuring that humanity (despite its acquisition of fire) would never be able to neglect the divine. And in the context of the other patriarchal myths of the Acropolis, the representation of Pandora could be seen as yet another argument for the necessity of male dominance, as a justification for patriarchy. Woman is the explanation for the fall from the Golden Age, when blessed men knew no grief, toil, pain, or evil.[48] She is the embodiment of extremes that "waste a man's substance and dry him up before his time."[49] Pandora (the first of her promiscuous, parasitic, deceitful breed) is the reason why Athena (virgin, male-oriented goddess of moderation, production, and rationality) is so great, and why men must construct and control society. One of the sayings inscribed on the Temple of Apollo at Delphi, along with such chestnuts as "Know Thyself" and "Nothing in Excess," was "Keep Woman under Rule."[50] The base of the Athena Parthenos said much the same thing another way.

Pandora, then, is a beautiful figure of dread, something, Hesiod says, for which men can find no device or remedy. She is quite literally a *femme fatale*. Though given "all gifts" by the gods, this female prototype, this mother of all mortal women, is in fact created to beguile men with her beauty and uncontrollable sexuality, to introduce falsehood and treachery and disobedience to their lives, to let loose all evils upon the world from her famous jar (and the pessimism is crushing, since Hope remains trapped, unavailable to mortal men).[51] Her very name (whatever it means, exactly) is therefore an enormous irony and deceit – a ruse given her not by Zeus or Athena but by Hermes, the god of tricksters, thieves, and liars.[52] She is no gift and no gift-giver, but a punishment, a trap, the price of the good of Promethean fire, the product but also the price of *tekhne*, the province of the goddess whose armed gold-and-ivory image loomed majestically above her [Fig. 132]. There is even the hint in Hesiod that, in opening her jar, she somehow violates her bond of marriage with Epimetheus – the bond over which Athena, as civic goddess, presides. In short, she is the other side of Athena. If she is a *parthenos*, it is in the sense that she is a maiden ready for marriage – sexually available, one who has not *yet* lost her virginity – which, of course, Athena is not. As the prototypical Woman, she is (potentially) promiscuous where Athena is asexual. She is unknowing whereas Athena is wise. She is useless whereas Athena is productive. She is artifice whereas Athena is artificer. She is the cause of helplessness where Athena is the inventor of technologies of all sorts. Pandora is, in effect, the Anti-Athena.

It is thus hard to believe that Pheidias intended the birth of Pandora to be *simply* an expression of the gifts that the gods have showered upon humanity in general or Athens in particular, much less that it is a sudden acknowledgment of the importance of women in Periklean society or an attempt to elevate them to, or near, true citizen status (we should be careful not to try to raise Pheidias's and Perikles's consciousness for them). While few Athenians, male or female, would have viewed the Acropolis – that is, the entire complex of its myths, cults, and images – as an overt instrument of oppression, it was, like any cultural enterprise, a social construction, and the realities of male-centered Classical Athenian society must therefore have informed it and its component parts.

It seems clear that on one level the creation of Pandora could be read as genuine praise of Athena Ergane and the other beneficent gods of Olympos. It is clear that the Athena Parthenos acknowledged the existence and necessity of women and marriage in the *polis*, accommodating them through the image of Pandora on its base. It is undeniable, too, that the women on the Parthenon

frieze shared in the same broad civic idealization as the men [Fig. 158]; later, the addition of monumental Karyatids near the center of the sanctuary, facing the Parthenon itself [Fig. 177], expanded the role, even the power, of the ideal female in the iconography of the site. But it is just as clear that the Parthenon and the entire Acropolis – the male-authored center and centerpiece of a male-dominated state – resolved the problem of the female by justifying the continued political exclusion of women through the very same figure of Pandora, and through the implicit juxtaposition of her daughters, the women of Athens, set at the margins of society, with the men of Athens, the legitimate sons of the autochthonous Erechtheus/Erichthonios, the "son" of Athena whose snaky avatar coiled up beside the goddess herself. The presence of Pandora below the feet of Athena visually established the proper terms of the male-female antithesis. There, below, was the purely feminine and dangerous woman (the source of all women), and there, above, was the armed goddess who discounts her own gender, who nobly aspires to the masculine, and who thus stands as the ideal icon of Athens – "the mother of the *polis*," as Euripides calls her.[53] In a sense, the antithesis is not merely between Pandora and the Parthenos, but also between Woman and the City.

In all this (and for all the many different levels of the scene) Pheidias was conventionally fifth-century. But one or two messages, aimed at a more restricted audience, may have been darker still. For while the Parthenon frieze on the exterior of the cella stresses the Olympian nature of the Athenians, placing them on the same exalted level as the gods who humanely await (or oversee) their arrival [Figs. 145, 150], the presence of Pandora within the cella (not to mention the glorious gold-and-ivory image of Athena herself) reasserts once more the essential distinction between mortal and immortal and the inferiority of humankind, a race that unlike the gods would, because of Pandora, know pain, labor, and suffering. Her juxtaposition with Athena, in other words, re-drew the line between mortal and divine that was blurred on the frieze (and some Athenians may have recalled that it was to widen the gap between gods and men – a gap narrowed by Prometheus – that Zeus created Pandora in the first place).

Finally, at a time when the Athenians were exposed to the atheistic or agnostic notions of philosophers like Perikles's friends Anaxagoras and Protagoras, when they were presented ideas of progress based upon the rational application of skill and knowledge (in a word, *tekhne*), Pheidias, supposedly himself a member of Perikles's inner circle of intellectuals, inserted into the glorifying sculptural program of the Parthenon the image of a living statue that called the very efficacy of *tekhne* – the skills of Hephaistos and Athena, the creators of Pandora – into question.[54] Her presence on the base of the Athena Parthenos represents the existence of evil and the possibility of catastrophe even in a patriotic Victory-paradise such as the one the Acropolis and Parthenon otherwise present.[55] Between the image of Woman below and the statue of Goddess above Pheidias thus introduced friction and dissonance. And the scene was, perhaps, his challenge to the Periklean intelligentsia, a warning that despite the patronage of Athena, goddess of technology and cunning, certain things are beyond devising, impossible to overcome, "without remedy" like Pandora herself; that despite all the *tekhnai* it had at its disposal Athens could still know irremediable evil, even disaster. And, of course, it would: just a couple of years after the Parthenon was completed, at the beginning of the Peloponnesian War, Athens was struck by a plague, one of the devastating evils that beautiful Pandora had let loose upon the world.

REFLECTIONS UPON THE GOLDEN AGE
THE LATE CLASSICAL ACROPOLIS, 400-322

In the past the city was wealthy and magnificent, but in private life no one man was held above the multitude. Here is the proof: if any of you know the kind of house that Themistokles or Miltiades or the illustrious men of that time had, you can see that it is no more impressive than those of the common people, while in contrast the public buildings and structures are so great and of such quality that there is no chance that future generations will surpass them – constructions like the Propylaia, the shipyards, the stoas, Peiraieus and the rest of them that now make up the city. But today everyone who takes part in politics is so rich that some have built themselves private houses that are more splendid than many public buildings. . . . As for the public structures you build and plaster over, I am ashamed to say how small and meagre they are. . . .

Demosthenes, *Against Aristokrates* 206-08 (delivered in 352)

Historical Background: The Fourth Century

Ten years after the humiliating end of the Peloponnesian War, the great Athenian general Konon (one of the few to have escaped the disaster at Aigospotamoi), got his revenge. In 394, off the promontory of Knidos, ships under his command destroyed the Spartan fleet and at a single blow ended the brief history of Spartan naval supremacy in the Aegean. It is a measure of the complex ironies of fourth-century Greece that the fleet Konon commanded was not Athenian, but Persian, and that when Konon returned to Athens in triumph he financed the rebuilding of the Long Walls with Persian money (which is what subsidized the Spartan victory in the Peloponnesian War and thus the destruction of the Long Walls in the first place). The fourth century made strange bedfellows – over and over again.

Greek history in the Late Classical period is simply bewildering. The first three-quarters of the fourth cen-

tury was an era of transient alliances and leagues and almost constant warfare interrupted by brief periods of fragile and unconvincing peace. Indeed, for all intents and purposes the general state of war initiated in 431 continued almost unabated down to 338, though the sides often changed. At first, into the void left by the collapse of the Athenian Empire, Sparta inserted an empire of her own and was found wanting. The great wealth that empire brought with it exacerbated the inequities within Spartan society; campaigns in Asia Minor against Persia (whose gold it had welcomed just a few years before) proved overly ambitious (400-396); and Spartan expansionism brought on the Corinthian War (395-386), with old allies (Boiotians, Corinthians, and Persians) and an old foe (a resurgent Athens) arrayed against her. A treaty brokered by Persia (which recognized the danger of renewed Athenian power) shored up the dominant Spartan position, but this so-called King's Peace (387/6)

was soon shattered by gratuitous Spartan aggression against Thebes. In 378 – exactly one hundred years after the founding of the Delian League – Athens, still dreaming imperial dreams, formed the Second Athenian Confederacy and for good measure aligned itself with Thebes, itself the head of a revived Boiotian League. A decisive Athenian naval victory over Sparta off Naxos in 376 – the first purely Athenian naval victory in thirty years – led to another suit for peace in 375/4. This peace, too, proved ephemeral, and in 371, on the battlefield of Leuktra, the Thebans, led by the great Epaminondas, stunned the Greek world by crushing the supposedly invincible Spartan infantry. Thebes now reigned supreme and that made Athens, its erstwhile ally, nervous. Fearing Thebes, Athens lent support to (irony of ironies) Sparta, though this policy succeeded principally in alienating the members of its own confederacy. In 362, on the plain of Mantineia, Theban and Spartan armies collided once again. Sparta lost the battle but Thebes lost Epaminondas and the death of this one man effectively ended the decade of Theban ascendancy.

With Sparta and Thebes exhausted, Athens, for the first time in nearly half a century, was once again the most important city in Greece. Predictably, its confederates – Byzantium, Rhodes, and others incited by King Mausolos of Karia – began to revolt almost immediately, leading to the War of the Allies (or Social War) of 357. Athens lost, and peace came again in 355. But by then the self-absorbed and self-destructive Greeks had begun to fall under the lengthening shadow of a new power rising in the north. In 359 Philip II (who as a youth had spent a few years as a hostage at Thebes and put them to good use learning Epaminondas's tactics) had ascended the throne of Macedon, a kingdom peopled, in the view of Greek intellectuals, by uncouth barbarians. Uncouth or no, Philip quickly consolidated his dominance of the Balkans, captured Olynthos in the Khalkidike (348), and began to play the patronizing Greeks, and especially the quarrelsome Athenians, like a lyre. In 338 it all came to a head. Using a dispute involving Delphi as his excuse, Philip invaded central Greece, forcing Thebes and Athens once more into uncomfortable alliance. On August 4, on the plain of Khaironeia, Philip annihilated the resistance, with the decisive blow delivered by cavalry under the command of his eighteen-year-old son, Alexander. Philip was as fine a diplomat as a general and the peace he offered the Athenians (whom he needed) was unexpectedly generous: when the young Alexander led an embassy to

Athens to return the remains of the Athenian dead and seal the peace, the Athenians gratefully (or perhaps just sycophantically) conferred citizenship upon both father and son. But the meaning of Khaironeia was clear: Greece had been unified from the outside by force, and for all intents and purposes the history of Greece was no longer the history of independent *poleis*. For the next sixteen years Athens retained virtually complete autonomy in its own domestic affairs, but it was compelled to abandon any further imperial ideas (which is how Athens really measured its freedom), to join the League of Corinth (Philip's means of controlling Greece), and so to become a state like other states. The Athenians still had ambitions and they would prove a thorn in the Macedonian side again, but their city's role as a major player on the world's political stage was nearing its end.

The story of Alexander's swift alienation from his father after Khaironeia, of Philip's assassination in 336 (which the Athenians, for the most part, cheered), and then of Alexander's decision to carry out a Panhellenic crusade that Philip had already conceived – the conquest of Persia in revenge for its invasion of Greece in 480 – is not our business here. Let it simply be noted that after teaching the Greeks a vicious lesson in 335 by annihilating a rebellious Thebes (everything but temples and Pindar's house was razed to the ground, and the Thebans themselves were either slaughtered or enslaved), and after leaving the Macedonian general Antipater as his regent in Europe, Alexander led his army across the Hellespont and into Asia in 334. The momentous victories he won at Granikos (334), Issus (333), and Gaugamela (331) shattered the Persian Empire, and the 20,000-mile-long swath he cut through Asia Minor, Mesopotamia, Persia, India, Phoenicia, and Egypt brought most of the known world under Greek political and cultural dominance – and at the same time made the Greek world mostly eastern. Alexander never returned to Greece, and when he died in Babylon in 323, just short of his thirty-third birthday, he left behind a different, divided, and heterogeneous Hellenistic world.

Athens and the Late Classical Acropolis

Athens in the fourth century was significantly different from what it had been in the fifth. Surprisingly, perhaps, it was not a poorer place – at least not on average, and not for long. To be sure, in the aftermath of the devastation of the Peloponnesian War, Attica suffered severe eco-

nomic hardship and poverty was rampant. But recovery was remarkably quick: by the middle of the fourth century farming and mining – which had long been the basis of Athenian prosperity – were back to normal, and the Peiraieus was a bustling trading center once again.[1] The big difference was in the widening gulf between rich and poor. Fortunes were to be made (in shipping, for example) and private wealth took on an importance it had not had before, attracting the notice of poets, artists, and philosophers alike. In Aristophanes's escapist comedy *Ploutos* (*Wealth*), produced in 388, the personified Wealth reigns supreme and even the god Hermes, a beggar now, takes a job in his kitchen. Aristophanes's Ploutos is at first a blind old man who distributes wealth indiscriminately (his sight is eventually restored by Asklepios, so that he might see and favor only the good). But that is not the only way the fourth century conceived of him. In an allegorical statue made by Kephisodotos and set up in the Agora in 375/4 to commemorate one of Athens's many brief respites from war, Ploutos was depicted as a chubby baby boy nestled in the arms of his handsome mother, *Eirene* (Peace).[2] The theme here was the condition necessary for civic rather than private prosperity. But Plato's *Republic*, written in the 370s, suggests that personal greed was an issue and a problem: Books 8 and 9 warn that the individual pursuit of gold leads to the division and destruction of the state. Despite Plato's admonitions, the focus of Athenian society began to shift from the public to the private sphere. The boundaries of Athenian society and the boundaries of Athenian public affairs, virtually indistinguishable in the fifth century, were no longer coincident. The family and the private individual now more strongly emerged beside the state and the public citizen; economics became as important an issue as politics (the fourth century saw the appearance of the first treatises devoted strictly to economics *per se*).[3] And for most of the century the new fashion for private ostentation (manifest in the creation of splendid houses and the proliferation of fine funerary monuments, for example) overshadowed any impetus for major programs of public works – a situation that a few civic-minded figures like Demosthenes lamented.

Politically, Athenian democracy nominally experienced a diffusion of power after 400: there was such an explosion in the number of boards, officials, magistrates, and overseers that, according to one estimate, by the mid-fourth century about a third of all Athenian (male) citizens held a public office of some kind.[4] On the other hand, with political power so fragmented (and with the Athenians generally reluctant to concentrate power in the hands of any one politician), the business of state came to be dominated not by annually elected archons or *strategoi*, as it had been in the past, but by professional orators, such as Demosthenes and Aeschines, and economic bureaucrats, such as Euboulos, who was in the 350s the administrator of the so-called Theoric Fund. Originally intended simply to provide the poor with tickets to the dramatic festivals of Athens, the Theoric Fund eventually had public expenditures of all kinds written against it and its comptroller – a financial manager rather than a politician in the old-fashioned sense of the term – became the most powerful figure in the state.

In the realm of literature, too, the differences with the fifth century are clear. Though the dramatic festivals of Athens still functioned, the golden age of Athenian tragedy was over. As for comedy, Aristophanes, as we have seen, continued to write into the 380s (though he typically avoided the kind of political controversies and parodies he once relished) and toward the end of the century (in 324 or 323) the social comedian Menander began his career. Still, the principal focus of Athenian literary and intellectual energies was now neither drama nor poetry, but philosophy. The fourth century was not *the* age of any tragedian or comedian in particular (the way the fifth century was the age of Aeschylus, Sophocles, Euripides, and Aristophanes) but of Plato and Aristotle.

Plato's *Republic* was an understandable utopian response to the turbulence of his times, but it is worth noting that he was no fan of the fifth century, either: he was a critic of Periklean democracy, of Periklean achievements, even of the traditional rituals and imagery that the Periklean era glorified. Though the Periklean building program had conservative opposition at the start, criticism quickly faded. Plato revived it, accusing Perikles of bad statesmanship by fashioning policies – and the building program was surely one of the things Plato had in mind – that corrupted the people with pay and the love of luxury.[5] Elsewhere, Plato implicitly rebukes the ostentation of Periklean Athens by making huge gold statues and gold, ivory, and silver-covered temples conspicuous features of his mythical barbarian island-continent of Atlantis. The allusion to Pheidias's chryselephantine Athena Parthenos [Fig. 132] – and even to the treasure-packed Parthenon itself [Fig. 126] – is subtle but clear: these are, in Plato's formulation, the kinds of opulent things that immoderate barbarians make.[6] Plato would even banish from his republic story-cloths like the *peplos*, the traditional cen-

terpiece of Acropolis iconography [Fig. 151]: the telling of the tale of the Gigantomachy in any form would not be allowed. The kind of myths depicted on the *peplos* or on the metopes or in the pediments of the Parthenon were false, and so would only corrupt the members of Plato's ideal state.[7] Clearly, Plato's utopia and historical Athens did not have much in common, and for him Periklean Athens was certainly nothing to emulate.

Plato's severe attack on the imagery and lavishness of the Periklean Acropolis was not unique in the fourth century.[8] But it was not typical, either. The standard response to the fifth century – especially to the Periklean era and its greatest physical manifestation, the Acropolis – was one of admiration and nostalgia, and the Propylaia, even more than the Parthenon, was held up to the Athenians as the most noble architectural achievement of the good old days and as an inspiration for what could still be achieved by right-thinking men. Demosthenes and Aeschines, who did not agree on much, at least agreed on that. A tried-and-true rhetorical tactic, Aeschines says in a speech delivered in 343, was to urge the Athenians, gathered in assembly on the Pnyx directly west of the Periklean gateway, "to look upon the Propylaia of the Acropolis, and remember the sea-battle at Salamis and the tombs and the trophies of our ancestors."[9] Whatever the political uses to which it was put, the Propylaia was recognized as one of the brightest stars in the constellation of monuments and events that had in the not-too-distant past made Athens the greatest city in Greece.

It was, in short, the fourth century that invented the notion of the Periklean "golden age." At the end of Aristophanes's *Ploutos*, for example, a procession gathers to install Wealth back on the Acropolis (inside the *opisthodomos*, to be exact) "where he formerly sat as guardian of the goddess' treasure": the point is that in 388 the Periklean age was regarded as a time of unmatched national prosperity.[10] It was also looked back upon as an era of unrivalled intellectual and cultural achievement. In 387/6 a law was passed requiring that plays by Aeschylus, Sophocles (the Periklean playwright par excellence), and Euripides – the "Old Masters" of Athenian tragedy – be revived each year; beginning in 340/39, old comedies were revived as well. In other words, the development of the idea of the Periklean "golden age" included the development of the idea of "the classic" itself: it was, after all, Sophocles's *Oedipus Tyrannos* (possibly produced soon after Perikles's death) that Aristotle promoted as the ideal Greek tragedy in his *Poetics*.[11] And while Late Classi-

cal Athenians may have found themselves overshadowed by their own High Classical past, they were also increasingly willing and eager to live off it, to exploit their cultural achievement as an argument for present and future status and privilege.

Of course, the fifth century loomed over the fourth literally as well as figuratively: the Acropolis that rose over Late Classical Athens was, after all, still High Classical in its essential elements. In fact, only one – at most two – notable architectural events took place on the fourth-century summit. The first was the insertion of the Chalkotheke – the Bronze Storehouse – into the trapezoidal space between the Sanctuary of Artemis Brauronia and the great rock-cut flight of steps west of the Parthenon [Fig. 3, no. 6; Fig. 189]. As we have noted, the Chalkotheke, though usually considered Periklean, may actually have been built as late as the 380s or 370s, when Athens's tenuous political and strategic circumstances in a time of nearly incessant warfare would have encouraged the construction not merely of an utilitarian warehouse on the Acropolis but of an arsenal – the items it stored included shields, armor, weapons, and even catapult parts – that reasserted the rock's ancient military character.[12]

The Chalkotheke was, then, the last major Classical addition to the summit. But conceivably the sanctuary experienced one more important change in design. If the controversial *Opisthodomos* was not the western section of the Parthenon after all but a separate structure (the repaired rear part of the late Archaic *Archaios Neos* [Fig. 3, no. 11; Fig. 93]), then the last great architectural event atop the Classical Acropolis was its dismantling, an act that would finally have cleared the space at the center of the Acropolis and, for anyone entering through the Propylaia, removed a major obstacle to the viewing of the Karyatid porch and thus to the appreciation of the significant relationship between the Erechtheion and the Parthenon. The demolition of the building (if it in fact existed) is often dated to around 353/2 (which is when we last find the term *Opisthodomos* in our literary sources).[13]

At all events, the history of the Late Classical Acropolis is primarily a history not of architecture, but of dedication and dedications. To be sure, this history was not always glorious, and Athena and her accumulated holdings on the Acropolis suffered a number of indignities and even crimes. Sometime between 386/5 and 353, for example, the *Opisthodomos* (whatever it was) was set on fire by the Treasurers of Athena (possibly in collusion with the Treasurers of the Other Gods) in an attempt to destroy evidence of their illegal loans of public funds;

A B

Fig. 203. Reconstruction, Monument of Konon and Timotheos. Drawing by D. Scavera, after Stevens 1946, fig. 9.

the guilty were thrown in jail.[14] We hear, too, that the "wings of the Nike" – which Nike is not specifically stated, but *the* Nike would have been the one in the hand of the Athena Parthenos [Fig. 132] – were mutilated by men who then took their own lives, and that splendid Persian spoils (specifically a silver-footed throne and Mardonios's own sword, taken from his hand as he lay dead on the plain of Plataia in 479) were stolen from the goddess's treasury.[15]

Despite such theft and vandalism, however, the fourth-century Acropolis benefitted from a great wave of dedications of all kinds in gold, silver, bronze, and other materials. The inventories of the treasures of the Parthenon document the vast wealth of the offerings, made by both private individuals and public bodies, stored indoors – dedications like the silver *phiale* decorated with a gorgoneion that Lysimakhe, mother of Telemakhos (presumably the founder of the Asklepieion on the south slope), gave around 398/7, or the gold neckband and gold rhyton dedicated to Athena Polias by Roxane, wife of Alexander the Great, or the scores of gold wreaths or crowns given by the Athenian people (the *demos*), by religious boards such as the *hieropoioi*, or even by foreign states (such as Naxos or Thasos or Samos) throughout the fourth century.[16]

In the open air there was a corresponding explosion in the sculptured population of the citadel. Now, it is true that some of the most important sculptors of the High Classical period (besides Pheidias) were represented by works set up on the summit in the last decades of the fifth century. In addition to his Prokne and Itys [Fig. 178] Alkamenes, for example, also made an Archaistic statue of Hermes Propylaios ("before the gate") and a Hekate Epipyrgidia ("on the tower," so called because it stood on the bastion beside the Nike temple).[17] Around 430 Lykios, Myron's son, made his "Bronze Boy Holding a *Perirrhanterion*," and a decade later Strongylion made his bronze Wooden Horse for Khairedemos, who dedicated it in the Sanctuary of Artemis Brauronia [Fig. 168]. Kresilas may have made the bronze statue of a wounded and dying warrior that Pausanias saw within the Propylaia and identified as Diitrephes; he almost certainly made a full-length portrait of Perikles set up on the Acropolis not long after his death in 429 – a portrait nicknamed "the Olympian" after its noble bearing [Fig. 44]. There are a few other impressive bits and pieces: a fragmentary relief of a trireme with men at oars, for example, or another with two gracefully posed women dated to the end of the century.[18] But the record of High Classical sculptural dedication is otherwise fairly sparse.

In contrast, the fourth-century record is comparatively rich: Late Classical Athenians may not have built much atop the Acropolis, but they filled the place with statues and stelai. Around 390, for example, on a large semicircular marble base located a few meters north of the Parthenon (the base was prominently aligned with the middle columns of the north colonnade), the Athenian people dedicated a bronze statue of Konon, the general whose naval victory over the Spartans in 394 and subsequent rebuilding of the city's walls marked the beginning of Athens's revival [Fig. 203a]. The portrait of Konon was originally flanked by spoils or trophies, so that the dedication was also a monument to the victory at sea. Konon was, we are expressly told, the first person in nearly a century to be honored by the Athenian state with a public portrait (Kresilas's portrait of Perikles would thus have been a private dedication). But after the dedication of Konon's image and another like it in the Agora (presumably shortly after the general's death), the practice of erecting honorific portraits took off.[19] A portrait of Iphikrates (another accomplished Athenian general of the Corinthian and later wars) was even set up "at the entrance" to the Parthenon itself (if the statue actually stood within the colonnade, it would have been by far the earliest of only three portraits of real people known to have been set inside the building).[20] This was precisely the sort of thing that orators

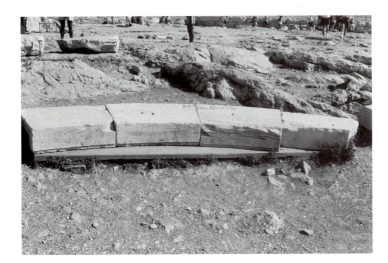

Fig. 204. Base of Monument of Kephisodotos, signed by Demetrios of Alopeke. Photo: author.

Fig. 205. Roman copy of portrait of Lysimakhe (?), by Demetrios of Alopeke (BM 2001). Courtesy Trustees of the British Museum.

like the nostalgic Demosthenes, who preferred the larger-than-life heroes of the fifth century to his own life-size contemporaries, bemoaned. When a statue of Konon's son Timotheos (a capable general but an altogether lesser figure who suffered disgrace in mid-career and even died an expatriate) was added to the father's base around or before 350 [Fig. 203b], Demosthenes must not have been pleased.[21]

The sculptors of the Konon and Timotheos monument are unknown, but we do know that Demetrios of Alopeke, a portrait specialist famous for his realism (some ancient critics even said he took verisimilitude too far), was very active on the early fourth-century Acropolis, being represented there by at least five different works. We have solid evidence for only one or two of them: fragments of a semicircular base that supported his statue of the general Kephisodotos [Fig. 204][22] and a circular, inscribed base that almost certainly supported his three-quarter-life-size bronze portrait of Lysimakhe, a priestess of Athena who served the goddess for sixty-four years – an obviously remarkable woman who was possibly the same Lysimakhe as the mother of Telemakhos (and dedicator of that expensive silver *phiale* to Athena recorded in the Parthenon inventories after 398/7) and probably the model for Aristophanes's formidable Lysistrata (their names mean virtually the same thing). Heads in London and Rome and a torso in Basel are sometimes thought to be Roman copies of the Lysimakhe [Fig. 205]. If so, with their thin lips, sunken cheeks, drooping eyes, wrinkled skin, and stooping pose, they would give some sense not only of the hard realism for which Demetrios was notorious but also of the many years of service Lysimakhe gave to her goddess.[23]

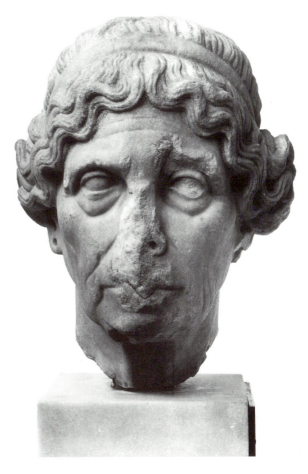

Portraits were not, of course, the only kinds of statues dedicated on the fourth-century Acropolis: there were mythological groups and images of divinities, too. Around the turn of the century, for example, Deinomenes (a sculptor about whom we hear little else) made statues of Io and Kallisto, legendary women who suffered the love of Zeus, the hatred of Hera, and metamorphosis into beasts (a cow and a bear, respectively); the group evidently stood somewhere east of the Parthenon.[24] Naukydes of Argos, apparently a younger relative of the great High Classical sculptor Polykleitos who worked around 400 or later, was known for a statue of a man sacrificing ram, and this could be the same as the group of Phrixos sacrificing the ram of golden-fleece fame that Pausanias noted on his tour somewhere beyond the Sanctuary of Artemis Brauronia.[25] Praxiteles, one of the greatest of all Late Classical sculptors, accepted at least two Acropolis commissions: a statue of Artemis Brauronia for her sanctuary and a Diadoumenos (a statue of a youth binding his hair with a fillet) to commemorate an athletic victory.[26] Leokhares, a slightly younger Athenian contemporary, spent even more time casting bronzes for the Acropolis. Pausanias saw his statue of Zeus in or near the sanctuary of Zeus Polieus. But Leokhares was also an accomplished portraitist, and there is epigraphic evidence for his six-figure bronze group portraying the family and ancestors of a certain Pandaites and Pasikles (the statues were cast with the collaboration of the lesser known Sthennis).[27] Leokhares was much sought after by the generals, kings and nabobs of the fourth century. Around 350, for example, he was employed at Halikarnassos, where he carved sculptures for the Mausoleion, a monumental tomb built for Mausolos, the Karian ruler who had urged Athens's allies to revolt in the Social War. And he made the chryselephantine images of Philip II of Macedon and his family – a group dynasty portrait – that stood in the so-called Philippeion built at Olympia after Khaironeia. The Olympia group included a portrait of Alexander, and a handsome but controversial head found on the Acropolis near the Erechtheion [Fig. 206], often thought to be a Roman copy, is perhaps better considered an original fourth-century Alexander portrait – perhaps even a work by Leokhares himself or a contemporary marble version of the gold-and-ivory image in Olympia.[28] In either case, its dedication on the Acropolis would have been an obvious attempt to curry favor with that impressive and powerful youth – a political act.

The Late Classical Acropolis was loaded with many other statues that cannot be associated with known

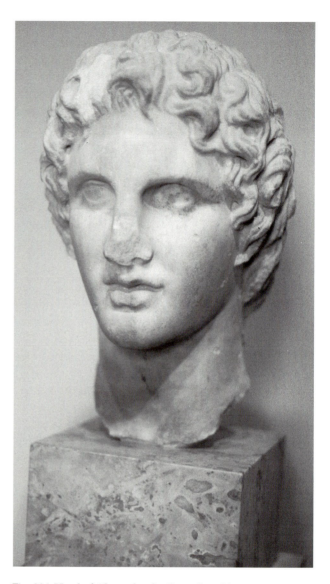

Fig. 206. Head of Alexander the Great, late 4th century? (Acropolis 1331). Photo: author.

sculptors – statues set up on bases in the scores of cuttings that still scar the bedrock, or in the various precincts of the sanctuary, or within the Propylaia, or on the terrace or even the steps of the Parthenon, which increasingly became a kind of platform for the display of freestanding sculpture. It is, perhaps, symptomatic of fourth-century votive energies that a new pit for the casting of bronzes was now dug into the south slope of the Acropolis directly below the Chalkotheke (where the Early Classical Bronze Athena had also probably been manufactured) [Fig. 122]: statues or statuettes that emerged from the casting-pit were presumably dedicated

on the summit.²⁹ And some idea of the sheer number and variety of fourth-century Acropolis bronzes can be gleaned from a fragmentary marble inscription apparently listing statues scheduled for recycling – statues missing limbs, eyes, shields, or other objects they once held in their hands (statues of children are surprisingly prominent in the inventory, but there are also bearded men and beardless youthless, a hoplite-racer, and even several Palladia). The preserved fragments (which represent only a small portion of the original stone) list twenty-five mostly damaged or deteriorated bronzes; the complete inscription would have listed far more. Though some of the listed items could have been as old as the fifth century, most would have been fourth-century dedications. In any case, they seem to have been intended for melt-down and recasting into new cultic equipment for the sanctuary (this was fair treatment for sacred dedications so long as the act was publicly recorded, along with the names of the dedicants of the original votives: the precious material stayed with the goddess, even if it was reprocessed).³⁰ The inventory has plausibly been dated to around 335 or 330, and so it would be an early document of the general policy of Athenian renewal and renovation initiated by Lykourgos, the most important Athenian statesman since Perikles.

The Lykourgan Silver Age

The history of Athens from 338 to 322 – an era we might deem the "latest Classical period" of Athens – is essentially the history of Lykourgos, his reforms, and his revitalization of the city.³¹ A member of the ancient and proud Eteoboutadai family (from whom the priestess of Athena Polias was always chosen), himself a priest of the cult of Poseidon-Erechtheus housed within the Erechtheion, a democratic supporter of Demosthenes's anti-Macedonian policies, and a man renowned for honesty, Lykourgos had been appointed chief financial officer of Athens just before Khaironeia, and so, when Athens lost the war, he found himself in a position to take full economic advantage of the peace. Again, Philip and Alexander left Athens free to manage its own internal affairs and this Lykourgos did for twelve years (down to 326) with consummate efficiency, skill, and the kind of visible results that Athens had not seen for a century. Before the critical battle the Athenian exchequer was often strapped: there were few public funds to do anything but carry out wars and cement alliances. But Khaironeia forced Athens from the international theater,

and this meant that public revenues could accrue at home once again. Peace really was the mother of wealth, as Kephisodotos's statue had promised, and under Lykourgos public revenues soon doubled or even tripled anything known before, averaging 1,200 talents (or more) a year.³² With the surplus Lykourgos initiated a building program that was clearly meant to rival (and whose cost, even adjusted for inflation, may have actually surpassed) that of Perikles himself.

It was against the standard of Perikles that Lykourgos measured himself and his actions. It was against the very real figure of Alexander that he jockeyed for political position. Certainly, there was no love lost between the two. Enraged at Athens's support for (and complicity in) the Theban revolt of 335, Alexander demanded that the Athenians surrender Lykourgos, Demosthenes, and other opponents, and there was no reason to expect he would have treated them any better than he had the Thebans. Alexander eventually calmed down – the Athenians were reluctant to give them up and magnanimity, he realized, was the better part of diplomacy – and so Lykourgos, Demosthenes, and all but one of the others were let off the hook.³³ For his part, Lykourgos, like other democrats, fervently hoped that Alexander would meet his end in Asia, and he directed the affairs of his city so that it would be economically and militarily ready for the day opportunity knocked. By financing the rebuilding of the Long Walls and other defenses (one of the earliest acts of his administration), by constructing or completing a new arsenal and shipsheds in the Peiraieus and fitting out four hundred triremes to fill them, by stockpiling weapons on the Acropolis, and by instituting new compulsory training and indoctrination programs for the *epheboi* (who swore their oath of loyalty in an impressive ceremony in the Sanctuary of Aglauros [cf. Fig. 8]), Lykourgos prepared Athens for a resumption of its status as an international power to reckon with. In the meantime he dismissed Alexander as a self-promoter and in 324 (not long before his own death) scorned Alexander's "suggestion" that he be deified as a son of Zeus, a new Olympian. "What kind of god can this be," Lykourgos asked, contemptuously, "when you would have to purify yourself *after* leaving his temple?" The Athenians, bitterly biding their time, deified Alexander anyway.

Even without direct Macedonian interference in the internal affairs of the city, it is clear that Lykourgan Athens could never quite escape the shadow of Alexander even when cast from such distant places as Granikos or Susa. After his victory at Granikos in 334, for exam-

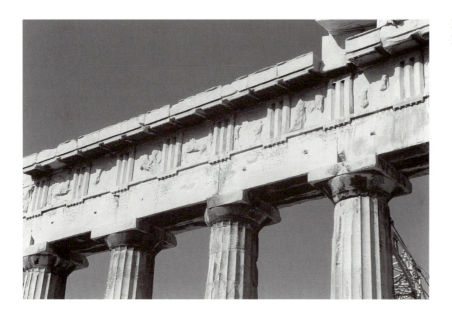

Fig. 207. East architrave of Parthenon.
Photo: author.

ple, Alexander sent 300 suits of Persian armor to the Acropolis and dedicated them to Athena. The panoplies were displayed inside the Parthenon along with the inscription: "Alexander, son of Philip, and the Greeks (except the Lakedaimonians) dedicated these spoils, captured from the barbarians who inhabit Asia."[34] And on the east (and principal) side of the Parthenon, he had fourteen large gilded shields (1.25m in diameter) dowelled onto the architrave below the Gigantomachy metopes to commemorate the battle: their round "ghosts" are still visible [Fig. 207]. There was one shield for every metope, and so the correspondence between the spoils of Granikos and images of another, if legendary, struggle for dominion over the world was exact and clear.[35] In addition, after entering the old Persian capital of Susa in early 330, Alexander sent back to Athens Antenor's bronze statues of Harmodios and Aristogeiton – the original Tyrannicides – stolen by Xerxes in 480 (the bronzes were then set up in the Agora beside Kritios and Nesiotes's Early Classical replacements).[36] At first glance, the dedication of the panoplies, the prominent display of the gilded shields, and the return of the Tyrannicides seem like flattering gestures of respect, even reverence, for the glorious heritage of democratic Athens and golden-age icons like the Parthenon. At some superficial level they probably were taken as such. But Alexander's return of the cherished Tyrannicides was fundamentally a political act meant to blunt Athenian opposition in his absence (it is not known whether anyone noted the irony of an autocrat returning statues of autocrat-killers), while the dedication of the armor and shields transformed the Parthenon, a monument commemorating Athenian victory over the Persians, into a monument commemorating *Alexander's* victory over them. It was also in the nature of a warning, even a rebuke. Most Athenians rooted for the Persians at Granikos; Athenian (as well as other Greek) exiles and mercenaries even fought on the Persian side. So the victory of "the Greeks" that Alexander's dedication celebrated was in part a victory over Athenians – and over Athenian hopes. The message was inescapable: the Athenians would support Alexander in the future or risk suffering the same fate as the enemy at Granikos.[37] This was dedication as political rhetoric, pure and simple: the Parthenon, the glory of the Acropolis, was turned against the city that built it.

Lykourgos could do little about such things: no offering to Athena, no matter how grating its message, could be refused. But Alexander's propagandizing did not distract him from his principal goal: urban renewal, the restoration and monumentalization of the Athenian cityscape. There are hints, here and there, that before Lykourgos the city of Athens (at least below the Acropolis) was run down, even decrepit. One source suggests that poor houses or slums were spreading over the Pnyx (the meeting-place of the Athenian assembly) [Fig. 2], another that there were many vacant lots within the city walls that, if given away, might attract a better class of people, and that the city's temples, forts, and docks were in need of repair. For Demosthenes, at least, the quality

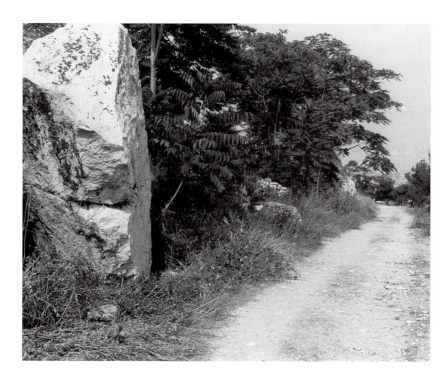

Fig. 208. View of *peripatos* (north slope). The *peripatos* inscription is inscribed on the bottom of the upright block of Acropolis limestone at left. Photo: author.

of the public buildings put up in the fourth century was an embarrassment.³⁸ It was upon the lower city, then, that Lykourgos justifiably lavished most of his attention and considerable resources. Realizing that he could not compete with Perikles atop the Acropolis (architecturally there was not much more to be done up there anyway), Lykourgos's goal was to mute the physical contrast between the lower and upper cities. It is as if he wished to create a Late Classical Athens of which the High Classical Acropolis could be proud.

There had been a few individual building projects in the fourth century before Lykourgos, and some were important. In the late 390s, again, Konon rebuilt the Long Walls linking Athens to the Peiraieus and the walls around Athens itself may have been overhauled as part of the same project.³⁹ Around the same time, a new wall was built to define the south edge of the terrace of the Archaic Spring House on the south slope of the Acropolis, just west of the Ionic stoa [Fig. 3, no. 26]: the wall incorporated within it the fifth-century marble stele with the inscription *horos krenes* ("boundary of the spring") [Fig. 3, no. 28; Fig. 194].⁴⁰ This wall not only established the limits of the Spring House terrace but also helped mark the line of the *peripatos*, the ancient path some thousand meters long that encircled the foot of the Acropolis (and thus the many sanctuaries above it on the slopes). The redefinition of the *peripatos*, undoubtedly a

lengthy process, seems to have been complete by the mid-fourth century. At least that is the date of an inscription carved onto a boulder of Acropolis limestone which at some point had broken off the face of the citadel above and landed just east of the open-air shrine of Eros and Aphrodite on the north slope: "length of the *peripatos*: five stades, eighteen feet," it reads [Fig. 208].⁴¹ Back on the south slope, the Athenian *demos* – that is, the state – assumed control over the cult of Asklepios sometime between 360 and 340, and some of the originally wooden structures of the Asklepieion (the propylon, for example, and the earliest *naiskos*) were probably then replaced in stone [Figs. 192, 193].⁴² The sanctuary now experienced an explosion of dedicatory activity, and a few elaborate votive reliefs hint at its appearance at the time [Fig. 196]. Finally, we hear that in the 350s and 340s Euboulos, Athens's first great financial officer, initiated a series of worthy public works (shoring up defenses, securing the water supply, and shipbuilding) that Lykourgos continued to fund.⁴³

Lykourgos's building campaign did not, then, emerge out of nothing. Still, for sheer scale and concentration of resources, labor, and energy, Athens had seen nothing like it since the Periklean golden age (Lykourgos's obvious model and inspiration). Besides the installations at the Peiraieus and the rebuilding of the walls, Lykourgos repaired and beautified the sanctuary at Eleusis in west-

ern Attica (where Perikles had built a Telesterion). Back in Athens he funded the expansion of the assembly-place on the Pnyx (presumably clearing the slums that had spread over the slopes of the hill in the process) and began the construction of two adjacent (and ultimately unfinished) stoas; the whole project is now dated to c. 335.[44] On the west side of the Agora he built a small temple to Apollo Patroos (Paternal Apollo), complete with an altar covered in gold, and he either built or completed a large fountainhouse in the Agora's southwest corner.[45] Just east of the city, outside the city wall, he improved and re-landscaped the ancient Lykeion (a gymnasion that was the training center for the *epheboi* as well as the site of Aristotle's new philosophical school) by adding a new *palaistra* (or wrestling ground) and planting trees.[46] And in a natural trough to the southeast of the city, across the Ilissos River [Fig. 2], he built Athens's first stadium – a simple racetrack with stone retaining walls along the sides and a *theatron* (or seating area) for spectators at one end. Lykourgos's stadium was finished just in time to hold the athletic competitions of the Greater Panathenaia of 330 (track contests had previously been held in the Agora).[47] Despite Athens's now considerable public wealth, Lykourgos did all this as economically as possible and, significantly, even twisted the arms of private benefactors – one of whom was not even an Athenian – to subsidize some of the projects.[48] By enlisting the rich in his urban campaign, Lykourgos attempted to shift the center of Athenian society back from the private to the public sphere: personal wealth was once more put in the service of the civic good.

Virtually every corner of the city thus benefitted from the Lykourgan program of civic regeneration – of rebuilding, expanding, or embellishing public and sacred spaces. This is true even atop the Acropolis, where Lykourgos built nothing, but reorganized, renewed, and repaired a lot. He is said to have stockpiled 50,000 missiles and many shields or heavy arms on the citadel, presumably in the Chalkotheke [Fig. 3, no. 6]; he stored naval equipment and catapult parts there as well.[49] And early in his administration (as we have seen) scores of damaged bronze statues were collected, recorded, and apparently recast into new sacred vessels or utensils. He devised a whole new system for inventorying the treasures of Athena. And according to one ancient source he "brought great sums of money to the Acropolis, providing ornament for the goddess, solid gold *Nikai*, gold and silver vessels for use in the processions, and enough gold ornament for one hundred

kanephoroi."[50] "Ornament for the goddess" probably refers not to any particular statue of Athena (say, new gold accoutrements for the statue of Athena Polias) but more generally to all the various precious objects that were in her possession. The reference to the "solid gold *Nikai*" is clear enough: Lykourgos restored the many Victories (actually made of bronze) that had been stripped of their gold plating to help alleviate the wartime financial crisis of 407/6. In so doing he essentially helped replenish the Athenian bank account. He also repaired an important statue of Athena Nike originally dedicated on the Acropolis from the spoils of victories won in 426/25.[51] All these activities (including a general melt-down and reprocessing of older gold and silver dedications) can be dated to the few years after 335/4 and reflect not only Lykourgos's concern for the careful management and increase of the treasures of Athena, but also his desire to re-decorate the sanctuary and its interiors with new precious objects ("the ornament of the goddess"), to restore works of the High Classical "golden age" (such as the Golden Nikai and the Athena Nike), and to revivify traditional processions like the Panathenaia, those sacred-civic spectaculars that, led by gold-bedecked *kanephoroi* and others who carried and displayed gold and silver vessels, formed so much a part of Athenian life [cf. Fig. 158].[52]

But the greatest mark Lykourgos left upon the Acropolis – indeed upon the entire Athenian cityscape – was his new Theater of Dionysos on the south slope, just beside the Odeion of his hero and exemplar [Fig. 3, no. 21; Fig. 209]. Actually, Lykourgos seems not only to have reconstructed the theater itself but also to have built a new temple to Dionysos Eleuthereus (to which Alkamenes's chryselephantine image of the god was now moved) just a few meters south of the original Archaic shrine. He also built a long Doric stoa defining the precinct on the north, set back-to-back with the theater. The archaeology of this complex is hard to interpret, and one ancient source suggests that Lykourgos merely "finished" the theater rather than rebuilt it from scratch.[53] Moreover, since the visible remains are predominantly Roman, it is difficult to reconstruct the appearance of the Lykourgan structure in every detail. But whatever the fourth-century theater's exact form, it is clear that Lykourgos was responsible for its monumentalization, for converting an insubstantial fifth-century installation that was little more than a modestly landscaped hillside with added wooden seats and an impermanent wooden stage-building [Fig. 191] into a great stone structure that radically

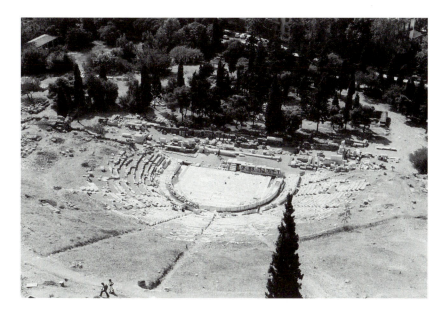

Fig. 209. View of Theater of Dionysos, south slope. Photo: author.

transformed the south face of the Acropolis. As part of the project, it was necessary to cut back the bedrock of the upper slope, creating an artificial, slightly curved vertical scarp known as the *katatome* [cf. Fig. 9]. Below that was the *theatron* itself, a great fan of concentric stone benches (capable of accommodating something like 15,000 spectators) radiating up the slope in wedges from a semicircular *orchestra*, behind which was the theater's first permanent stone stage (*skene*). Architecturally the Lykourgan theater was not the most impressive Greek theater of its time (that honor belonged to the theater at Epidauros). But it was far grander than anything Athens had known before. In fact, it was so impressive that the Athenian Assembly evidently chose to meet there more often than on the Pnyx, and it was there that the Athenian *epheboi*, after the completion of their first year of service, passed in impressive review before the citizenry. Taken together, the new theater, stoa, and temple re-created one of the most important public spaces of Athens, and so Lykourgos provided a new monumental setting for the display of Athenian religious, civic, and literary culture.[54] What he was about here and elsewhere was nothing less than the renewal of Athenian spectacle and ritual – the core of Athenian civic life.

Besides holding performances of tragedy and comedy, the Theater of Dionysos was also the scene of competitions in the choral song known as the dithyramb and possibly the *pyrrikhe* – the armed "war-dance" that had long been a Panathenaic event. Victorious *khoregoi* – wealthy men drafted by the state or the tribes to

sponsor and train the choruses and dancers – were allowed to celebrate by erecting monuments to themselves (the honor helped soften the sting of compulsory expenditure). The *khoregoi* for tragedy, comedy, and *pyrrikhe* typically set up stelai and statues. A certain Atarbos, for example, dedicated a bronze group upon a marble base decorated with reliefs of his eight well-drilled, tip-toeing, shield-bearing dancers, of seven robed choral-performers (like the dancers they are arranged in two groups), and of two other robed figures, one of whom is likely Atarbos himself [Fig. 210]: the monument was probably dedicated in 323, probably atop the Acropolis, which would make it one of the very latest Late Classical dedications on the summit.[55] *Khoregoi* for the dithyramb received bronze tripods for their trouble and typically dedicated them along a processional way – Pausanias says the street was simply named "Tripods" – that curved around the north and east slopes of the Acropolis, below the level of the *peripatos*, terminating at the sanctuary of Dionysos itself [Fig. 2].[56] Although the practice of erecting khoregic monuments along the street began as early as the fifth century, the Lykourgan period saw the appearance of some of the finest examples of the genre – above all, the well-preserved Monument of Lysikrates (335/4), which is essentially a grandiose marble cylinder, set on a high square base, decorated with Corinthian columns and carved with relief tripods and scenes of Dionysiac myth, and crowned with a floral ornament that in turn supported the prize tripod itself.[57] But khoregic monuments could be even more imposing

Fig. 210. Atarbos base (Acropolis 1338), probably 323. Photo: author.

Fig. 211. View of foundations of Nikias Monument, 320/19. Photo: author.

than this, and not all of them stood along the Street of the Tripods. In the same year of 320/19 – that is, just after the end of the Lykourgan era, and so technically in the early years of the Hellenistic period – a certain Nikias erected a large, Doric temple-like building just west of the Theater of Dionysos to commemorate his victory [Figs. 211, 212] while one Thrasyllos built a monumental architectural facade over the mouth of a cave in the *katatome* directly atop the last row of the theater, where its constant visibility would be assured [Fig. 9]. If not actually his rival in choral production, Thrasyllos was clearly vying with Nikias for the attention of the Athenians. At any rate, given the location, it is not surprising that this area continued to be a popular choice for khoregic monuments in the Hellenistic and Roman eras.[58]

It is in the Theater of Dionysos and its associated monuments that Lykourgan classicism – Lykourgos's veneration for the achievements of the fifth century – is most evident. His design for the theater conspicuously respected the Periklean Odeion next door. The east side of the *theatron* actually wrapped itself around the concert hall's northwest corner like one piece of a jigsaw puzzle clamping onto another, or, perhaps, the corner of the Odeion was allowed to insert (and assert) itself into the bowl of the theater [Fig. 3, nos. 20 and 21; Fig. 190]. One motive for rebuilding the theater in the first place must have been to give revivals of the plays of Aeschylus, Sophocles, and Euripides (mandatory since 387/6) a setting appropriate to their now "classic" status. Lykourgos not only passed a law standardizing the texts of the works of the three tragedians (making it a crime to depart from the authorized versions) but also set up bronze statues of them in the theater itself – idealized portraits of the "gods"

of Classical drama to remind the Athenians of how great their tragic poets once were.[59] In other words, the fourth-century theater – by far the single greatest monument of Late Classical Athens – was conceived as a tribute to the cultural achievement of the High Classical city. And even the design of the first stone *skene* – a long, Doric structure with a colonnade running along most of the facade, with at each end hexastyle projecting wings (*paraskenia*) that framed the action – was classicizing: whoever the architect was, he had closely studied the Doric Stoa of Zeus Eleutherios in the Agora (another product of the High Classical golden age, built around 430-420) and incorporated many of its features, including its broad Π-shaped plan.[60] So, just as Lykourgos fixed the texts of Classical tragedy by law, so he fixed the setting of their performance with a permanent stone building that was both literally and evocatively background, a structure that emulated a well-known monument of the golden age.

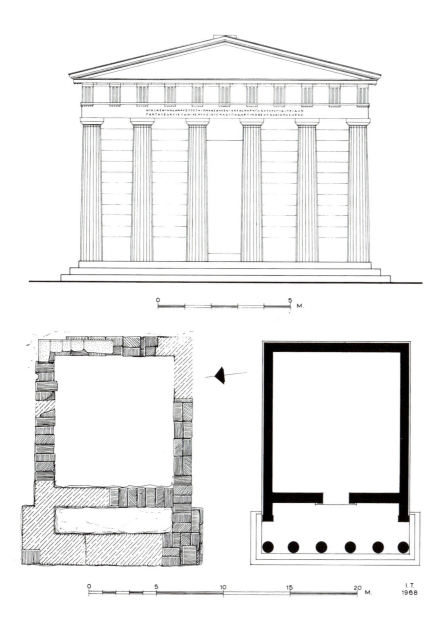

Fig. 212. Restoration and plans of Nikias Monument, 320/19. After Travlos 1971, figs. 459–460. Reproduced by permission of DAI-Zentrale, Berlin, and E. Wasmuth Verlag.

And this kind of classicism did not end with Lykourgos's administration or the Late Classical period. There is solid evidence, for example, that in the late fourth century someone, somewhere, built a replica of the Temple of Athena Nike as a khoregic monument. The design of the Nikias Monument, which had a facade of six Doric columns [Fig. 212], imitated the central block of the Propylaia [Fig. 166]. And the piered facade and even the pilaster-capitals of the Thrasyllos Monument [Fig. 9] were based on features of the Propylaia's southwest wing.[61] Here, then, on the south slope of the Acropolis, the fourth century neared its end with a series of deep, self-conscious bows in the direction of the fifth century, its culture, and the one building that stood out in the popular imagination as the greatest creation of the Periklean golden age: Mnesikles's gateway to the Acropolis. With its past reworked into its present, the Acropolis was becoming – indeed, it had become – a monument to itself.

By the time the Nikias and Thrasyllos Monuments were built, grandiose monuments and nostalgia for times past were about all Athens had left. Lykourgos's last year as *de facto* manager of Athenian affairs was 326; he died two years later. But his economic, military, and cultural reforms had restored the city to such a position of power, wealth, and self-confidence that upon learning of Alexander's own death in 323 the Athenians were ready to act. The temptation to build one last alliance against a "for-

eign" and "barbarian" power proved irresistible, and the popular assembly voted for war with Macedon. The stubborn dream of freedom (which for the Athenians largely meant the freedom to fashion another empire for themselves) soon dissipated in the waters of the Aegean, where Alexander's admiral destroyed the great navy Lykourgos had built, and on the Thessalian battlefield of Krannon, where the Macedonians decisively defeated Athens and her allies (322). The Late Classical period now ended, not with the death of Lykourgos or even of Alexander, but in the months after Krannon, when the Macedonian general Antipater turned Athens into an oligarchy, drove Demosthenes to suicide, and stationed troops in the Peiraieus. Athens still had its monuments and its glorious past, but it had lost its democracy, its freedom, its greatest voice, and control over its own fate. Without them, its Acropolis must have seemed of another, even more distant and irrecoverable age.

THE HELLENISTIC AND ROMAN ACROPOLIS

The Council of the Areiopagos, the Council of the Six Hundred, and the Athenian people [honor]
the Greatest Emperor Nero Caesar Claudius Augustus Germanicus, son of a God, when Tiberius
Claudius Nero, son of Philinos, was Hoplite-General for the eighth time, as well as Epimelete
and Nomothete, and the priestess [of Athena] was Paulina, daughter of Kapito.
Text of gilt bronze inscription (*IG* II² 3277)
added to the Parthenon's east facade in 61/2 AD [Figs. 207, 228].

Bad Signs

In 317 Kassander, Antipater's son and future king of
Macedon, took control of Athens and installed his crony,
Demetrios of Phaleron, as absolute ruler of the city.
Demetrios was a lightweight philosopher but a skilled
orator, and Macedonian troops stationed in the Peiraieus
were all the additional eloquence he needed. Though
personally extravagant and ostentatious, the philosopher-
tyrant banned the short-lived Athenian habit (begun
only in the Lykourgan period) of erecting grandiose
monuments to celebrate khoregic victories and, like
Plato two generations before, attacked the Propylaia (the
inspiration for more than one khoregic monument, Fig.
212) for its sumptuousness. Lykourgan-style classicism
was not to his taste.[1]

In 307 another Demetrios – this one the son of the
powerful Antigonos (another of Alexander's successors)
and a brilliant warrior who would soon earn the nick-
name Poliorketes (the Besieger) – drove Demetrios of
Phaleron from Athens and declared the city free. The
democracy was nominally restored, but the price was
grovelling servility. The Athenians conferred both king-
ship and divinity upon Antigonos and Demetrios, estab-
lished new festivals to worship them, and in their honor
created two new tribes (*Antigonis* and *Demetrias*) to add
to the ancient ten established two centuries before by
Kleisthenes. Gold or gilded portraits of Antigonos and
Demetrios were set up in the Agora near the Tyranni-
cides groups (new "tyranny-killers" to rate with the
old).[2] And, in yet another stroke of wretched excess, the
Athenians had images of both father and son woven into
the *peplos* delivered at the Greater Panathenaia of 306:
the Macedonians were apparently shown fighting giants
right beside the figures of Zeus and Athena themselves.[3]
When Kassander tried to take Athens back in 304,
Demetrios (who had been off fighting and besieging)
came to the rescue once more. And then the Athenians
(though they may in fact have had little choice in the
matter) took one of the most shameful votes in their his-
tory: they approved Demetrios's request that he and his
mistresses be allowed to reside "in the *opisthodomos* of
the Parthenon" (since the Athenians had already deified
him he considered himself Athena's little brother and so
a fitting houseguest). We do not know what happened
to the treasures that may still have been stored in the
opisthodomos (here, at least, that troublesome term surely
denotes the western room of the building [Fig. 128], since

the mighty Demetrios and his band could hardly be expected to spend the winter of 304/3 in a shallow porch partly exposed to the elements).[4] But it would have been entirely in character for Demetrios to use the gold and silver vases of Athena's sacred store as his personal tableware and avail himself of whatever utensils, thrones, and furniture he found suitable. It is no coincidence, then, that the long run of Parthenon inventories, inscribed annually on marble since 434 [cf. Fig. 36], appears to end around the time of his occupation of the building. Treasurers of Athena there may still have been, but since the treasures were in effect no longer under their or the democracy's control, publication of the accounts was pointless and politically unwise (since the items Demetrios expropriated would be conspicuous by their absence).[5] Still, this was not the worst of it. On the Acropolis sexual activity was taboo, yet Demetrios defiled the temple of his virgin "big sister" with wild orgies in which even Athenians took part.[6] The sanctuary had suffered the sacrilege of the Persians in 480/79 and it had seen isolated incidents of vandalism and theft before. But it had never known anything like this calculated, polluting debauchery.

The desecration did not end with Demetrios. In 301 he once again left Athens to do battle elsewhere and civil war broke out in the city. The ultimate winner was Lakhares (an ally of Kassander and thus a natural enemy of Demetrios). Lakhares probably made himself dictator in 295 but he did not dictate for long: the Besieger soon returned and lived up to his nickname. Still, Lakhares's brief reign took a terrible toll upon the Acropolis. According to a variety of ancient sources (and the inferences we draw from them), he plundered Athens of its gold and silver, robbed the gilded shields Alexander had had nailed to the east architrave of the Parthenon [Fig. 207] (patriotic Athenians old enough to remember the lessons of Granikos might not have minded too much), melted down the Golden Nikai that had been restored by Lykourgos, and even stripped the Athena Parthenos [Fig. 132] of its removable gold plates in order to pay his troops – something that the Athenians never did even in the darkest, poorest days of the Peloponnesian War. In short, Lakhares, following the precedent of Demetrios himself, used Athena's treasury as his own personal property (and if the official inventories of the Parthenon treasures had not already ended under Demetrios, they certainly ended now: there are none at all from the third century). As for his supposed denuding of the Athena Parthenos, however, there is some room for doubt. The

language of one ancient source to the effect that "Lakhares stripped the goddess bare" is conceivably metaphorical, meaning only that he deprived Athena of her wealth (as we might say a thief "robbed somebody blind").[7] But for Pausanias, at least, there was nothing metaphorical about it: he says explicitly that Lakhares stripped "the statue of Athena of its removable ornament."[8] And if that is what he did,[9] the chryselephantine image that Pausanias saw and that Hellenistic and Roman artists copied [cf. Figs. 25, 26, 199] was, in its gold if not its ivory parts, basically a third-century restoration[10] – Athena Parthenos the Second. At all events, Lakhares and his men could not eat gold and Demetrios's siege starved the city into submission. The tyrant managed to escape with a considerable sum in his pockets (for which, Pausanias says, he was eventually murdered).[11] In the spring of 294 the Athenians, brutalized by the siege and fearing the worst, gathered in the Theater of Dionysos to receive their once and future lord, Demetrios Poliorketes. Instead of exacting vengeance, however, he announced plans to restore once again what now passed for democracy in Athens. Still, Demetrios's scandalous residence within the Parthenon and Lakhares's plundering of the sanctuary were not auspicious ways for the Hellenistic period to begin on the Acropolis.

More Background

Although the history of Hellenistic and then Roman Athens spanned nearly eight centuries (longer than the Geometric, Archaic, and Classical periods combined), it can be summed up rather briefly. Athens began the era as a functioning city-state and it ended it as provincial town of no importance – a backwater. Sometimes it was a trophy for others (like Kassander and Demetrios) to fight over. Sometimes it was an object of admiration worth wooing with gifts.[12] Sometimes it was a nominally free city. Very often it stooped depressingly low in the direction of foreign powers.

Stooping was often necessary, since Athens was no longer a force to reckon with itself. A minor military power ever since the battle of Krannon, Athens could and did do little on its own initiative in the international arena. Moreover, it showed a remarkable talent for fighting losing battles and choosing the wrong side in the larger Mediterranean conflicts that swirled around it. For example, a romantic quest to free itself of Macedonian rule in 267 by aligning itself with Ptolemaic Egypt ended in defeat and humiliation in 261 (one of the consequences

was, for a brief period, the cancellation of the Greater Panathenaia). In 229 Athens bought off the Macedonians and regained its freedom (and a few years later it established a grandiose new festival in honor of its old friends, the Ptolemies).[13] But at the close of the third century Athens joined the Republic of Rome and its agent in the east, the Hellenistic kingdom of Pergamon, in another struggle with Macedon. In this case Athens chose its friends wisely and Rome won, but not before, in the autumn of 200, the Macedonians mercilessly ravaged the Athenian suburbs and the Attic countryside and destroyed its temples and monuments (the center of Athens itself was spared only because of the arrival of Roman legions). An age of renewed prosperity began in 166 when Rome presented the city with the gift of Delos. And Athenian courtship of Rome is reflected in public sacrifices to the Roman people and in the city's acceptance, sometime before 153, of the goddess Roma herself. It even established a new civic festival in her honor, the *Romaia*: the personification of another people and another city was now regularly worshipped in Athens.[14] But its infatuation with the now unquestioned (and since Rome's annihilation of Corinth in 146 increasingly detested) superpower of the ancient world did not last. In 88 Athenion, yet another philosopher with a tyrannical bent, led an uprising against the local pro-Roman regime, whereupon Athens threw its support to Mithridates, king of Pontos, in his revolt against Rome. The sad result: in 86 the legions of Lucius Cornelius Sulla besieged the city, tore down its walls, pillaged it, and massacred its inhabitants. A small band of defenders of the Acropolis, led now by yet another tyrant, Aristion, burned down the Odeion of Perikles rather than see its great timbers fall into the hands of Sulla's military engineers. But Sulla took his time and Aristion and his men, their position hopeless, eventually surrendered and were executed. In addition to the Odeion, the Asklepieion, the Theater of Dionysos, and other buildings on the slopes of the Acropolis were extensively damaged during the siege. And when (after neutralizing Mithridates in the east) Sulla returned in 84, he took 40 pounds of gold and 600 pounds of silver from the Acropolis, despoiled it and the city of many statues and paintings – an example that future Romans would eagerly follow – and even shipped columns from the still unfinished Temple of Olympian Zeus back to Rome. But as bad as Sulla was, the buildings atop the Acropolis – the Parthenon, the Propylaia, the Erechtheion, and the rest – apparently survived his visits more or less intact.[15]

Even with a pro-Roman government restored in Athens – just how pro-Roman is suggested by its invention of yet another festival, the *Sylleia*, to honor Sulla the destroyer – recovery was slow.[16] Pompey, passing through in 62, tried to make amends (and win Athenian support in his rivalry with Julius Caesar) by giving the city fifty talents ear-marked for restoration.[17] A decade later, Caesar called Pompey's donation with fifty talents of his own (the Athenians planned to used it to built a new market north of the Acropolis, though this so-called "Roman Agora" [Fig. 2] was not constructed until later). But in the civil wars fought by these and other Roman giants the Athenians habitually sided with the loser and suffered greatly for it. Having favored Pompey, Attica was once again laid waste before Caesar's decisive victory in 48. Caesar, who owed the Athenians nothing, let them off the hook with the pointed admonition that they would not always be able to depend upon the glory of their ancestors to save them from self-destruction.[18] But the Athenians did not heed his warning and in 44, in an almost knee-jerk reaction to Caesar's assassination, they sided with the conspirators Brutus and Cassius – two more "tyrant-slayers" to rank beside Harmodios and Aristogeiton[19] – against Octavian and Mark Antony (the first was Caesar's stepson and the future Augustus, the second Caesar's lieutenant). Naturally, Brutus and Cassius lost. Athens then supported Antony against Octavian in their struggle for control of the Roman world. Antony seems to have genuinely loved the city and headquartered there in the early 30s, and Athens ostensibly loved him right back. He styled himself as the "New Dionysos," and the Athenians may even have rededicated an earlier statue to him in that incarnation atop the south wall of the Acropolis.[20] Moreover, the city that had treated Demetrios Poliorketes like Athena's little brother now is said to have arranged for Antony to "marry" the goddess, impoverishing itself in the process by supplying a dowry of 1,000 talents.[21] Needless to say, none of this helped: Antony (and with him Kleopatra) lost to Octavian and his right-hand man Marcus Agrippa at Actium in 31.

Octavian thereupon visited Athens for the first time and, like Caesar before him, was magnaminous in victory. Still, even after Octavian became Augustus and the Roman Republic officially an Empire (in 27), Athens – or at least some Athenians – could still be unwisely and unnecessarily provocative. There is a story that just before Augustus visited the city for the second time in the winter of 22/21, a statue of Athena on the Acropolis

(probably the old, wooden, and portable Athena Polias) turned around to face west (that is, toward Rome) instead of east and spat blood. Whether this was a miracle or a symbolic protest staged by anti-Roman partisans, Augustus was not amused. For this and other slights (real or perceived) he punished Athens by depriving it of revenue-producing territories and by banning the lucrative practice of selling Athenian citizenship to wealthy foreigners: the Athenian economy thus took yet another hard hit.[22]

But the Athenocentric perspective in this litany of bad luck and bad choices is distorting, for while Sulla, Pompey, Caesar, Brutus, Antony, Agrippa, and Augustus loomed large on the narrow Athenian political stage, Athens played a relatively small role on their far wider one. While its stock rose considerably from time to time – Augustus did not hold a grudge and visited once again in 19 (this time, as we shall see, to a much warmer reception) – Athens owed its status in Hellenistic and Roman times less to any inherent strategic value or political importance than to the high regard in which it was held by generals and rulers who appreciated ancient history and the eternal symbolism of its role in the Persian Wars. Those by now nearly legendary struggles became appropriate prefigurations for new campaigns against "barbarians" and eastern kingdoms, just as Classical Athenians had found mythological justifications for their victories in the battles of gods against the giants and Greeks against the Amazons. Antony, for example, implicitly acknowledged the Nike-theme of the Acropolis and its artistic assertions of the superiority of west over east when he took a garland from Athena's sacred olive tree and water from the Klepsydra fountain as good luck charms upon setting off to do battle with the Parthians in 36 (he lost anyway).[23] Hellenistic and Roman Athens, in other words, still held the Persian card and, always heedless of Caesar's warning, sometimes played it skillfully.

Through it all, Hellenistic and Roman Athens retained its position as the cultural center of the Mediterranean world. No longer militarily or strategically significant, Athens's intellectual and artistic authority, the weight of its heritage, was nonetheless unmatched (even with the emergence of other flourishing centers of cultural power at such places as Alexandria). As the home of the ancient world's dominant philosophical schools – the Stoa, the Akademy, the Lykeion, the Garden – Athens was antiquity's greatest "university town," and its philosophers and teachers (Zeno, Karneades, Arkesilaos, Theophrastos, Epicurus, and their followers)

and their intellectual and ethical systems (such as Stoicism, Skepticism, Epicureanism) influenced and guided educated men throughout the Mediterranean. The ruling élites of the Hellenistic and Roman periods sent their sons to Athens to learn music, philosophy, literature, and rhetoric: Perikles's metaphorical School of Hellas thus literally became a school to the world. And with its renowned monuments (the Propylaia, the Parthenon, the Erechtheion, the Theater of Dionysos, and all the other marble, bronze, and chryselephantine productions of its glorious past) Athens remained the greatest physical expression – the venerable epitome – of Hellenism and thus of civilization itself.

As such it was not only the alma mater of privileged international youth but was also a principal stop on antiquity's version of the Grand Tour. The long list of princes, poets, literati, politicians, and generals who went to Athens not on official business but to study or just to see the sights includes: the future kings Attalos II of Pergamon and Ariarathes V of Cappadocia (who were fellow pupils of Karneades), and Antiochos IV (Epiphanes) of Syria; the Roman statesman Cicero (who in his twenties studied philosophy there and later stressed his fondness for the city, noting also that foreigners were captivated by the very power of Athens's name);[24] the poets Horace (author of the famous line "captive Greece captured its wild captor and brought the arts to rustic Latium"),[25] Vergil (who met up with Augustus in Athens in 19, shortly before his own death), Ovid and Propertius; the novelist Apuleius; the polymath Aulus Gellius; and the philosopher and biographer Plutarch; not to mention geographers like Strabo or tour-guide writers like Pausanias or itinerant lecturers like P. Aelius Aristides (whose *Panathenaic Oration*, delivered around 167 AD, is perhaps the last great, if flawed, statement of Athenocentrism, made though it was by a native of Asia Minor).[26] Still others – the good Roman emperor Marcus Aurelius and his evil son Commodus, for example – visited Athens on their way to initiation in the Eleusinian Mysteries, while Septimius Severus, a decade before becoming emperor, was forced to retire from active service and used attendance at lectures and the study of antiquities at Athens as a pretext.

The Idea of the Acropolis

Athens's power, in short, lay in its prestige. Its prestige resided in its history, schools, and cults, but also in its monuments, artifacts, and images, especially those on the

Acropolis [Fig. 4]. Of course, not every one treated the citadel well and, following Sullan precedent, Romans in particular had the habit of robbing it (and the wider city) of its treasures. Not long after Sulla made off with his 640 pounds of Acropolis silver and gold, for example, Verres (who would later infamously empty Sicily of its art and wealth) absconded with a huge amount of gold from the "temple of Minerva" in Athens (probably meaning the Parthenon rather than the Erechtheion).[27] A century later, the Roman emperor Gaius (Caligula) had at least seven statues removed from the Acropolis for his own use. Later still, the Athenians tried (how successfully we do not know) to prevent Nero's agent from seizing statues for his master, and no doubt they often had to defend the Acropolis from such imperial procurers.[28] Greed certainly drove the periodic despoliation of the still-rich Acropolis. But perhaps, too, there was a somewhat more forgiveable motive: a passionate desire to acquire the outward forms of good taste. And that sometimes meant the replication of Acropolis imagery when the originals themselves could not be had. In the second century AD, for example, a marble workshop in Athens busily churned out full-scale relief copies of excerpts from the Amazonomachy on the shield of the Athena Parthenos [Fig. 161]: a ship carrying at least twenty of these reliefs, probably intended for the Italian market, went down before getting very far out of the Peiraieus [Fig. 27].[29]

More important than imports or copies, however, was the very *idea* of Athens and the Acropolis – a valuable commodity for *parvenu* princes, generals, kings, and emperors wise enough to know that political legitimacy can be a product of cultural authority as well as military strength or dynastic right. Hellenistic kings and Roman emperors essentially employed two tactics (neither one of them particularly surprising or subtle) to insert the glorious idea of Athens into their royal or imperial image and so argue for their own cultural power. Either they could reproduce or allude to Athenian monuments in the statuary and architecture of their own capitals, thus remaking their cityscapes in the likeness of an idealized Classical Athens, or they could enrich Athens itself with new buildings or dedications, engaging one another in a kind of competition for the city's affections and posing as benefactors to rank beside Perikles or Lykourgos. Either way, they laid claim to the Athenian mantle by proposing an equation between themselves and the bright lights of the Classical "Golden Age."

The outstanding practitioners of both tactics were Hellenistic Pergamon and early imperial Rome. Perga-mon was a wealthy if at first small kingdom carved out of western Asia Minor in the early third century. Its first great claim to international fame was King Attalos I's victory, in 233, over a maurauding Celtic people known as the Gauls. In the early 220s, the Gauls threatened again and (with the aid of the Seleukids, a rival Macedonian dynasty that ruled Syria and other parts of Asia) attacked the steep and heavily fortified acropolis of Pergamon itself. The parallel with the Persian attack on the Athenian Acropolis in 480 was perhaps all too obvious to its defenders, but this time the barbarians failed to take the prize, and Attalos delivered the Gauls a decisive blow and (briefly) conquered extensive Seleukid territories in the process. Over the next 75 years Attalos and his successors turned their acropolis into a self-conscious display of Greekness to rival, if not supercede, the Athenian. For example, as part of a complex of monuments commemorating Attalos's victories over the Gauls and the Seleukids, a colossal version of Pheidias's colossal Bronze Athena (Promakhos) was very likely placed in the open on a round base in the sanctuary of the Pergamene patron goddess Athena Polias Nikephoros (Athena of the City, Bringer of Victory), herself seemingly a conflation of Acropolis Athenas, a goddess who was even honored in a quadrennial festival analogous to the Greater Panathenaia.[30] At all events, the Pergamene Athena Promakhos expropriated the rhetoric of the original: Attalos's heroic struggle against his enemies was equated with the hallowed Athenian struggle against the Persians. And this was not the only reincarnation of an image from the Classical Acropolis to be set up on the Pergamene citadel. A free copy of Alkamenes' Prokne and Itys [cf. Fig. 178] stood there, too.[31] And in a kind of building the Athenian Acropolis never knew – a library, second in the ancient world only to Alexandria's – there stood a loose version of the chryselephantine Athena Parthenos [Fig. 199], set up perhaps in the 180s during the reign of Attalos' son and successor Eumenes II. The Pergamene Athena is only a third the height of the Pheidian original (though it stands over 3m tall as it is), and it is marble rather than gold and ivory. But the stone was quarried on Mt. Pentelikon and the material thus enhanced the spiritual connection with Athens (in fact, the sculptor may have blocked out the statue in Attica, finishing it only upon his return to Pergamon). In any case, the Pergamene Athena Parthenos, surrounded by perhaps two hundred thousand scrolls preserving much of the literary production of ancient Greece, was (in A. Stewart's apt phrase) a "monument to culture, not

cult."³² And since a major percentage of those scrolls would have contained the works of Aeschylus, Sophocles, Euripides, Aristophanes, Thucydides, Plato, Aristotle, Demosthenes, Menander and so on, the Pergamene Athena would have been a monument to – and a symbol of – Athenian culture in particular. Now, as we have suggested, even the original Athena Parthenos was not an object of worship; still, it was a dedication, a sacred object. This Hellenistic Athena Parthenos was not even that. It was, instead, an ornament, an interior decoration meant to establish a properly classicizing mood in a "secular temple" devoted not to the gods but to a vast repository of texts – to the intellectual heritage of Athens and Greece. Finally, the greatest of all Pergamene monuments, the so-called Great Altar of Zeus (initiated by Eumenes II around 180), was decorated with a colossal frieze that not only repeated the tried-and-true Acropolis theme of the Gigantomachy – the cloaked reference here is, once again, to new Pergamene victories over the Gauls, with additional allusions to recent struggles with neighboring Bithynia, Pontos, and Seleukid Syria – but also fairly brimmed with quotations of the sculptures of the Parthenon itself. The powerfully diagonal figure of Zeus [Fig. 213] was clearly inspired by the Poseidon of the west pediment [Figs. 141, 143]; the Nike crowning Athena as she dispatches a pathetic giant [Fig. 214] was possibly inspired by the Nike on east metope 4 [Fig. 137]; the nearly frontal figure of Apollo, his cloak falling over his left arm behind him [Fig. 215], has as its model the majestic Lapith of south metope 27 [Fig. 138]; and so on. The sculptors of the Great Altar had done their homework. In short, the Attalids, by blatantly emulating some of the Acropolis's most familiar monuments, promoted their city as a "New Athens." They declared it the logical and rightful heir to the mantle of Hellenism and the new champion of civilization (meaning Greece) against barbarity (meaning just about everyone else). Through sculpture they thus expressed both their veneration of ancient Athens and their assumption of its ancient mission.

References to Athens and the Acropolis were also to be found in the capital of the Roman Empire, and not least of these was the pervasive use of marble itself. When Augustus boasted that he found Rome a city of brick but left it a city of marble,³³ he was really saying that he had left his capital looking more like – and better able to withstand comparisons with – the acknowledged cultural center of his empire, the ancient city where so many Romans went to study and see the marble sights.

Even when Augustus's massive beautification projects did not imitate the gleaming white monuments of the Acropolis, they emulated them. The influence Athens exerted here (as at Pergamon) was an influence born of cultural pressure, of the need to compete with and overcome a mighty cultural precursor. Architects and artisans in Augustus' employ had, in fact, an unusual opportunity to study a major Acropolis building in extraordinary detail, and the lessons had a powerful impact upon the monuments of Rome itself. Around 27 the Erechtheion, then almost four centuries old and damaged by a severe fire [Fig. 173], underwent massive renovations and revisions.³⁴ The west wall was almost entirely rebuilt and windows were now set between the engaged Ionic columns [Fig. 175]; the north door was reworked [Fig. 176]; architrave blocks were removed and replaced; the roof (which had apparently collapsed) was repaired; and new or replacement figures (such as a seated Apollo, a god especially linked with Augustus) were added to the frieze [Fig. 179]. By the time the project was complete, the Erechtheion was, structurally, as much Imperial Roman as it was Classical Athenian. We do not know who financed these repairs: the expense was so great that only Augustus himself (or else Marcus Agrippa) makes sense as a candidate. But Athenian builders and masons did the work, and the Romans put their experience to good use back in Rome. When Agrippa built a Temple to All the Gods (the original Pantheon) in the Campus Martius between 27 and 25, he imported an Athenian sculptor named Diogenes to carve its sculptures, including marble Karyatids that were possibly inspired by the Erechtheion's (casts may been taken during the renovations and shipped back to Rome).³⁵ There is no question that scores of Karyatids – exact (though reduced scale) copies of the Acropolis originals – stood in the upper level of the colonnades lining the magnificent marble-veneered Forum of Augustus built between 37 and 2 [Fig. 216], or that certain architectural details in the Forum (profiles of column bases, Ionic column capitals) replicated features of the Propylaia as well as the Erechtheion. Even the new Forum's Temple of Mars Ultor (Avenger) may, with its octastyle porch and relatively low pediment, have alluded to the wide facades of the Parthenon, just as the cult statue of Mars, which wore a helmet adorned sphinxes and *pegasoi*, "cited" the Athena Parthenos.³⁶ In the light of all these eclectic quotations of and references to the monuments of the Acropolis, it is suggestive that, according to Ovid (who had toured both sites), the

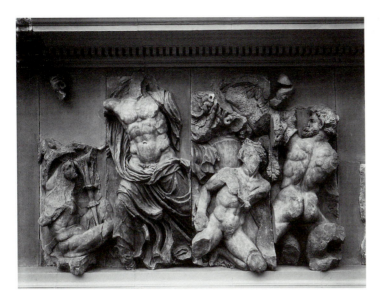

Fig. 213. Zeus fighting Giants, east frieze, Great Altar of Pergamon, c. 160. Courtesy Antikensammlung, Staatliche Museen zu Berlin, Preussischer Kulturbesitz.

Fig. 214. Alkyoneus, Athena, Ge, and Nike, east frieze, Great Altar of Pergamon, c. 160. Courtesy Antikensammlung, Staatliche Museen zu Berlin, Preussischer Kulturbesitz.

Fig. 215. Leto and Apollo fighting Giants, east frieze, Great Altar of Pergamon, c. 160. Courtesy Antikensammlung, Staatliche Museen zu Berlin, Preussischer Kulturbesitz.

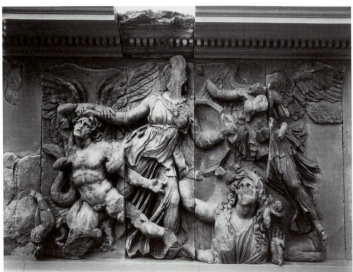

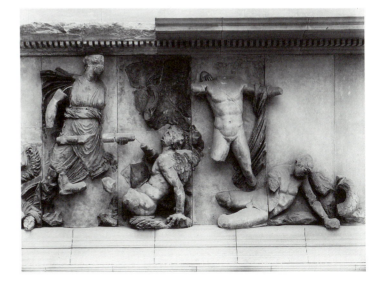

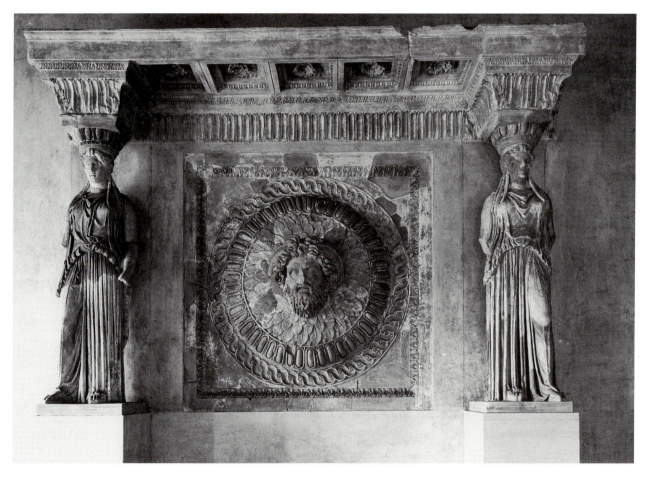

Fig. 216. Replicas of Erechtheion Karyatids, Forum of Augustus, Rome, 37–2. Courtesy Deutschen Archäologischen Instituts-Rome (Neg. 61.1059).

Forum of Augustus would have made a fitting monument to the victory of the gods over the giants – the battle that was at the center of Acropolis iconography.[37] And Augustan Rome's "Acropolisness" did not end there. On the north and south sides of the Altar of the Augustan Peace [Fig. 217], the finest sculptured monument of the era, a bifurcated or split-stream sacrificial procession consisting of the major participants in the pageant of Augustan Rome (the emperor himself and his family, Agrippa, magistrates, senators, and so on) played off against the anonymous split procession of the Parthenon frieze [Figs. 147, 158]. The historical replaces the ideal, the particular the generic, the time-bound the timeless – in short, the Roman the Greek. And that notion was near the core of Augustan ideology. For if Augustus commonly cited the monuments of Acropolis in the fabric of his own renewed city, it was not merely to imitate

or honor Athens: it was to transcend it, to argue that Rome had succeeded Athens as defender of civilization.[38] And this point was made in hot public performance as well as in cold marble. To mark the dedication of his new Forum in the year 2, Augustus staged a mock sea-battle in a specially built arena across the Tiber (the contest involved over thirty large ships and over 3,000 men, not counting rowers). This was entertainment for the masses, a gladiatorial show on water. But it was also highly charged political theater, for the event was, we are told, a re-enactment of the Battle of Salamis. That is, Augustus expropriated the symbolism of the Athenian victory over the Persians for his own purposes: it was to cite a noble precedent for and to confer a venerable legitimacy upon his own campaigns and ambitions in the east, specifically against the troublesome kingdom of Parthia, whose borders were more or less coterminous with those of ancient Persia, and which was to Rome what Persia had been to Classical Athens – a nearly constant eastern threat.[39]

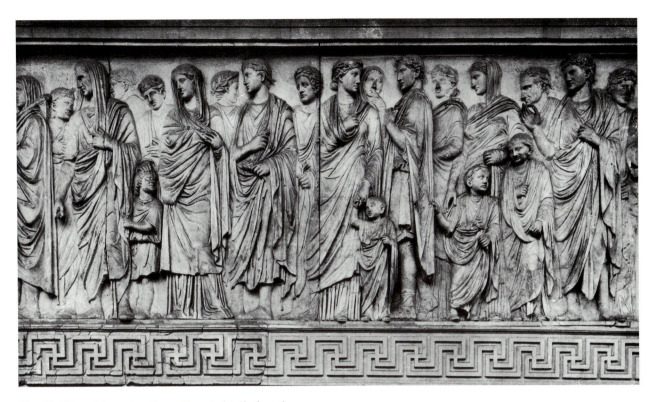

Fig. 217. Altar of Augustan Peace (Rome), detail of south frieze (Agrippa is the tall male figure at left). Courtesy Deutschen Archäologischen Instituts-Rome (Neg. 72.2403).

As at Pergamon, then, so at Rome: the idea of the Acropolis insinuated itself into the fabric of both those distant cities. And by quoting or emulating Acropolis forms or (in the case of Augustus) actually refighting Athenian victories, the rulers and makers of Pergamon and Rome created theaters for the display of their worthy commitment to the legacy of Hellenism. By posing as its new heroes, they accrued the cultural power that the very idea of Athens bestowed.

Pergamon and Rome on the Acropolis

If recollections of the Classical Acropolis marked both Hellenistic Pergamon and Imperial Rome, the impact of Pergamon and Rome was even more powerfully felt upon the Acropolis. Until the end of the third century, with only a few exceptions, the most spectacular works of art and architecture dedicated on the Acropolis had always been products of Athenians or of Athenian initiatives: the Acropolis was a place for *Athenian* display. In the Hellenistic and Roman periods, this was no longer

entirely true. Though the majority of new monuments were still Athenian ones, the summit and slopes of the Acropolis were heavily marked by monuments financed and dedicated by foreign rulers employing the tactic of the beneficent gift to court the aging but still handsome city and earn its blessing. For the most part, the Athenians seem to have enjoyed the attention and they came to rely upon the kindness of others for the embellishment and physical health of their citadel. Still, there was a price to be paid. The Acropolis was no longer a field solely for the expression of Athenian ideology and belief; on occasion the Athenians yielded it up, like a billboard, to the promotion of others.

The long list of foreign benefactors to the Acropolis begins with Attalos I of Pergamon. In 200 (when Pergamon and Athens were separately entreating Rome to aid them against Macedon) the Athenians invited Attalos to visit the city. His motive for going was more to consult with Roman legates in the Peiraieus than to court the Athenians, but he was still greeted by an extraordinary (and apparently genuine) display of affection when he reached the Dipylon Gate. The entire Athenian citizenry came out to meet and cheer him; priestesses and priests lined the Panathenaic Way; the temples were thrown open; sacrifices were prepared. The festivities concluded

269

with the Athenians naming a tribe after him and adding his name to the list of Eponymous Heroes. For his part, he reminded them of the many favors he had conferred upon them, and in return asked for their military support.[40]

Attalos did not specify what his past benefactions were.[41] But one of them was probably an unusually elaborate dedication set southeast of the Parthenon near or against the south citadel wall [Fig. 3]. This was a large group of half-life-size bronze figures representing dead, dying, or struggling giants, Amazons, Persians, and Gauls – the defeated enemies of the gods, of legendary Athenians, of real Athenians, and of the Pergamenes themselves.[42] The monument (called the Smaller Attalid Group to distinguish it from a group of larger statues at Pergamon itself) is known from Pausanias's brief description and from over twenty Roman copies in marble [Figs. 218, 219]. It is unlikely that any victors were included in the monument – the numbers of winners and losers would have been almost impossibly large – and so the theatrical Hellenistic work differed markedly from the battles still raging on and within the Parthenon nearby. Still, there were probably dozens of figures, though we have no clear idea how they were arranged. They might all have been placed on one very long base: that would have been typical. But perhaps the figures were set directly (and more dramatically) upon the

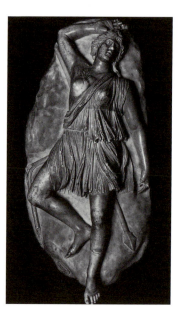

Fig. 218. Dead Amazon (Roman copy) from Smaller Attalid Group (Naples 6012). Courtesy Soprintendenza Archeologica delle Province di Napoli e Caserta.

Fig. 219. Four figures (Roman copies, partly restored) from the Smaller Attalid Group, c. 200. Clockwise from bottom left: dead Persian, dying Gaul, dead Giant, and dead Amazon. Museo Archeologico Nazionale, Naples. Photo: Brogi 5270. Alinari/Art Resource, NY.

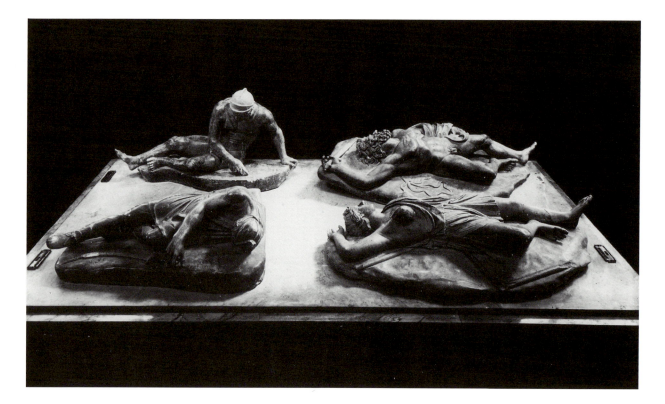

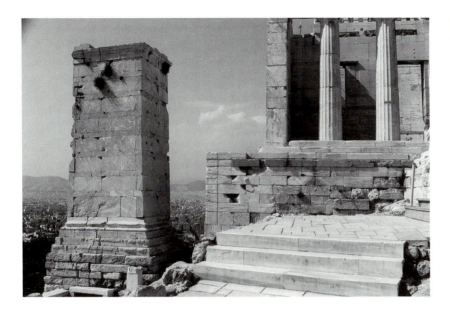

Fig. 220. Monument of Eumenes II (later rededicated to Marcus Agrippa), probably after 178. Photo: author.

Acropolis ground, so that the visitor would have made his way through them as if through a mytho-historical battlefield strewn with the justly conquered foes of civilization. At any rate, with this monument Attalos placed his defeat of the Gauls in venerable company and thus elevated himself to the level of giant-, Amazon-, and Persian-slayers, forcibly co-opting the imagery of the Parthenon. Not only did a Gigantomachy loom in the Parthenon's east metopes just to the northwest [Figs. 136, 207], but one Attalid Amazon even seems to have been modelled on a dead Amazon at the bottom of the shield of Athena Parthenos [Figs. 218, 161].[43] The quotations and their purpose were transparent: Attalos enlisted Hellenistic Pergamon in the same eternal struggle fought by gods, heroes, and Classical Athenians. That is, the full meaning of the Attalid Monument was revealed only in relation to the Parthenon, and in turn the Parthenon itself acquired a new dimension. For just as in the fifth-century Amazomachies and Gigantomachies and all the rest were considered mythical prefigurations of the Persian Wars, so now the battles depicted on the Parthenon would have seemed to prefigure Attalos's Gallic Wars: Athens, through the Parthenon, promised Pergamon.[44] The dialogue between the two monuments was thus loud and clear, and it proclaimed Attalos and Pergamon worthy heirs of Perikles and Athens – the same message being shaped back home atop the citadel of Pergamon itself. If the Smaller Attalid Group had indeed been dedicated on the Acropolis at or before the time of Attalos's state visit to Athens in 200, one reason he was welcomed to such

acclaim may have been that the new monument had already done its job. It had convinced the Athenians themselves that Pergamon and its king were the mighty new champions of their culture and heritage, the new end toward which Hellenism had been laboring.[45]

In the next century, too, the most spectacular additions to the Acropolis were Attalid works. At the Greater Panathenaia of 178 (or possibly the games of 182 or 186), all four sons of the now-deceased Attalos I entered various equestrian events and all four won.[46] To commemorate their individual victories, the brothers Eumenes II (king since 197) and the future Attalos II (159–138) erected grandiose monuments at two very prominent locations on the citadel. On a terrace below the northwest wing of the Propylaia (the Pinakotheke) and on almost the same line as the Temple of Athena Nike, which it formally balanced, Eumenes built a nearly nine-meter-tall, slightly tapering pillar of grey Hymettian marble to support a bronze four-horse chariot with charioteer or youths standing by its side [Fig. 3, no. 3; Fig. 220].[47] Obviously, no one approaching the entrance to the Acropolis could miss it and it would have seemed a preface to the ancient "victory text" to be found in all its complexity within the gates. Like its complement, the Nike temple across the way, it was another (if far more specific) architectural and sculptural statement of victory projecting from the west slope toward the city. A similar tower, again crowned by a bronze chariot flanked by standing youths, was built in honor of Attalos II at the northeast corner of the Parthenon itself [Fig. 221].[48] Built

Fig. 221. Reconstruction of Attalid Monument, northeast corner of Parthenon, probably after 178. Drawing by M. Korres, used by permission.

Fig. 222. The Stoa of Eumenes II, c. 197–159. Photo: author.

flush against the east steps and reaching nearly as high as the columns of the Parthenon itself, the monument obstructed the view of anyone negotiating that corner of the building, momentarily hiding at least the northernmost metopes of the Gigantomachy, particularly east 14, with Helios rising in his four horse chariot [cf. Fig. 133]. It may be that the eclipse of the divine chariot by the Attalid one was intentional (given the location it was certainly unavoidable). But there is no question that this Hellenistic victory monument would have seemed to crowd the Periklean, heavy-handedly inserting itself into the "plot" of victory – both the narrative and the field of victory – that now extended from the east facade of the Parthenon itself south to the battle monument of Attalos I.

The Attalids did not ignore the slopes of the Acropolis, either. Eumenes II spectacularly defined the south slope (which for most of its length west of the Asklepieion had been undistinguished) with a huge new stoa some 163 meters long, nearly 18 meters deep, and two storeys high, stretching from the Nikias Monument west of the Theater of Dionysos [Fig. 3, no. 27; Fig. 222].[49] Today its most conspicuous feature is one that would originally have been hidden from view: its massive back retaining wall, reinforced with arched buttresses to withstand the weight and pressure of the earth of the slope behind. The stoa was built primarily to provide storage for stage equipment and shelter for theatergoers, but it also faced onto a broad, pleasant terrace of its own and may have served more mundane functions in every-

day Athenian life. Certainly, it was well integrated into the flow pattern of those entering and exiting the Theater of Dionysos. The south branch of the peripatos, leading into the upper sections of the theater, ran above and behind the stoa, and its lower colonnade was within easy reach of spectators leaving the theater via the orchestra. Stairways at the ends of the stoa provided access to the various levels. Architecturally, the Stoa of Eumenes was very similar to the smaller and more commercial stoa built along the east side of the Agora by Attalos II [Fig. 2] to express his appreciation to Athens for his college days there (much as grateful alumni donate buildings to their alma maters today, though without the tax advantages), and it is possible that the two brothers used the same architect for both stoas.[50]

The Attalids were hardly the only foreign rulers to adorn or improve the Acropolis, and they may even have faced some stiff competition for the favor of the Athenians. Pausanias twice mentions a gilt-bronze *aigis* with the head of Medousa, or gorgoneion, at its center, placed high on the south wall of the Acropolis above the Theater of Dionysos [Figs. 4, 9].[51] As we have seen, Medousa (or her disembodied head) had long been an important leitmotif in the iconography of the Acropolis: bronze and marble Medousas had adorned its earliest temples [Figs. 70, 78]; gorgoneia decorated the aigises and shields of many Athenas standing or seated on the summit, including the Parthenos [Figs. 25, 161]; Myron's statue of Perseus, located just within the Propylaia, probably held one aloft in his hand; and it may be that a gilded gorgoneion adorned the south wall of the Acropolis even in Euripides's day.[52] But it is now generally agreed that the gorgoneion Pausanias saw was an early Hellenistic creation (though perhaps a replacement for a fifth-century original) and that the so-called Medousa Rondanini is a Roman marble copy of it [Fig. 223]: its twice-life-size scale is a tip-off, and so is the markedly downward tilt of its head (its model was clearly meant to be seen from below).[53] Details (the way the locks of hair are carved, for example) give away the Hellenistic date of the original, but the overall style is nonetheless classicizing. This gigantic face, glaring down apotropaically upon the city of Athens with an open, as if shrieking, mouth, was intended to blend in with the fifth-century monuments and styles that still dominated the citadel.

Now, Pausanias also says (twice) that the golden gorgoneion was dedicated by Antiochos and, though he neglects to say which one (there were lots), this must have been either Antiochos III, king of Seleukid Syria

Fig. 223. The so-called Medousa Rondanini. Courtesy Staatliche Antikensammlungen, Glyptothek München.

(223–187), or his youngest son, Antiochos IV (175–164), dubbed Epiphanes. The gorgoneion was in either case a fitting choice, since it not only was one of the oldest attributes of Athena and her Acropolis but was also the dynastic emblem of the Seleukids – their family crest. Antiochos Epiphanes is certainly a good candidate for the donor of the Acropolis gorgoneion. He was intensely committed to Athens; he had visited there before ascending the throne; once on it he ordered a copy of the Athena Parthenos for his capital at Antioch; and one of his earliest acts (in 174) was to hire a Roman architect (Cossutius) to resume work on the gigantic Temple of Olympian Zeus southeast of the Acropolis [Fig. 2], which had been left conspicuously unfinished since the original initiator of the project, the Peisistratid tyrant Hippias, was expelled 336 years before.[54] Moreover, as king he minted coins decorated with the gorgoneion and *aigis*, almost certainly a reference to the Acropolis dedication. Still, that only means he knew of the gorgoneion, and the archaeological evidence (which consists primar-

ily of reflections of the original in late third-century ceramics from Crete, of all places) just barely tilts in favor of his father, Antiochos III, instead. In that case, the occasion for the golden gift would most likely have been the king's successful military campaigns against Parthia and Bactria (212–206): that is, the Medousa was probably dedicated on the Acropolis to commemorate yet another victory of Hellenism over Asian barbarians – another variation on the Parthenon theme. And if that is so, its location was politically charged, for a position on the south wall above the Theater of Dionysos would place the gorgoneion – the badge of the Seleukid kingdom – directly below the Smaller Attalid Group [Figs. 218, 219], with its collection of the defeated foes of civilization (some perhaps just visible above the top of the wall) and its references to Pergamon's victories over the Gauls and, implicitly, the Seleukids themselves – victories won just a few years before Antiochos III became king. It is impossible to say which monument – the Pergamene (datable sometime between 220 and 200) or the Seleukid (created after 206) – came first; they could conceivably have been made simultaneously. But it is impossible to avoid the conclusion that Attalos I and Antiochos III used the Acropolis not merely as a place to display their cultural credentials but also as their political duelling ground, that their expensive dedications were the continuation of warfare by other means, and that their weapons of choice in the contest for the hearts and minds of the Athenians (and for the title Champion of Hellas) were magnificent and dramatically situated works of art.[55]

The construction of the Stoa of Eumenes [Fig. 222] ended the flurry of Attalid and Seleukid activity on the Acropolis and its slopes. After the middle of the second century, in fact, the impact of foreign rulers upon the citadel was only intermittent. Toward the middle of the first century Ariobarzanes II Philopater, king of Cappadocia (c. 63–52), rebuilt the Odeion of Perikles, destroyed by the Athenians themselves during Sulla's siege [Fig. 190]. The city of Athens was apparently too poor to undertake the massive job itself, and it is a sign of how far Athens had fallen that one of the major elements of the Periklean building program – indeed, one of the largest of all Athenian buildings – had to be rebuilt by a relatively minor foreign potentate (who hired two architects from Rome to do the job at that).[56]

Perhaps surprisingly, Roman emperors, with only one or two exceptions, seem to have left the summit of the Acropolis pretty much alone. Augustus and Agrippa were very active in the lower city. Augustus, for example, restored a variety of monuments that had fallen into disrepair. He built or finished the "Roman Agora" planned by Caesar. He apparently moved a Temple of Ares from a spot in the Attic countryside to the center of the Athenian Agora; nearby Agrippa built a new Odeion (c. 15) to accommodate performances and philosophical lectures (together, these benefactions plugged up the civic space of the old democratic city [Fig. 2] and so discouraged open assembly). Augustus may also have been behind the construction of a new propylon and the small south stoa of the Asklepieion [Fig. 193].[57] But with the exception of the comprehensive renovation of the Erechtheion around 27, imperfectly understood repairs to the east pediment of the Parthenon presumably undertaken at around the same time, and possibly a restoration of the base of the Bronze Athena (Promakhos) [Fig. 123],[58] Augustus carried out no new initiatives atop the Acropolis itself. The only major Augustan addition to the summit was (as we shall see) in his honor, but it was not his. It is as if the emperor did not wish to tamper with the composition of the sanctuary by inserting new monuments of his own. The idea of the Classical Acropolis was now powerful enough to both demand restoration and resist fundamental change.

For a hundred years after Augustus – years of economic stagnation if not decline in Athens – no Roman emperor showed any real interest in the city or its Acropolis.[59] A minor exception was Caligula (37–41 AD), whose interest the Acropolis could have done without (he robbed it of statuary). A major exception was Claudius (41–54 AD), who not only restored the statues Caligula had stolen[60] but was also the only post-Augustan emperor known to have funded a significant project on the citadel. Apparently early in his reign Claudius endowed a massive renovation of the approach to the Acropolis, replacing the old (and never quite finished) Classical ramp leading up the Propylaia with a broad flight of marble steps (and possibly repaving parts of the Panathenaic Way down below as well).[61] But Claudius is still the odd emperor out. And not even Hadrian (117–138 AD), who ended a century of imperial neglect with frequent visits and an enormous investment of funds and who adorned his own villa at Tivoli with yet more copies of the Erechtheion Karyatids – not even Hadrian left any certain mark on the summit of the Acropolis.

Hadrian's relationship with Athens – the cradle of the Hellenism to which he was so deeply committed[62] – was of long standing (he became an Athenian citizen and was

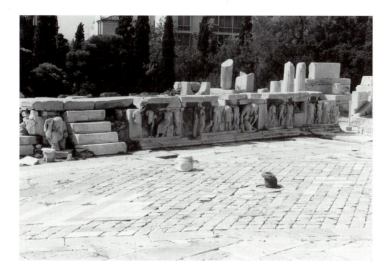

Fig. 224. The so-called Bema of Phaidros (5th c. AD) in the Theater of Dionysos, with re-used sculptures of the Hadrianic era. Photo: author.

even elected archon in 112 AD). His benefactions to the city once he became emperor were profound. Not only did he guarantee it a permanent grain supply and a fresh supply of water,[63] make it the administrative and religious center of a new league of Greek cities known as the Panhellenion (in 131/2 AD), and found three new international festivals that, together with an improved Panathenaia, made Athens the *Agon* Capital of the World, but he also essentially reoriented the old, densely settled city around new carefully plotted (and very Roman) centers of architectural order.[64] At the northeast corner of the Classical Agora [Fig. 2] he built a large basilica, probably for the use of officials appointed by Rome to manage the relations between Athens and the empire.[65] Further east, to the north of the Roman Agora, he built his library (with its vast porticoed court, exedrae, and rooms full of statues and paintings, it was more of a forum than a book repository).[66] And fifty meters further east, yet clearly aligned with both the Roman Agora and the library, he built a triple-naved building of mammoth proportions – it was larger than the Parthenon. This great edifice is often thought to have been the Temple to All the Gods (or Pantheon) twice mentioned by Pausanias (where, incidentally, an inscribed list of Hadrian's many gifts to Athens and Greece could be found). But it has recently been suggested that the building was not a temple at all, but a vast basilica used as the meeting-place for the representatives of the Panhellenion. Whatever it was, it, along with the Roman Agora and the Library of Hadrian, now defined the center of the imperial city: the old Classical Agora to the west was becoming something of a relic, an archaeological site [Fig. 2].[67] Another focus

of activity was located southeast of the Acropolis – "New Athens" – where Hadrian, at enormous expense, finally finished (in 131/2 AD) the twice-aborted Olympieion (the temple boasted a colossal chryselephantine statue of Zeus and the precinct was filled with scores of statues of Hadrian himself),[68] built an elaborate bath complex to the north of it, founded a sacred building to the south of it, and constructed a new gymnasium across the Ilissos.[69] The extant Arch of Hadrian, standing between the Acropolis and the Olympieion, honored the emperor for his patronage: it marked the division between the old city and the new in the process and also, commemorated his renewal of the city as a whole.[70] It is possible, too, that Hadrian financed yet another renovation of the Theater of Dionysos on the south slope [Fig. 209]: he presided over the Dionysia in 124/5 AD and the re-used Classicizing reliefs that now adorn the latest Roman stage (the so-called Bema of Phaidros) [Fig. 224] may originally have been carved for a stage building erected for that festival.[71] But the patron-emperor who could fund so much – a remaking of the city that rivaled Perikles's and Lykourgos's own – apparently did nothing atop the Acropolis itself.[72] Like Augustus and even Claudius before him, Hadrian apparently accepted the landscape of the Classical Acropolis as "the classic" or "ideal" one – the one that should endure essentially unchanged. The lower city could be redesigned and the approach to the Propylaia rebuilt. But nothing could be allowed to interfere with, say, the spatial relation of Parthenon to Erechtheion or of either to the Propylaia. The upper city was not just sacred: its Classical form was sacrosanct, virtually untouchable. The vessel could still be filled with

statues and monuments galore, but its basic shape remained as it was for the rest of antiquity. The summit of the Roman Acropolis was, then, Roman only in the details.

The Athenian Contribution

It is easy to overstate what Hellenistic kings and Roman emperors did atop the Acropolis, and to understate what the Athenians did there. For the Athenians themselves still had the strongest hand in its adornment – in the dedication of new statues and monuments, in the rededication and renovation of old ones, in the addition of new shrines and buildings (particularly on the south slope), and in the construction of one last temple – admittedly a small one – on the summit.

For most of the Hellenistic and Roman periods the Athenians dedicated monuments and made offerings for the same sort of reasons that had always inspired them to do so: to thank Athena and the gods, to commemorate success and service, and in the process to improve, enrich, or embellish the place. For example, around 300 a bronze statue of a victorious athlete was dedicated on a marble base decorated on three sides with reliefs of youths shown exercising and talking and scraping the dust off themselves (two of the athletes are labelled "Antigenes" and "Idomeneus") and around the same time a statue of a prizewinning *apobates* was set on a marble base whose run-of-the-mill relief was obviously intended to recall passages on the Parthenon frieze [cf. Fig. 156].[73] Early in the third century the Athenian general Olympiodoros, leader of a short-lived insurrection against Macedon, was honored with a bronze portrait, and so was an old woman apparently named Syeris, faithful servant to the priestess Lysimakhe (Pausanias notes both works).[74] Statues dedicated by private individuals are, it is true, hard to find in the epigraphic record of the third century, and this suggests some change in the perception and use of the summit as a place for personal display.[75] Still, votive activity atop the Acropolis by no means ceased. A few extant figurines of the so-called Tanagra type – lithe, elegant women swathed in drapery – probably represent only a small percentage of the total number of terracottas dedicated on the summit and slopes in the early Hellenistic period.[76] On a grander scale, a group of seven life-size bronze figures were at some point placed at the southern end of the broad flight of rock-cut steps west of the Parthenon [Fig. 163].[77] And twelve new shields were

attached to the east facade of the Parthenon in place of the fourteen originally dedicated by Alexander and removed by Lakhares [Fig. 207], though we do not know who replaced them or when (more shields or wreaths were at some point added to the north and south architraves of the building).[78] The Asklepieion received plenty of private sculptured dedications even in the third century, when such offerings were rare atop the Acropolis, and the south slope continued to be adorned with new khoregic monuments. In 271/0 Thrasykles, the son of Thrasyllos, placed prize tripods of his own on the khoregic monument of his father above the Theater of Dionysos and in the Roman period two tall columns crowned with tripods were placed on the rocky ledge above that [Fig. 9].[79] Roman-era dedications atop the Acropolis are also plentiful. And, apparently after a severe drought struck Athens during the Hadrianic period, a statue of Ge (Earth) beseeching Zeus for rain was set directly into a cutting in the bedrock some nine meters north of the seventh column (counting from the west) of the Parthenon's north colonnade [Fig. 225]. The rock-cut inscription at its side says simply "[Image] of Earth, Bearer of Fruit, according to the oracle" and the statue may well have depicted the goddess only from the waist up, as if she were emerging from the rock (that is, from herself) in a fashion that has precedents in Classical vase-painting, Hellenistic sculpture [cf. Fig. 214], and, perhaps, even in the Gigantomachy represented in the interior of the shield of the Athena Parthenos.[80]

So, too, Athenians – individual Athenians as well as the *demos* – were responsible for much of the architectural activity that occurred on the Hellenistic and Roman Acropolis, especially on the south slope, where they founded new sanctuaries or improved old ones.[81] For example, the Asklepieion's impressive marble Doric stoa (which incorporated the sacred spring and the older *bothros*) was probably begun in 300/299, and a new temple to Asklepios (parts of its superstructure have now been identified) was built on the foundations just south of the stoa's west end [Figs. 192, 193]. In the middle of the first century, after the Sullan destruction, one Diokles of Kephissia – a private citizen, not the state – paid for repairs to the sanctuary out of his own pocket.[82] On the southwest slope, on a level bedding cut into the limestone directly below the Nike bastion, a new house for the ancient cult of Aphrodite Pandemos (Aphrodite of the People United) and Peitho (Persuasion) was built around 287/86 [Fig. 3 no. 31]. The simple shrine was adorned with a frieze of doves, Aphrodite's sacred bird

Fig. 225. Inscription for Shrine of Ge (Earth), probably Hadrianic. Photo: author.

[Fig. 33]; the goddess may have sat enthroned with Peitho (and Eros) standing beside her within.[83] Sometime before the middle of the first century, a modest shrine for the divine Egyptian import Isis was established on the south slope just south of the Archaic Spring House, beside an even smaller Temple of Themis [Fig. 3 no. 29]. The extant remains of this Iseion – a *naiskos* (7.45m × 5.40m) with four Corinthian columns in its southern facade – are, in fact, Hadrianic in date and represent a rebuilding with funds donated by a wealthy Athenian woman (her name is unknown, but she also repaired the cult-statue of Isis and dedicated one of Aphrodite besides).[84]

But the most spectacular Athenian addition to the south slope was made around 160 AD, when Herodes Atticus began to build a new concert-hall [Fig. 3, no. 30; Fig. 226]. This fabulously rich and flamboyant Athenian came from Marathon and was the finest Greek orator of his day. But his first names were Tiberius Claudius. He lived in Rome as a young man and became a Roman senator and consul. And he was friend and teacher to Marcus Aurelius. His very life and career – essentially a Roman career – thus suggest how, at the highest levels of society, Roman and Athenian were now virtually indistinguishable. At any rate, Herodes Atticus had showered the city with his philanthropy before. For the celebration of the Greater Panathenaia of 142/3 AD, for

example, he had rebuilt Lykourgos's Panathenaic stadium with marble seats and staged a particularly grandiose procession highlighted by a huge thousand-oared ship said to have been guided through the streets of Athens, the *peplos* billowing on its mast, by means of underground machinery.[85] After the death of his Roman wife, Appia Annia Regilla, he honored her memory with the new marble Odeion – a semicircular hall set into the hillside at the end of the Hellenistic Stoa of Eumenes, which now physically linked the principal performing arts centers of the south slope (the Odeion and the Theater of Dionysos). The Odeion, completed around 174 AD, boasted ornate mosaic floors, an elaborate, twenty-eight-meter-high stage building, a magnificent cedar roof, and seating for over 5,000 spectators.[86] At all events, it is somehow fitting that the Odeion of Herodes Atticus – the last major architectural addition ever made to the ancient Acropolis – was made by a native Athenian, even one who was in many ways so Roman.

In the miscellany of statues, dedications, and buildings erected on the Hellenistic and Roman Acropolis by the Athenians themselves, perhaps the most notable series consists of monuments the Athenians set up to honor foreigners – to thank them for past benefactions or to court their future favor. And the list of such dedications

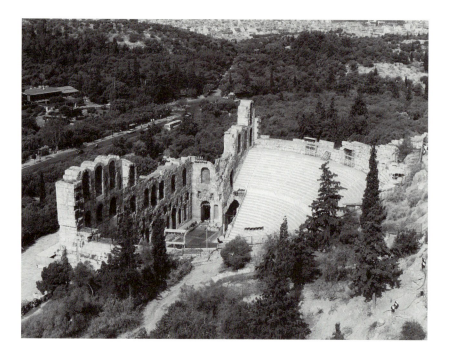

Fig. 226. Odeion of Herodes Atticus, c. 160–174 AD. Photo: author.

is very long indeed. Around the middle of the second century the Athenian *demos* dedicated an equestrian statue of Ptolemy VI Philometor, ruler of friendly Egypt and victor in a horse race run at the Panathenaia of 166, to thank him for some unspecified act: the statue was prominently placed beside the Erechtheion.[87] It seems that at roughly the same time the Athenians dedicated colossal bronze statues of Eumenes and Attalos – our sources are vague but they probably mean Eumenes II and Attalos II – somewhere on the summit, possibly atop the south citadel wall near the Smaller Attalid Group. A storm may have cast these images down into the Theater of Dionysos below just before the decisive battle of Actium in 31, which was bad news for Mark Antony, if one of the Attalid portraits had indeed been rededicated to him in the guise of Dionysos (his divine alter ego) earlier in the decade.[88] In fact, the Athenians shamelessly recycled the monuments of those who had once treated them so well, erasing old inscriptions and carving new ones, removing old heads from necks and inserting new ones in their place. Romans came, Attalids went, and the Athenians were as economical as they could be about making the changes. Thus, the formidable Monument of Attalos II at the northwest corner of the Parthenon [Fig. 221] was at some point in the early imperial period rededicated to Augustus (or Claudius).[89] Similarly, the Monument of Eumenes II before the Propylaia was rededicated to Agrippa to thank him for

his beneficence [Fig. 220]: a bronze portrait of the Roman was perhaps set into the Pergamene chariot atop the pillar.[90] Also at the entrance of the Acropolis the Athenians took the statue of horse and youth originally made by Lykios, son of Myron, for the victorious Athenian *hippeis* around the middle of the fifth century, had another similar group made (with a copy of the original inscription, so that the new bronze would appear to be by the hand of an "Old Master"), set the matched pair up on inscribed pedestals across from each other just west of the northwest and southwest wings of the Propylaia [Fig. 166; Plate IX, center foreground], and dedicated both to the emperor Tiberius's chosen successors, his nephew Germanicus and (probably) his own son, Drusus. Since the popular Germanicus visited Athens in 18 AD as commander of the eastern provinces, it is likely that all this was done to welcome him on his arrival at the Acropolis gates. But in any event the rededication of the fifth-century work and the creation of a Roman pendant to it would, for anyone approaching the Propylaia, have fused the Imperial Roman with the Classical Greek: the statues, with their Periklean backdrop, would have seemed the product of a single, long golden age, loftily presided over by the great Agrippa on his monument nearby [Fig. 220].[91]

More garden-variety flatteries included a large number of portraits of foreign kings and queens and Romans praised for their excellence (*arete*), good will (*eunoia*), or

beneficence (*euergesia*). For example, a statue of Glaphyra, wife of Augustus's crony Juba II of Mauretania (a learned king who seems to have repaired at least one building in Athens), was dedicated around 4 AD to honor the queen for her virtue: ever economical, the Athenians set the portrait on a base made from a piece of old Eleusinian limestone that had been removed from the Erechtheion during its early Augustan renovations and had been lying around for a couple of decades.[92] Sparing every expense, the Athenians also reused an older monument for the base of a group portrait, set up west of the Parthenon after 4 AD, honoring Augustus, Tiberius, Drusus, and Germanicus on the occasion of Augustus's official adoption of Tiberius and his designation as heir-apparent. On the base of other Acropolis portraits of Tiberius the Athenians labelled him "Benefactor."[93] Ironically, even portraits of Caligula (who had taken seven statues from the Acropolis) stood on the citadel: the Athenians could look the other way when they had to, and they even described him as benefactor of the city.[94] Unsurprisingly, Claudius, the most popular emperor in the century after Augustus, was honored with a series of portraits and altars.[95] And later imperial honorees included Trajan (a portrait of whom was added to the Julio-Claudian adoption group in the early second century AD) and Marcus Aurelius, who had kind words for the city's ancient majesty and who on a visit in 176 (and in consultation with Herodes Atticus) endowed and appointed five new chairs of philosophy and rhetoric for what might be called the University of Athens.[96]

But the most impressive imperial portraits of all were those of Hadrian and Julia Domna – not because of what they looked like, but because of where they were, inside the Parthenon. That Hadrian was so honored is, of course, no surprise: he was singlehandedly responsible for the city's renaissance in the early second century AD and deserved whatever honors the Athenians could afford.[97] It is still remarkable that they placed his bronze (or gilt bronze) likeness in the cella near the chryselephantine Athena [Fig. 132], as if he were the building's co-divinity.[98] The only other mortal known to have been honored with an image inside the Parthenon was Julia Domna, the wife of the emperor Septimius Severus (193–211 AD).[99] Though he had spent time in the city before ascending the throne, Septimius was no friend of Athens and even punished the city for some offense after he became emperor. It was probably to thank Julia Domna (an intellectual who must have admired Athens's philosophical traditions) for assuaging his

anger that the Athenians treated her in a way that was stunning even by their standards of sycophancy. Sometime between 195 and 198 AD, an inscription informs us,[100] the Athenians not only set up a golden statue of her (an *agalma*, it is called) within the Parthenon, but also rededicated the Erechtheion to her, adding not merely a portrait but a cult statue of her beside the sacrosanct olivewood image of Athena Polias and thus assimilating her personality to that of the patron goddess of the city. (The wooden image – by now perhaps a thousand years old or more – was undoubtedly deteriorating, and it was around the very time of Julia Domna's installation that the Christian apologist Tertullian called it "a rough stake and shapeless piece of wood").[101] The empress of Rome, at any rate, was now the living incarnation of Athena.

Nike Renewed

Clearly, if their flattery of the Romans was not always a pretty sight, the Athenians under the empire knew where their bread was buttered. Still, there are two exceptional works, added to the Acropolis early in the imperial period, that merit special attention, for they illustrate that on occasion the Athenians could artfully promote their own historical accomplishments behind a superficial servility. They still had ways of insisting on their own glorious past and of renewing the time-honored Acropolis theme of victory over the east.

Early in Augustus's reign, the Athenians took the extraordinary step of building a temple to him and the personified Roman people – the last significant architectural addition to the ancient summit and the only one of the Roman period [Fig. 3, no. 15; Plate X; Figs. 136, 227].[102] Placed about twenty-three meters east of the Parthenon, set on a roughly square foundation just where the natural bedrock begins to fall down and away, this Temple of Roma and Augustus – a cella-less ring of nine Ionic columns less than nine meters in diameter – was too small and too low to prevent the light of the rising sun from penetrating the east room of the Parthenon and illuminating the Athena Parthenos[103] and, placed as it was in the least developed area of the Acropolis, it did nothing to interfere with the relationships among the principal Classical buildings on the summit. If, as is likely, the entrance to the shrine was on the east side, the statues of Roma and Augustus placed within the circle would have faced east, too, away from the Parthenon (their backs, seen through the columns, would not have encouraged visits from pilgrims exiting the Periklean building and,

Fig. 227. Temple of Roma and Augustus (c. 20/19), inscribed architrave. Photo: author.

indeed, Pausanias does not mention it). Still, the diminutive Temple of Roma and Augustus had plenty of formal links to past Athenian architectural greatness. Its material was classic Pentelic marble; its Ionic columns were imitations of the Erechtheion's; and a block of the Erechtheion (which, again, had recently undergone a major renovation) was even built into its foundation, almost as if the Classical relic were set there to magically sanction or bless the Roman. But its primary architectural associations were with the Parthenon – it is aligned exactly along the Parthenon's east-west axis [Fig. 136] – and so were its symbolic associations. For this temple was built not only to introduce the worship of a living emperor to the city but also to commemorate Augustus's victory (diplomatic and propagandistic rather than military) over the Mesopotamian kingdom of Parthia in the summer of 20 (the Parthians, again, were to Rome what the ancient Persians had been to Greece and Athens five centuries before: eastern *barbaroi* and bogeymen beyond the boundaries of civilization). Begun by the Athenians (eager to make up for the provocations of 22/21) shortly after Augustus's "triumph" over the east, the temple was probably completed in time for his third and final visit to Athens late in the summer of 19. The Temple of Roma and Augustus, then, was both the house of the new imperial cult and, like the Parthenon itself, in the nature of a victory monument. Nor was its position randomly chosen: it plotted a new angle in the "field of Nike" already defined on the east by the facade of the Parthenon and on the south by the Smaller Attalid Group. Perfectly aligned with the Parthenon and thus with the Nike-bearing Athena Parthenos [Fig. 132], the Temple of Roma and Augustus essentially marked an

eastward extension of the Parthenon's own ideological geometry, an imperial insertion into the Acropolis's complex network of allusions to the west's triumph over the east – a theme eminently stated, of course, by the Parthenon itself but in the intervening centuries rephrased by Alexander's dedication of the shields of Granikos [Fig. 207] and Attalos I's representations of the fallen enemies of civilization [Figs. 218, 219]. The Athenians, in other words, appropriated Augustus's eastern triumph and injected it into the Acropolis's ancient web of Nike, making his success the latest manifestation of their own, all the while sincerely honoring the emperor and the city that now stood as the bulwark of the west.[104] The tactic evidently worked, for eighty years later they repeated it.

If the Acropolis was throughout its history a kind of evolving essay on the theme of victory, an instrument of Athenian political rhetoric, a kind of visual and spatial text in marble and bronze through which Athenians (and non-Athenians) represented themselves and their ideologies, then the last time its "victory text" was emended in a significant way occurred under Nero. And this time the Parthenon literally had a text written across it. In 61/2 AD, when Tiberius Claudius Novius (another Athenian with a Latin name) was the leading figure in the city and Paulina was priestess of Athena, the Athenians, apparently of their own accord, honored the "Greatest Emperor Nero Caesar Claudius Augustus Germanicus, son of a God" with a twenty-five-meter-long inscription of gilt bronze letters doweled into the spaces between the (restored) shields on the east architrave of the Parthenon.[105] The letters are gone; only the holes used for their attachment survive [Figs. 207, 228].

Fig. 228. The Neronian inscription on the east architrave of the Parthenon, 61/2 AD. After Carroll 1982, fig. 5.

Now, some scholars have thought that the Neronian inscription was just another case of the Athenians kowtowing before an undeserving emperor – that it marked either the rededication of the Parthenon itself to Nero or the dedication of a statue of him inside (or out). In fact, a few years before (between 54 and 61 AD) the Athenians had refurbished the Theater of Dionysos [Fig. 209], adding an ornate new stage building, and rededicated it to Nero (though the emperor fancied himself a poet and patron of the arts, he had nothing to do with the project).[106] But there is no evidence that the gilt inscription on the Parthenon marked that building's rededication to Nero (the way the Erechtheion would much later be rededicated to Julia Domna) or that a statue of Nero ever stood in the vicinity. Besides, to honor him with a glistening text written across the facade of the Parthenon seems a very odd thing for the Athenians to have done. Unlike Augustus and other emperors, Nero, though he took a grand tour of Greece, refused to set foot in the city and, unlike his immediate predecessor Claudius, he never did anything for it, even from afar: he built it no monuments, he conferred no favors upon it. As a result, the Athenians owed him nothing. They might, it is true, have hoped for something from him in the future, but the motivation behind the Neronian inscription could not have been gratitude or grovelling. It was more shrewd than servile and it had to do with the old Athenian strategy of equating the Parthians, the scourge of the Romans, with the Persians, their own ancient foe. As K. Carroll and A. Spawforth have stressed,[107] Nero, like Augustus, himself recognized the importance of the symbolism of the Persian Wars. In 57 or 58 (several years before the date of the Parthenon inscription) Nero, like Augustus before him, staged a mock seabattle beside the Tiber re-enacting the Battle of Salamis. Thus Nero, like Augustus, laid claim to being the new defender of western civilization against the barbarous east. In the first century AD, the Athenians must have realized that he – that any Roman emperor – was, too.

In fact, the Parthenon inscription was probably an honorific decree marking Athenian support for eastern campaigns Nero was then waging against Armenia and Parthia. In 61/2 the Roman victory was not yet won, and the celebration of *nike* was still premature. But Roman legions had met with some success, and to honor Nero for defeating more or less the same easterners that they themselves had defeated so long before (Persians, Parthians, what's the difference?) would have put the Athenians on the emperor's good side when he did hear of it (he might have been especially pleased to learn that the inscription honoring him loomed over the Temple of Roma and Augustus, Athens's monument to an earlier Parthian "triumph," Fig. 136). But it would also have renewed the symbolism of the Parthenon itself. On the one hand, the inscription conceded that Nero's empire was now what Athens once had been but could no longer be – the champion of the west. On the other, it made Nero's present policies another extension of Athens's long, glorious, and transcendent struggle with the east, and so rededicated the Parthenon to the ancient idea of victory, revivifying it. The Parthians once again became just another defeated foe, to be listed among the giants, Trojans, Amazons, Persians, and Gauls represented on the Parthenon and in the Smaller Attalid Group [Figs. 218, 219]. By honoring the emperor, then, Athens responded to Nero's and Rome's own use of the tradition of the Persian Wars by reclaiming it. The placement of the inscription on the front of the Parthenon – the greatest of all monuments to victory over the east – converted Nero into an instrument of traditional Athenian policy, for his Romans were now fighting the same good fight Athenians had programmatically fought long before.

The Hellenistic and Roman periods, then, saw the creation of a kind of polygonal field of victory between the Smaller Attalid Group, the Temple of Rome and Augustus, and the inscribed east facade of the Parthenon [Fig. 3]. The visitor who in 62 AD negotiated that zone

and entered the Parthenon itself would still have found Nike perched in the palm of the hand of the Athena Parthenos [Fig. 132]. But the image now personified victories over peoples of whom Perikles and Pheidias had never heard. It is easy to imagine that, had it been made of flesh and feathers instead of gold and ivory, this relic of the Periklean age would have flown off in chagrin at the inscription of Nero's name.[108] But perhaps, on second thought, it would have stayed right where it was. For despite all that had happened in the five centuries it had spent hovering there, despite all the different victories it embodied now, its essential symbolism, and its dignity, remained intact. The crown or wreath it offered to Athena and Athens was still what it has always been: the prize of victory over the barbarous east.

The irony is that, ultimately, the east would prove not to be the problem. When two and then three centuries later – long after Nero and the Hadrianic renaissance and Marcus Aurelius's visit and Julia Domna's assimilation to Athena Polias – devastation finally came to Athens and the Acropolis, it came from the barbarous north.

THE END OF THE ANCIENT ACROPOLIS

In a dream the philosopher thought he saw approaching him a woman of great beauty, who told him that he must quickly prepare his house "because the Athenian Lady wishes to live with you."

Marinus of Samaria, *The Life of Proclus* 30

In 267 AD, a savage Germanic tribe known as the Heruli, forced from their original home in Scandinavia to the area around the Black Sea, penetrated the flimsy defenses of the Roman Empire, invaded Attica, and sacked Athens for days before finally being driven off by 2,000 patriotic Athenians waging guerrilla war from behind trees and rocks. In 396 AD (fifteen years before plundering Rome itself), the fierce Alaric led his Visigoths into Greece by way of Thermopylai, took the Peiraieus, marched into Athens by way of the Dipylon Gate, and sacked it again.[1]

There is no question that, taken together, these two events had profound effects upon the ancient city, but recently there has been a reassessment of the evidence and a certain redistribution of blame. It used to be, for example, that any destruction detectable in the archaeological record of late Roman Athens was routinely considered the work of the Heruli. It now appears that the damage they did was relatively limited or, at least, geographically concentrated. For example, only a couple of buildings on the west side of the Classical Agora [Fig. 2] seem to have been destroyed in 267 – most of the old civic center survived unharmed – and the activities of Athens's rhetorical and philosophical schools (still so central to the city's culture and identity) were not seri-ously interrupted. Still, the Herulian attack was a wake-up call. It inspired the Athenians to build a new wall around a contracted and thus, it was hoped, more defensible urban center embracing the Acropolis itself, the area to the north (including the Roman Agora), and the south slope (with the Odeion of Herodes Atticus, the Stoa of Eumenes, the Asklepieion, and the Theater of Dionysos). The Athenians took their time with this so-called Post-Herulian wall – it may not have been completed until the 280s[2] – and they prominently (and often artfully) built pieces of assorted earlier monuments into its two faces: its fabric reveals not panic but a glorious (if mixed-up) past [Fig. 229]. And as part of the project the Athenians added the last important structure of the ancient Acropolis. Some forty meters west of and below the Propylaia, the Athenians built the outerwork known (after its discoverer) as the Beulé Gate [Fig. 3, no. 32; Fig. 230]. Bestriding the old wide marble stairway and flanked by high towers, its single narrow doorway usurped the five-gated Propylaia's ancient function and constricted any possible approach.[3]

Like the Post-Herulian wall in general, the Beulé Gate was built from older material: the triglyphs, metopes, and other rather handsomely arranged blocks come from the late fourth-century khoregic Monument

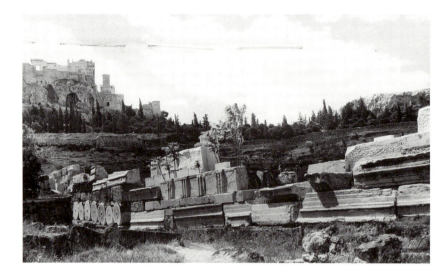

Fig. 229. Inner (east) face of Herulian wall, Agora. Photo: American School of Classical Studies at Athens: Agora Excavations.

Fig. 230. The Beulé Gate (inner or east face), after 267 AD. Photo: author.

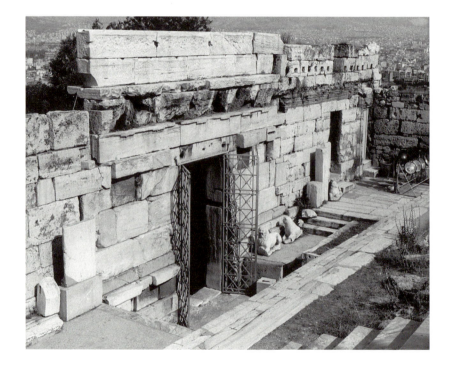

of Nikias on the south slope [Figs. 211, 212]. The Nikias Monument may have been a Herulian victim, but the mere availability of its fine, ancient stones was not the only reason why the builders of the Beulé Gate chose to quarry its blocks rather than another building's: the architecture of the Nikias Monument was itself modelled on the Propylaia, and so in this new incarnation it was a fitting and aesthetically harmonious prelude to the old Periklean gateway. The Beulé Gate, in other words, displays a twice-told classicism – it classicistically incorporates the fabric of a late fourth-century building that was itself classicistic – and proves that in the second half of the third century AD the Athenians, though forced by economic circumstances to re-use old stuff, had not lost their sense of style. Even so, the building of the gate marks a turning point in the history of the Acropolis. Although the Acropolis had always had both religious and strategic significance, its sacred role had predominated for at least 750 years (military uses of the Acropolis after the Persian sack of 480 – say, by those who resisted Sulla in 86 – were few and far between). With the construction of the Beulé Gate, however, the Acrop-

olis's defensive role, both real and potential, was emphasized in a way it had not been since Kimon and Perikles had rebuilt its citadel walls.[4] Having been for so long a sanctuary with walls, the Acropolis was now becoming a fortress with temples. The Acropolis had begun its monumental history (in the Late Bronze Age) as a fortress [Fig. 48] and now, for some 1,550 years after the construction of the Beulé Gate, a fortress it would remain.

If the extent of the Herulian destruction of Athens used to be overestimated, the extent of the Visigothic destruction used to be minimized, as if we could put stock in a story concocted a century after the fact that Athena and Achilles (why him and not Theseus?) appeared together "at the ramparts" (of the Acropolis, presumably) and persuaded Alaric to leave the city unharmed.[5] Now, the Athenians may well have bought him off and the tale would thus have put an ennobling mythic spin on the negotiations. But it is now also clear that the Visigoths did not leave before destroying those parts of the Agora that the Herulians had left untouched. So, too, a wave of violence that hit the south slope of the Acropolis in late antiquity – the Odeion of Herodes Atticus, the Asklepieion, the Theater of Dionysos were all severely damaged – was probably the work not of the Heruli (the usual suspects) but of Alaric instead.[6]

But the big question is: what, if anything, did the Heruli and the Visigoths do to the summit of the Acropolis, and which of them destroyed the Parthenon? That at some point in either the third or fourth century the building suffered a devastating fire and collapse is not much in dispute. Its massive wooden beams and rafters burned and fell, smoldering for days; its marble roof and tiles crashed to the ground; the east and west doors were destroyed; and everywhere marble surfaces cracked and peeled from the ferocious heat. The statue of Athena Parthenos the Second – gold leaf or gilt sheets and ivory on a wooden core – could not possibly have survived the conflagration and collapse. Oddly, there is no mention of this catastrophe in our literary or historical sources. But there is incontrovertible archaeological evidence not only for the destruction but also for an extensive repair in either the fourth or fifth century AD.[7] The interior double-decker colonnade of the east room, for example, was reconstructed with semi-fluted Doric columns cannibalized from one or two Hellenistic stoas in the lower city east of the Roman Agora, themselves destroyed by barbarian invaders [Figs. 2, 231]; Ionic columns from the same building were recut to make

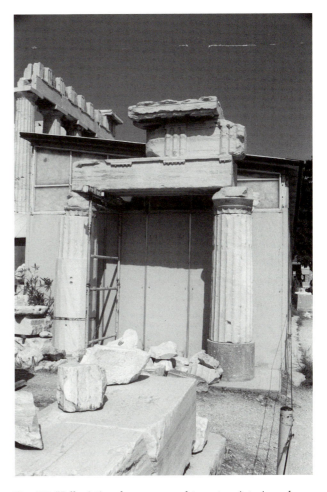

Fig. 231. Hellenistic columns re-used to restore interior colonnade of Parthenon cella after fire of 267 AD, as currently displayed south of Parthenon. Photo: author.

new roof beams. The west and east doors and thresholds were rebuilt using stones taken from a variety of earlier, destroyed monuments; the west door alone was repaired with (1) Classical inscriptions (including Parthenon inventories), (2) a part of the base of the Early Classical Pronapes Monument, (3) the base of (probably) the monumental double group of Erechtheus fighting Eumolpos and Theainetos and Tolmides seen by Pausanias,[8] and (4) pieces of that late fourth-century khoregic monument modelled on the Temple of Athena Nike. A new roof (covered mostly with cheaper terracotta tiles instead of marble ones) was installed, but only over the cella: the spaces between the cella walls and the exterior colonnade were left open to the sky (most of the Parthenon frieze was thus exposed to direct light for the first time). Finally, a new, slightly smaller, and no doubt much

poorer Athena was set atop a slightly smaller base inside – Athena Parthenos the Third, maybe a remake, maybe a reinvention, maybe even a different Athena altogether moved to this location and rebaptized.[9]

Our choices are these: if the Heruli destroyed the Parthenon (and presumably most of the other buildings on the summit), then the best opportunity for at least beginning the restoration would have come during the short reign of Julian the Apostate (361–363 AD), the pagan ruler of a Roman Empire that since 325 had been effectively Christian (and who, incidentally, had spent two happy months as a student in Athens before reluctantly leaving to assume power in the west).[10] This would mean, however, that the Parthenon remained a ruin for nearly a century before its restoration, and to some the gap has seemed much too long. Thus, a second opinion: the Parthenon was not destroyed until the late fourth century – presumably the victim of Alaric but possibly of accident or earthquake – and it was soon after repaired in the early fifth century, when Herculius (408–410 AD), Prefect of Illyricum (an important post), undertook a fairly impressive building program in the lower city, one that earned him a honorific portrait statue atop the Acropolis next to the ancient Bronze Athena (Promakhos).[11]

Our knowledge of the history of the late Roman Acropolis is so spotty that neither scenario inspires complete confidence, and others could be imagined.[12] But extensive wear in the *repaired* parts of the Parthenon strongly suggests that the Heruli were the culprits after all,[13] and in the religious and historical contexts of late Roman Athens a third-century ("Herulian") destruction followed by a fourth-century (loosely "Julianic") repair makes the best sense. Had Herculius restored the Parthenon – an unlikely event in any case, since he was probably a Christian[14] – we might have expected it to be part of some kind of revival of polytheism on the summit, no matter how modest. Instead, by the early fifth century the Acropolis had already begun its decline as the focus of Athenian cult: the basic fabric of Athenian religious life – rather, *pagan* Athenian religious life – appears to have been unravelling.[15] It is likely that by this time the Erechtheion [Fig. 173] had already ceased to function as the center of the cult of Athena Polias: the old wooden statue of Athena Polias may have finally crumbled or been destroyed, and with that the focus of official state religion would have been transferred, finally, to the Athena standing in the cella of the Parthenon.[16] It is likely, too, that the celebration of the

Greater Panathenaia came to an end in the early fifth century, around the very time of Herculius's purported restoration (which would be odd if he had just spent vast sums rebuilding the Parthenon). We are told in an inscription that a wealthy Neoplatonic philosopher named Plutarch three times subsidized the Greater Panathenaiac procession – and "drove the sacred ship and brought it near the Temple of Athena" – in the very late fourth and very early fifth century (the last time being perhaps in 406/7 or 410/11 AD).[17] But the regular celebration of the festival seems to have petered out soon if not immediately thereafter, and when around the middle of the fifth century two more rich Athenians offered to pay for one more celebration, they found no takers.[18] With the demise of the Panathenaia – it had been roughly a thousand years since the Peisistratid reorganization of the festival in 566 – the end of the ancient Acropolis was near.

The end cannot be said to have come, however, until the two monumental images of the citadel – the Bronze Athena (Promakhos) [Fig. 24] and the last Athena Parthenos – met their curious and sad fates. Since Herculius's portrait was set up near it around 410 AD, we know the Bronze Athena was at that time still standing where it always had been. What happened to it after that we cannot be sure. It is widely believed that the statue (like many other Classical masterpieces) was at some point moved to Constantinople, where, before the Senate House on the Forum of Constantine, it was reinstalled atop a Corinthian column of marble and porphyry (that must have been some column). At any rate, a bronze Athena very similar to the Pheidian one – thirty feet tall, standing with helmet, *aigis*, and gorgoneion, with outstretched right hand and slightly turned head – was duly noted by several witnesses from the ninth to the thirteenth centuries and is even shown (miniaturized, with upright spear and shield at her side) in an eleventh-century Byzantine manuscript illumination. This bronze Athena, we also know, was pulled down from its pedestal and destroyed by a drunken Byzantine mob in 1203 AD (the rioters thought the goddess, with her extended hand, was treacherously summoning the Crusaders). Thus, if it was in fact *the* Bronze Athena, the statue had to have been deported from the Acropolis to Constantinople sometime between 410 AD and the ninth century – and probably earlier in that period rather than later. In fact, it is likely that the Bronze Athena was taken down before the end of the fifth century – a year around 465 or 470 is one well-educated guess.[19]

The fate of the last Athena Parthenos is even murkier, but it is forever intertwined with the biography of Proclus, a philosopher from Lycia who became the head of the Athenian Neoplatonic school in 437 AD. Proclus lived in a large and fine house located very low on the south slope of the Acropolis (on a line roughly midway between the Odeion of Herodes Atticus and the Asklepieion, under the modern Street of Dionysios Areopagitos). He composed hymns to the gods (including Athena, "the shield-bearing goddess with a manly mind," as he calls her) and is said to have practiced pagan rituals and effected miraculous cures in the nearby Asklepieion – one of the few remaining magnets for observant polytheists.[20] Around 450 AD, wishing to avoid trouble with an increasingly aggressive Christian community armed with assorted imperial edicts attempting (often in vain) to ban pagan sacrifices and rites and even to destroy all temples,[21] Proclus left Athens for a year. And it was apparently sometime between his return and his death in 485 that he had his famous vision of Athena. The dream occurred after "the statue of the goddess which had been set in the Parthenon had been removed by those people who move what should not be moved," and in it the philosopher saw a gorgeous woman who told him to prepare for a divine guest who wished to dwell with him – "the Athenian Lady (kyria Athenais)," Athena herself. Those people who move what should not be moved are, of course, the Christians, and what they moved – and undoubtledly destroyed – was the Athena Parthenos: for all intents and purposes this act marked the final ascendancy of Christianity in the city. For the Neoplatonist, the loss of the statue might not have mattered so much: he could still welcome her spiritual presence – the "essence" of her divinity (a notion that might have puzzled Classical devotees of Athenian state religion, whose conception of the gods was so closely bound to tangible images of them) – into his own substantial home.[22] But it is in any case clear that by the last quarter of the fifth century AD, the great goddess lacked a statue and the Parthenon lacked a goddess. If we need to propose a date for the end of the ancient Acropolis, then this one – two generations before the Emperor Justinian banned the teaching of philosophy in the city and thus officially closed the "University of Athens" (529), a century before an invasion of Slavs destroyed the withering city once again (582/3), a century or more before the Parthenon was physically transformed into a Church of the Blessed Virgin (appropriate for the former house of a parthenos) and the Erechtheion converted into the Church of Mary, Mother of God – this date is as good as any. For in the time of Proclus, the Acropolis effectively ceased to be the rock of Athena.

EPILOGUE

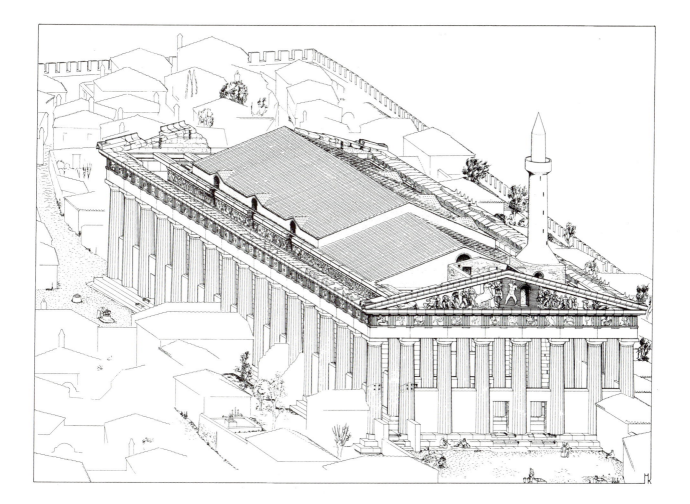

RESTORATION

(1) to enter freely within the walls of the Citadel, and to draw and model with plaster the Ancient Temples there.

(2) to erect scaffolding and to dig where they may wish to discover the ancient foundations.

(3) liberty to take away any sculptures or inscriptions which do not interfere with the works or walls of the Citadel.

Outline of the *firman* (permission) requested of the Turkish authorities

as recommended to Lord Elgin by his chaplain, Philip Hunt,

in a memorandum dated July 1, 1801.[1]

In 1686 AD an alliance of European powers led by Venice and financed by the Pope renewed their long-standing war on the Ottoman Empire. The next year the Venetian general Francesco Morosini led an army of international mercenaries to free Greece from the Turks who had ruled it for over two centuries. After securing the Peloponnesos, Morosini set his sights on Athens – a small town of about ten thousand Christians and Moslems dominated by a very big castle [Fig. 232]. The massive, buttressed battlements of the Acropolis had been built primarily during the so-called Frankish-Florentine period (1204–1456). It was then, for example, that the Propylaia was converted into a multi-storeyed fortified palace for the succession of dukes who lorded over the city: its walls are still marked by cuttings for wooden floor beams. The Classical building, in other words, was effectively imbedded within a Medieval one: the columns of the west porch and Pinakotheke were walled up and its west pediment was left, not quite fully submerged, as a decorative facade [Fig. 233]. The most distinguishing feature of the entire complex was now, in fact, a crenellated stone tower, some twenty-six meters high, built over the Propylaia's southwest wing. This so-

called Frankish Tower – it should rather be known as the Tuscan Tower, since it was built toward the end of the era by the Acciauoli, powerful merchant-dukes from Florence – dominated the skyline of Medieval Athens as much as the Parthenon itself.[2] At any rate, the castle that the Turks packed and defended in the middle of September 1687, was essentially a western one, though the easterners had, of course, added refinements of their own: in 1686, after the declaration of war, they dismantled the Temple of Athena Nike (which they had already converted into a powder magazine) and used its columns and blocks to build a new gun emplacement before the old Propylaia-Palace.

Ironically, Morosini was well aware that the already venerable fortifications of the citadel, heavy though they were, were no match for the engines of early modern warfare: the strategic significance of the Acropolis was therefore negligible. Still, the symbolic importance of the place was great and so, against his better judgment, Morosini ordered his troops to take up positions around it. The Turks refused an opportunity to surrender and Morosini was informed that they had stored their gunpowder (as well as their women and children) in the

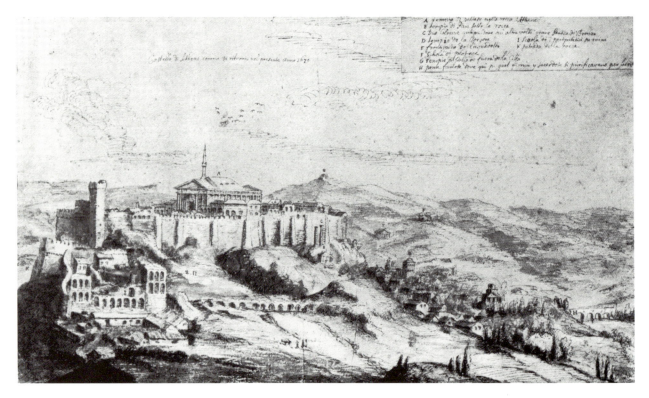

Fig. 232. Drawing of Athens and Acropolis from the south-west in 1670. Antikensammlung der Universität Bonn, reproduced by permission.

Fig. 233. Reconstruction of the western facade of the Propylaia, c. 1450. Drawing by T Tanoulas, used by permission.

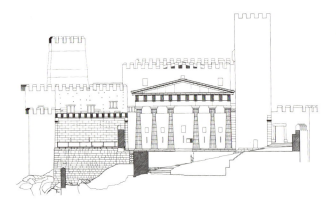

Parthenon. Though it was now a mosque, the Parthenon had once been the cathedral of Athens and the Turks, overestimating European reverence for holy buildings and the Classical past, were betting that Morosini would not train his artillery upon it.

They lost. A continuous bombardment began at noon on September 24, 1687, and the gunners, firing their cannon and mortars from the surrounding hills as well as from emplacements in the lower town, found it hard to miss [Fig. 234]. The Erechtheion must have been hit repeatedly. Early in the attack a corner of the Propylaia was blown away. And then on the evening of the 26th – the worst day in the history of the Acropolis (after the Persian sack of 480) – a single shell pierced the roof of the Parthenon and scored a direct hit on its powder magazine, igniting a colossal explosion that blew away the roof, two-thirds of the old cella walls, the old pronaos, eight columns in the north colonnade, six columns in the south, and the frieze slabs and metopes they carried. The women and children who had sought refuge within the Parthenon were killed by the concussion, crushed by collapsing blocks and beams, or burned to death. Three days later, after still more slaughter, with 300 dead and unbearable fires still raging, the Turks finally surrendered. Morosini then occupied the ruins

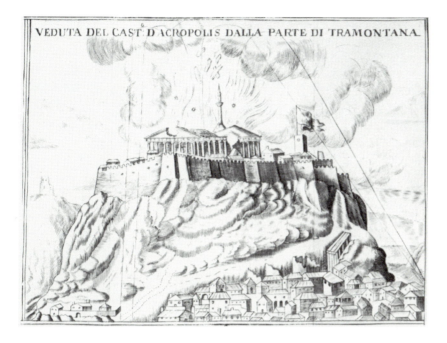

VEDUTA DEL CAST. D ACROPOLIS DALLA PARTE DI TRAMONTANA.

Fig. 234. The bombardment of the Acropolis, September 26, 1687. After Omont 1898, pl. XXXVI.

and attempted to remove the central sculptures from the Parthenon's west pediment, which had also been rocked by the explosion (he meant to add the marbles to Venice's growing and impressive collection of antiquities looted from the Eastern Mediterranean). Alas, his men were better shots than engineers and the tackle they used snapped, sending Poseidon [Fig. 141] and the horses of Athena's chariot crashing to the ground. Morosini's vandalism did not last, but neither did his occupation of the Acropolis. The general was wise enough not to try to lower any more sculptures from the Parthenon, and he was soldier enough to realize that the Turks would be back: they, too, had cannon. And so, in early April 1688, Morosini evacuated the city. In a strange and distant echo of 480 BC, the majority of Athenians escaped to Salamis, Aigina, and the Peloponnesos, just as they had before Xerxes's advance. Turkish forces soon indeed returned, ravaged the city, and refortified the Acropolis (repairing, incidentally, parts of the south citadel wall [Fig. 4] with scores of marble blocks and fragments of the central south metopes blown off the Parthenon, as well as with pieces of the Propylaia). Athens remained a part of the Ottoman Empire for another century and a half, and so the destruction of the Parthenon had been for absolutely nothing.[3]

It was said at the time, and has often been repeated since, that the Parthenon – "that famous temple of Minerva, which so many centuries and so many wars had

not been able to destroy"[4] – was in a nearly perfect state of preservation before Turkish miscalculation and European guns combined to blow it up.[5] But that depends on which Parthenon you mean. The Parthenon that came under attack in 1687 was very far from being the building that Iktinos and Kallikrates completed 2,119 years before [Fig. 127]. The intervening centuries had seen plenty of changes both minor and major, and the late Roman reconstruction (which, as we have seen, left the peristyle uncovered, repaired the Classical interior colonnades with Hellenistic columns [Fig. 231], and installed Athena Parthenos the Third on a smaller base) was just the beginning.

Christian rites may have been practiced within the Parthenon earlier, but the building was probably not physically converted into a church until the turn from the sixth to the seventh century AD.[6] The conversion left the basic structure (as the late Roman era had left it) more or less alone – with its interior colonnades the east room already conveniently resembled a basilica – but it required a 180-degree change in orientation [Fig. 235]. The door of the west chamber (which was itself now the narthex) became the sole entrance to the interior. Three doors were cut into the solid wall that had once divided the cella in two. And a small apse was built within the old *pronaos*, closing up the east entrance (the apse was largely constructed with blocks collected from a hodge-podge of ancient monuments, such as the appropriately semicircular base of the late Classical monument to the

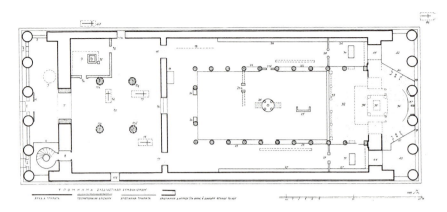

Fig. 235. Plan of the Parthenon as a Christian church. Drawing by M. Korres, used by permission.

Fig. 236. The windows and raised roof of the Christian Parthenon. Drawing by M. Korres, used by permission.

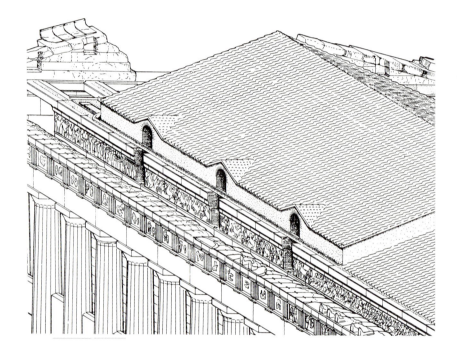

general Kephisodotos, Fig. 204). It is usually assumed that the center of the east pediment was destroyed as part of this alteration, though the apse did not extend so far as the east facade, and if the pediment really was destroyed then the Christians may just have used the project as an excuse for their pagan-bashing. On the other hand, three high windows, beneath a raised roof, were certainly cut through the Parthenon frieze on both the north and south sides: six slabs in all were destroyed [Fig. 236]. So, too, the north, east, and west metopes were over time heavily vandalized: north 32 [Fig. 134], which was probably taken for an Annunciation, and the south metopes [Fig. 139], for some reason, were spared.[7] The peristyle, open to the sky since the Herulian destruction,

even ceased to be a true peristyle: the intercolumniations were eventually closed with walls about half the height of the columns, and houses were gradually built up against them.

This "Byzantine Parthenon" – a Christian reinvention of a late Roman restoration of a High Classical building – itself underwent significant revisions over the next 800 years. The walls were covered with well over two hundred carved and painted inscriptions and frescoes [Fig. 237]. A circular marble pulpit or ambo (incorporating a block taken from the late Classical monument of Konon and Timotheos, Fig. 203) and a variety of altars and repositories filled the interior. In the twelfth century the east wall was rebuilt with a new, larger apse adorned

Fig. 237. Remains of large Frankish inscription, west cella wall of Parthenon. Photo: author.

with a mosaic of Mary, Our Lady of Athens. A watch-tower with spiral staircase was built at the southwest corner of the old cella (it may later have been converted to a bell tower). And vaulted tombs (including that of Duke Neri Acciauoli, who died in 1394) were even built beneath the floor.

In 1456 the Turks, fresh from their conquest of Constantinople, took Athens and began a long siege of the Acropolis: it ended only in 1458, when the citadel became the garrison of Turkish forces (they occupied a small village of simple houses densely packing the spaces between the ancient monuments). Perhaps two years later, during the visit of the great Sultan Mehmet II, the Parthenon was transformed once more, this time into a mosque that one well-travelled Turk would later claim to be the most magnificent in the world.[8] In fact, this conversion took a relatively minor toll upon the building [Fig. 238]. The walls (and thus the Christian frescoes) were whitewashed, though the mosaic of Our Lady of Athens in the apse apparently remained uncovered; windows were blocked up; and the Christian watchtower was transformed into a minaret. The structure was otherwise left more or less intact. Still, the destruction of the ancient sculptures clinging to the building continued apace (not just because they were pagan graven images, which was bad enough, but also because their marble limbs, torsos, and heads, burned in the kiln, proved ready sources of lime for mortar).

The wonder is that there was still so much of the Parthenon sculptures left to see when, during a lull in the hostilities between Europeans and Turks, an artist we know as Jacques Carrey of Troyes, attached to a French embassy sent by Louis XIV to improve relations with the Ottoman Empire, made his invaluable drawings.[9] The year was 1674, just thirteen years before Morosini's bombardment and the destruction of, for example, the central metopes on the south side of the building [Fig. 139]. With its peristyle columns still standing, with its west pediment still full of sculpture [Fig. 140], with its frieze and south metopes still mostly intact, the Parthenon that Carrey saw in 1674 was still obviously a Greek temple in origin and outward form. But with its peristyle roofless and walled up, with an interior fabric made up of so much re-used material, with its west entrance and doorways, with its Christian apse, mosaics, and windows, and with its whitewashed walls and Moslem minaret, the Parthenon that Morosini's gunners fired upon in 1687 would have seemed very strange to Perikles. It was almost as much a Medieval building as it was Classical.

The Parthenon of 1687 was, then, an architectural palimpsest, a monument whose fabric in details large and small revealed a multitude of earlier Parthenons (Periklean, Roman, and Christian as well as Moslem) and, indeed, incorporated blocks from dozens of ancient monuments. It was much the same with the other major edifices on the Acropolis. The Erechtheion became a church in the seventh century AD but, after the Turkish conquest, was transformed into a harem for the commandant of the Acropolis garrison; by the end of the eighteenth century, much of it was in ruins, and the north porch was used as an ammunition dump. In the sixth century AD a large vaulted cistern was inserted east of the Propylaia's Pinakotheke, on the spot of the northeast hall that Mnesikles planned but never built [Fig. 239]. In the seventh century the Propylaia's southwest wing became a small chapel; later still, as we have noted, the Propylaia became a formidable ducal palace; and in the early fifteenth century a church of San Bartolomeo was built over the (by then) ancient cistern at the northeast angle.[10] The Turks made their own changes internally, and around 1645 a bolt of lightning ignited gunpowder they had stashed in the northwest wing [Fig. 167] – an omen of the even greater disaster to come 42 years later. As for the Temple of Athena Nike [Fig. 182], it had indeed been nearly perfectly preserved when the Turks dismantled it and used its blocks for their new gun emplacement in 1686: for the next a century a half it was as if the elegant little temple had never been.[11]

The material history of the Parthenon itself did not, of course, end with the explosion of 1687, though it would

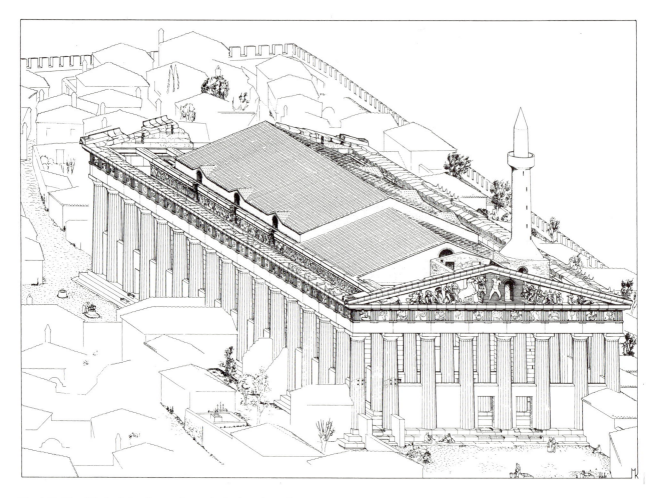

Fig. 238. The "Turkish Parthenon," as it looked in the 17th century. Drawing by M. Korres, used by permission.

always remain a roofless shell of its former self. Not long after the Turks re-took Athens a small domed mosque was set obliquely on its floor [Fig. 240]. This Parthenon, too, would for the next century and a half endure repeated damage and loss – from the petty vandalism of lime-burners and souvenir-hunters, to the removal of fallen sculptures dug up in the ruins around it, to assorted acts of God (in 1788 south metope 6 fell off the building in a storm and smashed into several pieces). Between 1749 and 1800 eight statues disappeared from the west pediment alone. But most notoriously, from July 31, 1801, until the middle of 1805, the Acropolis suffered the agents of Thomas Bruce, the seventh Earl of Elgin and British ambassador to Constantinople. His lordship's original purpose was merely to make measured drawings and plaster casts of the Parthenon sculptures in order to hasten "the progress of the Fine Arts" back home in Great

Britain. But his men, led by the Italian landscape painter Giovanni Battista Lusieri and the less than scrupulous Reverend Philip Hunt, liberally interpreted a vague Turkish *firman* (an official letter from the Ottoman Government conferring favors) and, with Elgin's enthusiastic if long-distance support (Elgin himself visited Athens only twice, and briefly), managed to strip the Parthenon of most of the surviving pedimental sculptures and south metopes and saw off most of the frieze from its blocks (to ease the weight for the trip back to England). Pieces of the Propylaia and Erechtheion (including a Karyatid from its south porch), not to mention assorted inscriptions and other marbles, were collected and removed as well.[12] Two decades later, during the Greek War of Independence, the Parthenon came under violent attack twice more, first by Greeks besieging Turks (1821–22) and then by Turks besieging Greeks (1826–27). While the Greeks fired upon their Acropolis only reluctantly and even offered to supply their foes with ammunition to prevent them from dig-

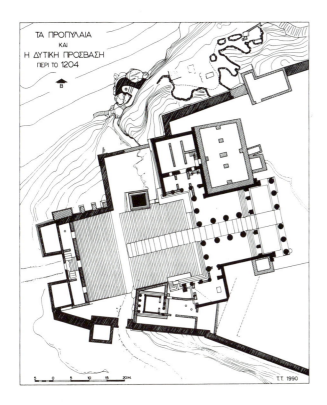

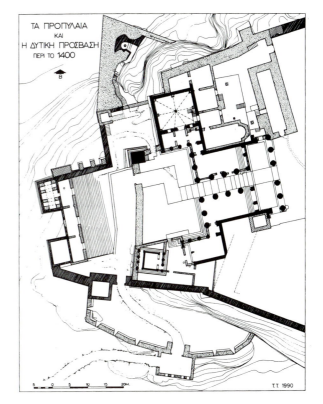

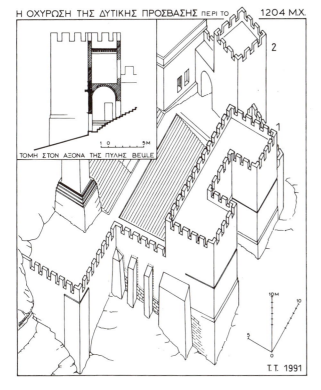

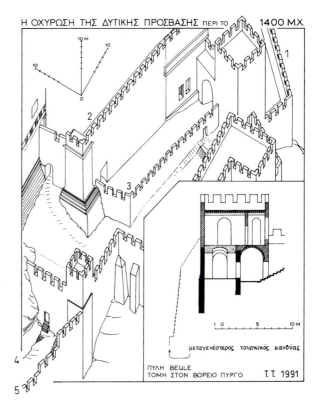

Fig. 239. Plans and reconstructions of the Propylaia in the
early 13th (left) and early 15th (right) centuries AD. Drawings
by T. Tanoulas, used by permission

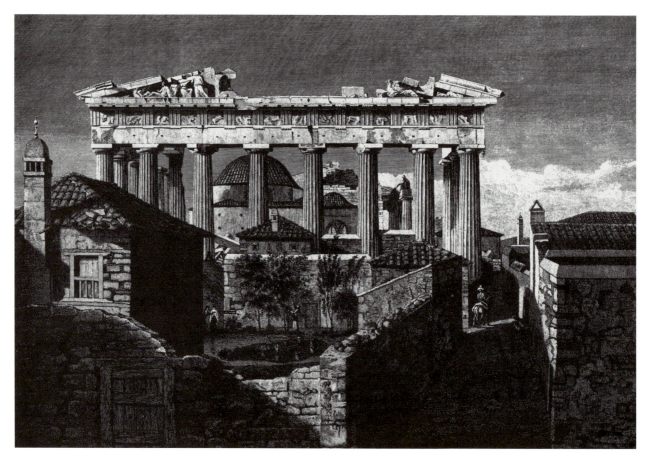

Fig. 240. Drawing of Parthenon from the east in 1765, by W. Pars. The small domed mosque built after the explosion of 1687 is visible through the columns. After Stuart and Revett 1789, vol. II, pl. I.

ging the lead out of the Parthenon's clamps to make bullets,[13] the Turks had no compunction about firing their guns, and the west columns of the Parthenon still show the scars of this final (and, by the way, successful) bombardment [Fig. 241].

When the last Turkish defenders of the Acropolis finally straggled out of the citadel on March 31, 1833, a contingent of Bavarian soldiers crisply marched in (they bivouacked in the mosque inside the Parthenon). In March 1835, they marched out again, and with that act of demilitarization the Acropolis – the symbolic center of Athens, itself the recently designated capital of the new Kingdom of Greece – ceased to be a fortress and became in fact what the young King Otto had the previous year officially declared it to be: an archaeological site. Almost immediately, and well into the next century,

the Acropolis underwent the most rapid and radical series of changes it had experienced since the Periklean era. These changes were intended to do two things: first, eliminate from the surface of the rock every trace of the "barbarians" (that is, Franks, Florentines, Turks) who had occupied and "contaminated" the sanctuary for so long, and, second, restore the "Classical purity" of the place. The first goal was achieved easily enough (which is not to say it was a good idea): it is not hard to knock stuff down. The second goal was impossible from the start, for the kind of purity the nineteenth-century stewards of the Acropolis had in mind never in fact existed.

The first fifty years of what we might call the Acropolis's "Removal and Restoration Period" saw, under the direction first of Bavarians and then Greeks, a nearly constant flurry of unsystematic, poorly documented, and often thoughtless demolition and excavation (to use the term loosely).[14] In 1835, the pieces of the Temple of Athena Nike were discovered when the Turkish gun battery below the Propylaia was dismantled: the temple was then partly and badly rebuilt, with many stones

298

arranged haphazardly (this – the first modern restoration of an Acropolis monument – was not actually completed until 1843–44). From 1836 to 1850 most of the Frankish and Turkish modifications of the Propylaia were removed. The vast triangular area between the Propylaia, Erechtheion, and Parthenon was cleared of the humble village that had filled it. The Erechtheion's north and south walls and porches were re-erected and restored (a copy of the Karyatid removed by Elgin was set in place in 1847). The *pronaos* of the Parthenon was explored (1839), a number of columns in the north and south colonnades and large parts of the cella walls were rebuilt, and the small mosque within was torn down (1841–1842). And in 1850 the Claudian stairway leading up to the Propylaia was partly restored.

The years between 1850 and 1885 were just as active. Ernest Beulé revealed the Post-Herulian gate named after him (1852–53) [Fig. 230]. The Parthenon's Christian apse was largely removed and the interior of the Erechtheion was excavated to bedrock (1862). Large portions of the southeast area of the Acropolis were dug, revealing such masterworks as the Moschophoros, the head of Athena from the Archaic Gigantomachy pediment, and the torso of the Kritios Boy (1863–66) [Fig. 242]. In 1875, amid great controversy, the Frankish (Tuscan) Tower at the south end of the Propylaia was demolished: the project was largely paid for by the renowned Heinrich Schliemann, who had discovered Troy only five years earlier. And then in 1885 the Removal and Restoration Period entered a new phase: for five years (until 1890) Panayiotis Kavvadias, aided by the German architects W. Dörpfeld and G. Kawerau, undertook massive, comparatively systematic but still poorly recorded excavations of the entire Acropolis summit,[15] overturning literally every cubic inch of earth above bedrock, revealing (among other things) the late Archaic podium of the Classical Parthenon [Fig. 106] and the foundations of the *Archaios Neos* [Fig. 82], the Chalkotheke, the Brauroneion, and the Temple of Roma and Augustus, as well as exhuming mounds of pre-Persian pottery and statues – particularly Archaic *korai* [Fig. 101] – from their mass graves.

By the time the nineteenth-century excavators got done with it, then, virtually nothing post-Classical remained standing and no plot of earth remained undug. But the restoration of the four principal Classical monuments – Parthenon, Propylaia, Erechtheion, Nike Temple – continued, largely under the direction of a well-intentioned but overmatched civil engineer

Fig. 241. The imprints of cannonballs on the western columns of the Parthenon. Photo: author.

named Nikolaos Balanos. Balanos's most grievous legacy was his wanton use of thousands of iron clamps and pins to keep the reset stones in place – iron whose corrosive effects and thermal expansion and contraction have cracked and shattered the marbles they were supposed to hold together. The Parthenon underwent several major operations – from 1898 to 1902 (when its western section received the most attention), in 1908 and in 1913, and then from 1922 to 1933 (when nine columns of the north peristyle and five of the south were fully or partly restored, together with their entablature, and the east pediment and cella walls were repaired). From 1902 to 1909 the Erechtheion was comprehensively and, it was thought, definitively restored (the south wall, for example, was rebuilt to its full height). The Propylaia was given similar treatment from 1909 to 1917 (when, for example, the east portico and coffered ceiling were

Fig. 242. Photograph taken c. 1866 showing Moschophoros, head of Athena from the Gigantomachy pediment of the *Archaios Neos*, and torso of the Kritios Boy after excavation. N. Catsimpoolas Collection, Boston, reproduced by permission.

repaired). And from 1935 to 1940, a second restoration of the Nike Temple, necessitated by the weakening of its foundations, took place (already a century after the first). Various smaller-scale repairs occurred during and after World War II. But since 1975, when the Committee for the Conservation of the Acropolis Monuments began its truly monumental task, the four major Classical structures on the summit have undergone comprehensive, meticulous, and brilliant (if sometimes controversial) restorations intended to incorporate within the buildings hundreds of blocks that, though they have long littered the site, have only recently been identified and properly assigned and, above all, to save the buildings as much as possible from a) the sometimes arbitrary and destructive restorations of earlier architects (Balanos's iron is now

replaced with titanium, and blocks that were randomly positioned before are being put where they belong), b) the effects of recent earthquakes, and c) the ravages of modern atmospheric pollution, which turns marble to friable and water-soluble gypsum and has required the recent removal of the last remaining original sculptures of the Parthenon and Erechtheion and their replacements by casts. The restoration of the Erechtheion, which was taken apart and put back together nearly from top to bottom, was completed in 1987 [Fig. 173]. Work on the Parthenon, Propylaia, and Nike Temple, originally scheduled to conclude before the century's end, is likely to continue well into the next millenium.

The important point is this: while the individual buildings have been and continue to be subject to vari-

ous degrees of restoration, the Acropolis we see today – the familiar panorama we will probably always see [Fig. 4] – is essentially what the archaeologists of the nineteenth century, under the powerful spell of Romanticism and Neo-Classicism, decided to leave us.[16] It is a picturesque configuration of ruins that was virtually sculpted out of the thick and chaotic mass of fortifications, hovels, and marble that covered the summit in 1834, a beautiful "tableau" consisting of a quartet of magnificent marble edifices tastefully keeping their distance, with enough empty space between them to allow streams of visitors to move comfortably through it all and constantly reframe their perspectives of the monuments and thus of Classical antiquity itself.

In a letter describing his reaction to the Acropolis on his first visit in 1904, Sigmund Freud recalled that "when, finally, on the afternoon after our arrival, I stood on the Acropolis and cast my eyes around the landscape, a surprising thought suddenly entered my mind: 'So all this really *does* exist, just as we learnt at school!'"[17] And in an essay dealing with the relation of architecture and film, the great Russian director Sergei Eisenstein wrote: "The Greeks have left us the most perfect example of shot design, change of shot and shot length. . . It is hard to imagine a montage sequence for an architectural ensemble more subtly composed, shot by shot, than the one that our legs create by walking among the buildings of the Acropolis. . . . [The Acropolis has the right] to be called the perfect example of one of the most ancient films."[18] Freud records a kind of excited incredulity commonly experienced even today, and Eisenstein had a point. But the composers of the particular montage that they and we admire so much now were modern Greeks, not ancient ones. The individual buildings are as modern restorations have left them, and the composition of solid marble and empty space we traverse today is the product of the nineteenth century AD, not the fifth or fourth BC: how unlike the Classical Acropolis [Fig. 124] it is, with no forest of statues and inscriptions and monuments clogging the spaces between the buildings, with no precinct or terrace walls or subsidiary buildings obscuring the views of the architectural main events. The ancient Acropolis never looked like Freud's, Eisenstein's, or ours; no Acropolis ever did. The Acropolis that exists [Fig. 4] is the product of what Early Modernism thought the Acropolis *ought* to look like: it is an image, a creation, a work of art. And if image is not quite everything, this one has become immensely successful: it is what we think of when we think of Classical Greece itself.

The image is powerful and resistent. The Acropolis has become an icon – so mighty that some regard the way it is as sacrosanct. But, the fact is, the Acropolis we see today is only one of many possible Acropolises. It has been argued that since time was never frozen on the citadel and the Acropolis has always existed in an historical continuum – Periklean architects themselves implicitly acknowledged as much by prominently incorporating or displaying Archaic and even Mycenaean walls and foundations into *their* sanctuary [cf. Figs. 54, 181] – the only "accurate" restoration of, say, the Parthenon would be one that somehow revealed the marks that the many periods of its historical and cultural use left upon it. The Parthenon was a church and mosque far longer than it was a temple (it was dedicated to the Virgin Athena for about nine centuries but to the Virgin Mary and then to Allah for thirteen). That later history, it has been argued, should be acknowledged with a display of at least some of the architectural evidence for the Christian and even the Moslem Parthenon. So, too, a standing portion of, say, the Frankish Tower [Fig. 232, 233] would speak (or would have spoken) eloquently of the citadel's long life as a Medieval fortress. That would, certainly, create a different image of the Acropolis from the one we are used to, and something would be lost as well gained (had something of the Frankish Tower survived or been reconstructed, for example, our appreciation of the Mnesiklean Propylaia as a discrete work unencumbered by later building would obviously be compromised). But few scholars today would dispute that the early removers and restorers were too eager to purge the rock of evidence for its "cultural stratigraphy" – for the many overlapping layers of its use.

Yet it does no good to blame nineteenth-century archaeologists for not subscribing to the tenets of late twentieth-century historic preservation, and the modern Acropolis is not just the result of what some abstract mentality thought it ought to look like. It is also the expression of a political ideal. In 1834 Greece was not yet entirely free of foreign domination (King Otto himself was an underage Bavarian prince foisted upon the Greeks by the European powers), but at least there was a Greece and it was independent. The Acropolis, to no one's surprise, was projected as the symbol not only of past Greek glory but also of new Greek freedom: it would bridge the gap across a Medieval and Moslem abyss. In that context the demolition of Frankish, Florentine, and Turkish buildings wherever they were to be

301

found was an *ideological* act, not merely an expression of Neoclassical taste: this was archaeology as politics. And so, while we can blame some of the excavators and restorers of the nineteenth-century Acropolis for their zealousness and carelessness, we cannot really blame them for tearing down every vestige of foreign occupation, for their passionate desire to fortify the idea of a new Greece with a marble-scape that shed the poor detritus of occupiers, or for leaving the Acropolis dominated by the four monuments that spoke most directly and movingly to the Greeks themselves. We do not fault Byzantine Christians for turning the Parthenon into a church or Moslem Turks for turning it into a mosque (what else should they have done?). Similarly, we should not fault nineteenth-century archaeologists for being men of their time, for choosing the fifth century BC (rather than, say, the fifteenth century AD) as their political and cultural ideal, or for wanting to make the Acropolis "purely" Greek and Classical once again.

Paradoxically, it is even true that the very way the Acropolis was cleared and its monuments restored – the "decontamination" of the place by the demolition of the small mosque within the Parthenon, the Frankish Tower, and every Turkish house, the re-erection of columns blasted over by the explosion of 1687, and so on – is as much a part of its cultural history as the actions of ancient or Medieval builders. If, then, the Acropolis as it is today is an artificial, even imaginary composition – the rendering of a sanctuary that never was exactly as it is – it is still in a sense an authentic cultural artifact, an artistic arrangement that tells us less about the Classical sanctuary than it might at first appear, but that certainly tells us a lot about a temperament that sought, rightly or wrongly, to restore the place as an ideological tool in the re-creation and promotion of a new nation. And if the Acropolis as the nineteenth century remade it, and as the current admirable restoration program will essentially leave it, ignores almost everything but its Classical efflorescence, we must also concede that any other possible Acropolis we might choose to reconstruct would be no less an artifice, no less a selection that future scholars, with a different ethos and a different agenda, might fault. No reconstruction will ever, perhaps, be definitive and the Restoration Period will never end.

APPENDICES

APPENDIX A

PAUSANIAS'S DESCRIPTION OF THE ACROPOLIS

Pausanias spent some twenty-five years researching and writing his *Description of Greece*. Evidently born to affluence in the city of Magnesia in Asia Minor (his travels must have taken a lot of money as well as a lot of time), Pausanias visited Athens and composed his guide to its monuments (which forms the core of the first book of his ten-book-long work) sometime between 155 and 161 AD.[1] He was thus further removed from the creation of many of the monuments he describes (Pheidias's Athena Parthenos, for example, dedicated in 438) than we are from, say, Michelangelo's creation of *David* (1501–04 AD). There are many monuments that he leaves out of his guide (such as the small but conspicuously placed Temple of Roma and Augustus east of the Parthenon, Fig. 227),[2] and there is much more we would like to know even about the monuments he does mention (for example, his identification of the subject of the Parthenon's frieze, had he only made one, would be as priceless as his identification of the subjects of the temple's pediments). Pausanias does not give distances between the monuments he visited (which would help us pinpoint some of them); he is known to have made mistakes (or to have recorded the errors of his own guides); he sometimes seems to retrace his steps without explicitly telling us so; he often simply says something is "worth seeing" without saying why; and he frequently digresses at length. For all that, the information he provides is crucial for our understanding of the Acropolis (as of so many other sites) and the essential trustworthiness of his descriptions cannot now be doubted. Indeed, it is safest to accept the witness of Pausanias unless there are compelling reasons to do otherwise.

Apparently starting out from the Prytaneion (Athens's "town hall," located in the area of the Archaic Agora east of the Acropolis) [Fig. 2], Pausanias took the Street of the Tripods, which curves around the eastern end of the citadel, to the sanctuary and Theater of Dionysos on its south slope [Fig. 3, no. 21]. At the theater he mentions a nearby structure said to have been a replica of Xerxes's tent (by which he means the Odeion,

or Concert Hall, originally built by Perikles but destroyed when Sulla took Athens in 86 and subsequently rebuilt), and then comments on the portraits of tragic and comic playwrights (including those of Menander, Euripides, Sophocles, and Aeschylus) on display within the Theater of Dionysos itself. He seems to have scaled the auditorium of the open-air theater to take a closer look at a large gilded-bronze head of Medousa (or gorgoneion), set upon Athena's *aigis*, dedicated high on the south wall of the Acropolis by Antiochos, king of Hellenistic Syria [cf. Fig. 223].[3] And above the highest seats he saw a cave with a prize-tripod set atop it: the khoregic Monument of Thrasyllos [Fig. 9]. He fails to mention the elaborate architectural facade Thrasyllos created for the cave, but does note within it a scene (painted, perhaps, rather than carved) of Apollo and Artemis slaying the children of Niobe. From the theater he moved westward along the south slope and mentions, in order: the tomb of Kalos (a skilled artisan murdered by his jealous uncle Daidalos);[4] the sanctuary of Asklepios ("worth seeing" for its many paintings and statues of the healing god and his children) [Fig. 192]; a temple of Themis [Fig. 3, no. 29][5] and, in front of it, a monument to Hippolytos, son of Theseus; a shrine supposedly established by Theseus himself to both Aphrodite of All the People (Pandemos) and Persuasion (Peitho) [Fig. 33]; and, finally, the apparently joint sanctuary of Earth, Nurse of Youth (Ge Kourotrophos), and Demeter the Green (Khloe). These last two shrines were located just below the bastion of the Temple of Athena Nike [Fig. 3, no. 31].[6] Conspicuously absent from Pausanias's description of the south slope is any reference to the Odeion of Herodes Atticus, a magnificent marble and limestone structure that is impossible to miss [Fig. 3, no. 30; Fig. 226]. But later in his guide (7.20.6) Pausanias himself explains the omission and helps us date the composition of his pages on Athens besides: "This odeion is not mentioned in my book on Attica because my description of Athens was finished before Herodes began the building [in memory of his wife, Regilla, who died in 160 or 161 AD]."

In the following translation of Pausanias's description of the summit of the Acropolis (Book 1.22.4–28.3), the longer and less relevant digressions are omitted. The Greek text is, with some modifications, that of W. H. S. Jones, *Pausanias: Description of Greece* (Loeb Classical Library, Cambridge, Mass., 1918).

1.22.4. There is only one entrance to the Acropolis: it provides no other way, since it is everywhere precipitous and its wall is strong. The Propylaia [Gateways, Fig. 166] has a ceiling of white marble, and for its ornament and the size of its blocks it has not been surpassed even up to my own day. I cannot say for sure whether the statues of horsemen are the sons of Xenophon or whether they were made just for decoration.[7] To the right of the Propylaia is the Temple of Wingless Victory [Fig. 181].[8] From here one can plainly see the sea, and it was here, so they say, that Aigeus hurled himself to his death. [5] For the ship that carried the children to Crete put to sea with black sails, but Theseus – he courageously sailed with them to fight the so-called Bull of Minos – promised his father that he would use white sails if he sailed back conqueror of the bull. Once he lost Ariadne, however, he forgot such things. Then Aigeus, when he saw the ship returning under black sail, thinking his son was dead, leaped from this spot and destroyed himself. There is a hero-shrine dedicated to Aigeus at Athens. [6] To the left of the Propylaia there is a building with pictures [Fig. 167].[9] Of those that time has not caused to fade away, there is Diomedes and Odysseus, the latter on Lemnos taking the bow from Philoctetes, the former taking the statue of Athena from Ilion. Among the pictures there is Orestes slaying Aigisthos and Pylades killing the sons of Nauplios, who had come to help Aigisthos; and there is Polyxena, about to be slaughtered beside the tomb of Achilles. It is good that in Homer this savage deed is omitted; but it seems to me Homer also did well by having Skyros captured by Achilles, which is nothing like those who say that Achilles dwelled on Skyros among virgins – this is what Polygnotos has painted. He also painted Odysseus surprising the women washing clothes with Nausikaa at the river, exactly as Homer described it. [7] There are other paintings, and an Alkibiades, whose portrait includes signs of the victory of his horses at Nemea. There is also Perseus travelling to Seriphos, bringing the head of Medousa to Polydektes. But I am not eager to tell the story of Medousa in my description of Attica. Among the other paintings – let me pass over the boy carrying water-jars[10] and the wrestler whom Timainetos painted – there is a Mousaios. I have read poems in which Boreas [the North Wind] gives Mousaios the gift of flight, but in my view Onomakritos wrote them, and nothing definitely by Mousaios survives, with the exception of a hymn to Demeter composed for the Lykomidai.

[8] At the very entrance to the Acropolis there is a statue of Hermes, which they call Propylaios.[11] And the Graces, they say, were made by Socrates, son of Sophroniskos, to whose stature as "the wisest of men" the Pythia was witness – a title she refused to give Anacharsis, who wanted it nevertheless and even travelled to Delphi to seek it.[12]

1.23.1. The Greeks say, among other things, that there were seven Wise Men. Among them, they say, were the tyrant of Lesbos[13] and Periander, the son of Kypselos. And yet Peisistratos and his son Hippias were more benevolent than Periander and wiser than he in both war and government, until, because of the death of Hipparkhos,[14] Hippias vented his rage against everyone, including a woman by the name of Lioness (Leaina). [2] When Hipparkhos died – what I am saying has not been written down before but is nonetheless held true by most Athenians – Hippias tortured her to death, since he knew she was the mistress of Aristogeiton and believed she could not possibly have been ignorant of the conspiracy. To make up for this, when the Peisistratid tyranny was put to an end, the Athenians dedicated a bronze lioness in memory of the woman. Beside it is a statue of Aphrodite, which, they say, was a dedication of Kallias and a work of Kalamis.[15]

[3] Next to it is a bronze statue of Diitrephes, who has been shot through with arrows.[16] Among other things this Diitrephes did, the Athenians say he led back home the Thracian mercenaries who arrived too late to join Demosthenes when he sailed out against Syracuse. [At this point Pausanias describes how Diitrephes captured the town of Mykalessos and how his Thracians massacred the populace, and then registers his surprise that Diitrephes could have been killed by arrows, since the only Greeks he knows who use the bow were the Cretans.] [4] Next to the statue of Diitrephes – I do not want to record the less notable images – there are statues of divinities: Hygeia [Health], who they say is the daughter of Asklepios, and Athena, also named Health [cf. Fig. 172].[17] [5] There is also a stone that is not big, but large enough for a small man to sit on; on this, they say, Silenos rested when Dionysos came to the land. "Silenoi" are what they call the oldest of the satyrs. [Pausanias here expresses his scholarly interest in satyrs and digresses to tell the tale of Euphemos the Karian, who on a voyage to Italy was blown off course to the Islands of the Satyrs. The creatures assaulted the women in his ship and violated one foreign woman, cast upon the shore to placate the satyrs, in a most unusual way.]

[7] Among the other things I know I saw on the Acropolis of Athens were a bronze boy holding a *perirrhanterion*[18] by Lykios, son of Myron, and Myron's own Perseus after having done what he did to Medousa. And there is a Sanctuary of Brauronian Artemis [Fig. 170]; the statue is the work of Praxiteles, but the goddess's name comes from the deme [township] of Brauron. The old *xoanon* [wooden image] is in Brauron – the Tauric Artemis, they call it. [8] The horse called The Wooden One is set up here, in bronze [cf. Fig. 168].[19] That the work of Epeios[20] was a siege machine built to break down the walls [of

Troy] everyone knows who does not think the Phrygians complete simpletons. It is said of that horse that it carried the best of the Greeks within it, and the design of the bronze one bears that out. Both Menestheus and Teukros are peeking out of it, and the sons of Theseus [i.e., Akamas and Demophon] besides. **[9]** Of the statues that are set up next after the horse, Kritios made the portrait of Epikharinos, who practiced the foot race in armor,[21] and Oinobios proved useful to Thucydides, the son of Oloros.[22] Oinobios successfully passed a decree allowing Thucydides to return to Athens from exile, though he was treacherously murdered when he returned; there is a monument for him not far from the Melitid Gates. **[10]** I omit the stories told about Hermolykos the pankratiast and Phormio, the son of Asopichos, since others have written about them.[23] [Nonetheless, Pausanias here adds the detail that the Athenians paid Phormio's heavy debts for him, thus allowing him to assume command of a naval expedition.]

1.24.1. Here there is an Athena striking Marsyas the Silenos because he wished to pick up for himself the flutes the goddess wanted thrown away. Across from these statues I have mentioned is the legendary fight of Theseus against the so-called Bull of Minos,[24] whether he was a man or a beast of the sort in the popular tale: even in our own day women have given birth to monsters far more wondrous than this. **[2]** There also stands a statue of Phrixos, son of Athamas, carried to the shore of Colchis by the ram: having sacrificed it to some god – so far as one can guess the one called Laphystios by the Orchomenians – and having cut out the thighs according to the custom of the Greeks, he watches them burn.[25] Next there are other statues, and a Herakles: he is strangling the snakes, as legend has it. There is an Athena rising from the head of Zeus. And there is also a bull, a dedication of the Council of the Areopagos,[26] which they dedicated for some reason or other: one could make many guesses why, if one wished. **[3]** I have said before[27] that the Athenians far exceed others in their zeal for religion: they were the first to give Athena the name Ergane [Worker]; they first set up limbless Herms; and together in the temple with them dwells the daimon [spirit] of good men.[28] Whoever prefers things made with artistry to those that are simply old may also look upon the following works. There is a man, by Kleoitas, wearing a helmet, and Kleoitas made his fingernails in silver.[29] There is also a statue of Earth beseeching Zeus to rain [cf. Fig. 225]: either the Athenians themselves needed rain or a drought had befallen all the Greeks. Here also are Timotheos, son of Konon, and Konon himself [Fig. 203].[30] Alkamenes dedicated the group of Prokne and Itys [Fig. 178],[31] she having already made up her mind about her son. Athena is represented displaying the olive tree, and Poseidon the sea-swell.[32] **[4]** And there is both a statue of Zeus by Leokhares, and one called Polieus [Of the City]: the established method of sacrificing to him I will write down, but not the traditional reason for it. Having placed barley mixed with wheat upon the altar of

Zeus Polieus [cf. Fig. 165], they leave it with no guard. The ox, which they have prepared for sacrifice and watch over, roams over to the altar and sets upon the grain. They call one of the priests "the ox-slayer," and he kills the ox, throws the axe down – for that is the custom – and flees. And they, as if they did not know who did the deed, bring the axe to trial. These things they do in the manner I have described.[33]

[5] For those entering the temple they name the Parthenon,[34] all the sculptures in what are called the pediments represent, in the front [that is, the east pediment, Fig. 136], the Birth of Athena, and in the one in back [the west pediment, Fig. 126] the Contest of Poseidon against Athena over the land. The statue [of Athena Parthenos, Fig. 132] itself is made of ivory and gold.[35] In the middle of her helmet there is set an image of the Sphinx – what is said about the Sphinx I will write down when I come to Boiotia[36] – and on each side of the helmet there are griffins carved in relief. **[6]** In his poems Aristeas of Prokonnesos says these griffins fight for gold with the Arimaspians beyond the Issedonians: he says the earth produces the gold the griffins guard, that the Arimaspians are all men born with one eye, and that griffins are beasts resembling lions, but have the wings and beak of an eagle. But let that be enough about griffins. **[7]** The statue of Athena is standing erect, with her dress reaching to her feet, and on her chest the head of Medousa is made of ivory. In one hand she holds a Nike [Victory] about four cubits tall;[37] in the other she holds a spear; and at her feet rests a shield and next to the spear there is a snake – this snake would be Erichthonios. On the base of the statue the birth of Pandora is carved in relief. It is said in Hesiod and other poets how Pandora was the very first woman; before her the race of women did not yet exist. I remember seeing there only the portrait of the emperor Hadrian, and, at the entrance, the portrait of Iphikrates, who achieved many wonderful things.

[8] Opposite the temple is a bronze Apollo, and they say Pheidias made the statue. They call it Parnopios [The Locust God], because when locusts were once ravaging their land the god said he would drive them away. That he did so, they know, but they do not say how. [Pausanias at this point recalls how locusts were destroyed three different times in his own day on Mt. Sipylos, near his probable hometown of Magnesia.]

1.25.1. There are on the Athenian Acropolis portraits of both Perikles, son of Xanthippos, and Xanthippos himself, who fought in the naval battle against the Medes at Mykale. The statue of Perikles [cf. Fig. 44] is set up elsewhere,[38] but next to the Xanthippos stands a statue of Anakreon of Teos,[39] the first poet after Sappho of Lesbos to write extensively about love: he has the look of a man singing while drunk. Deinomenes made the statues of women nearby – Io, daughter of Inachos, and Kallisto, daughter of Lykaon – and both their stories are exactly the same: the love of Zeus, the wrath of Hera, and the metamorphosis into an animal, Io into a cow, Kallisto into a bear.

[2] Close to the south wall Attalos dedicated groups representing the legendary war [of the gods] against the giants, who once dwelled around Thrace and on the isthmus of Pallene, the Athenians' fight against the Amazons, the action at Marathon against the Persians, and the destruction of the Galatians in Mysia: each of the figures is about two cubits long [Figs. 218, 219]. An Olympiodoros is set up there, too: he won glory both for the magnitude of what he did and especially for the timeliness of his actions, infusing resolve in men who had experienced continuous failures and who for that reason had no hope for anything good in the future. [At this point Pausanias digresses at length to sketch the history of Athens from the battle of Khaironeia in 338 to the revolt the courageous and popular Olympiodoros led against the Macedonians, culminating in an assault on Mouseion Hill in 288 that ended the Macedonian occupation of Athens. In the course of this history, Pausanias records that Lakhares, who cruelly, impiously, but briefly ruled Athens as tyrant in the very first years of the third century, stole golden shields from the Acropolis and even stripped "the statue of Athena" (presumably the Parthenos) of its gold before he escaped to Boiotia.]

1.26.3. Olympiodoros not only has honors on the Acropolis and in the Prytaneion in Athens, but there is also a painting of him at Eleusis. And the Elateans of Phokis dedicated a bronze Olympiodoros at Delphi because he came to their aid when they revolted from Kassander.

[4] Near the portrait of Olympiodoros stands a bronze statue of Artemis, surnamed Leukophryne; the sons of Themistokles dedicated it. For the Magnesians, whom Themistokles ruled by permission of the Great King [of Persia], hold Artemis Leukophryne in honor.

But I must carry on with my narrative, since I plan to cover all of Greece alike. Endoios was an Athenian by birth, and was a student of Daidalos; he even followed Daidalos to Crete when he fled because of the death of Kalos. There is a seated statue of Athena by him, with an inscription saying that Kallias dedicated it but that Endoios made it [cf. Fig. 99].[40] [5] There is also a building called the Erechtheion [Figs. 173, 174]: before the entrance is an altar of Zeus Hypatos (the Highest), on which they sacrifice no living thing but offer cakes, the custom also being not to use wine. Those who enter find altars of Poseidon, on which they also sacrifice to Erechtheus according to an oracle, of the hero Boutes, and, third, of Hephaistos. On the walls are paintings of members of the Boutadai family,[41] and also inside – for the building is double – there is sea-water in a reservoir. This is no great marvel, for other peoples who live inland also have such things – the Aphrodisians in Karia, for example. But this cistern is worth writing about because it produces the sound of waves when a south wind blows. And in the rock there is the form of a trident: these marks, it is said, appeared as evidence for Poseidon during the dispute over the land.

[6] The rest of the city and the whole of Attica alike are sacred to Athena – for even those who have established the worship of other gods in their demes hold Athena no less in honor – but the object considered by all most holy, even in the many years before the demes were unified, is the statue of Athena, kept on what is now known as the Acropolis but which was then known as the *polis* (city).[42] Legend has it that the statue fell from heaven. Whether this is so or not I will not get into, but Kallimachos made the golden lamp for the goddess.[43] [7] Having filled the lamp with olive-oil they wait for the same day one year later [to refill it], for the oil is enough for the lamp in the meantime, though it burns day and night. Its wick consists of Karpasian flax, which is the only kind that is fire proof; a bronze palm tree above the lamp reaches up to the ceiling and draws off the smoke. The Kallimachos who made the lamp, though inferior to the very best in this craft, was nonetheless the best of all in cleverness, so that he first drilled through stones and took the name *katatexitechnos* [Refiner of Art], or else adopted the name for himself after others had given it to him.

1.27.1. There is in the temple of [Athena] Polias[44] a Hermes made of wood, said to have been a dedication of Kekrops; it is not fully visible because of myrtle branches. The dedications worth mentioning include, among the old ones, a folding chair made by Daidalos and spoils taken from the Medes – the cuirass of Masistios, who commanded the cavalry at Plataia, and a short sword said to have been Mardonios'. Masistios, I know, was killed by Athenian horsemen, but, since Mardonios was killed fighting the Lakedaimonians by a Spartan, the Athenians could not have acquired the sword to begin with, nor is it very likely that the Lakedaimonians would have let them carry it away. [2] About the olive tree they have nothing to say, other than it was the goddess' evidence during the contest for the land. They also say that the olive was completely burned when the Mede set fire to Athens, but that on the very day it burned it grew back two cubits high.

[3] Adjacent to the temple of Athena is the Temple of Pandrosos: Pandrosos was the only one of the sisters[45] who was guiltless in the matter of the child [Erichthonios] entrusted to their care. There is something that amazed me here, and since it is not well-known to everyone I will write down what happens. Two maidens dwell not far from the Temple of Athena Polias [Fig. 3, no. 8], and the Athenians call them *Arrhephoroi* [Carriers of Sacred Things]. These girls live beside the goddess for some time, but when the festival arrives they do, at night, the following things. They put on their heads what the priestess of Athena gives them to carry – neither she who gives nor they who carry know what it is. There is a precinct in the city not far from [the sanctuary of] Aphrodite, nicknamed "in the Gardens," and through this there is a natural underground path. Down this the maidens go, and they leave below what they have carried down, but receiving something else – it is covered – they carry it back up.[46] At that point they release the girls from service, and bring other maidens to the Acropolis in

their stead. [4] Near the Temple of Athena is the statue of the old woman Syeris,[47] about a cubit high, said to be the servant of Lysimakhe, and there are large statues, in bronze, of men set apart in battle.[48] They call one of them Erechtheus, and the other Eumolpos. Yet those Athenians who know about antiquity could not have forgotten that Immarados, the son of Eumolpos, was the one killed by Erechtheus.[49] [5] On the base there are also statues of Theainetos, who prophesied for Tolmides, and Tolmides himself [whose military successes and death in battle Pausanias at this point summarizes]. [6] There are also ancient statues of Athena: nothing has fallen off, but they are very black and too fragile to survive a blow. They, too, were caught in the fire when the Athenians took to their ships and the Great King captured the city undefended by those in the flower of manhood. There is a boar hunt, though I do not know for sure if it is the Kalydonian boar, and a Kyknos fighting Herakles. They say this Kyknos killed, among others, Lykos of Thrace when prizes for single combat were proposed, but near the Peneios River he was killed by Herakles.

[7–8] [At this point Pausanias recounts two legends about Theseus: that he, as a child in Troizen, once attacked Herakles's lionskin thinking it was alive, and that, at the age of sixteen, he pushed away a rock to reveal tokens his father Aigeus had left for him.] A portrayal of this legend has been made on the Acropolis; everything is in bronze, except the rock.[50] [9] They have also set up another work commemorating a deed of Theseus, and the story goes like this. [Here Pausanias tells the story of the Cretan bull, which Herakles once captured but which, let loose, killed all it met until it reached Marathon in Attica.] [10] But at Marathon Theseus drove the bull to the Acropolis and, it is said, sacrificed it to the goddess; the votive offering is the dedication of the deme of the Marathonians.[51]

1.28.1. I cannot say for sure why they set up a bronze statue of Kylon, even though he planned a tyranny: I suppose it was because he was extremely handsome and was not obscure in fame, having captured an Olympic victory in the double-stade race, and married the daughter of Theagenes, tyrant of Megara. [2] Apart from the monuments I have listed there are two tithes the Athenians dedicated in the aftermath of war. First, a bronze Athena, financed from the spoils of the Medes who landed at Marathon, a work of Pheidias [Fig. 3, no. 7; Fig. 24]. The fight of the Lapiths and Centaurs and the rest of what has been wrought on the shield were, they say, engraved by Mys but designed for him, like the rest of his works, by Parrhasios, son of Euenor. The point of the spear of this Athena and the crest of her helmet are visible to sailors soon after they round Sounion. Second, there is a bronze chariot, a tithe of the spoils taken from the Boiotians and Chalcidians in Euboia.[52] There are two other dedications: a portrait of Perikles, son of Xanthippos, and, of all the works of Pheidias, the one most worth seeing – the statue of the goddess Athena, called Lemnia after those who dedicated it. [3] Except for the stretch that Kimon, son of Miltiades, built, the wall that surrounds the Acropolis [Figs. 4, 54] was built, it is said, by the Pelasgians, who once lived beneath the Acropolis. They say Agrolas and Hyperbios were the builders. When I inquired who they were, I was able to learn nothing, except that they were originally Sicilians who migrated to Akarnania.

At this point Pausanias (or his text) leaves the Acropolis, descending "not to the lower city but to just below the Propylaia," where he notes a fountain (the Klepsydra, Fig. 3, no. 17) and the cave-sanctuaries of Apollo and Pan on the northwest slope [Fig. 7]. He then moves on to the Areopagos (noting its altar of Athena Areia) and, nearby, the sanctuary of the Furies, a statue group of Plouto, Hermes, and Earth, a monument to Oedipus, and the ship used in the Panathenaia festival, which, he notes anticlimactically, is not the largest ship he has ever seen. Pausanias then directs his attention to the northwest, "outside the polis," to the Academy and Kerameikos cemetery beyond the Agora.

APPENDIX B
PLUTARCH ON THE PERIKLEAN BUILDING PROGRAM

Plutarch of Khaironeia (c. 45 AD to c.120 AD), prolific author, rhetorician, moral philosopher and, for the last part of his life, chief priest at Delphi, is most famous for his *Parallel Lives*, a set of twenty-three pairs of biographies of leading figures from Greek and Roman history, written as studies of the kind of virtue and character that produced "great men." Immensely entertaining as they are, the *Lives* are primarily anecdotal and didactic works, meant to edify and improve young men with good examples. Rigorous, analytical history they are not.

Although Plutarch knew Athens well (he went to school there), the fact remains that he wrote his *Life of Perikles* more than five hundred years after the death of his subject, probably during the reign of the emperor Trajan (98–117 AD). In fact, in the famous description of the building program that *Perikles* contains, Plutarch in important respects seems to have in mind the kind of highly centralized projects that characterized the Roman Empire of his own day, rather than Classical Greece, and in other respects he is misleading or incomplete. For example, the relationship between Perikles and the sculptor Pheidias that Plutarch describes is suspiciously like the one Trajan had with his master architect Apollodoros, and the implication that one of Perikles's major objectives in starting the program was to put the idle masses to work seems just as anachronistic (unemployment was a big problem in Plutarch's time, but probably not in Perikles's Athens). Although Plutarch states that Pheidias was in charge of the entire building program, a director of public works supervising virtually everything down to the last detail, the extremely heterogeneous styles of the Parthenon sculptures tell a different tale, and Plutarch himself lists different architects for different buildings. Moreover, we know from inscribed building accounts from the Acropolis that separate boards of commissioners (*epistatai*), elected annually by the people, oversaw each individual project, yet Plutarch knows nothing of their existence, and there is no evidence these boards were under the authority of any coordinating super-commissioner.[1] The kind of wide-ranging, all-powerful appointment that Plutarch imagines for Pheidias would simply not have been in character for democratic Athens. Finally, Pheidias seems to have (hurriedly) left the city around 438, a year or so before the inception of the Propylaia and before the carving of the Parthenon pediments had even begun (or at least had progressed very far). It is thus hard to see how Pheidias's role could have been as comprehensive as Plutarch says it was.[2] To be sure, Pheidias may well have acted as Perikles's general artistic advisor and he may even have sketched designs or fashioned clay models for others to execute in marble (it is not hard to imagine his big-name pupils Agorakritos and Alkamenes in charge of pediments or frieze). But the only work we know Pheidias himself created for the Periklean program was the gold and ivory Athena Parthenos (probably dedicated at the Greater Panathenaia of 438).

Plutarch and other sources also strongly imply that the Periklean building program was funded entirely by money diverted from the treasury of the Delian League (the 5,000 talents probably transferred to the Acropolis in 454). We do indeed know of at least one Periklean public work – a well-house built somewhere in Athens in the 430s – funded entirely from tribute.[3] But we also know from building accounts that the financing of the grander program on the Acropolis was not that simple. Perikles surely drew upon the accumulated reserves of the league, and he may also have specifically used that portion of annual imperial tribute that "legitimately" belonged to Athena and was deposited in her own treasury (the *aparkhai* or "first fruits," 1/60 of the total levy): that could have been one pillar of his successful defense against the politically-motivated accusations recounted by Plutarch. Yet the *aparkhai* by themselves would not have funded very much,[4] and so far as we know the *hellenotamiai* (the treasurers of the Greeks, that is, of the League) contributed to the costs of the Parthenon and its sculptures only five times in fifteen years. Far outweighing their contributions were those of the *tamiai* (the treasurers of Athena) who supplied the bulk of the funds

from Athenian reserves accumulated over previous decades (from the spoils of war, for example) and regular internal public revenues (harbor fees, court fines, rents, taxes, and so on). There were additional funds from less regular sources. A silver mine at Laureion, for example, is singled out as a financial backer of the Parthenon in 439/8 and of the Propylaia in 434/3. Rent from houses belonging to Athena helped finance the Propylaia. And even private contributions helped defray both the cost of the Athena Parthenos (they were applied to the costs of the Parthenon after the statue's completion) and the Propylaia.[5] It is, in any case, easy to overestimate the drain the Periklean building program put on the Athenian economy. Expensive it was, but to put things in perspective it is worth noting that the total cost of the Parthenon, the statue of the Athena Parthenos inside it, and the Propylaia – representing fifteen years of intense construction and artistry atop the Acropolis – may not have been much higher than the cost of a single military campaign at the start of the Peloponnesian War.[6]

All in all, Plutarch's description of the building program remains a vivid and engaging picture of Periklean Athens in action, but it must be used with considerable caution. The following translation of excerpts from the *Life of Perikles* is based on the text and commentary of P. A. Stadter (1989).

(XII.1) But what brought the greatest pleasure and embellishment to Athens, and the greatest astonishment to the rest of men, and what is now Greece's only evidence that her vaunted power and ancient wealth is no fiction – namely the construction of the dedications [that is, the buildings dedicated to Athena on the Acropolis] – this, of all the political acts of Perikles, is the one his enemies used to malign and slander in the assemblies most of all, shouting that "the people has lost its reputation and is ill-spoken of because it has transferred the common funds of the Greeks from Delos to itself, and that the most seemly excuse it had to use against its detractors, namely that it took the funds from Delos for fear of the barbarians and was now guarding them in a safe place, this excuse Perikles has destroyed. **(2)** And Greece must obviously think she is being terribly insulted and tyrannized, when she sees the tribute we have taken from her by force for the war used to gild and prettify our city like some vain woman, bedecking itself with expensive stones and statues and temples worth a thousand talents."

(3) Perikles would then instruct the people that they "did not owe the allies any accounting of their money so long as they defended them and kept the barbarians back, since they pay as tribute not a horse, not a ship, not a hoplite, but only money, which belongs not to those who give but to those who receive, if they indeed furnish what they receive the money for.[7] **(4)** And it is necessary for the city, once it has sufficiently equipped itself with what is required for the war, to apply its surplus to those things that, when complete, will bring it everlasting glory and, while under way, supply immediate prosperity, since all kinds of work and diverse needs develop, which stir every craft and rouse every hand, putting nearly the whole city under hire, so that it adorns and sustains itself at once." **(5)** For while the military campaigns supplied strong men in the prime of life with plenty from the common funds, he wanted the disorganized multitude of craftsmen neither to go without its share of income nor to receive money for idleness and leisure; and so with a rush of enthusiasm he proposed to the people projects for great constructions and plans for works requiring many skills and much time, so that those who stayed at home, no less than sailors, guards, and soldiers, might have an excuse for laying claim to and profiting from state funds. **(6)** Since the raw materials were stone, bronze, ivory, gold, ebony, and cypress, the crafts needed to work and perfect them were those of wood-workers, modelers, bronze-smiths, workers in stone, gilders, and shapers of ivory, painters, inlayers, engravers, but also the conveyors and deliverers of the materials, merchants and sailors and pilots by sea, and by land wagon-makers and keepers of oxen and muleteers and rope-makers and stone-haulers and leatherworkers and roadbuilders and miners. And since each craft, like a general with his own army, had in organized array its own mass of unskilled menial laborers, as the instrument and body of service, the requirements of the program distributed and scattered the city's wealth to virtually every age and condition.[8]

(XIII.1) But as the works rose, overwhelming in size yet also inimitable in form and grace, with the craftsmen striving to surpass their craft in the beauty of their workmanship, the most wondrous thing of all was the speed of their work. **(2)** For while it was thought that each one of these works would take many successive generations to reach an end, all of them were completed at the height of a single administration. . . . **(4)** For which reason the works of Perikles are to be especially wondered at, being made in so short a time, for all time. **(5)** For in beauty each one was then immediately ancient,[9] yet each seems fresh and newly-made even now. Thus a kind of newness always blooms over them, preserving their appearance untouched by time, as if his works were infused with an ever-fresh breath and ageless soul.

(6) Pheidias administered everything for him and was the overseer of everything, although the works also had great architects and artisans. **(7)** For example, Kallikrates and Iktinos built the Hekatompedon Parthenon,[10] while Koroibos began to build the Telesterion [i.e., the Hall of Mysteries] at Eleusis. It was he who set the columns on the ground floor and joined them with the architrave, but after he died Metagenes of Xypete carried out the frieze and the upper columns, and

Xenokles of Kholargos crowned it with the opening in the roof above the inner shrine.[11] For the long wall, which Socrates says he himself heard Perikles propose, Kallikrates was the contractor. **(8)** Kratinos lampoons this work for progressing so slowly:

> For so long (he says) Perikles has advanced the thing in words,
> but he does not move it forward at all in deed.

(9) The Odeion, built with an internal arrangement of many rows of seats and many columns, and with a roof that was steep and sloped down from a single peak, was, they say, a replica of the pavilion of the [Persian] king, and Perikles served as this project's supervisor. **(10)** And because of this Kratinos, in his *Thracian Women*, pokes fun at him again:

> The squill-headed Zeus! Here he comes,
> wearing the Odeion on his noggin,
> since ostracism-time has gone.

(11) At that time Perikles, ever ambitious, first passed a decree to hold a musical contest at the Panathenaia, and he himself was appointed contest-manager and decided how it was necessary for the competitors to play the flute, sing, and play the kithara. They watched these musical contests, both then and afterward, in the Odeion.

(12) The Propylaia of the Acropolis was built in five years, and Mnesikles was architect. A wondrous stroke of good fortune happened during construction and revealed that the goddess did not stand aloof from the project but took part in it and helped complete it. **(13)** For the most active and eager of the skilled workmen lost his footing and fell from a great height; he was in a sorry state, given up for dead by the physicians. Perikles was greatly disheartened, but the goddess appeared to him in a dream and prescribed a treatment which Perikles quickly used and easily healed the man. To commemorate this he set up a bronze statue of Athena Hygieia on the Acropolis beside the altar which had existed before, so they say.

(14) Pheidias himself made the golden statue of the goddess, and his name is inscribed as its creator on the stele. But nearly everything else was under his supervision as well, and he oversaw, as we have said, all the artisans through his friendship with Perikles. And this brought envy upon the one and slander upon the other, namely that Pheidias procured for Perikles free-born women who came to see the works under way. . . .

(XIV.1) When Thucydides [son of Melesias] and his political supporters denounced Perikles for squandering money and destroying the public revenues, he asked the people in the assembly if they thought he spent too much. And when they replied "Much too much," he said, "Then let the cost be charged not to you but to me, and I will put the inscription listing the dedications in my own name." **(2)** When Perikles said these words, either because they were struck by his magnanimous spirit or because they jealously wanted to take the credit for the works themselves, they cried out and urged him to spend and manage the public funds as he saw fit, sparing nothing. **(3)** And finally, setting down and risking a contest of ostracism against Thucydides, he banished him, and so destroyed the party that had been aligned against him.[12] . . .

(XXXI.2) [Plutarch has been recounting various criticisms of Perikles's conduct of Athenian affairs.] But the worst charge of all, yet the one that has the most witnesses, goes like this. Pheidias the sculptor was contractor for the statue [of Athena Parthenos], as I have said, and having become Perikles' friend and having the greatest influence with him he made enemies – some because he inspired envy, while others used him to make trial of the people and see what sort of judge of Perikles it would be. And these persuaded a certain Menon, one of Pheidias's assistants, to sit in the Agora as a suppliant and ask for immunity from prosecution in return for information and an accusation against Pheidias. **(3)** But when the people accepted the man's offer and the prosecution was held in the assembly, the charges of theft were not proven. For Pheidias, at the advice of Perikles, from the very beginning worked and affixed the gold on the statue in such a way that it was possible to take it all off and weigh it, which is precisely what Perikles bid his accusers to do. But the fame of his works weighed Pheidias down with others' jealousy, and especially [the charge] that when he made the battle against Amazons on the shield [of the Athena Parthenos] he carved a figure something like himself as a bald old man lifting up a rock in both hands, and that he put in a very beautiful image of Perikles fighting an Amazon. **(4)** The position of the arm, holding a spear in front of Perikles' face, is ingeniously made as if it desired to hide the likeness, though it is clear from either side. **(5)** Therefore Pheidias was taken to prison and died there of illness, though some say he died of poison provided by Perikles' enemies to discredit him. At the motion of Glaukon the people gave Menon, the informer, an exemption from public obligations and ordered the generals to take charge of the man's safety.

It is now clear both from archaeological evidence and the testimony of another ancient source (Philochoros *FGrHist* 328 F121) that, even if he was prosecuted, Pheidias did not die in prison in Athens but moved on to Olympia, where he was commissioned to create the gold-and-ivory statue of Zeus (one of the seven wonders of the ancient world). The story that Pheidias put a self-portrait and a portrait of Perikles on the shield of Athena Parthenos is likewise apocryphal, a patently post-Classical invention.[13]

APPENDIX C
CATALOGUE OF THE MAJOR BUILDINGS OF THE ACROPOLIS

The following abbreviations are used:

a Official name
b Date
c Architect or artist
d Cost
e Principal materials (preserved or known)
f Principal dimensions (in meters)
g Architectural order
h Sculptural decoration
i Principal ancient references or inscriptional evidence
j Select bibliography

ACROPOLIS SUMMIT

1. The Citadel Walls (Figs. 3, 4, 35)

a —
b 460s–430s
c Kallikrates, Mnesikles, *et al.*
d Unknown
e Mostly poros limestone with marble pieces. North wall and lower portion of south wall built primarily of reused material, including pieces from Archaic buildings destroyed by the Persians. Upper sections of south wall built primarily of newly quarried blocks.
f c. 730 (total length)
g —
h —
i Plutarch, *Kimon* 13.7; Pausanias 1.28.3; *IG* I³ 45.
j Mark 1993, 58–59, 62–63; Tanoulas 1992a; Dinsmoor, Jr. 1980, 63–64; Bundgaard 1976, 75–76, 125, 129; Travlos 1971, 53–54; Boersma 1970, 162 (cat. no. 20); Kavvadias and Kawerau 1906, cols. 26–28, 118.

2. The Sanctuary of Athena Nike (First Classical Phase) (Fig. 125)

a Sanctuary (*hieron*) of Athena Nike
b Early 440s?
c Kallikrates?
d —
e Poros limestone (from Aigina)
f Naiskos: c. 3.65 (length), 2.47 (width)
 Rectangular altar (east of naiskos): 1.245 (length), .782 (width) Square altar (northeast of naiskos): .935 × .94
 Precinct Retaining wall: c. 53 (total length)
g —
h —
i *IG* I³ 35.
j Mark 1993, 42–68, 104–07.

3. The Parthenon (Fig. 3 no. 13; Fig. 126)

a *Ho neos; hekatompedos neos*
b 447–432
c Pheidias ("general overseer" and master sculptor?), Iktinos and Kallikrates (architects)
d Building: c. 700–800 talents
 Statue of Athena Parthenos: c. 700–1,000 talents
e Pentelic marble throughout (approximately 30,000 tons); wood for rafters in ceiling of cella and roof; Pentelic marble ceiling coffers and roof tiles.
f Length (top of stylobate): 69.53
 Length (bottom step): 72.31
 Width (top of stylobate): 30.88 (c. 105 Attic feet)
 Width (bottom step): 33.68
 Interior length of west room (*parthenon*): 13.34
 Interior length of east room (*hekatompedon*): 29.87 (101.5 Attic feet)
 Peristyle: 8 × 17 (46 columns in all)
 Peristyle column height: 10.43
 Peristyle column diameter: 1.91
g Doric with Ionic features (Ionic columns in west room, continuous frieze atop cella wall, some mouldings).
h *Akroteria*:
 Corners: Nikai
 East and West Apex: Anthemia (floral ornaments)

Pediments (carved c. 438–432):

 East: Birth of Athena in the presence of
 Olympian gods

 West: Contest between Athena and Poseidon
 in the presence of Attic heroes and heroines

Metopes (92 in all, carved c. 447–442; height 1.2):

 East (14): Battle of Gods and Giants

 West (14): Battle of Greeks and Amazons

 North (32): Scenes from Trojan War

 South (32): Battle of Lapiths and Centaurs;
 subject(s) of central metopes (13–21) uncertain

Frieze (carved c. 442–432; total length 160m; height
 1m): Procession

Statue of Athena Parthenos (dedicated 438; height
26 cubits, or c. 11.5m, including base)

 Helmet decorated with sphinx and *pegasoi*

 Shield (exterior): Amazonomachy
 (in relief; figures possibly gilt bronze)

 Shield (interior): Gigantomachy
 (engraved, inlaid or painted ivory)

 Edges of Sandals: Centauromachy (relief)

 Base: Creation of Pandora in presence of 20
 divinities (relief; figures in gilt bronze or
 painted marble with golden attachments)

i Demosthenes 22.13, 76; Pausanias 1.24.5–7, 8.41.9;
Plutarch *Perikles* 13.6–7, 13.14; Pliny, *NH* 36.19; Vitruvius 7. *Praef.*12; *IG* I³ 436–451 (Parthenon building accounts); *IG* I³ 453–60 (Statue of Athena Parthenos); *IG* I³ 461 (doors).

j Mantis 1997; Pollitt 1997 and 1972, 71–105; E. B. Harrison 1996a, b; D. Harris 1995; Rhodes 1995; Hurwit 1995; Wesenberg 1995; Tournikiotis 1994; I. Jenkins 1994; Korres 1994a, b, c, d, g; Palagia 1993; Shefton 1992; Castriota 1992; Pedersen 1989; Boardman and Finn 1985; Berger 1984; Roux 1984; Despinis 1982; Ridgway 1981, 16–26, 42–54, 76–83; Coulton 1977, 108–17; Travlos 1971, 444–57; Leipen 1971; Bowie and Thimme 1971; Boersma 1970, 65–69, 177–78 (cat. no. 45); Herington 1955; Stevens 1955; Dinsmoor 1950, 159–79.

4. Building IV (Fig. 3, no. 16)

a *Heroon* of Pandion (?); *ergasterion* (?)

b 440s?

c —

d —

e Poros limestone foundations

f Precinct: c. 21 × 15
 Service Court: c. 19 × 15

g —

h —

i *IG* II² 1138, 1140, 1144, 1148, 1152

j N. Robertson 1996, 37–44; Kron 1976, 109–11; Bundgaard 1976, 77–78; Boersma 1970, 141 (cat. no. XXVII); Stevens 1946, 21–25; Kavvadias and Kawerau 1906, cols. 97–8.

5. The Great Rock-Cut Steps West of the Parthenon (Fig. 163)

a —

b 430s

c —

d —

e Bedrock and poros limestone

f Length: c. 35
 Original height of flight: c. 3.70

g —

h —

i —

j Stevens 1940, 24–40, 56–57; Judeich 1931, 241–43.

6. The Sanctuary of Zeus Polieus (Fig. 3, no. 14; Fig. 164)

a —

b 450–425 (remodelling of an older sanctuary)

c —

d —

e Poros limestone (foundations); wood; wattle

f West precinct: c. 26 × 16.5 (Stevens)
 East precinct: c. 18 × 25 (Stevens)
 Shrine in east precinct: c. 4.5 × 7 (Stevens)

g —

h No architectural sculpture extant, but a (cult?) statue of Zeus Polieus and another statue of the god by the fourth-century sculptor Leokhares were seen in or near the precinct.

i Pausanias 1.24.4; 1.28.10; Porphyry, *De abstinentia* 2.29; *IG* I³ 323, lines 53–54 (428/7).

j Mansfield 1985, 245–47; Boersma 1970, 146 (cat. no. XXXV); Stevens 1946, 12–15; and 1940, 79–86.

7. The Great Altar of Athena (Fig. 3, no. 12)

a —

b 450–425?

c —

d —

e Rock-cutting

f c. 15 × 8.5

g —

h —

i *IG* I³ 4 ("Hekatompedon Inscription," lines 9–10), 475, 476; Thucydides 1.126.

j E. B. Harrison 1996a, 50; and 1986, 117; Bancroft 1979, 58–61; Stevens 1940, 86.

8. The Propylaia (Fig. 3, no. 1)

a Propylaia

b 437–432

c Mnesikles

d 1,000 talents (Isocrates); 2,012 talents (Harpokration).

e Pentelic marble superstructure; blue-grey Eleusinian limestone also used ornamentally in steps, orthostates, and details (thresholds, benches).

f Width (entire, north-south): c. 48
Central hall: c. 25 × 20
Northwest wing: c. 15 × 12.5
Southwest wing: c. 7.5 × 12.5

g Doric; six Ionic columns inside west part of central hall.

h —

i Isokrates 7.66; Harpokration, *Lexicon* s.v. "Those Propylaia"; Demosthenes 22.13, 76; Pausanias 1.22.4–8; Plutarch, *Perikles* 13.12–13; *IG* I³ 462–66.

j Rhodes 1995, 68–74; Korres 1994b, 46; Tanoulas 1994a, b, c; 1992b; and 1987; Tomlinson 1990; Hellström 1988; Travlos 1971, 482–83; Boersma 1970, 70, 200–01 (cat. no. 72); Bundgaard 1957.

9. The Sanctuary of Artemis Brauronia (Fig. 3 no. 5, Fig. 170)

a —

b 430s?

c —

d —

e Poros limestone; rock-cuttings

f East precinct wall: c. 38 (north-south)
South Stoa: c. 7.25 × 15 (minimum east-west length) or 38.50 (maximum length)
East wing (final phase): c. 30.75 × 5.50 (interior width)

g Doric

h —

i Pausanias 1.23.7–8; *IG* II² 1514–31; *IG* I³ 895 (Strongylion's "Wooden Horse").

j Rhodes and Dobbins 1979; Linders 1972; Travlos 1971, 124; Boersma 1970, 72, 214 (cat. no. 89); Edmonson 1968; Stevens 1936, 459–70.

10. The Northwest Building (Fig. 3, no. 4; Fig. 171)

a —

b 437–432

c Mnesikles

d —

e Poros limestone

f Width (east–west, as built): c. 17.5
Length (east wall, as built): c. 15

g —

h —

i —

j Tanoulas 1994c and 1992b; Mark 1993, 63; Hellström 1988, 111–14; Boersma 1970, 229 (cat. 115); Kavvadias and Kawerau 1906, cols. 63–64, 67–70.

11. The Shrine of Athena Hygieia (Fig. 172)

a —

b c. 430–25

c Pyrrhos (sculptor of image)

d —

e Pentelic marble; image of bronze

f Semicircular base: c. .90 (top diameter); c. .90 (total height)
Altar platform: c. 3 × 2.5

g —

h Bronze statue of Athena Hygieia

i Pausanias 1.23.4; Plutarch, *Perikles* 13.12–13; Pliny, *NH* 22.44; *IG* I³ 506.

j Ridgway 1992, 137–38; Stadter 1989, 176–77; Travlos 1971, 124; Raubitschek 1949, 185–88; Stevens 1936, 451, 456.

12. Building III (The House of the Arrhephoroi?) (Fig. 3, no. 8)

a *Arrhephoreion?*

b Late fifth century?

c —

d —

e Poros limestone (foundations)

f Foundations of Building: c. 12 × 12

Court: c. 16 X 9 (interior)

g Doric?

h —

i Pausanias, 1.27.4; [Plutarch], *Lives of the Ten Orators: Isokrates* 839C.

j Jeppesen 1987,13–14; Mansfield 1985, 275–76; Bundgaard 1976, 34–35; Hill 1953, 178; Kavvadias and Kawerau 1906, cols. 76–78.

13. The Erechtheion (The Last Temple of Athena Polias) (Fig. 3, no. 9; Fig. 173)

a "The temple on the Acropolis in which the ancient image is"; "the temple of Athena Polias"; "the ancient temple" (*archaios neos*)

b Conceived mid-430s? Built c. 421–406/5 (with interruptions)

c Mnesikles? Philokles and Arkhilokhos (site supervisors during final building campaign, 409–406/5)

d —

e Pentelic marble, with foundations of Kara and poros limestone; dark Eleusinian limestone as background of frieze.

f Cella (stylobate, c. 22.46 × 11.63)

North porch (c. 7.55 × 10.72)

South porch (c. 3.56 × 5.57)

g Ionic

h Continuous Ionic frieze, subject(s) uncertain, with high-relief marble figures attached to dark limestone background

Length of frieze around cella: c. 49; height .617

Length of frieze on north porch: c. 25; height .683

Six Karyatids (ht. 2.31) in south porch

i Pausanias 1.26.5–1.27.4; [Plutarch], *Lives of the Ten Orators; Lykourgos* 843E; Strabo, 9.1.16; Vitruvius 4.8.4; *IG* I³ 474–79.

j Dix and Anderson 1997; Scholl 1995; Rhodes 1995, 131–40; D. Harris 1995, 201–22; Papanikolaou 1994; Jeppesen 1987; Mansfield 1985, 245–52; Ridgway 1981, 93–94, 105–08; Travlos 1971, 213–14; Boulter 1970; Boersma 1970, 87–88, 182 (cat. 50); Dinsmoor 1950, 187–95; Paton 1927.

14. The Sanctuary of Athena Nike (Final Classical Phase) (Fig. 3, no. 2; Fig. 182)

a —

b Bastion: begun late 430s?

Temple: 427–424 (Travlos); 424/23–418 (Mark)

c —

d —

e Sheathing of Bastion: Peiraieus limestone

Temple: Pentelic marble

f Temple: c. 8.17 × 5.40

Altar: c. 3.10 × 3.90

Precinct walls: north (c. 11.00); west (c. 10.50); south (c. 20)

g Ionic

h Temple frieze:

North: Battle of Greeks against Greeks (Athenians against Argives?)

South: Battle of Greeks against Persians (probably Marathon)

West: Battle of Greeks against Greeks (Athenians against Thebans?)

East: Assembly of Divinities

Pediments:

East: Gigantomachy

West: Amazonomachy

Akroteria (gilded bronze):

Apex: Bellerophon, Pegasos, and the Chimaira

Corners: Nikai (?)

Cult statue: Athena Nike, possibly seated, with pomegranate in right hand, helmet in left

Base of cult statue: frieze of uncertain subject

i Pausanias 1.22.4; 3.15.7 (cult statue); Harpokration, *s.v.* Nike Athena (cult statue); *IG* I³ 36, 64.

j E. B. Harrison 1997 and 1972; Rhodes 1995, 38–40, 113–19; Economakis 1994, 46, 169; Mark 1993, esp. 69–92; Donohue 1988, 54-57; Stewart 1985; Despinis 1976; Hölscher 1973, 92–94; Travlos 1971, 148–157; Boersma 1970, 132 (cat. no. XV) and 179 (cat. no. 47).

15. The Nike Parapet (Figs. 185–187)

a —

b c. 415–400

c Agorakritos (?) and others

d —

e Pentelic marble

f Height of parapet: 1.06

Total length: c. 31 (about 100 Greek feet)

g Ionic

h Approximately 50 Nikai leading and sacrificing cattle and erecting victory trophies, with a seated Athena (represented three times) presiding.

i —

j Simon 1997; Jameson 1994; Mark 1993, 90–91; Stewart 1990, 166–67, and 1985; Boardman 1985, 149–50; Ridgway 1981, 97–98; Brouskari 1974, 156–63; Pollitt 1972, 115–18; Carpenter 1929.

16. The Chalkotheke (Fig. 3, no. 6; Fig. 189)

a Chalkotheke (Bronze Store House)

b Periklean period or 380s/370s?

c —

d —

e Poros limestone (foundations); some material reused

f Length: 42.965
 Width: 21

g Doric (portico)

h —

i *IG* II² 1424a, 120, 1438, 1469 B, *et al.*

j Downey 1997; D. Harris 1991, *passim*; La Follette 1986; Travlos 1971, 196; Boersma 1970, 235 (cat. no. 126).

17. Monument of Eumenes II/Agrippa (Fig. 3, no. 3; Fig. 220)

a —

b Originally built c. 178 by Eumenes II of Pergamon; possibly rededicated to Mark Antony, certainly to Marcus Agrippa, in late first century.

c —

d —

e Grey (Hymettian) marble

f Foundation: 4.50
 Shaft height: 8.91
 Shaft width: 3.31 (east-west), 3.80 (north-south)

g —

h Bronze four-horse chariot with statue of Eumenes II, then Agrippa, set atop the monument.

i Plutarch, *Life of Antony* 60; *IG* II² 4122.

j Habicht 1997, 364; Korres 1994b, 47–48; Travlos 1971, 483; Hill 1953, 184.

18. Temple of Roma and Augustus (Fig. 3, no. 15; Fig. 227)

a Temple of Roma and Augustus Caesar

b 20/19

c —

d —

e Pentelic marble

f Greatest diameter: 8.60
 Diameter at stylobate: 7.36 (25 Attic feet)
 Height: 7.36 (from stylobate to sima)

g Ionic

h Statues of the personified Roma and Augustus set within the ring of columns

i *IG* II² 3173

j Schmalz (forthcoming); Hoff 1996, 185–94; Travlos 1971, 494; W. Binder, 1969.

THE SOUTH SLOPE

(Note: Because of its especially complicated history and many transformations from the late Archaic period to late antiquity, the Theater of Dionysos does not lend itself to easy tabulation and so is here omitted.)

19. The Odeion of Perikles (Fig. 3, no. 20; Fig. 190)

a Odeion (Music or Concert Hall)

b c. 440–430; rebuilt 63/2–52/1

c original architect unknown; Gaius and Marcus Stallius of Rome and Menalippos architects of rebuilding

d —

e Limestone (foundations); marble; wood (roof)

f c. 62.4 X 68.6

g —

h —

i Aristophanes, *Wasps* 1108–09; Xenophon, *Hellenika* 2.4.9, 24; Demosthenes 34.37; 59.52, 54; Andokides, *On the Mysteries* 38; Lykourgos, *Against Kephisodotos* 2; Vitruvius 5.9.1; Pausanias 1.20.4; Plutarch, *Perikles* 13.9–11; Appian *Mithridates*, 38. *IG* II² 3426, 3427 (rebuilding).

j M. C. Miller 1997, 218–42; Habicht 1997, 335–36; Kalligas 1994, 25–27; Hose 1993; Stadter 1989, 172–73; Korres 1980, 14–18; Robkin 1979; Travlos 1971, 387–91; Boersma 1970, 72 and 206 (cat. no. 79); Dinsmoor 1950, 211.

20. The Sanctuary of Asklepios and Hygieia (Fig. 3, no. 25; Fig. 192)

a Asklepieion; The Asklepieion in the City
b 420/19–412/11 (major additions and remodellings took place in fourth, third and first centuries and in the Augustan era).
c —
d —
e originally wood, later marble
f —
g —
h —
i Aristophanes, *Ploutos*, lines 659–747; Xenophon, *Memorabilia* 3.13.3; Pausanias 1.21.4; *SEG* XXV.226 (Telemakhos Monument); *Etymologicum Magnum*, s.v. Dexion.
j Aleshire 1991 and 1989, esp. 7–36; Ridgway 1983, 199–200; Wycherley 1978, 181–83; Travlos 1971, 127–42; Beschi 1967/8a.

21. Stoa of Eumenes II (Fig. 3, no. 27; Fig. 222)

a —
b 197–159
c —
d —
e Conglomerate, poros limestone, marble (both Hymettian and Pentelic)
f Length: c. 163
 Depth: c. 18
g Doric (exterior columns of lower storey), Ionic (exterior columns of upper storey and interior columns of lower storey), "Pergamene" for interior columns of upper storey.
h —
i Vitruvius 5.9.1
j Wycherley 1978, 184–85; Travlos 1971, 523; Dinsmoor 1950, 292–93.

22. Odeion of Herodes Atticus (Fig. 3, no. 30; Fig. 226)

a Odeion of Regilla (Herodes's wife)
b c. 160/61–174 AD
c —
d —
e Poros limestone, marble seating and veneer; roof of cedar
f Diameter of auditorium: c. 80
 Length of stage building: c. 92
 Height of facade: c. 28
g —
h —
i Philostratos, *Vitae Sophistarum* II, 1, 5.8; Pausanias 7.20.6.
j Travlos 1971, 378; Hill 1953, 112.

APPENDIX D
CHRONOLOGICAL TABLE

Neolithic (6000–3100 BC)

Early Neolithic
(6000–5000)

Middle Neolithic
(5000–4000)

Earliest habitation on the Acropolis?
Hut (or pit) on south slope

Late/Final Neolithic
(4000–3100)

Hamlets on slopes and summit (?)

Bronze Age (3100–1065 BC)

Early/Middle Bronze Age
(3100–1600)

Middle Helladic town on summit and slopes

Late Helladic (LH) or
Mycenaean Period (1600–1065)

	c. 1500	Earliest architectural remains atop Acropolis (LH I/II)
	c. 1270?	Terracing of summit Palace constructed (LH IIIB)
	1259/8	*Synoikismos* (unification) of Attica according to Parian Marble
	c. 1225/1200	Cyclopean fortification walls Mycenaean fountain (late LH IIIB)
	c. 1180/75?	Fountain abandoned, becomes dump (early LH IIIC)
	c. 1070/65	Palace goes out of use (end of LH IIIC)?

APPENDIX D

Dark (Iron) Age (1065–760 BC)

c. 1065–1000	Submycenaean settlement, graves on summit
c. 1000–900	Protogeometric settlement?
c. 900–760	Early/Middle Geometric settlement?

Archaic Period (760–480 BC)

c. 750–700	First Temple of Athena Polias (Late Geometric)?
c. 700–650	Second Temple of Athena Polias ?
632/1	Kylon seizes Acropolis, attempts tyranny
621/0	Drakon's law code
594	Solon's Reforms
575–550	Monumental ramp up west slope Renovation of Mycenaean bastion and gate (?) Establishment of Sanctuary of Athena Nike Building A
566/5	Founding of Greater Panathenaia
565–560	Bluebeard Temple (Third Temple of Athena Polias or First Temple on Parthenon site)
561/0	Peisistratos's first attempt at tyranny
c. 560	Moschophoros Earliest Acropolis *korai*
560–550	Pomegranate *kore*
557/6	Peisistratos's second attempt at tyranny
546–510	Continuous tyranny of the Peisistratids
550–540	Olive Tree pediment Building C Rampin Rider Lyons *kore* First Temple of Dionysos Eleuthereus (south slope)

320

	Earliest Sanctuary of Aphrodite and Eros (north slope)?
c. 530	Peplos *kore*
527	Death of Peisistratos; Hippias becomes tyrant
525–500	First Sanctuary of Artemis Brauronia
520–510	Antenor *kore*
514	Assassination of Hipparkhos
510	Overthrow of Peisistratid tyranny
508/7	Kleisthenes's democratic reforms
506	Victory monument commemorating defeat of Boiotians and Chalkidians
506?	Inauguration of *Archaios Neos* (Old Temple of Athena Polias, possibly fourth on north site)
c. 500	Building B Archaic cistern near entrance First Theater of Dionysos (south slope)
490	Battle of Marathon
490–480	"Older Parthenon," "Older Propylon" begun Euthydikos *kore* Monument of Kallimachos Sanctuary of Pan established (north slope cave)
480/79	Persian sack of Acropolis, destruction of Athens

Classical Period (480–322 BC)

480–475	Kritios Boy, Blond Boy
478/7	Founding of Delian League
c. 466	Battle of Eurymedon
c. 460	New citadel walls begun Pre–Erechtheion Klepsydra Fountain (northwest slope)

465/60–455/50	Bronze Athena (Promakhos) by Pheidias
460–450	"Mourning Athena" relief
454	Transfer of reserves of Delian League to Athens; League becomes Athenian Empire
c. 450	"Athena Lemnia" by Pheidias
449	Perikles proposes building program Temple of Athena Nike (first phase)?
447–432	Parthenon
438	Athena Parthenos dedicated
c. 440–30	Odeion of Perikles
437–432	Propylaia
c. 435	Erechtheion (final Temple of Athena Polias) conceived or begun?
434/3	Kallias Decrees
431	Peloponnesian War Begins
426	Major earthquake rocks monuments
c. 425	"Prokne and Itys" by Alkamenes
c. 425–420	Temple of Athena Nike (second phase)
421	Peace of Nikias
420/19	Asklepieion founded on south slope
415–400	Nike Temple parapet
406/5	Erechtheion finished
404	Peloponnesian War ends Spartans stationed on Acropolis
403	Athenian democracy restored

c. 390		Portrait of Konon (portrait of his son Timotheos added c. 350)
c. 380		Chalkotheke built?
c. 353		Demolition of Opisthodomos?
338–322		Age of Lykourgos Theater of Dionysos rebuilt
334		Battle of Granikos Alexander dedicates shields on Parthenon's east architrave
323		Death of Alexander
322		Battle of Krannon

Hellenistic Period
(322–31 BC)

320/19		Khoregic Monuments of Nikias and Thrasyllos (south slope)
304/3		Demetrios Poliorketes inhabits *opisthodomos* of Parthenon
300/99		Doric Stoa added to Asklepieion New Temple of Asklepios built
295		Lakhares reportedly strips Athena Parthenos of gold; statue eventually refitted with gilt sheets (Athena Parthenos II)
c.220–200		Smaller Attalid Monument (Attalos I)
c. 200		Gorgoneion of Antiochos III
c. 180–160		Stoa of Eumenes II
c. 178–150		Panathenaic Monuments of Eumenes II and Attalos II
146		Rome sacks Corinth
86		Capture of Acropolis by Sulla
c. 63–52		Rebuilding of Odeion of Perikles by Ariobarzanes II, king of Cappadocia

Roman Period
(31 BC–330 AD)

31 BC	Battle of Actium; Octavian defeats Antony
27 BC	Octavian becomes Augustus
Early 20s BC	Restoration of Erechtheion
c. 25 BC	Monuments of Eumenes II and Attalos II rededicated to Agrippa and Augustus
20/19 BC	Temple of Roma and Augustus
c. 45 AD	Claudius funds marble stairway to Propylaia
61/62 AD	Theater of Dionysos rededicated to Nero Neronian inscription set on Parthenon east architrave
117–138 AD	Reign of Hadrian Repair of Athena Parthenos II? Portrait of Hadrian in Parthenon
160–174 AD	Odeion of Herodes Atticus
176 AD	Marcus Aurelius visits Athens
202 AD (?)	Julia Domna assimilated to Athena Polias; her portraits displayed in Erechtheion and Parthenon
267 AD	Herulian Sack of Athens Parthenon burns, Athena Parthenos II destroyed
c. 270–280 AD	Beulé Gate Post–Herulian Wall

Late Roman (early Byzantine)
Period (330 AD–582/3 AD)

360s	Parthenon repaired; Athena Parthenos III installed
396	Alaric and Visigoths sack Athens
450–485	Bronze Athena (Promakhos) moved to Constantinople

	Athena Parthenos III removed and destroyed by Christians
529	Justinian closes philosophical schools
582/3	Destruction of Athens by Slavs

High Byzantine Period (582/3–1204 AD)

c. 600	Parthenon converted into Church of "Our Lady of Athens"
7th Century	Erechtheion converted into Church
1203	Mob destroys Bronze Athena (Promakhos) in Constantinople

Frankish–Florentine Period (1204–1456 AD)

1204	Athens falls to Franks
1206	Parthenon becomes Latin church Propylaia becomes ducal palace
1388	Acciauoli of Florence possess Acropolis
1388–1400	"Frankish Tower" built over south wing of Propylaia

Turkish Era (1456–1834 AD)

1458	Turks seize Acropolis
c. 1460	Parthenon converted into mosque
1645	Propylaia damaged when lightning ignites gunpowder stored within
1674	J. Carrey draws Parthenon sculptures
1687	Venetians besiege Acropolis, Parthenon blown up
1688	Turks recover Acropolis

After 1688	Small mosque built upon floor of roofless Parthenon
1801–5	Removal of Elgin Marbles
1821–22	Greeks besiege and capture Acropolis
1826–27	Turks besiege and recapture Acropolis
1833	Turks surrender Acropolis
1834	Acropolis declared archaeological site

**Restoration Period
(1834–Present)**

NOTES

Chapter 1

1. For the geology of Greece, Attica, and the Acropolis, see Lepsius 1893; Judeich 1931, 43–9; Trikkalinos 1972; Andronopoulos and Koukis 1976; Jacobshagen 1986; Gournelos and Maroukian 1990; and Higgins and Higgins 1996, esp. 26–30.

2. It has also been argued that the Acropolis is the remnant of a nappe, a huge rock that has slid or "migrated" through a variety of geological processes from its place of origin. In the case of the Acropolis, its original location may have been in the vicinity of Hymettos. See McPhee 1992, 70–1.

3. Now thought to be the "Cave of Aglauros"; see Dontas 1983.

4. Since 1977, as part of the massive conservation and restoration project still under way on the Acropolis, flexible wire nets and deep stainless steel and titanium alloy pins have been used to secure and anchor the most unstable portions of the outer faces of the rock. See Casanaki and Mallouchou 1983, 30–1.

5. Cf. Mountjoy 1995, 22.

6. These several springs, Plato suggests in a geological flight of fancy (*Kritias* 112c–d), are the remnants of a single great fountain on the site of the primeval Acropolis that was choked off by an earthquake.

7. Herodotos 7.140.

8. Thucydides 2.15.6. Inscriptions confirm that the Athenians could call the Acropolis simply *polis*; see Meiggs and Lewis 1988, no. 58 (Kallias Decree A, line 4).

9. Herodotos 8.44. Korres 1994b, 35, suggests "Kekropia" or "Kranaa."

10. "And so Athene of the flashing eyes spoke and crossed the barren sea; she left behind lovely Skheria,and reached Marathon and wide-wayed Athene . . . " (*Odyssey* 7.78–80).

11. See, for example, Apollodoros 3.14.1 ("Athena thus called the city Athens after herself"); also Hyginus, *Fabulae* 164, and Euripides, *Ion* 1555. See Burkert 1985, 139; Cook 1940, 224, 749; Guthrie 1955, 107; Simon 1980a, 179, and Simon 1983, 106. Perhaps *Athene* meant originally any "citadel rock." That may help explain why the worship of Athena was not limited to *this* rock or to Athens, and why Athena cannot be considered the projection of one city's religion upon the rest of Greece; cf. Hopper 1971, 68.

12. Herington 1955, 55. In fact, since the Athenian *polis*

(city-state) eventually encompassed all of Attica (and not just the city of Athens itself), the Athenians might have called themselves, more accurately, *Attikoi* ("inhabitants of Attika"). That they apparently did not even consider doing so suggests the strength of their special bond to Athena.

13. See Thucydides 2.39–41.

14. Cf. Euripides, *Suppliants* 1227–31.

15. Cf. Herington 1955, 56, and Loraux 1993, 66 (quoting Hegel: "Athena the goddess is Athens itself – i. e., the real and concrete spirit of the citizens").

Chapter 2

1. For the Greek conception of Gaia in later times see, for example, *Homeric Hymn XXX: To Earth, Mother of All*.

2. Vermeule 1972, 280.

3. See, for example, Plato, *Laws* 828. The opposition of earth and sky gods is a natural one and is found throughout the Near East, too; see Burkert 1985, 19, 201–2, and Scullion 1994.

4. Athena may not even have been the first divinity to be worshipped atop the Athenian Acropolis. Simon 1983, 105–6, suggests that Zeus, Pandrosos, and (Ge) Kourotrophos were three of the divinities who preceded her on the rock.

5. See Mylonas 1983, 207, and Rehak 1984.

6. Nothing, to my knowledge, prevents us from now identifying Mycenaean ivories representing figures with boar's tusk helmets, heretofore interpreted as male warriors, as this same goddess; see Mylonas 1983, 161, fig. 124.

7. Neith was, in fact, identified with Athena in Classical and Hellenistic times. Bernal 1987, 20–1, 51–2, has even argued that Athena originally *was* Neith – that she was a Bronze Age import to Greece from Egypt – and that the etymological source of the word "Athens" was the Egyptian *Hwt-Nit* ("House of the Goddess Neith"). This is, however, a theory few scholars are prepared to accept; see Ray 1990. In passing we might note (out of antiquarian interest and nothing more) that Bernal was long ago anticipated by Sigmund Freud; see "Leonardo da Vinci and a Memory of Childhood," in Strachey, ed., 1953, vol. 11, 94.

8. The tablet is Knossos V 52. The other deities mentioned are E-nu-wa-ri- jo (Enualios, later an alternative name for Ares), Pa-wa-jo (Paieon, an alternative for Apollo), and Po-se-da-o (Poseidon). See Chadwick 1976, 88–9. *A-ta-na* may also have occurred on a Linear B tablet from Mycenae itself (MY X 1), but the line is damaged and the restoration uncertain.

9. Cf. *Iliad* 6.305, and *IG* I³ 607 (the Glaukias base, c. 530–520) and 718 (the Smikros base, c. 500–480); also Brouskari 1974, 36 and fig. 45. Hesiod calls her *potnia*, too (*Theogony* 926).

10. The Mycenaean Potnia seems to be associated in the Linear B tablets with many of the same activities or spheres – craftsmanship and horses, for example – as Athena herself. Perhaps Athena was originally just one aspect of a greater goddess – the supreme Potnia. See Demargne 1984, 1016.

11. The conventional date of the Knossos tablets is c. 1375 and, as far as we can tell, Athens was at that time a relatively minor place. It would be surprising to find it referred to in a Cretan text (especially since Mycenae itself, by far the more powerful and influential mainland citadel, is not mentioned anywhere on the Knossos tablets). If, however, the tablets date considerably later than 1375 (perhaps as late as 1200, when the Athenian Acropolis had become more significant), the reference would be a little easier to explain.

12. Pausanias, 1.24.5.

13. Amyx 1988, 619.

14. For Arkhegetis as another title for Athena Polias, see Kroll 1982, 69.

15. Pallas is also sometimes thought to mean "virgin" or "young girl" (see, for example, Loraux 1993, 137–41) or "brandisher of weapons," or to refer to one of Athena's military conquests (Pallas, according to Apollodoros 1.6.2, was a giant whom Athena killed and flayed, using his skin as protection in battle). The word was problematic even in the days of Plato, who (*Kratylus* 406d–407a) has Socrates state the popular notion that "Pallas" derives from the practice of dancing in armor and thus shaking (*pallein*) the body and hand-held weapons: Athena is said to have danced such an armed dance (the so-called *pyrrhike*) at her birth. Despite all that, the word may be an old title (meaning something like *Potnia*) originally borrowed from Semitic, its exact meaning lost over time; see Burkert 1985, 139, and Heubeck, West, and Hainsworth 1988, 315.

16. Cf. Pseudo-Hesiod, *Shield of Herakles* 339. Athena Nike seems primarily to have been the goddess of *military* victory, though her province may have encompassed other forms of victory (athletic, poetic) as well; see Parker 1996, 90.

17. She even helps Diomedes wound Ares at *Iliad* 5.855–61; Ares does not care for her, either (*Iliad* 5.875–76). On the other hand, in Hesiod (*Theogony* 926) and in the *Homeric Hymn to Aphrodite* (10–11) she is described as taking pleasure in war and strife.

18. *IG* II² 4318 records an early fourth-century Acropolis dedication (by Deinomenes and his children) to "Athena Ergane Polias," which reminds us not to insist too much on rigid distinctions among her various aspects.

19. *Odyssey* 13.298–9. A few lines later (311), Odysseus himself is described as *polymetis*, "of much *metis*" (that is, resourceful).

20. See Detienne and Vernant 1991 generally and, for Athena's role in the *agon* or contest, esp. 228–9.

21. As early as Hesiod (*Works and Days*, 430), makers of plows were called "servants of Athena." Boutes, a relatively obscure Attic hero whose name means Ploughman or Ox-Man, possessed an altar and was an object of cult in the Temple of Athena on the Acropolis known as the Erechtheion (Pausanias 1.26.5); see Simon 1986.

22. Cf. *Iliad* 15.412.

23. See *Homeric Hymn to Aphrodite*, 12–13. At Corinth there was a sanctuary of Athena *Chalinitis*, Athena the Bridler; Pausanias 2.4.1. According to the Parian Marble, however, Erichthonios invented the chariot.

24. Cf. Castriota 1992, 218–19.

25. *Odyssey* 13.288–89; cf. 16.157–59.

26. The quotation appears in Plutarch, *Moralia* (*Precepts of Statecraft*), 802B. In this passage, Plutarch contrasts the worshippers of Athena Ergane, who work with their hands, with the worshippers of Athena Polias (and Themis), speakers who work with words (and implicitly with their brains).

27. *Homeric Epigram* 14.

28. *Odyssey* 6.232–34

29. Pindar, *Olympian* 7.50–51.

30. Boardman 1975a, fig. 322. Conspicuously uncrowned is a woman artisan working to one side. For differing interpretations, see Green 1961 and Kehrberg 1982.

31. *Iliad* 5.733–35; 14.178–79. On a terracotta loomweight from Tarentum in South Italy, even Athena's sacred owl is shown spinning wool; see Neils 1992, 107 and 151 (cat. 12).

32. *Odyssey* 2.116–18; 7.109–11.

33. *Works and Days* 63–64, 72; *Theogony* 573–5.

34. See Mansfield 1985; also E. J. W. Barber 1992.

35. Diodoros 4.14.3; cf. Apollodoros 2.4.11.

36. *Iliad* 8.362–69.

37. *Iliad* 1.197–222. It is interesting to contrast Athena's appeal to Achilles' reason with her very different strategy for stopping Herakles's murderous madness, as Euripides (*Heracles* 1001–8) describes it. She does not engage him in rational conversation; instead, she simply knocks him senseless with a rock. Unsubtle heroes call for unsubtle methods.

38. The *aigis* is a strange attribute, sometimes said to belong to Zeus and at any rate inconsistently described in our sources, that seems most of the time to be a cloak of goatskin fringed with snakes. In general, see Gantz 1993, 84–5.

39. *Iliad* 18.202–18.

40. Apollodoros 2.4.3 (shield); Pherekydes, frag. 26 (*aigis*). The head of the Gorgon (along with other visions of horror) is also said to be at the center of her *aigis* at *Iliad* 5.738–42 and in Euripides, *Ion* (987–97), where it is said that Athena killed a monster named Gorgo (there is no mention of Perseus in this version of the myth) and took its skin, fringed with serpents, to wear as her *aigis*. In many Archaic and Classical images of Athena the gorgoneion is often found in both places, on both shield and *aigis*, as if Medousa had *two* heads cut off. There is, in any case, no question of the gorgoneion's apotropaic func-

tion – that is, its ability to ward off evil. According to Euripides (*Ion* 1000–21), Kreousa, Erechtheus's daughter, tries to save her father's house by warding off usurpers with poisonous blood taken from the Gorgon's veins.

41. Pindar, *Olympian* 13.63–83.

42. Apollonios Rhodios 1.19.

43. *Odyssey* 13.332.

44. Herodotos 1.60.2–5.

45. Thucydides 1.70.

46. *Odyssey* 13.311–12.

47. See above all Demargne 1984.

48. For example, on the Gorgon Painter's dinos in the Louvre or on the François vase; see Beazley 1986, 16 (cf. plate 14, 1) and 27.

49. Ridgway 1992, 139, suggests that the woman is mortal because goddesses tend to wear not kerchiefs but *poloi* (round hats). However, on the east frieze of the Parthenon, Artemis wears a similar scarf; see Robertson and Frantz 1975, fig. 15.

50. Tertullian, *Apologia* 16.3.8; *Ad Nationes* 1.12.3. It is not clear that Tertullian actually saw the Athena Polias in person, however, and he mistakenly calls it "the Pallas of Attica."

51. Pausanias 1.26.6 (heaven); Eusebios, *Praeparatio Evangelica* 10.9.15 (Kekrops); Apollodoros 3.14.6 (Erichthonios); cf. Plutarch, *Moralia*, frag. 158.

52. *IG* I³ 474, line 1. It was also known more simply as the *Archaios Neos*, "the Ancient Temple (of Athena Polias)" – "ancient" not because the temple itself was old, but because of the antiquity of its cult statue.

53. For the texts see Mansfield 1985, 185–88.

54. Kroll 1982. The attribution to Endoios is found in Athenagoras, *Legatio* 17.3. For arguments against a reworking by Endoios, see Mansfield 1985, 178–84, and Ridgway 1992, 122, n. 8.

55. See Kroll 1982, 69–70; Jung 1982, 53–64; Shapiro 1989, 25. In the *Iliad* (6.301–03) the suppliant women of Troy place a robe (*peplos*) on the knees of an obviously seated statue of Athena, and some have taken the passage as a sign that the Athena Polias was seated, too. But the passage has nothing necessarily to do with the image on the Acropolis.

56. See Mantis 1997, 77–79.

57. Many of the ancient references to the *peplos* say the battle was between the Gods and the Titans (e.g. Euripides, *Iphigeneia in Tauris* 222–24), rather than the Giants, but the Greeks do not seem to have religiously distinguished the two races.

58. For the Dresden statue, see E. J. W. Barber 1992, 115, fig. 74; for the Euthydikos *kore* (Acro. 686) see Brouskari 1974, 127.

59. Acropolis 618; Brouskari 1974, 49 and fig. 90.

60. Pausanias 1.26.4; Brouskari 1974, 71–72, and figs. 134–35.

61. Pausanias 1.28.8–9. Athens was, however, not the only city that claimed to possess the statue (Sparta did, too, for example).

62. Boegehold 1995, 47–48. It is probably to the Palladion

and its "holy wooden image of Pallas" (and not, as some think, the statue of Athena Polias) that Orestes is told to flee in Euripides's *Electra* (1254–57) to escape the Furies: the statue would fend off their horrible snakes by stretching its own Gorgonshield over his head.

63. Shapiro 1989, 28 and pl. 8b–c.

64. D. Harris 1995, 134 (V.97); D. Harris 1992, 643.

65. North 25, with its representation of a representation, is not in its original location: it was set where it is during an early twentieth-century reconstruction of this part of the colonnade, and originally belonged a few metopes away. I owe this information to Manolis Korres.

66. For the Palladion in the north metopes, see Schwab 1996b.

67. Shapiro 1989, 36, suggests, in fact, that the various Palladia seen in Attic vase-painting were loosely based on a major Athena Promakhos set up on the Acropolis in the 560s. Demargne 1984, 1020, 1029–30, in contrast, derives the Promakhos type from the Palladion.

68. Shapiro 1989, 27–29, 36; Neils 1992, 37; Ridgway 1992, 127. Pinney, 1988, has suggested that the Panathenaic Athena represents not a fighting Athena (Promakhos) but a dancing one, performing the armed *pyrrhike* in celebration of her victory over the giants. The pyrrhic dance was indeed the subject of a contest at the Panathenaic Games [cf. Fig. 210].

69. Scholiast to Demosthenes, *Against Androtion* 13 (597.5).

70. E. B. Harrison 1996a, 28–34; Mattusch 1988, 169–72. Others (including M. Robertson 1975, 294) propose a height for the statue of 16 or 17 meters (or over 50 feet). For more on the statue and the surviving fragments of its base, see Chapter 7, 151–3.

71. *IG* I³ 435; Meritt 1936, 362–80.

72. Pausanias 1.28.2. This remark clearly indicates that the statue was tall enough to loom over the roof of the Propylaia and its surroundings.

73. Boardman 1985a, 203 and fig. 180; also Djordjevitch 1994. A few coins (if they really depict the Promakhos and not some other Athena) seem to show the goddess with a spear in her right hand and her left arm raised, holding her shield; see Imhoof-Blumer, Gardner, and Oikonomides 1964, 128–29, pl. Z, i–vii.

74. A slightly later date for the dedication of the statue (435/4) has sometimes been argued; see Stadter 1989, 286.

75. Still a good collection of the evidence is Leipen 1971. For the vase-painting (in the Hermitage), see Shefton 1982, esp. 159–60.

76. Pliny, *NH* 36.18, gives the height of the statue as 26 cubits, and the dimension he gave probably included the base. The height of the entire base (frieze plus lower and upper mouldings) has been variously estimated as 1.22 to 1.437m, the figured frieze itself as .88 to .937m; see Leipen 1971, 23, and E. B. Harrison 1996a, 49 n. 150.

77. Herodotus 8.41; Pausanias 1. 24.7.

78. Alan LeQuire, whose full-scale Athena Parthenos was

unveiled in Nashville in 1990 after eight years of work (about how long it took Pheidias to make the real one), believes a cantilevered wooden beam passing from arm to body could have made a supporting column unnecessary in the original; E. B. Harrison 1996a, 43, still favors the existence of the column. But Camp, 1996, announced the discovery in the Agora of an early fourth-century terracotta token or disk with a small version of the Athena Parthenos in relief. This image – one of the earliest extant representations of the statue – shows the Athena without out a supporting column beneath the outstretched right hand; instead, the snake appears there. Camp suggests that this was the original design of the statue, and that the statue was later remodelled: the column seen in many Roman copies was inserted to support the wavering right arm, and the snake was moved within the shield. Athenas perhaps loosely based on the Parthenos type with snakes coiled up on her right are indeed known in document reliefs as early as c. 427/26 and 394/93; see Lawton 1995, 113–14 (no. 65) and 90–1 (no. 16). On the other hand, a coin of Aphrodisias, dated to c. 375 and thus not far from the new Agora disk, shows the statue with a supporting tree-trunk (Neils 1992, 132 and cat. no. 57), while a document relief from the Acropolis of 355/54, though badly worn, clearly shows Athena Parthenos with the snake coiling within her shield on her left [Fig. 40]. It is perhaps not wise to reconstruct the original on the basis of small-scale images that had, first, to obey the demands of their own fields and functions.

79. Roux 1984, 316–17. For the water basin see Pausanias 5.11.10 and Stevens 1955, 267–70. The water (drawn, perhaps, from five deep wells dug into bedrock along the north flank of the Parthenon) may have slightly increased relative humidity in the room (and so protected the ivory and glue of the statue) but the principal purpose of the pool would have been aesthetic; see Gaugler and Hamill 1989.

80. Pausanias 1.25.7. For the tyrant Lakhares's vandalism of the statue and the nature of her second golden covering, see Chapter 12, 262. Even without Lakhares, the statue suffered from normal wear and tear over time: for example, four petals from the Nike's golden wreath fell off at some point before 402 or 401 (jarred loose, perhaps, by an earthquake) and were inventoried among the treasures of Athena; see D. Harris 1995, 133 (V.95).

Production of replicas of the Athena Parthenos and its parts seems to concentrate in the time of the Roman emperors Hadrian and Antoninus Pius (that is the probable date of the Peiraieus reliefs, for example), suggesting that artists had at that time a special opportunity to examine the statue and make copies, perhaps from scaffolding erected during a repair. I owe the suggestion to Judith Binder; see also E. B. Harrison 1988, 106.

8.1 Herington 1955, *passim*.

82. *IG* I³ 728, 745, 850.

83. Pausanias 3.15.7.

84. Mark 1993, 22–8, 93–8, argues for a seated marble image. Pausanias twice (3.15.7 and 5.26.6) refers to the statue as

a *xoanon*, and for this and other reasons N. Robertson 1996, 44–5, prefers a standing wooden image. But it is not clear that Pausanias actually saw the statue himself and the relief Robertson cites as a representation of the statue may be nothing of the kind. Both the material and pose of the image must remain in doubt. See Donohue 1988, 54–7; also Shapiro 1989, 27 and 31; Stewart 1990, 165; Ridgway 1992, 135–37.

85. Neils 1992, 47, 141, 154 (nos. 13, 15, 16).

86. Ridgway 1992, 140–2.

87. Pausanias 1.28.2.

88. Hartswick, 1983, questions the identification; Palagia, 1987, defends it; see also Stewart 1990, 261–63. E. B. Harrison 1988 and 1996a, 52–59, finds the Lemnian Athena in another type of statue altogether (the so-called Medici Athena).

89. Ridgway 1992, 130.

90. Pausanias 1.24.1, 2, 3. Pausanias does not date or attribute these works, so it is unclear whether the narratives were prototypes of the Parthenon pediments or reflections of them.

91. See in general Parker 1986.

92. Tritogeneia has also been translated as "She who was True Born"; see J. Harrison 1962, 500. But, in fact, Athena was said to have been born on the third day of the month of Hekatombaion, and so the epithet may mean simply "Born on the Third Day"; see Mikalson 1975, 23.

93. Burkert 1985, 142; cf. Parker 1986, 190.

94. *Odyssey* 8.266–332. Pindar, *Olympian* 7.35–38, is the first literary source to mention Hephaistos's role, though the artistic tradition is much older; see Gantz 1993, 51–2. Pindar here also, unusually, places the birth of Athena on the island of Rhodes.

In Archaic art the newborn goddess is fully formed though necessarily diminutive. Her immediate physical maturity in art seems a way of denying her a childhood since, in the Greek mind, childhood was a state of moral, intellectual, and physical imperfection; see Garland 1990, 161.

95. Apollodoros, I.6.1–2. For the myth generally, see Gantz 1993, 445–54.

96. See Pinney 1988; Euripides, *Ion* 1528–29.

97. See Vian and Moore 1988, nos. 104–6, 108, 110, 112–13; Shapiro 1989, 38.

98. See Moore 1995; Stähler 1972.

99. Schrader, et al. 1939, 288–90 and pls. 161–2 (no. 413); Brouskari 1974, 129 and fig. 247.

100. Herodotos 8.55. At 8.44 Herodotos also says that during Kekrops's kingship the people of the city acquired the name *Kekropidai*, after him. Athena may have earned the right to call the city after herself but, at least according to Herodotos, the inhabitants of the city did not name themselves after her (*Athenaioi*) until the reign of Erechtheus.

101. For a review, see Palagia 1993, 40–1 and J. Binder 1984.

102. Pausanias 1.26.2, 27.2. Mansfield 1985, 251–2, pointedly asks how the olive tree, trident-marks, and so on were

explained before the fifth century if the myth of the contest was in fact Classical in origin.

103. Herodotus 8.55.

104. Chadwick 1976, 88–89.

105. Hesiod, *Theogony* 278–80.

106. Around 480–475 one Isolokhos or Naulokhos – the first letters of his name are missing – dedicated a bronze *kore* on the Acropolis from (presumably) the profits of his successful fishing business. The dedicatory inscription (*IG* I³ 828) mentions the god of the golden trident but not Athena, and so may be one of the earliest offerings to Poseidon; cf. Raubitschek 1949, 261–2 (no. 229).

107. See Shapiro 1989, 105–8.

108. It has been suggested that Poseidon appeared symmetrically to Athena in the Gigantomachy pediment of the *Archaios Neos*, so that the association between the two divinities in monumental Acropolis art might be at least as old as the late sixth century; Moore 1995, 639.

109. There are some who question the identification of the Erechtheion with the Classical Temple of Athena Polias (the temple with the Karyatids) on the north side of the Acropolis; for the debate, see Chapter 8, 202.

110. *IG* I³ 873; Raubitschek 1949, 412 (no. 384).

111. Herodotos 8.44; Pausanias 1.27.4. Also see Spaeth 1991. The story of the war with Eleusis is told in Apollodorus 3.15.4–5. For possible remains of the base of the statue group, see Korres 1994f, 124.

112. See Kron 1976, 37–9. Also Kron 1988; Gantz 1993, 233–7; and Dowden 1992, 86. Another etymology for "Erechtheus" derives the name from the Greek verb for "rend, break, or shake violently," which might cast some light on the hero's relationship with Poseidon, the Earth-Shaker.

113. Reeder 1995, 250–66; Gantz 1993, 239–42; Parker 1986, 201. Cf. Euripides, *Ion* 267–70.

114. Mikalson 1976, 141 n. 1.

115. Apollodoros 3.14.6; for the daughters of Kekrops, see also Gantz 1993, 235–9. A rival tradition concerning Aglauros was that she voluntarily and heroically leaped to her death to save the city in time of war; Philochoros, *FGrHist* IIIB, 328 F 105.

116. *Eumenides* 13.

117. Parker 1986, 195; Dowden 1992, 86.

118. "Mother of our *polis*" is precisely what Euripides once calls her in the *Herakleidai*, 770–2.

Chapter 3

1. *IG* I³ 728. The bronze was perhaps a horse or horse and rider.

2. For the possible disappearance of some ancient festivals around 300, see Parker 1996, 270–1.

3. We have so many Archaic dedications only because the Persians sacked the Acropolis in 480 and the Athenians thereafter happened to build old, damaged monuments (like Telesinos's) into new citadel walls or bury them deep in the ground for archaeologists to dig up in the late nineteenth century. There was no such massive deposit – and hence no such large-scale preservation – of Classical material.

4. See Mikalson 1983, 115–16; D. Harris 1991, 56–7, and 1995, 224, also notes that individuals who made offerings listed in the inventories of the Parthenon treasures were not actually acknowledged and named in the inscriptions until the very end of the fifth century, from 403 on.

Parker 1996, 271, points out that there was a similar disappearance of private sculptured dedications from the Acropolis in the third century, too.

5. See D. Harris 1992, 645.

6. Walter 1923, 26–48, lists some 40 examples of votive reliefs that seem clustered around the very end of the fifth century and the beginning of the fourth.

7. See Chapter 2, n. 18 above, and Mikalson 1983, 141 n. 21. For a possible precinct of Athena Ergane west of the Parthenon, see Pausanias 1.24.3.

8. See Aleshire 1989, 12. Public sacrifices to Athena Hygieia, if not private offerings, evidently continued and are recorded as being part of the Panathenaic festival in the latter fourth century; see Parke 1977, 47.

9. Herodotos 8.52–53.

10. Thucydides 1.10.

11. Demosthenes, *De Falsa Legatione* 272; Aristides, *Orationes* 34.28.

12. Demosthenes, *Against Androtion* 76–7.

13. Aristides, *Panathenaic Oration* 16 and 191.

14. Lucian, *The Dead Come to Life* 41–2.

15. Thucydides 2.35–46 (esp. 2.41.4).

16. For the shield, see E. B. Harrison 1981. For the coins, see Price and Trell 1977, 77–8.

17. Plato's imaginative description of the antediluvian Athens and the Acropolis (*Kritias*, 111e–112d) does not count, since it is primarily an example of his skills as a myth-maker.

In the third century an historian and rhetorician named Hegesias of Magnesia, according to the geographer Strabo (9.1.16), described a panoramic view of Attica, noting Eleusis, the shrines known as the Leokorion in the Agora and the Theseion off the north slope of the Acropolis, and "the Acropolis and the mark of the great trident there," but apparently offered no further details. Unlike Pausanias, Strabo himself (early first century AD) devotes less than a paragraph to the whole citadel, specifically mentioning only the Temple of Athena Polias (the Erechtheion) and its eternal flame and the Parthenon. He begs off describing anything else for fear of not being able to stop once he started. For another Hellenistic panorama, see Habicht 1997, 170–2.

18. *Ion* 184–218.

19. *Iliad* 2.546–56; *Odyssey* 7.78–81 (where Marathon seems set on a par with the Acropolis); and, probably, *Odyssey* 11.322–23 (where Theseus is said to have intended to bring Ariadne to "the hill of sacred Athens"). Many scholars regard

these references to Athens and the Acropolis as sixth-century Athenian interpolations into the text; but see Kirk 1985, 179–80, 205–7.

20. Pindar, frags. 63 and 64 (Bowra). By *omphalos* Pindar probably means not the Acropolis, but the Altar of the Twelve Gods in the Agora; see Thompson and Wycherley 1972, 20, 133.

21. See Herington 1963, 73 n. 2; Roux 1984, 311; and Loraux 1993, 172. Euripides's *Ion* 9, and Aristophanes's *Thesmophoria-zousai* 318, mention Pallas of the Golden Spear, which could refer either to the Athena Parthenos or to the Bronze Athena (Promakhos) (if her bronze spear was gilded). A Euripidean fragment (fr. 41 Austin) might refer to either the Athena Parthenos or Athena Polias.

22. See, for example, Dio Chrysostom, *Orations* 12.50–52, and Quintilian 12.10.9.

23. Thucydides 2.13.

24. *Wasps* 1108–9; *Ploutos* 1190–93; see Ridgway 1992, 125–6.

25. *Ploutos* 659–747; Aleshire 1989, 13. Xenophon mentions the Asklepieion on the south slope, but briefly; *Memorabilia* 3.13.3.

26. *Ion* 10–14; 283; 491; 1433–6; *Hippolytos* 30–4 (cf. Pausanias 1.22.1); *Herakleidai*, 777–83. For the role of the Acropolis in the *Ion*, see Loraux 1993, 184–236.

27. See Webster 1967, 130; Burkert 1983, 148–9; and Parker 1986, 202–03 and 212 n. 64. For the new fragments of the play, see Austin 1968, 22–40.

28. Perhaps this is the gold gorgoneion of the statue of Athena Polias; perhaps it is a great gorgoneion set up on the south wall of the Acropolis, a precursor of one set up in Hellenistic times [Fig. 223]. See Seltman 1924, 50–1.

29. *Lysistrata* 264–5 (the Propylaia); 317–18 (Nike and trophy); 262 ("the holy image"), 344 ("goddess of the golden crest"); 742–55 (the bronze helmet); 486–88 (the treasure of Athena); 720–1 and 911 (Cave of Pan); 913 (Klepsydra); 722 (ropes and pulleys). There is also a reference to the rock's guardian snake (759) and the owls that dwelled on the Acropolis and kept the women awake at night (760); see Elderkin 1940.

30. See Loraux 1993, 148–51.

31. Pausanias 1.27.1; 1.24.3.

32. Pseudo-Xenophon (Old Oligrach), *Constitution of Athens* 3.2.8; Thucydides 2.38.

33. Cartledge 1985, 99. In the late fifth century, the Athenians felt the need to fix the order of state sacrifices and hired one Nikomakhos, the son of a slave, to do the job: the calendar was inscribed on the walls of the Royal Stoa (Stoa Basileios) in the Agora.

34. Roberts 1984, 122–23.

35. The participants walked to Skiron, a site almost three miles from the citadel on the border of Eleusinian territory, where the conclusive battle between Erechtheus, Athena's foster child, and Eumolpus, Poseidon's son who tried to conquer the Acropolis for his father, was said to have taken place;

see Parke 1977, 156–7; Simon 1983, 22–4, and Burkert 1983, 143–9.

36. Parke 1977, 60.

37. See Goldhill 1987; Cartledge 1985, 115–27; Parke 1977, 132; and Zaidman and Pantel 1992, 30.

38. *Clouds* 984.

39. Burkert 1983, 156–7. It may be, however, that the *Dipolieia* ceased to be practiced by around 300 or so; see Parker 1996, 270.

40. See, for example, Zaidman and Pantel 1992, 27.

41. For the *Dipolieia*, see Pausanias, 1.24.4 and 1.28.10–11; Burkert 1983, 136–43, and Simon 1983, 8–12. Our sources suggest the first *bouphonia* took place in the reign of Kekrops or Erechtheus.

42. The rite was supposedly a re-enactment of an ancient appeasement of the goddess, who was angered because a she-bear was once killed in her sanctuary; Reeder 1995, 321–2.

43. Linders, 1972, argues that the fourth-century inscribed inventories of Artemis's treasures found on the Acropolis (robes and garments make up a large percentage of the items listed) record offerings to Artemis at Brauron, not on the Acropolis itself.

44. *Odyssey* 2.69

45. The shrine was seen by Pausanias, 1.22.3; see Parke 1977, 149.

46. For the *Aphrodisia*, see Simon 1983, 48–51. For Aphrodite Pandemos, see also Shapiro 1989, 118–19.

47. For the archaeology of the north slope and the Sanctuary of Eros and Aphrodite, see Glowacki 1991.

48. For the traditional interpretation, see Simon 1983, 39–46; for a different view, see N. Robertson 1992, 15–16, and 1996, 60–2. See also Appendix A, n. 46.

49. Two dedications made by former *Arrhephoroi* to both Athena and Pandrosos offer some support for the theory connecting them to the daughters of Kekrops; see *IG* II² 3472 and 3315 and Larson 1995, 39–41. N. Robertson 1992, 16, suggests the rite had something to do with the feeding of Athena's sacred snake.

50. Aphrodite and Peitho were, again, important players in the mythological unification of Athens, with Theseus invoking their assistance. The fire that lit the altar of Athena during the Panathenaia was taken from the altar of Eros (the son of Aphrodite) outside the Dipylon gate; Parke 1977, 45. Some late Archaic Athenian coins have Athena on one side, Aphrodite Pandemos on the other; Simon 1983, 50. It is interesting to note as well that in ancient Mediterranean cultures warrior-goddesses such as Ishtar or Astarte were also love goddesses: Athena and Aphrodite were, in a sense, two sides of the same coin. Also, Loraux 1993, 151.

51. Thucydides 2.15; N. Robertson 1992, 32–40.

52. For the Kallynteria and Plynteria, see Parke 1977, 152–5, Simon 1983, 46–8, and, for a different understanding of the festivals and their sequence, N. Robertson 1996, 48–52. The

actual washing was done by two girls called "the Washers." For the view that just the clothing and ornaments of the statue were removed and cleaned, not the statue of Athena Polias itself, and that the washing may not have taken place at Phaleron at all, see Herington 1955, 30 and n. 2; Romano 1988, 130–1; and Ridgway 1992, 124. Could the stripping of the statue have been the subject of Parthenon south metope 21? Cf. Mantis 1997, 77–9.

53. Apollodoros 3.14.6 (implying Erichthonios founded the festival at the same time he set up the wooden image of Athena Polias on the citadel); Scholiast to Plato, *Parmenides* 127A; Pausanias 8.2.1; Plutarch, *Theseus* 24.3. Generally, Davison 1958; N. Robertson 1985 and 1992, 90–119.

54. Aelius Aristides, *Panathenaic Oration* 362, calls it the oldest, or second oldest, festival in Greece. It is sometimes thought that the *Iliad* refers to an early form of the Panathenaia when, at 2.546–51, it mentions a yearly sacrifice of rams and bulls on the Acropolis, at the temple of Athena where Erechtheus had been installed. But the meaning of the Greek is that the animals are sacrificed to Erechtheus, not Athena, and the animals are male, not female (as we would expect of animals offered to the goddess); see Kirk 1985, 206, and Mikalson 1976 (who argues that the Panathenaia was originally an annual festival sacred to Erechtheus). The passage is early evidence for sacrifices on the citadel, but not good evidence for the Panathenaia.

55. Mikalson 1975, 16, 23, points out that all the other Olympians had their birthdays in the first ten days of the month, and Athena should be no different.

56. See Pinney 1988; also, Ridgway 1992, 127.

57. Thucydides 6.56; Shapiro 1989, 29 and pl. 9a–b.

58. Plato, *Laws* 796B, 815A; *Kratylus* 406A–407B; Dionysios of Halikarnassus 7.72.7. For the *pyrrhike* and its prominence at the Panathenaia, see Borthwick 1970, who notes the common association on Greek vases of the dance and the Gigantomachy.

59. Parker 1996, 89–92; Develin 1989, 41. The same Hippokleides had earned fame as a handsome youth for losing an important potential bride by dancing, lewdly, on his head and not caring; see Herodotos 6.129 .

60. Plutarch, *Perikles* 13.11, says that Perikles first introduced musical competitions to the festival, but while he clearly was concerned with the musical aspect of the Panathenaia, built the Odeion on the south slope of the Acropolis probably to hold the contests, and may have instituted some changes in their administration, such competitions likely took place already by the second half of the sixth century. See Shapiro 1989, 41–3.

61. Pseudo-Plato, *Hipparchos* 228B. It is not clear whether all of *Iliad* and *Odyssey* had to be recited from beginning to end – the performances would have taken several days – or only whether selected episodes had to be recited in their proper order.

62. Shapiro 1989, 46; 1992.

63. On the Panathenaic ship and the sail-*peplos*, see Mansfield 1985, esp. 51–8 and 68–78. Mansfield suggests that in the entire history of the Greater Panathenaia there were only four such Panathenaic ships, that after the third or second century a new sail-*peplos* may not have been made for every celebration, and that in the years of the Greater Panathenaia two *peploi* were made – one for the statue, one for the ship. Also, E. J. W. Barber 1992, 112–14.

If a *peplos*-dress was presented to Athena Polias each year, it may seem strange that it was thought necessary to disrobe the statue and presumably wash the cloth at the Plynteria festival just two months before the presentation of a new one at the annual Panathenaia. Simon 1983, 66, suggests the statue "need not have been clothed with the new peplos [at the Panathenaia], which was instead added to Athena's treasures"; see also Shapiro 1989, 29–30 and n. 88. If so, the brand new *peplos* (and not simply a laundered one) could have been draped over the statue of Athena Polias at the Plynteria, when the exchange of the new garment for the old might have taken place and the old robe washed before storage.

64. *IG* I³ 507; Raubitschek 1949, 350–3 (no. 326); also 353–58 (nos. 327 and 328). But see Davison 1958, 30, who suggests that the inscription, though referring to the first Greater Panathenaia, may not have been carved until some time later. Also Travlos 1971, 2 and figs. 18–19, and Camp 1986, 45–6. For the location of the earliest *dromos* northeast of the Acropolis, see S. G. Miller 1995, 212–14. For the epigraphical evidence, see also Tracy 1991.

65. Since the back of the Burgon amphora shows an equestrian event (the two-horse chariot race) and not an athletic event, some would divorce it from the Greater Panathenaia of 566/5.

66. These cocks are problematic. They may be symbols of feistiness and competitiveness, or refer to Zeus, or to crowing at the dawn following the Battle of Gods and Giants; see Pinney 1988 and Neils 1992, 37–8.

67. See, however, Hamilton 1996, who argues that there was no necessary connection between the sports depicted on the prize amphorai and the events for which they were awarded.

68. For the text of the inscription (*IG* II² 2311), datable to c. 370, see Neils 1992, 16. Also, Johnston 1987.

69. Neils 1992, 39.

70. Aristotle, *Constitution of Athens* 60, 3. We do not know where the storerooms were, but the oil could have been conveniently stored in the so-called Northwest Building (a structure of apparently utilitarian character) located just north of the Propylaia against the north citadel wall [Fig. 3, no. 4]; for the building see also Chapter 8, 198.

71. For the dedication of the chorus leader, see Peppas-Delmousou 1971. For the *anthippasia*, Bugh 1988, 59–60.

72. Aristotle, *Constitution of Athens* 60.4; Neils 1992, 16, and 1994, 155–9; Kyle 1992, 95–6. Aristotle says, however, that the

winners of the *euandria* received a shield, so evidently the prizes could change from festival to festival.

73. Aristotle, *Constitution of Athens* 60.1–2. The board of *hieropoioi*, who originally administered the Greater Panathenaia, continued to manage the Lesser Panathenaia; see Davison 1958, 33.

74. Mikalson 1975, 34.

75. Neils 1992, 15.

76. See Thucydides 6.56–58; Aristotle, *Constitution of Athens* 18.4.

77. See Pollitt 1997.

78. Simon 1983, 61; but see Mansfield 1985, 238–9.

79. Burkert 1988, 34.

80. Such screaming accompanies the programmatic sacrifice described at great length in the *Odyssey* 3.417–63; also, Zaidman and Pantel 1992, 35.

81. *Clouds* 386.

82. Parke 1977, 39; Plautus, *Mercator* 65–7.

83. Demosthenes 25.99; Mikalson 1975, 14–15. For the *Epimenia*, see Herodotos 8.41.

84. Suda s.v. *Proteleia*; Jordan 1979, 32; Mansfield 1985, 189–97, who argues the *aigis* was not the gold ornament from the statue of Athena Polias, but a woolen, knotted net.

85. Herodotos 5.65.

86. Diodoros 20.110; Plutarch, *Demetrios* 23–27. See Chapter 12.

87. Xenophon, *Hellenica* 6.4.20. At least some of these meetings were to scrutinize the inventorying and weighing of the treasures stored on the Acropolis, as the inscriptions known as the Kallias Decrees (*IG* I³ 52) inform us.

88. *IG* II² 776; Jordan 1979, 30. The feast on the Acropolis at the end of the *Lysistrata* would, then, not have seemed odd to the Athenian audience. It has been suggested that the spacious halls originally planned for the east side of the Propylaia would have accommodated large-scale ritual dining. Though these plans were never fulfilled, the northwest wing of the Propylaia (the so-called Pinakotheke) may have served as a banquet room; see Hellström 1988 and Travlos 1971, 482.

89. Their official title was *hoi tamiai ton hieron chrematon tes Athenaias*, "the treasurers of the sacred property of Athena." See Aristotle, *Constitution of Athens* 43,1. Also, Develin 1989, 8, who notes that the number of *tamiai* may have varied slightly in different periods.

90. See D. Harris 1995.

91. For the regulation of dung disposal, see Jordan 1979, 45; for the prohibition against dogs, see Plutarch, *Aitia Rhomaika* 111, 290B–C. In 306/5, a dog somehow breached the security of the Acropolis, entered the Temple of Athena Polias (the Erechtheion), crossed into the neighboring Pandroseion, and jumped up on the altar of Zeus Herkeios. The event was considered a very bad omen (Philochoros, *FGrHist* 328, frag. 67)

92. Herodotus 5.71, 8.51.

93. Thucydides 1.96; Meiggs 1975, 234–8, 244. The date of the *Antigone* is unknown, but it is usually put around 440.

94. *IG* I³ 52 (Kallias Decrees); Meiggs and Lewis 1988, 154–61 (no. 58).

95. One Lysimakhe, we are told, served as priestess for 64 years; Pliny, *NH* 34.76

96. Burkert 1983, 149; Jordan 1979, 30–2.

97. We are told that from the late sixth century on she received a day's ration of grain and a small amount of cash every time there was a birth or death in the city; Aristotle, *Oikonomikos* 2.2.4; Jordan 1979, 32.

98. *IG* I³ 35; Meiggs and Lewis 1988, 107–11 (no. 44); Jordan 1979, 32–3.

99. Aristotle, *Constitution of Athens* 54.7.

100. *Constitution of Athens* 24.3; for the inscription (*IG* I³ 45) see Jordan 1979, 29, and Mark 1993, 64–5. These policemen were apparently citizens and thus distinct from the force of Skythian archers who patrolled the streets of the lower city.

101. These codes, first inscribed on rotating pillars of wood known as *axones*, then upon bronze or stone slabs known as *kyrbeis*, were displayed on the Acropolis at least for a time in the early fifth century, though they may not have been set there originally; see Stroud 1979, N. Robertson 1986, and T. L. Shear, Jr., 1994, 240–1.

102. For specific documents, Raubitschek 1949, 350–58 (*dromos* inscriptions); *IG* I³ 4, Jordan 1979, 19–55 (Hekatompedon Decrees); Jeffery 1990, 77, no. 21 (*tamiai* dedications); Meiggs and Lewis 1988, 25–7 (no. 14, Salamis Decree), 138–44 (no. 52, Chalkis settlement), 128–33 (no. 49, colony at Brea), 236–40 (no. 78, Sicilian expedition), 201–3 (no. 70, Herakleides), 133–6 (no. 50, tribute lists), 146–9 (no. 54, Athena Parthenos), 162–5 (no. 59, Parthenon), 165–6 (no. 60, Propylaia), 205–17 (no. 72, loans). For document reliefs from the Acropolis (for example, the monument recording the alliance with Korkyra), see Lawton 1995, 14–15 and *passim*. For the list of Plataians and lists of benefactors and debtors, see Thomas 1989, 64–6. For the list of Peisistratids and their crimes, see Thucydides 6.55. For the Arthmios decree, see Meiggs 1975, 508–12.

103. See Hedrick 1994; Davies 1994, 212; Davies 1993, 51–8; W. V. Harris 1989, 93–115, 328.

104. Thomas 1989, 66; D. Harris 1994.

105. For example, see Zaidman and Pantel 1992, 58, and Burkert 1988. When Attalos I of Pergamon entered Athens to general acclaim in the year 200, "all the temples" of the city were thrown open to celebrate, suggesting that they were typically closed; Polybios 16.25. But on this issue see Corbett 1970.

106. See Parke 1967, 82–5. Similarly, Pausanias mentions shrines or temple rooms that only priests or priestesses could enter (2.10.2; 8.47.5) or that were open only once or twice during the year (6.25.2, 9.25.3, 10.35.7).

107. *Ion* 219–23; Pausanias 2.4.6; 7.26.7; cf. 8.10.2.

108. Pausanias 5.11.4; Lucian, *Herodotus* 1–2; cf. *ibid.*, *De Morte Peregrini* 32, where throngs are said to have gathered in the *opisthodomos* on other occasions as well.

109. Sometime later a priest at the sanctuary of Hera at Argos attempted to prevent Kleomenes from sacrificing there because he was a foreigner; the priest was flogged and the sacrifice made; see Herodotos 6.81.

110. *IG* I³ 45; Mark 1993, 64–5.

111. Thucydides 2.17.1 (the passage deals with the outbreak of the Peloponnesian War and the necessity for the people of Attica to crowd within the city walls of Athens. He notes that under these emergency conditions Athenians took up residence in various temples and shrines, but were forbidden to occupy the Acropolis); Aristotle, *Constitution of Athens* 44.1.

112. Cf. *Lysistrata* 245–6.

113. *IG* II² 2292–2310. One can infer from Marinos's *Life of Proclus*, 10, that there were such Acro-guards as late as the fifth century AD: Proclus is said to have rushed up to the fortified gate late on the day he first arrived in Athens, only to find the porter about lock the gate (he let him in). But in fact it is not clear whether the gate referred to here is that of the Acropolis (which by that time would have been not the Propylaia but the so-called Beulé Gate, constructed in the late third century AD) or a gate in the city wall.

114. *IG* I³ 7; Davies 1993, 57–8.

115. *IG* II² 1424a, lines 386–7; D. Harris 1995, 243, 266.

116. *IG* I³ 52.

117. *Lysistrata* 482.

118. Pollux 7.128.

119. Thomas 1989, 65.

120. Van Straten 1974.

121. Cf. Rhodes 1995, 109, and D. Harris 1995, 112.

122. Isokrates 2.6; cf. Parker 1996, 129.

123. Zaidman and Pantel 1992, 46. There is some evidence, however, that any sacrifice involving a fire on the Acropolis required the presence and assistance of a priestess or priest; see Jordan 1979, 43.

124. Theophrastos, *Peri Eusebeias*, frag. 12; see Van Straten 1981, 66.

125. For Peisis's sheep (NM 6695), see *IG* I³ 543; de Ridder 1896, 192–93 (no. 529); and Van Straten 1981, 87 and fig. 24.

126. *IG* I³ 745; Raubitschek 1949, 84–5 (no. 79). Though the dedication (dated around 500) is addressed to [Athena] Parthenos, one of the two bronzes seems to have been of the Promachos type.

127. Van Straten 1981, 72. The idea the gods and mortals could make deals is as old as the first book of the *Iliad* (1.212–214), where it is Athena who initiates the negotiations. Cf. *Iliad* 6.269–78, where the Trojan women are told to take a robe and a promise of sacrifices to the temple of Athena and to ask the goddess for her pity and aid in return.

128. *Euthyphro* 14D–E.

129. Aristotle, *Constitution of Athens* 7.4. Anthemion's advancement has been dated to the mid-fifth century; see Raubitschek 1949, 206.

130. Mattusch 1988, 169, dates the bronze to c. 450.

131. *IG* I³ 872; Raubitschek 1949, 248–50 (no. 218).

132. *IG* II² 4326; Van Straten 1981, 77.

133. Van Straten 1981, 89.

134. Palagia 1995.

135. Parker 1996, 271. Dedications in honor of *Arrhephoroi* were made at least as late as the second century AD, when Sarapion and Chresime turned their daughter, Theano, over to the goddess, made a dedication to commemorate her service, and asked for Athena's blessing in return; see *IG* II² 3634.

136. For Lysimakhe's statue, see Pliny, *NH* 34.76. For Alkimachos's dedication, see Raubitschek 1949, 10–12 (no. 6) and 364–65 (no. 330); Raubitschek believes Acropolis 629, a statue of a scribe, belonged to this monument. See also Brouskari 1974, 52 and 64, and now Triandi 1994. Plutarch, *Themistokles* 31.1, reports that in Sardis Themistokles saw a bronze statue of a "water-carrying *kore*" that he had originally dedicated in Athens to commemorate his service as water commissioner, but which had been taken by the Persians in 480. Though it is not specifically stated that the bronze was dedicated upon the Acropolis – a location at, say, a fountainhouse in the Agora might be as likely – it remains a possibility.

137. Pausanias 1.1.2.

138. *IG* II² 4323.

139. *IG* I³ 511; Raubitschek 1949, 146–52 (no. 135); Pausanias 1.22.4; Bugh 1988, 45–50.

140. *IG* I³ 752, 666, 833 *bis*, and 880.

141. Plutarch, *Kimon* 5.2–3.

142. Pausanias 1.25.2; see also Chapter 12.

143. For Persian spoils in the Erechtheion, see Pausanias 1.27.1, and Demosthenes *Against Timokrates* 129.

144. The "Golden Nikai" were actually bronze figures covered with two talents (nearly 120 pounds) of gold plates apiece, paid for out of the spoils of war; they were in the care of the Treasurers of Athena. At least a dozen Nikai were made in the fifth century (our earliest reference to them is found in the Kallias Decrees of 434/3). Some, perhaps, were made by gold-workers who had assisted Pheidias in the creation of the Athena Parthenos (we know the names of two of the artists: Deinokrates, who made a Nike around 430–425, and Timodemos, who made one around 410). The last Golden Nike was dedicated in 374/3. At least eight existed at the start of the Peloponnesian War, but most were melted down for coinage toward the end of the conflict (407/6) and immediately afterward (404/3). They were restored in the latter part of the fourth century, only to be melted down once more at the start of the third. See Aristotle, *Constitution of Athens* 47.1; *IG* I³ 467–471; Thompson 1944; and Mattusch 1988, 174–6.

145. D. Harris 1995, V.317, V.421, V.426. Telemakhos was the founder of the sanctuary of Asklepios on the south slope.

146. D. Harris 1995, 134 (V.97), 141 (V.149).

147. *IG* I³ 823, 858; Raubitschek 1949, 80–82 (no. 76), 320–1 (no. 297).

148. For Lysander's and Roxane's dedications, see Parker 1996, 222, and D. Harris 1995, 234–5.

149. D. Harris 1995, 114, and *IG* II² 1553–1578.

150. *IG* I³ 699 (Raubitschek 1949, 246–8, no. 217) may be an example.

151. *IG* I³ 547 (Lysilla's dedication), *IG* I³ 794 (Smikythe's); *IG* I³ 546 (Phrygia's). In the case of Smikythe's dedication, I wonder whether *plyntria* could describe not her livelihood, but her function in the *Plynteria* festival; if so, she should perhaps not be counted among the working women of Athens. As for Phrygia (her name means "the Phrygian woman"), she was perhaps a metic.

152. *IG* II² 4334; Van Straten 1981, 92.

153. Brouskari 1974, 131.

154. See Raubitschek 1949, 465; Beazley 1946, 21–5. The first Acropolis vases with dedicatory inscriptions date around 700, though it is not clear whether their potters were the dedicants [cf. Fig. 62].

155. Acropolis 853. See Kurtz 1989, 39 and pl. 25.1

156. Kurtz 1989, 39–45; Van Straten 1981, 94 and fig. 34. For the incised relief (possibly part of a vase), which may show a boy mixing color while a larger, seated figure works at the wheel, see Schrader et al. 1939, 312–13 and fig. 57, and Kurtz 1989, 49.

15.7 *IG* I³ 627 (Eumares), 776 (Oinobios), 616 (Simon); 905 (Mneson); 646 (Smikros); 841 (Mekhanion); 589 (shipbuilder); 606 (architect); 828 (Isolokhos or Naulokhos). As Raubitschek notes (465) most of these dedications, by non-aristocrats, date after 510, when the democracy was established.

158. *IG* II² 1554, line 10.

159. D. Harris 1991, 445, and 1993; but see also Aleshire 1989, 67 and 313. A courtesan named Rhodopis was famous for her dedications at Delphi; see Herodotos 2.135.

160. Holloway, 1992, argues that *korai* were, in fact, the dedications of choice among businessmen and businesswomen.

161. *IG* I³ 700.

162. *Thetes* appear as rowers on the so-called Lenormant relief, perhaps dedicated on the Acropolis around 410 to commemorate their defense of the radical democracy against oligarchs; see Strauss 1996, 321, and Brouskari 1974, 176–7.

163. See D. Harris 1993; also Aleshire 1991.

164. Pausanias 5.21.1.

165. Rouse 1976, 75.

166. Cuttings for the suspension of votives have been identified in the walls of the Propylaia; see Tanoulas 1994a, 53–6.

167. D. Harris 1995, 142 (V.156). See also Alroth 1988.

168. Lee 1996.

169. In 320/19, Nikokrates melted down a group of *phialai* dedicated by manumitted slaves and remade them into five large silver *hydriai*. Nikokrates, who worked for the *tamiai* for over twenty years (from around 334 to 310), is the most often named of several metalworkers listed in the Parthenon inventories. He was even permitted to sign refashioned works; see D. Harris 1988

170. Demosthenes, *Against Androtion* 76; Plutarch, *Perikles* 12.1.

171. See Aelius Aristides, *Panathenaic Oration* 191.

Chapter 4

1. Immerwahr 1971, 16–17, 48 (219).

2. In fact, though its marble may have come from Mt. Pentelikon in eastern Attica, the figure's closest formal parallel comes from central Anatolia.

3. For a recent critique of the old "Mother goddess" hypothesis, see Talalay 1993, 37–44.

4. See Levi 1930–31; Travlos 1971, fig. 67 no. 92; Sinos 1971, 8 and fig. 5; and Treuil 1983, 287.

5. Vermeule 1972, 10–18.

6. See Immerwahr 1982.

7. For the Neolithic Acropolis, see Pantelidou 1975, 242–43.

8. The absolute chronology of the Aegean Bronze Age is extremely controversial, and there are a number of rival schemes. For recent discussions, see Dickinson 1994, 9–21; Manning 1995; and Warren and Hankey 1989.

9. See Pantelidou 1975, 245–6; Immerwahr 1971, 51–5; and Travlos 1971, 57.

10. The residents of Aghios Kosmas and Tsepi may themselves have been islanders, traders or entrepreneurs who set up shop on the mainland; R. L. N. Barber 1987, 136–37.

11. See Renfrew 1988, Drews 1988 (especially 3–24), and Diamant 1988.

12. For the importance of autochthony in Athenian ideology, see Chapter 10.

13. H. D. Hansen 1937, 554, figs. 10c–d.

14. Iakovidis 1983, 75; Pantelidou 1975, 247–8; Travlos 1971, 57.

15. Immerwahr 1971, 51– 54. For the tumulus, see Pelon 1976, 79–80.

16. The discovery of a single Minoan vase in a Middle Helladic I grave in the Kerameikos is enough to document Athenian contact with Crete at this time; see Rutter and Zerner 1984, 77.

17. Some scholars now place the turn from Middle to Late Helladic considerably earlier, c. 1680. See, for example, Manning 1995, 217–29.

18. Maran 1992.

19. For the *tholoi* of Mycenaean Attica (Thorikos A and B, Marathon, and Menidi) see Pelon 1976, 413–14.

20. See Camp 1986, 101–02. The *lithos* was where new Athenian magistrates swore their oaths of office.

21. Iakovidis 1983, 75.

22. The author of the Parian Marble, 1; see Jacoby 1904, 3.

23. Mountjoy 1995, 14, suggests, however, that the "LH I room" could in fact be LH II instead.

24. Mountjoy 1995, 16–17, 69–70; Dickinson 1977, 96. Another Marine Style vase, decorated with leaping dolpins, was found at Varkiza in Attica, brought back, perhaps, by some

Attic sailor who had been to Knossos; see Vermeule 1972, 142 and fig. 27.

By the end of LH II, according to the conventional history of the Bronze Age Aegean, Mycenaeans had violently established themselves at Knossos as the lords and masters of Crete, though it is impossible to say what role, if any, the Athenians played in the conquest.

25. Hood 1978, 147, and Mayer 1892. A gold signet-ring from an Agora chamber tomb of ca. 1400–1375 may also tenuously support a Cretan connection: it seems to show a bull-headed man (or a man wearing a bull mask) leading two women. In a romantic frame of mind, we may see this image as a representation of the Minotaur of Knossos and two Athenian captives; see Camp 1986, 27 and pl. VI.

26. Thucydides 2.15.3. Mountjoy, 1981, publishes the pottery from four wells on the south slope just behind the Stoa of Eumenes that were intentionally filled in in the early fourteenth century. For prehistoric remains in the area of the Ilissos, see Travlos 1971, 289–90.

27. Immerwahr 1971, 166.

28. Mountjoy 1995, 22–4, has re-examined the diagnostic pottery from these terraces and has suggested that they could in fact date to the LH IIIA period, which would make the Athenian palace they supported contemporary with those built at Mycenae and elsewhere: the Acropolis would then be in the Mycenaean architectural mainstream. But the evidence is equivocal, and even Mountjoy admits the traditional LHIIIB date is possible.

There is no evidence for any such terrace on the south side of the summit, in the vicinity of the later Parthenon, though one may well have existed there: construction of a massive podium in the early fifth century, among other projects, would have obliterated any traces of such early retaining walls. Travlos 1971, fig. 67, reconstructs another large terrace close to the Parthenon site.

29. Iakovidis 1983, 78. The nature and purpose of the shallow trench have, however, been questioned by Dinsmoor 1947, 122 n. 47; Beyer 1977, 50 and fig. 5; and Wright 1980, 64–5 n. 18, who interprets the "trench" as a natural fissure and questions the accepted reconstruction of the palatial terraces. It is admittedly hard to date such a cutting in bedrock.

30. The walls are called "Cyclopean" because later Greeks thought only those one-eyed giants could have lifted the stones into place; cf. Pausanias 2.16.5 and 2.25.8. The heavy stones, however, comprised only the inner and outer faces of the wall: rubble and earth filled the space between them.

For the date of the first Cyclopean walls at Mycenae (mid-fourteenth century) and Tiryns (early fourteenth century) and their thirteenth-century expansion, see Iakovidis 1983, 3, 71.

31. Mountjoy 1995, 41–2; Iakovidis 1983, 86–7.

32. It is useful to remember that olive oil would again be stored on the Acropolis in historical times, for distribution in prize amphorai at the conclusion of the Panathenaic games.

33. If, that is, the Panathenaia was not originally a festival culminating in the sacrifice of bulls and rams to Erechtheus, Athens's "first citizen" and the personification of Athenian autochthony. See *Iliad* 2.546–51 and Mikalson 1976.

34. Bundgaard 1976, 19–20, who quotes the interesting claim by Kleidemos, a fourth-century historian of early Athens, that the builders of the citadel "levelled the Acropolis."

35. Herodotos 5.64, 6.137; Pausanias, 1.28.3, names the builders of the Pelasgian wall as Agrolas and Hyperbios.

36. See Cromey 1991.

37. For the Mycenaean bastion and niche, see Mark 1993, 12–15, and Iakovidis 1983, 80.

38. For older reconstructions of the Acropolis gateway, see Mylonas 1966, 37–9, Travlos 1971, fig. 67, Dinsmoor, Jr., 1980, 1–5, and Iakovidis 1983, 79–81. A few of these reconstructions posit entrances on *two* sides of the bastion, which would have been poor strategic thinking (why give an attacking force an option, and why make your soldiers defend two approaches?).

39. See Wright 1994, who also points out that the eleven steps cut into the bedrock below the Nike bastion, sometimes considered Mycenaean, may just as well be Medieval, and that an arc of stones below the Classical Propylaia often thought to mark the curving northwest return of the Cyclopean fortification may instead have belonged to a low terrace wall.

40. As Mark 1993, 15, rightly points out. He suggests the bastion may have formed part of a preliminary defensive work below the Cyclopean wall, but the evidence for such a *proteichisma* is scanty.

41. Mountjoy 1995, 41, 45–6. Another view is that the northeast ascent remained in use not only after the Cyclopean wall was built (Mylonas 1966, 39–40) but also long after the end of the Bronze Age; see N. Robertson 1986, 159–60, and 1992, 117–18, and Shear 1994, 227, who believe the ascent was still open in the first half of the sixth century. The so-called late Mycenaean houses built over the ascent may in fact be much later (J. B. Rutter, personal communication).

42. See Mountjoy 1995, 41; Iakovidis 1983, 84–6; Hill 1953, 132–3.

43. Broneer 1939, 346. Higgins and Higgins 1996, 30, suggest the fountain may have been abandoned because of an insufficient flow of water.

44. The dumping of material lasted until access to the fissure and its two preserved upper flights of stairs was opened up from below, through the cave high on the north slope once thought to be the Cave of Aglauros. This established a new means of communication between the Acropolis summit and the slope; see Broneer 1939, 423. If it was through this cave that the young *Arrhephoroi* descended at night during the *Arrhephoria* on their way to the sanctuary of Aphrodite and Eros (see above, Chapter 3, 41–3), the upper stairs must have been maintained throughout antiquity.

45. There may be some distant memory of it preserved in Plato, *Kritias* 112c–d.

46. Thucydides 2.15; Plutarch, *Life of Theseus* 24.3.

47. Parian Marble, 20; Jacoby 1904, 8–9.

48. *Iliad* 2.546–56; cf. 569–80.

49. R. L. N. Barber 1987, 191, 197, cites evidence that Laureion was a significant source of copper, silver, and lead throughout the Aegean in the Late Bronze Age. Large amounts of lead found in the Mycenaean fountain also came from Laureion; Mountjoy 1995, 44.

50. Immerwahr 1971, 119 and 151, notes that there is from the entire Bronze Age Agora only one vase that came from beyond the Mycenaean world, and that Athens apparently did not participate in Mycenaean expansion into the eastern Mediterranean; also Camp 1986, 27.

51. Immerwahr 1971, 153.

52. Thucydides, 1.12

53. It is true that many sites in the Argolid, for example, are deserted now, but the population of LH IIIC Tiryns seems to have grown significantly, and this site has even been called a leading example of post-palatial "late Mycenaean city life"; see Kilian 1988, 135. The abandonment of sites does not necessarily mean vast depopulation: it is only the distribution of people that may have changed.

54. See, for example, Rutter 1992.

55. For a good review of the various theories (and the proposal of the infantry theory), see Drews 1993.

56. For example, in a small amount of dark, handmade burnished pottery – "barbarian ware," it has sometimes been called – that begins to turn up in many central and southern Greek sites at the end of LH IIIB and increasingly in LH IIIC; see Rutter 1990 and 1975, Kilian 1985, and Harding 1984, 216–27.

57. For several sides of the debate, Hooker 1976, 148–52, 163–80, 213–22, and Drews 1988, 203–25. Also, generally, Muhly 1992.

58. Pausanias 1.19.5; Herodotos 5.76; Lykourgos, *In Leocratem* 84–7. A mid-fifth century vase shows Kodros apparently saying a last good-bye to another Attic hero; see *ARV*2 1268, 1. And an inscription indicates that Kodros's tomb was found in the vicinity of the Acropolis (*IG* II² 4258).

59. Eusebius, *Chron.* 1, 181–90; also Drews 1983, 87.

60. There is the possibility that Kodros himself was an invention of the fifth century; see Shapiro 1989, 102 n. 11.

61. For the problem, see Mylonas 1966, 39–40; Bundgaard 1976, 26–31.

62. Immerwahr 1971, 110. There are, however, only a few that can be dated even to LH IIIB.

63. Mountjoy 1988, 26–9.

64. Mountjoy 1995, 51–2; the tomb is located in the area where Pausanias (1.21.4) saw the ancient Tomb of Kalos.

65. A well was dug a few meters west of the Classical Klepsydra and collection basins (and, perhaps, a shrine to water deities) were cut into the rock beneath the later paved court of the Klepsydra itself; Immerwahr 1971, 259–62; Smithson 1982.

66. Mountjoy 1995, 55; Iakovidis 1983, 87.

67. Mountjoy 1995, 50–51; Iakovidis 1983, 87; Bundgaard 1976, 17 and 147. Similar bronze hoards were found hidden in stone foundations at Mycenae and are interpreted as signs of enemy attack; see Mylonas 1966, 33 n. 42. Also, Desborough 1964, 48–9.

68. Iakovidis 1969 and 1980. Perati, with its cemetery of over 200 graves filled with sometimes innovative pottery and trinkets from as far afield as Cyprus, Syria, and Egypt, was established at the transition from LHIIIB to IIIC, perhaps around the same time that the Mycenaean fountain on the Acropolis north slope was abandoned after its collapse. Burials in the cemetery ended in the first half of the eleventh century. For the contemporary settlement on Raphtis island in the nearby bay of Porto Raphti, see Rutter 1992, 69–70.

69. Mountjoy 1988, 29.

70. Mountjoy 1995, 63–4; Styrenius 1967, 22–3, 31.

Chapter 5

1. Hurwit 1985, 93–100.

2. Another fragment (Graef and Langlotz 1909, pl. 10, no. 295) shows a corpse on its bier beneath a cutaway shroud – a *prothesis* (lying-in-state) scene.

3. Vanderpool 1974, 157.

4. See Shapiro 1989, 5, who regards the second quarter of the sixth century as the time when "the Akropolis was set aside as the principal sanctuary of the city goddess Athena."

5. But see also *Odyssey* 11.322–23.

6. Kirk 1985, 205.

7. See Drews 1983, 86–94.

8. Thucydides 2.15.6. According to Plutarch (*Theseus* 12), Aegeus, Theseus's father, even had his palace off the Acropolis, near the Olympieion to the southeast [Fig. 2].

9. Hornblower 1991, 262–6; also Diamant 1982, and Cavanagh 1991, who suggests Athens may already have been the seat of central authority in the tenth century, and that expansion into the Attic countryside from Athens after that date does not mesh with the usual model of a centralization into "Athens" of independent Attic polities.

10. Manville 1990, 77–8.

11. See also Plutarch, *Solon* 12.

12. Styrenius 1967, 22–3, 31. No grave had been dug atop the Acropolis since the Middle Helladic period. One wonders whether the later discovery of such a tomb in the vicinity of the later Erechtheion led to its identification as "the tomb of Kekrops."

13. Mountjoy 1988, 32.

14. Mazarakis-Ainians 1988. Hölscher 1991, 358–9, on the other hand, considers the legend of Aegeus's palace below the Acropolis to the southeast, near the Olympieion, as evidence for the reduction of stature of the post-Bronze Age Athenian "king" to a mere *primus inter pares*, dwelling on the same topographical level as other nobles. But the tradition, by its own

logic, is of little value, for Aegeus preceded Melanthus and Kodros by several generations and thus ruled long before the collapse of the Mycenaean world.

15. One rough estimate is that the Acropolis's adult population in the Submycenaean period numbered no more than ten; see I. Morris 1987, 77.

16. Mountjoy 1988, 29.

17. Perhaps the earliest known Greek export to the Levant after the end of the Bronze Age is an Attic Protogeometric vase of c. 900 found at Tyre (stratum IX); see Warren and Hankey 1989, 167.

18. Graef and Langlotz 1909, pls. 7, no. 212, and 9, no. 273. Also Desborough 1952, 93.

19. Smithson 1982, 154 n. 44.

20. Smithson 1982, 154; cf. Glowacki 1991, 20.

21. The so-called Heidelberg Graves; Styrenius 1967, 52–55; Desborough 1952, 2, 70–1, pl. 1 (Heidelberg B).

22. Styrenius 1967, 87–8, 91, 116 (adult cremations).

23. Brouskari 1980.

24. Graef and Langlotz 1909, pl. 10, no. 272; Coldstream 1968, 13 n. 2.

25. Perhaps the archaeological record of the Dark Age Acropolis was at least partly erased in the Late Geometric period itself, when increased building and votive activity – relandscaping the place, constructing a temple, setting up monuments – might have taken something of a toll.

26. Graef and Langlotz 1909, 23.

27. For example, Late Geometric vases have been found in the Bronze Age *tholos* tomb at Menidi; see Wolters 1899.

28. The fact that many Geometric sherds were apparently found in *Perserschutt* suggests that the earthmoving would had to have taken place before 480.

29. For the Cretan sherds, see Graef and Langlotz 1909, 31 (nos. 313–14); Coldstream 1968, 382; for the terracotta horses, see Casson and Brooke 1921, 322, 430; for the terracotta plaques, see Coldstream 1977, 332, and Boardman 1954, 195–97; for the box fragments, see Boardman 1954, 194, and Graef and Langlotz 1909, no. 281.

30. Some believe there are no Attic painted inscriptions earlier than those found on Mt. Hymettos, c. 700–675; Jeffery 1990, 76 (no. 3).

31. Jeffery 1990, 69–70 (no. 2).

32. Touloupa 1972; Coldstream 1977, 338.

33. *Works and Days* 654–9.

34. Sweeny et al. 1988, no. 13 (Athens NM 874).

35. The female tripod figure is Athens NM 6503; see de Ridder 1896, 293 (no. 771).

36. For example, Acropolis 6613, a remarkably alert, long-haired and helmeted fellow who might date just after the turn of the century and could be either a mortal warrior or a god (Zeus?). See generally Schweitzer 1971, 138–42.

37. Zimmermann 1989, 269–92 (nos. 3, 5, 26–8, 30, 34–5, 42–3, 45–7, 52–3). For the Lakonian horse, see 135 (no. 167).

38. Langdon 1987, 108.

39. But see Kyle 1987, 16–17.

40. Sourvinou-Inwood 1993, 10.

41. While it is possible that the crown of the old Mycenaean "bastion" [Fig. 55] was rebuilt in the late eighth century, the preponderance of the evidence suggests a later, early sixth-century date; Mark 1993, 17, 35.

42. Whitley 1991, 57–8.

43. Osborne 1989, 308–9; cf. Osborne 1994, 148–51.

44. Cf. Whitley 1991, 58; Hölscher 1991, 359.

45. I. Morris 1987, 205; Whitley 1994, 57.

46. For the date of the first annual archonship, see Develin 1989, 27–28. Pantakles, the first Athenian Olympic champion, won the stade race in 696 and the stade and diaulos in 692; Stomas won the stade in 644; Kylon won the diaulos in 640; Phrynon won the pankration in 636; see Kyle 1987, A40, A53, A60, and A68.

47. Manville 1990, 78–82, notes that the virtually lost code seems to have referred, loosely, to the boundaries of Attica and assumed a distinction between Athenians and non-Athenians.

48. S. P. Morris 1984, 9; Osborne 1989, 309.

49. Touloupa 1991, 242–54.

50. de Ridder 1896, 83 (no. 243); S. P. Morris 1984, 110–11.

51. S. P. Morris 1984, 99 and n. 48; de Ridder 1896, fig. 264 (no. 756). For the notion that the paucity of Eastern material represents not so much an Athenian failure or backwardness but a conscious rejection or suspicion of the exotic, see Whitley 1994.

52. S. P. Morris 1984, 45, 48, 53–4, 58–9. For a recent evaluation of the style itself, see Whitley 1994.

53. Jeffrey 1990, 76 (nos. 5a, b)

54. Boardman 1954, 194 n. 133, and *BCH* 76 (1952) 202, fig. 1; also, Graef and Langlotz 1909, pl. 11 (no. 265).

55. For the human figurines, see de Ridder 1896, figs. 213–14 (nos. 696–7, male figurines), 279 (no. 771, a nude female), and 282–3 (nos. 774–5, Daedalic females). For the terracottas, Casson and Brooke 1921, 322; also, R. J. H. Jenkins 1936, 31, 50–1, pls. III, 2, and VI, 8 (Daedalic terracotta head of local manufacture).

56. Touloupa 1991, 254–5.

57. de Ridder 1896, 147–53 (nos. 431–40); for the griffins in the Parthenon inventories, see D. Harris 1991, 189 and 191.

58. Inscribed base: *IG* I³ 589 (650–600 is the suggested date); Jeffery 1990, 71 and 76 (no. 7). Inscribed tile: Jeffery 1990, 292 and 304 (no. 7). It is really tempting to link this tile to Byzes, an early Naxian architect who, according to Pausanias (5.10.3), first promoted the practice of roofing buildings with marble tiles.

59. Vlassopoulou 1988, nos. 1–4. The date of these fragments is, however, controversial. According to N. A. Winter 1993, 213, no terracotta roof from the Acropolis is earlier than 590–580, though she elsewhere (64 n. 120, 79 n. 156) seems to admit the possibility that several fragments could be as early as 620–600.

60. For the sphinx plaques (e.g. Acropolis 232), see Ridgway 1993, 253 n. 6.23; for the lamps (Acropolis 190 and 3869), see Brouskari 1974, 66.

61. A shrine dedicated to Nymphe (the nymph who received bridal vases as offerings) was established very low on the south slope (south of the later Odeion of Herodes Atticus) by the middle of the seventh century; Travlos 1971, 361.

62. Nylander 1962; Wycherley 1978, 143. I am informed by Manolis Korres that one of the bases was slightly repositioned during the late nineteenth-century excavations; both bases have recently been reexamined.

63. N. Robertson 1986, 157–68; Shear 1994, 227.

64. Touloupa 1969; 1991, 54; Ridgway 1993, 305.

65. Shapiro 1989, 5

66. Cf. Tomlinson 1992, 48; N. Robertson 1986, 174–5.

67. There are other fortified sanctuaries, such as the sanctuary of Athena and Poseidon at Sounion or of Apollo at Thermon, but they are not common, and the walls are generally later than the shrines; see Sinn 1993, 103.

Chapter 6

1. Whitley 1994, 66 n. 1, notes "the historian's optimistic belief that, in protohistoric times, fragmentary pieces of evidence must somehow relate to one another."

2. French 1987, 3.

3. For recent evaluations of Solon's legislation and its relation to his poetry, see Manville 1990, 124–56, Welwei 1992, 161–206; and Anhalt 1993.

4. Develin 1989, 39–40.

5. Connor 1987, 46 (quoting G. Else).

6. Connor 1987, esp. 43–4. Connor rightly stresses that Peisistratos acted as the charioteer of Athena and thus as her subordinate, not the other way around.

7. Polyaenus 1.21.2; cf. Constitution of Athens 15.4. Thucydides (6.58) says the disarmament of the people took place in 514, after the murder of Hipparkhos.

8. Dontas 1983; see also S. G. Miller 1995, 236 n. 83 (answering unpublished criticisms of the identification).

9. Shear 1994, 227. The word used is the singular propylaion, perhaps to distinguish this gate from the plural Propylaia (the Classical building) on the west slope of the Acropolis with which both Polyaenus and Aristotle were certainly more familiar.

10. Constitution of Athens 16. See, however, Herodotos 1.59, where there is a hint of the repressiveness of the regime.

11. Herodotos 5.62–65.

12. Herodotos 5.78. Herodotos says the Athenians were not noted for military valor before, but forgets successes they enjoyed earlier in the century against Megara over the rights to the island of Salamis. Thucydides also says the tyrants were able to conduct wars successfully, though it is not clear what role mercenaries played (6.54).

13. M. Robertson 1975, 94–6; Brouskari 1974, 40–1; IG I³ 593.

14. The rule that the gender of the sacrificial animal should accord with the gender of the divinity was not hard-and-fast (cf. Aristophanes, Birds 971). There are a number of vase-paintings that have often been interpreted as showing the sacrifice of bulls to Athena, and the Victories on the Classical Nike parapet frieze [Fig. 187] are often thought to be dragging sacrificial bulls to her altar. But the subject of at least some of the vase-paintings is controversial (see Shapiro 1989, 30 and n. 94) and the Victories on the Nike parapet are probably not sacrificing bulls to Athena at all; see Simon 1997, Jameson 1994, and Carpenter 1929, pls. V and XXX.

15. Homer, Iliad 2.550–51; cf. IG II² 1357.

16. The Moschophoros was discovered in the southeast part of the Acropolis during the 1860s, though findspot and original location need not always correspond; see Hurwit 1989, 45–51.

17. Ridgway 1992, 129–30; Shapiro 1989, 28 and pl. 8b, c.

18. IG I³ 510; Jeffery 1990, 72, 77 and pl. 3 (no. 21)

19. IG I³ 507.

20. Brouskari 1974, 45. For the interpretation of the relief as a metope, see Korres 1994b, 38 and his drawing, our Fig. 77.

21. Dickins 1912, 125–6.

22. Acropolis 617 and 677; Brouskari 1974, 48 and 50 (figs. 86 and 91); Ridgway 1993, 143. It is sometimes suggested that the fairly high percentage of Naxian works – or, at least, works in Naxian marble – on the Acropolis could be a factor of Peisistratos' close ties with Lygdamis, the tyrant he installed on the island (see Payne and Young 1950, 12–13). But Acropolis works in Naxian marble long antedate Peisistratos' and Lygdamis' association (cf. Chapter 5, n. 58 and 60), and may simply reflect a long period of general good terms enjoyed by the two states.

23. For example, Acropolis 589; Brouskari 1974, 94.

24. Brouskari 1974, 43–4; Ridgway 1993, 63, 143–4. The kore is the first statue to show, in back, traces of the "claw chisel," a tool that has loomed large in chronological discussions of the Acropolis and that is now thought to have been invented in Egypt in the seventh century; see Palagia and Bianchi 1994.

25. Acropolis 630; Brouskari 1974, 37.

26. IG I³ 597. See Jeffery 1990, 73 (no. 25); Kyle 1987, 205–6 (no. A 38); Raubitschek 1949, 338–40 (no. 317). The date of the dedication seems to be around 550.

27. Acropolis 586 and 622; Brouskari 1974, 95 and 100–1.

28. Winter 1993, 155–7, pls. 60–2; Vlassopoulou 1988, xiv–xv (cat. 10 bis). The model may have been of Argive manufacture.

29. Boardman 1974, figs. 25.1, 2 (Acropolis 587); 47 (Acropolis 606); 49 (Acropolis 611); 64 (Acropolis 607); for the C Painter's and Kleitias' Acropolis vases, see Beazley 1986, 23 and 31–32. For the earliest gigantomachies, see Shapiro 1989, 38.

30. A poros-limestone altar (or table) dedicated to Athena by one Khairion (IG I³ 590) and a poros column (a support for a lost statue) dedicated to "the grey-eyed maiden" by someone

whose name began with Phy . . . (*IG* I³ 592) may date as early as 600–575, but there is no certainty; see Raubitschek 1949, 5–6 and 364–65, and also Jeffery 1990, 77 (nos. 12 and 13).

31. There are several fragments of terracotta antefixes and an eaves tile apparently from a building constructed around 590–580; see Winter 1993, 213–14 (no. 1); Vlassopoulou 1988, xiii–xiv (Cat. 5–7).

32. Eiteljorg 1995, 9–11.

33. See, for example, Travlos 1971, 53, 482.

34. For the reading of the name ("Patrokledes" instead of "Patrokles") see *IG* I³ 596.

35. Mark 1993, 20–8, 31–5; Mark dates the transformation of the bastion and the erection of altar and statue between 580 and 560. For the statue, see also Chapter 2, especially n. 84.

36. See S. G. Miller 1995, 212–14, who argues that the *dromos* (race or racetrack) was held or laid out in the area of the later Hellenistic Gymnasion of Ptolemy northeast of the Acropolis, in the area of the Archaic Agora, and that the track was not, as is usually thought, coterminous with the Panathenaic Way through the Classical Agora.

37. For the date of the ramp, see Vanderpool 1974; Winter 1982; and Eiteljorg 1995, 9 n. 1.

38. See, however, Osborne 1994, 152–4, who argues that Eleusis had been part of the Attic polity much earlier, perhaps even as early as the Dark Age.

39. Simon 1983, 24–7; Shapiro 1989, 67–71.

40. Simon 1983, 103. In the fifth century the statue was replaced with a gold and ivory image by Alkamenes.

41. NM 3131; Boardman 1978, fig. 201.

42. The new ramp up the west slope would naturally have facilitated the transportation of architectural material to the summit and might even have been built with that function in mind.

43. For a cogent review of the architectural evidence, see Bancroft 1979, 26–45; also Klein 1991b, 7–16.

44. See Korres 1994b, 38, and 1994c, 178, who restores felines in the metopes of the porches within the peristyle as well. For an alternative theory that the marble appliqué reliefs of reclining felines (parts of half a dozen survive) decorated not metopes but the top of the antae (end walls) of the porches of the cella within the colonnade, see Ridgway 1993, 284–5.

If the Gorgon functioned as an *akroterion*, perhaps Perseus appeared as another, so that the monster would have chased the hero (or vice versa) over the roof of the temple.

45. See Ridgway 1993, 286–7 and n. 7.26; Stewart 1990, 114. The most recent detailed treatments are Höckmann 1991 and Kiilerich 1988. For the political allegory, see Boardman 1972.

46. Palagia 1993, 42–3. Kekrops is often shown with snake legs on Athenian vases.

47. The name *Archaios Neos* (which seems to appear for the first time in an inscription of the 450s [*IG* I³ 7] and in a decree referred to in the *scholia* to Aristophanes, *Lysistrata* 273) is applied in our sources mostly to the Classical Erechtheion, which ultimately replaced the Archaic temple (it impinges on its foundations) and inherited the title from it; see Paton 1927, 434. It was called *Archaios Neos* not because it was old, but because it housed the ancient olivewood cult statue of Athena.

48. Major statements of Theory A are Plommer 1960, Beyer 1974, and Preisshoffen 1977.

49. Major statements of Theory B are Dinsmoor 1947; Dinsmoor, Jr., 1980, 28–30; and Ridgway 1993, 283. For the debate, see also Hurwit 1985, 238–45.

50. Cf. Childs 1994, 5 n. 14, and Korres 1994b, 38, whose opinion that the Bluebeard temple stood on the Parthenon site carries considerable weight. Still, any final decision between Theory A and Theory B must await the full publication of his discoveries under the Parthenon.

51. See Shapiro 1989, 27–9 and 36 and n. 145, who believes a new statue set out in the open was the model for the Panathenaic Athena; but see Ridgway 1992, 127–8.

52. Building B (late sixth century, Fig. 109, no. 110) is usually thought to have stood on the site of the northwest wing of the Classical Propylaia; see Klein 1991a and 1991b, 17–35, but also Eiteljorg 1995, 58 n. 104. For architectural terracottas belonging to at least four separate Acropolis buildings dating between 570 and 550, see Winter 1993, 214–19 (nos. 2–4), 220–3 (nos. 7–8).

53. Boardman 1978, figs. 196 and 197. For a summary of the generally futile attempts to attribute individual small pediments to particular small buildings (the Red Triton pediment to Building A, for example), see Boersma 1970, 239; also Bancroft 1979, 46–76.

54. For reconstructions of the west pediment with mythological groups, see Beyer 1974 and Stucchi 1981, 74–80, who, in addition to interpreting the Introduction pediment as Herakles in Hades, also reconstructs a group showing Herakles killing the Stymphalian birds in the left corner, instead of the Birth of Athena. But see Ridgway 1993, 289–90 and 318 (n. 7.31); Stewart 1990, 114; and Bancroft 1979, 68–9.

55. The hipped roof is a feature also found on the terracotta temple model dedicated on the Acropolis around 570, which might suggest either that this was a common kind of building on the early Acropolis or that this kind of building had special significance; see Winter 1993, 204–5.

56. *Iliad* 2.546–51.

57. Ridgway 1993, 290–1; also Kiilerich 1989.

58. There are a number of terracotta figurines of *hydriaphoroi* from the Acropolis; see Casson and Brooke 1921, 333.

59. Shapiro 1995, 43, compares the statuette to a woman on a later black-figure vase in New York (Metropolitan 53.11.1) who may be balancing the *peplos* on a similar cushion on her head.

60. Acropolis 696 (the very fragmentary Polos kore) also wore one; Brouskari 1974, 67.

61. Marszal 1988; Ridgway 1993, 147–8.

62. Jordan 1979, 47; Preisshofen 1977.

63. Mark 1993, 34–5.

64. Pausanias 1.22.6 and Travlos 1971, 482 and figs. 618–19.

65. Klein 1991b, 26–8, 33.

66. Bookidis 1982; Vlassopoulou 1988, xix (Cat. 30).

67. Klein 1991; 1991b, 32–5 (Buildings D and E).

68. Shapiro 1989, 20.

69. For the Archaic Great Altar, see Bancroft 1979, 58–61.

70. Scholiast on Aristides, *Panathenaikos* 13.189.4–5.

71. Cf. Hölscher 1991, 367 n. 49, who denies any connection between the temple and Peisistratos at all.

72. Shapiro 1989, 86; Hölscher 1991, 368.

73. Shapiro 1989, 119; Glowacki 1991, 46–64.

74. Shapiro 1989, 67–71. It now seems likely, however, that a new Hall of Mysteries, or Telesterion, at Eleusis was built not during Peisistratos' reign (as has been commonly thought) but during his sons' (or even later than that); see Clinton 1994, 162.

75. For statements and restatements of the theory, see Boardman 1972, 1975b, and 1985. For critiques, see Hurwit 1985, 247 n. 46 for bibliography, to which add R. F. Cook 1987, Boardman 1989, and Shapiro 1989, 157–163. Herakles was widely worshipped as a hero and no special explanation for his presence in Athenian art may be required. There are also some grounds for thinking Theseus to have been Peisistratos's hero, at least as much as Herakles; cf. Plutarch, *Theseus* 20. But none of this means that the tyrants (and especially the sons) could not have fostered Herakles's cults, and it is worth mentioning that Marathon, where Peisistratos landed in 546, was especially associated with the hero. The Marathonians even claimed that they were the first to recognize his divinity; Pausanias 1.15.3.

76. Korres 1994b, 41; the precise date of the Archaic monument is open to question.

77. Rhodes and Dobbins 1979, have analyzed three phases of the sanctuary's development, but they do not date them. If there was a Peisistratid Brarunion, it was in the same area, but did not cover exactly the same ground (since the Classical sanctuary was built partly over the Mycenaean circuit wall, which still formed the defenses of the Acropolis in the sixth-century).

78. For the vase (Acropolis 621, a krateriskos, dated c. 510), see Kahil 1981; fragments show a fawn, girls playing flutes, and another woman approaching a flaming altar. For the dogs (Acropolis 143 and 550), see Brouskari 1974, 57–8 (who suggests they flanked the entrance of the precinct) and Ridgway 1993, 201. Real dogs were not allowed on the Acropolis; statues of dogs were fine.

Morizot 1993 has suggested that Acropolis 122, the marble head of a creature usually thought to be a lion and datable to the second quarter of the century on stylistic grounds, is in fact the head of a bear, an animal particularly associated with Artemis Brauronia. If so, the origins of the sanctuary may lie in Peisistratos' period of ascendancy. But see also Osborne 1994, 147–51, who challenges the orthodox view that Peisistratos was instrumental in the linking of city and countryside by the establishment of cult.

79. The theory makes better sense if the date of the horsemen is placed after 546, which is, given the flexibility of Archaic chronology, not impossible; see Boardman 1978, fig. 114. Against the identification, Ridgway 1993, 200–1. Also, Eaverly 1995, 73–8 (cat. no. 1).

80. The theory that there was a decline in dedications c. 550–525 requires a certain manipulation of dates, making statues that could date early in the third quarter of the century even earlier (late second quarter) and making statues that could date late in the third quarter even later (early fourth quarter). I do not think the chronology of Archaic sculpture, which is based primarily on subjective stylistic assessments, allows such fine distinctions. In any case, dedicatory activity is, by everyone's account, in full swing in the years of Hippias's rule (527–510), when he, presumably, would also have lived atop the Acropolis; the logic of the argument does not hold.

Supporters of the theory that the Peisistratids lived atop the Acropolis include: Cornelius 1929, 24; Holland 1939, 294–8; Raubitschek 1949, 456; Kolb 1977; Travlos 1971, 53; Boardman 1978, 153–4 (who suggests that some of the small poros pediments decorated not temples or *oikemata* but the tyrant's palace, even while admitting that such a use of architectural sculpture on a private residence would be unprecedented); and French 1987, 55. For arguments against, see Parker 1996, 72 n. 18 and 84; Tanoulas 1992a, 158; and Boersma 1970, 14–15.

81. The remains of an Archaic cistern lying just northeast of the Classical Propylaia [cf. Fig. 109] have sometimes been thought to support the idea, since it would obviously be in the interest of any tyrant living atop the Acropolis to secure a water supply. (No such cistern seems to have existed as early as Kylon's conspiracy, which is said to have failed partly because he lacked water; Thucydides 1.126.9.) Still, the Archaic cistern is likely to date after 510 (that is, after the expulsion of the Peisistratids); see below, n. 101.

It has also been suggested that eight new wells were dug on the northwest slope of the Acropolis (representing the first major utilization of the area as a water source since the end of the Bronze Age) during the Peisistratid era and, since they may have been protected by the shadowy defensive work known as the Pelargikon, would have offered a secure supply for Hippias and his family during the seige of 510 (Herodotos 5.65 says the beseiged Peisistratids had plenty of water). For the wells, which were filled in c. 500–480, see Glowacki 1991, 38–9.

82. See Winter 1993, 224–7 (nos. 10, 11, 12). Another unknown building (with antefixes in the form of gorgoneia) was built around 520, during the reign of Hippias; *ibid.*, 227–8 (no. 14).

83. *Constitution of Athens* 16; cf. Thucydides 6.54.5–6.

84. We *do* hear that when, near the end of his rule, Hippias felt threatened, he started to fortify the hill of Mounichia in the Peiraieus, which seems redundant had he, like his father, already lived in a fortified palace on the Acropolis. The Spartans arrived in 510 before Mounichia was complete, necessitat-

ing Hippias's withdrawal to the Acropolis; see *Constitution of Athens* 19.2.

85. Camp 1994, 9–11; but see S. G. Miller 1995, 224 n. 4. The official dedicant of the Altar of the Twelve Gods was Hippias' son, Peisistratos the Younger, who also dedicated the altar of Apollo Pythios; see Meiggs and Lewis 1988, 19–20 (no. 11).

86. For the Shrine of Apollo Pythios and the Olympieion, see Travlos 1971, 100 and 402–03. There was an earlier temple (of uncertain date) on the spot of the Peisistratid Olympieion (usually dated around 520–515), so even here the tyrants seem to have developed a previously existing sanctuary rather than create a new one; Hölscher 1991, 368 and n. 54.

87. Winter 1993, 228 (no. 15).

88. Travlos 1971, 198. See also n. 74 above.

89. Shear 1994, 236, 241.

90. Thucydides 6.55.

91. Shear 1994.

92. The architectural sculpture from the Bluebeard temple – sometimes called the *Tyrannenschutt* (Tyrant's debris) – was apparently buried en masse in an area east and southeast of the Parthenon; at least that is where most pieces were found in the late nineteenth-century excavations.

93. For a recent argument dating the *Archaios Neos* to 510–500, see Childs 1994. A Peisistratid date is defended by Croissant 1993 and favored by Ridgway 1993, 291–5, who leaves open the possibility that the temple was begun by Peisistratids but with the marble pediments installed after the tyranny's end in 510.

94. Childs 1994, 1.

95. For the Nike *akroterion*, see Ridgway 1993, 151–2. For the lion's head waterspout (Acropolis 69), see Brouskari 1974, 58.

96. Camp 1994, 11, points out likely cultic connections between the Alkmeonidai, Kleisthenes's clan, and Poseidon.

97. Ridgway 1993, 395–7. Against the association: Childs 1994, 6 n. 59.

98. Moore 1995; Stähler 1972 and 1978. For a different view of the pedimental compositions, see Marszal 1997.

99. The relief (Acropolis 120): Mantis 1994 and Brouskari 1974, 129 and fig. 247. The group (Acropolis 293, 452, and 658): Brouskari 1974, 101 and fig. 195; Payne and Young 1950, 75 and pl. 122.

100. For the terracotta roofs, see Winter 1993, 228–32 (Nos. 16–18), and Vlassopoulou 1988, xx–xxii (cat. 32–9). Building B: Eiteljorg 1995, 58 n. 104 (who doubts its location beneath the northwest wing of the Propylaia); Tanoulas 1992a; Klein 1991b, 30–1; Boersma 1970, 35 and 233 (cat. 122).

101. Tanoulas 1994c, 181–82; Tanoulas 1992a; Wright 1994, 349–58. The South Slope spring house [Fig. 109, no. 114], sacred originally to the nymphs but eventually to many other deities, may have been built at this time as well; see Travlos 1971, 138.

102. This entrance court is notoriously difficult to place chronologically. Both Eiteljorg 1995, 85, and Dinsmoor, Jr., 1980, 27–31, date it to after 489/8, since they believe that the Blue-

beard temple (where the marble metopes came from) stood on the south side of the Acropolis [Fig. 83b] and that its metopes would not have been available until it was dismantled to make room for the Older Parthenon around 489. But if the Bluebeard Temple stood on the north site and was dismantled as early as 510 (to make room for the *Archaios Neos*), then the court could date any time between the late sixth century and the construction of the so-called Older Propylon in the 480s, which truncated the court. It also seems unlikely that the Athenians would have changed their minds about the Acropolis entrance twice within just a few years.

103. Tölle-Kastenbein, 1993, argues that around 500 the young democracy also began a far more massive project on the south side of the summit: the great podium that essentially raised and levelled off the sloping terrain on that side of the rock [Fig. 106]. She posits a platform 78m long and a little over 29m (100 Attic feet) wide – in other words, a Hekatompedon, perhaps *the* Hundred-Footer of the famous inscription; see also Németh 1993, whose date for the inscription (499/8 or 498/7 instead of the usual 485/4) is unlikely. If this enormous project was begun as early as 500 (it is usually, and I think rightly, dated to the years after 490) it may originally have been intended to support a new (but unrealized) building: a poros-limestone Pre-Parthenon; see Korres 1994d, 56. As we shall see, it certainly wound up supporting a new (but never completed) *marble* Pre-Parthenon, and then the Parthenon itself.

104. Holloway 1992.

105. Ridgway 1990a. For the controversial date of the Antenor *kore*, see most recently Childs 1993, 441. The idea that Nearchos, the dedicant of the huge Antenor *kore*, was a potter admittedly rests on the restoration of one, largely missing word inscribed on the base as [kerame]us (potter); *IG* I^3 628. This is not the only possible restoration, however, and even if it *is* correct, the word could refer to Nearchos's district or deme, not his occupation.

106. Ridgway 1993, 66, excludes true *kouroi* from the Acropolis. Fragments of another *kouros*, probably fallen down from the Acropolis summit, were found on the north slope; see Glowacki 1991, 94.

107. NM 6446; Mattusch 1988, 91–4.

108. Acro. 633; Payne and Young 1950, 46.

109. For the scribes, see now Triandi 1994, 83–6.

110. For late Archaic horsemen on the Acropolis, see Eaverly 1995, *passim*. Such freestanding equestrian statues on the Acropolis may have had reflections high above in temple pediments. Fragments of marble horses (including the impressive beast Acropolis 697, preserved only from mid-belly forward) and nude youths have recently been associated by I. Triandi, who would place the group in the pediment of a late sixth-century (and heretofore unsuspected) Acropolis temple; see Triandi 1994, 86–90, and Korres 1994c, 175–6.

111. This is not to say the Athenians now ignored Herakles, the panhellenic hero: a small marble Herakles, characteris-

tically wearing his lionskin, was dedicated on the Acropolis around 500; see Brouskari 1974, 96 (Acropolis 638).

112. See Shapiro 1989, 143–9.

113. Brouskari 1974, 62. Glowacki 1991, 96–7, identified the part of Theseus's upper left arm in debris from the north slope. It has been suggested that the Theseus-Prokrustes group was not freestanding, but served as an *akroterion* (for the *Archaios Neos*, for example, where its political symbolism would jibe nicely with the subtext of the Gigantomachy pediment). See Ridgway 1993, 295, 321, 329 (who notes that another small group often thought to represent a mythological "dice-game" – it really showed grooms kneeling beside their horses – filled a corner of a pediment) and Triandi 1994, 86–7.

Pausanias (1.27.7–10) saw two works depicting Thesean legends: one represented the young hero (in bronze) and the rock (in stone) under which Aegeus had placed boots and a sword as tokens of his rightful station; another showed Theseus and the Bull of Marathon, or perhaps just the bull alone. There is nothing to indicate their date, but if they were set up on the Acropolis before the Persian sack of the Acropolis in 480, the works Pausanias saw would have been later replacements.

114. Raubitschek 1949, 465; Boardman 1975a, 60.

115. Meiggs and Lewis 1988, 25–7 (no. 14). The Salamis decree, to be dated c. 508–506, reflects Kleisthenic Athens's concern with its defenses after the falling out with Kleomenes and Sparta.

116. Pausanias saw the statue near the Propylaia (1.23.1–2). Pliny, *NH* 34.72, adds the information that Amphikrates was the sculptor and that the lioness lacked a tongue, supposedly to signify Leaina's silence under torture. If the story is true, the lioness would have been a rare bronze survivor of the Persian sack of 480; see also Boardman 1986.

117. *IG* I³ 501; Meiggs and Lewis 1988, 28–9 (no. 15); Raubitschek 1949, 191–4 (no. 168) and 201–5 (no. 173). The choice of Eleusinian limestone for the original monument may have been a political one: it was at Eleusis that Kleomenes's final invasion of Attica in 506 was aborted.

118. When, around 507 or 506, Athenian emissaries approached the Persian governor at Sardis for assistance against further interference from Kleomenes and Sparta, they were asked who they were and where in the world they lived (Herodotos 5.73). A few years later, perhaps, Hippias, the old tyrant, made his way from Sigeion to Darius's court, where he urged the Great King to restore him to power.

119. Herodotos 6.105. See Borgeaud 1988, 133–36.

120. The South Slope spring house on the other side of the Acropolis [Fig. 109, no. 114] also became sacred to Pan in the fifth century.

121. Shapiro, 1988, favors an earlier date (c. 500) for the work.

122. For the inscription, see *IG* I³ 784 and Meiggs and Lewis 1988, 33–4 (no. 18). For the *kerykeion*, see Borgeaud 1988, 134 and 243 n. 7.

123. See Korres 1994c, 178.

124. It has been suggested that Aristides himself – a great general and leading politician – may have proposed the project; Boersma 1970, 39. For a very different and generally rejected chronology placing the construction of the Older Parthenon in the early Periklean era (after 454), see Bundgaard 1976, 138–139.

125. But see n. 103 above. Whenever the platform was built, its construction necessitated the dismantling of part of the south Mycenaean fortification wall, and the podium itself may have taken on the character of a defensive work; see Tschira 1972, 162–7; Tölle-Kastenbein 1993, 61–2. If the Bluebeard temple stood on the south side of the Acropolis rather than on the north, the construction of the podium would obviously have necessitated its demolition.

126. For the history of the Older Propylon, see Dinsmoor, Jr., 1980. But see Eiteljorg 1995, who concludes that the Old Propylon is an archaeological fiction and that until Mnesikles' construction of the monumental Classical Propylaia (437–432), the entrance to the Acropolis still consisted of the old (if repaired) Mycenaean gate [cf. Fig. 83] and a two-level courtyard, with the levels separated by a flight of steps, in front of it.

127. Korres 1995, esp. 50–9.

128. Korres 1994b, 41.

129. For the Older Parthenon, see especially Korres 1995; Travlos 1971, 444; Boersma 1970, 38–39; Dinsmoor 1934; Hill 1912.

130. Plutarch, *Themistokles* 10.4. It is likely that other cult statues – for example, the statue of Athena Nike – were removed as well.

131. Ruins northwest of the Erechtheion have now been interpreted (by A. Papanikolaou) as remnants of a defensive work hastily thrown up just before the Persian attack; see Korres 1994c, 178.

132. S. G. Miller 1995, 236 n. 83.

133. During the current restoration of the Parthenon, many Older Parthenon blocks have been discovered bearing the signs of intense heat; Korres 1994c, 176; Korres 1995, 107–8.

134. Mark 1993, 40–1.

135. Tanoulas 1992a, 160.

136. Despinis 1986; see also Ridgway 1993, 362 n. 8.12. Stylistically the carving seems transitional between the Archaic and the Early Classical, and it is impossible to say whether it dates just before 480 or just after. But the depicted myth almost certainly alludes to the Athenian struggle against the Persians (as the Amazon metopes on the Athenian Treasury at Delphi, dated now to the 480s, did, and as the Amazonomachy on the west metopes of the Parthenon would later).

137. Pausanias saw a few works (such as Endoios's Athena and the lioness of Leaina) that survived the onslaught; see 1.26.4 and 1.27.6 and above n. 116.

138. Euthydikos *kore* (Acropolis 686): Brouskari 1974, 127–8; Acropolis 302: Brouskari 1974, 127; Acropolis 692, Brouskari 1974, 131.

Chapter 7

1. Most notably the great bronze statues of Harmodios and Aristogeiton made by Antenor and set up in the new Classical Agora near the spot where they hacked Hipparkhos to death. Hippias, again, had escorted Xerxes's father Darius to Marathon, and the pair who killed Hippias's brother had become symbols of Athenian democracy. The removal of their images from the Agora was not merely pillage, but politics. Antenor's Tyrannicides were replaced in 477/6 by a new group created by Kritios and Nesiotes.

2. Herodotos 9.13. For the archaeological record of the Persian destruction, see T. L. Shear, Jr., 1993.

3. Herodotos 9.22; Pausanias 1.27.1. Demosthenes, 24.129, alleges that "Mardonios's sword" was stolen in the early fourth century; if so, Pausanias's testimony implies it was later recovered. "Mardonios's sword" (or what went by that name, since his actual weapon would have rightfully belonged to the Spartans who killed him) was hardly the only Persian weapon (or weapons in a Persian style) found on the Acropolis; see, for example, D. Harris 1995, 109–10. The Athenians surely also stored their split of the battle spoils – the gold and silver vases and furnishings and so on taken from Persian tents, as well as Persian armor and weapons – on the Acropolis; Herodotos 9.80–81.

4. Thucydides 1.93. See also Davies 1993, 41–8.

5. Thucydides 1.96–97.

6. Badian 1987; Stadter 1989, 149–51; but see Blamire 1989, 144–6.

7. A talent was a unit of weight equalling about 26 kilograms, or a little over 57 pounds.

8. Meiggs and Lewis 1988, 83–9 (no. 39), 111–17 (no. 45), 117–21 (no. 46), and 128–33 (no. 49); also Davies 1993, 69.

9. Goldhill 1987, 60–62.

10. See D. Harris 1994 and Davies 1993, 51–8.

11. Pausanias 10.10.1. Peisianax, Kimon's brother-in-law, was apparently responsible for the construction of the Stoa Poikile and the building was originally named after him (the Peisianakteion). Polynotos of Thasos, who also executed paintings for the Stoa Poikile, was said to have been one of the many lovers of Kimon's sister, Elpinike.

12. For the oath, its variants, and the controversies surrounding it, see Meiggs 1975, 504–7, and Blamire 1989, 151–2.

13. Theopompus (FGrHist 88 F 153); Fornara 1977, 96 (D).

14. For the problem of the *Perserschutt*, see Hurwit 1989, 63 and n. 74.

15. Pausanias 1.23.1–2; 1.26.4; 1.27.6; also above, Chapter 6, n. 116.

16. Cf. Bundgaard 1976, 134.

17. Eiteljorg 1995, 53–6, believes that the Persians severely damaged a part of the Cyclopean wall beside the Classical Propylaia and that Athenians thereafter repaired it in the same style (though what they built was not of the same quality as the original).

18. Plutarch, *Kimon* 13.6–7; Pausanias 1.28.3, who clearly distinguishes the south wall from the rest of the circuit, which he says was built by the Pelasgians.

19. Boersma 1970, 46 and 162 (cat. no. 20), notes technical similarities between the north and south walls as well; the south wall, for example, also has blocks from the *Archaios Neos* built in. It is now accepted, however, that much of both the north and south walls are Periklean, possibly as late as the 430s; see Chapter 8, 159–60.

20. Travlos 1971, 323; Smithson 1982, 143.

21. IG I³ 433; Meiggs and Lewis 1988, 163.

22. Dinsmoor 1947, 125–7; D. Harris 1991, 42. For Building E, also Boersma 1970, 62, 237 (cat. no. 131) and Klein 1991b, 32–33.

23. See Vlassopoulou 1988, xxiii–xxx (Cat. No. 41–63).

24. Bundgaard 1976, 77–8; Hurwit 1989, 44–5 and n. 4, and 63 n. 74.

25. Korres 1994b, 46; Korres 1988.

26. Mark 1993, 128–29.

27. Dinsmoor, Jr., 1980, 62–4. Two of the principal differences from the original gateway were the use of more slender columns and the use of red stucco to coat the walls of the building. Mark 1993, 64–5, 132–3, seems to prefer a date around 450–445, making the repair "Periklean," even though this would mean that the Acropolis lacked a serviceable gateway for nearly thirty years after the Persian sack, and that Perikles restored the old building about the same time that planning for Mnesikles's new Propylaia would have begun.

Column drums evidently belonging to the interior order of the Older Propylon have recently been identified in the foundations of both the Classical Propylaia and the Erechtheion; Korres 1988. Eiteljorg 1995, who denies the existence of the Older Propylon, argues for two Early Classical repairs or rebuildings of the old Mycenaean gate and two-level courtyard that he posits in its stead.

28. For Pheidias's workshop, see Boersma 1970, 243 (cat. no. 140).

29. It is obligatory to mention one revisionist (and not very plausible) theory that a second Parthenon was in fact started at Kimon's initiative in the 460s after Eurymedon and was half-done when Kimon's death left Perikles essentially in control of Athens. According to this theory, Perikles was an inveterate Kimon-hater who spitefully dismantled what had been built of the "Kimonian Parthenon" just so he could replace it with his own, grander temple (the Parthenon we see now); see Carpenter 1970, esp. 67. It is difficult to believe that such a remarkable scenario would not be at least alluded to in our sources, and for this and other reasons Carpenter's theory is generally dismissed. Also idiosyncratic is Bundgaard 1976, 138–9, who argues that the Older Parthenon itself was begun not in the 480s but after 454, that it thus could not have been a victim of the Persians, and that its only successor was the Periklean temple, begun a mere seven years later.

30. *IG* I³ 52 (the Kallias financial decrees); see Meiggs and Lewis 1988, 154–61 (no. 58). The treasures of the other gods included the holdings of temples and shrines below the Acropolis and elsewhere in Attica and were moved up to the Acropolis in 434/3 because of the threat of invasion by the Spartans; see also Meiggs 1975, 200–1.

31. For the *Opisthodomos*, see most recently D. Harris 1995, 2–5; Korres 1994b, 46–7; and Roux 1984. Another possibility is that the western part of the *Archaios Neos* was indeed restored after 479 but was demolished when the Erechtheion (which would have made it redundant) was finished before the end of the fifth century.

32. Herodotos's book, incidentally, was well-known in Athens by 425, when Aristophanes satitized it in his comedy *Akharnians* (lines 515ff).

33. See, however, Bancroft 1979, 5–6, who raises the possibility that the blackened walls Herodotos saw were those of the *Archaios Neos* itself, that the "*megaron* facing west" was a separate building altogether, and that there was by implication a "*megaron* facing east." In his description of the Persian capture of the Acropolis (8.53), however, Herodotos also mentions the *megaron*: it is where the defenders of the citadel took refuge, and that *megaron* could only have been the *Archaios Neos*.

N. Robertson 1996, 42, identifies Herodotos's *megaron* with Building IV in the southeast angle of the Acropolis, which he also believes was the Erechtheion. But why Herodotos should not have simply called it the Erechtheion, if such it was, is unexplained.

34. By Pausanias's day the new shoot (like the fish that got away, whose size grows with time) was said to have been *two* cubits long (1.27.2).

35. If the story of the contest between Athena and Poseidon for patronage rights to Athens was an invention of the Early Classical period, and if the cult of Poseidon was installed on the Acropolis only after the Persian Wars (see Chapter 2), then it is possible that the spot of his salt sea (as well as the mark of his trident) was defined only now.

36. Boersma 1970, 181 (cat. no. 49); Paton 1927, 125, 144; Holland 1924, 10, 16–23.

37. Cf. Casanaki and Mallouchou 1983, 92. Our fig. 115 is based loosely on a plan that is, as of this writing, unpublished but that was exhibited in Athens and elsewhere in Europe in the 1980s and is currently on display in the "Erechtheion Room" of the Center for Acropolis Studies (Makriyianni).

38. Mark 1993, 133.

39. *IG* I³ 6; Fornara 1977, 74–6 (no. 75). It is significant that the inscription does not mention the *Opisthodomos*, if the west part of the *Archaios Neos* had indeed been rebuilt to serve Athena Polias and her treasury and was called by that name.

40. *IG* I³ 7; Davies 1993, 57–8; Mark 1993, 133 n. 39. The inscription tells us that it itself was to be displayed "behind the *Archaios Neos*" (line 6).

41. Athens's finances benefitted not only from enemy spoils but also from the acquisition of raw materials and resources, such as the gold mines Kimon seized in Thrace after Eurymedon; Plutarch, *Kimon* 14.2. Since most of the architectural activity on the Acropolis appears to date after Eurymedon, one might argue that the (first) Peace of Kallias (465) freed the Athenians from the strictures of the Oath of Plataia, allowing them to rebuild shrines and buildings destroyed by the Persians. The failure to rebuild the Older Parthenon or the Temple of Athena Nike would in that case be attributable to other causes.

42. *IG* I³ 699; Raubitschek 1949, 246–8 (no. 217).

43. Pausanias 1.27.9–10; Shapiro 1988.

44. Herodotos 5.77; Pausanias 1.28.2; Meiggs and Lewis 1988, 28–9 (no. 15), who suggest the spot near the Bronze Athena may have been the location of the original (late-sixth-century) monument as well.

45. Brouskari 1974, 128; Ridgway 1970, 31, and 34–5. The *kore* dedicated by the fisherman Isolokhos (or Naulokhos) may also date just after 480 (see *IG* I³ 828). The Euthydikos *kore* [Fig. 19] is stylistically Early Classical, too, but has suffered from fire, was found near other *korai* destroyed in the sack, and is thus most likely pre-Persian; Dickins 1912, 242. Changes of style do not always respect round numbers like 480.

46. Hurwit 1989.

47. National Museum 6615 + 6930. Mattusch 1988, 116 and fig. 5.15b; Rolley 1986, 114, fig. 87.

48. Hurwit 1989; Ridgway 1993, 98 n. 3.12. Later still, in the 460s, the sculptor of the Blond Boy may also have carved the great (and stylistically similar) Apollo from the west pediment of the Temple of Zeus at Olympia, in which case his name might have been Alkamenes (not the later fifth-century sculptor by that name, but an earlier one); see Barron 1984.

49. Mattusch 1988, 94–5.

50. Acropolis 657; Dickins 1912, 194–5.

51 Pausanias 1.23.9. Though Pausanias mentions only Kritios, the base survives and bears the signature of both Kritios and his partner Nesiotes; see *IG* I³ 847.

52. Pariente 1993, 766.

53. Acropolis 644; Brouskari 1974, 100.

54. Acropolis 599; Brouskari 1974, 128–9; Dickins 1912, 133–34, suggests the figure is in fact a warrior wielding an axe.

55. *IG* I³ 511; see Raubitschek 1949, 146–52 (no. 135), and Bugh 1988, 45–50. Though the *Hippeis* dedication is usually thought to have been inspired by the Battle of Oinophyta in 457 – the same victory that probably inspired the replacement of the old Boiotian-Chalkidian monument – the date of the group is uncertain and could well be lowered to the 440s. For one thing, Lakedaimonios was the son of Kimon, and if he followed his father into exile he would only have returned around 452, when his father was recalled. For another, though Lykios could certainly have begun his sculptural career before 450, as the son of the Early Classical sculptor Myron he would have worked mostly in the 440s and 430s.

56. For the Pronapes monument, whose base blocks were much later reused in a repair of the west door of the Parthenon, see Korres 1994f, 124–25; IG I³ 880; Raubitschek 1949, 205–7 (no. 174); and Stevens 1946, 17–21.

57. Pausanias 1.23.7; Jeffery 1980.

58. Pausanias 9.30.1; 1.27.4; also Ridgway 1970, 86. For the discovery of blocks probably from the base of the Erechtheus-Eumolpos group built into the repaired west door of the Parthenon, see Korres 1994f, 124.

59. For example, the votive sheep offered by Peisis (NM 6695); de Ridder 1896, 192–3, and Schneider and Höcker 1990, fig. 53.

60. It is possible that Myron's cow had already been removed to Italy by Pausanias's day; Stewart 1990, 256.

61. Pausanias 1.23.7.

62. Pausanias 1.24.1; Pliny, NH 34.57–8. Also, Stewart 1990, 147; Daltrop 1980; Weis 1979; and Boardman 1985a, figs. 61–64. The vase, dated to c. 440, is Berlin, Staatliche Museen 2418. The violent Athena that Pausanias saw does not accord with the vase-painting of the subject. It is noteworthy that the only surviving bit of the fifth-century dithyrambic poet Melanippides's Marsyas (Fr. 2 Diehl) describes a moment close to the one represented in the group Pausanias records, and the poem and the sculpture may have had something to do with one another.

63. Pausanias 1.23.2 (if it stood in or near the Propylaia when Pausanias saw it, it must have been moved there from its original location elsewhere); IG I³ 876; Raubitschek 1949, 152–3 (no. 136); Lucian, Imagines 4. Kallias may have dedicated the Sosandra to commemorate his payment of a debt incurred by Kimon's father, Miltiades, thus "saving" the reputation of his family; see Pollitt 1990a, 47.

64. Brouskari 1974, 129–30; M. Robertson 1975, 179.

65. Jung 1995; Mayer 1989; Demargne 1984, 1015 (no. 625); Ridgway 1970, 48–9.

66. IG I³ 1147. Meiggs and Lewis 1988, 73–76 (no. 33).

67. Demargne 1984, 972 (no. 146); Mattusch 1988, 169 (c. 450).

68. Lucian, Imagines 6; cf. Himerios, Oratio 68.4, who praises a Pheidian Athena that has a "rosy hue" covering her cheeks instead of a helmet. For the debate over the statue, see Chapter 2, n. 88.

69. Pausanias 1.28.2; 9.4.1; Demosthenes, De Falsa Legatione 272. The scholiast on Demosthenes, Against Androtion 13 (597.5), however, agrees with Pausanias.

70. IG I³ 505; Raubitschek 1949, 198–201 (no. 172). See Meiggs 1975, 94–5, 416–17, for arguments against associating the inscribed base with the statue, and the statue with Kimon; also E. B. Harrison 1996, 29. Dinsmoor, 1967–8, believes the inscription belonged to a monument set up in the western part of the Acropolis to display cables from the destroyed bridge of boats that Xerxes built impiously across the Hellespont.

71. IG I³ 435; Mattusch 1988, 169–72; Meritt 1936, 362–80; Dinsmoor 1921. The inscription is arranged in three columns covering three years each; the length of time needed to create the work is consistent with other ancient monumental bronzes (such as the Colossos of Rhodes, which took twelve years; Pliny, NH 34.41).

72. For the bronze-casting workshop on the south slope, see Zimmer 1996.

73. See Vanderpool 1966.

74. E. B. Harrison 1996a, 28–34; Mattusch 1988, 169–70; R. J. H. Jenkins 1947; Pausanias 1.28.2.

75. The colossal egg-and-dart mouldings prominently lying near the site probably come from an Augustan-era repair; see Chapter 12, 274. For the big piece of Eleusinian limestone from the fabric of the pedestal currently resting atop the rock-cut wall defining the north side of the Sanctuary of Artemis Brauronia [Fig. 170], see Dinsmoor 1967–68.

76. Djordjevitch 1994. Plutarch, Themistokles 12.1, recounts a tale that as Themistokles desperately tried to convince the Greek allies to fight at Salamis, an owl flew in from the right (the side of good omen) and landed in the rigging of his ship, convincing his audience that he was right. For the owl at Marathon, see Aristophanes, Wasps 1086.

77. Demosthenes, De Falsa Legatione 272.

Chapter 8

1. Hansen 1982; Gomme 1933. There were perhaps 100,000 slaves in mid-fifth-century Attica, and thousands more metoikoi.

2. Aristotle, Constitution of Athens 37.2; Xenophon, Hellenika 2.3.13–14; 2.4.10.

3. Dinsmoor 1913, 78.

4. 2.65.9.

5. 1.23.6. For one of many discussions of the causes of the war, see Sealey 1976, 313–21, who also points out that from the Spartan perspective the war might have been called "the Athenian War." In fact, Thucydides himself never calls the conflict "the Peloponnesian War."

6. On the almost endlessly controversial Kallias Decrees (IG I³ 52) see Kallet-Marx 1989, 254–9; Meiggs and Lewis 1988, 154–61 (no. 58); Meritt 1982; Meiggs 1975, 200–1. The source of Athena's 3,000 talents is not clear, nor is it known whether they were transferred in one lump sum or had been paid in installments over many years. For the Golden Nikai, see Chapter 3, n. 144.

7. Thucydides 2.13. The 600 talents in allied contributions must include funds beyond the normal tribute, which did not exceed 400 talents. Thucydides's figure of 9,700 talents for the maximum accumulation of reserves on the Periklean Acropolis has been questioned; see, for example, Meritt 1982.

8. Thucydides 2.17.

9. Thucydides 3.89; Tanoulas 1994a, 53; Korres 1994e, 138.

10. Pausanias 4.36.6. Around the same time another statue

of uncertain material, but specifically an Athena Nike, was dedicated to commemorate victories over the Ambraciots, Korkyrean revolutionaries, and the Anaktorians; see *IG* II² 403, and Mark 1993, 113–14.

11. Meiggs 1975, 372.

12. Xenophon, *Hellenika* 1.6.1. It was either the just-completed Erechtheion or what remained (or what had been restored) of the late Archaic *Archaios Neos*. Is this the same fire that burned what Demosthenes terms the *Opisthodomos* (*Against Timocrates* 136)?

13. *IG* I³ 341; Harris 1991, 201–2.

14. It could also be that the empire's marble records – the tribute lists displayed on the Acropolis since 454 – were now vengefully shattered as well: the first stele [Fig. 113] is known from more than 180 fragments.

15. Krentz, 1979, notes that for the democracy to melt down Acropolis dedications to finance the war was one thing, but for the Thirty to do it to pay mercenaries was quite another (63); the relevant inscription is *IG* I³ 380 (= *SEG* XXI, 80).

16. Badian 1987, 17, 31–33, has introduced the idea of a second Peace of Kallias.

17. Plutarch, *Life of Perikles* 17; Stadter 1989, 201–4; Meiggs 1975, 512–15. Plutarch is our only ancient source for the Congress Decree, and he dates it vaguely to a time "when the Lakedaimonians began to become vexed at the growing power of the Athenians." That could have been just about any time from the late 470s down to 447, when work on the Parthenon began.

A document called the Papyrus Decree appears to date the decision to rebuild the Acropolis to Euthynos's archonship, which is firmly dated to 450/49. Logically, the sequence of events, even if compressed over a very short time, should have been: (1) the Peace of Kallias, (2) the Congress Decree, and (3) the decision to rebuild. Meiggs 1975, 151, dates the peace to 450, and that date just fits. Most scholars date it to 449. But Badian 1987, 32, dates the conclusion of the peace to 448. If he is right, there is a chronological problem, since the decision to rebuild (450/49) should not precede a peace treaty (448) that the decision presupposes.

18. The oath's provision to leave the temples destroyed by the Persians as memorials of their impiety might have been considered satisfied by the memorial built into the north Acropolis wall [Fig. 35].

19. Peiraieus "Corn Stoa": schol. Aristophanes, *Acharnians* 548; Lykeion: Harpokration, s.v. *Lykeion*.

20. *IG* I³ 49; Davies 1993, 97.

21. *IG* I³ 433; Boersma 1970, 230 (cat. 117).

22. For the controversial date of the building and its metopes and friezes (which occasionally show the influence of Parthenon sculptures), see Delivorrias 1997; Mark 1993, 102 n. 47; Camp 1986, 87; and Ridgway 1981, 26–9, 88. Also Wyatt and Edmonson 1984; Coulton 1984; Boersma 1970, 59–61.

23. For more on the thematic unity of the Acropolis, see Chapter 9.

24. Cf. Rhodes 1995, 28–41.

25. The Archaic citadel, for example, was still ringed by a basically Mycenaean fortification wall [Fig. 83].

26. There were other structures on the Acropolis in the second half of the fifth century besides the "principal" ones – workshops, for example, and a small poros-limestone building (the so-called Building D) known only from some stray architectural fragments. See Klein 1991b, 33–5.

27. Pausanias 1.28.3.

28. *IG* I³ 35.

29. See Chambers, Galucci, and Spanos 1990, and Mattingly 1993.

30. Mark 1993.

31. Mark 1993, 131–32, has pointed out certain technical similarities between the construction of the *naiskos* and of the upper sections of the North Acropolis wall, suggesting that Kallikrates may have been in charge of that project as well.

32. Roux 1984, 304–5; Herington 1955, 13. It is oddly symptomatic that in Perikles's speech praising the achievements and monuments of Athens (Thucydides 2.35–46), the Parthenon is not even mentioned by that or any other name.

33. Pausanias 1.24.5; Plutarch, *Perikles* 13.7. In his *Life of Cato* (5.3) Plutarch calls it just *Hekatompedon*.

34. Pedersen, 1989, has argued that these columns were not Ionic but Corinthian – the earliest of their kind.

35. *Parthenos* (as an epithet rather than as a cult title) appears in Acropolis inscriptions as early as around 500; see *IG* I³ 728 [Fig. 32], 745, 850.

36. Plutarch, *Demetrios* 23. D. Harris 1995, 4, notes an inscription (*IG* II² 1455) recording that damaged parts of the doors of the *hekatompedon* were stored in the *opisthodomos*, surely meaning the western room or porch of the Parthenon and not a totally different building.

37. According to Harpokration, Mnesikles and Kallikrates called the Parthenon the *Hekatompedos* not because of any actual dimension but because of "its beauty and happy proportions"; see Roux 1984, 304–5.

38. See D. Harris 1995, 2–5, 30. In 405/4 all the treasures seem to have been moved to the *hekatompedon*; some inventories of the *hekatompedon* thereafter mention objects "from the *parthenon*," indicating that it was a separate room.

39. Mansfield 1985, 203. Around the end of the fourth century, we are told (Diogenes Laertius 2.116), the Council of the Areopagos ran the philosopher Stilpon of Megara out of town for denying the divinity of the Athena Parthenos, and the tale might be taken as evidence for the statue's cult status. But Stilpon's argument was that the Athena was the product not of Zeus but of the mortal Pheidias and so could apply equally well to any man-made cult statue. In any case, the historicity of the whole story may be doubted; see Parker 1996, 278–9.

40. *Contra* Ridgway 1992, 135, and Mansfield 1985, 232 n. 19.

41. For the decoration of the doors, see *IG* II² 1455, and D. Harris 1995, 55–56.

42. D. Harris 1995, 25–7

43. Brulotte 1993; Korres 1984.

44. D. Harris 1995, 28–9; Meiggs and Lewis 1988, 227–9 (cat. 76); Fornara 1977, 161–2.

45. 1.91m. The diameter of the older column capitals had to be reduced about 20cm. See Korres 1995, 56.

46. It is easy to imagine that "the eight and a half boxes of rotten, useless arrows" listed in the Parthenon inventories came from some important field of battle against the Persians, perhaps even Marathon itself. See D. Harris 1995, 110 and 115 (V.3).

47. Demosthenes, *Against Androtion* 13, 76–7.

48. Pollitt 1972, 75.

49. McCredie 1979. Significantly, perhaps, Iktinos is cited as the lone architect of the Parthenon by both Strabo (9.395, 396) and Pausanias (8.41.9).

50. There were larger temples in Ionia and Sicily, and the unfinished Peisistratid Temple of Olympian Zeus southeast of the Acropolis [Fig. 2] would have been larger, too.

51. It is sometimes thought that in its combination of the Doric and Ionic orders – genuinely regional styles – the Parthenon was a distinctively Periklean attempt to claim symbolic leadership of all the Greeks, Dorian and Ionian alike. In fact, Doric and Ionic had been combined on the same building long before the Periklean building program. The Doric Temple of Athena at Assos (c. 530, in the Troad), for example, had an Ionic frieze as well as metopes; see Boardman 1978, 160 and fig. 216. On the Acropolis itself the *Archaios Neos* may have already had a continuous Ionic frieze [Fig. 95] and the walls of the Older Parthenon had an Ionic base-moulding. In the Early Classical Agora the Stoa Poikile (a Kimonian structure) had exterior Doric and interior Ionic columns.

52. Not every element of the Parthenon deviates from the perpendicular, however. The lines of the pedimental walls, the columns of the *pronaos* and *opisthodomos*, the walls of the doors, and the crosswall dividing the two rooms of the cella were, for example, purely vertical; Korres 1994d, 66.

53. Vitruvius 3.3.11, 3.4.5, 3.5.13.

54. For discussions of the aesthetic character of the refinements, see Coulton 1977, 108–12; Pollitt 1972, 74–6; and Mavrikios 1965.

55. Rhodes 1995, 109; Coulton 1977, 115.

56. Korres 1994a, 31–33; 1994c, 176; Pariente 1993.

57. Plutarch, *Perikles*, 31.2–3; E. B. Harrison 1996a, 40, 50; Palagia 1993, 8. One or two names (Xanthias and Thrax, or perhaps Xanthias the Thracian) have recently been found painted in red on the once-hidden faces of blocks in the entablature of the Parthenon, though it is unclear who he or they were – workers (even slaves) involved in construction or even in the carving of the metopes? see *AR* 1988–9, 9.

58. Despinis 1986. Greeks and Amazons also fought on some of the metopes of the Athenian Treasury at Delphi, dated to the 480s; see Boardman 1978, fig. 213.

59. Schwab, 1994, identifies the charioteer in north 1 as Athena.

60. Schwab 1996a.

61. Mantis 1997; 1989; 1986 (Mantis is currently preparing a comprehensive monograph on the south metopes and the newly identified fragments); Korres 1994c, 175.

62. For a review of the mythological interpretations of the central south metopes see Castriota 1992, 152–65; Robertson 1984; Ridgway 1981, 19–20; E. B. Harrison 1979; Simon 1975.

63. Mantis 1997, 72; 75–9. As Mantis concedes, a ritual interpretation of S19–21 cannot easily explain the semi-nudity of the female figure on the right side of S21.

64. Korres 1994a, 33; 1994c, 176.

65. See Chapter 2, 31–2.

66. For the theory that Zeus's thunderbolt appeared at the center of the pediment, see Simon 1980b.

67. Akroteria from a late fifth-century temple at Locri in south Italy show tritons supporting the rearing horses of dismounting youths in what are probably reflections of the groups of the west pediment; see Boardman 1995, fig. 166. But it has been suggested that Amphitrite's sea-monster is a Roman addition or replacement.

68. Spaeth 1991; cf. also Weidauer and Krauskopf 1992.

69. For the west pediment, see Palagia 1993, 40–59.

70. Palagia 1997 and 1993, 18–39. The response or relationship of the Parthenon to the Olympia temple, which it was clearly intended to eclipse as the grandest building on the mainland, is an important and complicated issue. Pheidias, again, may originally have planned metopes over the *pronaos* and *opisthodomos*, as in the Temple of Zeus; the Centauromachy of the south metopes had a colossal precedent in the west pediment of the Temple of Zeus; and the heights of the Parthenon columns, again, are almost exactly the same as those of the Temple of Zeus (only a quarter-inch off). On the other hand, Pheidias worked at Olympia after leaving the Parthenon program in 438, and his chryselephantine cult-statue of Zeus was clearly an attempt to outdo his own Athena Parthenos (and accordingly to ancient sources, it did).

71. For a possible small Birth of Athena in one of the pediments of the Bluebeard temple, see above Chapter 6, 112–13, and Fig. 86b.

72. B. F. Cook 1993.

73. On the Archaic Acropolis, there was an *oikema* with Karyatids [Fig. 88], an Ionic feature, and a gigantic Ionic column may have marked the Tomb of Kekrops; see also n. 51 above.

74. As noted above, there is now architectural evidence that *another* frieze ran around the top of the walls *within* the *pronaos* – that is, above the *pronaos* columns on the interior, over the east cella wall, and over the side walls of the *pronaos*, thus emphasizing the distinct, compartment-like nature of the porch [Fig. 130]. We are unable to say whether this interior frieze was ever executed or whether its subject was distinct from or the same as that of the much longer frieze on the cella exterior – an epilogue, as it were. See Korres and Bouras, 1983, 668–9; Korres 1994a, 33.

75. Stillwell 1969.

76. Osborne 1987.

77. See also Ridgway 1981, 77.

78. Kroll 1979.

79. I. Jenkins 1994, 19.

80. Younger 1991.

81. The similarity and visual association between this great animal and the rearing horses of Athena and Poseidon in the west pediment has often been pointed out. Yet if the frieze was carved before the pediments, as is usually thought, the horse on the west frieze cannot technically echo those in the pediment above. Perhaps the sculptor of this panel had seen the model for or drawings of the west pediment, or perhaps the designer of the west frieze was also the designer of the pediments. But perhaps, too, the execution of the frieze and the pediments substantially overlapped.

82. E. B. Harrison 1984.

83. Roccos 1995.

84. See Mattusch 1996, 44–5.

85. If Pheidias indeed designed the frieze, he may have been influenced by the assemblage of seated gods on the east frieze of the Archaic Siphnian Treasury at Delphi, where he had undertaken the Eponymous Heroes commission earlier in his career.

86. At Pellene in Achaia (7.27.2), Pausanias notes another chryselephantine statue of Athena by Pheidias and says it was made before his Athena on the Acropolis, though the reference is not explicitly to the Parthenos (it might be to the Bronze Athena). For the statue, see most recently E. B. Harrison 1996a, 38–52, and Chapter 2. For "Pheidias's Workshop" (Building VI, partly built, like the north citadel wall and the Parthenon itself, of Older Parthenon column-drums and blocks), see Ashmole 1972, 97–99, and Bundgaard 1976, 76.

87. E. B. Harrison 1981. The dramatically posed figure near the bottom of the shield with the arm covering the face is now considered an Amazon; E. B. Harrison 1997, 47 and n. 143.

88. Plutarch, *Perikles* 31.3–5; Stadter 1989, 294; Preisshofen 1974.

89. Pausanias 1.5.1–4.

90. A recent theory makes Building IV the Erechtheion; see N. Robertson 1996, 37–44. Judith Binder has suggested to me that Building IV was in fact the Chalkotheke, or Bronze Depot, often mentioned in inscriptions.

91. In contrast, he is fascinated with the Great Altar of Zeus at Olympia, a pile of ash twenty-two feet high, which he discusses at great length; Pausanias 5.13.8–14.3.

92. E. B. Harrison 1986, 117; E. B. Harrison 1996a, 50, withdraws that suggestion but just as speculatively places the frieze around the putative precinct of Athena Ergane at the north end of the great flight of rock-cut steps west of the Parthenon.

93. Herodotos (5.77) uses the same word for the simpler Older Propylon which, in the conventional reconstruction [Fig. 108], also had five doors. Interestingly, Pausanias (1.22.6) notes that "the building with pictures" [i.e., the Pinakotheke, or northwest wing] is "to the left of the Propylaia," as if he did not consider them parts of the same building. It is indeed possible that the term "Propylaia" referred only to the central gatehouse; see also Tomlinson 1990, 411–13.

94. Coulton 1977, 119–20. Though parts of Building B were built into the Propylaia's foundations, the evidence for its precise location is admittedly scant; Eiteljorg 1995, 58 n. 104, finds no reason to put it in the vicinity of the Propylaia.

95. The cutting for the ridge beam of the southeast hall is smaller than that of the northeast hall, and the southwest corner of the southeast hall (if built perfectly symmetrical to the northeast hall) would have encroached upon or broken through the Acropolis fortification wall.

96. Korres 1994b, 46 (drawing, bottom left); Tomlinson 1990.

97. T. L. Shear, Jr., 1981, 367. The never-finished ramp acquired a marble stairway in the Roman period; see Chapter 12.

98. Plutarch, *Perikles* 32.2; Meiggs 1975, 283, 500.

99. Tanoulas 1994a, 53, suggests that the rock-cut passageway through the center of the gatehouse received a marble floor by the end of the fifth century, but this would have been to facilitate the progress of the sacred Panathenaic procession.

100. Hellström 1988, 117–18; *IG* I³ 343–57.

101. Dinsmoor 1950, 201, mentions evidence for unrealized *akroteria* in the form of florals and griffins.

102. See Tanoulas 1994b, 167.

103. Demosthenes 22.13, 76; 23.208; Aeschines 2.74. For a critique of the sumptuousness of the building, see Cicero, *De Officiis* 2.60 (citing Demetrios of Phaleron).

104. Edmonson, 1968, proposed a fourth-century date for the founding of the Acropolis Brauroneion, but this seems impossible, given, among other things, the publication of a late sixth-century vase from the Acropolis characteristic of Artemis's cult; see Kahil 1981.

105. Pausanias 1.23.7. A reflection of Praxiteles's statue is sometimes seen in the so-called Artemis of Gabii in the Louvre, but the attribution is shaky; see Ajootian 1996, 124–6.

106. See D. Harris 1995, 141 (V.151). This in itself is not surprising, since the Parthenon also stored gold and silver objects dedicated to other deities as well (such as Aphrodite, Athena Nike, or Zeus Polieus).

107. It is sometimes thought "the Parthenon" at Brauron was a multi-roomed stoa in which the young girls (*arktoi*) who participated in the rites of the goddess would have slept and dined; in that case, the word would mean "the house of the maidens."

108. Tanoulas 1992a, b.

109. *IG* I³ 824.

110. There are traces of an earlier building on the same spot.

111. Bundgaard 1976, 34–5 (Aphrodite sanctuary); Jeppe-

sen 1987, 13–14 (Erechtheion). See also Appendix A, n. 46.

112. While it is usually assumed that the trident marks on the Acropolis were caused by the blow Poseidon struck against the rock during his contest with Athena, it should be noted that according to Euripides (*Ion* 281–82) Poseidon also destroyed Erechtheus with his trident.

113. The presence of a Classical cistern within the Erechtheion would presumably mean that at least part of the building was open to the sky; see Boersma 1970, 88.

114. Jeppesen 1987; Mansfield 1985, 245–52. N. Robertson 1996, 37–44, prefers to find the Erechtheion in Building IV (Heroon of Pandion, Fig. 162) at the southeast corner of the Acropolis.

115. Lawton 1995, 86–87 (cat. no. 8), 89–90 (cat. no. 14).

116. Mansfield 1985, 210.

117. Austin 1968, frag. 65.

118. See Mansfield 1985, 247–8.

119. Korres 1994b, 48; see Chapter 12, 266.

120. For these slit windows (once thought to be Medieval) see Korres 1994c, 178, and Casanaki and Mallouchou 1983, 92.

121. The crypt continued, by means of a small passageway, beneath the north side of the cella.

122. A few Submycenaean graves were located not far from the Kekropion [cf. Fig. 48], and one wonders whether the chance discovery of such tombs encouraged the original development of the shrine to the Bronze Age hero/king.

For the meaning of the Karyatids and their relation to the Kekropion, see Scholl 1995.

123. Dontas 1983.

124. A number of blocks (and probably the roof of the North porch) were not yet in place in 409/8, but most of the work supervised by Philokles and Arkhilochos consisted of smoothing the stones or giving the architecture its final decorative treatment (such as fluting the columns or carving the rosettes). And it appears that the statue of Athena Polias had already occupied the temple for some years before work was resumed.

125. Cf. I. M. Shear 1963.

126. Dinsmoor 1950, 203; Korres 1988.

127. Mark 1993, 85, 141.

128. The discovery of Older Propylon column-drums in its foundations, as well as in the Propylaia's, has suggested not only that Mnesikles designed both buildings but also that he began them at the same time; Korres 1988; Ridgway 1992, 126; and Dix and Anderson 1997. A vase by the Penelope Painter, stylistically datable to the 430s and probably alluding to the (re)building of the Pandroseion rather than the citadel walls, is also minor circumstantial evidence for the earlier date; see Fig. 53 and Cromey 1991.

129. Xenophon, *Hellenika* 1.6.1, mentions a fire in "the ancient temple of Athena." The phrase he uses is *palaios neos* instead of the usual *Archaios Neos* and since the reference is most likely an interpolation the whole story is suspect. See also n. 12 above.

130. Stewart 1990, 167–8.

131. Boulter 1970. The technique was evidently used for the base of the cult statues of Hephaistos and Athena in the Hephaisteion in the Agora, and since Alkamenes created those statues, some would see him as the designer of the Erechtheion frieze as well; see M. Robertson 1975, 345.

132. Glowacki 1995.

133. Quoted from M. Robertson 1975, 364.

134. It is possible but not certain that the Erechtheion's Phyromachos is the same as the Pyromachos said to have made (or decorated) Alkibiades's chariot; see Pliny, *NH* 34.80.

135. For the myth, see Gantz 1993, 242–4, and Connelly 1996.

136. Simon 1975; E. B. Harrison 1979. Spaeth, 1991, finds Boutes in the west pediment's reclining figure A; E. B. Harrison, 1984, tentatively finds him in the west frieze as well.

137. Again, I wonder whether the massive *peplos*-sail of the Greater Panathenaia, too large to be draped over the little statue of Athena Polias, was not somehow hung and displayed over the otherwise strikingly blank south wall of the Erechtheion.

138. *IG* I³ 64, dated to the 420s.

139. If the Nike Temple Decree (*IG* I³ 35), with its controversial three-barred sigma, is dated to the 420s instead of the early 440s, however, then it is the Ionic temple and bastion that must be credited to Kallikrates, not the little poros-limestone *naiskos* [Fig. 125].

140. See Tomlinson 1990, 411–13.

141. See especially Stewart 1985.

142. Felten 1984, 123–31, suggests the subjects were Greeks against Trojans.

143. In another portion of the frieze Kallimachos, the Athenian chief-of-staff, was depicted in the familiar striding pose of Harmodios from the venerable Tyrannicides group, emblem of democracy, by Kritios and Nesiotes. For the interpretation of the battle friezes, see most recently E. B. Harrison 1997.

144. E. B. Harrison 1997, 112–13, argues that the missing figure was male and should be Ares, a fitting companion for the goddess of victory. Still, Ares, the god the other gods love to hate, is rarely afforded so prominent a place in Classical iconography.

145. Cf. the east frieze of the Siphnian Treasury at Delphi; Boardman 1978, fig. 212.2.

146. Rhodes 1995, 116.

147. Anyone who delayed passing through the Propylaia and took a right from the ramp up the steps leading into the sanctuary of Athena Nike would have found his progress mirrored by a Nike, carved on the short eastern return, who climbs a stairway of her own; see Carpenter 1929, 10–11.

148. *IG* II² 334.20–1; Jameson 1994, 312; Parke 1977, 48.

149. Jameson 1994.

150. Simon 1997.

151. Lysistrata 317-18.

152. Simon 1997, fig. 15.

153. Rouse 1976, 75.

154. La Follette 1986. For a recent reevaluation of the plan of the Chalkotheke (reconstructing it with two rows of interior Ionic columns, for example) see Downey 1997, who also appears to accept a Periklean date.

155. The Sanctuary of Eros and Aphrodite [Fig. 34] had already been established on the north slope by the middle of the fifth century (it may even have been Peisistratid in origin), and the cults located here seem to have been personal or individual in nature rather than state-sponsored; see Glowacki 1991, 46-64.

156. In his tour of the south slope Pausanias (1.20.4) speaks of the Odeion (said to be a copy of Xerxes's tent) without actually naming or dating it. For new interpretations of the building and its symbolism, see M. C. Miller 1997, 218-42.

157. Shapiro 1992, 57, cites the precedent of Hipparchos's reorganization of the Panathenaic Homeric recitations in the late sixth century. Before their removal to the Periklean Odeion in the 440s, the *mousikoi agones* were possibly held in the Archaic Agora northeast of the Acropolis; S. G. Miller 1995, 218-19.

158. Csapo and Slater 1995, 79-80, 109-10.

159. For inscriptions relevant to the rebuilding (which took place between 63/2 and 52), see *IG* II² 3426, 3427.

160. Cf. Herodotos 9.70, 82.

161. For the evidence for the early Theater of Dionysos, see Wycherley 1978, 206-13.

162. Telemakhos brought back either a statue of the god, one of his sacred snakes, or both. In any case, his trip took him through Zea, in the Peiraieus, where there was another sanctuary of the god, founded perhaps just a year or so earlier. It is the goings-on at this sanctuary, at Zea, that Aristophanes is probably parodying in his play *Ploutos* (or Wealth); see Aleshire 1989, 11, and Parker 1996, 175-85.

163. For the Telemakhos Monument, see Beschi 1967/8a; Ridgway 1983, 199-200.

164. Wycherley 1978, 183. The wall may have marked the boundary between the Asklepieion and the so-called Pelasgikon or Pelargikon, the ancient zone at the foot of the western Acropolis thought to have been walled-in in the late Bronze Age. A stork appears next to the propylon on the Telemachos Monument and so may allude to the proximity of the Pelargikon (Stork's Place); see Ridgway 1983, 199.

165. Travlos 1971, 138. The wall into which the boundary stone is now set seems to date, however, to the early fourth century; Aleshire 1989, 22-3.

Chapter 9

1. Quoted in D. Wuttke, *Kosmopolis der Wissenschaft: E. R. Curtius und das Warburg Institute* (Baden-Baden 1989), appendix XV.

2. As Shapiro 1994, 128, has pointed out, many of the major events in Athenian history took place in years during which the Greater Panathenaia was celebrated: 514 (the death of Hipparkhos), 510 (the fall of the Peisistratid tyranny), 506 (the victory over Boiotia and Chalkis), 490 (Marathon). The Athenians must have come to associate the Panathenaia with those critical events and victories, making the festival – "the birthday party of Athenian democracy, as well as of Athena herself" – an even more appropriate subject for a public work of art.

3. Kardara 1961.

4. Connelly 1996.

5. Cf. Spaeth 1991. According to Pausanias (1.27.4), Erechtheus and Eumolpos also appeared in a bronze group standing near the Erechtheion (though Pausanias believed Erechtheus's foe should really have been Eumolpos's son, Immarados); for possible blocks from the base of the monument, see Korres 1994f, 124.

6. Connelly 1996, 55 n. 16, herself concedes that in the "Greek iconographic system [images should be] immediately recognizable to the viewer."

7. Connelly, 1996, suggests that these older daughters are preparing for their own sacrifice, despite the tradition (preserved in the fragmentary *Erechtheus* itself) that the king and queen had no intention of sacrificing more than one girl. Their actions, as Connelly herself reads them, contradict the very play that Connelly promotes as the key to the frieze.

For the identification of the girls as *Arrhephoroi*, see Wesenberg 1995, 151-64.

8. Apollodoros 3.14.6.

9. *Iliad* 2.550-51. In one of the fragments of the *Erechtheus* so fundamental to Connelly's theory (*Pap. Sorbonne* 2328), Athena ordains the sacrifice of *bulls* in honor of the daughters; Connelly 1996, 58.

10. E. B. Harrison 1984.

11. As Boardman 1991, among others, insists.

12. For a decisive critique of Connelly's thesis, see E. B. Harrison 1996b. See also DeVries 1994 and I. Jenkins 1994, 29 and 35.

13. For the Stoa Poikile and the Marathon painting, see Camp 1986, 66-72, and Pollitt 1990a, 141-5.

14. Pausanias 1.28.2; Scholiast on Demosthenes, *Against Androtion* 13.

15. Demosthenes, *Against Androtion* 13.

16. Boardman knows the Athenians fought and died at Marathon as hoplites, not cavalrymen, but he suggests that by being put on horseback on the frieze they have been literally and figuratively elevated and thus "heroized"; see Boardman 1977 and 1984. For two criticisms of the Marathon theory, see Simon 1983, 58-60, and I. Jenkins 1994, 26.

It is worth pointing out that there was a separate Athenian holiday of thanksgiving for the victory (the *Charisteria*, sacred to Artemis), in which armed *epheboi* (youths in military train-

ing) apparently marched on foot. Given this precedent – a sacred parade of infantry honoring the Marathonian dead – it would have been doubly hard for Athenians to read Marathon into the cavalcade. For *epheboi* at the Charisteria, see Simon 1983, 82, and Parke 1977, 55.

17. For the view that the Parthenon frieze is itself one vast votive relief, see Kroll 1979.

18. E. B. Harrison 1984, 234 (Theseus); Nagy 1992 (Perikles).

19. I. Jenkins 1994, 36.

20. E. B. Harrison 1984. Harrison's theory does not, however, adequately account for the ten ranks of horsemen or the eleven chariots on the north, nor does it explain why the pre-Kleisthenic Panathenaia – and that would essentially be a Peisistratid Panathenaia – would be represented on the more conspicuous north side of the Parthenon, while the contemporary Periklean procession would be placed on the less obvious south side. If she is correct, the Panathenaia of the by-gone age of tyrants would be "privileged" over the Panathenaia of the age of democracy – an odd choice for Perikles' friend Pheidias to have made.

21. Simon 1983, 55–62; for criticisms of Simon's theory, see I. Jenkins 1994, 28–9, and Hurwit 1995, 183 n. 61.

22. Gauer 1984; Boardman 1977 and 1984; Fehl 1961.

23. Osborne 1987. The uniformity of style on the frieze can, perhaps, be overstated, and in any case the idealized sameness of the figures – which is found in other non-Athenian works of the fifth century where democratic feelings cannot have been the motive – seems to have had a more philosophical, humanistic point: when mortals on the frieze resemble, through their good looks, the heroes and gods on the frieze [Fig. 150], then the differences between human and divine are less a matter of kind than of degree.

24. Castriota 1992, 184–229.

25. There is no evidence that the elders represented on the frieze [Fig. 154] carried branches (even painted ones) in their hands.

26. Neils 1992, 15.

27. See Pollitt 1997, 53. At the same time, no ancient source says they did *not* participate.

28. Holloway 1966. For a criticism, see I. Jenkins 1994, 26.

29. Lawrence 1951; Root 1985.

30. Beschi 1986.

31. Thucydides 2.38. For this view, see above all Pollitt 1997 and Wesenberg 1995; also Jenkins 1994, 32.

32. See Wesenberg 1995, 168–172; cf. Goldhill 1987, 61 and n. 20. For the relief, see Lawton 1995, 81 (cat. no. 1).

33. Wesenberg 1995, 151–164.

34. Simon 1983, 59–60; Bugh 1988, 59–60; Kyle 1992, 94. The *anthippasia* was also held at the Olympieia, a festival sacred to Zeus; see Parke 1977, 144.

35. Kyle 1987, 45–6.

36. For the debate over the identity of the "Eponymous Heroes," see most recently E. B. Harrison 1996b, 200–2; Connelly 1996, 67–8; I. Jenkins 1994, 33–34; and Nagy 1992.

37. Cf. Ridgway 1981, 78. It is worth noting that choral dances in the City Dionysia apparently took place at the Altar of the Twelve Gods in the Agora, so the Panathenaia was not the only Athenian festival to involve all the Olympians; Pickard-Cambridge 1968, 62.

38. Pausanias 1.28.2. Pausanias notes Parrhasios and Mys added other decoration or imagery to the shield but does not say what it was. It is just possible that a young Parrhasios was active in the Periklean era, but his was primarily a fourth-century career; see M. Robertson 1975, 324, 411–12, and Boardman 1985a, 203.

39. For Strongylion's "Wooden Horse," see Pausanias 1.23.7–8 and *IG* I³ 895; Hamdorf 1980; Raubitschek 1949, 208–09 (no. 176); and Stevens 1936, 460–1. Aristophanes may refer to the statue in his *Birds* (line 1128), in which case the statue was dedicated by 414, when the play was produced.

40 . Felten 1984, 123–31, argues that the north and south friezes of the Temple of Athena Nike (carved perhaps no more than a year or two before the Wooden Horse was created) also represented battles of Greeks and Trojans (not Greeks versus Greeks). The Trojan element in Strongylion's artistic environment would in that case have been even stronger and more obvious still.

Another work at the entrance of the Acropolis that would have prepared for the north metopes was a painting Pausanias (1.22.6) saw in the Pinakotheke representing Diomedes taking the Palladion from Troy; the statue was depicted in north metope 25.

41. Pausanias 1.24.2–3.

42. Pausanias 1.27.4; Korres 1994f, 124.

43. *IG* I³ 468.

44. Pausanias 4.36.6.

45. For the Hippeis monument, see Chapter 7, 147.

46. *IG* I³ 880.

47. *IG* I³ 893.

48. Pausanias 1.22.7.

49. M. Robertson 1975, 286–7; Stewart 1990, 164.

50. Cf. Korres 1994a, 33.

51. Detienne and Vernant 1991, 226.

52. Aristides, *Panathenaic Oration* 41.

53 . See, for example, Castriota 1992, 138–83; for a skeptical view, see Ridgway 1981, 18–19. But that the imagery of the Acropolis as a whole was read in antiquity as a promotion of the victory of the west over the east seems clear especially from later Hellenistic and Roman attitudes toward it; see, for example, Plutarch, *Anthony* 34, and Chapter 12.

54. Hall 1993, 115. For Amazons on the Areopagos, see Aeschylus, *Eumenides* 685–90.

55. In south metope 32, the Greek fighting the centaur may be Theseus. He is in any case posed like one of the Tyrannicides, so that the Centauromachy not only becomes an analogue for the Persian Wars but also for the victory of democracy over tyranny.

56. Holloway 1973, 123–4.

57. The Athenian equation of the Acropolis with Olympos was at least as old as the mid-sixth century, if the story about the ruse that led to Peisistratos's second tyranny is credible; see above, Chapter 6, 101.

58. As Pollitt 1997, 62, notes, sacrifices, contests, and military training are the three elements of Athenian civic life that Perikles emphasizes in his Funeral Oration (Thucydides 2.38–39).

59. Cf. I. Jenkins 1994, 32–3.

60. Crowther 1991.

61. Simon 1983, 63–4. Pausanias (1.22.7) saw a painting of the same subject – a youth carrying waterjars – in the Pinakotheke.

62. Thucydides 6.56.

63. Pollitt 1997; Bugh 1988, 66–7, 74–8. The 1,000-man cavalry had appended to it a contingent of 200 mounted archers who, admittedly, do not appear on the frieze.

64. One apparent problem with the interpretation of the cavalcade as a rendering of the new Periklean cavalry is that, except for the two "hipparchs," all the horsemen are beardless and thus youths, when there is evidence that the cavalrymen served well into their thirties; Bugh 1988, 62–5. But the beardlessness of the horsemen is probably symbolic: Greek funerary tradition endowed anyone fighting on behalf of his city with youth, and anyone who died on behalf of the city with eternal youth. The youthfulness of the horsemen is thus ideological and idealizing, not literal. See Osborne 1987, 103–4.

65. Castriota 1992, 218–19. There is, admittedly, a discrepancy between the expanded but still élitist cavalry and the complete absence from the frieze of any sign of the *thetes*, the poor Athenian citizens who rowed the ships of the Athenian fleet and who were therefore the real foundation of Athenian imperial might. The frieze, in other words, is not nearly as "democratic" as Periklean political life. Still, it may not be beside the point that Perikles's own sons were said to be the finest cavalrymen in Athens; Plato, *Meno* 94B.

66. Thucydides 2.41.

67. Thucydides 2.41.

Chapter 10

*This chapter is a revised version of Hurwit 1995. Pandora and her meaning on the Acropolis have recently become the subjects of increased attention; see, for example, I. Jenkins 1994, 40–42 (whose conclusions sometimes coincide with my own) and Connelly 1996, 72–6 (whose conclusions do not).

1. Stewart 1990, 157–8.

2. The Parthenon inventories hint at the use of gold (and even ivory) on the figures on the base; see D. Harris 1995, 116 (V.13) and 128 (V.80). E. B. Harrison 1996a, 50–1, favors painted marble reliefs with metal attachments.

3. Pausanias 1.24.7.

4. Pliny, *NH* 36.19. Cf. D. and E. Panofsky 1962, 9.

5. See Ridgway 1981, 165.

6. For a review of the history of reconstructions, see Leipen 1971, 25–6.

7. For the story and significance of Pandora, see Zeitlin 1995; Gantz 1993, 155–58; and Loraux 1993, 72–110.

8. *Theogony* 570–610.

9. The Hesiodic *Catalogue of Women* 2, mentions a Pandora, but this is the first Pandora's granddaughter.

10. Gantz 1993, 163–4.

11. Reeder 1995, 277–86; Shapiro 1994b, 63–70.

12. Pucci 1977, 97–8, suggests Hesiod was purposefully ambiguous, playing upon three possible meanings of the name at once ("Giver of All Gifts," "She Who Was Given All Gifts," "Gift of All the Gods").

13. A red-figure krater by the Niobid Painter (BM E 467), with Iris, Zeus, and Poseidon to the left of "Pandora" and Ares, Hermes, and, probably, Aphrodite to the right. See Reeder 1995, 282–4 (cat. 80).

14. Reeder 1995, 284–6 (cat. 81).

15. M. Robertson 1992, 164.

16. See J. Harrison 1900, 105–6; Loraux 1993, 84, 115 n. 17, and 241. For the bountiful gifts of Earth, see Plato, *Menexenus* 238. We know from Pausanias (1.31.4) that Anesidora could indeed be a cult epithet for earth goddesses such as Demeter.

17. West 1978, 165.

18. For example, it is not immediately clear why Pheidias chose "the birth of Aphrodite from the sea" as the subject for the base of the great chryselephantine statue of Zeus he made at Olympia (Pausanias 5.11.8).

19. One exception exists implicitly at *IG* I³ 35, lines 4–6, where the priestess of Athena Nike is to be chosen "from all the Athenians." See Loraux 1993, 116–20 and 247–8, who points out that even the phrase *Attikai gynaikes* ("women of Athens [or Attika]") is rare.

20. See Parker 1996, 4.

21. D. Harris 1993; also Chapter 3, 60.

22. Aristophanes, *Lysistrata* 641–7.

23. Simon 1983, 96–8.

24. A point stressed by Knox 1995, 18–19. For general reviews of the place of women in Greek and Athenian society, see Reeder 1995, 20–31; Fantham et al. 1994, 68–127; and Just 1989.

25. Aristotle, *Ath. Pol.* 26.4; for the Citizenship Law, see Boegehold 1994.

26. Thucydides 2.46.

27. When, in *Medea* (573–5), Jason declares that it would have been better for men if women had never existed – "Then life would have been good" – he obviously lacks Euripides' own sympathy towards women, but expresses what may have been a common view. See Just 1989, 273.

28. Hesiod, *Theogony* 927–9.

29. Augustine, *City of God* 18.9, citing the Roman writer Marcus Varro (116–27). The story is unlikely to have been orig-

inal with Varro, however. See Tyrrell and Brown 1991, 180–1; Castriota 1992, 145–7; Palagia 1993, 40.

30. Thucydides 1.2.6, 2.36.1; Herodotos 7.161.

31. Cf. Plato, *Menexenus* 245d.

32. For autochthony as a major subject of Athenian myth and discourse, see Loraux 1993, 37–71. Also, Tyrrell and Brown 1991, 138; Castriota 1992, 143–49, and Loraux 1986, 148–50, 277–8, 284, where she argues not only that "autochthony may even serve as an etiological myth for [the] exclusion of women [from Athenian society]" but also that the city described in Athenian funeral orations (*epitaphioi*) is "without gender" – like, we note, Athena herself. For the democratic value of autochthony, see Connor 1994, 38.

33. For example, *Odyssey* 2.268 and 22.206, where she becomes Mentor, Odysseus's trusted friend.

34. See Just 1989, 166.

35. May 1984.

36. Loraux 1993, 64 and n. 142.

37. Chapter 9 and Hall 1993.

38. Pollitt, 1990b, points out that the presence of Helios and Selene (who also framed the birth of Aphrodite on the base of Pheidias's later Zeus at Olympia) may be "a kind of allusion to the cosmology of Anaxagoras (in which the creation of the sun and moon from cosmic mind was seen as a crucial stage in the formation of a rational cosmos)." Anaxagoras, like Pheidias, enjoyed the patronage of Perikles, and so his ideas may well have informed Pheidias's artistic vision.

39. Schwab 1996b.

40. See Neils 1996b, 189–94; Mantis 1997, 75–9.

41. Pausanias 1.24.7.

42. *Suidas*, s.v. *parthenoi*, and Gantz 1993, 242–3. It was perhaps this Pandora who (again according to *Suidas*, s.v. *protonion*) was with her sisters the first to make garments of wool, above all a woolen robe worn by the priestess of Athena Polias; see Frazer 1898, vol. 2, 319–20. Connelly 1996, 72–6, imagines that it was the birth or even the apotheosis of this Pandora, the daughter of Erechtheus (and not the Hesiodic Pandora), that was depicted on the base, even though the Erechtheid's birth was of no importance in Athenian myth (it was her sacrifice that counted) and apotheosis is hardly a common subject in Classical art.

43. E. B. Harrison 1996a, 50, suggests that another scene of Pandora's birth decorated a marble parapet around the precinct of Athena Ergane, which has been tentatively located at the northwest corner of the Parthenon terrace, at the northern end of the great flight of rock-cut steps west of the building [Fig. 163]. The subject of the relief is not certain, however, and the surviving fragments were found in the Agora.

44. Philochoros, *FGrHist* 328 F 10 (Harpokration); see also Farnell 1896–1909, vol. I, 290. The link between Athena and Pandora has been thought so strange that "Pandora" has been emended to "Pandrosos," since she had a prominent sanctuary on the Acropolis next to the Erechtheion; see also Simon 1983, 61. But Aristophanes also seems to indicate the existence of a cult of Pandora, to whom was sacrificed a white-fleeced ram (*Birds* 971).

45. Parker 1986, 198; Castriota 1992, 146. For a discussion of the marriage theme, see Delivorrias 1994, 125–6, and Reeder 1995, 249.

46. Boardman and Finn 1985, 250; also Boardman 1985, 174, and Pollitt 1990b, 23 (who sees Pandora as the bringer of "the blessings of knowledge, power, and independence to mankind"). Cf. Leipen 1971, 58, and Herington 1955, 65.

47. Though at *Theogony* 590–1, Pandora is specifically said to be the progenitor only of the race of women, not of humanity as a whole.

48. *Works and Days*, 109–20.

49. Zeitlin 1990, 85.

50. Guthrie 1955, 183–4.

51. Gantz 1993, 157, suggests that *elpis* should mean not "hope" but "expectation" or "awareness," so that men would be denied the full knowledge of their sorry condition: trapping *elpis* in the jar, then, would be a kind of gift after all.

52. Faraone 1992, 102.

53. *Herakleidai* 770–2.

54. The nature of human progress had been a theme of Aeschylus's *Prometheus Bound*, where the crucified Titan takes credit for giving men fire, from which they will learn "many *tekhnai*" (254), and for teaching men the arts of construction, astronomy, arithmetic, and writing, the means of yoking animals and harnessing horses, the art of shipbuilding (441–71), the use of drugs to cure diseases, the arts of divination and sacrificing, and the trade of mining. "All of men's *tekhnai*," he concludes, "come from Prometheus" (476–506).

Mark, 1984, has argued that the arrangement of gods on the east frieze reflects Protagoras' notions of "limited" and "political" *tekhnai* (cf. Plato, *Protagoras* 320–2), with individual gods embodying different *tekhnai* (Athena and Hephaistos, for example, embody limited *tekhne*, while Zeus, Hera, and Apollo embody political *tekhne*). Cf. also Stewart 1990, 159.

It is, of course, dangerous to assume the teachings of Plato's Protagoras – a literary character – coincide exactly with the teachings of the fifth-century philosopher. But it may still be significant that in the myth of Man's creation told by "Protagoras" in Plato's dialogue, Prometheus and Epimetheus are there, but Pandora (or Woman) is not. Did Pheidias's insertion of Pandora into the sculptural program of the Parthenon serve as a correction to Protagoras' anthropology?

55. M. Robertson 1992, 239.

Chapter 11

1. French 1991.

2. For the statue see Stewart 1990, 173–4.

3. For example, Xenophon's *Oikonomikos*, concerned with the management of a household, or his *Ways and Means*, which outlines policies for the stimulation of public resources through commercial ventures.

4. Davies 1993, 228–32.

5. *Gorgias* 515–16.

6. *Kritias* 116; Onians 1979, 9–10.

7. *Republic* 2.378; cf. *Euthyphro* 6B–C.

8. Cf. Cicero, *De Officiis* 2.60, on Demetrios of Phaleron.

9. Demosthenes, *Against Androtion* 13, 76; *Against Aristokrates* 208 (see epigraph); Aeschines, *On the Embassy* 74–5.

10. *Ploutos* 1191–3.

11. P. Green 1973, 154–5; Davies 1993, 158.

12. La Follette 1986. For the Chalkotheke, see also Chapter 8 and Appendix C no. 16.

13. Demosthenes, *Against Timokrates* 136; Hill 1953, 138. Korres 1994b, 47, however, suggests that the *Opisthodomos* lasted even longer than this, even "for centuries." Demosthenes makes the last Classical reference to it when he refers to "the *tamiai*, both those of Athena and of the Other Gods, who were in office when the *Opisthodomos* burned." But the orator does not say when the fire occurred and it is not even clear from his words whether the *Opisthodomos* was still standing at the time of his speech.

14. Two ancient *skolia* (manuscript notes) on Demosthenes say the fire was intentionally set by Athena's own treasurers to cover up financial crimes but disagree on the location of the *Opisthodomos*, one putting it "behind [the statue] of the goddess," the other putting it vaguely "in back of the Acropolis." See Cohen 1992, 221–4; Lewis 1954, 47–8; Dinsmoor 1932.

15. Demosthenes, *Against Timokrates* 121, 129. These objects were apparently soon recovered; cf. Pausanias 1.27.1.

16. D. Harris 1995, *passim*.

17. For the Hekate, see M. D. Fullerton 1986.

18. For the trireme (or Lenormant) relief – one of the few times the poorest class of Athenian citizen (the *thetes* who served in the fleet) appears in the iconography of the Classical Acropolis – see Brouskari 1974, 176–7. For the relief of women (Demeter and Kore?), see M. Robertson 1975, 373–4, and Brouskari 1974, 170 (1348).

19. The early fourth-century Acropolis also sees the proliferation of document reliefs honoring foreign heads of state in patent attempts to court their favor; see Lawton 1995, 6.

20. Pausanias 1.24.7; Stevens 1946, 15. For the other two portraits, see Chapter 12, 279.

21. For the Konon-Timotheos dedication, see *IG* II² 3774; Pausanias 1.24.3; Demosthenes, *Against Leptines* 70; cf. *Against Aristokrates* 196; Richter 1984, 17; Stevens 1946, 4–10. It is generally assumed that Timotheos was honored in this manner after his death in 354, but this, considering the way his career ended, is problematic. Perhaps his portrait was in fact placed beside his father's while he still lived, after winning one of his notable victories. Although Greek portraits were usually posthumous, the practice of making portaits of living subjects began during the fourth century.

22. *IG* II² 3828. The Kephisodotos monument originally stood near the precinct of Artemis Brauronia. The curved base was, like many other ancient monuments, later reused as building material in the apse of the Christian church built within the Parthenon; see Korres 1994e, 146.

23. *IG* II² 3453; Stewart 1990, 274–5; Richter 1984, 158–9; M. Robertson 1975, 504–6. Cf. Pausanias 1.27.4, who appears to be referring to a statue of Syeris, an old woman who devoted many years of service to yet another priestess named Lysimakhe, this one dated to the early third century; the base of the Syeris also survives (*IG* II² 3464).

24. Pausanias 1.25.1

25. Pausanias 1.24.2. An empty base with the inscription "[N]aukydes the Argive made [this]" has in fact been found on the Acropolis; see Loewy 1885, 68 (no. 87).

26. Stewart 1990, 179, 278, and fig. 508. The statue of Artemis was duly noted by Pausanias, 1.23.7; see also Chapter 8 n. 105.

27. Pausanias 1.24.4 (Zeus); *IG* II² 3829; Ridgway 1990b, 49–50; Loewy 1885, no. 83 (Pandaites and Pasikles group).

28. Stewart 1993, 106–12; 1990, 284; *contra* Ridgway 1990b, 135.

29. Zimmer 1996; Mattusch 1988, 227–28.

30. *IG* II² 1498–1501A; D. Harris 1992. But see Mattusch 1996, 101–02, who doubts that these bronzes would have been subject to such "de-accessioning."

31. [Plutarch], *Lives of the Ten Orators* 841B–844A; Habicht 1997, 22–30; Schwenk 1985; Mitchel 1973.

32. In 346, for example, public revenues were said to have totaled only 600 talents. Yet Lykourgos was said to have spent 18,900 talents during his administration, for an average of 1,575 a year (*Lives of the Ten Orators* 852B). See also Demosthenes, *Fourth Philippic* 37–8, and Pausanias 1.29.16, where Lykourgos is said to have collected for the public treasury 6,500 more talents than Perikles.

33. For these events, see Arrian 1.10; P. Green 1991, 149–50.

34. Arrian 1.16. The Spartans were not yet part of the League of Corinth or his expeditionary force and Alexander pointedly snubbed them. At the same time, the term "the Greeks" was purposefuly ambiguous: the word emphasized Alexander's role as head of the League (and thus included the Athenians on his side whether they liked it or not) and it emphasized the Greekness of the Macedonians (who in fact formed the bulk of the army); see P. Green 1991, 181.

35. Korres 1994e, 138 and 158 n. 5. Forty-two smaller shields were eventually mounted on the architrave above the columns on the other three sides of the Parthenon, but these do not seem to have been the contributions of Alexander.

36. Arrian 3.16; 7.19 (where the return is dated to 323); also P. Green 1991, 307, 309. According to Pausanias (1.8.5), however, the Tyrannicides were returned not by Alexander but by one of his Hellenistic successors, Antiochos; another source (Valerius Maximus) suggests Seleukos I.

37. Habicht 1997, 18; P. Green 1991, 181; Mitchel 1973, 170.

38. Aeschines, *Against Timokrates* 81–2 (dated to 345);

Xenophon, *Ways and Means* 2.6, 6.1; Demosthenes, *Against Aristokrates* 206–8.

39. Wycherley 1978, 19.

40. Aleshire 1989, 22–3.

41. Travlos 1971, 228 and figs. 293–4. A stade was a length of 600 Greek feet, so the *peripatos* was by this measurement 3,018 feet long.

42. Aleshire 1989, 26–7, however, dates the surviving temple foundations (and the Doric stoa in its final form) to around 300; see also Aleshire 1991, 29 and 41; Travlos 1971, 127, dates the temple to the fourth century and the Doric stoa specifically to the Lykourgan period.

43. Mitchel 1973, 192–3.

44. Cf. Travlos 1971, 466–7 (230–326).

45. Camp 1986, 156–7, 159–61; [Plutarch], *Lives of the Ten Orators* 843F.

46. Aristotle returned to Athens from Macedon in 335, early in Lykourgos' administration. See Habicht 1997, 29; also Travlos 1971, 345; [Plutarch], *Lives of the Ten Orators* 841D.

47. Kyle 1987, 92–5; Travlos 1971, 498.

48. Mitchel 1973, 196–7. One Neoptolemos paid for the gilding of the altar of Apollo Patroos; a certain Deinias donated the land for the Panathenaic stadium; and Eudemos of Plataia provided the draught animals to do the heavy work of levelling the area and hauling stone. A marble stele publicly thanking Eudemos for his generosity was set up on the Acropolis in 330/29; see Schwenk 1985, 232–8. It is worth remembering that private contributions (though on a smaller scale) helped fund the Parthenon and the Propylaia, too; see Appendix B.

49. [Plutarch], *Lives of the Ten Orators* 852C; La Follette 1986, 79.

50. [Plutarch], *Lives of the Ten Orators* 852B.

51. Mark 1993, 113–14.

52. See Schwenk 1985, 108–26, and D. Harris 1995, 33–7.

53. [Plutarch], *Lives of the Ten Orators* 841D; Kalligas 1994; Townsend 1986; Wycherley 1978, 206–13; Mitchel 1973, 203; Travlos 1971, 537–52.

54. See Hölscher 1991, 377–8.

55. Boegehold 1996, 101–3; Boardman 1995, 133; Brouskari 1974, 20. The Atarbos base was found built into a later bastion on the Acropolis and could conceivably have been moved there from another location down below.

56. Pausanias 1.20.1; Choremi-Spetsieri 1994; Travlos 1971, 566.

57. Ridgway 1990b, 15–17; Travlos 1971, 348.

58. Travlos 1971, 357 (Nikias), 562 (Thrasyllos). Within the Thrasyllos Monument's cave Pausanias (1.21.3) saw a representation – most likely a painting – of the slaying of the Niobids.

59. [Plutarch], *Lives of the Ten Orators* 841F. Pausanias (1.21.1–2) says he saw many statues of tragic and comic poets in the theater but that, with the exception of portraits of Menander, Sophocles, Euripides, and Aeschylus, the poets who were on display were undistinguished.

60. Townsend 1986. For the Stoa of Zeus Eleutherios, see Camp 1986, 105–7.

61. Korres 1994f, 124; Dinsmoor 1950, 238–40; also Townsend 1985.

Chapter 12

1. Cicero, *De Officiis* 2.60; Ferguson 1911, 55–61. Demetrios also stopped the older practice of erecting lavish funerary monuments.

2. Fragments of a gilded bronze equestrian portrait of Demetrios from the Agora indicate that he wore a helmet adorned with *pegasoi* – a helmet not unlike the one worn by the Athena Parthenos (cf. Fig. 25). The association of the new Macedonian "god" with the old chryselephantine goddess would have been clear to all. See Houser 1982, 231.

3. Diodoros 20.46; Mansfield 1985, 56, 63–4. We are told (Plutarch, *Demetrios*, 12) that during the Panathenaic procession (it is not certain whether it was the procession of 306 or 302, evidently the last time the portraits of Demetrios and Antigonos appeared in the cloth) a terrific wind ripped the *peplos* in two as a sign of the displeasure of the gods at the honors conferred upon the Macedonians.

4. Plutarch, *Demetrios* 23; D. Harris 1995, 81, notes that the fourth-century inventories of the Parthenon treasures list all items as being "in the Hekatompedon" (meaning the building as a whole) without specifying which items were stored in which of its rooms.

5. D. Harris 1995, 37, 243.

6. Plutarch, *Demetrios* 26; Ferguson 1911, 118–19.

7. Athenaios 9.405 (quoting yet another Demetrios, this one a comic playwright); cf. [Plutarch], *Isis and Osiris* 379. Habicht 1997, 86; D. Harris 1995, 38; Linders 1987, 117. We might compare Lykourgos's reputation for "providing ornament for the goddess," meaning a variety of objects placed in her treasury; see [Plutarch], *Lives of the Ten Orators* 852B.

8. Pausanias 1.25.7; cf. 1.29.16.

9. No source explicitly states that the statue Lakhares stripped was the Athena *Parthenos*; the victim is only identified as Athena or the *agalma* (statue) of Athena. There is thus the small possibility that Lakhares removed the gold ornament not from the Parthenos but from the ancient olivewood statue of Athena *Polias* in the Erechtheion, which, as we know from fourth-century inscriptions, was decked out with removable necklaces, diadem, earrings, owl, *aigis*, gorgoneion, and *phiale* (this gold adornment had to be removable in order to facilitate the exchange of *peploi* and the rituals of the *Plynteria* festival). For the ornament of the Athena Polias, see Mansfield 1985, 138–9, 185–8.

10. Gilded copper sheets may have taken the place of the original solid gold ones; Korres 1994e, 138–39.

11. Pausanias 1.25.8.

12. To cite just two early Hellenistic examples, in 298 Lysimachos sent Macedonian timber for a new mast and in 282 or

278 Ptolemy sent Egyptian linen for new rigging for the Panathenaic ship; see Parker 1996, 263.

13. For the *Ptolemaia*, which became one of the four major festivals of Hellenistic Athens (alongside the *Panathenaia*, the *Dionysia*, and the *Eleusinia*), see Parker 1996, 274–5; Ferguson 1911, 242.

14. *IG* II² 1938; Ferguson 1911, 296, 366–7. These acts also reflect the presence in the city of a large number of Romans.

15. Appian, *Mithridates* 39; Habicht 1997, 305–7; Ferguson 1911, 455. It has often been thought that the Erechtheion caught fire during Sulla's siege and that its western section suffered particularly severe damage; see, for example, Mansfield 1985, 202. Korres 1994b, 48, however, dates the fire to the early Augustan era, and the decision not to raze the Acropolis summit may be behind Sulla's otherwise odd claim that "he had saved Athens from destruction;" see Hoff 1989, 270 n. 11. For damage to the Asklepieion, see Aleshire 1989, 16; for Sulla's despoliation of the Olympieion, see Pliny, *NH* 36.6.45.

16. But see Geagan 1979, 375.

17. Plutarch, *Pompey* 42.6.

18. Appian, *Bella Civilia* 2.368.

19. After the assassination of Caesar, the Athenians even set up statues of Brutus and Cassius beside those of the Tyrannicides (and thus also near those of Demetrios and Antigonos) in the Agora. There was thus a forest of tyranny-killers; see Cassius Dio 47.20.4, and Hoff 1989, 273.

20. The Athenians celebrated the Greater Panathenaia of 38 as "the Antonian Panathenaia of the god Antonius, the new Dionysos;" Habicht 1997, 362. A statue of Dionysos (Plutarch, *Life of Antony*, 60) or of Antony dressed up like the god (Cassius Dio 50.15) is said to have ominously fallen down from the Acropolis into the Theater of Dionysos below during a storm before the decisive Battle of Actium in 31; see Habicht 1997, 364; Ridgway 1990b, 287–8; and below n. 42.

21. Hoff 1989, 273–4; Habicht, 1997, 362, does not believe the story.

22. Cassius Dio 54.7.1–4; Hoff 1989, 268–9; for another view, Mansfield 1985, 174–7.

23. Plutarch, *Life of Antony* 34.

24. Cicero, *Att.* 115.26; *De Oratore* 3.11; Cicero also notes that in his day the Athenians themselves neglected learning; only foreigners enjoyed the schooling it provided.

25. Horace, *Epistulae* 2.1.156–7.

26. A less typical visitor was St. Paul, who visited for his own reasons and left deeply disturbed that the city was so full of idols; *Acts* 17.16.

27. Cicero, *Against Verres* 2.1.44–5, 2.4.71; Habicht 1997, 331.

28. Hoff 1994, 113, n. 101, and 116; Geagan 1979, 384.

29. Strocka 1967.

30. Künzl 1971, 22.

31. Ridgway 1981, 227–8.

32. Stewart 1990, 213–14. For the Pergamon Athena and other Hellenistic versions of the Athena Parthenos, see Weber 1993.

33. Suetonius, *Augustus* 28.

34. For the repairs, see Korres 1994b, 48; Paton 1927, 66–76, 223–4. The damage is, again, usually thought to have been sustained during the Sullan attack of 86, but this would mean that the home of the cult statue of Athena Polias would have been left in ruins for six decades; see above, n. 15. The Roman repair of the Erechtheion is the subject of a dissertation by Jeffrey Burden.

35. Richardson 1992, 283; Pliny, *NH* 34.13, 36.38.

36. Richardson 1992, 161; Zanker 1988, 199, 256–8; Wesenberg 1984.

37. Ovid, *Fasti* 5.533ff.

38. See Galinsky 1996, 360–1, on the limits of the Augustan imitation of Athens.

39. Augustus, *Res Gestae* 23; Cassius Dio 55.10.7; Spawforth 1994, 238.

40. Polybios 16.25.

41. Before 224 or so, he had financed a new teaching garden (the so-called Lakydeum) for the philosophical school known as Academy. See Habicht 1990, 562.

42. Pausanias 1.25.2; Pollitt 1986, 90–5; Ridgway 1990b, 287–96. Some scholars have suggested that at least the gods were present in the original group and that some of the figures were even perched perilously atop (rather than beside) the south citadel wall. This theory is based on Plutarch's note that a "Dionysos in the Gigantomachy" fell down into the Theater of Dionysos in a storm (*Life of Antony*, 60.2). But Plutarch may have confused his statues: the statue that fell may have been one of Antony in the guise of Dionysos, or may have belonged to an entirely different group. Cf. Habicht 1997, 364.

43. Ridgway 1981, 228.

44. There may have been one more point to the Attalid Monument. The fathers and grandfathers of the Gauls Attalos defeated in 233 had originally invaded Greece in 279; it was only after being repulsed at Delphi that the barbarians crossed the Hellespont and settled in Asia Minor, ultimately to threaten Pergamon. Interestingly, Athenians formed part of the Greek force that met the invading Gauls at Thermopylae in 278, but the defense of the pass failed; see Ferguson 1911, 158; Gardner 1902, 484. In short, Athenians and Pergamenes faced the same barbarian foe 45 years apart, and the Attalos did the better job of defeating them. Was there, then, a certain one-upmanship in the display of defeated Gauls among the other foes of civilization?

45. The precise date of the Attalid Monument is unknown, but since Attalos's visit to Athens in 200 was apparently arranged in some haste (see Polybios 16.25), it is unlikely that the monument could have been created specifically for that event. It remains possible that the commissioning, rather than the dedication, of the monument took place during his visit.

46. Habicht 1990, 568–9.

47. See Appendix C, Cat. 17.

48. Korres 1994c, 177–8; Korres 1994e, 139.

49. See Appendix C, Cat. 21.

50. For the Stoa of Attalos, see Camp 1986, 172–5.

51. Pausanias 1.21.3; 5.12.4.

52. Pausanias 1.23.7; Seltman 1924, 50.

53. See Belson 1980; Callaghan 1981; Stewart 1990, 219; but see Boardman 1985a, fig. 241. Interestingly, the gorgoneion would have appeared to loom not only over the Theater of Dionysos but also over the area of the Asklepieion. There is a story (Apollodoros 3.10.3) that Asklepios had received from Athena the miraculous blood of the gorgon, some of which was fatal poison, some of which could heal or even bring men back to life. The juxtaposition of Medousa's head (putatively still dripping?) high on the south wall with the healing shrine below might not, then, be coincidental; it might have imaginatively bridged the sanctuaries of Athena and Asklepios. In the *Ion* (lines 988–1015), however, Euripides says that Athena gave the drops of gorgon's blood not to Asklepios but to Erichthonios; since the play was probably written just a few years after the establishment of the Asklepieion in 420/19, Euripides's version suggests the Apollodoran tale might not yet have been current. Could, then, Apollodoros's version have been inspired by the gorgoneion that, at least from the early Hellenistic period on, hovered over the Asklepieion?

54. Vitruvius 7.15.17; Travlos 1971, 402–3. The colossal temple, Corinthian now instead of the originally planned Doric, would remain unfinished at the time of Antiochos IV Epiphanes's own death. In 86 Sulla had some of the columns removed to Rome; Pliny *NH* 36.6, 45.

55. If, on the other hand, Antiochos IV Epiphanes were the dedicant around 170, there would have been no real contest, since he was installed on the Seleukid throne with the help of the Attalids themselves; see Ferguson 1911, 299.

56. Ariobarzanes had once been a student, even an ephebe, in Athens; Habicht 1997, 335–6; Travlos 1971, 387. The Asklepieion, also damaged during the Sullan attack, underwent repairs around the same time; Aleshire 1989, 16.

57. *IG* II² 3120; Aleshire 1989, 16; Travlos 1971, 127–8. For Athens in the Augustan Age, the fundamental work remains Graindor 1927.

58. For the repairs to the east pediment, which may have included the replacement of at least one figure, see Palagia 1993, 13, 22, and 33 n. 65, and Korres 1994e, 140. For the Augustan repair to the base of the Bronze Athena (not necessarily financed by Augustus himself), see Dinsmoor 1967–8.

59. Graindor, 1931, remains basic for this period.

60. *IG* II² 5173–5179; Hoff 1994, 116 and n. 126.

61. T. L. Shear, Jr., 1981, 367; Geagan 1979, 384. Also Hoff 1994, 116, who argues that Claudius was also responsible for the Arcuated Building (the so-called Agoranomion) east of the "Roman Agora" and that this structure was in reality a monumental shrine for the imperial cult.

62. It is not for nothing that when Hadrian founded an institute of higher learning in Rome itself he named it the Athenaeum. For Athens under Hadrian, see Graindor 1934.

63. Spawforth and Walker 1985, 98–9; Travlos 1971, 242–3. A branch of the aqueduct Hadrian built – the first major water project in the city since the days of the Peisistratids – ran along the north slope of the Acropolis.

64. Boatwright 1983.

65. Camp 1986, 193.

66. Pausanias, 1.18.9, says it had 100 columns of Phrygian stone. It is sometimes thought that Hadrian also renovated the Roman Agora, but M. Hoff informs me that he has been unable to discover any evidence of Hadrianic activity here.

67. Pausanias 1.5.5; 1.18.9; Travlos 1971, 439–43; Spawforth and Walker 1985, 97.

68. Pausanias 1.18.6.

69. Boatwright 1994; Travlos 1971, 181 (Bath I); 429–31 ("shrine of the Panhellenion").

70. Adams, 1989, argues that the Arch of Hadrian was dedicated not by Hadrian himself but by the Athenian people.

71. Sturgeon 1977; Cassius Dio 69.16.1–2.

72. Unless he paid for another repair to the Athena Parthenos that *may* have taken place late in his reign; see Chapter 2, n. 80.

73. Brouskari 1974, 18 (Acropolis 3176 and 5460) and 23–24 (Acropolis 1326).

74. Pausanias 1.26.3–4; 1.27.4. Pausanias's text here is uncertain, but the base of an apparently early third-century statue of a Syeris, servant of Lysimakhe, is known from the Acropolis (*IG* II² 3464). This statue, signed by Nikomakhos, is not to be confused with the more famous portrait of an earlier Lysimakhe made by Demetrios of Alopeke in the early fourth century [Fig. 205].

75. Parker 1996, 271.

76. Higgins 1986, 118–19 and fig. 151 (Acropolis T1462); Casson and Brooke 1921, 329.

77. Stevens 1940, 30–2.

78. Korres 1994e, 139.

79. Travlos 1971, 562 and fig. 704. A seated statue of Dionysos, though datable to the early third century and found atop the Thrasyllos Monument, may not have been set there until much later in antiquity; Ridgway 1990b, 212–13.

80. *IG* II² 4758; Pausanias 1.24.3; Stevens 1946, 4. This drought might have been the occasion for Hadrian's construction of a new aqueduct for the city.

81. The north slope seems to have received less attention, though low on the slope, across the *peripatos* from the Sanctuary of Aphrodite and Eros, a strange sanctuary was apparently established in the first quarter of the third century: over 200 miniature *skyphoi* (cups) were found there still arranged in neat little rows on a rock-cut terrace, for reasons that defy our understanding. For this Skyphos Sanctuary (which, since it lay beyond the Peripatos, was probably not dependent upon the Acropolis), see Glowacki 1991, 65–73.

82. Aleshire 1989, 15, 25–8, 32–3; 1991, 27–9, 41.

83. Pausanias, 1.22.3, says the cult was founded by Theseus at the time of the *synoikismos* and that, though the original images no longer survived, the ones he saw were "the work of not obscure artists" (whom he nonetheless does not name); also Beschi 1967/68b; Simon 1983, 48–51; Shapiro 1989, 118. For the cult statues, see Dontas 1989.

84. Walker 1979. After mentioning the shrine of Themis, Pausanias (1.22.1) notes the monument of Hippolytos nearby. This memorial is probably to be identified with the Temple of Isis itself (which Pausanias does not explicitly mention). A temple to Aphrodite (whom Isis eventually assimilated) was supposedly built by Phaedra (Theseus's wife, who loved Hippolytos), as mentioned in Euripides's tragedy, *Hippolytos*, lines 29–32. Aphrodite herself speaks:

Before [Phaedra] ever came to this land of Troizen,
beside the rock of Pallas itself, within sight of this land,
she built a temple to the Kyprian,
loving a foreign love. In future time, the temple
built for a goddess will be named for Hippolytos.

85. Philostratos, *Lives of the Sophists* 2.556; J. Tobin has suggested that an ornate shed for the display of the ship was built on a hill above the rebuilt Panathenaic stadium [Fig. 2]. In any case, Herodes's vessel does not seem to have been the same Panathenaic ship that Pausanias (1.29.1) saw anchored at the foot of the Areopagos.

86. See Appendix C, Cat. 22.

87. *IG* II² 983, 2316; Ferguson 1911, 293, 298–9. The Ptolemaic dynasty had a long history of beneficence toward Athens. In the late third century, for example, a Ptolemy seems to have built a long colonnaded gymnasium northeast of the Acropolis: its columns would in late antiquity be used to repair the Parthenon; see Miller 1995, 203–9.

88. See Ridgway 1990b, 288; Ferguson 1911, 299; Plutarch, *Antony* 60.

89. Korres 1994e, 140; *IG* II² 3272. As G. Schmalz has suggested to me, the Smaller Attalid Group southeast of the Parthenon seems to have been restored or reworked around the same time; see *SEG* 26 (1976), no. 121, lines 25–7.

90. *IG* II² 4122; Hill 1953, 184. The rededication occurred sometime after 27 but before Agrippa's death in 12. The occasion may have been Agrippa's construction of the Odeion in the Agora below, easily visible from the terrace of the monument, or his financing of the restoration of the Erechtheion (if that was indeed his project). Some scholars believe the monument had already been re-dedicated once before, to Mark Antony; Habicht 1997, 364.

91. Pausanias, 1.22.4, tentatively identifies these horsemen as the "sons of Xenophon," but admits uncertainty. For the original group, see Chapter 7, 147; also Hill 1953, 184–5, and C. C. Vermeule 1968, 209–10.

92. *IG* II² 3437/8; see Miller 1995, 208 and 227 n. 20.

93. The inscriptions on the group base are remarkably brief; it is as if the honors were grudging. See Rose 1997, 138 (cat. 68); Geagen 1979, 386.

94. *IG* II² 3266, 3267.

95. E.g. *IG* II² 3272 (possibly) and 3276.

96. *IG* II² 3409.

97. The Athenians, in fact, named a tribe after him and added his portrait to the Monument of Eponymous Heroes in the Agora; Pausanias 1.5.5.

98. Pausanias 1.24.7; Geagan 1979, 399, suggests that, since he was styled as the son of Zeus, Hadrian would have been thought of as Athena's brother. Again, it has been suggested that the Athena Parthenos underwent restoration during Hadrian's reign (Chapter 2, n. 80). Although there is no evidence Hadrian paid for the repairs, his presence near the goddess – and the fact that Pausanias (1.24.7) remembers seeing nothing else in the cella but the Parthenos and the Hadrian (was it really that empty? Pausanias, 1.1.2, says a painted portrait of Themistokles hung in the Parthenon) – is suggestive.

99. A much earlier possibility is the fourth-century general Iphikrates, though Pausanias (1.24.7) says only that his portrait (set up c. 372/1) stood "at the entrance" of the building, which could mean just inside or outside it; see Stevens 1946, 15. On the other hand, there may have been many more portraits inside the Parthenon than our sources mention: G. Dontas, for example, has proposed that a group of at least six portraits of the emperor Caracalla (Julia Domna's son), Athena, Herakles, Alexander, Olympias, and Julia Domna herself was also set up within its peristyle; see *AR* 1984–5, 6, and C. C. Vermeule 1968, 400.

100. *IG* II² 1076; Oliver 1965; Geagan 1979, 408, 410; Mansfield 1985, 203. Athenian flattery of the Severans did not end with her or Caracalla, whose marble portraits are stored in the Acropolis Museum: around 209/10 AD they established a festival and public sacrifice to celebrate the news that her son Geta was elevated to the rank of Augustus (*IG* II² 1077).

101. Tertullian, *Ad Nationes* 1.12.3. Also Mansfield 1985, 137–8.

102. See Appendix C, Cat. 18. There were a few much later utilitarian modifications of Roman date: a cistern, for example, was set into the never-built northeastern wing of the Propylaia, apparently during the reign of Justinian; Tanoulas 1994b, 161.

103. Korres 1994e, 140.

104. For this reading of the Temple of Roma and Augustus and this "Persian War corner" of the Acropolis – though virtually every corner of the Acropolis was a "Persian War corner" – see also Carroll 1982, 67–69; Spawforth 1994, 234–5; Hoff 1996; and Schmalz (forthcoming), Chapter 1.

105. *IG* II² 3277; Carroll 1982. The inscription is placed asymmetrically on the architrave because its makers had to contend with the tall and potentially obfuscating Panathenaic Attalid Monument (now rebaptized in the name of Augustus) at the northeast corner of the Parthenon [Fig. 221]; see Korres 1994e, 158 n. 16. Significantly, perhaps, the only complete word

written between the last (northernmost) two shields – those closest to the monument – is Nero's title *Sebaston*, Greek for "Augustus."

106. *IG* II² 3182; Hoff 1994, 116–17. The mosaic diamond extending across the orchestra floor may have been added at this time, too. The theater was re-modelled again early in the next century: new marble statues (such as the so-called Omphalos Apollo, a Roman copy of an influential Early Classical bronze) joined the old portraits of Aeschylus, Sophocles, and Euripides as adornments of the place, and at some point a marble barrier was erected around the orchestra to separate spectators from the bloody gladiatorial contests that were now sometimes held in the theater; Wycherley 1978, 214–15; Travlos 1971, 538.

107. Carroll 1982; Spawforth 1994.

108. As it is, the Nike would not have had to endure the inscription very long: it was probably removed after Nero's inglorious death in 68. See Carroll 1982, 7.

Chapter 13

1. On the Herulian and Visgothic invasions, see Frantz 1988, 1–5, 49–56; Castrén 1989 and 1994. These were, incidentally, not the first times barbarians invaded Attica: in 170 AD, during the reign of Marcus Aurelius, the Kostoboks destroyed Eleusis and its sanctuary, though Athens itself escaped harm. And they would not be the last: the Vandals arrived in 467 or 476, and the Slavs devastated the city once more in 582/3.

2. Sironen 1994, 19–22.

3. For the Post-Herulian date of the Beulé Gate and its incorporation within the new wall, see M. B. Fullerton 1996.

4. Another towered gate just west of the Temple of Athena Nike was built at the same time as the Beulé Gate, and the Klepsydra fountain, protected by the Post–Herulian Wall, was now vaulted over as well; Tanoulas 1994a, 56. It is possible that a defensive work – a *phrourion* (watch-post or garrison) mentioned in an inscription honoring its restorer – had already been constructed on the west slope in the second century AD, perhaps in connection with the Kostobok invasion of 170; see *IG* II² 3193 and Frantz 1988, 118; also Geagan 1979, 410. Sironen 1994, 28–9, provides inscriptional evidence for yet another gateway built on the Acropolis around 325–350 AD.

5. Zosimos 5.6.1–3.

6. Frantz 1988, 51–2; Castrén 1989, 46. Synesius, bishop-elect of Cyrene, visited Athens not long after Alaric did (possibly in 399 but probably in 410) and compared it to a burned sacrificial victim with nothing left but the skin to hint at its original appearance (*Epistles* 136). Synesius was primarily bemoaning the city's philosophical decline, but the image fits the city's artistic and architectural condition around 400 as well.

7. It is also clear that discarded material from the Parthenon – broken ceiling coffers and columns from the original interior colonnade – were used in the foundations of a late

fifth-century AD stoa in the lower town; Frantz 1988, 78 n. 148.

8. 1.27.4–5.

9. For the repairs (and for the use of thirteen columns from the same Hellenistic building[s] as those used to renovate the Parthenon interior to repair the Doric stoa of the Asklepieion), see Korres 1994e, 140–6; Hill 1953, 127; also Miller 1995, 206–07. For the Classical monuments reused in the new west door, see Korres 1994f, 124–5.

As for the Athena Parthenos, one wonders whether Athens could have afforded a completely new monumental chryselephantine image at any time in the fourth or fifth centuries.

10. Korres 1994c, 177; Travlos 1973.

11. Frantz 1979; 1988, 63–5; for the statue of Herculius, see *IG* II² 4225. The final phase of the Theater of Dionysos (which was now used for assemblies rather than dramatic performances) may also date to the early years of the fifth century; Sironen 1994, 43–5 (no. 27), Castrén 1989, 46. This also seems to be when the so-called Bema of Phaidros was built and adorned with reliefs recycled from the Hadrianic phase of the building [Fig. 224].

12. The troubling gap between the supposed Herulian destruction of the Parthenon and a fourth-century or Julianic reconstruction could be substantially reduced if the building was destroyed not by the Herulians at all but by an accidental fire in the late third or early fourth century. So, too, we must ask what sense it made for the Athenians to build the impressive Beulé Gate if the sanctuary it led to, having been devastated by the Herulians, was left a ruin for nearly a century.

13. Korres 1994e, 143, and Korres and Bouras 1983, 136–7, cite such extensive wear to the (new) east door, threshold, and floor that a fifth-century repair is in their view "out of the question." The argument is that the Parthenon must have continued to function as it had for so a long time between its repair and its sixth- or seventh-century conversion into a church (when the east door was eliminated) that only a fourth-century repair makes sense. The argument, depending on estimates of how long it took to gouge the new floor with the pivoting new door, is ingenious but may not settle the controversy once and for all.

14. Fowden 1990, 499; *contra* Frantz 1988, 64.

15. There is little or no evidence that any temple in the Agora functioned as such after 400; Frantz 1988, 53–4, 109. Christianity, on the other hand, was making important strides, at least down in the lower city. For a re-evaluation of the status of Athenian Christians in the early fifth century, see Fowden 1990.

16. Mansfield 1985, 203.

17. Here we might mention the early fifth-century "Portrait of a Philosopher" (Acropolis 1313), sometimes thought to represent the Neoplatonic Plutarch himself. The head was probably found on the south slope; Frantz 1988, 43–4.

18. *IG* II² 3818; Frantz 1988, 64; Mansfield 1985, 69, 203; Castrén 1989, 47.

19. Frantz 1988, 76–7; R. J. H. Jenkins 1947; also Mattusch 1988, 169–70 and n. 62.

20. Frantz 1988, 42–4, 70–1. The Asklepieion seems to have closed down soon after Proclus's death in 485. The Neoplatonists used the Theater of Dionysos for their lectures but the encroachment of Christianity is apparent even here by the end of the fifth century, when a narrow Christian basilica was built over its east entrance or parodos; Travlos 1971, 538 and fig. 686.

21. Theodosius II's decree of 435, which called for the demolition of all temples, apparently had little effect in Athens *per se*; see Frantz 1988, 69. Still, the handwriting was on the wall.

22. Burkert 1988, 45.

Chapter 14

1. Quoted in St. Clair 1983, 88.

2. For the date of the tower, see Tanoulas 1994a, 65. The tower seems to be alluded to in Chaucer's *Knight's Tale*, lines 1056–7 and 1064–6 (I owe the reference to Judith Binder), in which case it would have to have been built before Chaucer's death in 1400 .

3. An eyewitness account of the bombardment and its aftermath survives as part of Cristoforo Ivanovich's "Istoria della Lega Ortodossa contro il Turco," found translated in Bruno 1974, 124–28. See also Mackenzie 1992, 18–22.

4. Ivanovich, in Bruno 1974, 126.

5. See, for example, Bowie and Thimme 1971, 5: "Any traveler permitted to enter the Turkish citadel of Athens before 1687 found the Parthenon still intact, its classical shape unchanged."

6. For the nature of the Christian Parthenon, see Korres 1994e, 146–50.

7. Because the Turkish village was apparently concentrated in the central, eastern, and western areas of the Acropolis, it is sometimes thought that the south metopes were less vulnerable. But Fig. 232 seems to show fairly dense settlement south of the Parthenon, too, and so the reliefs would have been just as obvious targets as those on the other sides of the building.

8. The traveller was Evliya Chelebi, writing around 1667; see Mackenzie 1992, 13.

9. See Bowie and Thimme 1971.

10. Tanoulas 1994a, 56; Korres 1994b, 49.

11. For the Turkish alterations to the Nike Temple bastion before 1686, see Mark 1993, 9.

12. For the history of Elgin's removal of the marbles and for the debate over the morality and legality of his actions, see St. Clair 1983; B. F. Cook 1984, 53–70; and Hitchens 1987.

13. R. Browning, in Hitchens 1987, 24. From 1824 to 1826, the Parthenon – once the house of the Virgin Athena – appropriately served as a school for *parthenoi*, the daughters of Greeks fighting in the War for Independence.

14. For the history of Acropolis excavation and restoration, see Mallouchou-Tufano 1994.

15. See Bundgaard 1974.

16. For the effects of the nineteenth century upon the Acropolis, and for the motivations of its excavators and restorers, see especially McNeal 1991, upon whom I have here heavily relied.

17. "A Disturbance of Memory on the Acropolis," in Strachey, ed., 1953, vol. 22 (1964), 239–48 (240–1).

18. Quoted in N. Payton, "Worlds for Habitation: Architecture and the Moving Image," *Places* 7 (1991), 90–1. I owe the reference to Kenneth Helphand.

Appendix A

1. See Habicht 1985, 11. The monumental project was not finished until 175 or 180 AD, at the end of the reign of Marcus Aurelius (the last Roman emperor Pausanias mentions).

Pausanias was hardly the first author to describe the monuments of the Acropolis: over three centuries earlier, for example, the geographer Polemon of Troy (c. 190), a specialist in inscriptions, wrote a work describing the votives on the citadel, and it took Heliodoros of Athens (c. 150?) fifteen books to describe its works of art. Both works are (except for a few quotations in later writers such as Athenaios) lost.

2. For an examination of the criteria Pausanias evidently used to choose the works he would discuss, see Arafat 1992.

3. Cf. Pausanias 5.12.4 .

4. The Daidalos-Kalos story has been read into the "lost" central metopes on the south side of the Parthenon, almost directly above; see M. Robertson 1984.

5. Walker 1979.

6. See Beschi 1967/68b.

7. The pedestal for one of these equestrian statues, set on either side of the approach to the Propylaia, is seen in the center foreground of Plate IX. One horseman was Classical in date, the other a Roman-era companion piece; see Chapter 12, 278.

8. That is, the Temple of Athena Nike. Beside the temple, Pausanias tells us elsewhere (2.30.2), stood a triple-bodied statue of Hekate, called Epipyrgidia (On the Bastion) and attributed to Alkamenes; see Stewart 1990, 267–8.

9. That is, the northwest wing of the Propylaia, known as the Pinakotheke, or Picture Gallery. Pausanias speaks of it as if it were a separate building.

10. Youths carrying water-jars – an unusual subject – are also present on the north frieze of the Parthenon [Fig. 155].

11. The Hermes Propylaios (Of the Gateway) is probably reproduced in later copies from Pergamon, Ephesos, and the Acropolis itself (Acropolis 2281). Inscriptions indicate that the sculptor was an Alkamenes, though it is not clear whether he was the well-known later fifth-century artist of that name, or a hypothetical Early Classical sculptor who might be called "Alkamenes the Elder." See Stewart 1990, 165, 267–7; Boardman 1985, 206 and fig. 189; Barron 1984; and Brouskari 1974, 22-3.

12. Elsewhere (9.35.3–7) Pausanias describes these statues

(or reliefs) of the Graces as three in number, draped, and the focus of mystery initiations. Palagia, 1990, locates the site of the Graces in the triangular area between the south wall of the Propylaia, the Mycenaean wall adjoining it, and the Nike Temple bastion. The tradition that the famous Socrates was, like his father, a stonemason or sculptor before taking up philosophy was engrained in later antiquity, and even Plato hints at an artistic ancestry (cf. *Euthyphro* 11B). Still, the Graces may have been carved by another Socrates altogether.

13. That is, Pittakos.

14. Hippias's brother, assassinated in 514 by the conspirators Harmodios and Aristogeiton.

15. For the inscribed base of the lost statue, see *IG* I³ 876. The work should be dated around or before 450 and thus, if it stood in or near the Propylaia, must have been moved there from its original location elsewhere.

16. The Diitrephes seems to be the same as the statue of "a wounded and dying man, in whom the spectator can sense how little life is left" made by the fifth-century sculptor Kresilas; see Pliny, *NH* 34.74–5. The statue seems to have stood atop an inscribed base from the Acropolis listing Hermolykos, son of Diitrephes, as dedicator and Kresilas as sculptor; *IG* I³ 883 and Raubitschek 1949, 141–4 (no. 132) and 510–13. Though Pausanias identifies this Diitrephes with an Athenian general whom Thucydides (7. 29, 8.64) mentions in his account of the Peloponessian War for the years 413 and 411, the inscription, on the basis of its letter forms, seems closer to the middle of the fifth century (c. 440).

17. Pausanias has now made his way through the Propylaia.

18. A *perirrhanterion* was a vessel for holy water, or lustral sprinkler. A fragmentary inscribed base (*IG* I³ 892) has been assigned to this work, datable to the 430s; see Jeffery 1980.

19. *IG* I³ 895.

20. Epeios was the legendary builder of the Trojan Horse; see *Odyssey* 8.492.

21. The base survives (*IG* I³ 847, c. 475–470) and bears the signature of both Kritios and his partner (bronze founder?) Nesiotes. Epikharinos was apparently shown with his legs bent at the start of the race.

22. The historian of the Peloponnesian War.

23. The "others" Pausanias means are Herodotos, who mentions Hermolykos (9.105), and Thucydides, who deals extensively with Phormio, a brilliant Athenian admiral of the 430s and early 420s, in the first two books of his history.

24. That is, the Minotaur.

25. The group of Phrixos and the sacrifice is sometimes attributed to Naukydes of Argos (c. 400) on the strength of Pliny's comment (*NH* 34.80) that the statue of a man (whom he leaves unidentified) sacrificing a ram was one of Naukydes's most prized works. There is, in fact, an empty base (reportedly found in this general vicinity) with the signature "[N]aukydes the Argive made [this];" see Loewy 1885, 68 (no. 87). The evidence is circumstantial, but the attribution of the Phrixos group to Naukydes is plausible.

26. Stevens 1940, 19–24, has reasonably suggested that a rectangular cutting in the bedrock at the foot of the northern end of the flight of rock-cut steps west of the Parthenon [Fig. 163] marks the location of this life-size bronze.

27. At 1.17.1.

28. Pausanias is here describing an area west or northwest of the Parthenon, but the text is problematic. See Judeich 1931, 241–3, and Stevens 1940, 56–7, who identified cuttings and blocks of a roughly square structure atop the north end of the rock-cut flght of steps west of the Parthenon [Fig. 163] as the remains of a monument to or shrine of Athena Ergane. Whether Athena Ergane had a separate temple in Pausanias's day or not, she is referred to only once in fifth-century literature, and she is not definitely known to have received any private dedications until the fourth century; see Mikalson 1983, 141 n. 21. Still, the idea that Athena was goddess of work and workers is clearly older than that, and some scholars accept the existence of a sixth-century cult and an elaborately decorated fifth-century precinct; see, for example, Ridgway 1992, 138–9, and E. B. Harrison 1996a, 50.

29. A bronze finger with a silver nail, allegedly from the Acropolis, is in the collection of the Art Museum, Princeton University, though, of course, there is no reason to link it with Kleoitas's warrior; see Mattusch 1996, 26 and fig. 1.18.

30. A block from this monument was later re-used in the ambo of the Christian Parthenon; see Korres 1994e, 148–9 and fig. 14.

31. The marble group Acropolis Museum 1358 must be the work Pausanias mentions, though it is uncertain, first, whether Alkamenes, the famous student of Pheidias, really dedicated the work or instead made it for someone else (say, Sophocles, who wrote a tragedy on the subject in the 420s and may have commissioned the work to celebrate the success of the drama); second, whether the surviving group is original or a Roman copy; and third, whether the head really belongs to the statue (the head has now been removed). Prokne, incidentally, was the daughter of the early Athenian king Pandion, who was possibly worshipped as a hero in a shrine in the southeast angle of the Acropolis (Fig. 3, no. 16).

32. This group, located near the eastern end of the Parthenon, reiterated the subject of the building's west pediment [Fig. 143], though there is no hint that the group on the ground was as violent.

33. Cf. Pausanias 1.28.10–11 on the origins of the rite in the days when Erechtheus was king.

34. At 8.41.9 Pausanias says the architect of the Parthenon was Iktinos (there is no mention of Kallikrates).

35. In the course of his description of Pheidias's chryselephantine statue of Zeus at Olympia (5.11.10) Pausanias mentions that there was before the Athena Parthenos a pool of water to help prevent the ivory of the statue from drying out (there was a pool of olive oil in front of the Zeus, which Pausanias thought was meant to counter the high humidity at

Olympia). The reflecting pool of the Parthenon was a later addition to the cella, though how long after the dedication of the Athena Parthenos is hard to say; see Stevens 1955, 267–70. Perhaps, as K. Lapatin has suggested to me, it was installed fairly soon, after Pheidias's experience with the oil basin in Olympia.

36. See 9.26.2–4.

37. That is, about six feet. Roman reflections of the Nike may be found in a marble head from the Agora (Agora S2354) and a torso from Cyrene (Philadelphia L–65–1); see Boardman 1985a, figs. 104–5.

38. Presumably this is the portrait Pausanias saw near the statue of Athena Lemnia as he left the Acropolis; see 1.28.2 and Richter 1984, 173–5.

39. This unattributed statue may be reflected in a Roman copy, in Copenhagen, of a work of about 440: it shows Anakreon shifting his hips and tilting his head, as if in song. See Boardman 1985a, fig. 235, and Richter 1984, 83–6.

40. Whether or not Acropolis 625 is Endoios's Athena, however, its state of preservation has long suggested that this was one of the few Archaic dedications known to have survived the Persian destruction of the Acropolis in 480. But see Bundgaard 1974, 16, for the argument that Acropolis 625 was part of the Persian debris after all (and thus that it cannot be Endoios's Athena), and that its weathered state is to be explained by long exposure in a breach of the north citadel wall.

41. The priestess of Athena Polias and the priest of Poseidon were always chosen from the members of this ancient clan (supposedly descended from Bronze Age kings); the family was also known as the Eteoboutadai.

42. Cf. Thucydides 2.15: "Up to the present day the Athenians still call the Acropolis 'the Polis,' because of their ancient settling of the place."

43. On this lamp and its possible location, see Palagia 1984; see, however, Mansfield 1985, 236–7, n. 30.

44. Pausanias' descriptions of the Erechtheion, the statue of Athena Polias and Kallimachos's lamp, and the contents of the Temple of Athena Polias seem to fuse uneasily, and his description of the cult-image as a work that is "kept on what is now called the Acropolis" after having already spent so many pages describing the citadel seems odd: perhaps the paragraph represents notes inserted later into his narrative. There are those who believe the Erechtheion and the Temple of Athena Polias were different buildings; see Chapter 8, 200–2.

45. That is, the three daughters of Kekrops (Pandrosos, Aglauros, and Herse).

46. On this troublesome passage, see Kadletz 1982. The phrase "in the city" (en tei polei) often means "on the Acropolis" (cf. 1.26.6 above), and so many scholars have placed this strange rite (the Arrhephoria) entirely on the Acropolis itself. In this view, the girls would start on the summit, the natural underground pathway would be part of the old Mycenaean

fountain [Fig. 57], and the sanctuary of Aphrodite would be the rock-cut shrine of Aphrodite and Eros on the north slope of the Acropolis [Fig. 34]; see Broneer 1932; Simon 1983, 39–40. But it is important to stress that Pausanias does not say the sanctuary of Aphrodite was the goal of the Arrhephoroi (though that has been the usual assumption), only that they came near it when they reached the unnamed precinct that was their goal. And elsewhere (1.19.2) Pausanias locates the Sanctuary of Aphrodite of the Gardens in the southeast part of the city, far from the Acropolis north slope and Mycenaean fountain.

47. The text here is uncertain, but the base of an apparently early third-century statue of a Syeris, servant of Lysimakhe, is known from the Acropolis (IG II² 3464). This dedication is not to be confused with the more famous portrait of an earlier Lysimakhe made by Demetrios of Alopeke in the early fourth century [cf. Fig. 205]. This Lysimakhe, Pliny informs us (NH 34.76), was priestess of Athena Polias for sixty-four years; though Pliny does not give its location, the Acropolis would be a logical place for the statue. In fact, we almost certainly have a portion of its base as well: no names are preserved in the inscription (IG II² 3453), but it does say something about "[six]ty–four years of service to Athena" – a remarkable coincidence.

48. Base blocks that may come from this monument have recently been identified; see Korres 1994f, 124.

49. The mythological tradition in fact varies, and in a number of ancient sources Eumolpos is indeed the victim of Erechtheus. The Erechtheus of this group is possibly the same as a statue of the hero, made by Myron, that Pausanias mentions later (9.30.1).

50. See Sourvinou-Inwood 1971, 108, for comments on this lost work. It may be depicted on coins; see Imhoof-Blumer, Gardner, and Oikonomides 1964, lxxii, 146, and DD ii.

51. See Shapiro 1988, who argues that the original monument was simply a standing bronze bull (that is, Theseus was absent), that it was dedicated in the years just before 500, that it did not survive the Persian destruction, and that the monument Pausanias saw was a marble replacement set up soon after 480 (a marble torso and muzzle survive).

52. The battle against the Boiotians and Chalcidians was fought around 506. The original monument, like so many others, was destroyed by the Persians in 480. But inscribed fragments from both the original pedestal for the four-horse chariot and from its Early Classical (c. 455) replacement (which Herodotos 5.77 also mentions) are known; see IG I³ 501A and B; Meiggs and Lewis 1988, 28–9; and Raubitschek 1949, 191–4 (no. 168) and 201–5 (no. 173). The location of the monument (to the left of one entering the [Older] Propylon, Herodotos says) was shifted during the construction of the Mnesiklean Propylaia, and cuttings in the rock next to the site of the Bronze Athena almost certainly mark its final location [Fig. 24].

Appendix B

1. Perikles is elsewhere said to have been *epistates* for the statue of Athena Parthenos, but it is unlikely he was more than one member of the board; Stadter 1989, 177.

2. See especially Himmelmann 1977; also Stewart 1990, 60–1; Stadter 1989, 166–7; Sealey 1976, 303; and Boersma 1970, 69.

3. *IG* I³ 49; Davies 1993, 97.

4. According to Meiggs and Lewis 1988, 88, it is unlikely that the total tribute of any year before 433 would have surpassed 400 talents. But even generously assuming an average of 400 talents for all fifteen years of work on the Parthenon and Propylaia, the *aparkhai* would not have exceeded a mere 100 talents in all (400 x 15 x 1/60). The Parthenon alone (not even counting the statue of Athena Parthenos inside) seems to have cost seven or eight times that much.

5. Dinsmoor 1913, esp. 64–5 and 78–9; also Meiggs and Lewis 1988, 165–6 (No. 60), and Hill 1953, 160. On the financing of the building program in general, see Kallet-Marx 1989 (who argues that the treasuries of Athena and the Greeks were not merged and that Athens was wealthy enough to afford the building program without drawing heavily upon imperial tribute). For different views, see Meiggs 1975, 154–5, 515-18; Samons 1993.

6. According to Thucydides 2.70, the siege of Poteidaia (432–430) cost 2,000 talents, and Poteidaia was hardly Athens' only military expense in those two years; see also Burkert 1985, 92.

7. Perikles here exaggerates in his own defense. For example, a number of allies did in fact supply ships and hoplites for several military campaigns; see Meiggs 1975, 139.

8. It is pleasant to think that one of the "workers in stone" or sculptors involved early on in the building program could have been the great Socrates who, born in 469, was the son of a stonemason or sculptor and who may have practiced that trade in his youth before taking up more rarified pursuits; cf. Pausanias 1.22.8.

Inscriptions detailing the last years of work on the Erechtheion (*IG* I³ 474–79) provide a remarkably similar list of the sorts of workers involved in that project: stoneworkers, sculptors, builders, woodworkers, scaffolding makers, joiners, encaustic painters, paint-pot carriers, sawyers, gluers, gilders, column-channelers, modellers in wax, and so on.

9. The word Plutarch uses is *arkhaios* (old, ancient) but the connotations here are "venerable," even "classic"; Stadter 1989, 165.

10. Literally, the Hundred-Footer Parthenon.

11. It is thought by some that the first architect of the Periklean Telesterion was Iktinos. After he was called to Athens to begin the Parthenon, Koroibos took over the project and altered Iktinos's plan; Boersma 1970, 72–3.

12. The year was 444/3.

13. See Stadter 1989, 294; Preisshofen 1974.

WORKS CITED

Adams, A. 1989. "The Arch of Hadrian at Athens," in Walker and Cameron 1989, 10–15.

Ajootian, A. 1996. "Praxiteles," in Palagia and Pollitt 1996, 91–129.

Aleshire, S. B. 1989. *The Athenian Asklepieion: The People, Their Dedications, and the Inventories*. Amsterdam.

Aleshire, S. B. 1991. *Asklepios at Athens: Epigraphic and Prosopographic Essays on Athenian Healing Cults*. Amsterdam.

Alroth, B. 1988. "The Positioning of Greek Votive Figurines," in R. Hägg, N. Marinatos, and G. C. Nordquist, eds., *Early Greek Cult Practice*. Stockholm. 195–203.

Amyx, D. A. 1988. *Corinthian Vase-Painting of the Archaic Period*. Berkeley.

Andronopoulos, B., and Koukis, G. 1976. *Geologiki-geotechniki meleti tis periochis Akropoleos Athinon*. Athens.

Anhalt, E. K. 1993. *Solon the Singer*. Lanham, Md.

Arafat, K. W. 1992. "Pausanias' Attitude to Antiquities," *BSA* 97, 387–409.

Ashmole, B. 1972. *Architect and Sculptor in Classical Greece*. London and New York.

Austin, C. 1968. *Nova Fragmenta Euripidea in Papyris Reperta*. Berlin.

Badian, E. 1987. "The Peace of Kallias," *JHS* 107, 1–39.

Bancroft, S. 1979. *Problems Concerning the Archaic Acropolis at Athens*. Diss. Princeton U. 1979. Ann Arbor, UMI.

Barber, E. J. W. 1992. "The Peplos of Athena," in Neils 1992, 103–17.

Barber, R. L. N. 1987. *The Cyclades in the Bronze Age*. Iowa City.

Barron, J. P. 1984. "Alkamenes at Olympia," *BICS* 31, 199–211.

Beazley, J. D. 1946. *Potter and Painter in Ancient Athens*. Oxford.

Beazley, J. D. 1986. *The Development of Attic Black-Figure*. Revised ed. Berkeley.

Belson, J. D. 1980. "The Medusa Rondanini: A New Look," *AJA* 84, 373–8.

Berger, E. 1977. "Parthenon-Studien," *AntK* 20, 124–141.

Berger, E., ed. 1984. *Parthenon-Kongress Basel: Referate und Berichte*. Mainz.

Bernal, M. 1987. *Black Athena*. Vol. I. New Brunswick, N.J.

Beschi, L. 1967/8a. "Il Monumento di Telemachos, fondatore dell'Asklepieion ateniese," *ASAtene* 29/30, 381–436.

Beschi, L. 1967/8b. "I sanctuari di Afrodite Pandemos, Ghe Kourotrophos, Demeter Chloe e l'Heroon di Egeo," *ASAtene* 29/30, 517–28.

Beschi, L. 1986. "*He Zophoros tou Parthenona: Mia Nea Prostase Hermeneias*," in Kyrieleis 1986, vol. II, 199–224.

Beyer, I. 1974. "Die Reliefgiebel des alten Athena–Tempels der Akropolis," *AA (JdI 89)* 639–51.

Beyer, I. 1977. "Die Grossen Reliefgiebel des alten Athenatempels, Akropolis," *AA (JdI 92)*, 44–74.

Binder, J. 1984. "The West Pediment of the Parthenon: Poseidon," in *Studies Presented to Sterling Dow*. Greek, Roman, and Byzantine Studies Monographs 10. Durham, N.C. 15–22.

Binder, W. 1969. *Der Roma-Augustus Monopteros auf der Akropolis in Athen und sein typologischer Ort*. Stuttgart.

Blamire, A. 1989. *Plutarch: Life of Kimon*. With Translation and Commentary. Institute of Classical Studies, Bulletin Supplement 56. London.

Boardman, J. 1954. "Painted Votive Plaques and an Inscription from Aegina," *BSA* 49, 183–201.

Boardman, J. 1972. "Herakles, Peisistratos, and Sons," *RA* 1972, 57–72.

Boardman, J. 1974. *Athenian Black Figure Vases*. London.

Boardman, J. 1975a. *Athenian Red Figure Vases: The Archaic Period*. London.

Boardman, J. 1975b. "Herakles, Peisistratos, and Eleusis," *JHS* 95, 1–12.

Boardman, J. 1977. "The Parthenon Frieze – Another View," in U. Höckmann and A. Krug, eds., *Festschrift für Frank Brommer*. Mainz. 39–49.

Boardman, J. 1978. *Greek Sculpture: The Archaic Period*. New York and Toronto.

Boardman, J. 1984. "The Parthenon Frieze," in Berger 1984. 210–15.

Boardman, J. 1985a. *Greek Sculpture: The Classical Period*. London.

Boardman, J. 1985b. "Image and Politics in Sixth Century Athens," in H. A. G. Brijder, ed., *Ancient Greek and Related Pottery*. Amsterdam. 239–47.

Boardman, J. 1986. "Leaina," in H. A. G. Brijder, A. A. Drukker, and C. W. Neeft, eds., *Enthousiasmos: Essays on Greek and Related Pottery Presented to J. M. Hemelrijk*. Amsterdam. 93–6.

Boardman, J. 1989. "Herakles, Peisistratos, and the Unconvinced," *JHS* 109, 158–59.

Boardman, J. 1991. "The Naked Truth," *OJA* 10, 119–21.

Boardman, J. 1995. *Greek Sculpture: The Late Classical Period*. London.

Boardman, J., and Finn, D. 1985. *The Parthenon and its Sculptures*. Austin.

Boatwright, M. T. 1983. "Further Thoughts on Hadrianic Athens," *Hesperia* 52, 173–6.

Boatwright, M. T. 1994. "Hadrian, Athens, and the Panhellenion," *JRA* 7, 426–31.

Boegehold, A. L. 1994. "Perikles' Citizenship Law of 451/0," in Boegehold and Scafuro 1994, 57–66.

Boegehold, A. L. 1995. *The Athenian Agora XXVIII. Lawcourts at Athens: Sites, Buildings, Equipment, Procedure, and Testimonia*. Princeton.

Boegehold, A. 1996. "Group and Single Competitions at the Panathenaia," in Neils 1996a, 95–105.

Boegehold, A. L. and Scafuro, A., eds., 1994. *Athenian Identity and Civic Ideology*. Baltimore.

Boersma, J. S. 1970. *Athenian Building Policy from 561/0 to 405/4 B.C.* Groningen.

Bookidis, N. 1982. "Attic Terracotta Sculpture: Acropolis 30," in *Studies in Athenian Architecture and Topography Presented to Homer A. Thompson*. Hesperia Supplement 20, 1–8. Princeton.

Borgeaud, P. 1988. *The Cult of Pan in Ancient Greece*. Trans. K. Atlass and J. Redfield. Chicago.

Borthwick, E. K. 1970. "P. Oxy. 2738: Athena and the Pyrrhic Dance," *Hermes* 98, 318–31.

Boulter, P. N. 1970. "The Frieze of the Erechtheion," *Antike Plastik* 10, 7–28.

Bowie, T., and Thimme, D. 1971. *The Carrey Drawings of the Parthenon Sculptures*. Bloomington and London.

Broneer, O. 1932. "Eros and Aphrodite on the North Slope of the Acropolis," *Hesperia* 1, 32–55.

Broneer, O. 1939. "A Mycenaean Fountain on the Athenian Acropolis," *Hesperia* 8, 317–429.

Brouskari, M. 1974. *The Acropolis Museum*. Athens.

Brouskari, M. 1980. "A Dark Age Cemetery in Erechtheion Street, Athens," *BSA* 75, 13–31.

Brulotte, E. L. 1993. "Display of Offerings and Use of Space in the Hekatompedon of the Parthenon," *AJA* 97, 310 (abstract).

Bruno, V. J., ed. 1974. *The Parthenon*. New York.

Bugh, G. R. 1988. *The Horsemen of Athens*. Princeton.

Buitron–Oliver, D., ed. 1997. *The Interpretation of Architectural Sculpture in Greece and Rome*. Studies in the History of Art, 49. Center for Advanced Study in the Visual Arts, Symposium Papers XXIX. Hanover and London.

Bundgaard, J. A. 1957. *Mnesikles: A Greek Architect at Work*. Copenhagen.

Bundgaard, J. A. 1974. *The Excavation of the Athenian Acropolis, 1882–1890*. Copenhagen.

Bundgaard, J. A. 1976. *Parthenon and the Mycenaean City on the Heights*. Copenhagen.

Burkert, W. 1983. *Homo Necans: The Anthropology of Ancient Greek Sacrificial Ritual and Myth*. Berkeley.

Burkert, W. 1985. *Greek Religion*. Oxford.

Burkert, W. 1988. "The Meaning and Function of the Temple in Classical Greece," in M. V. Fox, ed., *Temple in Society*. Winona Lake. 27–47.

Callaghan, P. 1981. "The Medusa Rondanini and Antiochos III," *BSA* 76, 59–70.

Camp, J. McK., II. 1986. *The Athenian Agora*. New York.

Camp, J. McK., II. 1994. "Before Democracy: Alkmaionidai and Peisistratidai," in Coulson et al. 1994, 7–12.

Camp, J. McK., II. 1996. "Excavations in the Athenian Agora, 1994–95," *AJA* 100, 394–95 (abstract).

Carpenter, R. 1929. *The Sculpture of the Nike Temple Parapet*. Cambridge, Mass.

Carpenter, R. 1970. *The Architects of the Parthenon*. Harmondsworth and Baltimore.

Carroll, K. K. 1982. *The Parthenon Inscription*. Durham, N.C.

Cartledge, P. 1985. "The Greek Religious Festivals," in P. E. Easterling and J. Muir, eds., *Greek Religion and Society*. Cambridge. 98–127.

Casanaki, M., and Mallouchou, F. 1983. *The Acropolis at Athens: Conservation, Restoration, and Research, 1975–1983*. Athens.

Casson, S., and Brooke, D. 1921. *Catalogue of the Acropolis Museum*, Vol. II. Cambridge.

Castrén, P. 1989. "The Post–Herulian revival of Athens," in Walker and Cameron 1989, 45–9.

Castrén, P., ed. 1994. *Post–Herulian Athens: Aspects of Life and Culture in Athens, A.D. 267–529*. Helsinki.

Castriota, D. 1992. *Myth, Ethos, and Actuality: Official Art in Fifth–Century B.C. Athens*. Madison.

Cavanagh, W. G. 1991. "Surveys, Cities and Synoecism," in J. Rich and A. Wallace-Hadrill, eds., *City and Country in the Ancient World*. London. 97–118.

Chadwick, J. 1976. *The Mycenaean World*. Cambridge.

Chambers, M., Gallucci, R., and Spanos, P. 1990. "Athens' Alliance with Egesta in the Year of Antiphon," *ZPE* 83, 38–63.

Childs, W. A. P. 1993. "Herodotos, Archaic Chronology, and the Temple of Apollo at Delphi," *JdI* 108, 399–441.

Childs, W. A. P. 1994. "The Date of the Old Temple of Athena on the Athenian Acropolis," in Coulson et al. 1994, 1–6.

Choremi-Spetsieri, A. 1994. "*E odos ton Tripodon kai to khoregika mnemeia sten arkhaia Athena*," in Coulson et al. 1994. 31–42.

Clinton, K. 1994. "The Eleusinian Mysteries and Panhellenism in Democratic Athens," in Coulson et al., 161–72.

Cohen, E. E. 1992. *Athenian Economy and Society: A Banking Perspective*. Princeton.

Coldstream, J. N. 1968. *Greek Geometric Pottery*. London:

Coldstream, J. N. 1977. *Geometric Greece*. New York.

Connelly, J. B. 1996. "Parthenon and *Parthenoi*: A Mythological Interpretation of the Parthenon Frieze," *AJA* 100, 53–80.

Connor, W. R. 1987. "Tribes, Festivals, and Processions in Archaic Greece," *JHS* 107, 40–50.

Connor, W. R. 1994. "The Problem of Athenian Civic Identity," in Boegehold and Scafuro 1994, 34–44.

Cook, A. B. 1940. *Zeus*, III. Cambridge.

Cook, B. F. 1984. *The Elgin Marbles*. Cambridge, Mass.

Cook, B. F. 1993. "The Parthenon, East Pediment A-C," *BSA* 88, 183–5.

Cook, R. F. 1987. "Pots and Pisistratean Propaganda," *JHS* 107, 167–171.

Corbett, P. E. 1970. "Greek Temples and Greek Worshippers," *BICS* 17, 149–58.

Cornelius, F. 1929. *Die Tyrannis in Athen*. Munich.

Coulson, W. D. E., Palagia, O., Shear, T. L., Jr., Shapiro, H. A., and Frost, F. J., eds. 1994. *The Archaeology of Athens and Attica under the Democracy*. Oxbow Monographs 37. Oxford.

Coulton, J. J. 1977. *Ancient Greek Architects at Work*. Ithaca, N.Y.

Coulton, J. J. 1984. "The Parthenon and Periklean Doric," in Berger 1984, 40–4.

Croissant, F. 1993. "Observations sur la date et le Style du Fronton de la Gigantomachie, Acr. 631," *REA* 95, 61–77.

Cromey, R. D. 1991. "History and Image: The Penelope Painter's Akropolis," *JHS* 101, 165–73.

Crowther, N. B. 1991. "The Apobates Reconsidered (Demosthenes lxi.23–9)," *JHS* 101, 174–6.

Csapo, E., and Slater, W. J. 1995. *The Context of Athenian Drama*. Ann Arbor.

Daltrop, G. 1980. *Il gruppo mironiano di Atena e Marsia nei Musei Vaticani*. Vatican City.

Davies, J. K. 1993. *Democracy and Classical Greece*. Second ed. Cambridge, Mass.

Davies, J. K. 1994. "Accounts and Accountability in Classical Athens," in Osborne and Hornblower 1994, 201–12.

Davison, J. A. 1958. "Notes on the Panathenaea," *JHS* 78, 23–41.

Delivorrias, A. 1994. "The Sculptures of the Parthenon: Form and Content," in Tournikiotis 1994, 99–135.

Delivorrias, A. 1997. "The Sculpted Decoration of the So-called Theseion: Old Answers, New Questions," in Buitron-Oliver 1997, 83–107.

Demargne, P. 1984. "Athena," *LIMC* II, 955–1044.

de Ridder, A. 1896. *Catalogue des bronzes trouvés sur l'Acropole d'Athènes*. Paris.

Desborough, V. R. d'A. 1952. *Protogeometric Pottery*. Oxford.

Desborough, V. R. d'A. 1964. *The Last Mycenaeans and their Successors*. Oxford.

Despinis, G. 1976. *Ta glypta ton aetomaton tou naou tes Athenas nikes*. Athens.

Despinis, G. 1982. *Parthenoneia*. Athens.

Despinis, G. 1986. "*Thrausmata anaglyphon apo te Notia pleura tes Akropoles*," in Kyrieleis 1986. Vol. I, 177–80.

Detienne, M., and Vernant, J. P. 1991. *Cunning Intelligence in Greek Culture and Society*. Chicago.

Develin, R. 1989. *Athenian Officials, 684–321 B.C.* Cambridge.

DeVries, K. 1994. "The Diphrophoroi on the Parthenon Frieze," *AJA* 98, 323 (abstract).

Diamant, S. 1982. "Theseus and the Unification of Athens," in *Studies in Attic Epigraphy, History, and Topography Presented to Eugene Vanderpool*. Hesperia Supplement 19, 38–50. Princeton.

Diamant, S. 1988. "Mycenaean Origins: Infiltration from the North?" in E. B. French and K. A. Wardle, eds., *Problems in Greek Prehistory*. Bristol. 153–9.

Dickins, G. 1912. *Catalogue of the Acropolis Museum*. Vol. 1. Cambridge.

Dickinson, O. 1977. *The Origins of Mycenaean Civilisation*. Göteborg.

Dickinson, O. 1994. *The Aegean Bronze Age*. Cambridge.

Dinsmoor, W. B. 1913. "Attic Building Accounts, I: The Parthenon," *AJA* 17, 53–80.

Dinsmoor, W. B. 1921. "Attic Building Accounts, IV: The Statue of Athena Promachos," *AJA* 25, 118–29.

Dinsmoor, W. B. 1932. "The Burning of the Opisthodomus at Athens," *AJA* 36, 143–72, 307–26.

Dinsmoor, W. B. 1934. "The Date of the Older Parthenon," *AJA* 38, 408–48.

Dinsmoor, W. B. 1947. "The Hekatompedon on the Athenian Acropolis," *AJA* 51, 109–51.

Dinsmoor, W. B. 1950. *The Architecture of Ancient Greece*. London.

Dinsmoor, W. B. 1967–68. "Two Monuments on the Athenian Acropolis," in *Charisterion eis A. K. Orlandon*, vol. 4. Athens. 145–55.

Dinsmoor, W. B., Jr., 1980. *The Propylaia to the Athenian Akropolis, Volume I: The Predecessors*. Princeton.

Dix, T. K., and Anderson, C. A. 1997. "The Eteocarpathian Decree (*IG* I^3 1454) and the Construction Date of the Erechtheion," *AJA* 101, 373 (abstract).

Djordjevitch, M. 1994. "Pheidias' Athena Promachos Reconsidered," *AJA* 98, 323 (abstract).

D'Ooge, M. L. 1908. *The Acropolis of Athens*. New York.

Donohue, A. A. 1988. *Xoana and the Origins of Greek Sculpture*. Atlanta.

Dontas, G. 1983. "The True Aglaurion," *Hesperia* 52, 48–63.

Dontas, G. 1989. "Ein verkanntes Meisterwerk in Nationalmuseum von Athen. Der Marmorkopf G 177 und Überlegungen zum Stil Euphranors," in H.-U. Cain, H. Gabelmann, and D. Salzmann, eds., *Festschrift für Nikolaus Himmelmann*. Mainz. 143–50.

Dowden, K. 1992. *The Uses of Greek Mythology*. London and New York.

Downey, C. 1997. "The Chalkotheke on the Athenian Acropolis: Form and Function Reconsidered," *AJA* 101, 372–3 (abstract).

Drews, R. 1983. *Basileus: The Evidence for Kingship in Geometric Greece*. New Haven and London.

Drews, R. 1988. *The Coming of the Greeks*. Princeton.

Drews, R. 1993. *The End of the Bronze Age*. Princeton.

Eaverly, M. A. 1995. *Archaic Greek Equestrian Sculpture*. Ann Arbor.

Economakis, R., ed. 1994. *Acropolis Restoration: The CCAM Interventions*. London.

Edmonson, C. 1968. "Brauronian Artemis in Athens," *AJA* 72, 164–5 (abstract).

Eiteljorg, H., II. 1995. *The Entrance to the Athenian Acropolis before Mnesikles*. Boston.

Elderkin, G. W. 1940. "Aphrodite and Athena in the *Lysistrata* of Aristophanes," *CP* 35, 387–96.

Fantham, E., Foley, H. P., Kampen, N. B., Pomeroy, S. B., Shapiro, H. A. 1994. *Women in the Classical World*. New York and Oxford.

Faraone, C. A. 1992. *Talismans and Trojan Horses*. New York and Oxford.

Farnell, L. R. 1896–1909. *The Cults of the Greek States*. Oxford.

Fehl, P. 1961. "The Rocks on the Parthenon Frieze," *Journal of the Warburg and Courtauld Institutes* 24, 1–44.

Felten, F. 1984. *Griechische tektonische Friese archaischer und klassischer Zeit*. Waldsassen–Bayern.

Ferguson, W. S. 1911. *Hellenistic Athens*. London.

Fornara, C. W. 1977. *Archaic Times to the End of the Peloponnesian War*. Baltimore and London.

Fowden, G. 1990. "The Athenian Agora and the Progress of Christianity," *JRA* 3, 494–501.

Frantz, A. 1979. "Did Julian the Apostate Rebuild the Parthenon?" *AJA* 83, 395–401.

Frantz, A. 1988. *The Athenian Agora, XXIV. Late Antiquity: A.D. 267–700*. Princeton.

Frazer, J. G. 1898. *Pausanias' Description of Greece*. London.

French, A. 1987. *Sixth–Century Athens: The Sources*. Sydney.

French, A. 1991. "Economic Conditions in Fourth–Century Athens," *Greece and Rome* 38, 24–40.

Fullerton, M. B. 1996. "The Post–Herulian Wall at Athens Reconsidered," *AJA* 100, 396 (abstract).

Fullerton, M. D. 1986. "The Location and Archaism of the Hekate Epipyrgidia," *AA* 1986, 669–75.

Galinsky, K. 1996. *Augustan Culture: An Interpretive Introduction*. Princeton.

Gantz, T. 1993. *Early Greek Myth: A Guide to Literary and Artistic Sources*. Baltimore and London.

Gardner, E. A. 1902. *Ancient Athens*. New York.

Garland, R. 1990. *The Greek Way of Life*. Ithaca.

Gauer, W. 1984. "Was geschieht mit dem Peplos?" in Berger 1984, 22029.

Gaugler, W. M., and Hamill, P. 1989. "Possible Effects of Open Pools of Oil and Water on Chryselephantine Statues," *AJA* 93, 251 (abstract).

Geagan, D. J. 1979. "Roman Athens: Some Aspects of Life and Culture I: 86 B.C.–A.D. 267," *ANRW* II.7.1, 371–437.

Glowacki, K. T. 1991. *Topics Concerning the North Slope of the Akropolis at Athens*. Diss. Bryn Mawr 1991. Ann Arbor, UMI.

Glowacki, K. T. 1995. "A New Fragment of the Erechtheion Frieze," *Hesperia* 64, 325–31.

Goldhill, S. 1987. "The Great Dionysia and Civic Ideology," *JHS* 107, 58–76.

Gomme, A. W. 1933. *The Population of Athens in the Fifth and Fourth Centuries B.C.* Oxford.

Gournelos, T., and Maroukian, H. 1990. "Geomorphological Observations Concerning the Evolution of the Basin of Athens," *Geologica Balcanica* 20, 15–24.

Graef, B., and Langlotz, E. 1909. *Die Antiken Vasen von der Akropolis zu Athen*, I. Berlin.

Graindor, P. 1927. *Athènes sous Auguste*. Cairo.

Graindor, P. 1931. *Athènes de Tibère à Trajan*. Cairo.

Graindor, P. 1934. *Athènes sous Hadrien*. Cairo.

Green, J. R. 1961. "The Caputi Hydria," *JHS* 81, 73–5.

Green, P. 1973. *Ancient Greece: An Illustrated History*. London.

Green, P. 1991. *Alexander of Macedon, 356–323 B.C.* Berkeley, Los Angeles, and Oxford.

Guthrie, W. K. C. 1955. *The Greeks and Their Gods*. Boston.

Habicht, C. 1985. *Pausanias' Guide to Ancient Greece*. Berkeley.

Habicht, C. 1990. "Athens and the Attalids in the Second Century B.C.," *Hesperia* 59, 561–77.

Habicht, C. 1997. *Athens from Alexander to Antony*. Cambridge, Mass., and London.

Hall, E. 1993. "Asia Unmanned: Images of Victory in Classical Athens," in J. Rich and G. Shipley, eds., *War and Society in the Greek World*. London and New York. 108–33.

Hamdorf, F. 1980. "Zur Weihung des Chairedemos auf der Akropolis von Athen," in *STELE: Tomos eis mnemen N. Kontoleontos*. Athens. 231–235.

Hamilton, R. 1996. "Panathenaic Amphoras: The Other Side," in Neils 1996a. 137–62.

Hansen, H. D. 1937. "The Prehistoric Pottery on the North Slope of the Acropolis, 1937," *Hesperia* 6, 539–70.

Hansen, M. H. 1982. "The Number of Athenian Citizens, 451–309 B.C.," *American Journal of Ancient History* 7, 172–189.

Harding, A. 1984. *The Mycenaeans and Europe*. London.

Harris, D. 1988. "Nikokrates of Kolonos, Metalworker to the Parthenon Treasures," *Hesperia* 57, 329–37.

Harris, D. 1991. *The Inventory Lists of the Parthenon Treasures*. Diss. Princeton U. 1991. Ann Arbor: UMI.

Harris, D. 1992. "Bronze Statues on the Athenian Acropolis," *AJA* 96, 637–52.

Harris, D. 1993. "Greek Sanctuaries, Forgotten Dedicants: Women, Children, and Foreigners in the Parthenon, Erechtheion, and Asklepieion," *AJA* 97, 337 (abstract).

Harris, D. 1994. "Freedom of Information and Accountability: The Inventory Lists of the Parthenon," in Osborne and Hornblower 1994, 213–25

Harris, D. 1995. *The Treasures of the Parthenon and Erechtheion*. Oxford.

Harris, W. V. 1989. *Ancient Literacy*. Cambridge, Mass.

Harrison, E. B. 1972. "The South Frieze of the Nike Temple and the Marathon Painting in the Stoa," *AJA* 76, 353–78.

Harrison, E. B. 1979. "Apollo's Cloak," in G. Kopcke and M. B. Moore, eds., *Studies in Classical Art and Archaeology: A Trib-*

ute to Peter Heinrich von Blanckenhagen. Locust Valley, N.Y. 91–8.

Harrison, E. B. 1981. "The Motifs of the City-Siege on the Shield of the Athena Parthenos," *AJA* 85, 281–317.

Harrison, E. B. 1984. "Time in the Parthenon Frieze," in Berger 1984, 230–4.

Harrison, E. B. 1986. "The Classical High-Relief Frieze from the Athenian Agora," in Kyrieleis 1986, vol II. 109–17.

Harrison, E. B. 1988. "Lemnia and Lemnos: Sidelights on a Pheidian Athena," in M. Schmidt, ed., *KANON: Festschrift Ernst Berger*. Basel. 101–7.

Harrison, E. B. 1996a. "Pheidias," in Palagia and Pollitt 1996, 16–65.

Harrison, E. B. 1996b. "The Web of History: A Conservative Reading of the Parthenon Frieze," in Neils 1996a, 198–214.

Harrison, E. B. 1997. "The Glories of the Athenians: Observations on the Program of the Frieze of the Temple of Athena Nike," in Buitron-Oliver 1997, 109–25.

Harrison, J. 1900. "Pandora's Box," *JHS* 20, 99–144.

Harrison, J. 1962. *Epilegomena to the Study of Greek Religion and Themis*. New Hyde Park, N. Y.

Hartswick, K. J. 1983. "The Athena Lemnia Reconsidered," *AJA* 87, 335–46.

Hedrick, C. 1994. "Writing, Reading, and Democracy," in Osborne and Hornblower 1994, 157–74.

Hellström, P. 1988. "The Planned Function of the Mnesiklean Propylaia," *OpAth* 17, 107–21.

Herington, C. J. 1955. *Athena Parthenos and Athena Polias: A Study in the Religion of Periklean Athens*. Manchester.

Herington, C. J. 1963. "Athena in Athenian Literature and Cult," in G. T. W. Hooker, *Parthenos and Parthenon*. Greece and Rome Supplement 10. Oxford. 61–73.

Heubeck, A., West, S., and Hainsworth, J. B. 1988. *A Commentary on Homer's Odyssey*, Vol. I. Oxford.

Higgins, M. D., and Higgins, R. 1996. *A Geological Companion to Greece and the Aegean*. Ithaca.

Higgins, R. 1986. *Tanagra and the Figurines*. Princeton.

Hill, B. H. 1912. "The Older Parthenon," *AJA* 16, 535–8.

Hill, I. T. 1953. *The Ancient City of Athens*. London.

Himmelmann, N. 1977. "Phidias und die Parthenon–Skulpturen," in *Bonner Festgabe Johannes Straub*, Bonn 67–90.

Hitchens, C. 1987. *The Elgin Marbles*. London.

Höckmann, U. 1991. "Zeus besiegt Typhon," *AA* 1991, 11–23.

Hoff, M. C. 1989. "Civil Disobedience and Unrest in Augustan Athens," *Hesperia* 58, 267–76.

Hoff, M. C. 1994, "The So-called Agoranomion and the Imperial Cult in Julio-Claudian Athens," *AA* 1994, 93–117.

Hoff, M. C. 1996. "The Politics and Architecture of the Athenian Imperial Cult," in A. Small. ed., *Subject and Ruler: The Cult of the Ruling Power in Classical Antiquity*. JRA Supplement 17. 185–200

Holland, L. B. 1924. "Erechtheum Papers, I, II, III," *AJA* 28, 1–23, 142–69, 402–25.

Holland, L. B. 1939. "The Hall of the Athenian Kings," *AJA* 43, 289–28.

Holloway, R. R. 1966. "The Archaic Acropolis and the Parthenon Frieze," *Art Bulletin* 48, 223–6.

Holloway, R. R. 1973. *A View of Greek Art*. New York.

Holloway, R. R. 1992. "Why Korai?" *OJA* 11, 267–74.

Hölscher, T. 1973. *Griechische Historienbilder des 5. und 4. Jahrhunderts vor Chr.* Würzburg.

Hölscher, T. 1991. "The City of Athens: Space, Symbol, Structure," in A. Molho, K. Raaflaub, and J. Emlen, eds., *City States in Classical Antiquity and Medieval Italy*. Ann Arbor. 355–80.

Hood, S. 1978. *The Arts in Prehistoric Greece*. Harmondsworth.

Hooker, J. T. 1976. *Mycenaean Greece*. London, Henley, and Boston.

Hopper, R. 1971. *The Acropolis*. London.

Hornblower, S. 1991. *A Commentary on Thucydides. Vol. I (Books I–III)*. Oxford.

Hose, M. 1993. "Kratinos und der Bau des Perikleischen Odeions," *Philologus* 137, 3–11.

Houser, C. 1982. "Alexander's Influence on Greek Sculpture as Seen in a Portrait in Athens," in B. Barr-Sharrar and E. N. Borza, eds., *Studies in the History of Art, 10*. National Gallery of Art, Washington. 229–38.

Hurwit, J. M. 1985. *The Art and Culture of Early Greece, 1100–480 B.C.* Ithaca.

Hurwit, J. M. 1989. "The Kritios Boy: Discovery, Reconstruction, and Date," *AJA* 93, 41–80.

Hurwit, J. M. 1995. "Beautiful Evil: Pandora and the Athena Parthenos," *AJA* 99, 171–86.

Iakovidis, S. 1969. *Perati: To Nekrotapheion, i–iii*. Athens.

Iakovidis, S. 1980. *Excavations of the Necropolis at Perati*. Occasional Paper 8, Institute of Archaeology. Los Angeles.

Iakovidis, S. E. 1983. *Late Helladic Citadels on Mainland Greece*. Leiden.

Imhoof-Blumer, F., Gardner, P., and Oikonomides, A. N., 1964. *Ancient Coins Illustrating Lost Masterpieces of Greek Art*. Chicago.

Immerwahr, S. A. 1971. *The Athenian Agora, XIII: The Neolithic and Bronze Ages*. Princeton.

Immerwahr, S. A. 1982. "The Earliest Athenian Grave," in *Studies in Athenian Architecture and Topography Presented to Homer A. Thompson*. Hesperia Supplement 20. Princeton. 54–62.

Jacobshagen, V., ed. 1986. *Geologie von Griechenland*. Berlin.

Jacoby, F. 1904. *Das Marmor Parium*. Berlin.

Jacoby, F. 1926. *Die Fragmente der Griechischen Historiker*, II. Berlin.

Jameson, M. 1994. "The Ritual of the Athena Nike Parapet," in Osborne and Hornblower 1994, 307–24.

Jeffery, L. H. 1980. "Lykios Son of Myron: The Epigraphic Evidence," in *STELE: Tomos eis mnemen N. Kontoleontos*. Athens. 51–4.

Jeffery, L. H. 1990. *The Local Scripts of Archaic Greece*. Revised ed. with a Supplement by A. W. Johnston. Oxford.

Jenkins, I. 1985. "The Composition of the so–called Eponymous Heroes on the East Frieze of the Parthenon," *AJA* 89, 121–27.

Jenkins, I. 1994. *The Parthenon Frieze*. Austin.

Jenkins, R. J. H. 1936. *Dedalica*. Cambridge.

Jenkins, R. J. H. 1947. "The Bronze Athena at Byzantium," *JHS* 67, 31–3.

Jeppesen, K. 1987. *The Theory of the Alternative Erechtheion*. Aarhus.

Johnston, A. W. 1987. "IG II² 2311 and the Number of Panathenaic Amphorae," *BSA* 82, 125–9.

Jordan, B. 1979. *Servants of the Gods: A Study in the Religion, History, and Literature of Fifth-Century Athens*. Hypomnemata 55. Göttingen.

Judeich, W. 1931. *Topographie von Athen*. Munich.

Jung, H. 1982. *Thronende und sitzende Götter*. Berlin.

Jung, H. 1995. "Die sinnende Athena," *JdI* 110, 95–147.

Just, R. 1989. *Women in Athenian Law and Life*. London and New York.

Kadletz, E. 1982. "Pausanias 1.27.3 and the Route of the Arrhephoroi," *AJA* 86, 445–6.

Kahil, L. 1981. "Le 'cratérisque' d'Artemis et le Brauronion de l'Acropole," *Hesperia* 50, 253–63.

Kallet-Marx, L. 1989. "Did Tribute Fund the Parthenon?" *ClAnt* 8, 252–66.

Kalligas, P. G. 1994. "*He Periokhe tou Hierou kai tou Theatrou tou Dionysou sten Athena*," in Coulson et al. 1994, 25–30.

Kardara, Ch. 1961. "*Glaukopis–Ho Arkhaios Naos kai to Thema tes Zophorou tou Parthenonos*," *AE* 1961, 61–158.

Kavvadias, P., and Kawerau, G. 1906. *Die Ausgrabung der Akropolis vom Jahre 1885 bis zum Jahre 1890*. Athens.

Kehrberg, I. 1982. "The Potter-Painter's Wife," *Hephaistos* 4, 25–35.

Kiilerich, B. 1988. "Bluebeard – A Snake-Tailed Geryon?" *OpAth* 17, 123–36.

Kiilerich, B. 1989. "The Olive-Tree Pediment and the Daughters of Kekrops," *Acta ad Archaeologiam et Artium Historiam Pertinentia* 7, 1–21.

Kilian, K. 1985. "Civiltà micenea in Grecia: nuovi aspetti storici ed interculturali," in *Magna Grecia e Mondo Miceneo*. Taranto 1983–85. 53–96.

Kilian, K. 1988. "Mycenaeans Up to Date," in E. B. French and K. A. Wardle, eds., *Problems in Greek Prehistory*. Bristol. 115–52.

Kirk, G. S. 1985. *The Iliad: A Commentary*, Vol. I (Books 1–4). Cambridge.

Klein, N. L. 1991a. "A Reconstruction of the Small Poros Buildings on the Athenian Acropolis," *AJA* 95, 335 (abstract).

Klein, N. L. 1991b. *The Origin of the Doric Order on the Mainland of Greece: Form and Function of the Geison in the Archaic Period*. Diss. Bryn Mawr 1991. Ann Arbor: UMI.

Knox, B. 1995. "Author, Author," *New York Review of Books* 42.18, 16–20.

Kolb, F. 1977. "Die Bau-, Religions- und Kulturpolitik der Peisistratiden," *JdI* 92, 99–138.

Korres, M. 1980. "*A Ephoreia Proistorikon kai Klasikon Arkhaioteton Akropoleos*," *AD* 35 B' (1988), 9–21.

Korres, M. 1984. "Der Pronaos und die Fenster des Parthenon," in Berger 1984, 47–54.

Korres, M. 1988. "Acropole: Travaux de restauration," *BCH* 112, 612.

Korres, M. 1994a. "The Sculptural Adornment of the Parthenon," in Economakis 1994, 29–33.

Korres, M. 1994b. "The History of the Acropolis Monuments," in Economakis 1994, 35–51.

Korres, M. 1994c. "Recent Discoveries on the Acropolis," in Economakis 1994. 175–9.

Korres, M. 1994d. "The Architecture of the Parthenon," in Tournikiotis 1994. 55–97.

Korres, M. 1994e. "The Parthenon from Antiquity to the 19th Century," in Tournikiotis 1994. 137–161.

Korres, M. 1994f. *Melete Apokatastaseos tou Parthenonos*, 4. Athens.

Korres, M. 1994g. "Der Plan des Parthenon," *AM* 109, 53–120.

Korres, M. 1995. *From Pentelicon to the Parthenon*. Athens.

Korres, M., and Bouras, Ch. 1983. *Melete Apokatastaseos tou Parthenonos*, 1. Athens.

Krentz, P. 1979. "*SEG* XXI, 80 and the Rule of the Thirty," *Hesperia* 48, 54–63.

Kroll, J. H. 1979. "The Parthenon Frieze as a Votive Relief," *AJA* 83, 349–52.

Kroll, J. H. 1982. "The Ancient Image of Athena Polias," in *Studies in Athenian Architecture, Sculpture, and Topography Presented to Homer A. Thompson*. Hesperia Supplement 20. Princeton. 65–76.

Kron, U. 1976. *Die zehn attischen Phylenheroen* (*AM Beiheft* 5). Berlin.

Kron, U. 1988. "Erechtheus," in *LIMC* IV, 923–51.

Künzl, E. 1971. *Die Kelten des Epigonos von Pergamon*. Würzburg.

Kurtz, D. C. ed. 1989. *Greek Vases: Lectures by J. D. Beazley*. Oxford.

Kyle, D. G. 1987. *Athletics in Ancient Athens*. Leiden.

Kyle, D. G. 1992. "The Panathenaic Games: Sacred and Civic Athletics," in Neils 1992, 77–101.

Kyrieleis, H., ed., 1986. *Archaische und Klassische griechische Plastik*. Mainz.

La Follette, L. 1986. "The Chalkotheke on the Athenian Acropolis," *Hesperia* 55, 75–87.

Langdon, S. 1987. "Gift Exchange in the Geometric Sanctuaries," in *Gifts to the Gods: Boreas* 15, 107–13.

Larson, J. 1995. *Greek Heroine Cults*. Madison, Wis. and London.

Lawrence, A. W. 1951. "The Acropolis and Persepolis," *JHS* 71, 111–19.

Lawrence, A. W. 1996. *Greek Architecture*. Fifth ed., revised by R. A. Tomlinson. New Haven and London.

Lawton, C. L. 1995. *Attic Document Reliefs: Art and Politics in Ancient Athens*. Oxford.

Lee, M. M. 1996. "The Findspots of the Korai from the Acropolis at Athens," *AJA* 100, 395 (abstract).

Lefkowitz, M. R., and Fant, M.B. 1992. *Women's Life in Greece and Rome*, Second ed. Baltimore.

Leipen, N. 1971. *Athena Parthenos: A Reconstruction*. Toronto.

Lepsius, R. 1893. *Geologie von Attika*. Berlin.

Levi, D. 1930–31. "Abitazioni preistorische sulle pendici meridionale dell'acropoli," *ASAthene* 13–14, 411–98.

Lewis, D. 1954. "Notes on Attic Inscriptions," *BSA* 49, 17–50.

Linders, T. 1972. *Studies in the Treasure Records of Artemis Brauronia in Athens*. Stockholm.

Linders, T. 1987. "Gods, gifts, society," in T. Linders and G. Nordquist, eds., *Gifts to the Gods*. Uppsala. 115–27.

Loewy, E. 1885. *Inschriften griechischer Bildhauer*. Leipzig.

Loraux, N. 1986. *The Invention of Athens*. Cambridge, Mass.

Loraux, N. 1993. *The Children of Athena*. Princeton.

Mackenzie, M. 1992. *Turkish Athens: The Forgotten Centuries, 1456–1832*. Reading.

Mallouchou–Tufano, F. 1994. "The History of Interventions on the Acropolis," in Economakis 1994, 69–85.

Manning, S. W. 1995. *The Absolute Chronology of the Aegean Early Bronze Age: Archaeology, Radiocarbon, and History*. Sheffield.

Mansfield, J. M. 1985. *The Robe of Athena and the Panatheniac "Peplos"*. Diss. University of California at Berkeley. 1985. Ann Arbor: UMI.

Mantis, A. 1986. "Neue Fragmente von Parthenonskulpturen," in Kyrieleis 1986, vol. II, 71–76.

Mantis, A. 1989. "Beiträge zur Wiederherstellung der mittleren Südmetopen des Parthenon," in H.–U. Cain, H. Gabelmann, and D. Salzmann, eds., *Festschrift für Nikolaus Himmelmann*. Mainz. 109–14.

Mantis, A. 1994. "A Contribution to the Restoration of the Relief Acropolis Museum 120" (in Greek), *AD* 42 (1987), 30–34.

Mantis, A. 1997. "Parthenon Central South Metopes: New Evidence," in Buitron–Oliver 1997, 67–81.

Manville, P. B. 1990. *The Origins of Citizenship in Ancient Athens*. Princeton.

Maran, J. 1992. *Kiapha Thiti: Ergebnisse der Ausgrabungen II.2: 2. Jt. v. Chr.: Keramik und Kleinfunde*. Marburger Winckelmann–Programm 1990. Marburg.

Marinatos, N., and Hägg, R., eds. 1993. *Greek Sanctuaries: New Approaches*. London and New York.

Mark, I. S. 1984. "The Gods on the East Frieze of the Parthenon," *Hesperia* 53, 289–342.

Mark, I. S. 1993. *The Sanctuary of Athena Nike in Athens: Architectural Stages and Chronology*. Hesperia Supplement 26. Princeton.

Marszal, J. R. 1988. "An Architectural Function for the Lyons Kore," *Hesperia* 57, 203–6.

Marszal, J. R. 1997. "The Sculptural Program of the Old Athena Temple at Athens," *AJA* 101, 346 (abstract).

Mattingly, H. B. 1993. "New Light on the Athenian Standards Decree (*ATL* II, D14)," *Klio* 75 , 99–102.

Mattusch, C. C. 1988. *Greek Bronze Statuary*. Ithaca and London.

Mattusch, C. C. 1996. *Classical Bronzes: The Art and Craft of Greek and Roman Statuary*. Ithaca and London.

Mavrikios, A. 1965. "Aesthetic Analysis Concerning the Curvature of the Parthenon," *AJA* 69, 264–8.

May, L. A. 1984. "Above Her Sex: The Enigma of the Athena Parthenos," *Visible Religion* 3, 106–23.

Mayer, M. 1989. "Zur 'sinnerden' Athena," in H.-U. Cain, H. Gabelmann, and D. Salzmann, eds., *Festschrift für N. Himmelmann*. Mainz. 161–8.

Mayer, M. 1892. "Mykenische Beiträge I," *JdI* 7, 80–81.

Mazarakis-Ainians, A. J. 1988. "Early Greek Temples: Their Origin and Function," in R. Hägg, N. Marinatos, and G. C. Nordquist, eds., *Early Greek Cult Practice*. Stockholm. 105–19.

McCredie, J. R. 1979. "The Architects of the Parthenon," in G. Kopcke and M. B. Moore, eds., *Studies in Classical Art and Archaeology: A Tribute to P. H. von Blanckenhagen*. Locust Valley, N.Y. 69–73.

McNeal, R. A. 1991. "Archaeology and the Destruction of the Later Athenian Acropolis," *Antiquity* 65, 49–63.

McPhee, J. 1992. "Annals of the Former World," *The New Yorker* (Sept. 14), 70–71.

Meiggs, R. 1975. *The Athenian Empire*. Oxford.

Meiggs, R., and Lewis, D. 1988. *A Selection of Greek Historical Inscriptions to the End of the Fifth Century B.C.* Revised ed. Oxford.

Meritt, B. D. 1936. "Greek Inscriptions," *Hesperia* 5, 355–441.

Meritt, B. D. 1982. "Thucydides and the Decrees of Kallias," in *Studies in Attic Epigraphy, History and Topography*. Hesperia: Supplement 19. Princeton. 112–121.

Mikalson, J. D. 1975. *The Sacred and Civil Calendar of the Athenian Year*. Princeton.

Mikalson, J. D. 1976. "Erechtheus and the Panathenaia," *AJP* 97, 141–53.

Mikalson, J. D. 1983. *Athenian Popular Religion*. Chapel Hill and London.

Miller, M. C. 1997. *Athens and Persia in the Fifth Century B. C.* Cambridge and New York.

Miller, S. G. 1995. "Architecture as Evidence for the Identity of the Early *Polis*," in M. G. Hansen, ed., *Sources for the Ancient Greek City–State*. Copenhagen. 201–42.

Mitchel, F. W. 1973. "Lykourgan Athens, 338–322," in C. G. Boulter et al., eds., *Lectures in Memory of Louise Taft Semple: Second Series*. Cincinnati. 163–214.

Moore, M. B. 1979. "Lydos and the Gigantomachy," *AJA* 83, 79–100.

Moore, M. B. 1995. "The Central Group in the Gigantomachy of the Old Athena Temple on the Acropolis," *AJA* 99, 633–9.

Morizot, Y. 1993. "Un Ours ou deux pour Artemis, une Sculp-

ture de l'Acropole d'Athènes reconsidérée, une figurine en terre cuite de Thasos," *REA* 95, 29–44.

Morris, I. 1987. *Burial and Ancient Society*. Cambridge.

Morris, S. P. 1984. *The Black and White Style: Athens and Aegina in the Orientalizing Period*. New Haven and London.

Mountjoy, P. A. 1981. *Four Early Mycenaean Wells from the South Slope of the Acropolis at Athens*. Miscellanea Graeca 4. Gent.

Mountjoy, P. A. 1984. "The Bronze Greaves from Athens: A Case for a LH IIIC Date," *OpAth* 15, 135–146.

Mountjoy, P. A. 1988. "LH IIIC Late versus Submycenaean," *JdI* 103, 1–33.

Mountjoy, P. A. 1995. *Mycenaean Athens*. Jonsered.

Muhly, J. D. 1992. "The Crisis Years in the Mediterranean World: Transition or Cultural Disintegration?" in W. A. Ward and M. Joukowsky, eds., *The Crisis Years: The 12th Century B.C.*. Dubuque, Ia. 10–26.

Mylonas, G. E. 1966. *Mycenae and the Mycenaean Age*. Princeton.

Mylonas, G. 1983. *Mycenae Rich in Gold*. Athens.

Nagy, B. 1992. "Athenian Officials on the Parthenon Frieze," *AJA* 96, 55–69.

Neils, J., ed. 1992. *Goddess and Polis: The Panathenaic Festival in Ancient Athens*. Hanover and Princeton.

Neils, J. 1994. "The Panathenaia and Kleisthenic Ideology," in Coulson et al. 1994, 151–60.

Neils, J., ed. 1996a. *Worshipping Athena: Panathenaia and Parthenon*. Madison, Wis.

Neils, J. 1996b. "Pride, Pomp, and Circumstance: The Iconography of the Procession," in Neils 1996a. 177–97.

Németh, G. 1993. "Übersetzung und Datierung der Hekatompedon-Inschrift," *JdI* 108, 76–81.

Nylander, C. 1962. "Die sog. mykenischen Säulenbasen auf der Akropolis in Athen, *OpAth* 4, 31–77.

Oliver, J. H. 1965. "Livia as Artemis Boulaia at Athens," *CP* 60, 179.

Omont, H. 1898. *Athènes au XVIIe siècle*. Paris.

Onians, J. 1979. *Art and Thought in the Hellenistic Age*. London.

Osborne, R. 1987. "The Viewing and Obscuring of the Parthenon Frieze," *JHS* 107, 98–105.

Osborne, R. 1989. "A Crisis in Archaeological History? The Seventh Century B. C. in Attica," *BSA* 84, 297–322.

Osborne, R. 1994. "Archaeology, the Salaminioi, and the Politics of Sacred Space in Archaic Attica," in S. E. Alcock and R. Osborne, eds., *Placing the Gods: Sanctuaries and Sacred Space in Ancient Greece*. Oxford. 143–60.

Osborne, R., and Hornblower, S., eds. 1994. *Ritual, Finance, Politics: Athenian Democratic Accounts Presented to David Lewis*. Oxford.

Palagia, O. 1984. "A Niche for Kallimachos' Lamp?" *AJA* 88, 515–21.

Palagia, O. 1987. "In Defense of Furtwängler's Athena Lemnia," *AJA* 91, 81–84.

Palagia, O. 1990. "A New Relief of the Graces and the *Charites* of Socrates," in M. Geerard, ed., *Opes Atticae*. The Hague. 347–56.

Palagia, O. 1993. *The Pediments of the Parthenon*. Leiden.

Palagia, O. 1995. "Akropolis Museum 581: A Family at the Apaturia?" *Hesperia* 64, 493–501.

Palagia, O. 1997. "First Among Equals: Athena in the East Pediment of the Parthenon," in Buitron–Oliver, 1997, 29–49.

Palagia, O., and Bianchi, R. S. 1994. "Who Invented the Claw Chisel?" *OJA* 13, 185–97.

Palagia, O. and Pollitt, J. J. eds., 1996. *Personal Styles in Greek Sculpture*. Yale Classical Studies 30. Cambridge.

Panofsky, D. and E. 1962. *Pandora's Box: The Changing Aspects of a Mythical Symbol*. New York.

Pantelidou, M. 1975. *Ai Proistorikai Athenai*. Athens.

Papanikolaou, A. 1994. "The Restoration of the Erechtheion," in Economakis 1994, 137–49.

Pariente, A. 1993. "Chronique des Fouilles en 1992," *BCH* 117, 764–66.

Pariente, A. 1994. "Chronique des Fouilles en 1993," *BCH* 118, 698–700.

Parke, H. W. 1967. *Greek Oracles*. London.

Parke, H. W. 1977. *Festivals of the Athenians*. Ithaca, N.Y.

Parker, R. 1986. "Myths of Early Athens," in J. Bremmer, ed., *Interpretations of Greek Mythology*. Totowa, N. J., 187–214.

Parker, R. 1996. *Athenian Religion: A History*. Oxford.

Paton, J. M., ed. 1927. *The Erechtheum*. Cambridge.

Payne, H., and Young, G. M. 1950. *Archaic Marble Sculpture from the Acropolis*, Second ed. London.

Pedersen, P. 1989. *The Parthenon and the Origin of the Corinthian Capital*. Odense.

Pelon, O. 1976. *Tholoi, Tumuli, et cercles funéraires*. Paris.

Peppas–Delmousou, D. 1971. "Das Akropolis-Epigramm *IG* I² 673," *AM* 86, 55–66.

Pickard–Cambridge, A. 1968. *The Dramatic Festivals of Athens*. Second ed. Oxford.

Pinney, G. F. 1988. "Pallas and Panathenaea," in J. Christiansen and T. Melander, eds., *Proceedings of the Third Symposium on Ancient Greek and Related Pottery*. Copenhagen. 465–77.

Plommer, H. 1960. "The Archaic Acropolis: Some Problems," *JHS* 35, 127–59.

Pollitt, J. J. 1972. *Art and Experience in Classical Greece*. Cambridge.

Pollitt, J. J. 1986. *Art in the Hellenistic Age*. Cambridge.

Pollitt, J. J. 1990a. *The Art of Ancient Greece: Sources and Documents*. Cambridge.

Pollitt, J. J. 1990b. "The Meaning of Pheidias' Athena Parthenos," in B. Tsakirgis and S. F. Wiltshire, eds., *The Nashville Athena: A Symposium, 21 May 1990*. Nashville. 21–23.

Pollitt, J. J. 1997. "The Meaning of the Parthenon Frieze," in Buitron-Oliver 1997. 51–65.

Preisshofen, F. 1974. "Phidias–Daedalus auf dem Schild der Athena Parthenos?" *JdI* 89, 50–69.

Preisshofen, F. 1977. "Zur Topographie der Akropolis," *AA* (*JdI* 92), 74–84.

Price, M. J., and Trell, B. L. 1977. *Coins and their Cities*. London and Detroit.

Pucci, P. 1977. *Hesiod and the Language of Poetry*. Baltimore and London.

Raubitschek, A. E. 1949. *Dedications from the Athenian Acropolis*. Cambridge, Mass.

Ray, J. D. 1990. "An Egyptian Perspective," *Journal of Mediterranean Archaeology* 3, 77–81.

Reeder, E. D., ed. 1995. *Pandora: Women in Classical Greece*. Baltimore.

Rehak, P. 1984, "New Observations on the Mycenaean Warrior Goddess," *AA*, 535–45.

Renfrew, C. 1988. *Archaeology and Language: The Puzzle of Indo-European Origins*. New York.

Rhodes, R. F. 1995. *Architecture and Meaning on the Athenian Acropolis*. Cambridge.

Rhodes, R. F., and Dobbins, J. J. 1979. "The Sanctuary of Artemis Brauronia on the Athenian Acropolis," *Hesperia* 48, 325–41.

Richardson, L., Jr. 1992. *A New Topographical Dictionary of Ancient Rome*. Baltimore and London.

Richter, G. M. A. 1984. *The Portraits of the Greeks*. Abridged and revised by R. R. R. Smith. Ithaca, N.Y.

Ridgway, B. S. 1970. *The Severe Style in Greek Sculpture*. Princeton.

Ridgway, B. S. 1981. *Fifth Century Styles in Greek Sculpture*. Princeton.

Ridgway, B. S. 1983. "Painterly and Pictorial in Greek Relief Sculpture," in W. Moon, ed., *Ancient Greek Art and Iconography*. Madison and London. 193–208.

Ridgway, B. S. 1990a. "Birds, 'Meniskoi,' and Head Attributes in Archaic Greece," *AJA* 94, 583–612.

Ridgway, B. S. 1990b. *Hellenistic Sculpture I: The Styles of ca. 331–200 B.C.* Madison.

Ridgway, B. S. 1992. "Images of Athena on the Akropolis," in Neils 1992, 119–42.

Ridgway, B. S. 1993. *The Archaic Style in Greek Sculpture*. Second ed. Chicago.

Roberts, J. W. 1984. *The City of Sokrates*. London and Boston.

Robertson, M. 1975. *A History of Greek Art*. Cambridge.

Robertson, M. 1984. "The South Metopes: Theseus and Daidalos," in Berger 1984. 206–8.

Robertson, M. 1992. *The Art of Vase-Painting in Classical Athens*. Cambridge.

Robertson, M., and Frantz, A. 1975. *The Parthenon Frieze*. New York.

Robertson, N. 1985. "The Origin of the Panathenaia," *Rheinisches Museum für Philologie* 128, 231–95.

Robertson, N. 1986. "Solon's Axones and Kyrbeis, and the Sixth-Century Background," *Historia* 35, 147–76.

Robertson, N. 1992. *Festivals and Legends: The Formation of Greek Cities in the Light of Public Ritual*. Toronto.

Robertson, N. 1996. "Athena's Shrines and Festivals," in Neils 1996a, 27–77.

Robkin, A. L. H. 1979. "The Odeion of Perikles: The Date of its Construction and the Periklean Building Program," *Ancient World* 2, 3–12.

Roccos, L. J. 1995. "The Kanephoros and Her Festival Mantle in Greek Art," *AJA* 99, 641–66.

Rolley, C. 1986. *Greek Bronzes*. London and Fribourg.

Romano, I. B. 1988. "Early Greek Cult Images and Cult Practices," in R. Hägg, N. Marinatos, and G. C. Nordquist, eds., *Early Greek Cult Practice*. Stockholm. 127–34.

Root, M. C. 1985. "The Parthenon Frieze and the Apadana Reliefs at Persepolis," *AJA* 89, 103–20.

Rose, C. B. 1997. *Dynastic Commemoration and Imperial Portraiture in the Julio-Claudian Period*. Cambridge.

Rouse, W. H. D. 1976. *Greek Votive Offerings*. Reprint ed. Hildesheim and New York.

Roux, G. 1984. "Pourquoi le Parthénon?" *CRAI* 1984, 301–17.

Rutter, J. B. 1975. "Ceramic Evidence for Northern Intruders in Southern Greece at the Beginning of the Late Helladic III C period," *AJA* 79, 17–32.

Rutter, J. B. 1990. "Some Comments on Interpreting the Dark–surfaced Handmade Burnished Pottery of the 13th and 12th Century B.C. Aegean," *JMA* 3, 29–49.

Rutter, J. 1992. "Cultural Novelties in the Post-Palatial Aegean World: Indices of Vitality or Decline?" in W. A. Ward and M. Joukowsky, eds., *The Crisis Years: The 12th Century B.C.* Dubuque, Ia. 61–78.

Rutter, J. B. and C. W. Zerner 1984. "Early Hellado-Minoan Contacts," in R. Hagg and N. Marinatos, *The Minoan Thalassocracy: Myth and Reality*. Stockholm. 75–82.

St. Clair, W. 1983. *Lord Elgin and the Marbles*. Oxford and New York.

Samons, L. J., II, 1993. "Athenian Finance and the Treasury of Athena," *Historia* 42, 129–38.

Schmalz, G. (forthcoming). *Athens after Actium: Public Building and Civic Identity under the Early Principate (31 B.C.–A.D. 115)*. Chapel Hill.

Schneider, L., and Höcker, C. 1990. *Die Akropolis von Athen*. Köln.

Scholl, A. 1995. "Choephoroi: Zur Deutung der Korenhalle des Erechtheion," *JdI* 110, 179–212.

Schrader, H., Langlotz, E., and Schuchhardt, W.-H. 1939. *Die archaischen Marmorbildwerke der Akropolis*. Frankfurt am Main.

Schwab, K. A. 1994. "The Charioteer in Parthenon North Metopes 1," *AJA* 98, 322 (abstract)

Schwab, K. A. 1996a. "Parthenon East Metope XI: Herakles and the Gigantomachy," *AJA* 100, 81–90.

Schwab, K. A. 1996b. "The North Metopes of the Parthenon and the Palladion," *AJA* 100, 383 (abstract).

Schweitzer, B. 1971. *Greek Geometric Art*. London and New York.

Schwenk, C. J. 1985. *Athens in the Age of Alexander*. Chicago.

Scullion, S. 1994. "Olympian and Chthonian," *ClAnt* 13, 75–119.

Sealey, R. 1976. *A History of the Greek City States, 700–338 B.C.* Berkeley and Los Angeles.

Seltman, C. 1924. *Athens, Its History and Coinage before the Persian Invasion.* Cambridge.

Shapiro, H. A. 1988. "The Marathonian Bull on the Athenian Acropolis," *AJA* 92, 373–82.

Shapiro, H. A. 1989. *Art and Cult under the Tyrants in Athens.* Mainz am Rhein.

Shapiro, H. A. 1992. "*Mousikoi Agones*: Music and Poetry at the Panathenaia," in Neils 1992, 53–75.

Shapiro, H. A. 1994a. "Religion and Politics in Democratic Athens," in Coulson et. al. 1994, 123–9.

Shapiro, H. A. 1994b. *Myth into Art: Poet and Painter in Classical Greece.* London and New York.

Shapiro, H. A. 1995. "The Cult of Heroines: Kekrops' Daughters," in Reeder 1995, 39–48.

Shear, I. M. 1963. "Kallikrates," *Hesperia* 32, 375–424.

Shear, T. L., Jr. 1981. "Athens: From City–State to Provincial Town," *Hesperia* 50, 356–377.

Shear, T. L., Jr. 1993. "The Persian Destruction of Athens," *Hesperia* 62, 383–482.

Shear, T. L., Jr. 1994. "*Isonomous t'Athenas Epoiesaten*: The Agora and the Democracy," in Coulson et al., 1994. 225–48.

Shefton, B. 1982. "The Krater from Baksy," in D. Kurtz and B. Sparkes, eds., *The Eye of Greece: Studies in the Art of Athens.* Cambridge. 149–81.

Shefton, B. 1992. "The Baksy Krater Once More and Some Observations on the East Pediment of the Parthenon," in H. Froning, T. Hölscher, and H. Mielsch, eds., *Kotinos: Festschrift für Erika Simon.* Mainz. 241–51.

Simon, E. 1975. "Versuch einer Deutung der Südmetopen des Parthenon," *JdI* 90, 100–20.

Simon, E. 1980a. *Götter der Griechen.* Munich.

Simon, E. 1980b. "Die Mittelgruppe in Westgiebel des Parthenon," in H. H. Cahn and E. Simon, eds., *Tainia: Roland Hampe zum 70. Geburtstag.* Mainz, 239–55.

Simon, E. 1983. *Festivals of Attica: An Archaeological Commentary.* Madison.

Simon, E. 1986. "Boutes," in *LIMC* III, 152–3.

Simon, E. 1997. "An Interpretation of the Nike Temple Parapet," in Buitron-Oliver 1997, 127–43.

Sinn, U. 1993. "Greek Sanctuaries as Places of Refuge," in Marinatos and Hägg 1993, 88–109.

Sinos, S. 1971. *Die vorklassischen Hausformen in der Ägäis.* Mainz.

Sironen, E. 1994. "Life and Administration of Late Roman Attica in the Light of Public Inscriptions," in Castrén 1994, 15–62.

Smith, R. R. R. 1991. *Hellenistic Sculpture.* London.

Smithson, E. L. 1982. "The Prehistoric Klepsydra: Some Notes," in *Studies in Athenian Architecture and Topography Presented to Homer A. Thompson.* Hesperia Supplement 20, 141–54. Princeton.

Sourvinou–Inwood, C. 1971. "Theseus Lifting the Rock and a Cup near the Pithos Painter," *JHS* 91, 94–109.

Sourvinou–Inwood, C. 1993. "Early Sanctuaries, the Eighth Century and Ritual Space," in Marinatos and Hägg 1993, 1–17.

Spaeth, B. S. 1991. "Athenians and Eleusinians in the West Pediment of the Parthenon," *Hesperia* 60, 331–62.

Spawforth, A. 1994. "Symbol of Unity? The Persian-Wars Tradition in the Roman Empire," in S. Hornblower, ed., *Greek Historiography.* Oxford. 233–47.

Spawforth, A. J. S., and Walker, S. 1985. "The World of the Panhellenion: I. Athens and Eleusis," *JRS* 75, 78–104.

Stadter, P. A. 1989. *A Commentary on Plutarch's Pericles.* Chapel Hill and London.

Stähler, K. 1972. "Zur Rekonstruction und Datierung des Gigantomachiegiebels von der Akropolis," *Antike und Universalgeschichte* (Festschrift H. E. Stier). Münster. 88–112.

Stähler, K. 1978. "Der Zeus aus dem Gigantomachiegiebel der Akropolis?" *Boreas* 1, 28–31.

Stevens, G. P. 1936. "The Periclean Entrance Court of the Acropolis of Athens," *Hesperia* 5, 443–520.

Stevens, G. P. 1940. *The Setting of the Periclean Parthenon.* Hesperia Supplement 3. Princeton.

Stevens, G. P. 1946. "The Northeast Corner of the Parthenon," *Hesperia* 15, 1–26.

Stevens, G. P. 1955. "Remarks upon the Colossal Chryselephantine Statue of Athena in the Parthenon," *Hesperia* 24, 240–76.

Stewart, A. 1985. "History, Myth, and Allegory in the Program of the Temple of Athena Nike, Athens," in *Studies in the History of Art*, 16. National Gallery of Art, Washington. 53–73.

Stewart, A. 1990. *Greek Sculpture: An Exploration.* New Haven and London.

Stewart, A. 1993. *Faces of Power: Alexander's Image and Hellenistic Politics.* Berkeley.

Stillwell, R. 1969. "The Panathenaic Frieze: Optical Relations," *Hesperia* 38, 231–41.

Strachey, J. ed. 1953. *The Standard Edition of the Complete Works of Sigmund Freud.* London.

Strauss, B. 1996. "The Athenian Trireme, School of Democracy," in J. Ober and C. Hedrick, eds., *Demokratia.* Princeton. 313–25.

Strocka, V. M. 1967. *Piräus-reliefs und Parthenos-Schild.* Bochum.

Stroud, R. 1979. *The Axones and Kyrbeis of Drakon and Solon.* Berkeley.

Stuart, J., and Revett, N. 1789. *The Antiquities of Athens.* London.

Stucchi, S. 1981. *Divagazioni archeologiche*, 1. Rome.

Sturgeon, M. C. 1977. "The Reliefs on the Theater of Dionysos in Athens," *AJA* 81, 31–53.

Styrenius, C.–G. 1967. *Submycenaean Studies.* Lund.

Sweeny, J., Curry, T., and Tzedakis, Y. 1988. *The Human Figure in Greek Art.* Athens and Washington, D.C.

Talalay, L. E. 1993. *Deities, Dolls, and Devices: Neolithic Figurines from Franchthi Cave, Greece.* Bloomington and Indianapolis.

Tanoulas, T. 1987. "The Propylaia of the Acropolis since the 17th Century," *JdI* 102, 413–83.

Tanoulas, T. 1992a. "The Pre-Mnesiklean Cistern on the Athenian Acropolis," *AM* 107, 129–60.

Tanoulas, T. 1992b. "Structural Relations between the Propylaea and the Northwest Building of the Athenian Acropolis," *AM* 107, 199–215.

Tanoulas, T. 1994a. "The Propylaea and the Western Access of the Acropolis," in Economakis 1994, 52–68.

Tanoulas, T. 1994b. "The Restoration of the Propylaea," in Economakis 1994, 150–67.

Tanoulas, T. 1994c. "New Discoveries at the Propylaea," in Economakis 1994, 180–83.

Thomas, R. 1989. *Oral Tradition and Written Record in Classical Athens*. Cambridge.

Thompson, D. B. 1944. "The Golden Nikai Reconsidered," *Hesperia* 13, 173–209.

Thompson, H. A. and Wycherley, R. E. 1972. *The Agora of Athens*. The Athenian Agora, Vol. XIV. Princeton.

Tölle–Kastenbein, R. 1993. "Das Hekatompedon auf der Athener Akropolis," *JdI* 108, 43–75.

Tomlinson, R. 1990. "The Sequence of Construction of Mnesikles' Propylaia," *BSA* 85, 405–13.

Tomlinson, R. 1992. *From Mycenae to Constantinople: The Evolution of the Ancient City*. London and New York.

Touloupa, E. 1969. "Une Gorgone en bronze de l'Acropole," *BCH* 93, 862–84.

Touloupa, E. 1972. "Bronzebleche von der Akropolis in Athen: Gehämmerte geometrische Dreifüsse," *AM* 87, 57–76.

Touloupa, E. 1991. "Early Bronze Sheets with Figured Scenes from the Acropolis," in D. Buitron-Oliver, ed., *New Perspectives in Early Greek Art*. Studies in the History of Art, 32. Hanover and London. 241–71.

Tournikiotis, P., ed. 1994. *The Parthenon and its Impact in Modern Times*. Athens.

Townsend, R. F. 1985. "A Newly Discovered Capital from the Thrasyllos Monument," *AJA* 89, 676–80.

Townsend, R. F. 1986. "The Fourth-Century Skene of the Theater of Dionysos at Athens," *Hesperia* 55, 421–38.

Tracy, S. V. 1991. "The Panathenaic Festival and Games: An Epigraphic Enquiry," *Nikephoros* 4, 133–153.

Travlos, J. 1971. *Pictorial Dictionary of Ancient Athens*. New York.

Travlos, J. 1973. "*He pyrpolesis tou Parthenonos hypo ton Eroulon kai he episkeue tou kata tous khronous tou Autokratoros Ioulianou,*" *AE* 1973, 218–36.

Treuil, R. 1983. *Le Néolithique et le Bronze Ancien Égéens*. Athens.

Triandi, I. 1994. "*Paratereseis se duo omades glyton tou telous tou 6ou aiona apo ten Akropole,*" in Coulson et al., 1994, 83–91.

Trikkalinos, J. K. 1972. *Die Geologie der Akropolis: Kleintektonische Untersuchungen*. Athens.

Tschira, A. 1972. "Untersuchungen im Süden des Parthenon," *JdI* 87, 158–231.

Tyrrell, W. B., and Brown, F. S. 1991. *Athenian Myths and Institutions: Words in Action*. New York and Oxford.

Van Straten, F. T. 1974. "Did the Greeks Kneel before their gods?" *BABesch* 49, 159–89.

Van Straten, F. T. 1981. "Gifts for the Gods," in H. S. Versnel, ed., *Faith, Hope, and Worship: Aspects of Religious Mentality in the Ancient World*. Leiden. 65–151.

Vanderpool, E. 1966. "A Monument to the Battle of Marathon," *Hesperia* 35, 93–105.

Vanderpool, E. 1974. "The Date of the Pre-Persian City-Wall of Athens," in D. W. Bradeen and M. F. McGregor, eds., *PHOROS: Tribute to Benjamin Dean Meritt*. Locust Valley, N. Y. 156–160.

Vermeule, C. C. 1968. *Roman Imperial Art in Greece and Asia Minor*. Cambridge, Mass.

Vermeule, E. 1972. *Greece in the Bronze Age*. Chicago.

Vermeule, E., and Karageorghis, V. 1982. *Mycenaean Pictorial Vase Painting*. Cambridge, Mass.

Vian, F., and Moore, M. B. 1988. "Gigantes," in *LIMC* IV, 191–270.

Vlassopoulou, Chr. 1988. *Decorated Architectural Terracottas from the Athenian Acropolis*. Princeton.

Walker, S. 1979. "A Sanctuary of Isis on the South Slope of the Athenian Acropolis," *BSA* 74, 243–57.

Walker, S., and Cameron, A., eds. 1989. *The Greek Renaissance in the Roman Empire*. Institute of Classical Studies, Bulletin Supplement 55. London.

Walter, O. 1923. *Beschreibung der Reliefs im Kleinen Akropolismuseum in Athen*. Vienna.

Warren, P., and Hankey, V. 1989. *Aegean Bronze Age Chronology*. Bristol.

Weber, M. 1993. "Zur Überlieferung der goldelfenbeinstatue des Phidias im Parthenon," *JdI* 108, 83–122.

Webster, T. B. L. 1967. *The Tragedies of Euripides*. London.

Weidauer, L., and Krauskopf, I. 1992. "Urkrönige in Athen und Eleusis: Neues zur 'Kekrops'-Gruppe des Parthenonwestgiebels," *JdI* 107, 1–16.

Weis, H. A. 1979. "The 'Marsyas' of Myron: Old Problems and New Evidence," *AJA* 83, 214–19.

Welwei, K.-W. 1992. *Athen: Vom neolithischen Siedlungsplatz zur archaischen Grosspolis*. Darmstadt.

Wesenberg, B. 1984. "Augustusforum und Akropolis," *JdI* 99, 161–85.

Wesenberg, B. 1995. "Panathenäische Peplosdedikation und Arrhephorie: Zur Thematik des Parthenonfrieses," *JdI* 110, 149–78.

West, M. L. 1978. *Hesiod: Works and Days*. Oxford.

Whitley, J. 1991. *Style and Society in Dark Age Greece*. Cambridge.

Whitley, J. 1994. "Protoattic Pottery: A Contextual Approach," in I. Morris, ed., *Classical Greece: Ancient Histories and Modern Ideologies*. Cambridge. 51–70.

Winter, F. E. 1982. "*Sepulturae intra urbem* and the Pre-Persian Walls of Athens," in *Studies in Attic Epigraphy, History, and Topography Presented to Eugene Vanderpool*. Hesperia Supplement 19, 199–204.

Winter, N. A. 1993. *Greek Architectural Terracottas from the Prehistoric to the End of the Archaic Period*. Oxford.

Wolters, P. 1899. "Vasen aus Menidi, II," *JdI* 14, 103–35.

Wright, J. C. 1980. "Mycenaean Palatial Terraces," *AM* 95, 59–86.

Wright, J. C. 1994. "The Mycenaean Entrance System at the West End of the Akropolis of Athens," *Hesperia* 63, 323–60.

Wyatt, W. F., Jr., and Edmonson, C. E. 1984. "The Ceiling of the Hephaisteion," *AJA* 88, 135–67.

Wycherley, R. E. 1978. *The Stones of Athens.* Princeton.

Younger, J. G. 1991. "Evidence for Planning the Parthenon Frieze," *AJA* 95, 295 (abstract).

Zaidman, L. B., and Pantel, P. S. 1992. *Religion in the Ancient Greek City.* Cambridge.

Zanker, P. 1988. *The Power of Images in the Age of Augustus.* Ann Arbor.

Zeitlin, F. I. 1990. "Playing the Other: Theater, Theatricality, and the Feminine in Greek Drama," in J. J. Winkler and F. I. Zeitlin, eds., *Nothing to Do with Dionysos?* Princeton. 63–96.

Zeitlin, F. I. 1995. "The Economics of Hesiod's Pandora," in Reeder 1995, 49–56.

Zimmer, G. 1996. "Bronze-Casting Installations on the South Slope of the Acropolis," *AJA* 100, 382–83 (abstract).

Zimmermann, J.-L. 1989. *Les Chevaux de Bronze dans L'Art Géométrique Grec.* Mainz and Geneva.

INDEX